History of Art

The Western Tradition

REVISED SIXTH EDITION

VOLUME 1

History of Art

The Western Tradition

REVISED SIXTH EDITION

VOLUME I

H. W. Janson

Anthony F. Janson

UPPER SADDLE RIVER, NEW JERSEY 07458

Library of Congress Cataloging-in-Publication Data

Janson, H. W. (Horst Woldemar), (date)
 History of art / H. W. Janson and Anthony F. Janson.– Rev. 6th ed.
 p. cm
 Includes bibliographical references and index.
 ISBN 0-13-182623-9 (hardcover)—ISBN 0-13-182895-9 (trade)—ISBN 0-13-182622-0 (v. 1)—ISBN 0-13-192621-7 (v. 2)
 1. Art–History. I. Janson, Anthony F. II. Title.

N5300 .J3 2003
 709–dc21 2003000760

EDITORIAL DIRECTOR: Charlyce Jones Owen
EXECUTIVE EDITOR: Sarah Touborg
MANAGING EDITOR AND PROJECT MANAGER: Julia Moore
COPY EDITOR: Margaret Oppenheimer
EDITORIAL ASSISTANT: Julia Doran Chmaj
PROJECT ASSISTANT: Sasha Anderson
MEDIA EDITOR: Anita Castro
ART DIRECTOR: Beth Tondreau
DESIGN AND PRODUCTION: BTDNYC. *Designers:* Mia Risberg, Beth Tondreau; *Project Manager*: Erica Harrison
COVER, JACKET, AND SLIPCASE DESIGN: BTDNYC
PHOTO EDITING, RIGHTS AND REPRODUCTION: Laurie Winfrey of Carousel
ILLUSTRATOR: John McKenna
MAPS: Adrian Kitzinger
INDEXER: Peter Rooney
DIRECTOR OF PRODUCTION AND MANUFACTURING: Barbara Kittle
PREPRESS AND MANUFACTURING MANAGER: Nick Sklitsis
PREPRESS AND MANUFACTURING BUYER: Sherry Lewis
SENIOR MARKETING MANAGER: Christopher Ruel
MARKETING ASSISTANT: Kimberly Daum

COVER: Urel, detail of figure 2-22, *Mai and His Wife, Urel.* Limestone relief. c. 1375 B.C. Tomb of Ramose, Thebes, Egypt

This book was set in 11.15/13.25 Granjon. It was printed and bound in Italy by Mondadori Printing S.P.A.
The cover was printed in Italy by Mondadori Printing S.P.A.

NOTE ON THE PICTURE CAPTIONS: Each illustration is placed as close as possible to its first discussion in the text. Measurements are given throughout, except for objects that are inherently large: architecture, architectural sculpture, interiors, and wall paintings. Height precedes width. A probable measuring error of more than one percent is indicated by "approx."

Titles of works are those designated by the institutions owning the works, where applicable, or by custom.
Dates are based on documentary evidence, unless preceded by "c."

The birth, death, and ruling dates of individuals, when contained within parentheses, are abbreviated throughout the text as follows: b. = born; d. = died; r. = ruled; fl. = flourished.

©2004 by Pearson Education
Upper Saddle River, NJ 07458

Printed in Italy
10 9 8 7 6 5 4 3 2 1

ISBN 0-13-182622-0

Pearson Education Ltd., London
Pearson Education Australia Pty, Limited, Sydney
Pearson Education Singapore, Pts. Ltd.
Pearson Education North Asia Ltd., Hong Kong
Pearson Education de Mexico, S.A. de C.V.
Pearson Education—Tokyo, Japan
Pearson Education Malaysia, Pte. Ltd.
Pearson Education, Upper Saddle River, New Jersey

Contents

[ALL SIDEBARS ARE IN SMALL ITALICS]

Preface and Acknowledgments to the First Edition

The title of this book has a dual meaning: it refers both to the events that *make* the history of art and to the scholarly discipline that deals with these events. Perhaps it is just as well that the record and its interpretation are thus designated by the same term. For the two cannot be separated, try as we may. There are no "plain facts" in the history of art—or in the history of anything else for that matter, only degrees of plausibility. Every statement, no matter how fully documented, is subject to doubt and remains a "fact" only so long as nobody questions it. To doubt what has been taken for granted, and to find a more plausible interpretation of the evidence, is every scholar's task. Nevertheless, there is always a large body of "facts" in any field of study; they are the sleeping dogs whose very inertness makes them landmarks on the scholarly terrain. Fortunately, only a minority of them can be aroused at the same time, otherwise we should lose our bearings; yet all are kept under surveillance to see which ones might be stirred into wakefulness and locomotion. It is these "facts" that fascinate the scholar. I believe they will also interest the general reader. In a survey such as this, the sleeping dogs are indispensable, but I have tried to emphasize that their condition is temporary and to give the reader a fairly close look at some of the wakeful ones.

I am under no illusion that my account is adequate in every respect. The history of art is too vast a field for anyone to encompass all of it with equal competence. If the shortcomings of my book remain within tolerable limits, this is due to the many friends and colleagues who have permitted me to tax their kindness with inquiries, requests for favors, or discussions of doubtful points. I am particularly indebted to Bernard Bothmer, Richard Ettinghaúsen, M. S. İpşiroğlu, Richard Krautheimer, Max Loehr, Wolfgang Lotz, Alexander Marshack, and Meyer Schapiro, who reviewed various aspects of the book and generously helped in securing photographic material. I must also record my gratitude to the American Academy in Rome, which made it possible for me, as art historian in residence during the spring of 1960, to write the chapters on ancient art under ideal conditions, and to the Academy's indefatigable librarian, Nina Langobardi. Irene Gordon, Celia Butler, and Patricia Egan have improved the book in countless ways. Patricia Egan also deserves the chief credit for the reading list. I should like, finally, to acknowledge the admirable skill and patience of Philip Grushkin, who is responsible for the design and layout of the volume; my thanks go to him and to Adrienne Onderdonk, his assistant.

H. W. J.

1962

Preface and Acknowledgments to the Revised Sixth Edition

This edition marks the fortieth anniversary of Janson's *History of Art.* That is remarkable in itself. No less notable is that until now there have been only two authors: H. W. Janson, who wrote much of the book at the American Academy in Rome, and myself, who took over the revisions upon his death in 1982. Actually, I have been associated with Janson's *History of Art* since 1961, when, still in my teens, I proofread much of the original edition over the summer in the Amsterdam office of Harry N. Abrams, Inc. Without that experience, I probably would not have become an art historian. My "apprenticeship" consisted of revising my parents' *Story of Painting for Young People* and *A Basic History of Art* under my father's nominal supervision. Yet, somehow I never really expected to take on the full *History of Art,* and merely assumed it would be turned over to some famous scholar. Least of all was I prepared to take on the responsibility for it so soon after my father's unexpected death in 1982.

Those who have known the book over the years will recognize my increasing contribution, which is now roughly equal to my father's. The original character of the book has inevitably changed in the process—whether for better or worse I leave to the reader to judge. One thing has not changed: Janson's *History of Art* continues to be based on a humanist vision. It makes no claim to have adopted newer theories and approaches to the subject, which I consider perfectly legitimate in their own way. (See "Approaches to Art History" in the Introduction.) The book is still based on the experience of looking at works of art in person and, through thoughtful seeing, understanding what they have to say.

Although there have been only two authors, there have now been nearly a dozen different editors who have put red pencil to manuscript over the years. Thus my main objective in this edition was to restore the integrity of voice and style, which had become noticeably frayed by the Sixth Edition, and to give it the directness that characterizes the writing of both authors. I have also made innumerable small factual corrections throughout the book, which specialists will recognize. Toward that end, I engaged Dr. Mary Ellen Soles, who has given me much good advice in the past, to review Part One for errors and provide suggestions that proved extremely helpful. For the same reasons, I also asked modernist Joe Jacobs to contribute entries on Jeff Koons and Andreas Gursky and to suggest other choices, such as Alison Saar.

A new feature of this edition is the Primer of Art History by Julia Moore, which provides a handy starting point for understanding the field and its basic concepts, as well as the fundamentals of visual analysis, which had been treated at the end of previous Introductions. Another new feature is extended captions featuring commentaries by a number of the great art historians of the past, as well as some from the present. Although it was not possible to accommodate as many of the founders of the discipline as I would have liked, the intent is to honor the giants on whose shoulders we still stand, whether we admit it or not. Having known quite a few of them personally, it is a privilege for me to quote some of their finest insights.

The most significant change in content is Chapter Fourteen, "The Late Renaissance." Its previous title, "Mannerism and Other Trends," was cumbersome as well as misleading. I have chosen to look at the period from the other end of the telescope, so that it now takes the religious art seriously and ties it to the Catholic Reform movement, whose early history I have traced in some detail because it is so little known to most readers. I would like to express my gratitude to my colleague James McGivern for guiding me to the latest literature on the theology of the period, which over the past few years has revolutionized our understanding of the Counter Reformation, as the movement is also known, and to David Lyle Jeffrey of Baylor University, for reading the chapter to ensure its accuracy. I have also rearranged Early Renaissance art according to genres instead of chronological sequence, which many readers found confusing. Finally, I have followed the reinterpretation of Etruscan funerary art initiated in recent years by German and English art historians, which gives new meaning to this fascinating subject.

I have undertaken the task of adding the historical setting systematically to the text wherever it is relevant, rather than solely for its own sake—lest it float irrelevantly like fat on top of chicken soup (as Gustav Mahler's music was once aptly described) without mixing with the art itself. Most of this background is to be found in Parts One and Two, although a large amount of the historical framework has also been supplied for several chapters in Part Three. Because I was a history major as an undergraduate, it is the one thing I have always felt this book needed most, along with a proper representation of women and minority artists, which I have added over the years. My approach to history emphasizes people and events that have affected art history , rather than social history. While admirable in itself, social history too often ignores the work of art by focusing exclusively on context, while adding more background material than most readers and students can assimilate. As in previous editions, the history of music and theater is treated in separate "boxes" within chapters for those who share my enthusiasm for these art forms. Several of them have been updated, especially those on twentieth-century music owing to my "discovery" of the work of a number of composers, particularly Shostakovich's chamber music.

I want to correct a serious but unintentional omission from the preface to the Sixth Edition. My former student Gregory Plow wrote an independent study paper under me on Raphael's Stanza della Segnatura frescoes, which led me to rethink their meaning. While we reached somewhat different conclusions, his help was invaluable, not only in digging up research that was sometimes hard to find, but also in bouncing ideas off each other. This experience was wonderfully stimulating and rewarding for both of us, and represents the finest ideal of teaching, which was first established by Plato at the grove of Akademia outside Athens.

There is a larger debt as well. Plow and his closest friend, David Myers, who wrote an equally splendid honor's thesis under me on Thomas Cole's "The Cross of the World," inspired me to rethink the meaning of Christianity and its contribution to the art and culture of the past, which gave rise to the sweeping changes in the chapter on the Late Renaissance and elsewhere in this edition A great deal of religious art in the West is badly misunderstood because many art historians, it is safe to say, are nonbelievers. They include Christianity as part of iconography and history without accepting it or comprehending it in spiritual terms, especially in the terms it was understood by the faithful as it evolved over time and space. Good students learn from good teachers. Fortunately, the reverse is true, too: Good teachers learn from good students. It is thus with great pleasure that I can at last properly acknowledge the contribution of two of my best pupils.

This edition marks the passing of an era in several important respects. La Martinière Groupe, which purchased Harry N. Abrams, Inc., from the Los Angeles Times-Mirror Corporation several years ago, recently sold the textbook division to Prentice Hall, Inc., which has distributed this and other Abrams books to the college market from the beginning of the association between the two firms in 1962, which was brought about by the publication of Janson's *History of Art*. Then in June

2002, Paul Gottlieb, Abrams' long-time publisher, who built the company into what it became and was its very heart and soul, died unexpectedly. He was a reassuring presence as long as he was still associated, however distantly, with Abrams. He passed away shortly after accepting the opportunity to lead the photography publisher Aperture. Paul was more than my publisher. He was a friend and ally to whom I could turn for advice on the most sensitive professional and personal matters. When the occasional differences of opinion arose, we simply agreed to disagree, even after the most heated exchange. All of us who knew him well feel a gaping hole that stubbornly refuses to close.

I want to express my gratitude to the many people of who have worked so hard on this book. Above all I want to acknowledge Julia Moore, Director of the Textbook Division at Abrams for more than ten years, who has been an important muse and intellectual collaborator for me. She understands what makes Janson unique and has maintained that standard against the odds. In this edition, Julia was assisted in-house by a most gifted editorial assistant, Julia Chmaj, who I am sure will one day make her own mark as an art historian, and who handled even the most difficult chores calmly and ably; and by freelance copy editor Margaret Oppenheimer. Beth Tondreau of Beth Tondreau Design was the art director of this beautiful edition and directed its production, which maintains the high quality of the past. I also want to thank Barbara Lyons, now retired, who for many editions went out of her way to procure some extremely rare photographs. Equally resourceful and dogged in pursuing images was Laurie Platt Winfrey of Carousel Research, which was responsible for assembling the illustrations and reproduction rights. My sincere appreciation goes to the many others at Prentice Hall and Abrams, who are too numerous to include here but who are listed in the masthead, for their invaluable contributions to the success of this edition, which I believe is the best one yet.

A. F. J.

January 2003

This edition is dedicated to Helen, who has launched my ship a thousand times.

Primer of Art History

The Introduction to this book, which begins on page 22, has been written by H. W. Janson and Anthony F. Janson over a period of more than 40 years. Although presented as a deceptively simple narrative, the Introduction is actually a gathering of eloquent linked essays, some of which explore questions that are among the most meaningful we could be asked: What is art? What is essential to the creation of art? What makes a visual artist different from other people? Why does an artist make art? Does it matter whether anyone besides the artist sees and experiences the things an artist creates? Is your opinion as good as the next person's? These questions have many possible responses and, wisely, the Jansons ask us to try to answer them for ourselves, with as much authenticity as we can summon.

This brief Primer of Art History, by contrast, does not ask profound questions. Its two purposes are quite plain. One is to introduce you to the field of art history as a humanistic discipline. The other is to provide you with a set of basic tools to take with you on your journey with art from prehistory to the present.

The oldest surviving expressions of human culture are prehistoric. Almost 90,000 years ago, human beings began fashioning and decorating beads—evidence of symbolic thinking—and they had been shaping specialized tools far longer. Recent genetic studies suggest that spoken languages probably developed more than 50,000 years ago. Then, about 30,000 years ago, our ancestors began painting subtly expressive images of animals on the walls of caves in southern Europe. Thus the tangible evidence we have of our distant ancestors' lives and values is their handiwork and their art. When you study art history, from the very beginning you are engaging with real objects of human experience. As the Jansons' Introduction says so eloquently, however, art objects are not ordinary, forced-by-necessity creations, but are things made to satisfy uniquely human aspirations and longings.

The Field

Art history is a relatively new field of study compared, for example, to literature and philosophy. In the United States, art history began to flourish as a scholarly discipline and a college and university curriculum only in the twentieth century, and mostly after World War II. (Technology affected art history's late start, because until the advent of photography and of printing technologies that could reproduce images cheaply enough to circulate widely, it was rare for one person to see, remember, and compare a great number of physical objects—to say nothing of publishing illustrated books and articles about art.) Art appreciation, which is taught at colleges and universities and is an important component of museum education programs, invariably includes some art history in the process of exposing and sensitizing us to visual culture. Likewise, art history's more rigorous and systematic study of art across time inevitably ignites a lifelong appreciation of the objects of study.

ART HISTORIANS. Men and women who devote their lives to the study of art are called art historians. Most art historians

have advanced degrees, and most are passionate and articulate about art and ideas. This edition of *History of Art* draws attention to these qualities in 24 extended captions that capture the rigor, passion, and curiosity of some of this century's most distinguished art historians.

What, besides teaching, do art historians do? Some research and write, thus contributing to art history's body of knowledge or disseminating what is known to a wider audience. Others are museum professionals: curators, administrators, archivists, and conservators. Fewer independent experts advise museums and collectors about acquisitions. Some gallery owners and staff are art historians, and so are a number of publishing professionals, especially editors. What they all share is a pervading sense of excitement about the object of their attention, art.

APPROACHES. Like all fields of inquiry, art history has undergone some fundamental changes. For a long time, art history was confined to the so-called fine arts of painting, sculpture, and architecture. Drawing and the graphic arts—works printed on paper—were also included. Stained glass and decorated (illuminated) manuscripts were regarded as painting, and so qualified as fine art. Photography was admitted to the field of study a few decades ago. More recently, art historians have expanded the definition of art to include works in many mediums (*mediums,* not *media,* is the art historian's preferred plural; medium is the material the artist uses to make the artwork). Today textiles and other fiber arts, metalworking and silver- and goldsmithery, ceramics, glass, beadwork, and mixed mediums are in art history's realm. Modern and contemporary art, especially, has forced open the borders by constantly questioning and expanding the range. Happenings (one-time performed creations staged by artists in the 1950s), earth art, video art, performance art, installations, computer art, and almost anything selected by an artist and declared to be art are now generally acknowledged to be forms of art-making.

Not all art historians approach the subject the same way. Some concentrate on *connoisseurship:* the way art looks. They note and savor visual elements—such as line, color, shape, mass—and the materials and techniques the artist used to create a work of art, then analyze how these were brought together to achieve a certain appearance and have a certain effect. The visual elements are referred to as *formal elements,* and the term *formalism* denotes art history that emphasizes the art object per se, comparatively independent of historical and other non-artistic influences. A formalist looks first and foremost to other artworks to find the answers to why something looks the way it does and what the artist meant by it.

Clearly allied to formalism is *iconography,* the description of images and the study of their meanings, which includes decoding visual symbols (see below, "Symbols"). *Iconology,* which is related to iconography, is the science of images' meanings synthesized with insights from many other fields, such as psychology, sociology, and economics; this process greatly expands the context of any work's creation—and thus possibility for larger interpretation of its meaning. Iconography and iconology were for many years a mainstream tradition of art history. Only recently have they shared the stage with newer schools that view art history from the vantage points of gender, nationality, politics, social criticism, and the humanistic disciples. The most important of these are discussed at the end of the Introduction.

Art historians who take into consideration what was happening at the time and place of an artwork's creation to explain why a work looks the way it does are practicing *contextualism* and are known as *contextualist* art historians. They explore questions such as: What do we know about the artist? Who had political and economic power at the time? Who paid for artworks, and what were the motives of these people, called patrons? What ideas were circulating in educated circles at the time? Today, most art history, including Janson's *History of Art,* is a fusion of formalism and contextualism.

Where Will You Find Art?

The answer is, "Almost everywhere." We can experience it firsthand or secondhand. Museums are obvious places for face-to-face encounters with the real thing. However, art sheltered in museums is separated from the original context of its creation, whether dug from the site of a long-buried civilization, taken from a church or palace, or even removed from the living room wall of a wealthy collector One of the pleasures of studying art history is that it equips us to re-create the contexts, which we bring to bear on art wherever we find art: painted on the inside walls of caves, built as architectural sites all over the world, carved into rock, laid into floors, woven into special garments, erected in parks and malls, installed in corporate offices and private dwellings, and now, winking at us from computer screens.

When we look at reproductions of art, as we do in illustrated books, journals, magazines, posters, and notecards, in the darkened classroom, and on CDs, dedicated websites, and the Internet, we trade quantity for quality. Only real objects can tell us size and scale, true color and texture, and can reveal aesthetic attributes too subtle to capture except by direct experience. Still, most of us begin our relationship with art through the medium of reproductions, invariably accompanied by words.

The Specialized Vocabulary of Art

The fundamental quality of art is visual and/or spatial. We need to "read" art and architecture in their terms. To do so, however, it is almost essential to master and use the vocabulary and grammar that have been devised to help convert the visual experience into the common currency of language. We need to accept the premise that words are symbolic translations of the visual experience, which is a powerful and direct transaction between eye and mind. Much of the great power of images lies in that fact.

The better we understand the specialized vocabulary, grammar, and syntax of art history, the more we benefit from the work of people who spend their lives looking at and making sense of art. Art historians and critics are, after all, attempting to bring order and meaning to this vast—and specialized—form of human expression.

BASIC TERMINOLOGY. Both two-dimensional art (paintings and works of graphic art, for example) and three-dimensional sculpture rely on descriptors such as *representational, realistic, abstract,* and *nonobjective* to broadly categorize an artist's visual approach to a subject. **Representational art** has subject matter that is recognizable from the natural world. **Realistic art** shows a high degree of imitation, or verisimilitude, of the actual object or subject. **Abstract art** simplifies and alters the appearance of actual forms (they can still be recognizable) for various purposes, often to suggest an essence or universality. **Nonobjective art** deals with forms that lack any reference to the natural world. Also referred to as **nonrepresentational** or **nonfigurative,** it relies solely on the interplay of formal visual elements. Much modern art is nonobjective.

FORMAL ELEMENTS. What are the formal elements? They include *line, shape, mass,* and *color,* as well as texture and composition. **Line** can be drawn to define outlines, edges, and contours of forms and delineating shapes. Line imparts direction and movement, even when it is not a continuous mark. Implied lines, which our eyes seek out and our brains mentally connect, can be pictorially as effective as an actual, continuous line.

Shape is a two-dimensional form, an area on a flat plane. **Form** is three-dimensional, occupying a volume of space. Sculpture that is freestanding is **mass.** So is architecture. But you experience architecture by moving around, into, and through it, not merely around it, as you have to do with sculpture.

Texture and color, which are activated by light, are the two other most important formal elements. Texture can refer to the actual surface quality of a work of art or architecture or to the surface that the artist has imitated.

Full understanding of color lies in the realm of physics. **Color** is the effect on our brains of light of differing wavelengths reflected off objects. The source light is usually white light, which is a combination of all colors. Objects absorb particular parts of white light, while reflecting others, so that they give the optical impression of having a particular color. It is helpful to understand the meaning of three color-related terms when you are reading about art. They are *hue, value,* and *intensity.* **Hue** refers to the essential color. The visible colors of a rainbow are the so-called spectral hues of red, orange, yellow, green, blue-violet and violet. In the case of a rainbow, when the white light of the sun passes through drops of water in the air, the raindrops become like crystal prisms that separate wavelengths of light into the spectral hues.

Value refers to the degree of lightness or darkness of a color. Two additional terms are sometimes used when describing value. One is **tint,** a color lighter than the hue's normal value, and the other is **shade,** a color darker than normal. Thus, apple green is a tint of pure green, and forest green is a shade. Finally, there is the term **intensity** (also called *saturation* or *chroma*). Intensity is the degree of a hue's purity. The closer a color is to the original rainbow-spectrum hue, the higher its intensity and the brighter its appearance.

THE ILLUSION OF SPACE. Artists working in two-dimensional arts are challenged with representing the real world of three-dimensionality on a flat plane. The flat surface, termed the **picture plane,** is the field on which the artist builds the illusion of space and three-dimensionality. **Picture space** is a term for what is created in that illusion. Artists have devised many pictorial strategies for suggesting space and objects in space, among them:

The *picture plane* is the actual, physical surface on which the artist works. It may be a wall, a wood panel, canvas, shield, box lid or whatever surface is chosen. The *picture space* is the apparent depth—the pocket of space that seems to exist behind the picture plane—created by the use of perspective.

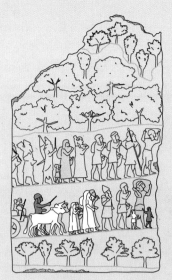

In *vertical perspective*, objects in the lower zone or zones are to be understood as closer to the viewer than objects in the upper zone or zones. *Overlapping* is another way of indicating relative position of objects in space; it relies on our experience that forms partly obscured behind other forms are further distant from us. In this loose rendering of an Akkadian tablet, we see both vertically arranged and overlapping forms. Notice that although all feet are on the same ground-line, the upper parts of some of the animals and people overlap. Both these methods of suggesting depth and distance prevailed until the fifteenth century.

vertical stacking of forms, the **overlapping** of forms, and the illusion of distance by gradation of color from intense to pale, often bluish hues (**atmospheric** or **aerial perspective**).

Atmospheric, or *aerial, perspective* relies on re-creating in color the appearance of distance: colors that pale as the distance deepens or are bluish or hazy. This detail is from a sixteenth-century altarpiece painted by a northern European artist. **(Hieronymus Bosch. Detail from the central panel of *The Adoration of the Magi* triptych. c. 1510. Oil on panel. The Prado, Madrid)**

Since the Italian Renaissance in the fifteenth century, the Western tradition has settled on **scientific,** or **linear, perspective** as the most satisfactory method. It is based on two observations. One is that forms look smaller the farther away they are, and the other is that parallel lines (such as railroad tracks) appear to converge and vanish at the point in the distance where sky meets earth. Scientific perspective assumes the artist's (and viewer's) fixed position and one or more **vanishing points** on a **horizon line.**

ONE-POINT PERSPECTIVE

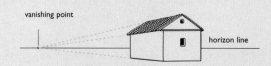

One-point perspective has all planes and angles receding along imaginary lines to a single point on a real or imaginary *horizon line,* the so-called *vanishing point.*

TWO-POINT PERSPECTIVE

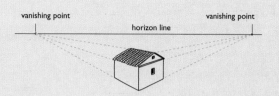

In *two-point perspective,* planes are angled to two different points on the horizon line.

Another way artists suggest three-dimensionality is with the depiction of **light.** It is, after all, light that allows us to perceive forms. In the dark, form is invisible. By manipulating the range from light to dark, called the *value scale,* artists can define forms by suggesting shadow, and they can tell us where the light source is.

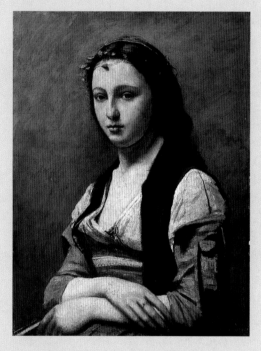

In this painting by Corot, the figure's appearance of three-dimensionality is created chiefly by the manipulation of light and shadow. The cast shadows indicate the direction of the light source. (Jean-Baptiste-Camille Corot. *The Woman with the Pearl.* c. 1858–68. Oil on canvas. Musée du Louvre, Paris)

COMPOSITION. The way an artist puts the formal elements together is called **composition.** Whether it be a painting, a sculpture, or even a work of architecture, composition is distinctive from artist to artist and from culture to culture. Composition is one of the most closely studied attributes of an artwork, especially in formalist art history, because composition is one of the most revealing dimensions of style in a work of art.

STYLE. The word *style* used in art history is different from other, more general uses for the word. With art, it describes the combination of distinguishing characteristics that imprint a work of art as the creation of a certain artist, or time, or place. As the Jansons say so eloquently in their Introduction, "To art historians the study of styles is of central importance. It not only enables them to find out, by means of careful analysis and comparison, when, where, and often by whom a given work was produced, but it also leads them to understand the artist's intention as expressed through the style of the work."

SUBJECT MATTER. What else reveals the artist's intention? **Subject matter**—so to speak, the topic of an artwork—is an obvious clue to intention. Although the choice is always significant in itself, subject matter is neutral. But the way the artist handles the subject is infinitely variable and is not neutral. Subject matter does not need to be pictorially recognizable. An artist intending to create an expression of grief, for example, has many choices, from making a realistic portrayal of a person grieving the death of a loved one, to a totally nonobjective, subjective evocation of the emotional state of grief. The subject matter will be the same. The appearance, or form, will be utterly different.

SYMBOLS. For as long as people have been making images, they have been devising and using pictorial **symbols** to represent abstract ideas or abstract dimensions of real objects. The earliest written languages employ pictographic symbols to stand for objects and ideas; Egyptian hieroglyphics are examples of this. The evangelists of New Testament theology are often represented by symbols: an angel or human being for Matthew, a lion for Mark, a steer for Luke, and an eagle for John. At this level, these images can be either symbols for the individual evangelists or, when shown in connection with a picture of an evangelist, an **attribute,** or visual identifier of the figure in the picture. Symbols constitute a language of their own, and iconography, one of art history's most fascinating sub-disciplines, is devoted to exploring their meaning.

SYMBOLS OF THE EVANGELISTS

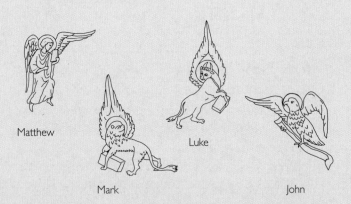

Matthew

Mark

Luke

John

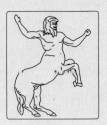

Centaur

The centaur—the part human/part horse creature of ancient Greek mythology—is symbolic in a different way. One of its references is to the dual nature of man: the wild and irrational alongside the rationally self-controlled. Another is to the body/mind duality and conflict so prevalent in Western thinking.

FORM AND CONTENT. Symbols are form. Their meaning is an aspect of content. **Form** is what we see in a work of art, what is visible. It is indisputable. What we interpret from the form is called **content**—the message or meaning of the work. The content of the realistic and the nonrepresentational images of grief mentioned above will vary for every single viewer, not just because the forms are different but because every person brings a different set of experiences, emotional makeup, cultural conditioning, and kinds of knowledge to his or her experience.

Content is nourished by whatever knowledge we can bring to our encounters with works of art, including knowing the times and places of their creation, having an understanding of style, and possessing an informed notion of what the artist intended to say. But it is also fed by life itself. It is safe to say that the more you know about life, the more you know about art, because you bring broader and richer experience to your encounters.

Museum Labels and Illustration Captions

Museums as places where the general public can go to see and learn more about art are a relatively recent invention. As permanent as they seem today, museums as we know them did not exist before the eighteenth century. The same is true of privately owned galleries, which sell works of art. Art museums are as large as The Metropolitan Museum of Art in New York City or Musée du Louvre (the Louvre) in Paris and as small as a one- or two-room exhibition space associated with a college or university to house a small or specialized collection.

What almost all museums have in common is a strong educational component, including a lot of explanatory written material: illustrated catalogues and labels and informative interpretations (wall texts) that appear in proximity to artworks. In addition, most museums have websites (see pages 1003–07, Art and Architecture Websites, for many museum website addresses).

Museum labels and **illustration captions** in a book such as this one use specialized conventions:

1 Name of artist. Usually given first name first, the artist's name is followed by nationality and life dates. From the information in this label, we learn that although Duchamp was born in France, the Philadelphia Museum of Art refers to him as American. (In fact, he did spend many decades of his long life in the U.S.)

2 Name of work. The Philadelphia Museum of Art is among a slowly growing number of institutions to place the title of the work before the name of the artist.

The title a museum gives to a work in its possession is considered authoritative and should be used. When titles are changed, it is usually because research has revealed important reasons to rename a work.

3 Date of work. The date of creation usually follows the name of the work.

4 Material. The medium is oil paint on canvas. Technique will be given when it is relevant. An example would be "cast bronze."

5 Dimensions. Size is sometimes given and sometimes omitted in museum labels. Dimensions in a caption are given height before width before depth, often in both imperial (inches/feet) and metric (centimeters/meters) measure. Size is deceiving in reproductions. Measurements are less critical to have when one is standing in front of the original.

6 Donor or collection information. While not essential information to identifying the work of art, the names of the donors who gave the work to the institution—or donated funds used to purchase it—are part of the work's history. Museums want to credit the generosity of donors, who are vital to the health of the institution.

7 Accession number. Invariably the last item of information on a museum label, the accession number is a unique identifying code. Usually, it includes the year the work came into the collection, in this case, 1950.

8 Copyright information. More and more, as copyright of artworks is claimed by institutions, heirs of artists, and image providers, copyright information appears in illustration captions. This copyright line indicates that Succession Marcel Duchamp holds copyright of this image and is represented by Artist Rights Society, New York (ARS, NY).

Some museums provide additional information and interpretation in the form of **wall text**. When an installation has a lot of written information on the walls, it almost begins to replicate the experience of reading an art book. In that case, the challenge to us is how to balance our attention between the artwork and the information about it.

JULIA MOORE
January 2003

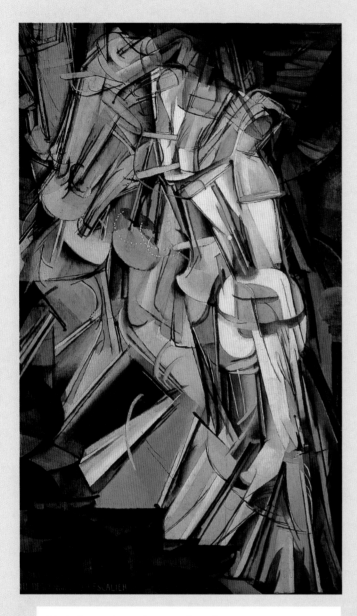

2 *Nude Descending a Staircase (No. 2)*

1 Marcel Duchamp, American, born France, 1887–1968

3 1912

4 Oil on canvas

5 58 x 35" (147.3 x 89 cm).

6 The Louise and Walter Arensberg Collection, 1950

7 950-134-59

8 **[in an illustration caption]**
 © Succession Marcel Duchamp, 2001, ARS, NY

Introduction

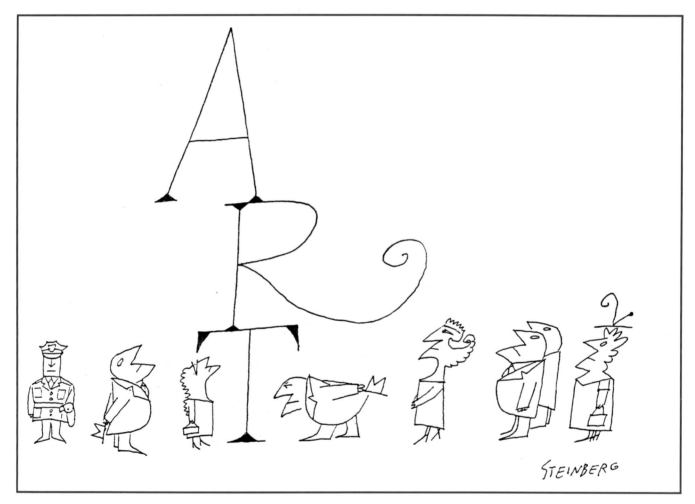

ART AND THE ARTIST

What is art? Few questions have given rise to so many different answers. The problem, as we see in the above cartoon, is that art is an object and a word. Both vary widely in different times and places and in different cultures. In the past hundred years they have changed so much that all the old definitions and even the categories of art are obsolete. The reason is not hard to find: more change occurred in the twentieth century than in any other period in history. The modern era has been both exhilarating and disturbing. It opened up new horizons that greatly expanded life's

possibilities, but at the same time it challenged our most cherished beliefs. Art as we know it is a direct outgrowth of the industrialized world, with its advanced technology, global economy, large middle-class yet highly fragmented society, and democratic institutions. Under such unique conditions it is impossible to come up with a universally valid definition of art. We must therefore leave this task to philosophers and aestheticians.

Nevertheless, there is still a good deal that can be said. Looking again at our cartoon, we see that art is not just any kind of object. It is an aesthetic object. Art is meant to be looked at and appreciated for its own sake. Its special qualities set art apart, so that it is often placed away from everyday life—in museums, caves, or churches—though much of it was made to be lived with. What does aesthetic mean? It is defined as "that which concerns the beautiful." Of course, not all art is beautiful to each person's eyes, but it is still art. No matter how unsatisfactory, the term will have to do for lack of a better one.

Aesthetics is a branch of philosophy that has occupied thinkers from Plato to the present day. Like all philosophical matters, it is subject to debate. During the last hundred years, aesthetics has also become a field of psychology, which has come to equally little agreement. Why is this so? On the one hand, people the world over make many of the same basic judgments. Our brains and nervous systems are the same because, according to recent theory, every human being is descended from one woman who lived in Africa a quarter-million years ago. On the other hand, taste is a product of culture, which is so varied that it is impossible to judge art by any one set of standards. It seems, therefore, that we cannot establish absolute standards for judging art. Instead, we must view works of art in the context of the culture in which they were created, whether past or present. How indeed could it be otherwise, so long as art is still being created all around us, opening our eyes almost daily to new experiences and forcing us to adjust our thinking?

Imagination

We all dream. That is imagination at work. To imagine means to make an image—a picture—in our minds. Human beings are not the only creatures who have imagination. Animals also dream. However, humans are the only creatures who can tell one another about imagination in words, pictures, or music. No other animal has ever been observed to draw a recognizable image spontaneously in the wild. In fact, their only images have been produced under carefully controlled laboratory conditions that tell us more about the experimenter than they do about art. There can be little doubt, though, that humans have the ability to create art. By the age of five every normal child has drawn a moon pie-face. This ability is one of our most distinctive features.

Imagination is a mysterious gift. It can be viewed as the link between the conscious and the subconscious, where most of our brain activity takes place. It is the glue that holds our personality, intellect, and spirituality together. Because it responds to all three, it acts in ways that are determined by the mind. Imagination is important, as it allows us to conceive of all kinds of possibilities in the future and to understand the past in a way that has real survival value. It therefore is an essential part of our makeup. In contrast, the ability to make art must have been acquired relatively recently in the course of human evolution. Human beings have been walking the earth for nearly 4.5 million years, although our own species (homo sapiens) is much younger than that. By comparison, the oldest known prehistoric art was made only about 35,000 years ago, but it was undoubtedly the culmination of a long process of development that we cannot trace because the record of the earliest art is lost.

Who were the first artists? In all likelihood, they were shamans. Like the legendary Greek poet Orpheus, who sang his words while playing the lyre, they were believed to have divine powers of inspiration and to be able to enter the underworld of the subconscious in a deathlike trance—but

unlike ordinary mortals, they could then return to the realm of the living. With this unique ability to penetrate the unknown and express it through art, the artist-shaman gained control over the forces hidden in human beings and nature. Even today artists are magicians whose work can mystify and move us—an embarrassing fact to civilized people, who do not like to give up their veneer of rational control.

Creativity

The making of a work of art is much like the story of Creation told in the Bible. However, this divine ability was not fully realized until Michelangelo described the creative experience as "liberating the figure from the marble that imprisons it." Perhaps that is why the concept of creativity was once reserved for God, as only he could give material form to an idea. In human terms, the metaphor of birth comes closer to the truth than the notion of a transfer or projection of an image from the artist's mind. The making of a work of art is both joyous and painful, full of surprises, and in no sense mechanical. Moreover, artists themselves tend to look upon their creations as living things. This magical aspect of art was given charming expression by the Roman poet Ovid in his *Metamorphoses*. He tells the story of Pygmalion, who carved such a beautiful statue of the nymph Galatea that he fell in love with it and prayed to Venus, the goddess of love, to bring it to life. Fortunately for him, his wish was granted. (The tale is familiar to us as the basis for the musical *My Fair Lady*.) We can readily understand the tale when it comes to realistic sculpture. But would the artist feel the same way today, when abstract art is the norm? Strange though it may seem, the answer is Yes, as the cartoon on this page suggests. The reason is that a work represents the artist's highest aspirations and deepest understanding, no matter what form it takes.

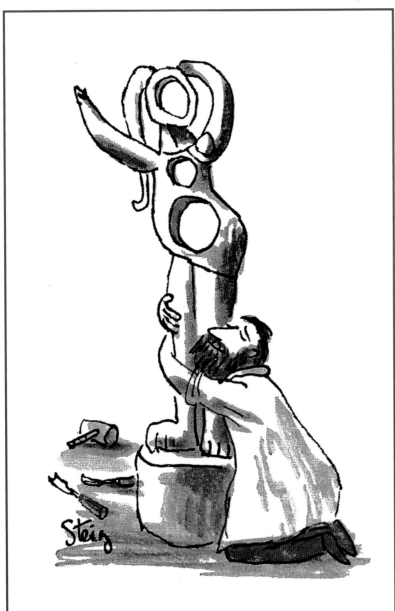

The creation of a work of art has little in common with what we usually mean by making. It is a strange and risky business in which the makers never quite know what they are making until they have actually made it. To put it another way, making art is like a game of hide-and-seek in which the seekers are not sure what they are looking for until they have found it. In some cases, it is the bold "finding" that impresses us most; in others, it is the strenuous "seeking." For the non-artist, it is hard to believe that this uncertainty, this need to take a chance, is the essence of the artist's work. Whereas artisans generally attempt what they know to be possible, artists are driven to attempt the impossible—or at least the improbable or seemingly unimaginable. What defines art, then, is not any difference in materials or techniques from the applied arts. Rather, art is defined by the artist's willingness to take risks in the quest for bold, new ideas.

What sets great artists apart from others is not simply the desire to seek but the mysterious ability to find. This talent is often called a "gift," implying that it is a sort of present from some higher power. It is also described as "genius," a term that originally meant that a higher power— a kind of "good demon"—inhabits and acts through the artist. When creativity is at its height, artists speak of being inspired by the muses that were believed to govern the liberal arts in antiquity. And when the well runs dry, they feel as if the muse has abandoned them.

Inspiration is sometimes experienced as a sudden leap of the imagination, but only rarely does a new idea emerge full-blown like the Greek goddess Athena from the head of Zeus, her father. Instead, it is usually preceded by a long period in which all the hard work is done without finding the solution to the problem. At the critical point, the imagination makes connections between seemingly unrelated parts. Ordinarily, artists work with materials that have little or no shape of their own. The creative process then consists of a long series of smaller leaps of the imagination and the artist's attempts to give them form by shaping the material.

One of the attributes that distinguishes great artists is their great mastery of technique, which enables them to give their ideas full expression in visible form. Their superior ability is recognized by other artists, who admire their work and seek to emulate it. This is not to say that facility alone is all that is needed. Far from it! The academic painters and sculptors of the nineteenth century were among the most proficient artists in history—as well as the dullest. Clearly, the making of a work of art should not be confused with manual skill or craftsmanship. Some works of art may demand a great deal of technical skill; others do not. And even the most painstaking piece of craft does not deserve to be called a work of art unless it involves a leap of the imagination.

Nor should talent be confused with aptitude. Aptitude is what the artisan needs. It means a better-than-average knack for doing something. An aptitude is fairly constant and specific. It can be measured with some success by means of tests that permit us to predict future performance. Creative talent, on the other hand, is utterly unpredictable. It can be spotted only on the basis of past performance. Even past performance is not enough to ensure that a given artist will continue to produce on the same level. Some artists reach a creative peak early in their careers and then "go dry," while others, after a slow start, may do astonishingly original work in middle age or even later.

Originality and Tradition

Originality is what distinguishes art from craft. It is the yardstick of artistic greatness or importance. Unfortunately, it is also very hard to define. The usual synonyms—uniqueness, novelty, freshness—do not help us very much. Unless a work is a copy, the problem comes not in deciding whether it is original but in saying exactly how original it is. In addition, every work of art has its own place in tradition. Without tradition—the word means "that which has been handed down to us"—no originality would be possible. Tradition provides the platform from which artists make their leap of the imagination. The place where they land becomes the point of departure for further leaps. Tradition also serves as the meeting ground of art and craft. What the art student or apprentice learns are skills and techniques: ways of drawing, painting, carving, designing—established ways of seeing.

For us, too, tradition is essential. Whether we are aware of it or not, tradition is the framework within which we form our opinions of works of art and assess their originality. This is especially true of masterpieces, the standards by which we measure other works of art. A masterpiece is a work that can bear close scrutiny and withstand the test of time. Such judgments are always subject to revision, however. In fact, tastes have varied greatly over time. Works that were once thought of as cornerstones of tradition have been discarded, while others that were ignored or even despised are now seen as important. Thus the "canon," or core body, of Western art is not static and

unchanging but is constantly shifting. Although it is fashionable to attack the idea of a canon, some works really are better than others, whether we wish to acknowledge it or not.

Meaning and Style

Why do people create art? Surely one reason is the urge to adorn themselves and decorate the world around them. Both are part of a larger desire, not merely to remake the world in their image but to recast themselves and their environment in ideal form. Art is, however, much more than decoration. Like science and religion, it fulfills the urge of human beings to understand themselves and the universe. This function makes art especially important and worthy of our attention. Art allows us to communicate our understanding in ways that cannot be expressed otherwise. In art, as in language, people invent symbols that convey complex thoughts in new ways. We must think of art not in terms of prose but of poetry, which is free to rearrange words and syntax in order to convey new, often multiple, meanings and moods. A work of art likewise suggests much more than it states. And as with poetry, the value of art lies equally in what it says and how it says it. But what is art trying to say? Artists often provide no clear explanation, since the work itself is the statement. If they could say what they mean in words, they would be writers instead.

Nevertheless, art is full of meaning, even if its content is slender or obscure at times. What do we mean by content? The word refers not only to a work's subject and literal meaning (its iconography) but to its appearance as well, for the visual elements are themselves filled with significance. Hence the content of art is inseparable from its formal qualities, that is, its style. For that reason, understanding a work of art begins with a sensitive appreciation of its surface. (In fact, art can be enjoyed for its purely visual appeal.) The word *style* is derived from stilus, the writing tool of the ancient Romans. Originally, it referred to distinctive ways of writing—the shape of the letters as well as the choice of words. Today it refers to the distinctive way in which a thing is done. In the visual arts, style means the specific way in which the forms that make up any given work of art are chosen and fitted together. To art historians the study of styles is of great importance. Not only does it enable them to find out, through careful analysis and comparison, when, where, and by whom something was produced, it also leads them to understand the artist's intention as expressed in the way it looks. This intention depends on both the artist's personality and the context of time and place. Thus art historians often speak of "period styles."

Art, like language, requires that we learn the style and outlook of a country, period, and artist if it is to be understood properly. Style need only be appropriate to the intent of the work. This idea is not always easy to accept. Westerners are used to a tradition of naturalism, in which art imitates nature as closely as possible. But accurate reproduction of visual phenomena, called illusionism, is just one means of expressing an artist's understanding of reality. Truth, it seems, is indeed relative. It is a matter not simply of what our eyes tell us but also of the concepts through which our perceptions are filtered. An image is a separate and self-contained reality that has its own ends and responds to its own rules as determined by the artist's creativity. Even the most convincing illusion is the product of the artist's imagination and understanding, so that we must always ask why this subject was chosen and expressed in this way rather than in some other way.

Self-Expression and Audience

The birth of a work of art is a very private experience, so much so that many artists can work only when they are alone and refuse to show their unfinished works to anyone. Yet for the birth to be successful, the work must be shared with the public. Artists do not create art just to satisfy themselves. They want their work validated by others. In fact, the creative process is not completed until

the work has found an audience. In the end, works of art exist in order to be liked rather than to be debated. This paradox can be resolved once we understand what artists mean by "public." They are concerned not with the public at large but with their particular public, their audience. What matters to them is quality rather than wide approval. This audience is a limited and specialized one. Its members may be other artists as well as patrons, friends, critics, and interested viewers. What they all have in common is an informed love of works of art—an attitude that is at once discriminating and enthusiastic which lends particular weight to their judgments. They are, in a word, experts, people whose authority rests on experience and knowledge (see the cartoon on this page).

Tastes

The road to expertise in art is open to anyone who wants to take it. All that is required is an open mind and a capacity to absorb new experiences. The biggest roadblock is the old saying, "I don't know much about art, but I know what I like." When they say, "I know what I like," people really mean, "I like what I know [and I am uncomfortable with whatever is unfamiliar]." Such likes are not products of personal choice; they are imposed by habit and culture. Art is part of the fabric of our daily life; we see it all the time, even if only in the form of magazine covers, advertising posters, war memorials, television, and the buildings where we live, work, and worship. Much of this art, to be sure, is pretty shoddy, representing the common denominator of popular taste. Still, it is art of a sort, and since it is the only art most people experience, it molds their ideas about art in general. When faced with unfamiliar art, they often ask, "Why is that art?" when what they really mean is, "Why is that good art?" Deciding what is art and rating a work of art are two separate problems. Even if there were a tried-and-true way of distinguishing art from non-art, it would not necessarily help in measuring quality. Even so, people tend to combine these two problems into one.

But isn't the average person's opinion just as valid as an expert's? This notion has strong appeal in a democratic society. Let's see if it holds up to closer scrutiny. Take any subject in which you have some expertise. It might be sports, cars, carpentry, fashion, pop music. If I happen to be ignorant in the same area, is my judgment really as good as yours? Of course not! The expert always has the edge. As you also know from your own experience, having expertise in a subject greatly increases

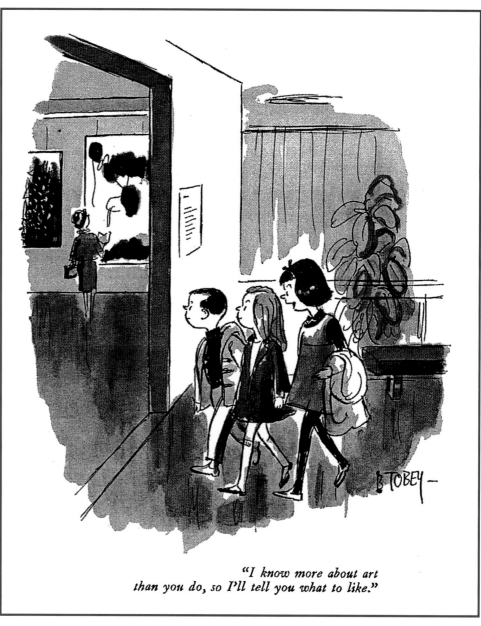

"*I know more about art than you do, so I'll tell you what to like.*"

your enjoyment. The same is true of art. As their understanding grows, most people find themselves liking many more things than they had thought possible. They gradually acquire the courage of their own convictions, until they are able to say, with some justice, that they know what they like.

LOOKING AT ART

How we experience art has changed greatly over the course of history. To view art, most people go to museums. Museums, however, are a relatively recent invention. Although the Akropolis in Athens included a pinakotheke, or painting gallery, the idea of a museum ("home of the muses") where the public can go for inspiration arose only in the early nineteenth century. Before then, most people could see art only in churches. Except in seventeenth-century Holland, only wealthy collectors, most often members of the aristocracy, could afford to own art. Today museums have become temples where anyone can worship at the altar of art. Of course, most works of art were not created for such a setting. The art in museums is not the only kind worth looking at. On the contrary, it should provide the point of departure for exploring other forms of art.

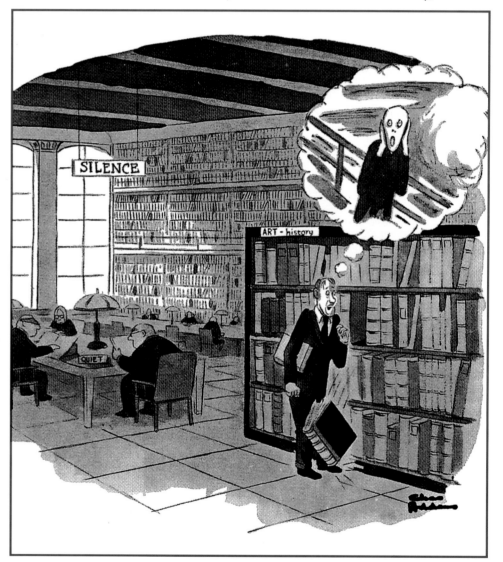

Books like this one can serve as a guide to art, but no text or reproduction can substitute for viewing original works, even in an era when the written word has higher status than artists and their works. To those who love art, few pursuits are more pleasurable. A major benefit is being able to understand cartoons about art, since their humor is not obvious to everyone. Finding the cartoon on this page amusing requires knowing the painting entitled *The Scream* by Edvard Munch (see fig. 23-21). Learning to look at art is not an easy task, however, for art has become commonplace. We live in a sea of images that convey the culture and learning of modern civilization. Fueled by the mass media, this "visual background noise" has become so much a part of our daily lives that we take it for granted. In the process, we have become desensitized to art as well. Anyone can buy cheap paintings and reproductions to decorate a room, where they often hang unnoticed, perhaps deservedly so. It is small wonder that we look at the art in museums with equal casualness. We pass quickly from one object to another, sampling them like dishes in a cafeteria line. We may pause briefly before a famous masterpiece that we have been told we are supposed to admire. But we are likely to ignore the equally beautiful and

important works around it (see the cartoon on page 27). We will have seen the art but not really looked at it.

Looking at great art is not an easy task, for art rarely reveals its secrets at first glance. While the experience of a work can be electrifying, we sometimes do not realize its impact until it has had time to filter through our imagination. It even happens that something which at first repelled or confused us emerges many years later as one of the most important artistic events of our lives. If we are going to get the most out of art, we will have to learn how to look and think for ourselves in an intelligent way, which is perhaps the hardest task of all. After all, we will not always have someone at our side to help us. In the end, the confrontation of viewer and art remains as solitary an act as making it.

Art represents the play between artists' imaginations and their surroundings. It also provides a personal record of life as it has been experienced by people at very different times and places. Because so much goes into art, it makes many of the same demands on us that it did on the person who created it. For that reason, we must be able to respond to a work on many levels. To understand it therefore requires a knowledge of both art history and life. The two go hand in hand. The more one knows about one, the more one can appreciate the other.

What people get out of art varies greatly from person to person. We each have different talents. Just as some people have a special ability in athletics or a knack for fixing things, others have a bent for spirituality or philosophy, or they may possess a historical imagination or a playful mind. Moreover, we each have different backgrounds and experiences. Thus we bring different skills to bear on looking at art, just as artists do in making it. Variety is indeed the spice of life. The world would be a dull place if everyone had the same views and backgrounds. Fortunately, there is room for almost limitless diversity. At the same time, there are broad common denominators, including culture and tradition, that bind us together just as much as human nature itself does.

APPROACHES TO ART HISTORY

The art historical approach of this book is often labeled *formalistic* insofar as it is concerned with the evolution of style. Thus it is akin to connoisseurship, although this should not be taken to mean the visual analysis of aesthetic qualities. It also draws on *iconography,* that is, the meaning of a work of art, and what art historian Erwin Panofsky called *iconology,* its cultural context. This book takes a classical approach to art history as defined by three generations of mainly German-born scholars—including H. W. Janson, a student of Panofsky. It is well suited to introducing beginners to art history by providing the framework for how to look at and respond to art in museums and galleries—something both authors have greatly enjoyed throughout their lives. In nearly every case, the works illustrated here (or very similar ones) have been seen by one or both authors to be certain that they are indeed worthy of inclusion. In some cases we have changed our minds, especially when it comes to recent art that has not had the benefit of time to gain the historical perspective needed for a full appraisal.

Readers should be aware that there are other approaches. The oldest is Marxism, which views art in terms of the social and political conditions determined by the prevailing economic system. Marxist analysis has been especially useful in treating art since the Industrial Revolution, which created the conditions that were analyzed by Karl Marx in the mid-nineteenth century. It remains to be seen what will become of Marxist art history in the wake of the collapse of Communism in Russia and Eastern Europe.

Psychology, too, has added many insights into the meaning works of art have for their creators, particularly when that meaning is hidden even from the artists themselves. The more

extreme attempts to psychoanalyze Leonardo and Michelangelo, for instance, have caused some scholars to distrust this method. But some works, such as Fuseli's *The Nightmare* (whose meaning was analyzed by H. W. Janson in a pioneering article), cannot be understood without it (see fig. 21-43).

Three newer approaches—feminism, multiculturalism, and deconstruction—are perhaps the most radical of all. Feminism reexamines art history from the point of view of gender. Because this approach is embedded in current gender politics, there is a risk that a major shift in social outlook might call some of feminism's conclusions into question. In principle, however, feminist theory can be applied to all of art history. It certainly forces us to reconsider what is "good" art. After all, when this book first appeared, not a single woman artist was included—nor was one to be found in any other art history survey. Today such omissions seem nothing short of unthinkable.

Feminism is related to the larger shift toward multiculturalism, which addresses the gap in our understanding of the art of nontraditional and non-Western cultures. Why should we not include artists who express very different sensibilities from that of the European and American mainstream? Indeed, there is no reason whatsoever not to. However, this book is limited to Western art for both practical and philosophical reasons. I have chosen instead to focus on the contribution of African-American art. In the process, however, I have taken a stand about what art is most important that not all readers will agree with, since it favors universalism over ethnocentrism. In part, this reflects my own views on the stereotyping ethnocentrism fosters on both sides of the racial fence. In my opinion, such an approach is doomed as a cultural dead end, although I cannot deny that art with a racial "edge" has a legitimate place. Feminism and multiculturalism have both attacked the "canon" of masterpieces in this and similar books as embodying male chauvinism and colonialist attitudes. Readers should judge the issue for themselves. I would only point out that one must walk before one can run.

Because they are so central to postmodern thought, semiotics and deconstruction are briefly summarized toward the end of the book. I am sympathetic to semiotics, which I first became interested in more than 20 years ago, although I find Noam Chomsky's theory of linguistics more satisfying. Deconstruction has likewise made art historians consider meaning in new ways that have breathed fresh life into the field. Nevertheless, I know from classroom experience that it is nearly impossible for beginning art history students to understand semiotics. Deconstruction is even more taxing. What began as a feud between two schools of French semiologists has spread to art history, where it pits older, mostly German-trained scholars against a younger generation. And perhaps that is the point. People are constantly reinventing art history in their image. But if art history reflects our times, the reader may wonder how it can have any claim to objectivity and, hence, validity. In fact, people's understanding of history has always changed with the times. How could it be otherwise? It seems almost necessary for each generation to reinvent history so that we may understand both the past and the present. Yet the danger is that ideology, regardless of its noble intent, will undermine the search for truth, no matter how relative truth may be. Such a thing

happened during the 1930s, when scholarship was made to serve the political ends of dictatorships—which led Panofsky and Janson to leave Germany.

Neither author of *History of Art* is an ideologue. Both are (in the case of my father, were) humanists who believe that the study of humane letters is enjoyable and enriching. Such a view requires that scholarly discourse be temperate, although it is rarely dispassionate. I would encourage the reader to examine all forms of art history with an open mind. One cannot view something as rich and complex as art from a single perspective any more than it is possible to see a diamond from a single vantage point. Each approach can add to our understanding. To be sure, a plea for tolerance may seem outdated at a time when art history, like all fields, has become so contentious. In this regard, scholarship reflects the rapid political change, social unrest, ideological dogmatism, and religious fanaticism that characterize postindustrial society and the new world order that is emerging in its wake. Let all ideas meet the test of the marketplace of ideas,

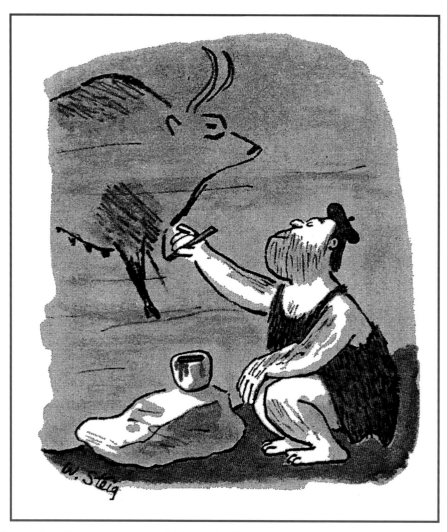

where they can be discussed openly and fairly. Let us also allow everyone to tend his own intellectual garden in peace. Some may have a larger plot than others, but even the biggest of them is rather small in the scheme of things, as H. W. Janson, among the most famous art historians of his time, came to understand.

Both authors have given a great deal of thought to this book, which is written in the authoritative tones that intellectuals habitually adopt as their public voice. It is difficult, of course, to resist the temptation to pontificate—to hand down the "canon" as if it were immutable. Yet, if the truth be told, the experience of surveying such a broad field as art history provides a lesson in humility. One becomes only too aware of the painful omissions and how little one knows about any given subject in this age of increasing specialization. If it requires the egotism of the gods to undertake such a project in the first place, in the end one sees it clearly for what it is: an act of hubris. It also requires a faith in the power of reason to produce such a synthesis, something that is in short supply these days.

ART HISTORY IS MORE THAN A STREAM OF ART OBJECTS CREATED OVER TIME. IT IS CLOSELY TIED TO HISTORY ITSELF, THAT IS, THE RECORDED EVIDENCE OF HUMAN EVENTS.

We must therefore consider the *concept* of history. History, we are often told, began with the invention of writing by the "historic" civilizations of Mesopotamia and Egypt some 5,000 years ago. Without writing, the growth we have known would have been impossible. However, the development of writing seems to have taken place over a period of several hundred years—roughly between 3300 and 3000 B.C., with Egypt in the lead—after the new societies were past their first stage. Thus "history" was well under way by the time writing could be used to record events.

The invention of writing serves as a landmark, for the lack of written records is one of the key differences between prehistoric and historic societies. But as soon as we ask why this is so, we face some intriguing problems. First of all, how valid is the distinction between "prehistoric" and "historic"? Does it merely reflect a difference in our *knowledge* of the past? (Thanks to the invention of writing, we know a great deal more about history than about prehistory.) Or was there a real change in the way things happened, and in the kinds of things that happened, after "history" began? Obviously, prehistory was far from uneventful. Yet the events of this period, decisive though they were, seem

The Ancient World

slow-paced and gradual when measured against the events of the last 5,000 years. The beginning of "history," then, means a sudden increase in the speed of events, a shift from low gear to high gear, as it were. It also means a change in the *kinds* of events. Historic societies literally make history. They not only bring forth "great individuals and great deeds" (one definition of history) by demanding human effort on a large scale, but they make these achievements *memorable*. And for an event to be memorable, it must be more than "worth remembering." It must also occur quickly enough to be grasped by human memory, not spread over many centuries. Taken together, memorable events have caused the ever-quickening pace of change during the past five millennia, which begin with what we call the ancient world.

This period was preceded by a vast prehistoric era of which we know almost nothing until the last Ice Age in Europe, which lasted from about 40,000 to 8000 B.C. (There had been at least three previous ice ages, alternating with periods of subtropical warmth, at intervals of about 25,000 years.) At that time, the climate between the Alps and Scandinavia resembled that of present-day Siberia or Alaska. Huge herds of reindeer and other large plant-eating animals roamed the plains and valleys, preyed upon by the ancestors of today's lions and tigers, as well as by our own ancestors. These people liked to live in caves or in the shelter of overhanging rocks. Many such sites have been found, mostly in Spain and in southern France. The Ice Age coincides with the phase of prehistory known as the Late Stone

Age, or Late Paleolithic era, because tools were made from stone. Adapted almost perfectly to the special conditions of the receding Ice Age, it was a way of life that could not survive beyond that era.

The Stone Age came to a close with what is termed the Neolithic Revolution. And a revolution it was, even though it was preceded by a period of transition that extended over several thousand years during the Mesolithic Age. It first occurred in the Fertile Crescent of the Near East (an area covering what is now Turkey, Iraq, Iran, Jordan, Israel, Lebanon, and Syria) sometime around 12,000–8000 B.C., with the first successful attempts to domesticate animals and food grains. The Neolithic came later, brought by peoples from Anatotia in Turkey, to Europe but then spread much more rapidly.

The cultivation of regular food sources was one of the most decisive achievements in human history. People in Paleolithic societies had led the unsettled life of the hunter and food gatherer, reaping wherever nature sowed. They were at the mercy of forces that they could neither understand nor control. But having learned how to ensure a food supply through their own efforts, they settled down in permanent villages. A new discipline and order entered their lives. There is, then, a very basic difference between the Neolithic and the Paleolithic, despite the fact that at first both still depended on stone for tools and weapons. The new way of life brought forth a number of new crafts and inventions long before the appearance of metals. Among them were pottery, weaving, and spinning, as well as basic methods of construction in wood, brick, and stone. When metallurgy in the form of copper finally appeared in southeast Europe around 4500 B.C., at the beginning of the so-called Neolithic era, it was as a direct outgrowth of the technology gained from pottery. As such, it did not in itself constitute a major advance; nor, surprisingly, did it have an immediate impact.

The Neolithic Revolution placed humans on a level at which they might well have remained indefinitely. The forces of nature never again challenged people as they had in the Paleolithic era. In a few places, however, there was a new threat, one posed not by nature but by people themselves. Evidence of it can be seen in the earliest Neolithic fortifications, built almost 9,000 years ago in the Near East. What was the source of the human conflict that made these defenses necessary? Competition for grazing land among groups of herders, or for water and arable soil among farming communities? The basic cause, we suspect, was that the Neolithic Revolution was too successful. It allowed population groups to grow beyond the available food supply. This situation might have been resolved through constant warfare, which could have reduced the population. Or the people could have united in larger and more disciplined social units for the sake of group efforts—such as building fortifications, conducting war, and distributing resources, goods, and services—that no loosely organized society could achieve on its own.

We do not know the outcome of the struggle in the region. (Future excavations may tell us how far the urbanizing process extended.) But about 3,000 years later, similar conflicts, on a larger scale, arose in the Nile Valley and again in the plains of the Tigris and Euphrates rivers. The pressures that forced the people in these regions to abandon Neolithic village life may well have been the same. These conflicts created enough pressure to produce the first civilizations. (The word *civilization* derives from the

Latin term for city, *civilis*.) The new societies that emerged were organized into much larger units—cities and city-states—that were far more complex and efficient than had ever existed before. First in Mesopotamia and Egypt, somewhat later in neighboring areas, and in the Indus Valley and along the Yellow River in China, people henceforth lived in a more dynamic world. Their ability to survive was challenged not by the forces of nature but by human forces: by tensions and conflicts arising either within society or as the result of competition between societies. Efforts to cope with these human factors have proved to be a far greater challenge than the earlier struggle with nature. The problems and pressures faced by historic societies thus are very different from those faced by peoples in the Paleolithic or Neolithic eras.

These momentous changes also spurred the development of new technologies in what we term the Bronze Age and the Iron Age, which, like the Neolithic, are stages, not distinct eras. The casting of bronze, an alloy of copper and tin, first began in the Middle East around 3500 B.C., at the same time that the earliest cities arose in Egypt and Mesopotamia. The smelting and forging of iron were invented about 2000–1500 B.C. by the Hittites, an Indo-European-speaking people who settled in Cappadocia (today's east-central Turkey), a high plateau with abundant copper and iron ore. Indeed, it was the competition for mineral resources that helped to create the conflicts that beset civilizations everywhere.

For the sake of brevity, our discussions of historical background throughout this book will deal with the forces and individuals that determined the course of Western civilization and are most directly relevant to art history. Such an approach admittedly comes at the expense of studying the social context of ordinary human beings, which is of great interest in itself. It must be remembered that until very recently the vast majority of people who have inhabited Europe and North America led lives that were brutish and short (as one historian has noted of existence in medieval England). This situation still prevails throughout much of the world. Long after the onset of the Industrial Revolution in the late eighteenth century, a typical family scraped by at subsistence farming, regardless of the social, economic, and political structure which they were powerless to affect except in rare circumstances. Instead, they were at the mercy of nature and their rulers, and subject to the ravages of war and disease. Rather than repeat this tragic litany of misery at every step of the way, we have chosen to focus on the small "elite" group who shaped history, while keeping in mind that this picture is vastly simplified.

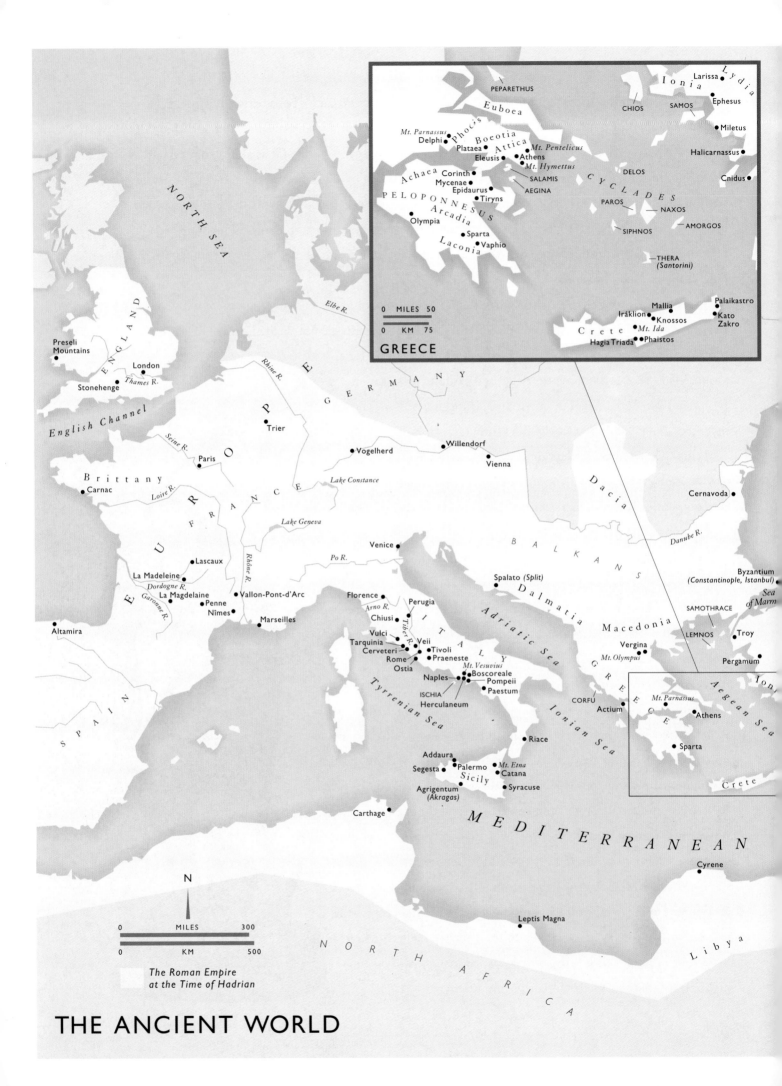

GREECE

PEPARETHUS

Ionia Larissa

Lydia

Euboea

CHIOS SAMOS Ephesus

Miletus

Mt. Parnassus *Phocis*
Delphi Boeotia Halicarnassus

Plataea Attica *Mt. Pentelicus*

Eleusis Athens DELOS Cnidus

Mt. Hymettus

Achaea Corinth CYCLADES

Mycenae SALAMIS

Epidaurus AEGINA

PELOPONNESUS Tiryns PAROS NAXOS

Arcadia SIPHNOS AMORGOS

Olympia

Sparta

Laconia Vaphio THERA
(Santorini)

Palaikastro

Mallia

Iráklion Knossos Kato
Zakro

Crete *Mt. Ida*

Hagia Triada Phaistos

0 MILES 50

0 KM 75

NORTH SEA

Preseli
Mountains

ENGLAND

London

Stonehenge *Thames R.*

Elbe R.

GERMANY

English Channel

E U R O P E

Rhine R.

Trier

Seine R.

Paris

Vogelherd

Willendorf

Vienna

Dacia

Brittany

Carnac

Loire R.

FRANCE

Lake Constance

Cernavoda

Lake Geneva

Lascaux

Rhône R.

BALKANS

Danube R.

La Madeleine

Dordogne R.

La Magdelaine

Garonne R. Penne

Nîmes

Vallon-Pont-d'Arc

Venice

Po R.

Spalato (Split)

Dalmatia

Byzantium
(Constantinople, Istanbul)

Sea
of Marm

Altamira

Marseilles

Florence

Arno R.

Perugia

ITALY

Chiusi

Tiber R.

SPAIN

Vulci

Veii

Tarquinia Cerveteri Tivoli

Rome Praeneste

Ostia

Mt. Vesuvius

Naples Boscoreale

Pompeii

ISCHIA Paestum

Herculaneum

Tyrrhenian Sea

Adriatic Sea

Macedonia

Vergina

Mt. Olympus

GREECE

SAMOTHRACE

LEMNOS

Troy

Pergamum

Ionian Sea

CORFU

Actium

GREECE

Mt. Parnassus

Aegean Sea

Athens

Ioni

Riace

Sparta

Addaura

Palermo *Mt. Etna*

Crete

Segesta Catana

Sicily

Agrigentum
(Ákragas) Syracuse

Carthage

MEDITERRANEAN

Cyrene

N

MILES 300

KM 500

The Roman Empire
at the Time of Hadrian

NORTH AFRICA

Leptis Magna

Libya

THE ANCIENT WORLD

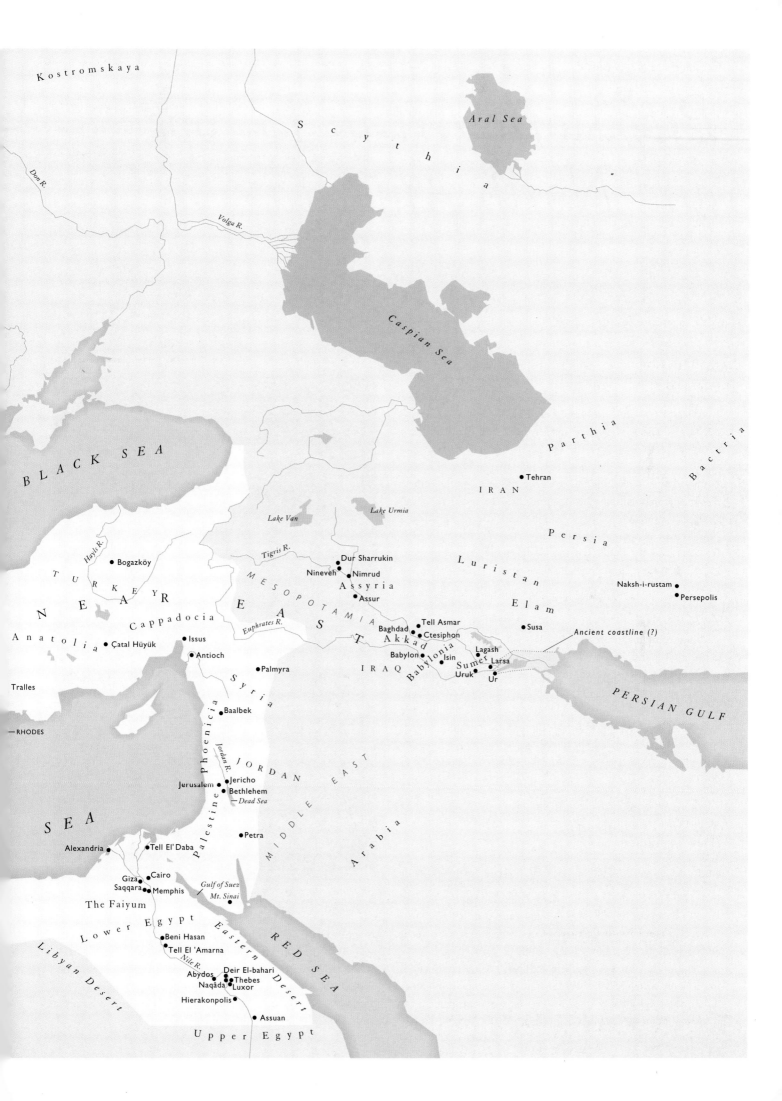

Kostromskaya

Don R.

Volga R.

S c y t h i a

Aral Sea

Caspian Sea

BLACK SEA

P a r t h i a

B a c t r i a

Lake Van

Lake Urmia

● Tehran

I R A N

Hayls R.

● Bogazköy

P e r s i a

Tigris R.

Dur Sharrukin
Nineveh ● ● Nimrud

L u r i s t a n

T U R K E Y

N E A R

E A S T

M E S O P O T A M I A

Assyria
● Assur

E l a m

Naksh-i-rustam ● ● Persepolis

Cappadocia

Euphrates R.

Tell Asmar
Baghdad ● ●
● Ctesiphon

● Susa

A n a t o l i a ● Çatal Hüyük

● Issus

Akkad

Babylon ● ● Isin
● Lagash
Larsa

Ancient coastline (?)

● Antioch

I R A Q

Babylonia

Sumer

Tralles

● Palmyra

Uruk ● ● Ur

PERSIAN GULF

S y r i a

● Baalbek

— RHODES

P h o e n i c i a

Jordan R.

J O R D A N

M I D D L E E A S T

Jerusalem ● ● Jericho
● Bethlehem
— *Dead Sea*

S E A

P a l e s t i n e

A r a b i a

● Petra

M I D D L E E A S T

Alexandria ●

● Tell El' Daba

Giza ● ● Cairo
Saqqara ● ● Memphis

Gulf of Suez

Mt. Sinai

The Faiyum

L o w e r E g y p t

E a s t e r n D e s e r t

R E D S E A

● Beni Hasan
● Tell El 'Amarna

L i b y a n D e s e r t

Nile R.

Deir El-bahari
Abydos ● ● Thebes
Naqâda ● ● Luxor

● Hierakonpolis

● Assuan

U p p e r E g y p t

Prehistoric Art in Europe and North America

When did human beings start creating works of art? What prompted them to do so? What did these works of art look like? Every history of art must begin with these questions—and with the admission that we cannot answer them. Our earliest known ancestors began to walk on two feet about 4 million years ago, on the African plains. We do not know how they used their hands. Not until more than 2 million years later do we meet the earliest evidence of toolmaking. Humans must have been using tools all along, however. After all, apes will use a stick to knock down a piece of fruit, or a stone to throw at an enemy. The *making* of tools is a more complex matter. It demands the ability to think of sticks as "fruit knockers" and stones as "bone crackers," not only when they are needed for such purposes but at other times as well.

Once people were able to do this, they gradually found that some sticks and stones had a handier shape than others. They put these aside for future use as tools because they had begun to connect *form* and *function*. The sticks, of course, have not survived, but a few of the stones have. These large pebbles or chunks of rock show the marks of repeated use for the same task, whatever that task may have been. The next step was to try chipping away at these stones in order to improve their shape. With it we enter a phase of human development known as the Late Paleolithic period, which in Europe lasted from about 40,000 to 8000 B.C.

THE OLD STONE AGE

Cave Art

CHAUVET. The most striking works of Paleolithic art are the images of animals incised, painted, or sculptured on the rock surfaces of caves. In the Chauvet cave in southeastern France, we meet the earliest paintings known to us, which date from about 30,000 years ago. Ferocious lions, panthers, rhinoceroses, bears, reindeer, and mammoths are depicted with extraordinary vividness, along with bulls, horses, birds, and occasionally humans. These paintings already show an assurance and refinement far removed from any humble beginnings. What a vivid, lifelike

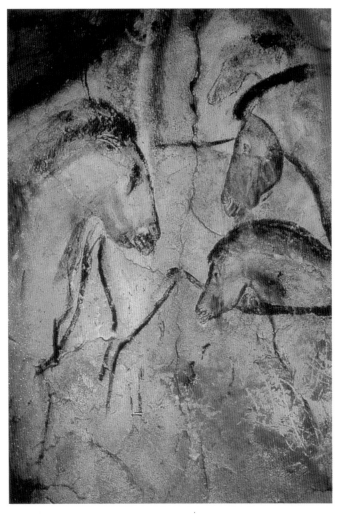

1-1. *Horses*. Cave painting. c. 28,000 B.C. Chauvet cave, Vallon-pont-d'Arc, Ardèche gorge, France

image is the depiction of horses seen in figure 1-1! We are amazed not only by the keen observation and the forceful outlines but also by the power and expressiveness of these creatures. It is highly unlikely that images such as this came into being all at once. They must have been preceded by thousands of years of development about which we know nothing at all.

ALTAMIRA AND LASCAUX. On the basis of differences among tools and other remains, scholars have divided later "cavemen" into several groups, each named after a specific site. Among these, the so-called Aurignacians and Magdalenians stand out for the gifted artists they produced and for the important role art must have played in their lives. Besides Chauvet, the major cave painting sites are at Altamira in northern Spain (fig. 1-2) and Lascaux in the Dordogne region of France (fig. 1-3). At Lascaux, as at Chauvet, bison, deer, horses, and cattle race across walls and ceilings. Some of them are outlined in black, others are filled in with bright earth colors, but all show the same uncanny sense of life. The style in both caves is essentially the same despite a gap of thousands of years—evidence of the stability of Paleolithic culture. Gone, however, are the fiercest beasts.

How did this amazing art survive intact over so many thousands of years? The question can be answered easily enough. The pictures never appear near the mouth of a cave, where they would be open to easy view and destruction. They are found only in dark recesses, as far from the entrance as possible

1-2. *Wounded Bison.* Cave painting. C. 15,000–10,000 B.C. Altamira, Spain

1-3. Axial Gallery, Lascaux. 15,000–10,000 B.C. (Montignac, Dordogne), France

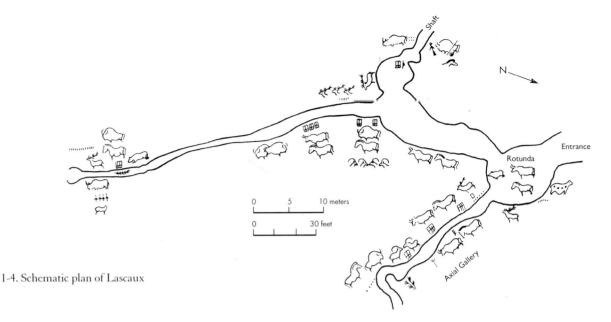

1-4. Schematic plan of Lascaux

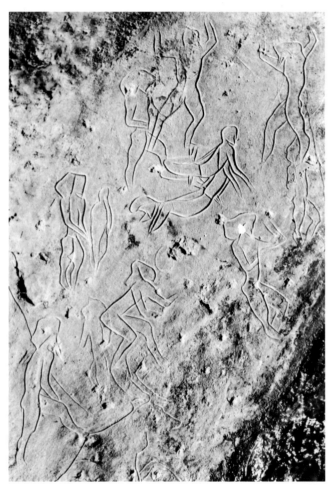

1-5. *Ritual Dance (?)*. Rock engraving. c. 10,000 B.C. Height of figures approx. 10" (25.4 cm). Cave of Addaura, Monte Pellegrino (Palermo), Sicily

(fig. 1-4). Some can be reached only by crawling on hands and knees. Often the path is so complex that one would soon be lost without an expert guide. In fact, the cave at Lascaux was discovered by chance in 1940 by some boys whose dog had fallen into a hole that led to the underground chamber.

What purpose did these images serve? Because they were hidden away in order to protect them from intruders, they must have been considered important. There can be little doubt that they were made as part of a ritual. But of what kind? The standard explanation, based on "preliterate" societies of modern times, is that they are a form of hunting magic. According to this theory, in "killing" the image of an animal, people of the Late Stone Age thought they had killed its vital spirit. This later evolved into fertility magic, carried out deep in the bowels of the earth. But how are we to account for the presence at Chauvet of large meat eaters too dangerous to be hunted? Perhaps the cavemen took on the identity of lions and bears to aid in the hunt. Although it cannot be disproved, this proposal is not completely satisfying, for it fails to explain many curious features of cave art.

There is growing agreement that cave paintings must embody a very early form of religion. If so, the creatures found in them have a spiritual meaning that makes them the distant ancestors of the animal divinities and their half-human, half-animal cousins we shall meet throughout the Near East and the Aegean. Indeed, how else are we to account for these later deities? Such an approach accords with animism—the belief that nature is filled with spirits—which was found the world over in the indigenous societies that survived intact until recently.

The next logical step, the development of cave rituals dealing with both human beings and animals (or at least humans dressed as animals), seems to be confirmed by a group of Paleolithic drawings found in the 1950s on the walls of the cave of Addaura, near Palermo in Sicily (fig. 1-5). These images, incised into the rock with quick and sure lines, show human and some animal figures in dancelike movements. As at Lascaux, several layers of images are superimposed on one another. Here, then, we seem to be on the verge of the fusion of human and animal identity found in the earliest historical religions of Egypt and Mesopotamia.

Cave art is also important as the earliest evidence of a long tradition found in civilizations everywhere: the urge to decorate walls and ceilings with images that have a spiritual meaning. Because they were not constructed, caves such as Lascaux do not qualify as architecture. Yet they served the same function as a

church or temple. In that sense, they are the forerunners of the religious architecture featured throughout this book.

How did cave painting originate? In many cases the shape of an animal seems to have been suggested by the natural formation of the rock: its body coincided with a bump, or its contour followed a vein or crack. We all know how our imagination sometimes makes us see images in clouds or blots. At first, Stone Age artists may have merely reinforced the outlines of such images with a charred stick. It is tempting to think that those who were very good at finding images of that kind were given a special status as artist-shamans. Then they were able to perfect their image-hunting until they learned how to make images with little or no help from chance formations.

Small Carved and Painted Objects

Apart from large-scale cave art, the people of the Late Paleolithic also produced hand-sized drawings and carvings in bone, horn, or stone, skillfully cut with flint tools. The earliest found so far are small figures of mammoth ivory, made 30,000 years ago, which came from a cave in southwestern Germany. But even they are so refined that they must have been preceded by thousands of years of development. The graceful, harmonious curves of a running horse (fig. 1-6) could hardly be improved upon by a later sculptor. Many years of handling have worn down some details. (The two converging lines on the shoulder, indicating a dart or wound, were not part of the original design.)

Some of these carvings suggest that they, too, may have stemmed from a chance resemblance. Earlier Stone Age people were content to collect pebbles in whose natural shape they saw some special quality. Echoes of this approach sometimes can be felt in later pieces. The *Woman of Willendorf* (fig. 1-7), one of many such female figurines, has a roundness that recalls an egg-shaped "sacred pebble." Her navel, the central point of the design, is a natural cavity in the stone. Such carvings are often thought to be fertility figures, based on the spiritual beliefs of the "preliterate" societies of modern times. (Although the idea is tempting, we

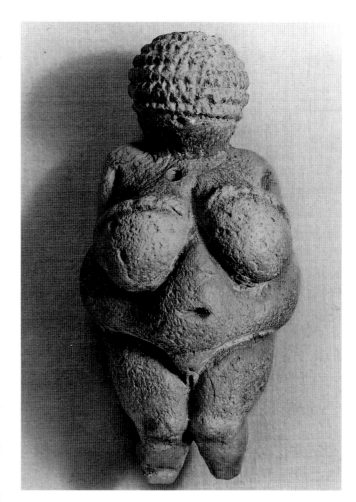

1-7. *Woman of Willendorf.* c. 25,000–20,000 B.C. Limestone, height 4⅜" (11.1 cm); shown actual size. Naturhistorisches Museum, Vienna

cannot be sure that such beliefs existed in the Old Stone Age.) The masterful bison in figure 1-8 owes its expressive outline in part to the contours of the palm-shaped piece of reindeer horn from which it was carved. It is a worthy companion to the splendid beasts at Altamira, Lascaux, and Chauvet.

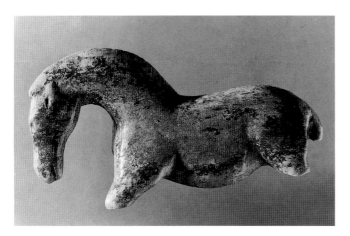

1-6. *Horse,* from Vogelherd cave. c. 28,000 B.C. Mammoth ivory, length 2½" (6.4 cm). Private collection

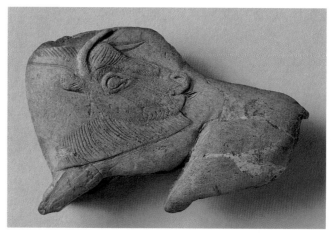

1-8. *Bison,* from La Madeleine near Les Eyzies (Dordogne). c. 15,000–10,000 B.C. Reindeer horn, length 4" (10.1 cm). Musée des Antiquités Nationales, St.-Germain-en-Laye, France

THE NEW STONE AGE
Neolithic Europe

The art of the Late Stone Age in Europe as we know it marks the highest achievement of a way of life that began to decline soon after the end of the last Ice Age around 11,000 years ago. Unfortunately, the tangible remains of New Stone Age settlements tell us very little about the spiritual life of **Neolithic** societies. Those remains, uncovered by excavation, include stone tools of ever greater refinement and beauty. A great variety of clay vessels covered with abstract patterns have also been found. None of these items can be compared to the painting and sculpture of the Paleolithic. The shift from hunting to husbandry must have been accompanied nonetheless by profound changes in the people's view of themselves and their world, which must have been reflected in their art. A few new sites have been discovered by archaeologists in recent years, and they have yielded some new evidence. Perhaps future excavations will help fill in the picture.

JERICHO. Prehistoric Jericho (now in the West Bank territory), the most extensively excavated site thus far, has provided some tantalizing discoveries. These include a group of impressive sculptured heads dating from about 7000 B.C. (fig. 1-9). They are actual human skulls whose faces have been reconstructed in tinted plaster, with pieces of seashell for the eyes. The subtlety and precision of the modeling, the gradation of planes and ridges, and the feeling for the relationship of flesh and bone are remarkable, quite apart from the early date. The features, moreover, do not conform to a single type; each has a strongly individual cast. Mysterious as they are, these Neolithic heads point to Mesopotamian art (compare fig. 3-5). They are the first sign of a type of portraiture that will continue until the collapse of the Roman Empire more than 7,000 years later.

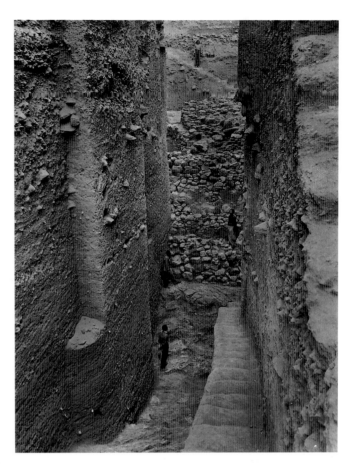

1-10. Early Neolithic wall and tower, Jericho, Jordan. c. 7000 B.C.

Unlike Paleolithic art, which had grown from the perception of chance images, the Jericho heads are not intended to "create" life but to perpetuate it beyond death by replacing the flesh with a more lasting substance. From the circumstances in which they were found, we gather that these heads were displayed above ground while the rest of the body was buried beneath the floor of the house. We may presume that they belonged to honored ancestors whose beneficent presence was thus ensured. Paleolithic societies, too, buried their dead, but we do not know what ideas they associated with the grave. Was death merely a return to the womb of mother earth, or did they have some conception of the beyond?

The Jericho heads suggest that some peoples of the Neolithic era believed in a spirit or soul, located in the head, that could survive the death of the body. Thus it could affect the fortunes of later generations and had to be appeased or controlled. Apparently the preserved heads were "spirit traps" designed to keep the spirit in its original dwelling place. They express the sense of tradition, of family or clan continuity, that sets off the settled life of the village from the roving existence of the hunting group. And Neolithic Jericho was a well-settled community. It was a fortified town protected by walls and towers of rough masonry to safeguard the spring that gave life in this arid region (fig. 1-10). Houses were made of baked mud brick with neat plaster floors; stone, being scarce, was used only for foundations. Surprisingly, the people of Jericho had no pottery. The technique of baking clay in a kiln was not invented until several millennia later. It requires a large amount of wood, which was not readily available in Jericho.

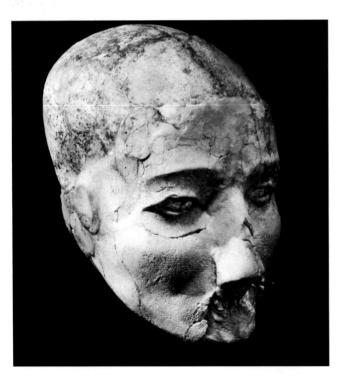

1-9. Neolithic plastered skull, from Jericho. c. 7000 B.C. Lifesize. Archaeological Museum, Amman, Jordan

ÇATAL HÜYÜK. Excavations at Çatal Hüyük in Anatolia (modern Turkey) brought to light another Neolithic town, roughly a thousand years younger than Jericho. Its residents traded in ores and obsidian (a volcanic glass used for cutting), making it a center of metalworking. The people lived in houses built of mud bricks and timber, clustered around open courtyards. Since there were no streets, the houses had no front doors, only doors facing onto the courtyards. People probably entered through a hole in the roof that doubled as a smoke hole.

Only a small, mostly residential portion of the site was uncovered during the initial excavations in the 1950s and '60s. The results of more recent work suggest that most religious activity took place in individual homes, each of which seems to have had its own altar. The settlement did include a number of religious shrines, the oldest found so far. On their plaster-covered walls we find the earliest paintings on a man-made surface. Animal hunts, with small running figures surrounding huge bulls or stags (fig. 1-11), remind us of cave paintings. This similarity is a sign that the Neolithic Revolution must have been a recent event, but the balance has already shifted: these hunts appear to be rituals honoring the deity to whom the bull and stag were sacred. They thus continue the transformation of animals into gods that began in the Old Stone Age.

Compared to the animals of the cave paintings, those at Çatal Hüyük are simple and static. Here it is the hunters who are in motion. Animals associated with female deities appear even more rigid. A pair of leopards form the sides of the throne of a fertility goddess (fig. 1-12). The most surprising of the wall paintings at Çatal Hüyük is a view of the town itself, with the twin cones of an erupting volcano above it (fig. 1-13). The densely packed houses are seen from above, while the mountain is shown in profile, its slope covered with dots representing blobs of lava. Such a volcano can still be seen from Çatal Hüyük. Its eruption must have terrified the people of the town. How could they have viewed it as anything but the manifestation of a deity's power? Nothing less could have brought forth this image, halfway between a map and a landscape.

POTTERY. The Near East became the cradle of civilization: to be civilized means to live as a citizen, a town dweller. The change

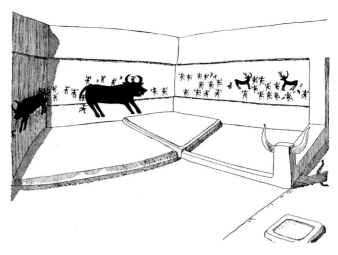

1-11. *Animal Hunt.* Restoration of Main Room, Shrine A.III.1, Çatal Hüyük (after Mellaart). c. 6000 B.C. 27 x 65" (68.5 x 165 cm)

1-12. *Fertility Goddess,* from Shrine A.II.1, Çatal Hüyük. c. 6000 B.C. Baked clay, height 8" (20.3 cm). Archaeological Museum, Ankara, Turkey

1-13. *View of Town and Volcano.* Wall painting, Shrine VII.14, Çatal Hüyük. c. 6000 B.C.

is marked by the rise of fired-clay pottery, which first appeared in the Near East about 5000 B.C. From there it spread to Europe during the Mesolithic era, the transitional period between the last Ice Age and the Neolithic era. Pottery, being breakable but durable, has survived in large numbers of fragments, known as shards. These pieces can often be pieced together to reconstruct entire pots. Because the earliest shards uncovered by archaeologists are so scattered, it is unclear whether pottery making at first arose independently in several places or was transmitted through direct contact. Over time, the patterns of distribution become clearer, with different forms that make it possible to chart successive changes in culture.

A great variety of clay vessels covered with abstract patterns have been found. Painted pottery notable for its ambitious size and sophisticated decoration seems to have appeared first in Mesopotamia during the sixth millennium B.C. From there it was diffused southwest to Egypt and across the Fertile Crescent to Anatolia in Turkey. Later it reached the northern shore of the Mediterranean and continued in a great arc around the Balkans in southeastern Europe, from which the finest examples come. The decoration on the pots from the Ukraine in fig. 1-14 has a skill and liveliness unmatched before Minoan Kamares ware (see fig. 4-11). By 3500 B.C., high-quality pottery was being made throughout western Europe as well, from central Germany to France and as far north as Denmark. In Denmark, pottery took on a particularly distinctive character; many of the shapes and patterns were derived from basket weaving.

FIGURINES. There may be a vast chapter in the development of art that is largely lost because Neolithic artists worked mainly in wood or other impermanent materials. Baked clay figurines, however, sometimes provide a tantalizing hint of Neolithic religious beliefs. The earliest European examples, produced in the Balkans about 5000 B.C. under Near Eastern influence, have their closest relatives in Asia Minor (compare fig. 1-12). But one dating to about 3000 B.C. (fig. 1-15) has, despite the massive legs, an almost girlish figure,

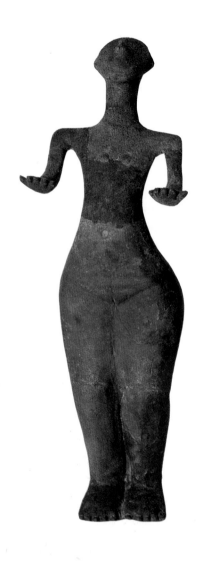

1-15. *Woman,* from Hluboké Masuvky, Moravia, Czechoslovakia. c. 3000 B.C. Clay, height 13" (33 cm). Vildomec Collection, Brno

which lends her a surprisingly modern appearance. With arms and head raised in a gesture of worship, our statuette radiates a very human charm that is as irresistible now as the day she was made.

Bronze Age Europe

MENHIRS, DOLMENS, AND CROMLECHS. Long after the introduction of bronze about the middle of the third millennium B.C., a sparse population in central and northern Europe continued to lead a simple tribal life in small village communities. Hence there is no clear distinction from the Neolithic. Neolithic and Bronze Age Europe never reached the level of social organization necessary to produce the masonry construction of Jericho or the urban community of Çatal Hüyük, although rough stone fortifications have been discovered at Early Bronze Age sites in the Carpathian mountains in southeastern Europe. Instead we find monumental stone structures of a different kind, first in France and Scandinavia and then in England. These structures are termed *megalithic* because they are made of huge blocks or boulders used either singly or placed upon each other without mortar. Even today these monuments, built about 4500–1500 B.C., have a superhuman air about them, as if they are the work of a race of giants.

The simplest are **menhirs**: upright slabs that served as grave markers. Sometimes they were arranged in rows, as at Carnac in

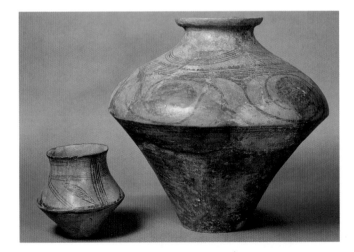

1-14. Biconical vessels of the Tripole group, Ukraine. c. 3000 B.C. Red burnished ware, dimensions of left vessel 5¼ x 5⁹⁄₁₆" (13.1 x 14.1 cm); dimensions of right vessel 13⅛ x 14½" (33.5 x 37 cm). Ashmolean Museum, Oxford

northern France. Carnac features another type as well, known as **dolmens**. Originally underground, these are tombs resembling "houses of the dead." The walls are upright stones, and the roof is a single giant slab (fig. 1-16). Finally, there are the so-called **cromlechs**, found only in the British Isles, which were the settings of religious rites. The huge effort required to construct these circles of large, upright stones could be compelled only by religious faith—a faith that almost literally demanded the moving of mountains.

STONEHENGE. The last and most famous of the cromlechs is Stonehenge in southern England (figs. 1-17, 1-18, and 1-19). What we see today is the result of several distinct building campaigns, beginning in the New Stone Age and continuing into the early Bronze Age. During the first phase, from roughly 3500 to 2900 B.C., a nearly continuous circle (henge) was dug into the chalk ground. A silted ditch was added about 3300–2140 B.C., then the avenue down to the Avon River sometime from 2580 to 1890 B.C. The sandstone (sarsen) circle of evenly spaced trilithons, each consisting of two uprights (posts) and a horizontal slab (lintel), was erected during the early Bronze Age Wessex culture, between 2850 and 2200 B.C. (fig. 1-17). These immense stones were evidently dragged

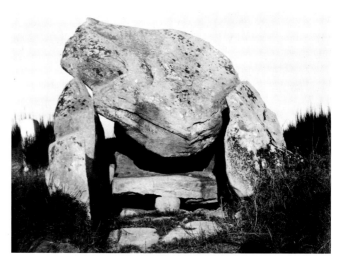

1-16. Dolmen, Carnac (Brittany), France. c. 1500 B.C.

from Marlborough Downs, some 20 miles away—a feat as awesome as raising them. But it is far from clear whether the inner bluestone circle and horseshoe, which date from several hundred years later (2480–1940 B.C.), were deposited by glaciers or carried by carts

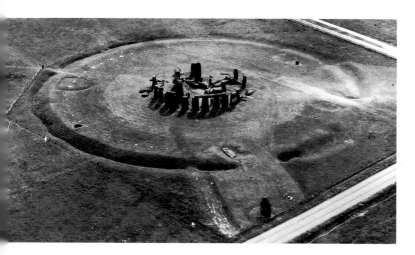

1-17. Stonehenge (aerial view), Salisbury Plain (Wiltshire), England. c. 2000 B.C. Diameter of circle 97' (29.6 m)

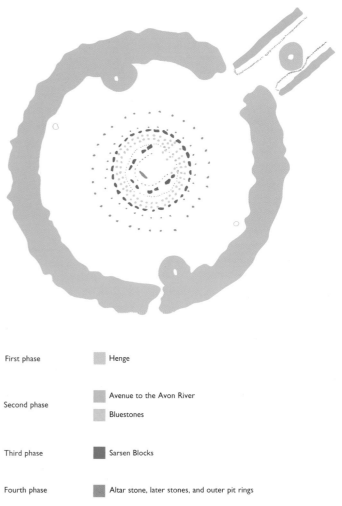

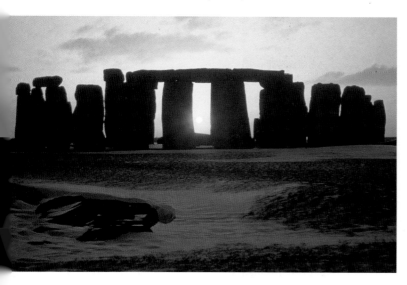

1-18. Stonehenge at sunset

First phase	■ Henge
Second phase	■ Avenue to the Avon River
	■ Bluestones
Third phase	■ Sarsen Blocks
Fourth phase	■ Altar stone, later stones, and outer pit rings

1-19. Diagram of original arrangement of stones at Stonehenge (after a drawing by Richard Tobias)

and rafts from the Preseli Mountains in Wales some 200 miles to the west. During the final phase, from 2030 to 1520 B.C., this arrangement was echoed in two similarly marked circles and a smaller horseshoe that enclose an altarlike stone at the center (fig. 1-19).

Why was Stonehenge built in the first place? The widely held belief that the so-called Heel Stone was positioned so that the sun would rise directly above it on the day of the summer solstice (when the sun is farthest from the equator) has long been shown to be incorrect. It appears that Stonehenge was originally aligned with the major and minor northern moonrises. Only later did the structure become oriented toward the sun. The Heel Stone and fallen "Slaughter Stone," along with other stones and the axis of the causeway, were rearranged in the direction of the midsummer sunrise.

Each of Stonehenge's building phases was linked to broader changes during the Neolithic and Bronze Ages. Burial mounds, called barrows, and henges from as early as 3500 B.C. have been found in Scandinavia and northern Britain. They reflect the changeover to a settled, agrarian way of life. That they continued to be built until about 2000 B.C. testifies to a relatively stable Neolithic culture. However, the people who created the Wessex culture probably crossed the English Channel from Brittany in northwestern France, where megalithic horseshoes constructed along astronomical axes are far more common than in England. They brought along Bronze Age technologies and ideas that must have seemed revolutionary to the local population, who initially put up a stiff resistance. At Stonehenge and elsewhere in southern England, these newcomers imposed their own traditions on established practices. In addition to erecting even larger cromlechs, they buried their leaders in barrows lined with boulders, making them, in effect, underground dolmens. Some of these tombs even have a rudimentary form of vaulting known as **corbeling**, which is also found in Mycenaean "beehive" tombs (see fig. 4-14) and Etruscan tumulus tombs (see pages 166–167). Stonehenge was eventually abandoned about 1100 B.C. as part of another change that occurred during the late Bronze Age: the preference for cremation over burials for the dead.

By definition, menhirs and dolmens are monuments. Not only are they large, but they commemorate the dead. Whether they and cromlechs should be termed architecture is also a matter of definition. We tend to think of architecture in terms of enclosed interiors, but we also have landscape architects, who design gardens, parks, and playgrounds. Open-air theaters and sports stadiums are likewise thought of as architecture. To the ancient Greeks, who coined the term, *architecture* meant something higher *(arch)* than the usual construction or building *(tecton,* which meant carpenter)—much as an archbishop ranks above a bishop. Architecture differed from practical, everyday building in scale, order, permanence, and purpose. A Greek would have viewed Carnac and Stonehenge as architecture, since the builders of those structures rearranged nature into settings for human activities that expressed shared beliefs. We, too, will be able to accept them as architecture once we understand that it is not necessary to *enclose* space in order to define it. If architecture is "the art of shaping space to human needs and aspirations," then Carnac and Stonehenge more than meet the test.

Neolithic North America

The "earth art" of the Mound Builders, prehistoric Indians of North America, may be compared to the megalithic monuments of Europe in terms of effort. These mounds vary greatly in shape and purpose as well as in date, ranging from about 2000 B.C. to the time of the Europeans' arrival in the late fifteenth century. Of particular interest are the "effigy mounds" in the shape of animals, presumably the totems of the tribes that produced them. The most spectacular is the Great Serpent Mound (fig. 1-20), a snake some 1,400 feet long that slithers along the crest of a ridge by a small river in southern Ohio. The huge head, its center marked by a heap of stones that may once have been an altar, occupies the highest point. It appears that the natural formation of the terrain inspired this extraordinary work of landscape architecture, as mysterious and moving in its way as Stonehenge.

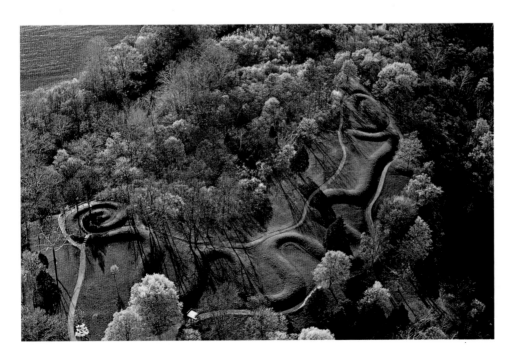

1-20. Great Serpent Mound, Adams County, Ohio. c. 1070 A.D. Length 1,400' (426.7 m)

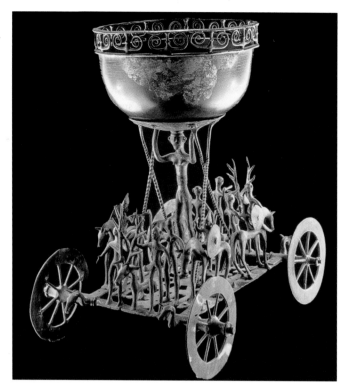

1-21. Cult Wagon, from Strettweg, Austria. 7th century B.C. Bronze, height 13⅛" (33.3 cm); length 17½" (44.5 cm). Steiermarkisches Landesmuseum Joanneum, Graz

1-22. Flagon, from Basse-Yutz, Lorraine region, France. 5th century B.C. Bronze, coral, and enamel, height 15" (39.6 cm). The British Museum, London

Iron Age Europe

HALLSTATT CULTURE. The introduction of iron during the eighth century B.C. had little immediate impact on the way of life in Central and Northern Europe. More important was the growth of trade with Greece and Italy, which had begun to emerge into the light of history. An excellent example of the art that prevailed during the seventh century B.C. is a bronze cult wagon from Strettweg, Austria, found not far from the burial ground at Hallstatt that gave its name to the culture of the early Iron Age in central Europe (fig. 1-21). The Hallstatt Geometric includes a curious mixture of styles. The nude warriors recall the stick figures in wood and bronze, as well as rock carving, found throughout the North. But the female deity with a large, shallow dish on her head is very close to early Geometric Greek bronzes. So is the cart itself, although it is of a type unique to Hallstatt culture. The impact of western Greek colonies in Italy and Etruria can also be seen in this and other Hallstatt bronzes. That influence is not surprising, given the growing commerce and the likely route over which Bronze Age culture was carried. These sources do not, however, explain the meaning of the ritual portrayed. The scene has been described variously as a hunt, a sacrifice, or a harvest celebration, but there is no solid evidence to support any of these proposals. Whatever its purpose, the Strettweg cult wagon remains the most tantalizing evidence we have of the early Iron Age culture in Europe.

LA TÈNE CULTURE. Hallstatt Culture was followed in the mid-fifth century B.C. by La Tène Culture, named for the underwater site on Lake Neuchâtel in Switzerland where it was first unearthed. La Tène is synonymous with the art of the Celts. Hallstatt culture is sometimes identified with them as well, for the two

occurred in adjacent areas, and eventually overlapped. However, it is best to treat Hallstatt as a precursor of La Tène. The Celts had settled in southwest Germany and eastern France (the area later known as Gaul by the Romans) during the second millennium B.C. They expanded across much of Europe and into Asia Minor, where they fought the Greeks (see page 158). Pressed by neighboring Germanic peoples, who had come from the Baltic region, they crossed the English Channel in the fourth century B.C. and colonized Britain and Ireland. At the beginning of the century, they invaded Italy and even conquered Rome. They were not fully put down until Julius Caesar defeated Vercingetorix in 46 B.C.

La Tène thus represents the Celts at the height of their culture, when they enjoyed considerable power and wealth from their far-flung trade. Like Hallstatt art, Celtic bronzes are a mixture of elements. The best pieces, such as a pair of early fourth-century B.C. flagons from Basse-Yutz in the Lorraine region of France (fig. 1-22), are very sophisticated indeed. They adapt an Etruscan shape that had previously been imported as a luxury item, and add lids and spouts decorated with Hallstatt motifs. The animal-style handles, while similar to Scythian and Persian motifs (see pages 84–85), were probably derived from the Greeks, who became the leading gold- and silversmiths in the sixth century B.C. The intricate inlay of red enamel and coral, imported from the Mediterranean, is characteristic of Celtic art in its abstract patterns. Yet we have no sense of eclecticism, thanks to the masterly integration of elements and superb workmanship. In contact with the civilizations of the Near East and Mediterranean, La Tène Culture flourished, even as northern Europe remained "prehistoric" until a few hundred years before the birth of Jesus.

CHAPTER TWO

Egyptian Art

Egyptian civilization has long been considered the most rigid and conservative ever. Plato said that Egyptian art had not changed in 10,000 years. Perhaps *enduring* and *continuous* are better terms for it, although at first glance all Egyptian art between 3000 and 500 B.C. does have a certain sameness. The basic pattern of Egyptian institutions, beliefs, and art was formed during the first few centuries of that vast time span and was maintained until the end. Over the years, however, Egypt went through ever more severe crises that threatened its survival. Had it been as inflexible as supposed, Egyptian civilization would have collapsed long before it finally did. Egyptian art alternates between conservatism and innovation, but it is rarely static. Moreover, its greatest achievements had a decisive influence on Greek and Roman art. Thus we still feel ourselves linked to the Egypt of 5,000 years ago by a continuous tradition.

The facts of geography had much to do with the character and continuity of Egyptian civilization. The Nile river, the longest in the world, governs daily life in much of Egypt to this day. It has two branches. The first, the White Nile, originates in the headwaters of Lake Victoria. The second, the Blue Nile, rises from Lake Tana in the highlands of Ethiopia and joins the White Nile near Khartoum in the Sudan. Both branches are fed by numerous tributaries along the way, including the Sobat and Atbara rivers. North of Khartoum the Nile falls in a series of six cataracts. Below the first cataract (actually the last one), it flows 450 miles to Cairo, then fans out into a broad delta that empties into the Mediterranean Sea. Whereas the White Nile is relatively constant, the Blue Nile, fed by heavy summer rains in the Lake Plateau, is the source of life-giving annual floods. Before the completion of the Assuan dam in 1970 controlled the flow of water, it also brought silt that replenished the valley. Beyond the thin strip of fertile valley lies the desert ("the red land"), created by the arid trade winds blowing from the west.

For several hundred years, the country was presumably governed by local rulers who barely outranked tribal chiefs. From these territories emerged two rival kingdoms: Upper Egypt, to the south, with its capital at Naqada near Thebes, and Lower Egypt near the Nile Delta. Judging from pottery made in the fourth millennium B.C., Upper Egypt was more advanced at first. The struggle between them ended when the Upper Egyptian kings conquered Lower Egypt and combined the two realms. They molded the Nile Valley from Assuan to the Delta into a single state and increased its fertility by regulating the river waters through dams and canals.

THE OLD KINGDOM

DYNASTIES. In the third century B.C., the priestly historian Manetho divided the list of kings into thirty-one dynasties, a practice that we still follow today. The history of Egypt begins with the First Dynasty shortly after 3000 B.C. (The dates of the earliest rulers are difficult to translate precisely into our calendar. The dating system used in this book is by French Egyptologist Nicolas Grimal.) The time of transition between prehistory and the First Dynasty is called the predynastic period. The next major period, known as the Old Kingdom, lasted from about 2700 B.C. until about 2190 B.C., the end of the Sixth Dynasty. This method of counting historic time by dynasties conveys both the strong Egyptian sense of continuity and the prime importance of the pharaoh (king), who was not only the supreme ruler but also a god. The pharaoh transcended all people, for his kingship was not a privilege derived from a superhuman source but was absolute and divine. This belief was the key feature of Egyptian civilization and largely shaped the character of Egyptian art.

We do not know the exact steps by which the early pharaohs established their claim to divinity, but we know their historic achievements. They molded the Nile Valley from the First Cataract (falls) at Assuan to the Delta into a single state and increased its fertility by regulating the river waters through dams and canals.

TOMBS AND RELIGION. Of these vast public works nothing remains today, and very little has survived of ancient Egyptian palaces and cities. Our knowledge of early Egyptian civilization rests almost entirely on tombs and their contents. The survival of

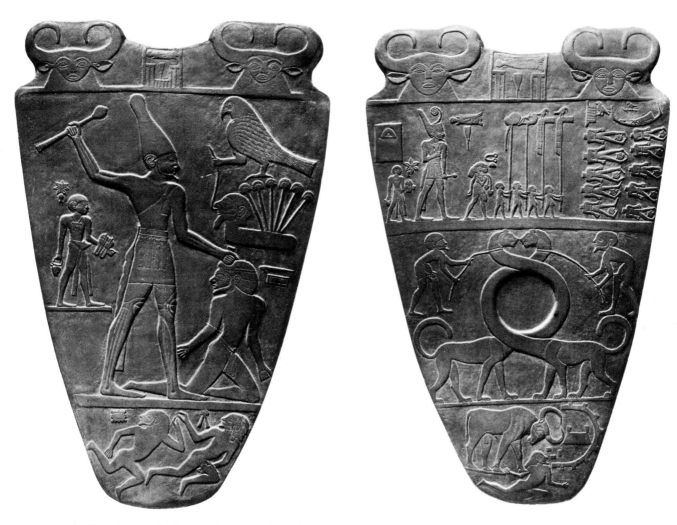

2-1, 2-2. *Palette of King Narmer* (both sides), from Hierakonpolis. c. 3150–3125 B.C. Slate, height 25" (63.5 cm). Egyptian Museum, Cairo

these structures is no accident, since they were built to last forever. Yet we must not make the mistake of concluding that the Egyptians viewed life on this earth mainly as a road to the grave. Their cult of the dead is a link with the Neolithic past, but the meaning they gave it was new. The dark fear of the spirits of the dead that dominates primitive ancestor cults seems entirely absent. Instead, the Egyptian attitude was that people must provide for their own afterlives. They therefore equipped their tombs as replicas of their daily environment for their spirits *(kas)* to enjoy. In order to make sure that the ka had both a home and a body to dwell in, tombs usually included a statue of the individual in case the mummified corpse was destroyed.

There is a blurring of the line between life and death in this practice, which was perhaps the main reason behind these mock households. People could look forward to active, happy lives without being haunted by fear of the great unknown, since they knew that their kas would enjoy the same pleasures as they did by providing for them in advance. In a sense, the Egyptian tomb was an investment in peace of mind. Such, at least, is the impression one gains of Old Kingdom tombs. Later, this concept of death was altered by a tendency to subdivide the spirit or soul into two or more separate identities, as well as by the introduction of the weighing of souls. Only then do we find expressions of the fear of death.

Sculpture

PALETTE OF KING NARMER. One of the kings who helped to unite Egypt was Narmer, who appears on the ceremonial slate palette in figures 2-1 and 2-2. In many ways, the Narmer palette can be claimed as the oldest *historical* work of art we know, 3150–3125 B.C. Not only is it the earliest surviving image of a historical personage identified by name, but its character is no longer primitive. In fact, it already shows most of the features of later Egyptian art. The Narmer palette evidently celebrates a victory over Lower Egypt. (Note the different crowns worn by the king.) However, its meaning is largely ceremonial. Egypt had already been unified under earlier kings, so that the traditional identification of Narmer with King Menes, the founder of the First Dynasty, is unlikely.

Let us first "read" the scenes on both sides. (The fact that we are able to do so is another sign that we have left prehistoric art behind.) The meaning of these **reliefs** (sculpture in which the image stands out from a flat background) is made explicit by **hieroglyphic** labels. (*Hieroglyph* means sacred pictorial writing.) This system of writing was of very recent origin. (See discussion below.) The meaning is also made clear by symbols that convey precise messages and—most important—through the rational orderliness of the design.

The main elements of the Narmer Palette can already be seen in rudimentary form in a limestone scene discovered in 1995 at Gebel Tjauti some 25 miles northwest of Luxor. Dating from 3200–3150 B.C., it seems to show the legendary King Scorpion after his victory over the city of Naqada. It probably represents the first of two kings of the same name in the late predynastic period. The Scorpion relief includes the scorpion hieroglyph, as well as several others, notably that of the falcon-god Horus directly above the scorpion, making this the oldest known example of Egyptian writing. The second King Scorpion (sometimes also called Zekhen) is represented on a mace-head from Hierakonpolis of about 3250–3150 B.C. (Ashmolean Museum, Oxford). It was found in his tomb at Abydos, which included numerous pottery shards from the late predynastic Naqada period inscribed with the scorpion hieroglyph. The mace-head is far more disciplined than the earlier relief, and approaches the Narmer palette in its use of ground lines and combination of profile and frontal views.

In figure 2-1, Narmer, seen wearing the white crown of Upper Egypt, has seized a fallen enemy by the hair and is about to slay him with his mace. Two more defeated enemies are placed in the bottom compartment. (The small rectangular shape next to the man on the left stands for a fortified town or citadel.) Facing the king in the upper right we see a complex bit of picture writing: a falcon standing above a clump of papyrus plants holds a tether attached to a human head that "grows" from the same soil as the plants. This image repeats the main scene on a symbolic level. The head and papyrus plant stand for Lower Egypt, while the victorious falcon is Horus, the local god of Upper Egypt. The parallel is plain. Horus and Narmer are the same; both are gods triumphing over human foes. Narmer's gesture must therefore not be seen as representing a real fight. The enemy is helpless from the start, and the slaying is a ritual rather than a physical act. We know it is ritual because Narmer has taken off his sandals (the court official behind him carries them in his left hand), a sign that he is standing on holy ground. (The same notion is found again in the Old Testament, apparently as the result of Egyptian influence, when the Lord commands Moses to remove his shoes before he appears to him in the burning bush.)

On the other side of the palette (fig. 2-2), the king again appears barefoot and is wearing the red crown of Lower Egypt and followed by the sandal carrier. He walks behind a group of standard-bearers to inspect the beheaded bodies of prisoners. The bottom compartment depicts the victory on a symbolic level. The pharaoh is represented as a strong bull trampling an enemy and knocking down a citadel. (A bull's tail hanging down from Narmer's belt in both images became part of the pharaoh's cere-monial garb for the next 3,000 years.) Only the center section does not convey a clear meaning. The intertwined snake-necked lions and their two attendants have no identifying features. However, similar beasts are found in "protoliterate" Mesopotamian cylinder seals of about 3300–3200 B.C., an art form that was soon adopted in Egypt as well (see Chapter Three). There they combine the lioness attribute of the mother goddess with the copulating snakes that signify the god of fecundity. They thus form a fertility symbol that unites the female and male principles in nature. Here they perhaps refer to the union of Upper and Lower Egypt. Whatever their meaning on Narmer's palette, their presence is evidence of contact between the two civilizations at an early and critical stage of their development. They do not reappear in Egyptian art.

THE LOGIC OF EGYPTIAN STYLE. The Narmer palette has a clear inner logic that is readily apparent. What strikes us first is its strong sense of order. The surface is divided into horizontal bands, or registers. Each figure stands on a line, or strip, denoting the ground. The only exceptions are the attendants of the long-necked beasts, whose role seems mainly ornamental; the hieroglyphic signs, which belong to a different level of reality; and the dead enemies, which are seen from above instead of from the side. The modern way of depicting a scene as it would appear to a single viewer at a single moment is as alien to Egyptian artists as it was to those of the Neolithic era. They strive for clarity, not illusion, and therefore pick the most characteristic view in each case.

But they impose a strict rule on themselves. When the angle of vision changes, it must be by 90 degrees, as if sighting along the edges of a cube. Hence only three views are possible: full face, strict profile, and vertical from above. Any other position is embarrassing. (Note the rubberlike figures of the fallen enemies at the bottom of figure 2-1.) Moreover, the standing human figure does not have a single main profile. Instead, it has two different profiles, which must be combined for the sake of clarity. The method of doing this (which was to survive unchanged for 2,500 years) is shown in the large figure of Narmer in figure 2-1. Eye and shoulders are in frontal view, head and legs in profile. This formula was worked out so as to show the pharaoh (and all those who moved in the aura of his divinity) in the most complete way possible. And since the scenes depict solemn and, as it were, timeless rituals, our artist was not concerned with the fact that this method of depicting the human body made movement or action almost impossible. Indeed, the frozen quality of the image seems well suited to the divine nature of the pharaoh. Mere mortals act; he simply is.

Whenever any movement requiring some sort of effort must be depicted, the Egyptian artist abandons the combined view, for such activities are always performed by underlings whose dignity does not have to be preserved. Thus in our palette the two animal trainers and the four men carrying standards are shown in strict profile, except for the eyes. The composite view seems to have been created specifically by artists working for the royal court to convey the majesty of the divine king. It never lost its sacred flavor, even in later times, when it had to serve other purposes as well.

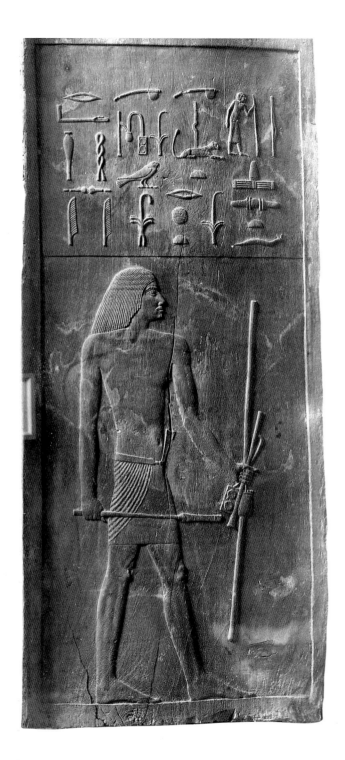

Third Dynasty

The beauty of the style we saw in the Narmer palette did not develop fully until about five centuries later, during the Third Dynasty, especially under the reign of its greatest ruler, King Djoser. From the Tomb of Hesy-ra, one of Djoser's high officials, comes the masterly wooden relief (fig. 2-3) showing the deceased with the emblems of his rank, including writing materials, since the position of scribe was highly honored. The view of the figure matches that of Narmer on the palette, but the proportions are far more balanced and harmonious. The carving of the physical details shows keen observation as well as great delicacy of touch.

ARCHITECTURE. When we speak of the Egyptians' attitude toward death and afterlife, we do not mean that of the average Egyptian. We are referring to the outlook of the small aristocratic caste clustered around the royal court. The tombs of this class of high officials, who were often relatives of the royal family, are usually found near the pharaohs'. Their shape and contents reflect, or are related to, the tombs of the kings. We still have a great deal to learn about the origin and significance of Egyptian tombs, but the concept of afterlife we find in the so-called private tombs initially seems to have applied only to the privileged few because of their association with the pharaohs. Ordinary mortals could look forward only to a shadowy afterlife in the underground realm of the dead. As early as the Fourth Dynasty, wealthy individuals built tombs in imitation of royal examples, complete with paintings and reliefs, cut into the bedrock near Giza.

MASTABAS. The standard form of these tombs was the mastaba (the word comes from the Arabic for "bench" because of their shape): a brick-shaped mound faced with brick or stone. The mastaba was built above the burial chamber, which was deep underground and linked to the mound by a shaft (figs. 2-4 and

2-3. *Portrait Panel of Hesy ra,* from Saqqara. c. 2660 B.C. Wood, height 45" (114.3 cm). Egyptian Museum, Cairo

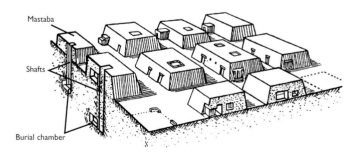

2-4. Group of mastabas (after A. Badawy). 4th Dynasty

2-5). Inside the mastaba were a chapel for offerings to the ka and a secret cubicle for the statue of the deceased (see fig. 2-5).

PYRAMIDS. Royal mastabas became quite large as early as the First Dynasty, and their exteriors sometimes resembled those of a royal palace. During the Third Dynasty, they developed into step pyramids. The best known (and probably the first) is that of King Djoser (fig. 2-5; see also fig. 2-6), which was built over a traditional mastaba in a series of expanding layers (see figs. 2-5–2-7). The pyramid itself, unlike later ones, is a solid structure with underground burial chambers. Its function was not so much funereal as memorial and religious. It declares the pharaoh's supreme power and divine status. The height and shape suggest Mesopotamian ziggurats (see fig. 3-4). The step pyramid, too, was perhaps intended to bridge the gap with the heavens by serving as the "stairway" and "jumping-off point" for Djoser to ascend to the heavens and fulfill his cosmological role as a god.

FUNERARY DISTRICTS. The modern imagination, enamored of "the silence of the pyramids," has created a false picture of these monuments. Pyramids were not isolated structures in the middle of the desert but rather were part of vast funerary districts,

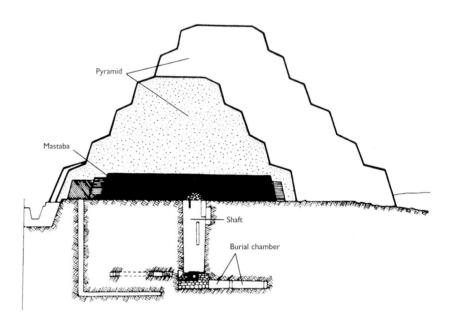

2-5. Transverse section of the Step Pyramid of King Djoser, Saqqara

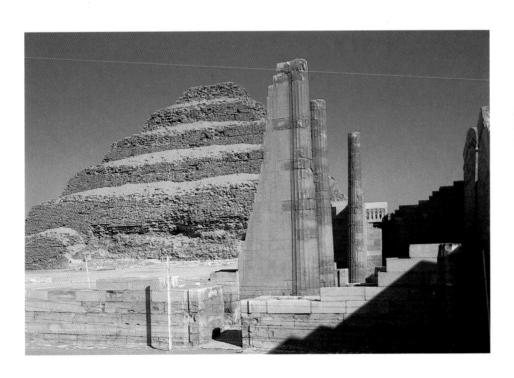

2-6. Imhotep. Step Pyramid of King Djoser, Saqqara. 3rd Dynasty. c. 2681–2662 B.C.

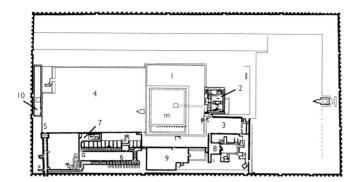

2-7. Plan of the funerary district of King Djoser, Saqqara (M. Hirmer after J. P. Lauer)

(1) pyramid (m=mastaba); (2) funerary temple; (3, 4, 6) courts; (5) entrance hall; (7) small temple; (8) court of North Palace; (9) court of South Palace; (10) southern tomb

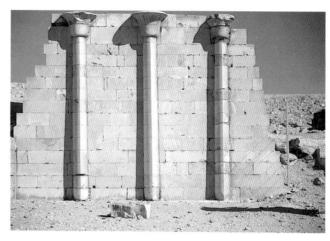

2-8. Papyrus-shaped half-columns, North Palace, funerary district of King Djoser, Saqqara

with temples and other buildings that were the scene of great religious celebrations during the pharaoh's lifetime and after. The funerary district around the Step Pyramid of Djoser (fig. 2-7) is both the earliest and the first built entirely of stone, which had been used sparingly before that time. Enough of it has survived for us to see why its creator, Imhotep, came to be revered as the founder of Egyptian culture. He was both vizier (overseer) to the king and high priest of the sun-god Ra. Imhotep is the first artist whose name has been recorded in history, as well as the first in a line of Egyptian architects who are known to us.

Imhotep's achievement is impressive not only for its scale but also for its unity, which embodies the concept of the pharaoh to perfection. The funerary district proclaims Djoser king of both Upper and Lower Egypt. There are two of everything, including a north and a south palace. Also, for the first time, there is a second tomb (no. 10 on the plan in fig. 2-7), which traditionally had been located at Abydos halfway up the Nile. The large courtyard (no. 4) to the south of the pyramid was used for ritual purposes during the pharaoh's coronation, which was to be reenacted there as part of the Sed festival to celebrate his jubilee 30 years later. (Djoser's reign lasted only 19 years.) Imhotep must have had a remarkable intellect as well as outstanding ability—he was renowned as an astronomer and later deified as a healer. In this regard he set a precedent for the great architects who followed in his footsteps. Even today architects address the important ideas and issues of our time.

COLUMNS. Egyptian architecture had begun with structures made of mud bricks, wood, reeds, and other light materials. Although Imhotep used cut-stone masonry, his architectural forms reflected shapes and devices developed for less durable materials. Thus we find several kinds of columns—always engaged (set into the wall) rather than freestanding—which echo

the bundles of reeds or wooden supports that used to be set into mud-brick walls in order to strengthen them. But the very fact that they no longer had their original function made it possible for Imhotep and his fellow architects to make them serve a new, expressive purpose. The idea that architectural forms can express anything may seem hard to grasp at first. We tend to assume that unless forms have a clear-cut structural role, such as supporting or enclosing, they are mere decoration. But the slender, tapered, fluted columns in figure 2-6, or the papyrus-shaped half-columns in figure 2-8 do not simply decorate the walls to which they are attached. They interpret them and give them life. Their proportions, the feeling of strength and resilience they convey, their spacing, the degree to which they project—all share in this task.

We shall learn more about the expressive role of columns when we discuss Greek architecture, which adopted the Egyptian stone column and developed it further. For the time being, let us note another factor that may enter into their design: announcing the symbolic purpose of the building. The papyrus half-columns in figure 2-8 are linked with Lower Egypt (compare the papyrus plants in fig. 2-1); hence they appear in the North Palace of Djoser's funerary district. The South Palace has columns of a different shape, which is linked with Upper Egypt.

Fourth Dynasty

THE PYRAMIDS OF GIZA. Djoser's successors adapted the step pyramid to the smooth-sided shape that is familiar to us, a process that took several generations. The first to do so was Sneferu, the founder of the Fourth Dynasty. He built three pyramids, of which the most important is the so-called "Red" or "Bent" Pyramid at Dahshur where he was probably buried. (The two earlier step pyramids were later remodeled.) The development of

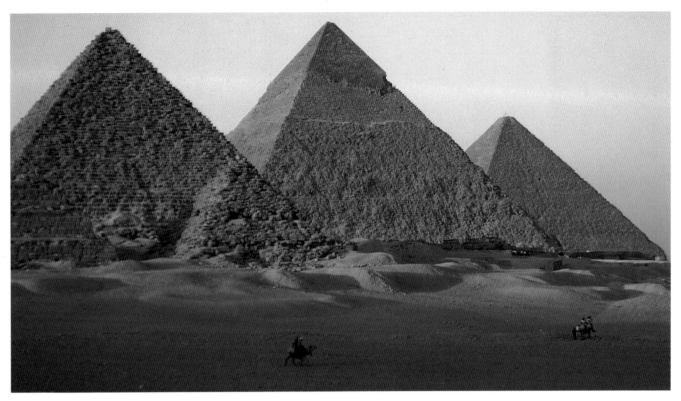

2-9. The Pyramids of Menkaure (c. 2533–2515 B.C.), Khafre (c. 2570–2544 B.C.), and Khufu (c. 2601–2528 B.C.), Giza

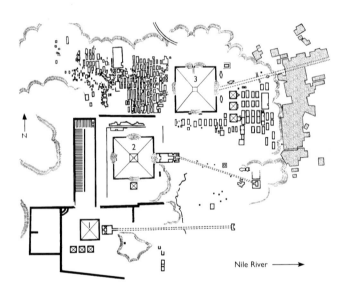

Nile River ➡

2-10. Plan of the pyramids at Giza: (1) Menkaure; (2) Khafre; (3) Khufu

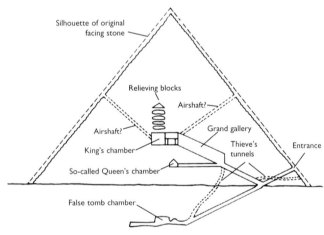

Silhouette of original facing stone

Relieving blocks

Airshaft?

Airshaft?

King's chamber

Grand gallery

Thieve's tunnels

Entrance

So-called Queen's chamber

False tomb chamber

2-11. North-south section of Pyramid of Khufu (after L. Borchardt)

the pyramid reaches its climax during the Fourth Dynasty in the three great pyramids at Giza (figs. 2-9 and 2-10), the earliest and largest of which was built by Sneferu's son, Khufu. They originally had an outer casing of carefully dressed stone, which has disappeared except near the pinnacle of the Pyramid of Khafre. The top of each was covered with a thin layer of gold. The pyramid evidently was identified with the pharaoh's "father," Ra, and perhaps served as the final resting place of the sun. The three differ from one another in scale, as well as in some details, but the basic features are shown in the section of Khufu's pyramid (fig. 2-11). The

burial chamber is near the center of the structure rather than below ground, as in the Step Pyramid of Djoser. This placement was a vain attempt to safeguard the chamber from robbers.

According to a recent theory, the three pyramids at Giza are arranged in the same formation as the stars in the constellation Orion, which was identified with the god Osiris. One of the so-called air shafts in the king's chamber of the Pyramid of Khufu pointed to the polar stars in the north, which are always visible; in ancient times the other lined up with Orion, which could be seen in the southern sky after an absence of some two months (the

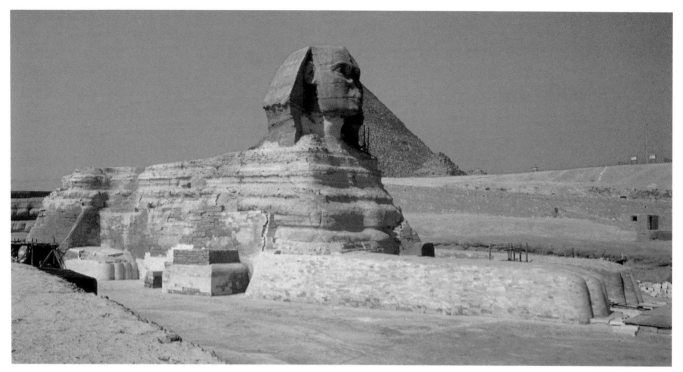

2-12. The Great Sphinx, Giza. c. 2570–2544 B.C. Sandstone, height 65' (19.8 m)

position of Orion has since changed). The shaft thus served as a kind of "escape hatch" that allowed the pharaoh to take his place as a star in the cosmos. Another hidden shaft in the queen's chamber was aligned with the star of Isis (Sirius). It seems to have been used in the ritual of fertilization and rebirth described in the Egyptian Book of the Dead. The proposal, although controversial, is tantalizing, for it helps to explain many puzzling features of the pyramids in light of the Pyramid Texts of the two dynasties that followed. [See Primary Sources, no. 1, page 210.]

Clustered about the three Great Pyramids are several smaller ones and a large number of mastabas for members of the royal family and high officials (see fig. 2-10). The unified funerary district of Djoser has given way to a simpler arrangement. Adjoining each of the Great Pyramids to the east is a mortuary temple, where the pharaoh's body was brought for embalming and last rites. From there a causeway leads to a second temple at a lower level, in the Nile Valley, about a third of a mile away. This arrangement represents the final step in the evolution of kingship in Egypt. It links the pharaoh to the eternal cosmic order by connecting him, in both physical and ritual terms, to the Nile River, whose annual cycles give life to Egypt and dictate its rhythm to this very day.

The pyramids of Giza mark the high point of pharaonic power. After the end of the Fourth Dynasty, less than two centuries later, pyramids on such a scale were never attempted again in the Old Kingdom, although more modest ones continued to be built. The world has always marveled at the sheer size of the Great Pyramids as well as at the technical accomplishment they represent. To design and build them required both considerable skill and a grasp of geometry. Egyptian mathematics seems to have been based on practical problem-solving rather than abstract numbers. Despite this limitation, which precluded the development of the formulas that underlie higher mathematics, it was possible to calculate the volume of a pyramid, for example, by using a complex sequence of steps to arrive at the correct answer. The ingenious methods used to construct the pyramids are even more remarkable, given the simple tools and measuring devices available to the builders. Much of the work was done with stone tools, such as chisels, axes, and balls, although some metal ones were also used.

The pyramids have come to be seen as symbols of slavery, with thousands of men forced by cruel masters to work at their construction. Such a picture may not be entirely just. Records show that much of the work was paid for, and that shelter, clothing, and food (part of it in mead, a form of beer) were often furnished. It may be closer to the truth to view these monuments as vast public works that provided a livelihood for a good part of the population, up to 3,000 people. At the same time, criminals, prisoners of war, and others were forced to work on the pyramids. Even under the best conditions, the labor was hard and dangerous.

THE GREAT SPHINX. Next to the valley temple of the Pyramid of Khafre stands the Great Sphinx, which was carved from the live rock (fig. 2-12). (*Sphinx* is an ancient Greek word for "strangler"; it was probably derived from the Egyptian *shesep ankh*, meaning "living image.") It is an even more impressive symbol of divine kingship than the pyramids themselves. The royal head rising from the body of the lion reaches a height of 65 feet. Damage inflicted during Islamic times has obscured the details of the face, and the top of the head is missing. Despite its location, the Great Sphinx bears, in all probability, the features not of Khafre but of Khufu. The statue can be regarded as a colossal guardian figure in the guise of the lion god Ruty. (Lions became associated with the pharaoh, perhaps through hunting, as early as the predynastic period, when they were still plentiful. The **sphinx** in its original form was a griffin, a mythical beast that is part eagle and part lion.) Its

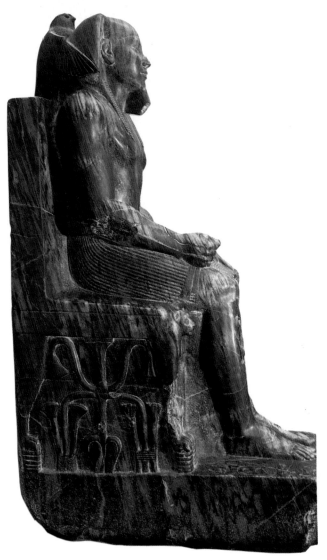

2-13. *Khafre,* from Giza. c. 2500 B.C. Diorite, height 66" (167.7 cm).
Egyptian Museum, Cairo

awesome majesty is such that the Great Sphinx could also be con-
sidered an image of the sun-god a thousand years later, when the
lion became the personification of Ra (see page 63). It acquired this
connection through its nearness to the temple of the solar deity
Harmakhis, which lies just in front of it.

PORTRAITURE. Apart from great works of architecture, the
chief glories of Egyptian art are the portrait statues found in
funerary temples and tombs. The finest one is of Khafre, and came
from the valley temple of his pyramid (fig. 2-13). Carved of dio-
rite, an extremely hard stone, it shows the king enthroned, with
the falcon of the god Horus enfolding the back of the head with
its wings. (The pharaoh was often equated with Horus as the son
of Osiris and Isis; the association, in different form, is also seen in
the Narmer palette, fig. 2-1.)

Here the "cubic" view of the human form appears in full force.
After marking the faces of the block with a grid, the sculptor drew

the front, top, and side views of the statue, then worked inward
until these views met. This approach encouraged the development
of the systematic proportions used in representing the pharaoh. In
fact, the canon of forms can be readily deduced, so standardized
did it become, although it varied somewhat over time. The grid
system and carving techniques used in Egyptian sculpture were
not very different from what was used for the pyramids at Giza.
The result is a figure almost overwhelming in its firmness and
immobility. Truly, it is a fitting vessel for the spirit! The body, at
once powerful yet idealized, is completely impersonal. Only the
face suggests some individual traits, as will be seen if we compare
it with Menkaure (fig. 2-14), Khafre's successor and the builder of
the third and smallest pyramid at Giza.

Menkaure and his queen, Khamerernebty, are standing. Both
have the left foot forward, yet there is no hint of forward move-
ment. These are idealized portraits; a similar but much smaller
group, showing Menkaure between two goddesses, hardly differs

in appearance. Since the figures are about the same height, they allow us to compare male and female beauty as interpreted by one of the finest Old Kingdom sculptors. The artist knew not only how to contrast the structure of the two bodies but also how to emphasize the soft, swelling forms of the queen through her close-fitting gown.

The sculptor who carved the statues of Prince Rahotep and his wife Nofret (fig. 2-15) was less subtle. They owe their lifelike appearance to their vivid coloring. (Other such statues, including Menkaure's, must also have been painted in this way, but the coloring has survived intact in only a few instances.) The darker body

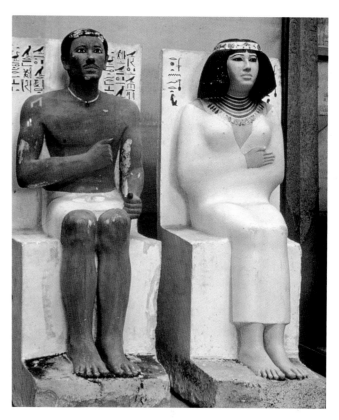

2-15. *Prince Rahotep and His Wife, Nofret.* c. 2580 B.C. Painted limestone, height 47¼" (120 cm). Egyptian Museum, Cairo

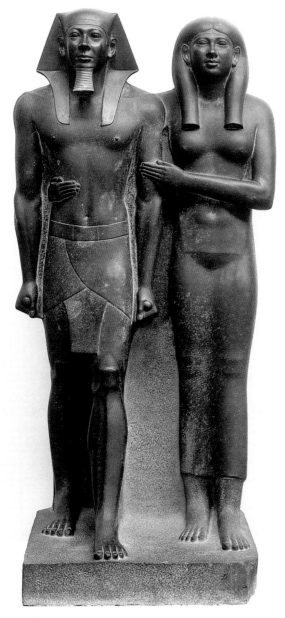

2-14. *Menkaure and His Wife, Queen Khamerernebty,* from Giza. c. 2515 B.C. Slate, height 54½" (138.4 cm). Museum of Fine Arts, Boston. Harvard–Museum of Fine Arts Expedition

color of the prince is the standard for males in Egyptian art. The eyes have been inlaid with shining quartz to make them look as alive as possible, and the portrait quality of the faces is striking.

Standing and seated figures are the basic forms of Egyptian large-scale sculpture in the round. At the end of the Fourth Dynasty, a third pose was added, as symmetrical and immobile as the first two: a scribe sitting cross-legged on the ground. The finest of these scribes dates from the beginning of the Fifth Dynasty (fig. 2-16). The name of the sitter (in whose tomb at Saqqara the statue was found) is unknown, but we must not think of him as a secretary waiting to take dictation. Rather, he was a high court official, a "master of sacred—and secret—letters." The solid, incisive treatment of form bespeaks the dignity of his station, which at first seems to have been restricted to the sons of pharaohs. Our example stands out for the vividly alert expression of the face and for the individual handling of the torso, which records the somewhat flabby body of a man past middle age.

Another invention of Old Kingdom art was the portrait bust. This type of sculpture is so familiar that we tend to take it for granted, yet its origin is puzzling. Was it simply a cheap substitute for a full-length figure? Or did it have a purpose of its own, perhaps as an echo of the Neolithic custom of keeping the head of the deceased separate from the rest of the body (see page 42)? Be that

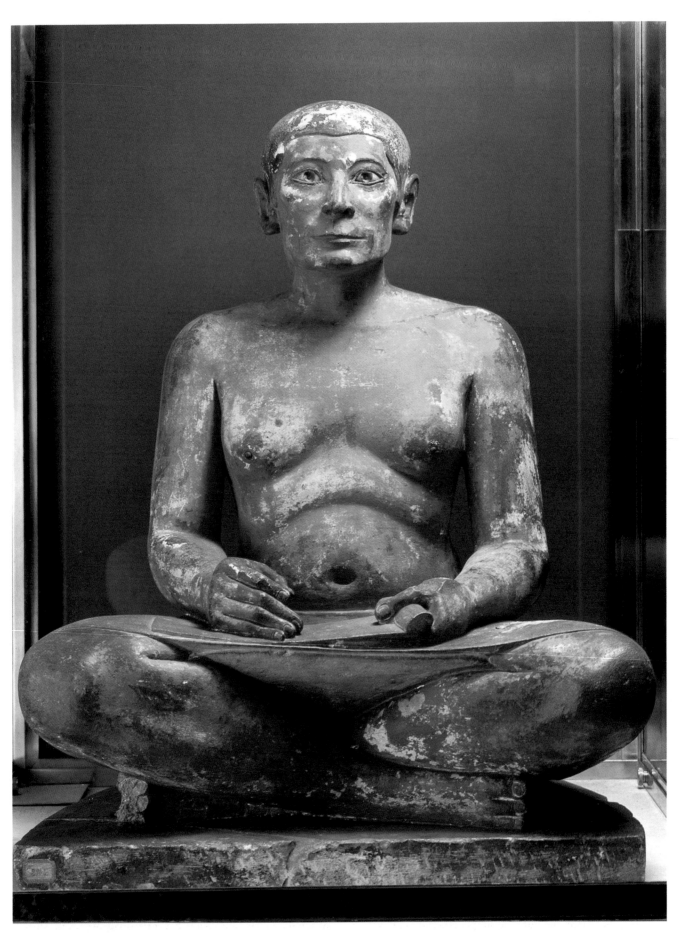

2-16. *Seated Scribe,* from Saqqara. c. 2400 B.C. Limestone, height 21" (53.3 cm). Musée du Louvre, Paris

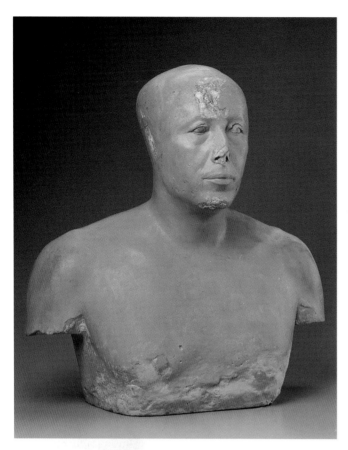

2-17. *Bust of Vizier Ankh-haf,* from Giza. c. 2520 B.C. Limestone, partially molded in plaster, height 21" (53.3 cm). Museum of Fine Arts, Boston. Harvard–Museum of Fine Arts Expedition

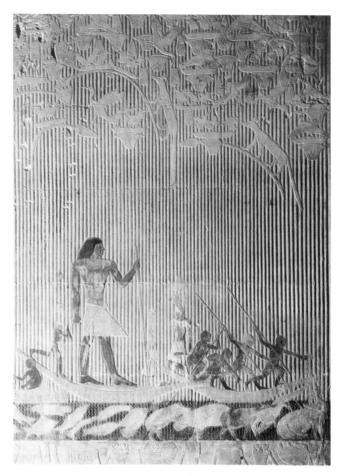

2-18. *Ti Watching a Hippopotamus Hunt.* c. 2510–2460 B.C. Painted limestone relief, height approx. 45" (114.3 cm). Tomb of Ti, Saqqara

as it may, the earliest of these busts (fig. 2-17) is also the finest. Indeed, it is one of the great portraits of all time. In this noble head, we find a memorable image of the sitter's character. With remarkable skill the artist has rendered the subtle distinction between the solid shape of the skull and its soft, flexible covering of flesh, aided by the well-preserved color.

TOMB DECORATION. Scenes of daily life were a standard feature of Egyptian tombs. Some of the most remarkable are found in one built for the architectural overseer Ti at Saqqara. The hippopotamus hunt in figure 2-18 is of special interest because of its landscape setting. The background is a papyrus thicket. The stems form a regular design that erupts in the top zone into an agitated scene of nesting birds menaced by small predators. The water in the bottom zone, marked by a zigzag pattern, is equally crowded with struggling hippopotamuses and fish. All these, as well as the hunters in the first boat, are carefully observed and full of action. Only Ti himself, standing in the second boat, is immobile, as if he belongs to a different world. Towering above the other men, he is in the passive, timeless stance used for funerary portrait reliefs and statues (compare fig. 2-3).

Ti does not direct the hunt; he simply observes. His passive role is typical of representations of the deceased in all such scenes

from the Old Kingdom. It seems to be a way of conveying that the body is dead but the spirit is alive and aware of the pleasures of this world, although the man can no longer take part in them directly. We should also note that these scenes do not depict the dead man's favorite pastimes. If they did, he would be looking back, and such nostalgia is foreign to the spirit of Old Kingdom tombs. Instead, these scenes form a seasonal cycle. They are a sort of calendar of human activities for the spirit of the deceased to watch year in and year out.

The hunt may have symbolic meaning as well. Osiris, the mythical founder of Egypt, was associated with the Nile and the underworld as the god of fertility, death, and resurrection. In ancient tradition, he was murdered and dismembered by his brother Seth, who sealed him in a casket that was cast into the Nile. Seth scattered Osiris' remains after the casket was retrieved by Osiris' consort, Isis. She eventually recovered his parts and reassembled them into the first mummy, from which she conceived her son, Horus. Horus avenged his father's death by besting Seth in a series of contests lasting 80 years. As a result, Osiris became lord of the underworld, Horus the ruler of the living, and Seth the god who governed the deserts. The hippopotamus was often viewed as an animal of evil and chaos that destroyed crops, and thus as the embodiment of Seth. In turn, the deceased may be likened to

Osiris. The papyrus thicket was where Isis hid Horus to protect him from Seth, so that it was seen as a place of rebirth, much like the tomb itself. Finally, the boat traditionally carried the ka through its eternal journey in the afterlife.

Scenes of daily life offered artists a welcome opportunity to widen their powers of observation. We often find astounding bits of realism in the description of plants and animals. Note, for example, the hippopotamus in the lower right-hand corner turning its head in fear and anger to face its attackers. Such a sympathetic portrayal is as delightful as it is unexpected in Old Kingdom art. Even more remarkable is the variety of poses among the hunters, which breaks the rules observed in the figure of Ti.

THE MIDDLE KINGDOM

After the collapse of centralized pharaonic power at the end of the Sixth Dynasty, Egypt entered a period of political disturbances and ill fortune that was to last almost 700 years. During most of this time, power was in the hands of local or regional overlords, who rekindled the old rivalry between Upper and Lower Egypt. Many dynasties followed one another in rapid succession. Only two, the Eleventh and Twelfth, which make up the Middle King-

dom (2040–1674 B.C.), are significant. During this period a series of able rulers, beginning with Mentuhotep II, the king who reunited Egypt about 2052 B.C., managed to reassert themselves against the provincial nobility. However, the authority of the Middle Kingdom pharaohs tended to be personal rather than institutional. The spell of divine kingship, having once been broken, never regained its old power. Soon after the close of the Twelfth Dynasty the weakened country was taken over by the Hyksos (the term essentially meant "foreign ruler"), a group of western Asiatic peoples of somewhat mysterious origin who had evidently been living in Egypt for some time. They seized the Delta area and ruled it for 150 years until their defeat by King Ahmose of Thebes about 1552 B.C.

ARCHITECTURE. The unsettled times gave rise to a great deal of experimentation by Egyptian artists, even though they continued to look back to the Old Kingdom. The most spectacular example was the funerary monument at Deir el Bahri of Mentuhotep II, the king who reunited Egypt around 2052 B.C. and began the Eleventh dynasty (see fig. 2-26, left complex). Now in ruins, it was a terraced structure that extended into the living rock. It was topped off with a pyramid or, more likely, a mastaba. As such, it was a brilliant mixture of traditional elements with new ones introduced by Mentuhotep's Middle Kingdom predecessors.

PORTRAITURE. The authority of the Middle Kingdom pharaohs tended to be personal rather than institutional. Egyptian sculptors faced the challenge of imposing a sense of individuality on established forms, which they managed to do with great inventiveness. The unquiet spirit of the Middle Kingdom is reflected in royal portraits such as the one in figure 2-19 of Sesostris III. There is a real sense of shock on first seeing this strangely modern face. The serene assurance of the Old Kingdom has given way to a troubled expression that testifies to the difficulty of holding power as an act of supreme will. (Sesostris III nevertheless ranks with Mentuhotep II as one of the great pharaohs of the Middle Kingdom.) At first glance the link with tradition seems to have been broken entirely. Lacking its royal trappings, our fragment displays a physical and psychological realism that bespeaks a new level of self-awareness. Here is another enduring achievement of Egyptian art, one that was destined to live on in Roman portraiture.

Middle Kingdom sculpture ranges from colossal statues to smaller figures of the utmost delicacy and precision. A captivating example of the latter is a portrait of Lady Sennuwy, the wife of Prince Hepzefa, provincial governor of Assiut, although the statue was actually found at Kerma in Upper Nubia (fig. 2-20). She reminds us of Queen Khamerernebty in fig. 2-14, but her features have a refinement and the figure a youthful slenderness unknown in earlier Egyptian art. The same elegance is found in Middle Kingdom literature, which achieved classic status. So did the style announced in the statue of Lady Sennuwy, which probably originated in Thebes and remained influential well into the New Kingdom.

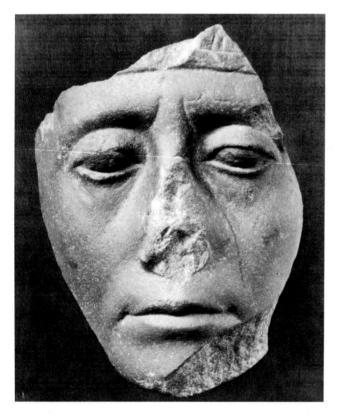

2-19. *Portrait of Sesostris III* (fragment). c. 1850 B.C. Quartzite, height 6½" (16.5 cm). The Metropolitan Museum of Art, New York

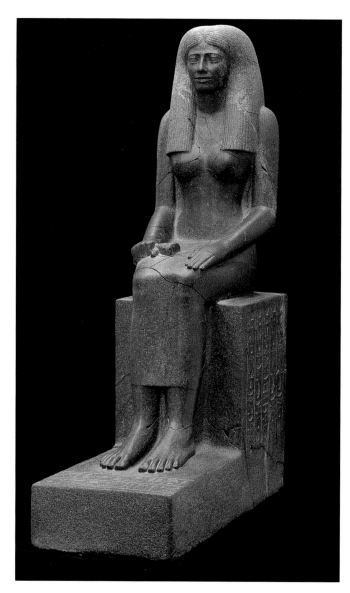

2-20. *Statue of the Lady Sennuwy.* c. 1920 B.C.
Granite, height 67³⁄₄" (172 cm), depth 45⁷⁄₈" (116.5 cm).
Museum of Fine Arts, Boston

2-21. *Feeding the Oryxes.* c. 1928–1895 B.C. Detail of a wall painting.
Tomb of Khnum-hotep, Beni Hasan

PAINTING AND RELIEF. A relaxation of the rules can also be seen in Middle Kingdom painting and relief sculpture, which often depart from convention. This loosening is most evident in the decoration of the tombs of local princes at Beni Hasan. Because they were carved into the living rock, these tombs have survived better than most Middle Kingdom monuments. The mural *Feeding the Oryxes* (fig. 2-21) comes from the rock-cut tomb of Khnum-hotep. (As the emblem of the prince's domain, the oryx antelope seems to have been a sort of honored pet in his household.) According to the standards of Old Kingdom art, all the figures ought to share the same **ground-line.** If not, the second oryx and its attendant ought to be placed above the first (a system known as vertical recession). Instead, the painter employs a secondary groundline only slightly higher than the primary one. As a result the two groups are related in a way that is similar to normal appearances. This interest in spatial effects can also be seen in the awkward but bold **foreshortening** of the shoulders of the two attendants. If we cover up the hieroglyphic signs, which emphasize the flatness of the wall, we can "read" the depth with surprising ease.

THE NEW KINGDOM

The 500 years after the Hyksos were expelled, which make up the Eighteenth, Nineteenth, and Twentieth dynasties, represent the third and final flowering of Egypt. Once again united under strong kings, the country extended its frontiers far to the east, into Palestine and Syria; hence this period is known as the empire as well as the New Kingdom. Its art covers a wide range of styles and quality, from rigid conservatism to brilliant inventiveness, and from massive ostentation to delicate refinement. These different strands are interwoven into fabric so complex that, as with the art of imperial Rome 1,500 years later, it is difficult to come up with a representative sampling of New Kingdom art that adequately conveys its flavor and variety.

EIGHTEENTH DYNASTY

Wall Paintings and Reliefs

Perhaps not surprisingly, New Kingdom artists at first turned to the style of the Middle Kingdom. The result was a traditionalism that was more flexible than may at first appear. It is seen at its best in a low relief (fig. 2-22) from the tomb of Ramose at the new capital, Thebes. The relief was done at the end of the reign of Amenhotep III, whom Ramose served as vizier before moving to Tell el'Amarna under Akhenaten. As a result, the tomb, lavishly decorated with paintings and reliefs, remained unfinished. Our detail has a subtlety that was never surpassed. Here beauty has become an end in itself. To a striking degree, the artist succeeds in the quest for a more refined vocabulary, which soon took the place of the heroic forms of the Old Kingdom.

The experimental spirit of Middle Kingdom wall painting was revived intact during the New Kingdom. In the Theban

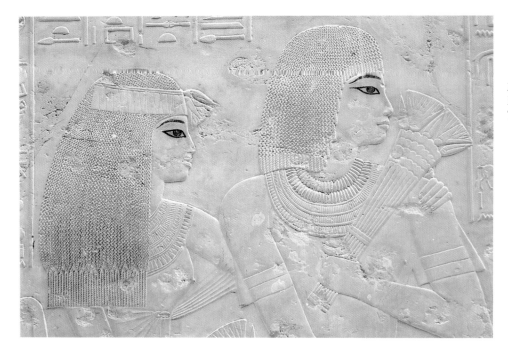

2-22. *Mai and His Wife, Urel.*
Detail of a limestone relief. c. 1375 B.C.
Tomb of Ramose, Thebes

2-23. *A Pond in a Garden.*
Fragment of a wall painting,
from the Tomb of Nebamun,
Thebes. c. 1400 B.C.
The British Museum, London

tomb of Nebamun, it blossoms into a fascination with nature (fig. 2-23). Such gardens were a feature of wealthy homes during the New Kingdom. Besides providing a home for fish and fowl, the pool had sacred overtones, thanks to the life-giving power of water. (A nearly identical garden with Osiris and Maat is often depicted in The Book of the Dead; see below). The scene has a freshness and attention to detail that are unequaled in Egyptian art (compare fig. 2-21). The artist must surely have been aware of Minoan wall painting, which shares these very qualities (see Chapter Four).

Aegean art must also have influenced how the movement of animals was shown in Egyptian art around the same time. This theory is supported by the discovery at Tell el-Daba, in the eastern delta, of Minoan-style fresco remnants (including the

2-24. *Musicians and Dancers,* fragment of a wall painting from the Tomb of Nebamun, Thebes. 1350 B.C. Height 24" (61 cm). The British Museum, London

earliest-known bull-jumping scene; compare fig. 4-10) painted toward the beginning of the Eighteenth Dynasty. Strangely enough, they may well have been done by an Egyptian artist who had visited Crete. Yet the influence can hardly have been one-sided. Egypt had a rich landscape tradition reaching back to the Old Kingdom that had always provided opportunities to break the rules (compare fig. 2-18).

Happily, the two facets of New Kingdom art were not mutually exclusive. Innovation and beauty are united in a banquet scene from the same tomb that gives us a tantalizing glimpse of Egyptian dance and music (fig. 2-24). If only we knew what it sounded like! Pictures such as this provided the ka with all the earthly pleasures in the afterlife. The artist depicts the rapt inspiration of the musicians and the graceful movements of the dancing girls, while enriching the surface with lavish decoration. For all its gaiety, our detail probably represents the annual funerary "feast of the valley," when the god Amun would cross the Nile from Karnak to visit the tombs on the west bank and bless the deceased.

Architecture

THE TEMPLE OF HATSHEPSUT. The climactic period of the New Kingdom extended from about 1500 B.C. to the end of the reign of Ramesses III in 1145 B.C. During this era tremendous architectural projects were carried out, centering on the region of Thebes. The return of prosperity and stability was first marked by the revival of Middle Kingdom architectural forms to signify royal power. Thus the funerary temple of Queen Hatshepsut (fig. 2-25), built by her vizier Senenmut about 1478–1458 B.C. against the rocky cliffs of Deir el-Bahri, imitates Mentuhotep II's funerary temple of more than 500 years earlier (seen to the left in our illustration, fig. 2-26), which now lies in ruins. Hatshepsut's is, however, very much larger. (A third temple, built somewhat later by her nephew, Tuthmosis III, was sandwiched between them and was not unearthed until 1961.) The worshiper is led toward the holy of holies—a small chamber cut deep into the rock—through three large courts on ascending levels, which are linked by ramps flanked by long **colonnades**. Together they form a processional road similar to those at Giza, but with the mountain instead of a pyramid at the end. The ramps and colonnades echo the shape of the cliff. This magnificent union of architecture and nature makes Hatshepsut's temple the rival of any of the Old Kingdom monuments.

The temple complex (fig. 2-26) was dedicated to Amun and several other deities. During the New Kingdom, divine kingship was asserted by claiming the god Amun as the father of the reigning monarch. By combining his identity with the sun-god Ra, Amun became the supreme deity, ruling the lesser gods much as the pharaoh dominated the provincial nobility.

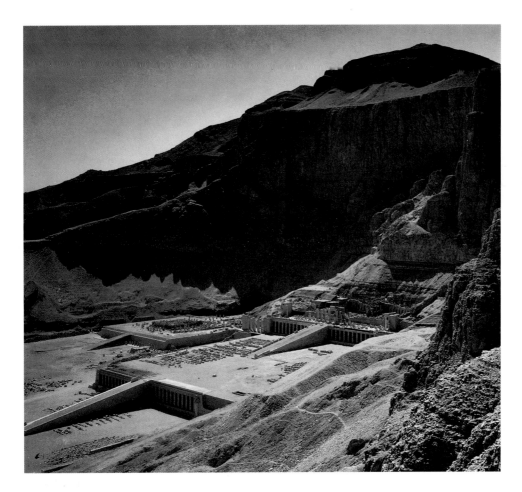

2-25. Temple of Queen Hatshepsut, Deir el-Bahri. c. 1478–1458 B.C.

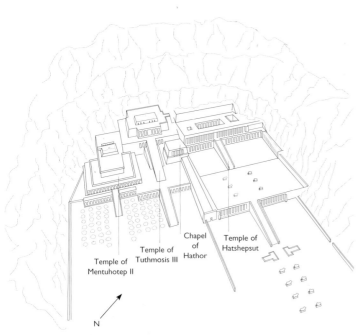

Temple of Mentuhotep II
Temple of Tuthmosis III
Chapel of Hathor
Temple of Hatshepsut
N

2-26. Reconstruction of temples, Deir el-Bahri, with temples of Mentuhotep II, Tuthmosis III, and Queen Hatshepsut (after a drawing by Andrea Mazzei/Archivio White Star, Vercelli, Italy)

AKHENATEN. Over time the priests of Amun grew into a caste of such wealth and power that they posed a threat to royal authority. The pharaoh could maintain his position only with their consent. Amenhotep IV, the most remarkable figure of the Eighteenth Dynasty, tried to defeat them by proclaiming his faith in a single god, the sun-disk Aten, whose cult had been promoted by his father, Amenhotep III. He changed his name to Akhenaten ("Effective for the Aten"), closed the Amun temples, and moved the capital to central Egypt, near modern Tell el'Amarna. However, his attempt to place himself at the head of a new faith did not outlast his reign (1348–1336/5 B.C.).

Of the great projects built by Akhenaten hardly anything remains above ground. He must have been a revolutionary not only in his religious beliefs but in his artistic tastes as well. Through his choice of masters, he fostered a new style. Known as the Amarna style, it can be seen at its best in a sunk relief portrait of Akhenaten and his family (fig. 2-27). The intimate domestic scene suggests that the relief was meant to serve as a shrine in a private household. The life-giving rays of the sun help to unify the composition and identify the royal couple as the living counterparts of Aten. Despite their very human qualities, their divine status is proclaimed by the new ideal, with its oddly haggard features and overemphatic outlines.

That this was a conscious choice, not merely an exaggeration of their anatomy, can be seen in the way the features of Akhenaten's queen, Nefertiti, have been subtly altered to resemble his (compare fig. 2-28). The same must be true of the egg-shaped skulls of the three princesses, one of them still an infant. They express the theme of life and creativity, and are not simply a genetic oddity. The seem-

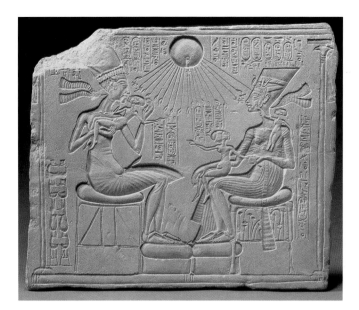

2-27. *Akhenaten and His Family.* c. 1355 B.C. Limestone, 12¾ x 15¼" (31.1 x 38.7 cm). Staatliche Museen zu Berlin, Preussischer Kulturbesitz, Ägyptisches Museum

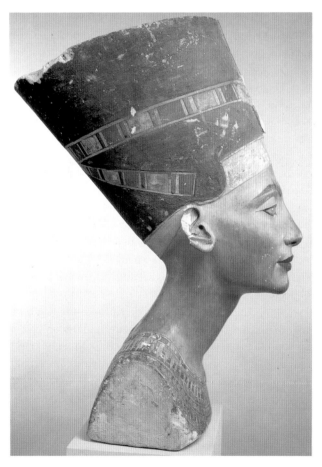

2-28. *Queen Nefertiti.* c. 1348–1336/5 B.C. Limestone, height 19" (48.3 cm). Staatliche Museen zu Berlin, Preussischer Kulturbesitz, Ägyptisches Museum

ingly playful gestures, so appealing to modern eyes, are intended to ward off evil spirits and protect the household from harm. The informal, tender poses nonetheless defy all conventions of pharaonic dignity and bespeak a new view of humanity.

The contrast with the past becomes strikingly clear if we compare the Amarna relief with the detail from the Tomb of Ramose (see fig. 2-22), which is only slightly earlier in date. The subtlety of the carving, the precision of the lines, and the refinement of the forms in the latter make the treatment of Akhenaten seem, at first glance, like a brutal caricature. In actual fact, the royal family scene is equally skillful in its execution. The sculptor separates the complex overlapping planes with surprising ease. What distinguishes this style is not greater realism so much as a new sense of form that seeks to unfreeze the traditional immobility of Egyptian art. Not only the contours but the shapes seem more pliable, nearly antigeometric.

Despite its unique qualities, the Amarna revolution was partly an outgrowth of developments earlier in the Eighteenth Dynasty. The process was already highly evolved under Akhenaten's father, Amenhotep III. Indeed, the new ideal can already be seen emerging in certain portraits of Hatshepsut. The famous bust of Nefertiti (fig. 2-28), the greatest masterpiece of the "Akhenaten style," does not abandon the style found in the Ramose relief. Rather, it relaxes the forms for the sake of a more elegant effect, reminding us that her name means "the beautiful one is come." Its perfection comes from a command of geometry that is at once precise— the face is completely symmetrical—and wonderfully subtle. Strangely enough, the bust remained unfinished. (The left eye lacks the inlay of the right). It was left behind with a nearly identical head in the workshop of the royal sculptor Thutmose when he moved from Amarna to Memphis after Akhenaten's death.

Thutmose, like Imhotep before him, must have been a great genius—court records call him the "king's favorite and master of the works"—one who could give visible form to the pharaoh's ideas. He is not the first Egyptian artist known to us by name, but he is the first we can identify with a personal style. Thutmose was the last of several sculptors in succession who were mainly responsible for the Amarna style. This union of a powerful patron and a sympathetic artist is rare. We shall not see it again until Periklean Greece (see page 128).

TUTANKHAMEN. Akhenaten's successor, Smenkhkara, died soon after becoming pharaoh. The throne then passed to Tutankhamen, who was only about nine or ten years old at the time. Tutankhamen, who may have been Akhenaten's nephew, was married to Akhenaten's daughter Ankhesenpaaten; he died at the age of 18, perhaps of tuberculosis. (There is no solid evidence to support the popular conspiracy theories that he was murdered.) He owes his fame entirely to the fact that his is the only pharaonic tomb that has been found in our times with most of its contents intact. The immense value of the objects makes it easy to understand why grave robbing has been practiced in Egypt ever since the Old Kingdom. Tutankhamen's gold coffin (fig. 2-29) alone weighs 250 pounds. Even more impressive is the exquisite workmanship of the coffin cover, with its rich play of colored inlays against the polished gold surfaces.

The old religion was restored by Tutankhamen and his short-lived successor, the aged Ay, Akhenaten's uncle, who seems to have served as his vizier and married his widow perhaps to preserve, rather than usurp, the throne. The process was completed under Horemheb, who had been head of the army under Tutankhamen

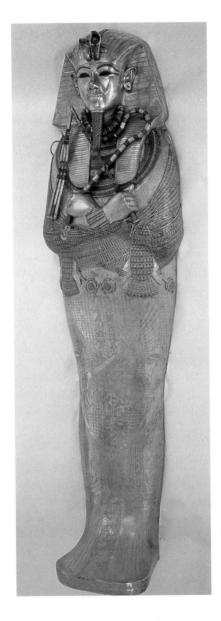

2-29. Cover of
the coffin of
Tutankhamen.
18th Dynasty. Gold,
height 72" (182.9 cm).
Egyptian Museum,
Cairo

PHOTO: LEE BOLTIN
PICTURE LIBRARY,
HASTINGS-ON-HUDSON, NY

and became the last king of the Eighteenth Dynasty. He set out to erase all traces of the Amarna revolution, but its effects could be felt in Egyptian art for some time to come. Thus the scene of workmen struggling with a heavy beam (fig. 2-30), from a battle scene in Horemheb's own tomb at Saqqara, shows a freedom and an expressiveness that would have been unthinkable in earlier times.

Papyrus Scrolls

Since the First Dynasty, if not before, books in the form of scrolls had been made of papyrus plants, which grow in large numbers in the marshes of the Nile Delta. Such scrolls came to be used throughout the Mediterranean. (The modern book, or codex, was not invented until Roman times; see page 242.) Perhaps the most important of these texts was The Book of the Dead, which began to appear shortly before the New Kingdom. Most examples were produced around 1300–1250 B.C., although some date from a hundred years earlier and there are later ones as well. This collection of over 200 incantations, or spells, was usually placed inside the coffin or included in the mummy bandaging itself. It was derived in part from Old Kingdom pyramid texts of the Fifth Dynasty and coffin texts of the Eleventh and Twelfth Dynasties, at the height of the Middle Kingdom. During this period we may say that the afterlife was democratized. No longer was it the sole right of the pharaoh and his court. Now everyone was entitled to it, by invoking the right magic. What is new in The Book of the Dead is the emphasis on morality, which culminates in Chapter 125 with the weighing of the soul and judgment of the dead by Osiris. [See Primary Sources, no. 1, page 210.] Even more remarkable is that this scene was often depicted, making it among the earliest examples of true book illustration we know of. Moreover, it was copied in wall paintings, thus creating a link between the two mediums that endured in Early Christian art.

Let us look closely at this chapter as seen in The Book of the Dead of Hunefer, one of the finest examples that has come down to us (fig. 2-31). It conforms to a well-defined type that must have been passed from one workshop to another. The style, derived from traditional tomb painting, has been adapted to the format of

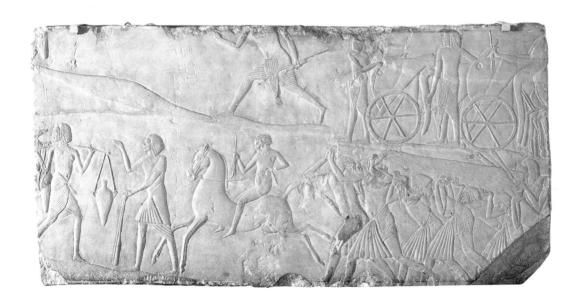

2-30. *Workmen Carrying a Beam.* Detail of a relief, from the Tomb of Horemheb, Saqqara. c. 1325 B.C. Museo Civico, Bologna

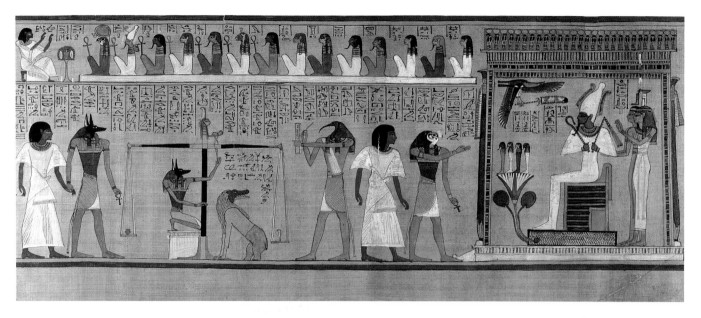

2-31. *The Weighing of the Heart and Judgment of Osiris,* from The Book of the Dead of Hunefer. 1285 B.C. Painted papyrus, height 15⅝" (39.5 cm). The British Museum, London

the scroll through a process known as continuous narration. At the left, Hunefer is led into the Hall of the Two Truths by Anubis, the jackal-faced guardian of the underworld. Anubis then weighs the heart of the dead against the ostrich feather of Maat, whose head appears on the top of the scales. Maat, the goddess of truth and justice, symbolized the divine order and governed ethical behavior; hence her feather was an emblem of law. The results are recorded by the ibis-headed scribe Thoth, who was sometimes shown in the guise of a baboon. Looking on with keen interest is Ammut, the devourer of those whose evil deeds made them unworthy of an afterlife. She has the head of a crocodile, the body and legs of a lion, and the hind quarters of a hippopotamus—all ferocious beasts.

The deceased had to swear to each of the deities seen overhead that he had not sinned. Having been declared "true of voice," he is presented by Horus to his father, Osiris, shown here with Isis and her sister Nephthys, mother of Anubis and protector of the dead. In front of the throne are the four sons of Horus standing on a white lotus blossom, symbol of rebirth. Also known as the four gods of the cardinal points, they protected the internal organs that were removed as part of the embalming process and placed in containers known as canopic jars. Above, a symbol of Horus (identified by his sacred *udjat* eye, which restored Osiris to health) bears an ostrich feather representing the favorable judgment of Maat. It is a strange realm indeed, at least to modern eyes. Yet once we know how to read the scene, we recognize in it the forerunner, thematic and moral, of the Last Judgment with its weighing of souls, which was to become one of the great subjects of medieval Christian art (compare fig. 10-24). Moreover, The Book of the Dead is remarkably similar in places to the Bible of the Hebrews, who are generally thought to have lived in Egypt from the seventeenth through the late thirteenth century B.C., but probably wrote the earliest Old Testament texts much later. (The origin of the word *Hebrew* is obscure, but it seems to have meant "wanderer" in Egyptian.)

LATER ARCHITECTURE

THE TEMPLE AT LUXOR. The rulers of the New Kingdom devoted an ever-greater share of their architectural energies to building huge temples of Amun. The cult's center was Thebes, which included Karnak and Luxor on the east bank of the Nile, and Deir el-Bahri on the west bank. Beyond lay the Valley of the Kings to the north and the Valley of the Queens to the south. Vast temple complexes at Karnak and Luxor that had been begun during the Middle Kingdom were greatly enlarged during the Nineteenth Dynasty.

At Luxor, Amenhotep III had replaced an earlier temple with a huge new one. It was completed by Ramesses II, the greatest of the New Kingdom pharaohs, who built on an unprecedented scale. The complex (figs. 2-32, 2-33, and 2-34) is typical of later Egyptian temples. The **facade** (the side that faces a public way, at the far left in our illustration) consists of two massive walls with sloping sides that form the entrance. This unit, which is known as the gateway or pylon (fig. 2-32, far left, and fig. 2-33), leads to the court (fig. 2-34, A). The court is in the shape of a parallelogram because Ramesses II changed its axis to conform with the direction of the Nile. We then enter a pillared hall, which brings us to the second court (fig. 2-34, B and C; fig. 2-32, center and right). On its far side we find another pillared hall. Beyond it is the temple itself, a series of symmetrically arranged halls and chapels. They shield the holy of holies, a square room with four columns containing a colossal statue of Amun (fig. 2-34, extreme right). The temple was regarded as the actual house of the god, an idea found later in Greece. The cult statue, as his manifestation, was bathed, anointed, clothed, and fed by priests in elaborate daily rituals.

The entire complex was enclosed by high walls that shut off the outside world. Except for the monumental pylon (fig. 2-33), such a structure is designed to be seen from within. Ordinary worshipers were confined to the courts and could merely marvel at the forest

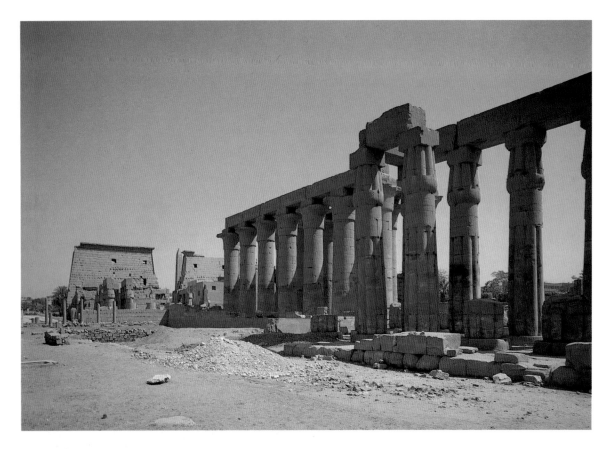

2-32. Court and pylon of Ramesses II (c. 1279–1212 B.C.) and colonnade and court of Amenhotep III (c. 1350 B.C.), temple complex of Amun-Mut-Khonsu, Luxor

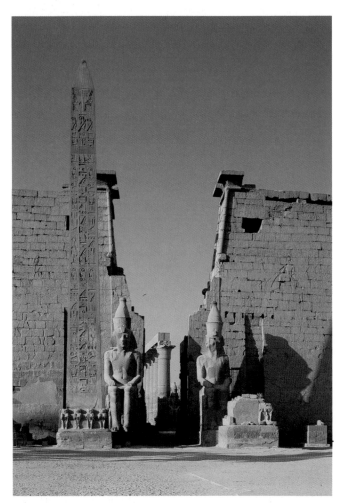

2-33. Pylon and court of Ramesses II, Temple of Amun, Luxor. c. 1279–1212 B.C.

of columns that screened the sanctuary (known as a hypostyle hall, for its many columns). The columns had to be closely spaced, for they supported the stone **lintels**, or horizontal members, of the ceiling, which were necessarily short to keep them from breaking under their own weight. Yet the architect has consciously exploited this condition by making the columns far heavier than they need to be. The viewer feels almost crushed by their sheer mass. The effect is certainly impressive, but it is also rather coarse when measured against earlier masterpieces of Egyptian architecture. We need only compare the papyrus columns of the colonnade of Amenhotep III with their remote ancestors in Djoser's North Palace (see fig. 2-8) to see how little of the genius of Imhotep survived at Luxor. The decline is even more obvious in the massive statues that flank the pylon of Ramesses II (fig. 2-33). Although as skillfully carved as ever, they are a far cry from the alert, muscular figure of Khafre (see fig. 2-13) from which they descend.

The most interesting sculptural works at the temples at Luxor, Karnak, and elsewhere are the reliefs of hunting and combat. These subjects were intended to glorify the pharaoh by showing him defeating age-old enemies. Even hunting, based on ancient ritual, was primarily of symbolic significance. Both kinds of scenes represent him as the protector of his people by equating his prowess in hunting with his courage in battle, and often there is little difference between them. Such scenes had been common since the late years of the Old Kingdom and were revived in the early Eighteenth Dynasty, when they were standardized. There is an even older custom, stretching back to the Fourth Dynasty, of reliefs that document actual military campaigns. During the Old Kingdom these most often show the plundering of Asiatic cities. It was the Middle Kingdom pharaohs Mentuhotep II and

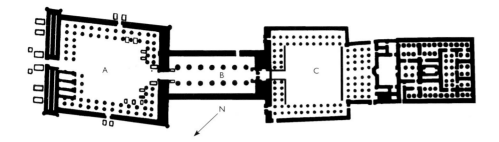

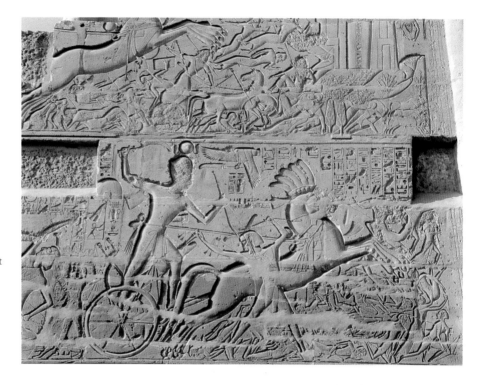

2-35. *Sety I's Campaigns,* Temple of Amun at
Karnak, Thebes (exterior wall,
north side of hypostyle). c. 1280 B.C.
Sandstone, sunk relief

especially Amenhotep III who initiated the custom of recording battles on a monumental scale and in great detail. The hunting scenes in figure 2-35 (lower register) and sacking the Hittite city of Kadesh on the Orontes river (upper register) in the temple of Amun at Karnak combine aspects of both traditions. Following convention, the king and his horse-drawn chariot remain frozen against a background filled with hieroglyphs and soldiers, who are much smaller in scale in order to glorify his role. Victory seems assured by the pharaoh's might and the ruthless efficiency of his forces, although neither battle was, in fact, decisive. Despite the frantic activity, the carving seems strangely uninspired. Only in certain details, such as the hapless prisoners in another scene, do we still find echoes of the Amarna style as seen in Horemheb's tomb (compare fig. 2-30). In any event, the precedent established by Egyptian artists was eventually taken up by the Assyrians, who were just beginning to assert their power, and later by the Romans, who were to conquer the entire region.

THE DECLINE OF EGYPT

As an expression of pharaonic power the temples at Luxor and Karnak are without equal—perhaps justifiably, for the Ramesside period, as the Nineteenth and Twentieth dynasties are known, represents the height of Egyptian power. Nevertheless, the artistic degeneration anticipates the decline of Egypt itself. About 1076

B.C., barely 70 years after the end of the reign of Ramesses III, the country began a long period of decay. The priests gained more and more power, until the cult of Amun took control during the Twenty-first Dynasty. Egyptian civilization ended in a welter of esoteric religious doctrines.

The last phase of ancient Egypt belongs to the Greeks and the Romans. The country was conquered in 323 B.C. by Alexander the Great, who founded the city of Alexandria before his death later that year. His general Ptolemy (died 284 B.C.) became king, beginning a dynasty that lasted until Ptolemy XIV, Cleopatra's son by the Roman emperor Julius Caesar, was put to death by Augustus in 30 B.C. Egypt nevertheless flourished economically under the Greeks and Romans, who established a vibrant trade with China via the famous "Silk Road," which ran across the northern steppes of Asia, then snaked south to Canton. Later they developed an equally important sea trade with India from Berenike, Myos Hormos and other ports along the Red Sea that have only recently begun to be excavated. They relied on Indian-built ships which, at 180 feet in length, were the largest of the time and capable of carrying a thousand tons of cargo, a huge amount. Alexandria became the leading center of learning in the Graeco-Roman world, but late Egyptian art, although no less skillful, is a strange mixture of stale conventions and foreign influences. It was not until the Christian era that Egyptian art flourished briefly once again in encaustic portraits on Coptic Egyptian mummy cases (see fig. 7-55).

Ancient Near Eastern Art

SUMERIAN ART

It is an astonishing fact that civilization emerged in several places at about the same time. Between 3500 and 3000 B.C., when Egypt was being united under pharaonic rule, Syria and another great civilization arose in Mesopotamia, the "land between the rivers." Indeed, the latter may well claim to have developed first, even though writing began in Egypt slightly earlier. The pressures that forced the people of both regions to abandon Neolithic village life may well have been the same. For close to 3,000 years these two regions retained their distinct characters, even though they had contact with each other from the beginning and their destinies were interwoven in many ways.

Today Mesopotamia is a largely arid plain, but there is written, archaeological, and artistic evidence that at the dawn of civilization it was covered with lush vegetation. Unlike that of the Nile, the valley of the Tigris and Euphrates rivers is not a narrow, fertile strip protected by deserts on either side. Instead, it is a wide, shallow trough crisscrossed by the two rivers and their tributaries. With few natural defenses, it is easily entered from any direction.

Thus the facts of geography tended to discourage the idea of uniting the entire area under a single head. Rulers who had this ambition did not appear, so far as we know, until about a thousand years after the beginning of Mesopotamian civilization, and they succeeded in carrying it out only for brief periods and at the cost of almost continuous warfare. As a result, the history of ancient Mesopotamia has no underlying theme of the sort that divine kingship provides for Egypt. It is a mix of local rivalries, foreign incursions, and the sudden upsurge and collapse of military powers.

Against this background, the continuity of the region's cultural traditions is remarkable. This common heritage was largely created by the founders of Mesopotamian civilization, whom we call Sumerians, after Sumer, the region in which they lived, near the junction of the Tigris and Euphrates rivers. The origin of the Sumerians remains obscure. Their language is not related to any other known tongue. Sometime before 4000 B.C., they came to southern Mesopotamia from Iran. There, within the next thousand years, they founded a number of city-states. They also developed a distinctive form of writing in **cuneiform** (wedge-shaped) characters on clay tablets. This phase, which corresponds to the predynastic period in Egypt, is called "protoliterate"; it leads to the early dynastic period, from about 3000 to 2340 B.C. (The chronology used here is by J. A. Brinkman.)

It now appears that a third civilization began in the upper region of the Tigris and Euphrates valley in northeastern Syria around 3500 B.C. Recent excavations at Tell Hamoukar have unearthed a massive city wall and a large building that suggest a centralized form of government, perhaps under a chief. Although the settlement was much smaller than Sumer, the many seals, some of genuine artistic merit, indicate a well-developed administrative system for handling transactions. This culture appears to have lacked writing, one of the essential ingredients of civilizations, although ongoing excavations, may yet reveal further clues about the growth of Tell Hamoukar and other sites, including perhaps the development of writing.

ARCHAEOLOGICAL CONDITIONS. The first evidence of Bronze Age culture is seen in Sumer about 4000 B.C. Unfortunately, the archaeological remains of Sumerian civilization are scanty compared with those of ancient Egypt. Because there was no stone for building, the Sumerians used mud brick and wood, so that almost nothing is left of their structures but the foundations. Nor did they share the Egyptians' concern with the afterlife, although some rich tombs from the early dynastic period, in the shape of vaulted chambers below ground, have been found in the city of Ur. Our knowledge of Sumerian civilization thus depends largely on chance fragments, including vast numbers of inscribed clay tablets, brought to light by excavation. Yet we have learned enough to form a general picture of this vigorous, inventive, and disciplined people.

RELIGION. Each Sumerian city-state had its own local god, who was regarded as its "king" and owner. It also had a human ruler—the steward of the "king"—who led the people in serving the deity; in effect, he was a priest-king. The local god, in return, was expected to speak for the people of the city-state among the other gods, who controlled the forces of nature, such as wind and weather, water, fertility, and the heavenly bodies. The idea of divine ownership was not

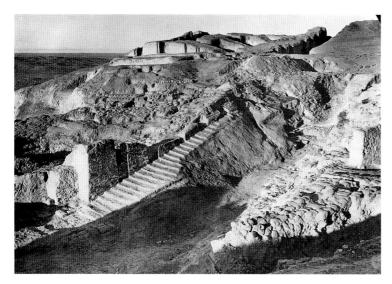

3-1. Remains of the "White Temple" on its ziggurat, Uruk (Warka), Iraq. c. 3500–3000 B.C.

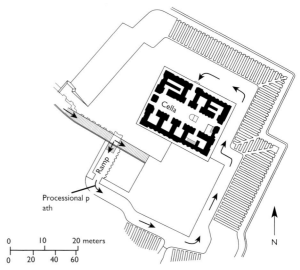

3-2. Plan of the "White Temple" on its ziggurat (after H. Frankfort)

a pious fiction. The god was believed to own not only the territory of the city-state but also the labor of the population and its products. All these were subject to his commands, which were transmitted to the people by his human steward, the ruler. The result was a system that has been dubbed "theocratic socialism," a planned society administered from the temple. The temple controlled the pooling of labor and resources for communal projects such as the building of dikes and irrigation ditches, and it collected and distributed much of the harvest. Detailed written records were required to carry out so many duties. Hence it is no surprise that early Sumerian texts deal largely with economic and administrative rather than religious matters, although writing was a priestly privilege, as it was in Egypt.

ARCHITECTURE. The role of the temple as the center of both spiritual and physical life can be seen in the layout of Sumerian cities. The houses were clustered about a sacred area that was a vast architectural complex containing not only shrines but workshops, storehouses, and scribes' quarters as well. In their midst, on a raised platform, stood the temple of the local god. Perhaps reflecting the Sumerians' origin in the mountainous north, these platforms, known as **ziggurats**, soon reached considerable heights. They can be compared to the pyramids of Egypt in the immense effort required to build them and in their effect as landmarks that tower above the plain.

The most famous ziggurat, the biblical Tower of Babel, has been destroyed, but a much earlier example, built shortly before 3000 B.C. (and thus several centuries before the first pyramids), survives at Warka, the site of the Sumerian city of Uruk (called Erech in the Bible). The mound, 40 feet high, has sloping sides reinforced by brick masonry. Stairs and ramps lead up to the platform on which stands the sanctuary, called the "White Temple" because of its whitewashed brick exterior (figs. 3-1 and 3-2). Its heavy walls, with regularly spaced projections and recesses, are well enough preserved to suggest the original appearance of the structure. The main room, or cella (fig. 3-3), where sacrifices were made before the statue of the god, is a narrow hall that runs the length of the tem-

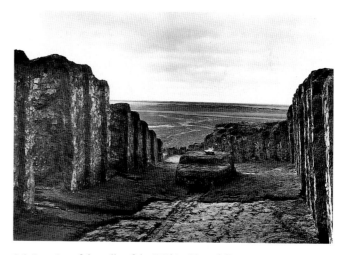

3-3. Interior of the cella of the "White Temple"

ple and is flanked by smaller chambers. Its main entrance is on the northeast side, rather than on the side facing the stairs or on one of the narrow sides of the temple, as one might expect. To understand why this is the case, we must view the ziggurat and temple as a whole. The entire complex is planned in such a way that the worshiper, starting at the bottom of the stairs on the east side, is forced to go around as many corners as possible before reaching the cella. In other words, the path is a sort of angular spiral.

This "bent-axis approach" is a basic feature of Mesopotamian religious architecture, in contrast to the straight, single axis of Egyptian temples (see fig. 2-34). During the following 2,500 years, it was elaborated into ever-taller ziggurats rising in multiple stages. These were generally erected by the priest-king in his role as royal builder. The one built by King Urnammu at Ur about 2100 B.C. and dedicated to the moon-god Nanna had three levels (fig. 3-4). Little is left of the upper two stages, but the bottom one, some 50 feet high, has survived fairly well, and its facing of brick has been restored. What was the inspiration behind these structures? Certainly not the kind of pride attributed to the builders of

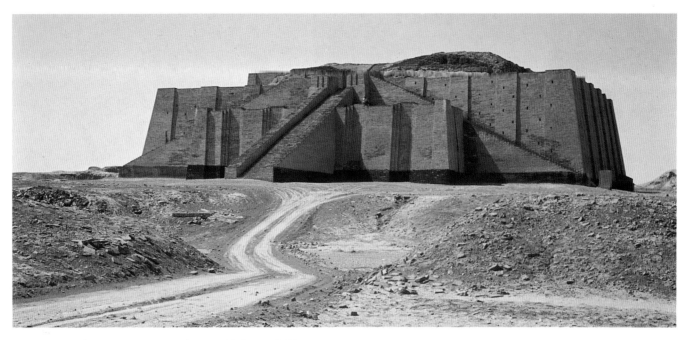

3-4. Ziggurat of King Urnammu, Ur (Muqaiyir), Iraq. c. 2100 B.C.

the Tower of Babel in the Old Testament. Rather, they reflect the belief that mountaintops are the dwelling places of the gods. (We need only think of the Mount Olympus of the Greeks.) The Sumerians felt they could provide a fitting home for a god only by creating their own artificial mountains.

STONE SCULPTURE. The image of the god to whom the White Temple was dedicated—probably Anu, the god of the

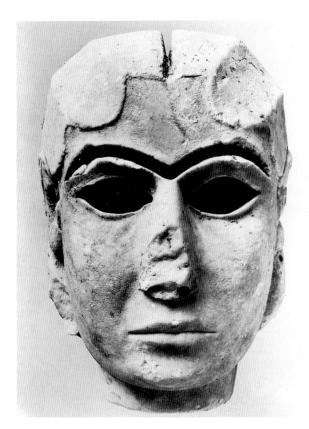

3-5. *Female Head,* from Uruk (Warka). c. 3500–3000 B.C. Limestone, height 8" (20.3 cm). Iraq Museum, Baghdad

sky—is lost. But a splendid female head from the same period at Uruk (Warka) may have belonged to another cult statue, perhaps of the mother goddess (fig. 3-5). It is carved from limestone, and the hair, eyes, and eyebrows were inlaid with colored materials. The rest of the figure, which must have been close to lifesize, was probably of wood. This head is on a par with the finest works of Egyptian Old Kingdom sculpture. The softly swelling cheeks and the delicate curves of the lips, combined with the steady gaze of the huge eyes, is at once sensuous and severe.

It was the geometric and expressive aspects of the Uruk head, rather than the realistic ones, that survived in the stone sculpture of the early dynastic period. They can be seen in a group of figures from Tell Asmar (fig. 3-6) that were carved about five centuries later than the head. The entire group must have stood in the cella of a temple, contemporary with the pyramid of King Djoser, dedicated to Abu, the god of vegetation. Although the two tallest figures have been thought to represent Abu, the god of vegetation, and a mother goddess, it is likely that all are **votive** statues of priests and worshipers. Despite the difference in size, all but the kneeling figure to the lower right have the same pose of humble worship. The priests and worshipers communicated with the god through their eyes. The enormous eyes of these figures convey the sense of awe the Sumerians felt before the often terrifying gods they worshiped. Their stare is emphasized by colored inlays, which are still in place.

The concept of representation had a very direct meaning for the Sumerians: the gods were believed to be present in their images, and the statues of the worshipers served as stand-ins for the persons they portrayed, offering prayers or transmitting messages to the gods. Yet none of them shows any attempt to achieve a real likeness. The bodies as well as the faces are highly simplified so as not to distract attention from the eyes, "the windows of the soul." If Egyptian sculpture was based on the cube, Sumerian forms were derived from the cone and cylinder. Arms and legs have the roundness of pipes, and the long skirts are as smoothly curved as if they had been turned on a lathe. This preference for

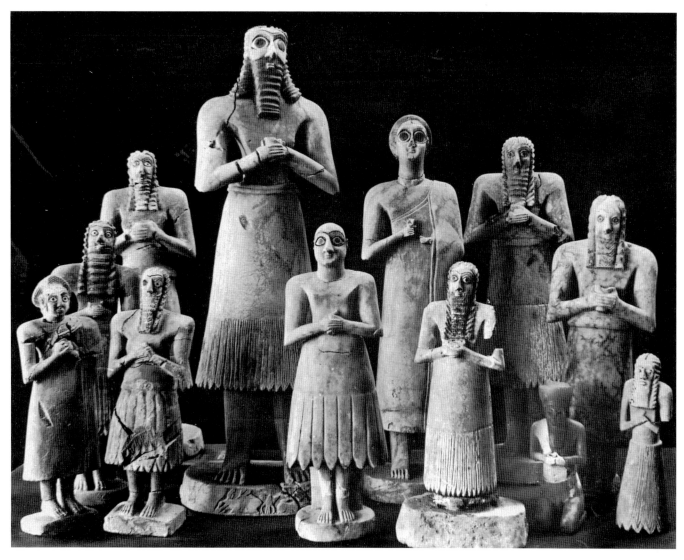

3-6. Statues, from the Abu Temple, Tell Asmar, Iraq. c. 2700–2500 B.C. Limestone, alabaster, and gypsum, height of tallest figure approx. 30" (76.3 cm). Iraq Museum, Baghdad, and The Oriental Institute Museum of the University of Chicago

round forms may have stemmed in part from the shape of the blocks supplied from afar, since suitable material was in short supply. However, it appears even in later times, when Mesopotamian sculpture had acquired a far greater variety of shapes.

ASSEMBLED SCULPTURE. The simplification of the Tell Asmar statues is characteristic of the carver, who works by cutting forms out of a solid block. A far more realistic style is found in Sumerian sculpture that was made not by subtraction but by addition; such works are either **modeled** in soft materials for **casting** in bronze or put together from varied substances such as wood, gold leaf, and lapis lazuli. Some **assemblages** of the latter kind, roughly contemporary with the Tell Asmar figures, have been found in the tombs at Ur mentioned earlier. They include the fascinating object shown in figure 3-7, an offering stand in the shape of a ram rearing up against a flowering tree. The marvelously alive animal

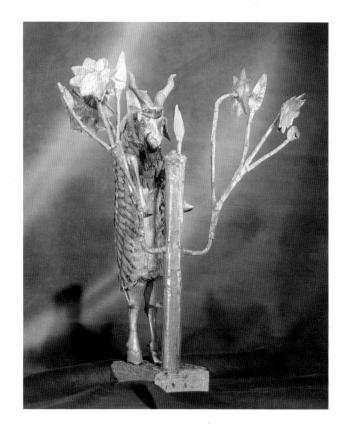

3-7. *Ram and Tree.* Offering stand from Ur. c. 2600 B.C. Wood, gold, and lapis lazuli, height 20" (50.7 cm). University of Pennsylvania Museum, Philadelphia

3-8. *Imdugud and Two Stags.* c. 2500 B.C. Copper over wood, 3'6⅛" x 7'10" (1 x 2.3 m). The British Museum, London.

The friezes of stone animals discovered in the Protoliterate temples of Warka [see page 71] find their counterpart in metal at Al 'UbaidWe do not know where these friezes appeared in the building, since they were discovered in a trench, thrown there, no doubt, on the occasion of a renovation of the temple. We are equally in the dark about a great symbolic panel, found in the same temple [fig. 3-8]. It shows in the centre the lion-headed eagle Imdugud, gripping a stag with either claw. The gesture does not represent aggression but affinity: the same deity is symbolized by bird and deer. . . .If the eagle is correctly interpreted as the embodiment of the black rain-clouds, his presence in the temple of the Mother Goddess Ninhursag (Lady of the Mountain) is easily explained. At Lagash the god was said to enter the temple "like a rumbling storm, like a bird of prey descrying its victim" when he arrived for his sacred marriage with the goddess. The absence of plant motifs in the copper relief is compensated by the large number of rosette flowers which were composed of petals cut from red and white stone mounted upon terracotta nails which were fixed in the walls of the temple.

The heads of the three animals on the copper panel are cast separately. Such cast heads are found occasionally in the ruins without any trace of the decayed bodies of sheet copper. They may, therefore, belong not to architectural friezes of the type just described, but to objects of perishable materials, such as furniture. Lion heads, for instance, were used ornamentally as parts of a wooden sledge; and the heads of herbivores occur on harps. It is possible that differences in pitch correspond with an attachment to harps of the head of a bull, a cow, a calf, or a goat.

—Henri Frankfort. *The Art and Architecture of the Ancient Orient.* Pelican History of Art Series. New Haven: Yale University Press, 1997, [pp. TK]. Originally published in 1954 by Penguin Books Ltd.

The Dutch archaeologist and historian of culture **HENRI FRANKFORT** (1897–1954) is remembered as a scholar of enormous breadth whose great contribution was to integrate the study of early civilizations of the Near East and Egypt. He directed excavations of Akhenaten's el' Amarna between 1925 and 1929, then headed The Oriental Institute of the University of Chicago's Assyrian site at Khorsabad from 1929 to 1937. Likewise, he was an important figure in the study of Early Dynastic Sumerian culture. He held several distinguished teaching posts, including at the University of Chicago, and was director of the Warburg Institute in London from 1949 until his death in 1954. The information-rich passage quoted above is from his great survey, published just after his untimely death.

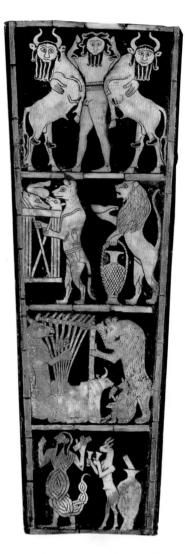

3-9. Inlay panel from the soundbox of a harp, from Ur. c. 2600 B.C. Shell and bitumen, 12¼ x 4½" (31.1 x 11.3 cm). University of Pennsylvania Museum, Philadelphia

has an almost demonic quality as it gazes from between the branches of the symbolic tree. And well it might, for it is sacred to the god Tammuz and thus embodies the male principle in nature. Even more striking is the copper relief of the storm god Imdugud in the guise of a lion-headed eagle between two heraldically arranged stags (fig. 3-8). In this relief, which probably came from a lintel over a doorway, the awesome power of Mesopotamian gods and goddesses becomes terrifyingly real.

This association of animals with deities is a carryover from prehistoric times (see pages 39–41). We find it not only in Mesopotamia but in Egypt as well (compare the falcon of Horus in fig. 2-1). What distinguishes the sacred animals of the Sumerians is the active part they play in mythology. Much of this lore has not come down to us in written form, but we catch glimpses of it in representations such as those on a panel of inlay work from a harp (fig. 3-9) that was recovered together with the offering stand at Ur. The hero embracing two human-headed bulls in the top compartment was such a popular subject that its design has

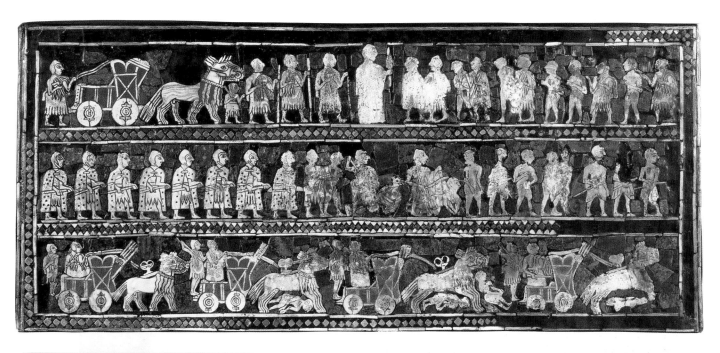

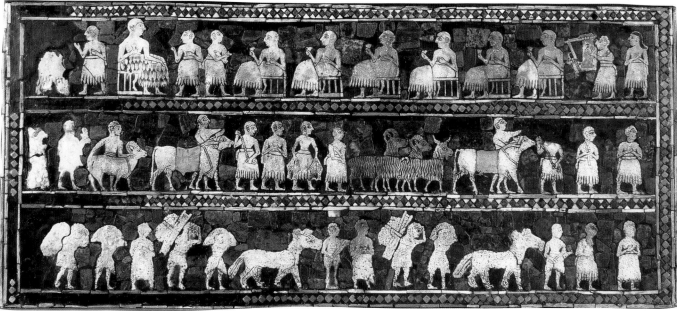

3-10. *Standard of Ur,* front and back sides. c. 2600 B.C. Wood inlaid with shell, limestone, and lapis lazuli, height 8" (20.3 cm). The British Museum, London

become a rigidly symmetrical, decorative formula. The other sections, however, show animals performing human tasks in surprisingly lively fashion. The wolf and the lion carry food and drink to an unseen banquet, while the ass, bear, and deer provide music. (The bull-headed harp is the same type as the instrument to which our panel was attached.) At the bottom, a scorpion-man and a goat carry objects they have taken from a large vessel.

The artist who created these scenes was far less constrained by rules than Egyptian artists were. Even though these figures, too, are placed on ground-lines, there is no fear of overlapping forms or foreshortened shoulders. We must be careful not to mistake the intent. What strikes us as delightfully humorous was most likely meant to be viewed seriously. If only we knew the context! The animals, which probably descend from tribal totems or worshipers wearing masks, presumably represent deities engaged in familiar human activities. Yet we may view them as the earliest known ancestors of the animal fable that flourished in the West from Aesop to La Fontaine. The ass with the harp, and the hero between two animals survived as fixed images; we meet them again almost 4,000 years later in medieval sculpture.

The royal *Standard of Ur,* which celebrates an important military victory, further shows Sumerian artists' skill at inlay work (fig. 3-10). The side depicting "war" records the conquest itself in fascinating detail, including costume elements and a row of chariots

pulled by wild asses known as onagers, with a driver and spear-man in each chariot. The "peace" side shows officials celebrating as animals are brought in for the feast, while on the bottom register onagers and other spoils are being brought back. The triangular end panels also had animal scenes. The figures have the same squat proportions and rounded forms as the statues from Tell Asmar. Here the artist combines profile and frontal views in the manner seen in Egyptian art, which became the convention in Mesopotamia as well.

CYLINDER SEALS. An art form distinctive to Mesopotamia was the cylinder seal. These seals, which have survived in vast numbers, were used to seal jars and secure storerooms with the same clay found in writing tablets. Many are not of high quality, reflecting their administrative purpose, but the finest are very beautiful. Our example (fig. 3-11) shows the feeding of the temple herd, which will soon be sacrificed. (Note the goblets to receive the animals' blood.) Both were important functions of the priest-king, identified by his distinctive costume and hat, as shepherd of his people. The stone is carved with great skill. What a wealth of detail has been included in this relief only a few inches high! The artist shows a real feel for nature. We can readily imagine the hilly land-scape and rams straining to eat the rosette-shaped leaves of the tree that seems to blossom from the priest-king himself. In effect, he becomes Tammuz, the shepherd-god of fertility who was identi-fied particularly with the ram (see fig. 3-7). Cylinder seals such as this provide us with information that is often absent from the written records. The seals include many gods and heroes whose identities are not otherwise known. From this evidence it is clear that a great deal is missing from our knowledge of Mesopotamian life and culture.

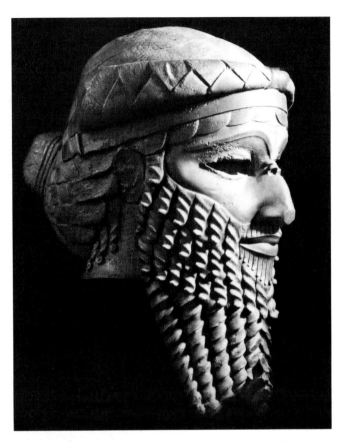

3-12. *Head of an Akkadian Ruler,* from Nineveh (Kuyunjik), Iraq. c. 2300–2200 B.C. Bronze, height 12" (30.7 cm). Iraq Museum, Baghdad

Akkadian Art

Toward the end of the early dynastic period, the theocratic social-ism of the Sumerian city-states began to decay. The local "stewards of the god" became ruling kings. The more ambitious tried to enlarge their domains by conquering their neighbors. At the same time, the Semitic-speaking inhabitants of northern Mesopotamia

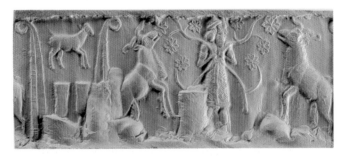

3-11. *Priest-King Feeding Sacred Sheep,* from vicinity of Uruk (Warka). c. 3300 B.C. Marble cylinder seal, height 2⅛" (5.4 cm); diameter 1¾" (4.5 cm). Staatliche Museen zu Berlin, Preussischer Kulturbesitz, Vorderasiatisches Museum

drifted south in ever-larger waves, until they outnumbered the Sumerian peoples in many places. Although these newer arrivals adopted many features of Sumerian civilization, they were less bound to the tradition of the city-state. Sargon of Akkad (his name means "true king," even though he usurped the throne of the northern city of Kish before founding Akkad) openly pro-claimed his ambition to rule the entire earth. Sargon succeeded in conquering Sumer, as well as northern Syria and Elam, about 2334 B.C. He also combined the Sumerian and Akkadian gods and goddesses in a new pantheon. His goal was to unite the coun-try and break down the traditional link between cities and their local gods.

Under the Akkadians, Sumerian art faced a new task: glorify-ing the monarch. The most impressive work of this kind that has survived is a magnificent portrait head in bronze from Nineveh (fig. 3-12). Despite the gouged-out eyes (once inlaid with precious materials), it remains both majestic and moving. Equally admirable is the richness of the surfaces framing the face. The braided hair and the finely curled strands of the beard are shaped with incredible precision, yet they do not lose their organic char-acter and become mere ornament. The complex technique of cast-ing and chasing has been handled with a mastery that places this head among the greatest works of any period.

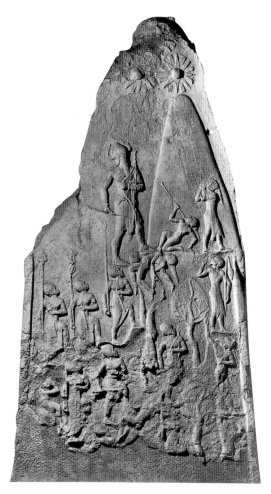

3-13. *Victory Stele of Naram-Sin*. c. 2254–2218 B.C.
Stone, height 6'6" (2 m). Musée du Louvre, Paris

THE STELE OF NARAM-SIN. Sargon's grandson, Naram-Sin, had himself and his victorious army immortalized in relief on a large **stele** (fig. 3-13). This upright stone slab was used as a marker and was later carried off as booty to Susa, where it was found by archaeologists. There are no ground-lines here. We see the king's forces advancing among the trees on a mountainside. Above them, Naram-Sin stands triumphant, as the defeated enemy soldiers plead for mercy. He is as vigorous as his men, but his size and isolated position give him superhuman status. Moreover, he wears the horned crown hitherto reserved for the gods. There is nothing above him except the mountaintop and the celestial bodies, his "good stars."

Ur

The rule of the Akkadian kings came to an end when tribes from the northeast descended into the Mesopotamian plain and gained control of it for more than half a century. They were driven out in 2112 B.C. by king Urnammu of Ur (the modern Muqaiyir), builder of the ziggurat in fig. 3-4, who reestablished a united realm that was to last a hundred years.

GUDEA. During the period of foreign dominance, Lagash (the modern Telloh), one of the lesser Sumerian city-states, managed to remain independent. Its ruler, Gudea, who lived at about the same time as Urnammu, took care to reserve the title of king for Lagash's city-god, Ningirsu, and to promote his cult by an ambitious rebuilding of his temple. [See Primary Sources, no. 2, pages 210–11.] Nothing remains of the temple, but Gudea had numerous statues of himself placed in the shrines of Lagash. (Some 20 examples, all of the same general type, have been found so far.) However devoted he was to the Sumerian city-state, Gudea seems to have inherited the sense of personal importance of the Akkadian kings, although he prided himself on his relations with the gods rather than on his secular power.

The statue of Gudea in figure 3-14 tells us much about how he viewed himself. It was dedicated to Geshtinanna, the goddess of poetry and the interpreter of dreams, for it was in a dream that Ningirsu ordered Gudea to build a temple when the Tigris failed to rise. The king was actively involved in the building of the ziggurat. He not only laid out the temple according to the design revealed to him by Enki, the god of building, but also helped make and carry the mud bricks. (A second statue shows him seated with

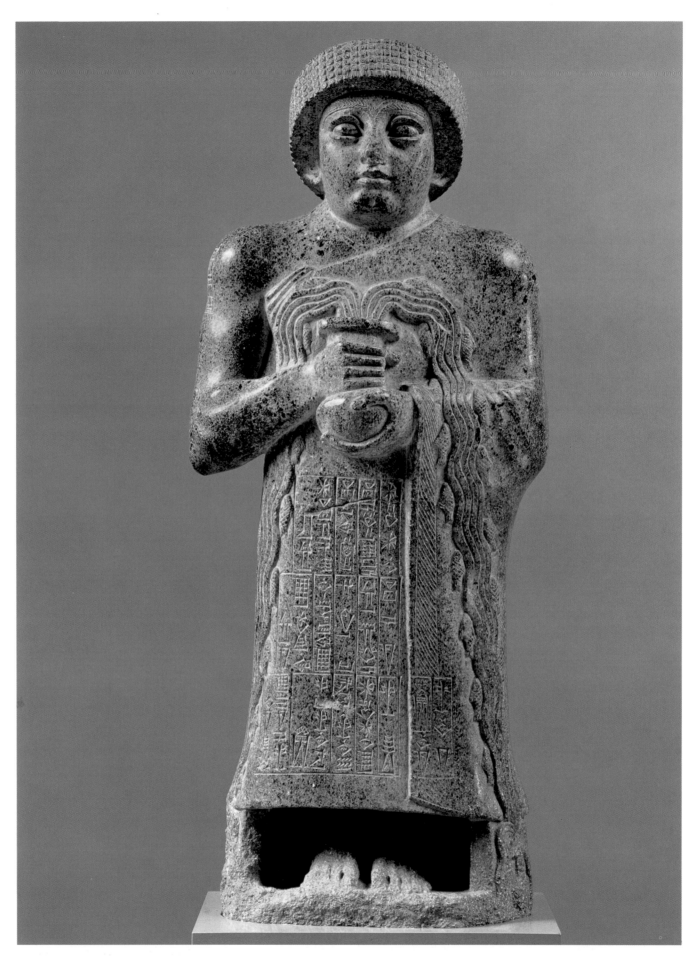

3-14. *Gudea,* from Lagash (Telloh), Iraq. c. 2120 B.C. Diorite, height 29" (73.7 cm). Musée du Louvre, Paris

the **ground plan** on his lap; see fig. PS-2, p. 210.) The process had to be followed scrupulously to ensure the sanctity of the ziggurat, or else the god would be displeased. We can be sure that Gudea's effort was rewarded, as the statue was an offering to Geshtinanna for her role in helping to end the drought. He is holding a vase from which flow two streams of life-giving water that represent the Tigris and Euphrates rivers. (Mesopotamia, we recall, was known as the Land of the Two Rivers.) This attribute, which was reserved for water goddesses and female votive figures, may also allude to the king's role in providing irrigation canals and attests to his benevolent rule.

Because the statue conforms to the same general type as others of Gudea, we may speak of a canon of forms for the first time in Mesopotamian art. (*Canon* means "rule.") Such consistency was probably inspired by Egyptian sculpture, which was based on set proportions. Moreover, the statue is carved of diorite, a hard stone favored by the Egyptians, and has been worked to a high finish that invites a play of light upon the features. The figure nevertheless contrasts with Egyptian statues such as those in figures 2-13 and 2-15. The Sumerian carver has rounded off all the corners to emphasize the cylindrical quality of the forms, although the fleshy roundness is far removed from the geometric simplicity of the Tell Asmar statues. Equally characteristic is the muscular tension in Gudea's bare arm and shoulder, compared with the passive, relaxed limbs of Egyptian sculpture.

Babylonian Art

The late third and the early second millennium B.C. was a time of turmoil in Mesopotamia. It gave rise to the city-states of Isin and Larsa, which rivaled Ur. Central power collapsed about 2025 B.C., when the governor of Isin refused to send aid to Ur during a famine. In 2004 Sumer fell to the Elamites from the east; a century later the Amorites from the northwest conquered several cities. As we might expect, the art and architecture that have come down to us from this period are modest.

Sculpture consists for the most part of small terra-cotta reliefs. Among them is a cult statue of remarkable quality (fig. 3-15). The sculpture is modeled so deeply as to be nearly in the round, lending it a monumentality that belies the modest size. Who can this winged creature with taloned feet be? She is Inanna-Ishtar, whose emblem is the lion. One of the most widely worshiped of all Mesopotamian deities, she unites the Sumerian goddess of fertility with the winged Semitic goddess of war and hunting. The four-horned headdress is a sign of divinity. The figure's voluptuous nudity is characteristic of Ishtar in her guise as the goddess of love, identified with the planet Venus. Missing, however, are Ishtar's key attributes: weapons in her hands as well as sprouting from her shoulders. Instead, she bears the rod and ring of kingship, which she brought with her into the underworld for her consort Tammuz's return.

During Ishtar's descent, the goddess of death strips her of all her clothing, which eventually is returned to her, and she emerges transformed. Ishtar thus is also a goddess of death and resurrection. This aspect is denoted by the owl, which also estab-

lishes her as Kilili, the forerunner of the Assyrian storm goddess Lilitu and the Semitic demon Lilith. Such a mingling of identities is typical of Sumerian religion after Sargon. Yet the image, not seen before in Mesopotamian art, remains unique, and is never found again.

Order was restored in 1792 B.C, when Babylon assumed the role formerly played by Akkad and Ur. Hammurabi (r. 1792–1750 B.C.), the founder of the Babylonian dynasty, is by far the greatest figure of the age. Combining military prowess with a deep respect for Sumerian tradition, he saw himself as "the favorite shepherd" of the sun-god Shamash, whose mission was "to cause justice to prevail in the land." Under Hammurabi and his successors, Babylon became the cultural center of Sumer. The city was to retain this prestige for more than a thousand years after its political power had waned.

THE CODE OF HAMMURABI. Hammurabi's greatest achievement is his law code. Justly famous as one of the earliest uniform written bodies of law, it is amazingly rational and humane. This code is engraved on a tall diorite **stele**, or stone slab, that has at its top a scene showing Hammurabi meeting Shamash (fig. 3-16). (Note the rays coming from the sun-god's shoulders.)

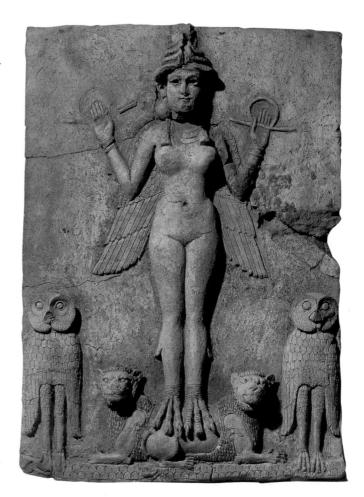

3-15. *Inanna-Ishtar*. c. 2025–1763 B.C. Terra-cotta, height approx. 20" (50.8 cm). Collection Goro Sakamoto, Kyoto, Japan

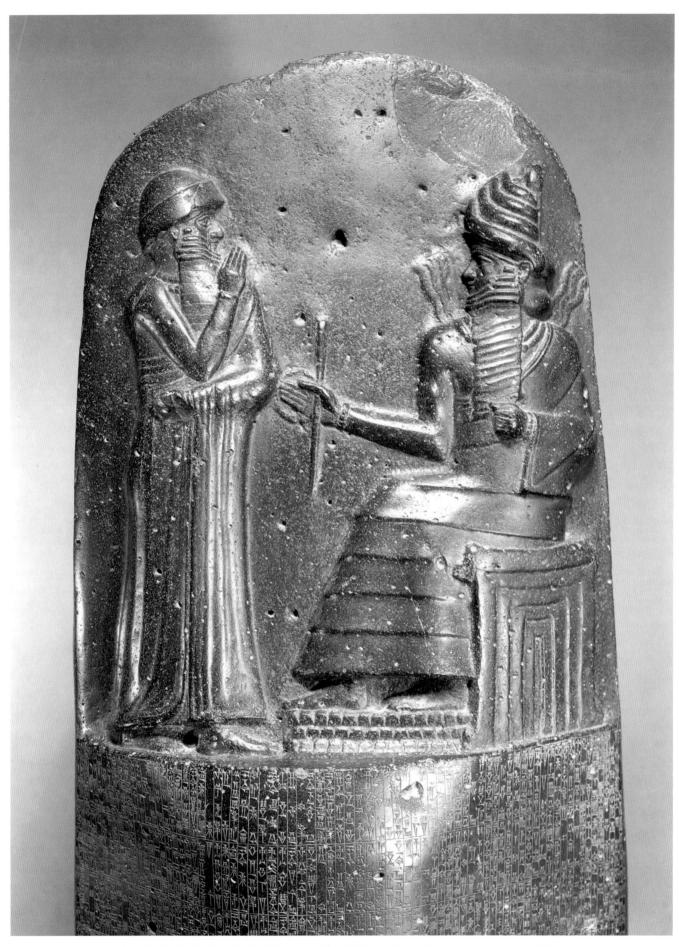

3-16. Upper part of stele inscribed with the Law Code of Hammurabi. c. 1760 B.C. Diorite, height of stele approx. 7' (2.1 m); height of relief 28" (71 cm). Musée du Louvre, Paris

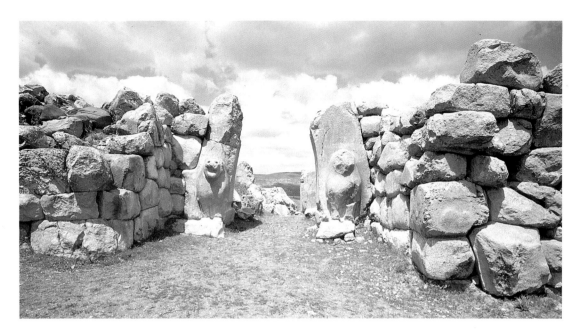

3-17. The Lion Gate, Bogazköy, Anatolia, Turkey. c. 1400 B.C.

The god holds the ring and rod of kingship, which here probably stand for justice as well. The ruler's right arm is raised almost in a speaking gesture, as if he were reporting his work to the divine king. The image conforms to a type of "introduction scene" found on cylinder seals: an individual, his hand raised in prayer, is led by a goddess before a seated deity who bestows his blessing or, if it be an enthroned king, his office. Hammurabi is, then, a supplicant, but in this case he appears without the benefit—or need—of a divine intercessor. Hence his relationship to the god is unusually direct.

Although this scene was carved four centuries after the Gudea statues, it is closely related in both style and technique. The relief here is so high that the two figures almost give the impression of statues sliced in half compared to the pictorial treatment of the stele of Naram-Sin (see fig. 3-13). As a result, the sculptor has been able to render the eyes in the round, so that Hammurabi and Shamash gaze at each other with an immediacy that is unique in works of this kind. The figures recall the statues from Tell Asmar (see fig. 3-6), whose enormous eyes indicate an attempt to establish the same rapport between humans and gods in an earlier phase of Sumerian civilization.

THE HITTITES. Babylon was overthrown in 1595 B.C. by the Hittites, an Indo-European tribe that had probably entered Turkey from southern Russia in the late third millennium B.C. and settled on the rocky plateau of Anatolia. They had emerged as a power around 1800 B.C. and rapidly expanded their empire under Hattusilis I 150 years later. Their capital, Hattusa, near the present-day Turkish village of Bogazköy, was protected by fortifications constructed of large, roughly cut stones. Flanking the gates were lions and other guardian figures protruding from the blocks that formed the jambs of the doorway (fig. 3-17). The Hittite empire, which reached its height between 1400 and 1200 B.C., extended over most of modern-day Turkey and Syria. Its greatest king, Suppiluliuma I (r. c. 1380/40–c. 1320 B.C.), was directly involved with the Egyptian pharaohs Akhenaten and Tutankhamen (see pages 64–66). About 1360 B.C., the Hittites attacked the Mitannians, a people of Hurrian stock who had entered eastern Turkey around the same time as the Hittites. The Mitannians had formed a kingdom in the northern parts of Syria and Mesopotamia, including the city-state of Assur. They were allies of the Egyptians, who could send no effective aid because of the internal crisis provoked by the religious reforms of Akhenaten. Hence the Mitannians were defeated.

THE KASSITES. Meanwhile, Babylon was taken over by the Kassites from the northwest, who traded with the Amarna pharaohs during the mid-fourteenth century B.C. They in turn were toppled by the Elamite king Shutruk-Nahhunte I about 1157 B.C., approximately the same time that the Medes and Persians began entering western Iran. However, a second Kassite dynasty quickly seized power and rose to great heights under Nebuchadnezzar I (r. 1125–1104 B.C.). Their typical art form was the kudurru, a kind of boundary stone set up in temples to record land grants. The finest depicts King Marduk-nadin-akhe (r. 1099–1082 B.C.), the grandson of Nebuchadnezzar I, known as "the avenger of his people" (fig. 3-18). Despite the apparent debt to the statue of Gudea and the Law Code of Hammurabi (see figs. 3-14 and 3-16), the slab is an important advance. It has been argued that there is no such thing as a true Kassite style, but despite a debt to the art of Ur and Babylon, this dynasty established a revised canon of forms and new standard of skill that were taken over with very little change in the reliefs of the Assyrians, who conquered southern Mesopotamia soon thereafter.

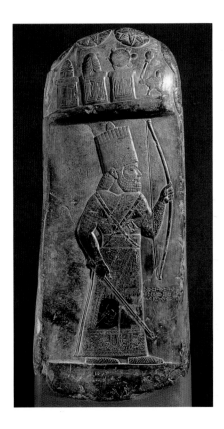

3-18. *Kudurru (Boundary Stone) of Marduk-nadin-akhe.* 1099–1082 B.C. Black limestone, height 24" (61 cm). The British Museum, London

ASSYRIAN ART

The city-state of Assur, located on the upper course of the Tigris, had regained its independence with the defeat of the Mitannians by the Hittites. Under a series of able rulers, beginning with Ashur-buballit (r. 1363–1328? B.C.), who also had contact with the Amarna kings, the Assyrian empire gradually expanded. In time it covered not only Mesopotamia proper but the surrounding regions as well. At the height of its power, from about 1000 to 612 B.C., the empire stretched from the Sinai Peninsula to Armenia. Even Lower Egypt was successfully invaded about 670 B.C.

Palaces and Their Decoration

The Assyrians, it has been said, were to the Sumerians what the Romans were to the Greeks. Assyrian civilization drew on the achievements of the south but adapted them to fit its own distinct character. The temples and ziggurats they built were based on Sumerian models, while the palaces of their kings grew to unprecedented size and magnificence.

NIMRUD. Although the Assyrians, like the Sumerians, built in brick, they liked to line gateways and the lower walls of interiors with reliefs of limestone (which was easier to obtain in northern Mesopotamia). These panels were devoted to glorifying the power of the king, either by detailed depictions of his military conquests or by showing the sovereign as the killer of lions. In the reliefs illustrating the conquests of the royal armies, every campaign is shown in detail, with inscriptions giving further data. The Assyrian forces always seem to be on the march: they are shown meeting the enemy at every frontier of the empire, destroying his strong points, and carrying away booty and prisoners. There is neither drama nor heroism in these scenes—the outcome is never in doubt—and they are often repetitious. Yet they are filled with fascinating vignettes. Our detail, from the Palace of Ashurnasirpal II (r. 883–859 B.C.) at Nimrud (Calah), shows the enemy fleeing an advance party (fig. 3-19). They swim on inflatable animal skins across a river toward their fortified city, while the king and two women look on in horror. The figures are the descendants of King Maduk-nadin-akhe in figure 3-18. As the earliest large-scale efforts at narrative in Mesopotamian art, they represent an achievement of great importance. Earlier Sumerian art did not describe the progress of specific events in time and space; even the scene on the stele of Naram-Sin is symbolic rather than historic. Assyrian artists may have been aware of Middle and New Kingdom Egyptian reliefs, which depicted military campaigns in considerable detail beginning with the tomb of Horemheb (see fig. 2-30). The

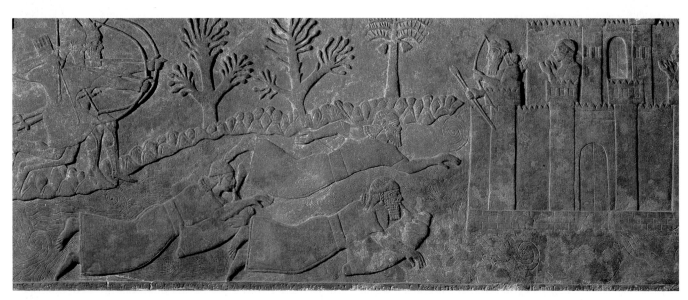

3-19. *Fugitives Crossing River,* from the Northwest Palace of Ashurnasirpal II, Nimrud (Calah), Iraq. c. 883–859 B.C. Alabaster relief, height c. 39" (98 cm). The British Museum, London

battle scenes from Nimrud are similar to those carved in the reigns of Sety I and Ramesses II during the Ramessid period (compare fig. 2-35). Yet the Assyrian sculptor had to develop new techniques to cope with the demands of pictorial storytelling.

LION HUNTS. As in Egypt, the royal lion hunts were more like ritual combats than actual hunts: the animals were released from cages into a square formed by troops with shields. (At a much earlier time, lion hunting had been an important duty of Mesopotamian rulers as the "shepherds" of the communal flocks.) The Assyrian sculptors rise to their greatest heights in depictions of such scenes. In figure 3-20, the lion attacking the royal chariot from the rear is clearly the hero of the scene. Of magnificent

strength and courage, the wounded animal seems to embody all the dramatic emotion of combat that we miss in the battle reliefs. The dying lion on the right is equally impressive in its agony—so different from the way the Egyptian artist had interpreted the hippopotamus hunt in figure 2-18.

DUR SHARRUKIN. The same impression of royal power was reinforced at the entrance to the palace of Sargon II (r. 721–705 B.C.) at Dur Sharrukin (modern Khorsabad), which dates from the second half of the eighth century B.C. It was surrounded by a citadel with turreted walls that shut it off from the rest of the town. Figure 3-21 shows one of the two gates of the citadel during excavation. The two guardian figures (called lamassus) are an odd

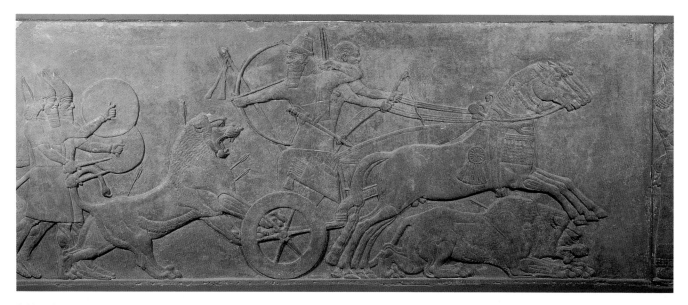

3-20. *Ashurnasirpal II Killing Lions,* from the Palace of Ashurnasirpal II, Calah (Nimrud), Iraq. c. 850 B.C. Limestone, 3'3" x 8'4" (1 x 2.54 m). The British Museum, London

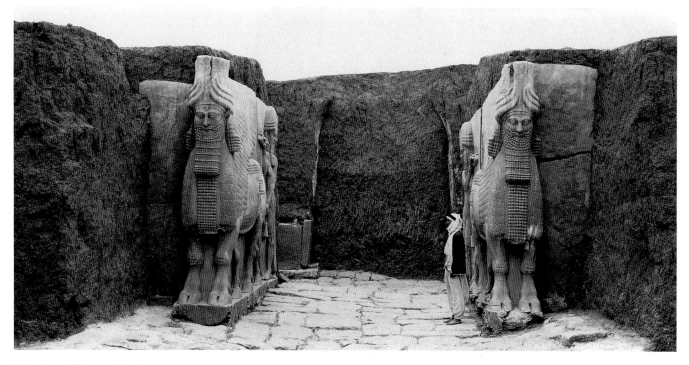

3-21. Gate of the Citadel of Sargon II, Dur Sharrukin (Khorsabad), Iraq (during excavation). 742–706 B.C.

mixture of relief and sculpture in the round: each has a fifth leg so that it will seem complete from the side. They must have been inspired by Hittite examples such as the Lion Gate at Bogazköy (see fig. 3-17). Awesome in size and appearance, the gates were meant to impress visitors with the authority of the king.

Neo~Babylonian Art

The Assyrian empire came to an end in 612 B.C., when Nineveh fell to the Medes (an Indo-European-speaking people from western Iran) and Babylonians. Under the Chaldean dynasty, the ancient city had a final brief flowering between 612 and 539 B.C., before it was conquered by the Persians. The best known of these Neo-Babylonian rulers was Nebuchadnezzar II (r. 604–c. 561 B.C.), the builder of the Tower of Babel and the renowned hanging gardens of Babylon.

Whereas the Assyrians had used carved stone slabs to decorate their structures, the Neo-Babylonians (who were farther removed from the sources of such slabs) substituted baked and **glazed** brick. This technique, too, had been developed in Assyria. Now, however, it was used on a far greater scale, both for surface ornament and for reliefs. Its distinctive effect is evident in the Ishtar Gate of Nebuchadnezzar's sacred precinct in Babylon, which has been rebuilt from the thousands of glazed bricks that covered its surface (fig. 3-22). The procession of bulls, dragons, and other animals of molded brick within a framework of vividly colored ornamental bands has a grace and gaiety that remind us again of that special genius of ancient Mesopotamian art for portraying animals.

PERSIAN ART

Persia, the mountain-fringed high plateau to the east of Mesopotamia, takes its name from the people who occupied Babylon in 538 B.C. (See the discussion of the Achaemenids below.) Today the country is called Iran, its older and more suitable name. The Persians were latecomers who arrived on the scene only a few centuries before they began their conquests. Iran has been inhabited since prehistoric times and seems to have been a gateway for migrating tribes from the Asiatic steppes to the north as well as from India to the east. The new arrivals would settle down for a while, dominating or mingling with the local population, until the next wave of immigrants forced them to move on—to Mesopotamia, Asia Minor (roughly, Asian Turkey), or southern Russia.

THE ANIMAL STYLE. Not much is known about the movements of these nomadic tribes; the information we have is vague

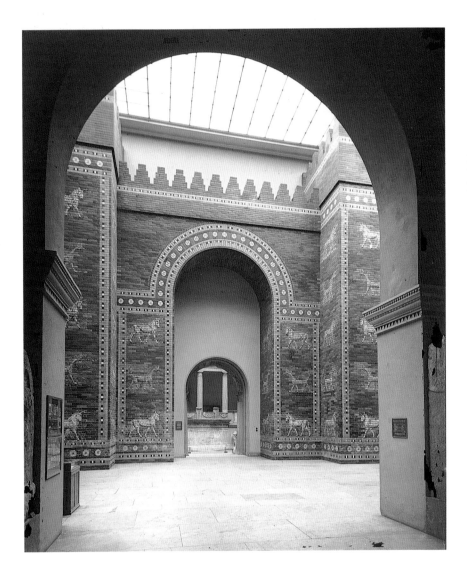

3-22. Ishtar Gate (restored), from Babylon, Iraq. c. 575 B.C. Glazed brick. Staatliche Museen zu Berlin, Preussischer Kulturbesitz, Vorderasiatisches Museum

3-23. Painted beaker, from Susa. c. 5000–4000 B.C. Height 11¼" (28.3 cm). Musée du Louvre, Paris

and uncertain. Since such peoples left no permanent structures or records, we can trace their wanderings only by careful study of the items they buried with their dead. These objects, made of wood, bone, or metal, are a distinct kind of portable art called nomad's gear. They include weapons, bridles, buckles, fibulas (large clasps or brooches) and other articles of adornment, as well as cups, bowls, and the like. They have been found over a vast area, from Siberia to Central Europe, from Iran to Scandinavia. Such articles have in common not only their ornamental design but also a set of forms known as the **animal style**. This style's main feature, as the name suggests, is the decorative use of animal motifs in abstract and imaginative ways.

One of the sources of the animal style appears to be ancient Iran. We find its earliest ancestors on the prehistoric painted pottery of western Iran. An example is the beaker in figure 3-23, which shows an ibex (mountain goat) reduced to a few sweeping curves, so that the body becomes an appendage of the horns. The racing hounds above the ibex are little more than horizontal streaks. When we look closely, we see that the stripes below the rim are long-necked birds. In Sumer this style soon gave way to an interest in the organic unity of animal bodies (see figs. 3-7 and 3-9), but in Iran it survived despite the strong influence of Mesopotamia.

Several thousand years later, in the tenth to seventh centuries B.C., the style reappears in western Iran. Although the exact origin and date of most objects are by no means certain, the remains of the gold belt in fig. 3-24 are probably from Ziwiye in the north-

3-24. Fragment of a belt, probably from Ziwiye. Late 8th century B.C. Gold sheet, width 6½" (16.5 cm). The British Museum, London

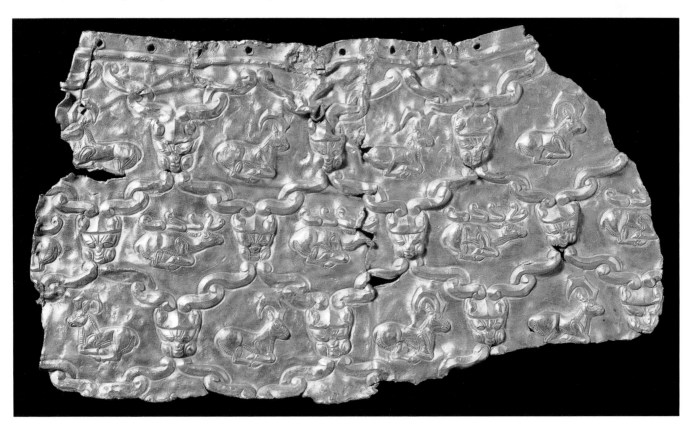

western part of the country, which was ruled in the seventh century B.C. by the Manneans. Here the animal style is at its finest—and most puzzling. The kneeling ibex is a descendant of the specimen on the vase from Susa. But what are we to make of the other creatures? The stag, which is not native to the region, is a motif transported from the steppes of Central Asia by the Scythians. The alternating rows of ibexes and stags are enclosed in a pattern of abstract lion heads; this pattern was native to Urartu (the biblical Ararat) in eastern Turkey, which was conquered by Sargon II of Assyria in 714 B.C. Similar belts of bronze have also been found in Urartian tombs.

The Scythians belonged to a group of nomadic Indo-European tribes, including the Medes and the Persians, that began to filter into Iran soon after 1000 B.C. The animal style of the Scythians merged with that of the Luristan region in western Iran during the late eighth century B.C. These tribes, however, were makers of bronze. Although goldsmithing was of ancient origin and widely diffused (see figs. 3-7 and 4-16–4-18), it was probably the Phoenicians who translated the animal style into gold. A breastplate from the same hoard as our belt depicts Phoenician deities in a similar fashion; both are strikingly similar to Phoenician gold and silver bowls of about the same time. These seafaring traders, originally from Canaan, began ranging throughout the Mediterranean Sea after the fall of Mycenae about 1200 B.C.

The seventh century B.C. was a time of intense contact between East and West. The cultural exchange gave rise to the Orientalizing style in Greece (see pages 109–110), which in turn contributed new motifs to the Near East. The Phoenicians played a key role in this process. They were superb craftsmen in various metals, including gold, who made use of motifs derived from their travels. Around 800 B.C. they settled on nearby Cyprus, which soon became a center of silver- and goldsmithing and which was equally open to diverse influences. Whether Phoenician (as seems likely) or Cypriot, the artist who created our gold belt has brought together the elements of the animal style into a superb design and fashioned it with impressive skill.

The Achaemenids

The Near East long remained a vast melting pot. During the middle of the sixth century B.C., however, the entire region came under the sway of the Persians ruled by the Achaemenid dynasty. After overthrowing Astyages, king of the Medes, Cyrus the Great (r. 550–530/29 B.C.) conquered Babylon in 538 B.C. Along with the title "King of Babylon," he assumed the ambitions of the Assyrian rulers. The empire Cyrus founded continued to expand under his successors. Egypt as well as Asia Minor fell to them, while Greece escaped by a narrow margin in the early fifth century B.C. At its height, under Darius I (r. 521–486 B.C.) and his son Xerxes (r. 485–465 B.C.), the Persian empire was far larger than the Egyptian and Assyrian empires combined. This huge domain endured for two centuries, and during most of its life it was ruled both efficiently and humanely. For an obscure tribe of nomads to have achieved all this is little short of a miracle. Within a single generation, the Persians not only learned how to administer an empire

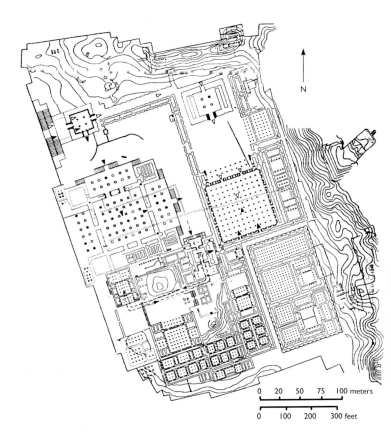

3-25. Plan of the Palace of Darius and Xerxes, Persepolis. 518–460 B.C. Solid triangles show the processional route taken by Persian and Mede notables; open triangles indicate the way taken by heads of delegations and their suites.

but also developed a highly original monumental art to express the grandeur of their rule.

Despite their genius for adaptation, the Persians held onto their own religious beliefs, which were drawn from the prophecies of Zoroaster (Zarathustra). This faith was based on the dualism of Good and Evil, embodied in Ahuramazda (Light) and Ahriman (Darkness). Since the cult of Ahuramazda centered on fire altars in the open air, the Persians had no religious architecture. Their palaces, on the other hand, were huge and impressive.

PERSEPOLIS. The most ambitious of these palaces, at Persepolis, was begun by Darius I in 518 B.C. Assyrian traditions are the strongest single element throughout the vast complex, which consisted of a great number of rooms, halls, and courts on a raised platform (fig. 3-25). Yet they do not determine the character of the building, for they have been combined with influences from every corner of the empire to create a new, uniquely Persian style.

Columns are used on a grand scale at Persepolis. The Audience Hall of Darius and Xerxes, a room 250 feet square, had a

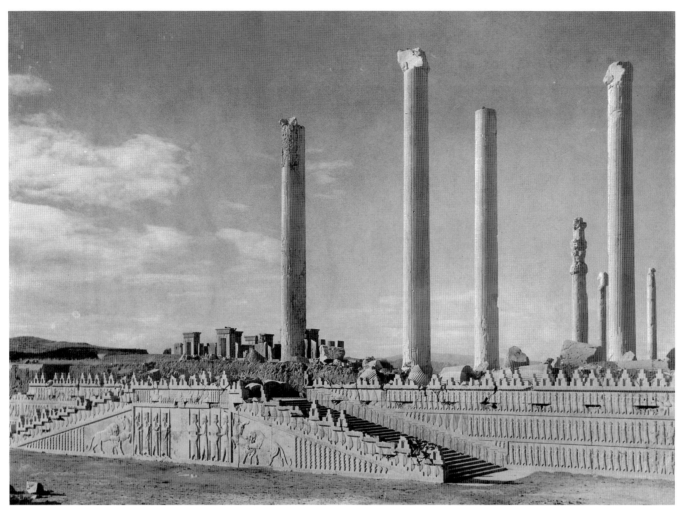

3-26. Audience Hall of Darius and Xerxes,
Persepolis, Iran. c. 500 B.C.

wooden ceiling supported by 36 columns 40 feet tall, a few of which are still standing (fig. 3-26). Such a massing of columns suggests Egyptian architecture (compare fig. 2-32), and Egyptian influence can also be seen in the ornamental detail of the bases and capitals. However, the slender, fluted shaft of the Persepolis columns is derived from the Ionian Greeks in Asia Minor, who are known to have sent artists to the Persian court.

The columns are crowned by a strange "cradle" for the beams of the ceiling (fig. 3-27). Composed of the front parts of two bulls or similar creatures, it has no precedent. While the animals them-

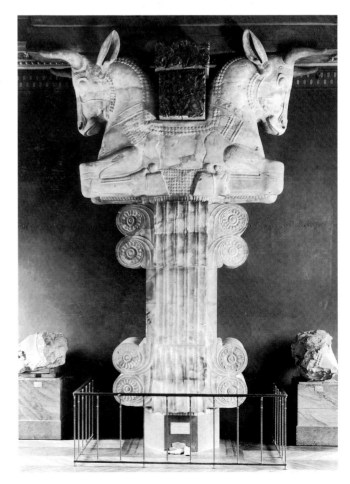

3-27. Bull capital, from Persepolis. c. 500 B.C. Musée du Louvre, Paris

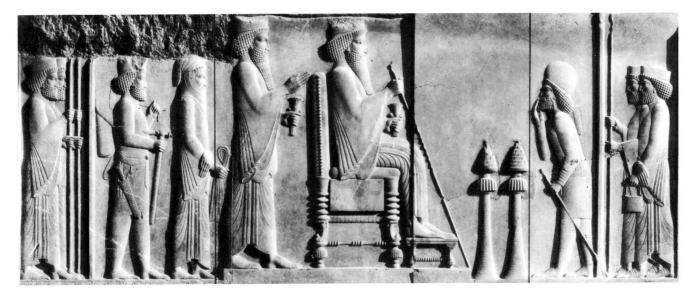

3-28. *Darius and Xerxes Giving Audience*. c. 490 B.C. Limestone, height 8'4" (2.5 m). Archaeological Museum, Tehran, Iran

selves are of Assyrian origin, the way they are combined suggests a greatly enlarged version of the animal style from western Iran. This seems to be the only instance of Persian architects drawing upon their artistic heritage of nomad's gear.

The double stairway leading up to the Audience Hall is decorated with long rows of marching figures in low relief. Their repetitive, ceremonial character emphasizes a subservience to the architectural setting that is typical of all Persian sculpture. We find it even in scenes of special importance, such as *Darius and Xerxes Giving Audience* (fig. 3-28). Here the expressive energy and narrative skill of Assyrian relief have been rejected in favor of formal grandeur. Even here, we discover that the Assyrian-Babylonian heritage has been enriched in one important way. There is no prior instance in Near Eastern sculpture for the layers of pleated folds we see in the Darius and Xerxes relief. Another surprising effect is the way the arms and shoulders of these figures press through the fabric. These innovations stem from the Ionian Greeks, who had created such figures in the course of the sixth century B.C. Hence the style of the Persian carvings is a softer, more refined echo of the Mesopotamian tradition.

Persian art under the Achaemenids, then, is a remarkable marriage of many diverse elements. Yet it lacked a capacity for growth. The style that developed under Darius I about 500 B.C. continued without major change until the end of the empire. The Persians, it seems, could not move beyond their preoccupation

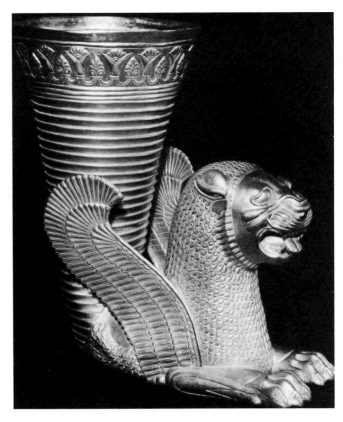

3-29. Rhyton. Achaemenid. 5th–3rd centuries B.C. Gold. Archaeological Museum, Tehran, Iran

with decorative effects regardless of scale, a carryover from their nomadic past. There is no real difference between the bull capital (see fig. 3-27) and the rhyton, or drinking horn, in figure 3-29, which maintains the animal style in the senmurv, a mythical creature with the body of a lion sprouting griffin's wings and a peacock's tail that is transformed almost miraculously into the body of the drinking cup. The ferocious beast, descended from the animals of Assyrian reliefs (see fig. 3-20), has been tamed, thanks to the small scale and fine goldsmith's work, which reveals a debt to the belt in figure 3-24. The tradition of portable art in Achaemenid Persia, unlike monumental architecture and sculpture, somehow managed to survive the more than 500 years when the Persian empire was under Greek and Roman domination. It flowered once more when Persia regained its independence under the Sassanians.

Sassanian Art

Mesopotamia, like Egypt, eventually became part of the Greek and Roman world, although it retained aspects of its ancient culture. The Achaemenids were toppled by Alexander the Great (356–323 B.C.) in 331 B.C. After his death eight years later, his realm was divided among his generals. Seleucis (r. 305–281 B.C.) received much of the Near East, aside from Egypt, which was given to Ptolemy (see page 69). The Seleucids were succeeded by the Parthians, who gained control over the region in 238 B.C. The Parthians were fierce fighters who fended off the Romans until the time of Trajan in the second century A.D. Although their power later declined, it was not until 224 A.D. that Artabanus V, the last Parthian king, was overthrown by one of his governors, Ardashir (died 240 A.D.). Ardashir founded the Sassanian dynasty, which endured until it fell to the Arabs in 651 A.D.

His son, Shapur I (r. 240–272 A.D.), proved as ambitious as Darius had been and greatly expanded the empire. He even succeeded in defeating the Roman emperors Gordian III (r. 238–244 A.D.), Phillipus the Arab (r. 244–249), and Valerian (r. 253–260 A.D.). Shapur commemorated his victory over two of the Roman emperors in an immense relief carved into rock (fig. 3-30). The source of this scene is a well-known subject in Roman sculpture, except that here the emperors, rather than the barbarians, have been defeated. The style, too, is Roman (compare fig. 7-36), but the flattening of the volumes and the ornamental treatment of the

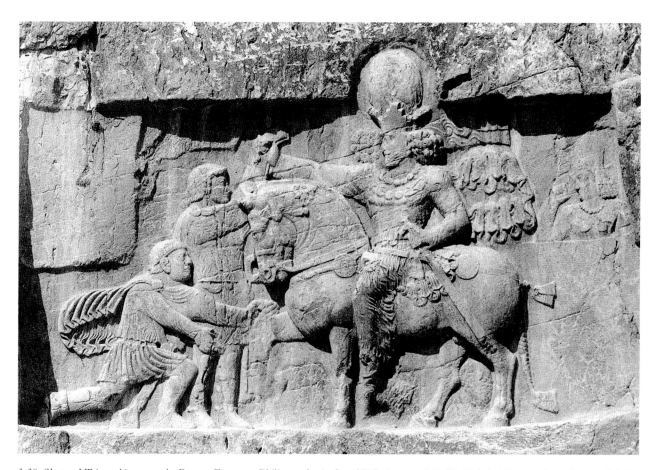

3-30. *Shapur I Triumphing over the Roman Emperors Philippus the Arab and Valerian.* A.D. 260–72. Naksh-i-Rustam (near Persepolis), Iran

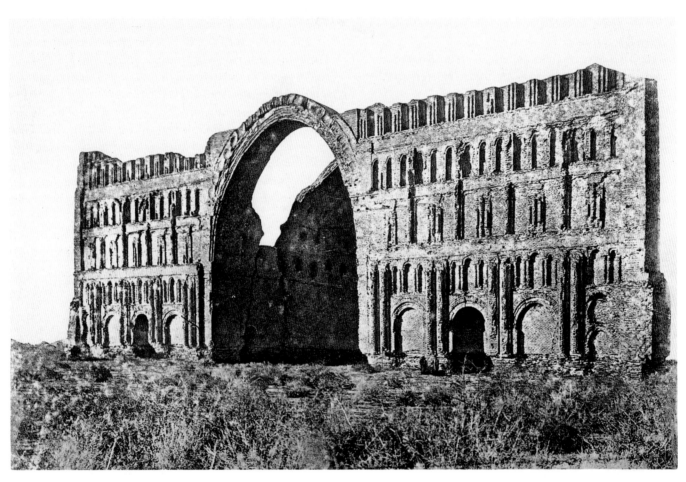

3-31. Palace of Shapur I, Ctesiphon, Iraq. 242–72 A.D.

draperies indicate a revival of Persian qualities. The way the two elements are held in balance is what makes the relief so impressive. A blending of Roman and Near Eastern elements can also be seen in Shapur I's palace at Ctesiphon, near Babylon, with its huge brick-vaulted audience hall (fig. 3-31). The blind arcades of the facade, strikingly Roman in flavor (compare fig. 7-11), again emphasize decorative surface pattern.

Monumental art under Sassanian rule proved as incapable of further evolution as it had under the Achaemenids. Metalwork and textiles, on the other hand, continued to flourish. The chief glory of Sassanian art is its silver bowls, such as the example in figure 3-32. Turned on a lathe and silver-gilt with mercury highlights, it is a marvel of craftsmanship. In this miniaturized form, a rich tradition lives on. The subject, probably King Peroz I hunting gazelles, is the descendant of Assyrian royal hunts. It also reaches back to Egyptian art, but with overtones of the animal style (compare figs. 2-18, 3-20, and 3-24). In typical Sassanian fashion, a strong Roman element has been added to this blend of Near Eastern motifs: the rider is related to *Hadrian Hunting a Boar* (fig. 7-47), which has its roots in Greek Classical art (compare fig. 5-56). Finally, the style remains distinctly Phoenician in flavor.

Much Sassanian ware was exported both to Constantinople and to the Christian West, where it had a strong effect on the art of the Middle Ages. And since its manufacture was resumed after the Sassanian realm fell to the Arabs in the mid-seventh century, it served as a source of design motifs for Islamic art as well.

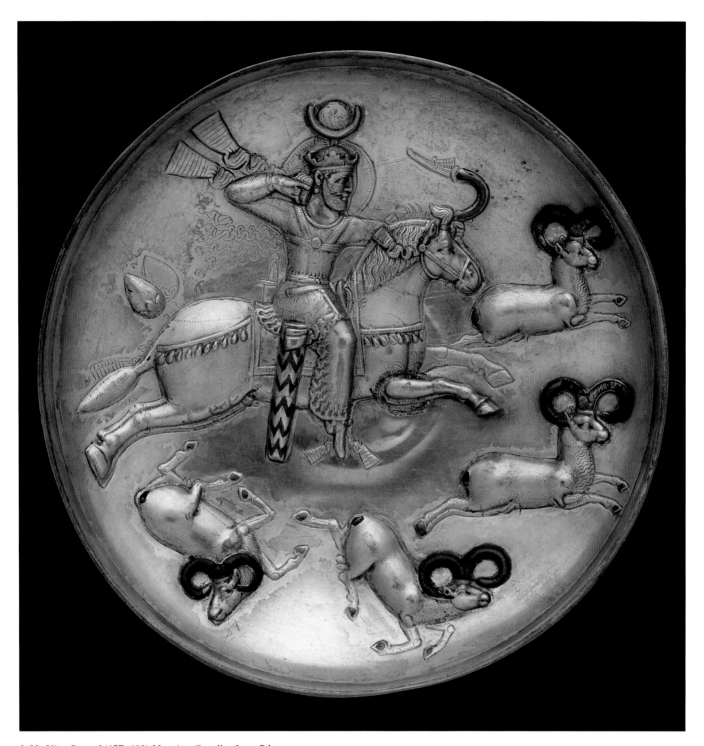

3-32. *King Peroz I* (457–483) *Hunting Gazelles.* Late 5th century A.D.
Silver-gilt, engraved, embossed, and inlaid with niello, diameter 8⅝" (21.9 cm).
The Metropolitan Museum of Art, New York

FLETCHER FUND, 1934 (34.33)

CHAPTER FOUR

Aegean Art

If we sail from the Nile Delta northwestward across the Mediterranean, our first glimpse of Europe will be the eastern tip of Crete. To the north we find a scattered group of small islands, the Cyclades, one of several clusters that dot the Aegean Sea. A little farther on is the mainland of Greece, facing the coast of Asia Minor. The island of Crete, then, lies south and east of Greece. The region is largely mountainous, with few large areas of flat, arable land. As a result, communities, although mainly agrarian, tended to be small and scattered—a fact that, along with ceaseless migration throughout the Bronze Age, encouraged extraordinary diversity and independence. Thus, Homer says of Crete, "There are many men in it, beyond counting, and ninety cities. They have not all the same speech; their tongues are mixed. There dwell Achaeans, there great-hearted native Cretans, there Cydonians, and Dorians in three divisions, and noble Pelasgians."

To archaeologists, *Aegean* is not just a geographical term. They use it to refer to the civilizations that flourished in this area during the third and second millennia B.C., before the development of Greek civilization proper. There were three closely related yet distinct cultures: Minoan (after the legendary King Minos), on the isle of Crete; Cycladic, on the small islands north of Crete; and Helladic, on the Greek mainland, which includes Mycenae. Each has in turn been divided into three phases: Early, Middle, and Late, which correspond, very roughly, to the Old, Middle, and New Kingdoms in Egypt. Their greatest artistic achievements date from the latter part of the Middle phase and from the Late phase. Despite significant local differences, there were clearly interactions between these regions, so that we may also speak of a shared culture and style.

Aegean civilization was long known only from two epic poems by Homer (the *Iliad* and the *Odyssey*) and from Greek legends centering on Crete. The earliest excavations—by Heinrich Schliemann during the 1870s in Asia Minor and Greece and by Sir Arthur Evans in Crete shortly before 1900—were undertaken to find out whether these tales had a factual basis. Since then, a great deal of fascinating material has come to light, far more than written sources would lead us to expect. But even now, the lack of written records makes our knowledge of Aegean civilization much more limited than our knowledge of Egypt or the ancient Near East. Consequently, the meaning of these continual archaeological discoveries is hotly debated.

We nevertheless know, for example, that Troy was inhabited almost continuously from about 3000 B.C. on, despite being repeatedly destroyed by earthquakes and fires. Thanks to its strategic location near the Hellespont (Dardanelles), the strait linking the Aegean and the Sea of Marmara, the site flourished after 1900 B.C. and was an important trade center under the Hittites (see page 000). It declined after the Trojan War around 1250 B.C. and was largely abandoned between 1100 and 700 B.C., when the Greeks colonized the area and named it Ilios. After being razed in 85 B.C. by the Roman general Sulla (see page 176), the city again prospered under the Roman empire. Ultimately it disappeared until the founding of Constantinople at Byzantium on the Bosporus, the strait that connects the Sea of Marmara with the Black Sea (see page 36).

MINOAN SCRIPT AND LINEAR B. In Crete a system of writing was developed about 2000 B.C. A late form of this Minoan script, called Linear B, which was in use about six centuries later both in Crete and on the Greek mainland, was deciphered in the early 1950s. The language of Linear B is Greek, yet this apparently was not the language for which Minoan script was used before the fifteenth century B.C. Hence being able to read Linear B does not help us to understand earlier Minoan inscriptions. Moreover, most Linear B texts are inventories and records. They do reveal something about the history, religion, and political organization of the people who wrote them, but provide us with relatively little of the background knowledge required for an understanding of Aegean art, despite intensive archaeological excavations being carried out all across Crete.

Although the forms of Aegean art are linked to Egypt and the Near East on the one hand and to later Greek art on the other, they are no mere transition between these worlds. They have a haunting beauty of their own that belongs to neither. Among the many remarkable qualities of Aegean art are its freshness and spontaneity, which make us forget how little we know of its meaning.

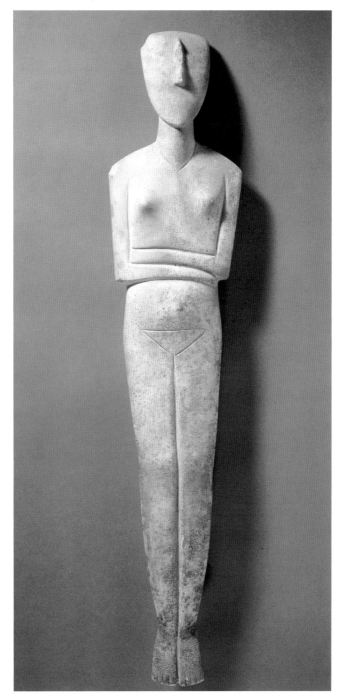

4-1. Figure, from Amorgos, Cyclades. c. 2500 B.C. Marble,
height 30" (76.3 cm). Ashmolean Museum, Oxford, England

CYCLADIC ART

After about 2800 B.C. the people of the Cycladic Islands often
buried their dead with marble sculptures of a peculiarly impres-
sive kind. Almost all of them represent a nude female figure with
arms folded across the chest (fig. 4-1). They also share a distinctive
form, which at first glance recalls the angular, abstract qualities of
Paleolithic and Neolithic sculpture. Generally they have a flat,
wedge-shaped body; a strong, columnar neck; a tilted oval shield
of a face; and a long, ridgelike nose. (Other features were painted

in.) Within this narrowly defined and stable type, however, the
Cycladic figures show wide variations in scale and shape that lend
them a surprising individuality. The best of them represent a late,
highly developed phase dating to about 2500–2400 B.C.

Our example has a disciplined refinement utterly beyond the
range of Paleolithic or Neolithic art. The longer we study this
piece, the more we become aware of its elegance and sophistica-
tion. What an extraordinary feeling for the organic structure of
the body is shown in the delicate curves of the outline and in the
hints of roundness at the knees and abdomen! Even if we discount

its deceptively modern look, the figure is a bold departure from anything we have seen before. There is no lack of female figures in earlier periods, but almost all of them are descended from the heavy-bodied type of the Old Stone Age (see fig. 1-7). In fact, the earliest Cycladic figurines, too, were of the same kind.

We do not know what led Cycladic sculptors to adopt the "girlish" ideal of figure 4-1. The transformation may have been related to a change in religious beliefs and practices. Perhaps there was a shift away from the mother and fertility goddesses known to us from Asia Minor and the ancient Near East, whose ancestry reaches back to the Old Stone Age. The largest Cycladic figures were probably cult statues to a female divinity who may have been identified with the sun in the great cycle of life and death. The smaller ones might have been displayed in household shrines or even used as votive offerings. Although their meaning is far from clear, their purpose was not simply funereal. Rather, they were important objects that were included in graves with other items from everyday life. There they served as either presents for the deity or provisions for the afterlife. Rarely were they freestanding. Although most have been found in a reclining position, they may also have been propped upright during their normal use.

Be that as it may, the Cycladic sculptors of the third millennium B.C. produced the oldest large-scale figures of the female nude we know. In fact, for many hundreds of years they were the only ones to do so. In Greek art, we find very few nude female statues until the middle of the fourth century B.C., when Praxiteles and others began to create cult images of the nude Aphrodite (see fig. 5-69). It can hardly be by chance that the most famous of these Venuses were made for sanctuaries located on the Aegean Islands or the coast of Asia Minor, the region where the Cycladic idols had flourished.

A second group of figures, evidently produced at a slightly later date by a single workshop and distributed throughout the Aegean, represents musicians playing harps and double-flutes—instruments that were used by the Greeks as well (see box pages 139–140). The statuette in figure 4-2 probably shows a bard singing his legend. An unusually complex work for its time, it was carved by a gifted artist who makes us feel the poet's visionary rapture through the rounded forms and tilt of the head.

MINOAN ART

Minoan civilization is by far the richest, as well as the most unusual, of the Aegean world. What sets it apart, not only from those of Egypt and the Near East but also from the classical civilization of Greece, is its lack of continuity. The different phases appear and disappear so abruptly that they must have been caused by sudden violent changes affecting the entire island of Crete. They seem to be due to archaeological accidents as well as historical forces. Yet Minoan art, which is gay, even playful, and full of rhythmic motion, conveys no hint of such threats.

Architecture

The first of these abrupt shifts occurred about 2000 B.C. Until that time, during the thousand years of the Early Minoan era, the Cre-

tans had not advanced much beyond the Neolithic level of village life, although they do seem to have engaged in some trade that brought them into contact with Egypt. Then they created not only their own system of writing but also an urban civilization, centering on several great palaces. At least three palaces were built in short order at Knossos, Phaistos, and Mallia. Little is left of this sudden spurt of large-scale building. The three early palaces were all destroyed at the same time, about 1700 B.C., evidently by an earthquake. After a short interval, new and even larger structures were built on the same sites, only to be demolished by another earthquake about 1450 B.C. After that, Phaistos and Mallia were abandoned, but the palace at Knossos was occupied by the Mycenaeans, who took over the island almost immediately.

Minoan civilization therefore has a complicated chronology. Archaeologists divide the era that concerns us into three periods: Early Minoan, beginning around 3000 B.C.; the Old Palace period, comprising Middle Minoan I and Middle Minoan II, which together lasted from 2000 B.C. until about 1700 B.C.; and the New Palace period, including Middle Minoan III, Late Minoan IA, and Late Minoan IB, which ended around 1450 B.C. (The dates of these internal divisions, which are constantly being debated, need

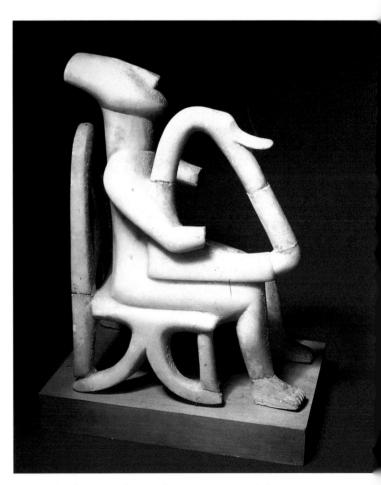

4-2. *Harpist,* so-called Orpheus, from Amorgos, Cyclades. Latter part of the 3rd millennium B.C. Marble statuette, height 8½" (21.5 cm). National Archaeological Museum, Athens

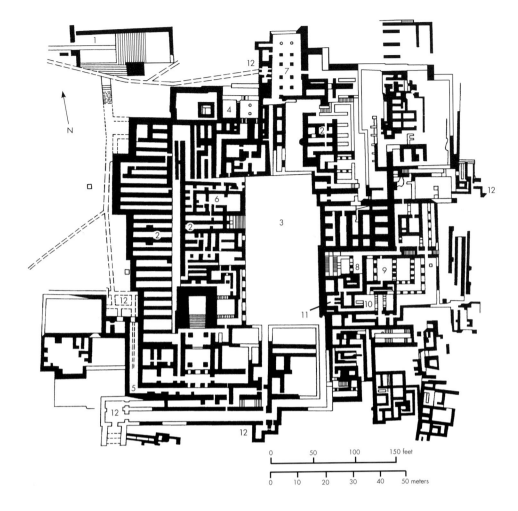

4-3. Plan of the Palace of Minos, Knossos, Crete. The palace is organized in two wings, to the east and west of a central court, and is on several levels.

(1) stairway and theater area
(2) storerooms
(3) central court
(4) antechamber
(5) corridor of the procession
(6) throne room
(7) north pillar hall
(8) hall of the colonnade
(9) hall of the double axes
(10) queen's megaron
(11) queen's bath
(12) entrances and atriums

0 50 100 150 feet
0 10 20 30 40 50 meters

not concern us here.) The eruption of the volcano on the island of Thera (the modern Santorini) occurred during the New Palace period, at the end of Late Minoan IA. It did little damage to Crete, however, and ushered in the Late Minoan IB period, which marked the peak of Minoan civilization. For our purposes, we need only remember that the Old Palace period coincides very roughly with the Middle Kingdom, and the New Palace period with the onset of the New Kingdom in Egypt.

The "new" palaces are our main source of information about Minoan architecture. The one at Knossos, called the Palace of Minos, was the most ambitious (fig. 4-3). It covered a large area and contained so many rooms that it survived in Greek legend as the labyrinth (maze) of the Minotaur, a half-human, half-bull offspring of Queen Pasiphae that devoured Athenian youths and maidens to avenge the death of Minos' son Androgeous at Athenian hands, until he was killed by Theseus. The site has been systematically excavated and partly restored. Although it was carefully designed and built, there was no striving for a unified effect, and the exterior was modest compared with those of Assyrian and Persian palaces (see fig. 3-26). The individual units are

rather small and the ceilings low (figs. 4-4 and 4-5), so that even those parts of the structure that were several stories high could not have seemed very tall.

Nevertheless, the numerous **porticoes** (roofed entranceways), staircases, and air shafts must have given the palace an open, airy look. Some of the interiors, with their richly decorated walls, still retain their elegant appearance. The masonry construction is excellent, but the columns were always of wood. Although none of the columns has survived (those in fig. 4-4 are reconstructions), their form is known from paintings and sculptures. They had a smooth **shaft** tapering downward and were topped by a wide, cushion-shaped **capital**. About the origins of this type of column, which in some contexts could also serve as a religious symbol, or about its possible links with Egyptian architecture, we can say nothing at all.

Who were the rulers that built these palaces? We do not know their names or deeds, except for the legendary Minos, who was one of three sons born of Europa after she was abducted by Zeus in the guise of a bull (see fig. 17-14). The archaeological evidence suggests that they were not warriors. No fortifications have been

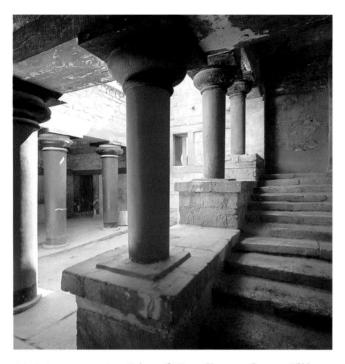

4-4. Staircase, east wing, Palace of Minos, Knossos, Crete. c. 1500 B.C.

found anywhere in Minoan Crete, and military subjects are almost unknown in Minoan art. Nor is there any hint that kings were sacred like those of Egypt or Mesopotamia, although they may have presided at religious festivals and their palaces certainly were centers of religious life. However, the only parts that can be identified as places of worship are small chapels, which suggests that religious ceremonies took place out of doors, or at outlying shrines. There are also a number of underground burial vaults. The most important room in the palace was the megaron. This long hall typically had a hearth at the center and a roof supported by four columns. It was entered through a porch and vestibule. Although the exact functions of many rooms is far from clear, the existence of storerooms and workshops, as well as so-called offices that may have served any number of purposes, indicate that the palace at Knossos was not only a royal residence but a center of administration and commerce. Shipping and trade were a major part of Minoan economic life, to judge from elaborate harbor constructions and from Cretan export articles found in Egypt and elsewhere. Perhaps, then, the king should be viewed as the head of a merchant aristocracy. Just how much power he had and how far it extended are still unknown.

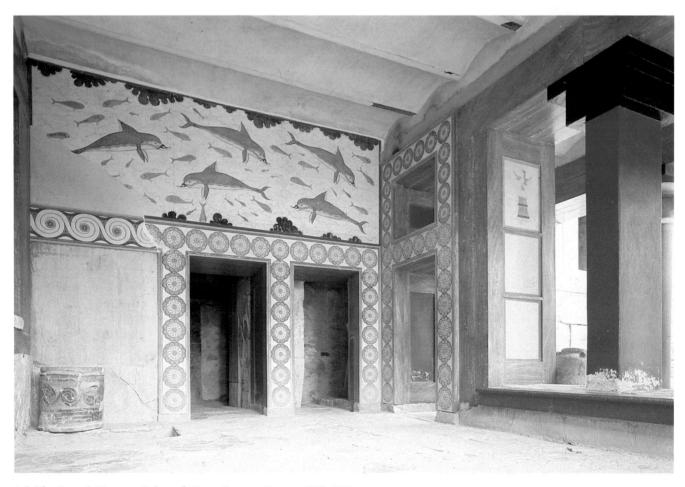

4-5. The Queen's Megaron, Palace of Minos, Knossos, Crete. c. 1700–1300 B.C.

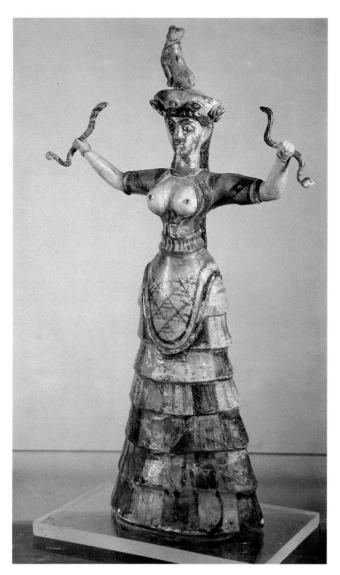

4-6 *"Snake Goddess,"* from the palace complex, Knossos.
c. 1650 B.C. Faience, height 11⅝" (29.5 cm).
Archaeological Museum, Iráklion, Crete

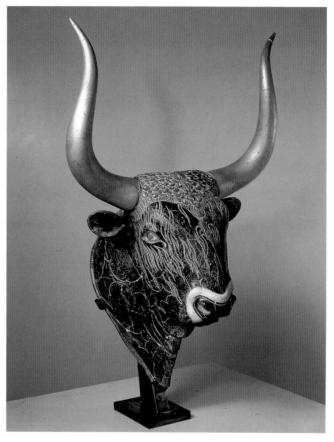

4-7. Rhyton in the shape of a bull's head, from Knossos.
c. 1500–1450 B.C. Serpentine, crystal, and shell inlay (horns restored),
height 8⅛" (20.6 cm). Archaeological Museum, Iráklion, Crete

Sculpture

The religious life of Minoan Crete centered on certain sacred places, such as caves or groves. Its chief deity (or deities?) was female, akin to the mother and fertility goddesses we have met before. Since the Minoans had no temples, we are not surprised to find that they lacked large cult statues. Several statuettes of about 1650 B.C. from Knossos must represent the goddess, although the costumes endow them with a secular, "fashionable" air (compare fig. 4-8). One of them (fig. 4-6) shows her with a snake in each hand and a headdress topped by a feline creature. Snakes are associated with earth deities and male fertility in many ancient religions, just as the bared breasts of this statuette suggest fecundity. The style hints at a possible foreign source: the voluptuous bosom, the conical shape of the figure, the large eyes and arched eyebrows

suggest a kinship—indirect, perhaps through Asia Minor—with Mesopotamian art (compare fig. 3-15).

Minoan civilization also featured a cult centering on bulls (see below). One of them is shown tamed on a splendid rhyton (fig. 4-7) that may have been a ritual vessel. (It was filled from a hole in the neck, while another hole below the mouth served as a spout.) Carved from serpentine stone, with painted crystal eyes, a shell-inlay muzzle, and incised lines to indicate its shaggy fur, it creates an astonishingly lifelike impression despite its small size. (The horns are restored.) Not since the offering stand from Ur (see fig. 3-7) have we seen such a magnificent beast in the round. Can it be that the Minoans learned how to carve from the artistic descendants of Mesopotamians more than a thousand years earlier? Interestingly enough, Egyptian tomb paintings of 1500–1450 B.C. depict Cretans carrying such bull rhytons.

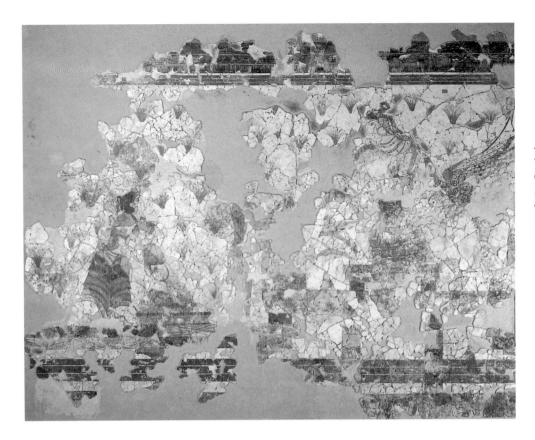

4-8. *Crocus Girl* (left) and *"The Mistress of the Animals"* (right). Mural fragments from Akrotiri, Thera (Santorini). c. 1670–1620 B.C. National Archaeological Museum, Athens

Paintings, Pottery, and Reliefs

After the earlier palaces were destroyed, there was an explosive increase in wealth and a remarkable outpouring of creative energy that produced most of what we have in Minoan art and architecture. The most surprising achievement of this sudden flowering is mural painting. Unfortunately, the murals that covered the walls of the new palaces have survived mainly in fragments. We rarely have a complete composition, let alone the design of an entire wall.

The settlement at Akrotiri on the island of Thera has been extensively excavated and a large number of frescoes recovered, the earliest Minoan examples we have. Belonging to the Late Minoan IA period (c. 1670–1620 B.C.), they vary greatly in subject and style. Of these, the most remarkable is the scene of a young woman offering crocuses (the source of saffron) to a snake goddess. Nicknamed *"The Mistress of the Animals,"* the deity is seated on an altar with an oil jar (fig. 4-8). What an astonishing achievement it is, despite its fragmentary state and the artist's occasional problems with anatomy. The contrast between the girlish charm of the crocus bearer and the awesome power of the goddess is striking. We would recognize the goddess's special status even if she were not seated on the thronelike altar, with a snake in her hair (which makes her a forerunner of Medusa; see page 109) and a griffin behind her.

The flat forms, silhouetted against the landscape, recall Egyptian painting, and the treatment of the plants also suggests Egypt-

ian art. While Minoan wall painting may owe its origin to Egyptian influence, it reveals an attitude very different from that of the Egyptians. To the Minoans, nature was an enchanted realm on which they focused from the very beginning. Egyptian painters could explore nature only by relaxing the conventions of their art. The frescoes at Akrotiri include the first pure landscape paintings known to us. Not even the most adventurous Egyptian artist of the Middle Kingdom would have devoted an entire composition to the out-of-doors. (Figure 2-23, after all, is not only later but also a fragment of a much larger mural whose content we can only guess at.) Our painting (fig. 4-9) evokes the dunes along the coast of Thera, but the artist has given the scene a liveliness and beauty that manifest the same sense of wonder we found in the encounter between mortal and goddess in figure 4-8.

Marine life (as seen in the fish and dolphin fresco outside the fancifully named "Queen's Megaron" in fig. 4-5) was a favorite subject of Minoan painting after 1600 B.C. The floating world of Minoan wall painting was an imaginative creation so rich and original that its influence can be felt throughout Minoan art during the era of the new palaces. Instead of permanence and stability we find a passion for rhythmic movement, and the forms themselves have an oddly weightless quality. They seem to float, or sway, in a world without gravity. It is as if the scenes took place under water, even though a great many show animals and birds among luxuriant vegetation.

We sense this quality even in *"The Toreador Fresco,"* the most dynamic Minoan mural recovered so far (fig. 4-10). (The darker

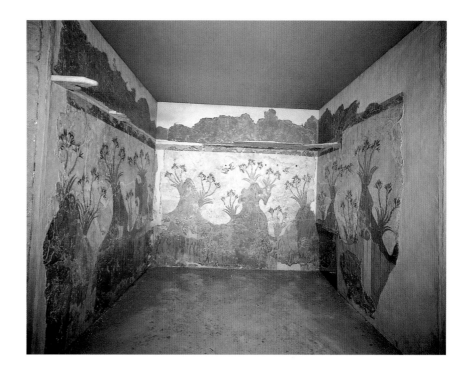

4-9. *Landscape.* Fresco from Akrotiri, Thera. c. 1600–1500 B.C. National Archaeological Museum, Athens

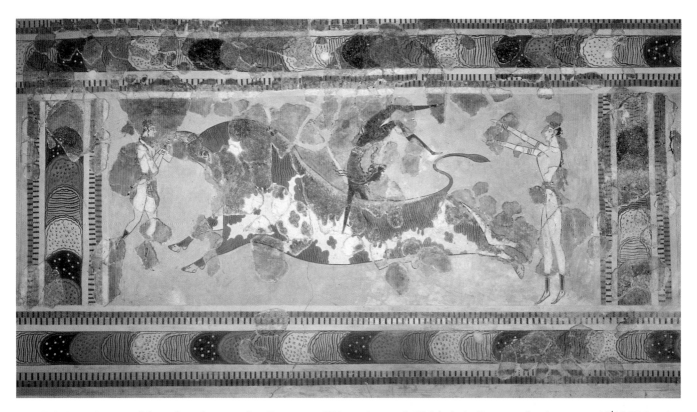

4-10. *"The Toreador Fresco,"* from the palace complex, Knossos. c. 1500 B.C. (restored). Height including upper border approx. 24½" (62.3 cm). Archaeological Museum, Iráklion, Crete

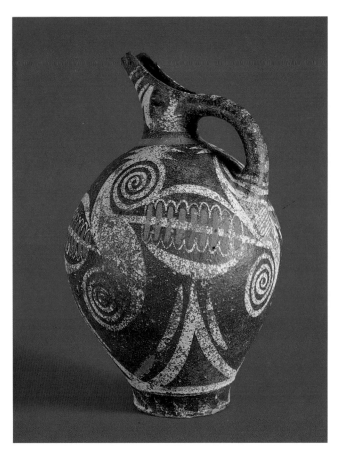

4-11. Beaked jug (Kamares style), from Phaistos. c. 1800 B.C. Height 10 ⅝" (27 cm). Archaeological Museum, Iráklion, Crete

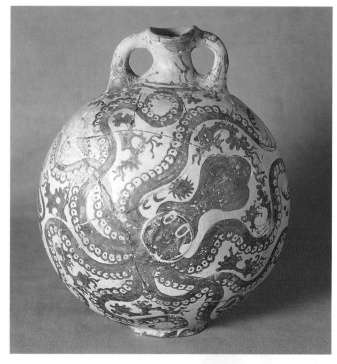

4-12. *"Octopus Vase,"* from Palaikastro, Crete. c. 1500 B.C. Height 11" (28 cm). Archaeological Museum, Iráklion, Crete

patches are the original fragments on which the restoration is based.) The conventional title should not mislead us. What we see here is not a bullfight but a ritual game in which the performers vault over the back of the animal. Two of the slim-waisted athletes are girls, distinguished—as in Egyptian art—mainly by their lighter skin color. The bull was a sacred animal to the Minoans, and bull-vaulting occupied an important place in their religious life. There are echoes of such scenes in the Greek legend of the youths and maidens sacrificed to the Minotaur (see page 95). The three figures probably show different phases of the same action. But if we try to "read" the fresco as a description of what went on during these performances, we find it strangely ambiguous. This does not mean that the Minoan artist was lacking in skill. It would be absurd to find fault for failing to achieve what was never intended in the first place. Fluid, effortless movement clearly was more important than precision or drama. The painting idealizes the ritual and stresses its harmonious, playful aspect to the point that the performers behave like dolphins frolicking in the sea.

The floating world of Minoan wall painting was an imaginative creation so rich and original that its influence can be felt throughout Minoan art during the era of the new palaces. At the time of the earlier palaces, between 2000 and 1700 B.C., Crete had developed a type of pottery (known as Kamares ware after the center where it was discovered) that was famous for its technical perfection and its dynamic, swirling ornament consisting of organic

abstractions filled with life (fig. 4-11). This in no way prepares us for the new designs drawn from plant and animal life. Some vessels are covered with fish, shells, and octopuses, as if the sea itself had been caught within them (fig. 4-12).

Monumental sculpture, had there been any, might have retained its independence. The Minoan sculptor confined himself to small-scale works, however, which are often closely akin to the style of the murals. The vivid relief on the so-called *Harvester Vase* (fig. 4-13) depicts a procession of slim, muscular men, nude to the waist, carrying long-handled tools that look like a combination of scythe and rake. The lower part, which was made separately, is lost; the whole was originally gilt. A harvest festival? Perhaps, or more likely, a sowing festival. Here again the lively rhythm of the composition takes precedence over descriptive clarity. Our view of the scene includes four singers led by one who directs the singing, perhaps a priest, who is swinging a sistrum (a rattle of Egyptian origin, which further suggests an interchange between the two civilizations). They are bellowing with all their might, especially the "choirmaster," whose chest is so distended that the ribs press through the skin. What makes the relief so remarkable is its emphasis on physical strain, its energetic, raucous gaiety. How many works of this sort did Minoan artists produce? The *"Boxer" Rhyton* and the *Chieftain Cup* of the same material, all by the same hand and likewise once covered with gold, were found in the same room at Hagia Triada on the southern side of Crete. (All are now in the local museum.) Vessels of steatite were common during the

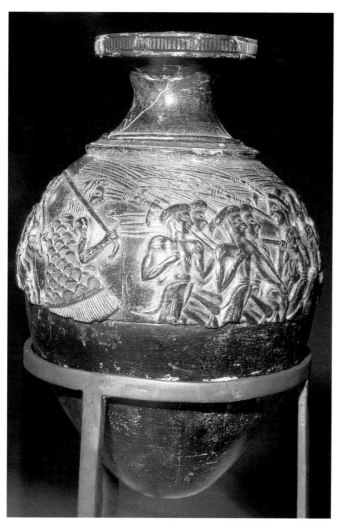

first half of the fifteenth century B.C., as it was plentiful on Crete, but stones imported from other Aegean islands were also used. Although the this artist was unique, the *Harvester Vase* recalls the Vaphio Cups of around the same time, which were made of gold (compare figs. 4-17 and 4-18). Only once have we met anything at all like it: in the relief of workmen carrying a beam (see fig. 2-30), carved almost two centuries later in the Akhenaten style (see pages 64–65). Could pieces like the *Harvester Vase* have stimulated Egyptian artists during that brief but important period?

MYCENAEAN ART

Along the southeastern shores of the Greek mainland there were during Late Helladic times (c. 1600–100 B.C.) a number of settlements that corresponded in many ways to those of Minoan Crete. They, too, for example, were grouped around palaces. Their inhabitants have come to be called Mycenaeans, after Mycenae, the most important of these sites, near the southern tip of Greece. Since the works of art unearthed there by excavation often showed a strikingly Minoan character, the Mycenaeans were at first thought to have come from Crete. It is now agreed that they were the descendants of the earliest Greek clans, who had entered the country sometime after 2000 B.C.

Tombs and Their Contents

For some 400 years, these people had led a pastoral life in their new homeland. Their modest tombs contained only simple pottery and a few bronze weapons. Toward 1600 B.C., however, they suddenly began to bury their dead in deep-shaft graves. A little later, burials were in conical stone chambers, known as beehive tombs. This trend reached its height toward 1300 B.C. in structures such as the one shown in figures 4-14 and 4-15. These tombs were built of

4-13. *Harvester Vase*, from Hagia Triada. c. 1500–1450 B.C. Stone/Steatite. Archaeological Museum, Iráklion, Crete

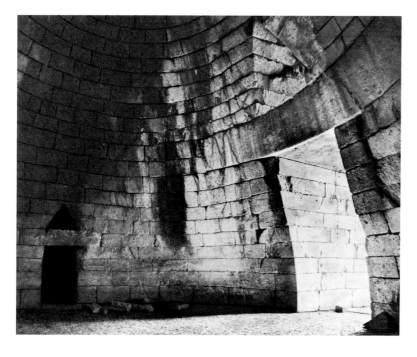

(LEFT) 4-14. Interior, Treasury of Atreus, Mycenae, Greece. c. 1300–1250 B.C.

4-15. Section, Treasury of Atreus

concentric layers of precisely cut stone blocks that taper inward toward the highest point. (This method of spanning space is called **corbeling.**) The discoverer thought it far too ambitious for a tomb and gave it the misleading name of Treasury of Atreus. Burial places as elaborate as this can be matched only in Egypt during the same period.

The Treasury of Atreus had been robbed of its contents long ago, but other Mycenaean tombs were found intact. Their contents caused even greater surprise: beside the royal dead were placed masks of gold or silver, presumably to cover their faces. If so, these masks were similar in purpose (if not in style) to those found in pharaonic tombs of the Middle and New Kingdoms. There was also considerable personal equipment such as drinking vessels, jewelry, and weapons. Many of these pieces were of gold and exquisite in workmanship. Some, such as the gold vessel in the shape of a lion's head (fig. 4-16), show a bold style of smooth planes bounded by sharp ridges, which suggests contact with the Near East. Others are so Minoan in flavor that they might be imports from Crete or made by Mycenaean artists working in a Cretan style.

The problem "Minoan or Mycenaean" is central to two gold cups from a Mycenaean tomb at Vaphio near Sparta (figs. 4-17 and 4-18). They were probably made about 1500–1450 B.C., around the same time as the *Harvester Vase*. But where, for whom, and by whom? The issue is not as idle as it may seem, for it tests our ability to distinguish between the two neighboring cultures. It also forces us to consider every aspect of the cups. Do we find anything in their style or content that is un-Minoan? On the one hand, we note the similarity of the human figures to those on the *Harvester Vase*, and of the bulls to the animal in "*The Toreador Fresco.*" To be sure, the men on the *Vaphio Cups* are not engaged in the Cretan bull-vaulting game but in catching the animals on the range. However, this subject also occurs in Minoan art, contrary to earlier opinion. On the other hand, we cannot overlook the fact that the design on the cups does not quite match the rhythmic movement of Minoan compositions. The powerful bulls are putting up a real struggle, and one of the captors is being trampled. Such violence is rare in Minoan, but not Mycenaean art. While it is generally accepted that the cups are by a Minoan artist working for Mycenaean patrons, they are equally likely to be by a Mycenaean trained in the Minoan tradition.

MYCENAE, CRETE, AND EGYPT. In the sixteenth and fifteenth centuries B.C., Mycenae presents a complicated picture. What appears to be an Egyptian influence on burial customs is combined with a strong artistic influence from Crete and with great wealth, as expressed in the lavish use of gold. We need a theory that involves the Mycenaeans with Crete as well as Egypt about a century before the new palaces were destroyed. Such a theory—fascinating though hard to confirm in detail—runs as follows: between 1700 and 1580 B.C., the Egyptians were trying to rid themselves of the Hyksos, who had seized the Nile Delta (see page 60). They gained the aid of warriors from Mycenae, who returned home laden with gold (of which Egypt had an ample supply) and impressed with Egyptian funerary customs. The Minoans, not military soldiers but famous as sailors, ferried the Mycenaeans back and forth, so that they, too, had closer contact with Egypt. This hypothesis may help to explain their sudden prosperity toward 1600 B.C. It may also account for the rapid development of naturalistic wall painting (see also pages 62–63). In any event, the close relations between Crete and Mycenae, once established, were to last a long time.

Architecture

The great monuments of Mycenaean architecture were all built between 1400 B.C., when Linear B script began to appear, and 1200 B.C. Apart from such details as decorative motifs or the shape of the columns, Mycenaean architecture owes little to the Minoan tradition. The palaces were hilltop fortresses surrounded by defensive walls of huge stone blocks. This type of construction, unknown in Crete, was similar to the Hittite fortifications at Bogazköy (see fig. 3-17). The Lioness Gate at Mycenae (fig. 4-19) is the most impressive remnant of these massive ramparts, which inspired such awe in the Greeks of later times that they were regarded as the work of the Cyclopes, a mythical race of one-eyed giants. Even the Treasury of Atreus, although built of smaller and more precisely shaped blocks, has a Cyclopean lintel (see fig. 4-14).

The stone relief over the doorway of the Lioness Gate is another departure from the Minoan tradition. The two lionesses

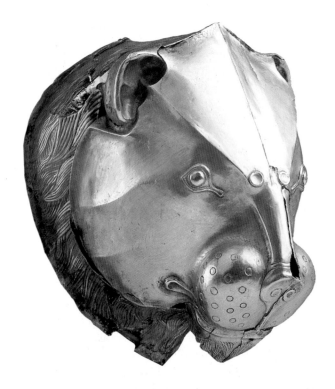

4-16. Rhyton in the shape of a lion's head, from a shaft grave at Mycenae. c. 1550 B.C. Gold, height 8" (20.3 cm). National Archaeological Museum, Athens

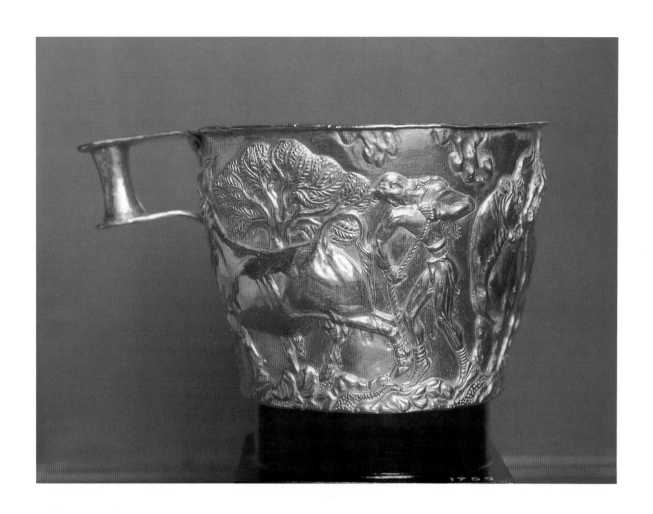

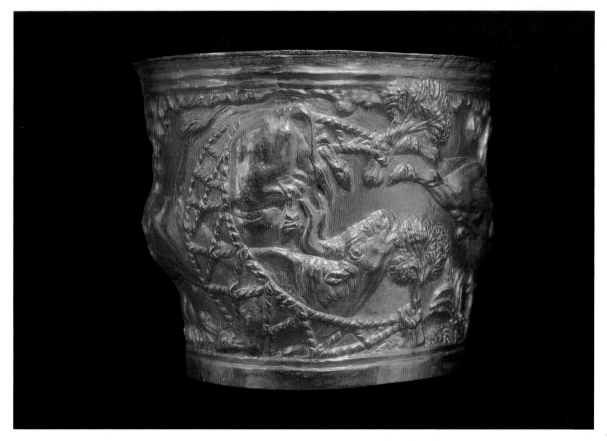

4-17, 4-18. *Vaphio Cups.* c. 1500–1450 B.C. Gold, heights 3"; 3½" (7.5; 9 cm). Shown actual size.
National Archaeological Museum, Athens

flanking a symbolic Minoan column have the same grim, heraldic majesty as the golden lion's head in figure 4-16. Their function as guardians, their tense, muscular bodies, and their symmetrical design again suggest an influence from the Near East. We may at this point recall Homer's *Iliad* and *Odyssey*, which recount the events of the Trojan War and its aftermath, which brought the Mycenaeans to Asia Minor soon after 1200 B.C. It seems likely, however, that the Mycenaeans began to cross the Aegean, for trade or war, much earlier than that.

The center of the Mycenaean palace was the audience hall, called the megaron. Only its plan is known for certain: like Minoans megarons, it consisted of a large rectangular room with a round hearth in the middle and four columns to support the roof beams (fig. 4-20). It was entered through a deep porch with two columns and an antechamber. This design is basically an enlarged version of the simple houses of earlier generations; its ancestry can be traced back to Troy as early as 3000 B.C. There may have been a rich decorative scheme of wall paintings and ornamental carvings to stress its dignity as the king's residence.

Sculpture

As in Crete, Mycenaean religious architecture was confined to modest structures with cult statues set apart from the palaces, which also included small shrines. A wide variety of gods were worshiped in them, although their identity is sometimes a matter of dispute. Mycenaean religion incorporated not only Minoan elements but also influences from Asia Minor. There were also deities of Greek origin, including a number of the later Olympian gods, such as Poseidon. But gods have an odd way of merging or exchanging their identities, so that the religious images in Mycenaean art are hard to interpret.

What, for instance, are we to make of the exquisite little ivory group (fig. 4-21) found in a shrine next to the palace at Mycenae in 1939? The style and costume of the piece—its curved shapes and flexible movements—echo Minoan art, which suggests a Cretan origin or at least an artist from Crete working on the Greek mainland for Mycenaean patrons. However, the carving also has an unmistakably Near Eastern air (compare figs. 3-5 and 3-15),

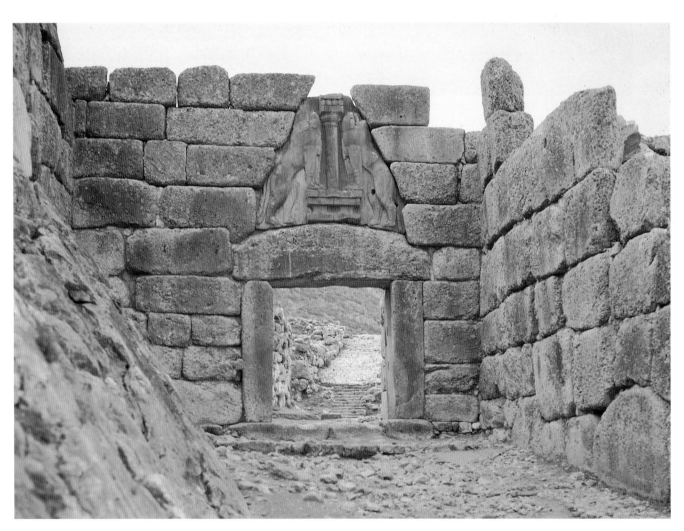

4-19. The Lioness Gate, Mycenae, Greece. 1250 B.C.

4-20. Plan of a Mycenaean megaron

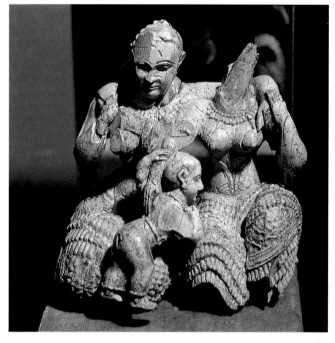

4-21. *Three Deities,* from Mycenae. 14th–13th century B.C. Ivory, height 3" (7.5 cm). National Archaeological Museum, Athens

which perhaps indicates a Mycenaean artist working in the Cretan tradition, yet receptive to other influences. The subject, too, is new, which points to a later date, in the thirteenth century B.C. rather than the fourteenth. Two kneeling women, closely united, tend a single child. But who are they? The proposal that they are two queens to whom offerings were made is far from satisfactory, since it fails to account adequately for the presence of the child. The natural interpretation would be to regard the now-headless figure as the mother, since the child clings to her arm and turns toward her. The second woman, whose left hand rests on the other's shoulder, would then be the grandmother. Such three-generation family groups are a well-known subject in Christian art, in which we often find St. Anne, the Virgin Mary, and the Infant Christ combined in similar fashion.

The memory of these later works colors our view of the Mycenaean ivory. Perhaps the closest connection is the mother goddess Demeter and her daughter Persephone (Proserpine) with Iakchos, a forerunner of Bacchus, all of them linked to Zeus in various Greek myths (see box page 111, fig. 5-61 and fig. 19-6). However, there is also a widespread myth about a divine child who is abandoned by his mother and reared by nymphs, goddesses, or even animals. His name varies from place to place and includes Bacchus and Zeus. Thus our ivory may show a motherless child god with his nurses. The real mystery, however, lies deeper: in the tender play of gestures, the intimate human feeling that binds the three figures together. Nowhere in ancient art before the Greeks do we find gods—or people, with only one exception (see fig. 2-27)—expressing affection with such warmth and eloquence.

Something quite new is reflected here, a familiar view of divine beings that makes the Minoan snake goddess (see fig. 4-6) seem even more awesome and remote. Was this change of attitude, and the ability to express it in art, a Mycenaean achievement? Did they inherit it from the Minoans? Or did it originate with a new wave of immigrants on the Greek mainland? Whatever the case, our ivory group opens up a realm of experience that was to be explored by Greek artists.

Greek Art

Because of the vast gaps in time and culture from the present, the works of art discussed so far seem alien, no matter how fascinating they may be. Greek architecture, sculpture, and painting, by contrast, are immediately recognizable as the direct ancestors of Western civilization, despite their debts to earlier art. A Greek temple reminds us of the bank around the corner, a Greek statue brings to mind countless other statues that we have seen somewhere, and a Greek coin makes us want to reach for the small change in our own pockets. By the same token, the tradition linking us with the ancient Greeks can be a handicap as well as an advantage in looking at Greek art. Sometimes the contribution of original works is obscured by our familiarity with later imitations.

Another complication in the study of Greek art arises from the fact that we have three separate, and sometimes conflicting, sources of information on the subject. There are, first of all, the monuments themselves, a reliable but often inadequate source, with many gaps. Then we have Roman copies that tell us something about important works which would otherwise be lost to us entirely. These copies, however, pose a problem. Some are of such high quality that we cannot be sure that they really are copies. Others make us wonder how closely they follow their model—especially if we have several copies, all slightly different, of the same lost original—and how much they owe to the creativity of the Roman sculptor.

Finally, there are the literary sources. The Greeks were the first people in history to write at length about their own artists, and their accounts were eagerly collected by the Romans, who handed them down to us. Some of these survive in at least fragmentary form. From them we learn what the Greeks themselves considered their most important achievements in architecture, sculpture, and painting. This written testimony has helped us to identify some celebrated artists and monuments, but much of it deals with works of which no visible trace remains today, while other works, which do survive and which strike us as among the greatest masterpieces of their time, are not mentioned at all. To reconcile the literature with the copies and the original works, and to weave these strands into a coherent picture of the development of Greek art, is a difficult task, in spite of the enormous amount of work that has been done since the beginnings of archaeological scholarship some 250 years ago.

Who were the Greeks? We have met some of them before, such as the Mycenaeans, who came to Greece about 2000 B.C. Other Greek-speaking tribes entered the peninsula from the north toward 1100 B.C. These newcomers absorbed the Mycenaeans and gradually spread to the Aegean Islands and Asia Minor. From the mid-eighth through the mid-sixth centuries B.C., there was a wave of colonization as the Greeks expanded across the Mediterranean. During this time, they created what we now call Greek civilization. They were driven partly by a shortage of land, partly by the lack of metal to equip their warriors, since warfare was an almost constant fact of life. We do not know how many separate tribal units there were at first, but three main groups, who settled mainland Greece, the coast of Asia Minor, and the Aegean Islands, stand out. They are the Aeolians, who took over the north; the Dorians, who inhabited the south, including the Cycladic Islands; and the Ionians, who colonized Attica, Euboea, most of the Aegean Islands, and the central coast of nearby Asia Minor. In the eighth century B.C., the Greeks also spread westward, founding important settlements in Sicily and southern Italy.

Despite a strong sense of kinship based on language and shared beliefs, which were expressed in such traditions as the four great Panhellenic (all-Greek) festivals, the Greeks remained divided into many small city-states. This pattern may be an echo of age-old tribal loyalties, an inheritance from the Mycenaeans, or a response to the geography of Greece, whose mountain ranges, narrow valleys, and jagged coastline would have made political unification difficult. Perhaps all of these factors worked together. In any event, the intense rivalry of these states undoubtedly spurred the growth of ideas and institutions.

Our own thinking about government uses many terms of Greek origin that reflect the evolution of the city-state. They include *monarchy* (from *monarches,* sole ruler), *aristocracy* (from *aristokratia,* rule of the best), *tyranny* (from *tyrannos,* despot), *oligarchy* (from *oligoi,* a small ruling elite), *democracy* (from *demos,* the people, and *kratos,* sovereignty), and, most important, *politics* (derived from *polites,* the citizen of the *polis,* or city-state).

Of the two leading rival powers, Athens and Sparta, we know much less about the latter for lack of written records and histories. Sparta was ruled by kings *(basileis),* first in pairs, then singly. Her conquest of Messenia in the eighth and seventh centuries B.C. gave

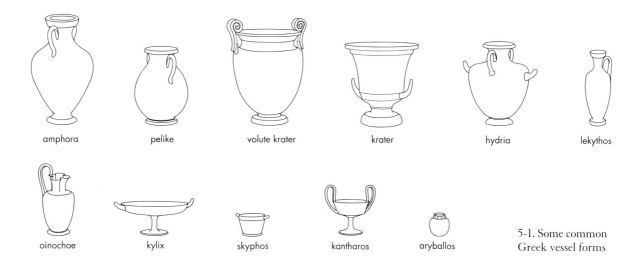

amphora pelike volute krater krater hydria lekythos

oinochoe kylix skyphos kantharos aryballos

5-1. Some common Greek vessel forms

Sparta a large population of serfs *(helots),* virtual slaves who provided its food but required a standing army to subdue them. Compulsory military service made the city the most powerful in Greece, but came to determine the entire complexion of Spartan life and society. To its credit, Sparta opposed tyranny, which it overthrew whenever possible, as much out of ideology as self-interest.

In Athens, the growth of democracy was spurred partly by a revolution in warfare beginning in the eighth century B.C. This was the rise of a large, well-armored infantry from the citizenry that largely replaced the aristocratic cavalry and charioteers. These soldiers were known as *hoplites.* Military service brought with it a demand for a larger voice in governance. Even Athens, however, was never a true democracy. At first, only a relatively small minority of the population, chiefly wealthy landowners and merchants, could participate in the Areopagus (assembly). Women and ordinary people *(demos),* including peasants and the lower classes, played little or no direct role in civic life, except by threats against the Eupatridae (the well-born). Moreover, slavery was the accepted practice in Athens, as it was everywhere in the Greek world.

The first democratic reforms came in 594 B.C., when Solon decreed that all citizens should be free from slavery and legal oppression, and gave the demos a voice by forming a popular council *(ekklesia).* In 510 B.C., Kleisthenes divided Attica into ten tribes consisting of three *trittys,* each with a fixed number of people from whom were drawn 50 representatives to the *boule* (Council of 500). At first the boule limited the role of the popular council by preparing all its business in advance. Finally, the power of the popular assembly was greatly increased in 462 B.C. under Perikles. Nevertheless, the Athenian state was ruled mainly by oligarchies and tyrants (notably Peisistratos, who reigned 546–528 B.C.) throughout most of the sixth century B.C.; by generals such as Perikles and Alkibiades in the fifth century B.C.; and by demagogues, including Kleon and Hyperbolos, during the fourth century B.C.

The dominance of Athens and Sparta notwithstanding, the other city-states jealously guarded their power and independence. In the end, however, the Greeks paid dearly for their inability to broaden the concept of the state beyond the local limits of the polis. They engaged in constant warfare involving shifting alliances and banded together only when threatened by their common enemy, the Persians. The Persians first invaded Greece in 490 B.C. under Darius I (see page 86), only to be repulsed at the Battle of Marathon by a much smaller contingent of Athenians. They invaded again ten years later under Darius's son, Xerxes I, who was defeated in a series of famous battles at Thermopylae, Salamis, and Plataea in 480–479 B.C. After less than a half-century of peace, Athens, backed by the Delian League, resumed its old rivalry with Sparta and her ally, the Peloponnesian League, which led to the Peloponnesian War (431–404 B.C.). Although Sparta won with the help of the traitor Alkibiades, who fled Athens amid a religious scandal, its victory proved short-lived. And while Athens quickly regained its empire, it soon faced a new rival in Thebes, which defeated Sparta in 371 B.C. The result was a stalemate which left Greece so weak that it was easily defeated in 346–338 B.C. by Phillip II of Macedonia who was described as the greatest man of his time. He was surpassed by his son, Alexander the Great, who conquered all of Asia Minor, including Egypt, before his death in 323 B.C., which led to the Hellenization of the known civilized world.

THE GEOMETRIC STYLE

The formative phase of Greek civilization covers about 400 years, from about 1100 to 700 B.C. We know very little about the first three centuries of this period, but after about 800 B.C. the Greeks rapidly emerged into the full light of history. The earliest specific dates that have come down to us are from that time. The main ones are the founding of the Olympian Games in 776 B.C., the starting point of Greek chronology, as well as slightly later dates for the founding of various cities. Also during that time the oldest Greek style in the fine arts, the so-called Geometric, developed. We know it only from painted pottery and small-scale sculpture. (Monumental architecture and sculpture in stone did not appear until the seventh century B.C.) The two forms are closely related. The pottery was often adorned with the same kinds of figures found in sculpture, which was made of clay or bronze. The crudest figurines are close to Mycenaean examples in clay, while the slightly larger, more sophisticated ones recall Minoan bronzes. There are distant echoes of Hittite bronzes as well.

Greek potters soon developed a considerable variety of shapes. (The basic ones are shown in fig. 5-1.) Chief among them was the

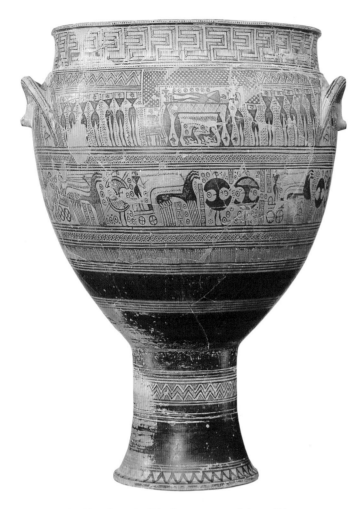

5-2. *Dipylon Vase* from the Dipylon cemetery, Athens. 8th century
B.C. Height 40½" (102.9 cm). The Metropolitan Museum of Art,
New York

ROGERS FUND, 1914

amphora, a two-handled vase for storing wine or oil. Variants were
the *pelike* and the *stamnos,* used for wine or water; these liquids
could also be poured from a type of jar known as an *oinochoe.* The
principal vessel for water was the *hydria.* Wine was heavily diluted
with water in a *krater,* which came in assorted shapes. This mix-
ture was drunk from a shallow cup, the *kylix;* a deeper one called
a *kantharos;* or the bowl-shaped *skyphos.* Despite the scanty archae-
ological remains, there is sufficient evidence that these drinking
cups, and perhaps the amphora, developed from silver examples.
The main oil bottles were the *lekythos,* often used for burial
offerings, and the tiny *aryballos* for perfume. Each type was well
adapted to its function, which was reflected in its form. As a result,
each shape presented unique challenges to the painter, and some
became specialists at decorating certain types of vases. However,
the larger pots generally attracted the best artists because they
provided more generous fields on which to work. Since both the
making and the decorating of vases were complex processes, these
were usually separate professions, but the finest painters were
sometimes potters as well.

THE DIPYLON VASE. At first the pottery was decorated only
with abstract designs: triangles, "checkerboards", concentric cir-

cles. Toward 800 B.C. human and animal figures began to appear
within the geometric framework. In the most mature examples
these figures formed elaborate scenes. The one shown here (fig. 5-
2), from the Dipylon cemetery near the double gate at the north-
western corner of Athens, belongs to a group of very large vases
that served as grave monuments. Its bottom has holes through
which liquid offerings (libations) could filter down to the dead
below. On the body of the vase we see the deceased lying in state,
flanked by figures with their arms raised in a gesture of mourn-
ing. Below is a funeral procession of chariots and warriors on foot.

The most remarkable thing about this vase is that it does not
refer to an afterlife. Its purpose is to commemorate the dead. Here
lies a worthy man, it tells us, who was mourned by many and had
a splendid funeral. Did the Greeks, then, have no concept of a
hereafter? They did, but to them the realm of the dead was a col-
orless, ill-defined region where the souls, or "shades," led a feeble
and passive existence without making any demands upon the liv-
ing. When the warrior Odysseos conjures up the shade of Achilles
in Homer's *Odyssey,* all the deceased hero can do is mourn his own
death: "Speak not conciliatorily of death, Odysseos. I'd rather
serve on earth the poorest man . . . than lord it over all the wasted
dead." Although the Greeks marked and tended their graves, and
even poured liquid offerings (libations) over them, they did so in
a spirit of pious remembrance, rather than to satisfy the needs of
the deceased. Clearly they had refused to adopt the elaborate bur-
ial customs of the Mycenaeans (see pages 101–102). Nor is the
Geometric style an outgrowth of the Mycenaean tradition. It is a
fresh, in some ways primitive, start. Yet it also owes a great deal to
Near Eastern art: the repertory of forms can be traced back to pre-
historic Mesopotamian pottery, although how they survived to be
transmitted to the Greeks is not known.

Given the limited repertory of shapes, the artist who painted
our vase has achieved a remarkably varied effect. The width, den-
sity, and spacing of the bands are subtly related to the structure of
the vessel. Interest in representation is limited, however. The fig-
ures or groups, repeated at regular intervals, are little more than
another kind of ornament. They form part of the same overall pat-
tern, so that their size varies according to the area to be filled.
Organic and geometric elements still coexist in the same field, and
often it is hard to distinguish between them. **Lozenges** indicate
legs, whether of a man, a chair, or a bier. Circles with dots may or
may not be human heads. The **chevrons,** boxed triangles, and
other shapes between the figures may be decorative or descrip-
tive—we cannot tell.

Geometric pottery has been found not only in Greece but in
Italy and the Near East as well. This wide distribution is a clear
sign that Greek traders were established throughout the eastern
Mediterranean in the eighth century B.C. What is more, they had
already adapted the Phoenician alphabet to their own use, as we
know from inscriptions on these same vases. The greatest Greek
achievements of this era, however, are the two Homeric epics, the
Iliad and the *Odyssey.* The scenes on Geometric vases barely hint at
the narrative power of these poems. If our knowledge of eighth-
century Greece were based on the visual arts alone, we would
think of it as a far simpler and more provincial society than the lit-
erary evidence suggests.

There is a paradox here. Perhaps at this time Greek civilization was so language-minded that painting and sculpture were less important than in later centuries. If that was the case, the Geometric style may have been something of an anachronism, a conservative tradition about to burst at the seams. Representation and narrative demand greater scope than the style could provide. The dam finally burst toward 725 B.C., when Greek art entered another phase, which we call the Orientalizing style, and new forms came flooding in.

THE ORIENTALIZING STYLE

As its name implies, the new style reflects influences from Egypt and the Near East. Spurred by increasing trade with these regions, Greek art absorbed a host of Oriental motifs and ideas between about 725 and 650 B.C., and was profoundly transformed in the process. It would be difficult to overestimate the impact of these influences. Whereas earlier Greek art is Aegean in flavor, the Orientalizing phase has a new monumentality and variety. Its wild exuberance reflects the efforts of painters and sculptors to master the new forms that came in waves, like immigrants from afar. The later development of Greek art is unthinkable without this vital period of experimentation.

Some of the subjects and motifs that we think of as typically Greek were, in fact, derived from Mesopotamia and Egypt, where they had a long history reaching back to the dawn of Near Eastern civilization. Another major source was Syrian art of the previous 150 years, when the region was ruled by the Aramaeans; the result was a crude but vigorous blend of Hittite and Assyrian art. The Greeks were active at the port of Al Mina, at the mouth of the Orontes River in northern Syria. So were the Etruscans and Phoenicians, who also played an important intermediary role as both artists and traders (see pages 150–151). It was the merging of these influences with Aegean tendencies and the distinctive Greek cast of mind that soon gave rise to what we think of as Greek art proper.

THE ELEUSIS AMPHORA. The change becomes evident if we compare the large **amphora** (a vase for storing wine or oil) from Eleusis (fig. 5-3) with the *Dipylon Vase* of a hundred years earlier (fig. 5-2). Geometric ornament has not disappeared from this vase altogether, but now it is confined to the foot, handles, and lip. New, curvilinear motifs—such as spirals, interlacing bands, palmettes, and rosettes—appear everywhere. On the shoulder of the vessel is a frieze of fighting animals, derived from Near Eastern art. But the major areas are given over to narrative, which now dominates the vase.

The Greek myths and legends (see box page 111) were a vast source of subjects for narrative painting. These tales, many of which can be traced back to the Akkadians (see page 76–77), were the result of mixing local Doric and Ionic deities and heroes into the pantheon of Olympian gods and Homeric sagas. They also represent a comprehensive attempt to understand the world. The Greek interest in heroes and deities helps to explain the appeal of oriental lions and monsters to the Greek imagination. These terrifying creatures embodied the unknown forces faced by the hero.

This fascination can be seen on the Eleusis amphora. The figures have gained so much in size, power, and descriptive precision that the decorative patterns scattered among them can no longer interfere with their actions. Ornament of any sort is now separate and less important than representation.

The neck of the Eleusis amphora shows the blinding of the one-eyed Cyclops Polyphemos, a son of Poseidon, by Odysseos and his companions, whom the giant had imprisoned. The story, recounted in the *Odyssey* but undoubtedly known from other retellings, is portrayed with memorable directness and dramatic force. If these men lack the beauty we expect of epic heroes in later art, their movements have an expressive vigor that makes them seem thoroughly alive. The slaying of another monstrous creature is depicted on the body of the vase, which has, however, been so badly damaged that only two figures have survived intact. They are **Gorgons**, sisters of the snake-haired Medusa, whom Perseus (partly seen fleeing to the right) beheaded with the aid of the gods. Even here we notice an interest in the articulation of the body that goes far beyond the limits of the Geometric style.

The Eleusis vase belongs to a group of ceramics called Proto-Attic. They are the ancestors of the great tradition of vase painting that was soon to develop in Attica, the region around Athens. A second family of Orientalizing vases is known as Proto-Corinthian,

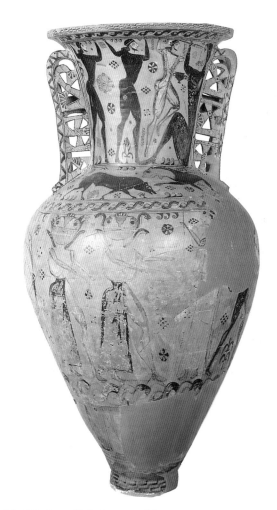

5-3. *The Blinding of Polyphemos and Gorgons,* on a Proto-Attic amphora. c. 675–650 B.C. Height 56" (142.3 cm). Archaeological Museum, Eleusis, Greece

5-4. Proto-Corinthian perfume vase. c. 650 B.C. Height 2" (5 cm). Musée du Louvre, Paris

since it points toward the later pottery of Corinth. These vases, noted for their spirited animal motifs, show close links with the Near East. Some of them, such as the perfume vase in figure 5-4, are shaped like animals. The enchanting little owl, streamlined to fit the palm of a woman's hand and yet so animated in pose and expression, helps us to understand why Greek pottery came to be in demand throughout the Mediterranean world.

ARCHAIC VASE PAINTING

The Orientalizing phase of Greek art was a period of transition, in contrast to the stable Geometric style. Once the new elements from the East had been assimilated, another style emerged, as well defined as the Geometric but much greater in range. This was the Archaic, which lasted from the later seventh century to about 480 B.C., the time of the famous Greek victories over the Persians. During the Archaic period, we see the unfolding of the artistic genius of Greece, not only in vase painting but also in architecture and sculpture. While Archaic art lacks the balance and sense of perfection of the Classical style of the later fifth century, it has such freshness that it is often considered the most vital phase of Greek art.

Greek architecture and sculpture on a large scale must have begun to develop long before the mid-seventh century. Until that time, however, both were mainly of wood, and almost nothing of them has survived except the foundations of a few buildings. The desire to build and sculpt in stone, for the sake of permanence, was the most important new idea that entered Greece during the Orientalizing period. Moreover, the revolution in material and technique must have brought about decisive changes of style as well, so

that we cannot safely reconstruct the appearance of the lost wooden temples or statues on the basis of later works. In vase painting, on the other hand, there was no such break in continuity. It thus seems best to deal with Archaic vases before we turn to the sculpture and architecture of the period.

The significance of Archaic vase painting is in some ways completely unique. Decorated pottery, however great its value to archaeologists, rarely enters the mainstream of the history of art. We think of it, in general, as a craft or industry. This remains true even of Minoan vases, despite their exceptional beauty and technical refinement, and the same may be said of most of Greek pottery. Yet if we study such pieces as the *Dipylon Vase* or the amphora from Eleusis, they are impressive for their sheer size and for their narrative paintings. We cannot escape the feeling that they are among the most ambitious works of art of their day.

There is no way to prove this, of course—far too much has been lost—but it is clear that these objects are highly individual. They are not routine ware produced in quantity according to set patterns. Archaic vases are generally a good deal smaller than their predecessors, since pottery vessels no longer served as grave monuments (which were now made of stone). Their painted decoration, however, shows a far greater emphasis on pictorial subjects (see fig. 5-6). Scenes from mythology, legend, and everyday life appear in endless variety, and the artistic level is often very high, especially among Athenian vases. After the middle of the sixth century B.C., many of the finest examples bear the signatures of the artists who made them. This shows not only that potters, as well as painters, took pride in their work but also that they could become famous for their personal style. Such signatures do not necessarily mean much in themselves. They are no more than useful labels unless we know enough of an artist's work to gain some insight into his personality. Some Archaic vase painters have such distinctive styles that their artistic "handwriting" can be recognized even without a signature. In a few cases we are lucky enough to have dozens of vases (in one instance, over 200) by the same hand, so that we can trace one master's development over a considerable period. Archaic vase painting thus introduces us to the first clearly defined personalities in the history of art. (Signatures occur in Archaic sculpture and architecture as well, but they have not helped us to identify the personalities of individual masters.)

Archaic Greek painting was, of course, not confined to vases. There were murals and panels, too. Almost nothing has survived of them, but we can form some idea of what they might have looked like from the wall paintings in Etruscan tombs of the same period (see figs. 6-3 and 6-4). How were these large-scale works related to the vase pictures? We do not know, but since all Archaic painting was essentially drawing filled in with solid flat color, murals could not have looked very different from vase pictures.

According to the literary sources, Greek wall painting did not come into its own until about 475–450 B.C., after the Persian wars. During this period artists gradually discovered how to model figures and objects and how to create a sense of spatial depth. [See Primary Sources, no. 3, page 211] From that time on, vase painting became a lesser art, since depth and modeling were beyond its limited technical means; by the end of the fifth century its decline was obvious. Thus the great age of vase painting was the Archaic era.

All early civilizations and preliterate cultures had creation myths to explain the origin of the universe and humanity's place in it. Over time, these myths evolved into complex cycles that represent a comprehensive attempt to understand the world. The Greek stories of the gods and heroes—the myths and legends—were the result of combining local Doric and Ionic deities and folktales with the pantheon of Olympian gods. These tales had been brought to Greece from the ancient Near East through successive waves of immigration. The gods and goddesses, though immortal, were very human in behavior. They quarreled and had children with each other's spouses and often with mortals as well. They were sometimes threatened and even overthrown by their own children. The principal Greek gods and goddesses, with their Roman counterparts in parentheses, are given below.

Zeus (Jupiter), god of sky and weather, was the king of the Olympian deities. His parents were Kronos and Rhea. It had been prophesied that one of Kronos' children would overthrow him, and he had thus taken the precaution of eating his children as soon as they were born. After Zeus' birth, Rhea hid him so that he would not suffer the same fate as his siblings. Zeus later tricked Kronos into disgorging his other children, who then overthrew their father with the help of the earth goddess, Gaea. Gaea was both the mother and wife of the sky god Uranus and the wife of Pontus, god of the sea. She was also the mother of the Cyclops, who forged the weapons of the Olympians, as well as the Titans and Hundred-Handed Ones. The descendants of the Titans included Atlas (who was credited with holding up the earth), Hekate (an underworld goddess), Selene (goddess of the moon), Helios (a god of the sun), and Prometheos (a demigod, who gave humanity the gift of fire and was severely punished for doing so). After the defeat of Kronos, Zeus divided the universe by lot with his brothers Poseidon (Neptune), who ruled the sea, and Hades (Pluto), who became lord of the underworld.

Zeus fathered Ares (Mars, the god of war), Hephaestos (Vulcan, the god of armor and the forge), and Hebe (the goddess of youth) with his queen, Hera (Juno), goddess of marriage and fruitfulness, who was both his wife and sister. He also had numerous children through his love affairs with other goddesses and with mortal women. Chief among his children was Athena (Minerva), goddess of war. She was born of the liaison between Metis and Zeus, who swallowed her alive because, like his own father, he was told he would be toppled by one of his offspring. Athena later emerged fully armed from the head of Zeus. Although a female counterpart to the war god Ares, Athena was also the goddess of peace, a protector of heroes, a patron of arts and crafts (especially spinning and weaving) and, later, of wisdom. She became the patron goddess of Athens, an honor she won in a contest with Poseidon. Her gift to the city was an olive tree, which she caused to sprout on the Akropolis. Poseidon had offered a useless saltwater spring.

Zeus sired other goddesses, among them Aphrodite (Venus), the goddess of love, beauty, and fertility. She became the wife of Hephaestos and a lover of Ares, by whom she bore Harmonia, Eros, and Anteros. Aphrodite was also the mother of Hermaphroditos (with Hermes), Priapos (with Dionysos), and Aeneas (with the Trojan prince Anchises). Artemis (Diana), who with her twin brother Apollo was born of Leto and Zeus, was the virgin goddess of the hunt. She was also sometimes considered a moon goddess with Selene and Hekate.

Zeus begat other major gods as well. Hermes (Mercury), son of Maia, was the messenger of the gods, conductor of souls to Hades, and the god of travelers and commerce. He was sometimes credited with inventing the lyre and the shepherd's flute. The main god of civilization (including art, music, poetry, law, and philosophy) was the sun-god Apollo (Helios), who was also the god of prophecy and medicine, flocks and herds. Apollo was opposite in temperament to Dionysos (Bacchus), the son of Zeus and of either Persephone (Proserpine), queen of the underworld, or the moon goddess Selene. Dionysos was raised on Mount Nysa, where he invented wine making. His followers, the half-man, half-goat satyrs (the oldest of whom was Silenus, the tutor of Dionysos) and their female companions, the nymphs and humans known as maenads (bacchantes), were given to orgiastic excess. However, there was a temperate side to Dionysos. As the god of fertility, he was also the god of vegetation, as well as the god of peace, hospitality, and the civilized arts.

Until about 475 B.C., the best vase painters must have enjoyed as much prestige as other artists. Whether or not their work reflects the lost wall paintings directly, it deserves to be viewed as a major achievement.

THE BLACK-FIGURED STYLE. The difference between Orientalizing and Archaic vase painting is one of artistic discipline. In the amphora from Eleusis (see fig. 5-3), the figures are shown partly as solid silhouettes, partly in outline, or as a combination of both. Toward the end of the seventh century, Attic vase painters adopted the "black-figured" style, in which the entire design is silhouetted in black against the reddish clay. Internal details are scratched in with a needle; white and purple may be added on top of the black to make certain areas stand out. This technique favors a decorative, two-dimensional effect.

In a kylix (drinking cup) by Exekias of about 540 B.C. (fig. 5-5), the slender, sharp-edged forms have a lacelike delicacy, yet also resilience and strength, so that the design adapts itself to the circular surface without becoming mere ornament. Dionysos reclines in his boat (the sail was once entirely white), which moves with the same ease as the dolphins, whose lithe forms are balanced by the heavy clusters of grapes.

5-5. Exekias. *Dionysos in a Boat*. Interior of an Attic black-figured kylix.
c. 540 B.C. Diameter 12" (30.5 cm). Staatliche Antikensammlungen, Munich

But why is he at sea? According to a Homeric hymn, the god of wine had once been abducted by Etruscan pirates. He then caused vines to grow all over the ship and frightened his captors until they jumped overboard and were turned into dolphins. We see him on his return journey—an event to be gratefully recalled by every Greek drinker—accompanied by seven dolphins and seven bunches of grapes for good luck.

While the spare elegance of Exekias' drawing retains something of the spirit of Geometric pottery, the forms portrayed on an amphora attributed to the slightly younger painter Psiax (fig. 5-6) find their direct source in the forceful Orientalizing style seen in the blinding of Polyphemos in the Eleusis amphora. The scene on the amphora by Psiax shows Herakles killing the Nemean lion, the first of the hero's 12 labors (see box below). The image of Herakles reminds us of the hero on the sound-box of the harp from Ur (see fig. 3-9). Both show a man facing unknown forces in the form of terrifying creatures. The lion also serves to underscore the hero's might and courage against demonic powers. The scene on Psiax's amphora is all grimness and violence. The two heavy bodies are locked in combat, so that they almost grow together into a

THE HERO IN GREEK LEGEND

The early Greeks interpreted the meaning of events in terms of fate and human character rather than as accidents of history, in which they had little interest before about 500 B.C. The main focus in the writings of Greek authors was on explaining why the legendary heroes of the past seemed incomparably greater than people of their own day. Some of these heroes were historical figures, but all were believed to be descendants of the gods, who often had children with mortals. Such a lineage helped to explain the hero's extraordinary power. This power (called *arete* by the Greeks) could, in excess, lead to overweening pride (*hubris*) and to moral error (*hamartia*). The tragic results of hamartia were the subject of many Greek plays, especially those by Sophokles. The Greek ideal became moderation in all things, personified by Apollo, the god of art and civilization. Arete came to be identified over time with personal and civic virtues, such as modesty and piety.

The greatest of all Greek heroes was Herakles (Hercules to the Romans). The son of Zeus and the princess Alkmene, he became the only mortal ever to ascend to Mount Olympos upon his death. His greatest exploits were the 12 labors. Undertaken over 12 years at the command of King Eurystheos in Tiryns, they were acts of atonement by Herakles for killing his own wife and children after he was driven mad by Hera (the wife of Zeus) for his excesses.

5-6. Psiax. *Herakles Strangling the Nemean Lion,* on an Attic black-figured amphora from Vulci, Italy. c. 525 B.C.
Height 19½" (49.5 cm). Museo Civico dell'Età Cristiana, Brescia, Italy

Greek theater combined words, music, and dance, reflecting its origin in revels which began to be held four times yearly in honor of the wine god Dionysos during the ninth century B.C. The hymns in praise of Dionysos, called *dithyrambs,* that were sung at these theatrical presentations continued to be improvised until the early sixth century B.C., when they began to be set down in literary form by Arion of Corinth (c. 625–585 B.C.), the city that also claimed to have invented comedy. The main development of Greek theater began in 534 B.C., the year Athens reorganized the Dionysian festival and held the first drama contest, which was won by Thespis, who added spoken texts to what had previously been sung. (Thespis, who was also the first actor, is honored with the use of the term *thespian* to denote actors and actresses.) Unfortunately, out of the more than 1,000 plays that are recorded, we have only 31, composed by four writers in Athens during the fifth century B.C. Each of these authors had a distinct literary personality. Aeschylos (c. 523–456 B.C.) was the most philosophical; Sophokles (c. 496–406 B.C.) the most psychologically penetrating; Euripides (c. 480–406 B.C.) the most modern and gripping; while Aristophanes (c. 448–c. 388 B.C.) reigned supreme in comedy. Despite their great differences, all relied on past myths and history, which they freely altered.

Initially the author was also the principal actor, but this practice became unnecessary, as well as undesirable, after Aeschylos introduced a second actor, to which Sophocles added a third. In addition to writing and directing his play, each author was generally responsible for composing his own music, training the actors and chorus, and devising his own choreography for the annual contests. Even though the number of festivals was increased over time, acting never became a full-time profession, and the chorus was always made up solely of amateurs, who underwent a rigorous training. Despite the fragmentary remains, we know that substantial portions of Greek tragedies were set to music. (*Tragedy* originally meant "goat song" in ancient Greek.) Thus the Greek chorus intoned its lines to musical accompaniment while moving in intricate patterns on the stage. Tragedians could be innovators in music as well as drama. Sophokles introduced new musical modes and Euripides promoted chromaticism. Nevertheless, drama generally followed the lead of the dithyrambists and kitharodes (kithara players) in musical matters. For example, Agathon,

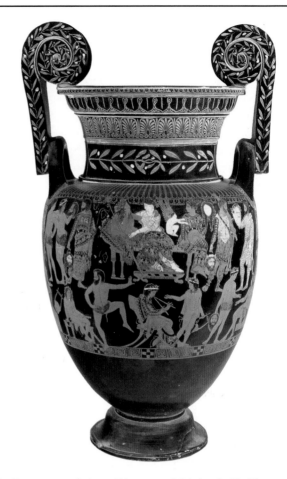

The Prononomos Painter. *Dionysos and Ariadne Amidst Players and Characters of the Theater.* End of 5th century B.C. Volute krater. National Museum, Naples

who won his first tragedy contest in 416 B.C., was an unabashed modernist noted for his sensuous and intricate melodies.

Our understanding of Greek tragedy is largely based on Aristotle's *Poetics.* This book was derived from lectures he gave around 335 B.C. at the Lyceum, the sacred grove of Apollo Lyceius near Athens where he established his school. With his inquisitive mind, everything became the subject of systematic philosophical thought. Aristotle's argument proceeds from the belief that tragedy is the highest form of drama and that *Oedipus Rex* by Sophokles is its greatest representative. His theory is based on the complex idea of imitation. By this he means "not of men

single unit. Lines and colors have been added with utmost economy in order to avoid breaking up the massive expanse of black. Yet both figures show such a wealth of anatomical knowledge and skillful foreshortening that they give an illusion of existing in the round. (Note the way the abdomen and shoulders of Herakles are rendered.) Only in such details as the eye of Herakles do we still find the traditional combination of front and profile views.

THE RED-FIGURED STYLE. Psiax must have found the silhouette-like black-figured technique limiting. The technique

made foreshortening unduly difficult, for example. Thus in some of his vases he tried the reverse procedure of leaving the figures red and filling in the background. This red-figure technique gradually replaced the older method toward 500 B.C. Its advantages can be seen in figure 5-7, a krater for mixing wine of about 510 B.C. by Euphronios showing Herakles wrestling the giant Antaios. The details have been applied by squeezing a bladder rather like a pastry tube rather than incising them, or by freely drawing them with the brush. As a result, the picture depends far less on the profile view than before. Instead, the artist uses the internal lines to

but of life, an action," which is conveyed by plot, words, song, costumes, and scenery. Plot is the very soul of tragedy, for through it is revealed the moral quality (ethos) of the main character. In "complex" dramas, the hero achieves a new understanding (peripety) as the result of a reversal in fortune that is brought about by an error in moral judgment (hamartia) rather than evil intent. To be successful, the plot must have unity of action and preferably take place within one day, though not necessarily in the same place, as later theorists demanded. The concept of overweening pride (hubris) credited to Aristotle is nowhere to be found in the *Poetics,* and the importance of emotional release (katharsis) has been overstated mainly because of Sigmund Freud, the founder of early-twentieth-century psychiatry.

Comedy was represented by the bawdy satyr play, the distant ancestor of modern burlesque theater, which seemingly was invented by Pratinas in the late sixth century B.C. The only surviving examples are Euripides' *Cyclops* and a fragment from Sophokles' *The Trackers,* both parodies of tragic dramas. Entirely different in character and perhaps origin are the comic plays of Aristophanes, which are commentaries on the contemporary scene. Be it society, politics, war, or literature, no subject was too sacred for his irreverent satire. His favorite targets were philosophers and his fellow dramatists. Nothing of later Greek comedy remains, but we know from other documents that it centered on the daily life of the middle class.

The visual arts contributed surprisingly little to Greek theater, which made sparse use of scenery. (The term derives from *skena,* the hut where actors changed their costumes.) Scene painting probably began around the middle of the fifth century B.C. and is variously credited to Aeschylos or Sophokles. According to the first century B.C. Roman architect and historian Vitruvius, scene painting consisted of architectural designs on a flat surface. It also made use of *pinakes* (painted panels) and *periaktoi* (triangular prisms) that were rotated. However, Vitruvius looked on the Classical past through distinctly Roman eyes, as did the poet Horace, who wrote about Greek tragedy and comedy. In all likelihood, scenery was very simple and changes minimal. Indeed, the advances sometimes attributed to Greek scenographers, especially in illusionism, appear to have been much later developments made in Roman times not long before Vitruvius himself.

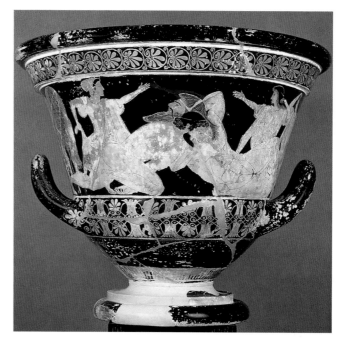

5-7. Euphronios. *Herakles Wrestling Antaios,* on an Attic red-figured krater. c. 510 B.C. Height 19" (48 cm). Musée du Louvre, Paris

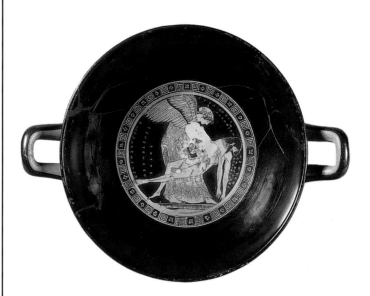

5-8. Douris. *Eos and Memnon.* Interior of an Attic red-figured kylix. c. 490–480 B.C. Diameter 10½" (26.7 cm). Musée du Louvre, Paris

show boldly foreshortened and overlapping limbs, precise details of costume (note the pleated dresses of the women), and intense facial expressions. He is so fascinated by these new effects that he has made the figures as large as possible. They almost seem to burst from the field of the vase!

A similar striving for monumental effect, but with more harmonious results, may be seen in the *Eos and Memnon* by Douris (fig. 5-8), one of the masterpieces of late Archaic vase painting. It shows the goddess of dawn holding the body of her son, who had been killed and stripped of his armor by Achilles. In this moving evocation of grief, Greek art touches a mood prophetic of the Christian *Pietà* (see fig. 11-54). Notable, too, is the expressive freedom of the draftsmanship: the lines are as flexible as if they had been drawn with a pen. Douris knows how to trace the contours of limbs beneath the drapery and how to contrast vigorous outlines with more delicate secondary strokes, such as those indicating the anatomical details of Memnon's body. This vase is also of interest for its inscription, which includes the signatures of both painter and potter, as well as a dedication typical of Greek vases: "Hermogenes is beautiful."

THE SYMPOSIUM. The four vases we have just discussed were associated with wine. Obviously they were not meant for everyday use. (Unadorned vases served that purpose.) Decorated vases were reserved for major occasions, the most important of which was the symposium *(symposion)*, an exclusive drinking party for men. The participants reclined on couches around the edges of a room; in the middle was a large mixing bowl, overseen by a master of ceremonies, who filled the drinkers' cups. Music, poetry, storytelling, and word games accompanied the festivities. The event often ended in lovemaking, which is frequently depicted on drinking cups. There was also a serious side to symposia, as described by Plato and Xenophon, centering on debates about politics, ethics, and morality.

THE CHANGING GREEK WORLDVIEW. The Greek vases we have looked at show a gradual change in attitude toward myth and legend. Let us examine the evolution more closely. The Eleusis amphora (see fig. 5-3) presents a play on vision. After slaying Medusa, whose hideous faces could turn any man who looked at her to stone, Perseus flees her sisters, the Gorgons. Meanwhile Odysseos deprives the Cyclops of his sight. The artist, in turn, gives us a "sharp-eyed" portrayal of these fascinating figures who belong to another realm. We see a change in black-figured vases. Exekias (see fig. 5-5) brings the human into more intimate, yet whimsical, contact with the divine, as Dionysos sails the watery mix of wine in the cup held by the drinker. In Psiax's amphora (see fig. 5-6), the realm of legend still remains at one remove from the human. The combat emphasizes Herakles' might in overcoming the fearsome lion. The outcome is never in doubt, as can be seen from the composition and the gesture of Athena, the patron goddess of heroes.

The decisive shift comes in red-figure vase painting. The heightened naturalism made possible by the new technique allowed the artist to explore new worlds of feeling. Euphronios takes care to show even subtle differences in appearance between Herakles and Antaios (see fig. 5-7) in order to make clear the distinction in their characters, which the Greeks called *ethos* (see box page 115). And whereas Psiax's lion roars in rage, Euphronios makes us feel the suffering, not just the pain, of the shaggy Antaios, who clearly will lose out to the neatly coiffed Herakles. He also depicts the fear of the mortal women on either side, who support the combatants but cannot protect them. For the first time we see sympathy for the vanquished as victim.

The circle of myth, legend, and human experience is closed in the cup with Eos and Memnon (fig. 5-8). Memnon was defeated by Achilles after their mothers sought the help of Jupiter, who weighed their souls on a scale that tipped against Memnon. Douris renders the tragedy of death with unforgettable tenderness. He invites the drinker to think about the meaning of this poignant image and question the role of the hero and the gods who intervene in fate. Was Achilles' soul really greater than Memnon's, especially since they were otherwise evenly matched? How is individual worth measured? Can Memnon's death be justified against the grief of a mother's loss? This altered conception is not confined to vase painting. It is part of a more complex understanding of life found in Greek philosophy, literature, and theater—changes that

must have been discussed in symposia as well. We shall meet this new view again in architectural sculpture (compare figs. 5-53, 5-54, and 5-55). The latter, however, belongs for the most part to religious buildings that also served as civic monuments, so its content was often determined by historical events and hence is less personal than vase painting.

ARCHAIC SCULPTURE

The new motifs that distinguish the Orientalizing style from the Geometric—fighting animals, winged monsters, scenes of combat—had reached Greece mainly through the importation of ivory carvings and metalwork from Phoenicia or Syria. Those pieces reflected Mesopotamian as well as Egyptian influences. They do not help us, however, to explain the rise of monumental architecture and sculpture in stone about 650 B.C., which must have been based on knowledge of Egyptian works that could be studied only on the spot. We know that small colonies of Greeks existed in Egypt at the time. But why, we wonder, did the Greeks suddenly develop a taste for monumental art, and how did their artists master stone carving so quickly? All the Greek sculpture we know from the Geometric period consists of simple clay or bronze figurines of animals and warriors only a few inches in size. The matter may never be cleared up, for the oldest surviving Greek stone sculpture and architecture show that the Egyptian tradition had already been absorbed and Hellenized.

Kouros and Kore

Let us consider two very early Greek statues: a small female figure of about 650 B.C. probably from Crete (fig. 5-9) and a lifesize nude youth of about 600 B.C. (fig. 5-10). If we compare them with their Egyptian forerunners (see fig. 2-14), the similarities are striking. We note the block-conscious, cubic character of all four statues; the way they stand with the left leg forward; the slim, broad-shouldered silhouette of the male figures; the position of their arms; their clenched fists and emphatic kneecaps. Shoulders, hips, and knees are all on parallel lines. The wiglike treatment of the hair, the close-fitting garment of the female figure, and her raised arm are also much alike. Judged by Egyptian standards, the Archaic statues seem rather primitive: rigid, oversimplified, awkward, less realistic. Whereas the Egyptian sculptor allows the legs and hips of the female figure to press through the skirt, the Greek shows a solid mass from which only the toes protrude.

But the Greek statues have virtues of their own. First of all, they are truly free-standing. In fact, they are the earliest large stone images of the human figure in the entire history of art that can stand on their own. Egyptian carvers had never freed statues completely from the stone. They remain immersed in it, so that the empty spaces between the forms are always partly filled. There are never any holes in Egyptian stone figures. The Greek sculptor, in contrast, does not mind holes in the least. The arms are separated from the torso and the legs from each other, unless they are encased in a skirt, and the carver goes to great lengths to cut away all the rest of the stone. (The only exceptions are the tiny bridges between the fists and the thighs of the nude youth.)

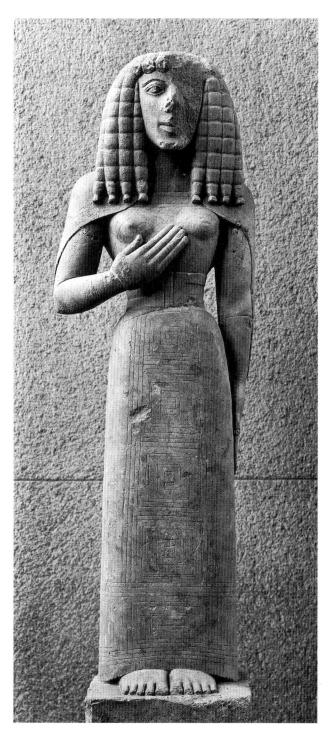

5-9. *Female Figure (Kore)*. c. 650 B.C. Limestone, height 24 ½"
(62.3 cm). Musée du Louvre, Paris

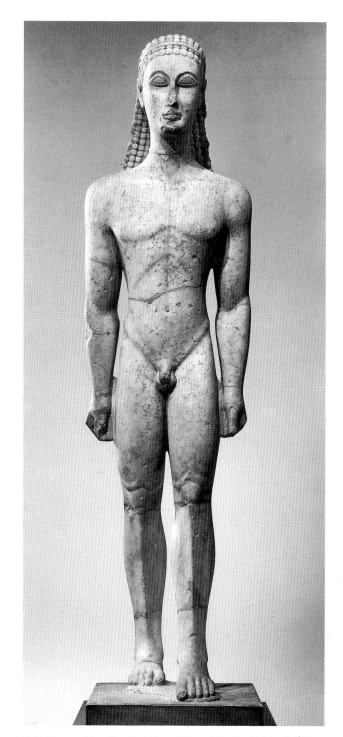

5-10. *Kouros (Standing Youth)*. c. 600 B.C. Marble, height 6'1 ½"
(1.88 m). The Metropolitan Museum of Art, New York

FLETCHER FUND, 1932

Apparently the Greeks felt that a statue must consist only of stone that has representational meaning within an organic whole. This is not a question of technique but of artistic intention. Even though the kouros in fig. 5-10 still closely follows the Egyptian canon of proportions, the Greek figures are very different in spirit from the Egyptian statues. While the Egyptian figures seem becalmed by a spell for all time, the Greek images are tense and full of hidden life. The direct stare of their huge eyes offers the most telling contrast to the gentle, faraway gaze of the Egyptian figures.

Whom do they represent? We call a female statue of this type a *Kore* (Maiden), a male one a *Kouros* (Youth). These terms gloss over the difficulty of identifying them further. The Kouros is always nude while the Kore is clothed. (In art, as in life, public nudity in ancient Greece was acceptable for males, but not for females.) Both were produced in large numbers throughout the Archaic era. Some are inscribed with the names of artists ("So-and-so made me") or with dedications to various deities. These, then, were votive offerings. But in most cases we do not know whether they represent the donor, the deity, or a divinely favored person such as a victor in

athletic games. Others were placed on graves, yet they represent the deceased only in a broad (and completely impersonal) sense. This lack of differentiation seems to be part of the essential character of these figures. They are neither gods nor mortals but something in between, an ideal of physical perfection and vitality shared by mortal and immortal alike.

Although their general types remained constant, the artistic treatment of the Kouros and the Kore shows the same dynamic we have traced in Archaic vase painting. The pace of this development is clear if we compare the Kouros of figure 5-10 with one that was carved some 75 years later (fig. 5-11). An inscription on its base identifies the latter as the funerary statue of Kroisos, who had died a hero's death in battle. Like all such figures, it was painted. (Traces of color can still be seen in the hair and the pupils of the eyes.) Instead of the sharp planes of the older statue, we now find swelling curves. The body shows greater monumentality, but also has a new elasticity. Anatomical details are rendered more func-

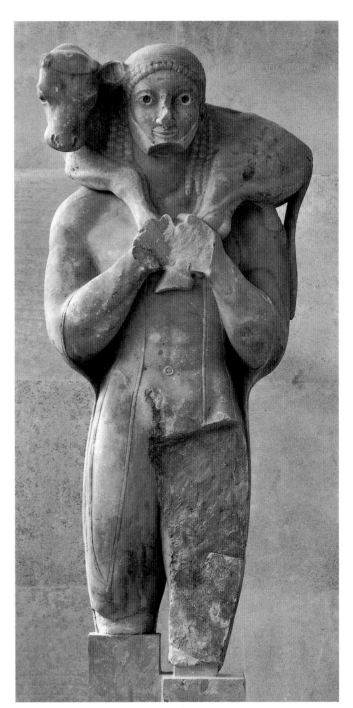

5-12. *Calf-Bearer.* c. 570 B.C. Marble, height of entire statue 65" (165 cm). Akropolis Museum, Athens

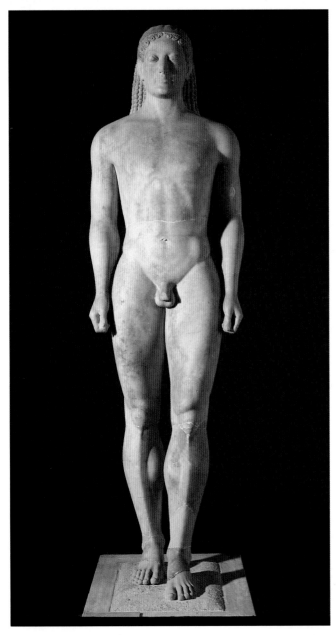

5-11. *Kroisos (Kouros from Anavysos).* c. 525 B.C. Marble, height 6'4" (1.9 m). National Archaeological Museum, Athens

tionally than before. The style of the *Kroisos* thus corresponds to Psiax's *Herakles* (fig. 5-6). Here we witness the transition from black-figured to red-figured in sculptural terms.

There are numerous statues from the middle years of the sixth century marking previous way stations along the same road. The magnificent *Calf-Bearer* of about 570 B.C. (fig. 5-12) is a votive figure that represents the donor, Rhonbos, with the sacrificial animal he is offering to Athena. Needless to say, it is not a portrait, any more than the *Kroisos* is, but it shows a type: the beard indicates a fully mature man. The *Calf-Bearer* originally stood in the conventional Kouros pose, and its body conforms to the Kouros ideal. Its vigorous, compact forms are emphasized, rather than obscured,

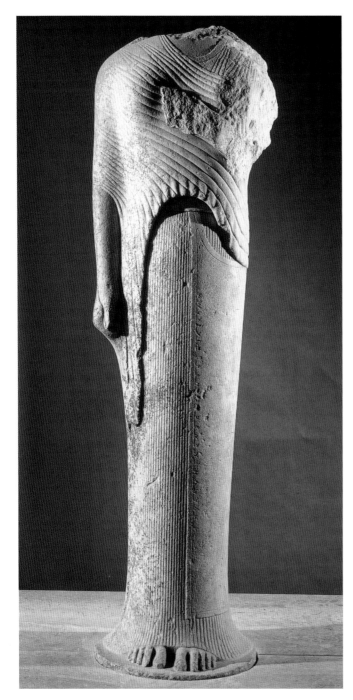

5-13. *"Hera,"* from Samos. c. 570–560 B.C. Marble, height 6'4" (1.9 m). Musée du Louvre, Paris

by the thin cloak, which fits like a second skin, except at the elbows. The face, framed by the soft curve of the animal, no longer has the masklike quality of the early Kouros. The features have, as it were, caught up with the rest of the body. They, too, are expressive of life: the lips are drawn up in a smile. We must be careful not to assign any psychological meaning to this "Archaic smile," for the same radiant expression occurs throughout sixth-century Greek sculpture, even on the face of the dead hero Kroisos. Only after 500 B.C. does it gradually fade out.

The Kore type shows more variations than the Kouros, although it follows the same pattern of development. Because it is a clothed figure, the Kore poses the problem of how to relate body

and drapery. It is also likely to reflect changing habits or local styles of dress. Thus the statue in figure 5-13, carved about the same time as the *Calf-Bearer,* does not represent a more evolved stage of the Kore in figure 5-9. Rather, it reveals an alternative approach to the same basic task. She is the earliest of ten very similar figures from around the same time. This Kore was found in the Temple of Hera on the island of Samos with two other figures, one seated, one reclining. The base of the Genelaos Dedication, as it is known, bears the inscription: "Cheramyes dedicated me to Hera as an offering." She may well have been an image of the goddess because of her size as well as her dignity. Whereas the earlier Kore echoes the planes of a rectangular slab, the *"Hera"* seems like a column come to life. Instead of clear-cut accents, such as the nipped-in waist in figure 5-9, we find a smooth flow of lines uniting limbs and body. Yet the majestic effect of the statue depends not so much on its abstraction as on the way the form blossoms into the swelling softness of a living body. The upward sweep of the lower third of the figure gradually divides to reveal several layers of garments, and its pace is slowed further as it meets the protruding shapes of arms, hips, and torso. In the end, the drapery, so architectonic up to the knee region, turns into a second skin of the kind we have seen in the *Calf-Bearer.* She would appear far more human if she still had her head, which must have been similar to that of figure 5-14 from another sculpture of the same type. She presents an unprecedented ideal of femininity: beautiful, young, yet dignified—in a word, statuesque.

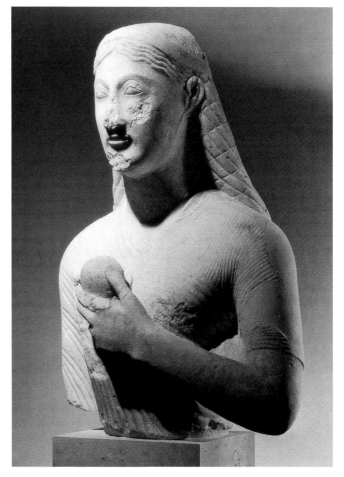

5-14. *Head.* c. 525–550 B.C. Marble, height 21½" (54.5 cm). Akropolis Museum, Athens

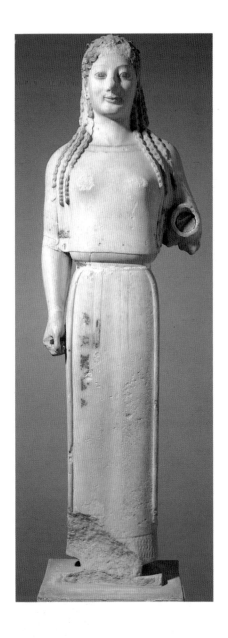

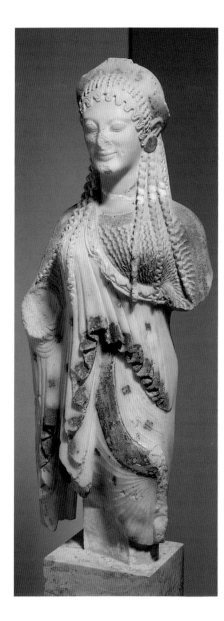

(FAR LEFT) 5-15. *Kore in Dorian Peplos,* known as *Peplos Kore.* c. 530 B.C. Marble, height 48" (122 cm). Akropolis Museum, Athens

(NEAR LEFT) 5-16. *Kore,* from Chios (?). c. 520 B.C. Marble, height 21⅞" (55.3 cm). Akropolis Museum, Athens

The Kore of figure 5-15, in contrast, seems a direct descendant of our first Kore, even though she was carved a full century later. She, too, is blocklike rather than columnar, with a strongly accented waist. The simplicity of her garments is new, however. The heavy cloth of the peplos forms a distinct layer over the body, covering but not hiding the rounded shapes beneath. The left hand, which extended forward to offer a votive gift, must have given the statue a spatial quality quite beyond that of the two earlier Kore figures. Equally new is the more organic treatment of the hair, which falls over the shoulders in soft, curly strands, in contrast to the rigid wig in figure 5-9. Most noteworthy of all is the full, round face with its enchanting expression—a gentler, more natural smile than any we have seen so far. Here, as in the *Kroisos,* we sense the approaching red-figured phase of Archaic art.

Our final Kore (fig. 5-16), from about a decade later, has none of the severity of *Peplos Kore,* although both were found on the Akropolis of Athens. In many ways she seems more like the *"Hera"* from Samos. In fact, she probably came from Chios, another island of Ionian Greece. The grandeur of the *"Hera,"* however, has given way to a refined grace. The layers of the garment (the light Ionian chiton, which replaced the peplos in fashion) still loop around the body in soft curves, but the play of richly differentiated folds, pleats, and textures has almost become an end in itself. Color played an important role in such works, and we are fortunate that so much of it survives in this example.

Architectural Sculpture

When the Greeks began to build temples in stone, they were heir to an age-old tradition of architectural sculpture. The Egyptians had been covering walls and columns with reliefs since the Old Kingdom, but these carvings were so shallow (for example, figs. 2-18 and 2-30) that they did not break the continuity of the surface and had no weight or volume of their own. Thus they were related to their architectural setting only in the same limited sense as wall paintings (with which they were, in practice, interchangeable). This is also true of the reliefs on Assyrian, Babylonian, and Persian buildings (for example, figs. 3-20 and 3-28). In the Near East, however, there was another kind of architectural sculpture, which seems to have begun with the Hittites: the guardian monsters

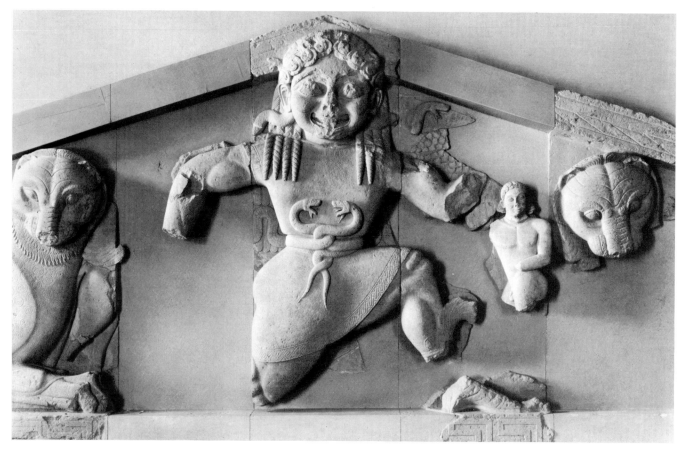

5-17. Central portion of the west pediment of the Temple of Artemis at Corfu, Greece. c. 600–580 B.C. Limestone, height 9'2" (2.8 m). Archaeological Museum, Corfu, Greece

protruding from the blocks that framed the gateways of fortresses or palaces (see figs. 3-17 and 3-21). This tradition must have inspired, perhaps indirectly, the carving over the Lioness Gate at Mycenae (see fig. 4-19). There is an important difference, however. The Mycenaean guardian figures are carved in high relief on a huge slab, but this panel is thin and light compared to the enormous Cyclopean blocks around it. In building the gate, the Mycenaean architect left an empty triangular space above the lintel, for fear that the weight of the wall above would crush it. That space was then filled with the relatively lightweight relief. Here we have a new kind of architectural sculpture: a separate work integrated with the structure rather than a modified wall surface or block.

THE TEMPLE OF ARTEMIS, CORFU. That the Lioness Gate relief is the direct ancestor of Greek architectural sculpture is clear when we look at the facade of the early Archaic Temple of Artemis on the island of Corfu, built soon after 600 B.C. (figs. 5-17 and 5-18). The sculpture is confined to a triangle between the ceiling and the sides of the roof. This area, called the pediment, need not be filled in at all except to protect the wooden rafters behind it against moisture. It demands not a wall but merely a thin screen. And it is against this screen that the pedimental sculpture is displayed.

Technically, these carvings are in high relief, like the guardian lionesses at Mycenae. However, the bodies are strongly undercut

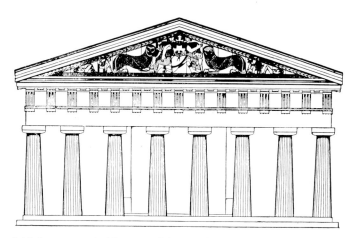

5-18. Reconstruction drawing of the west front of the Temple of Artemis at Corfu (after Rodenwaldt)

so that they are nearly detached from the background. Even at this early stage, the sculptor wanted the figures to be independent of their architectural setting. The head of the central figure actually overlaps the frame. Who is this frightening creature? Not Artemis, surely, although the temple was dedicated to that goddess. As a matter of fact, we have met her before: she is Medusa, one of the Gorgons, a descendant of those on the Eleusis amphora (see fig. 5-3). (A trio of nearly identical figures appears on a

black-figure amphora of about the same time.) Her purpose here, and that of the two huge lions, was to ward off evil from the temple and the sacred image of the goddess within. (The other pediment, of which only small fragments survive, had a similar figure.) She acted as a monumental and frightening hex sign. On her face, the Archaic smile appears as a hideous grin. And to emphasize how alive and real she is, she is shown running, or rather flying, in a pinwheel stance that conveys movement without actual locomotion.

The heraldic arrangement of the Gorgon and the two animals reflects an Oriental scheme that we know, not only from the Lioness Gate at Mycenae, but from many earlier examples as well (see fig. 3-9, top). Because of its ornamental character, it fits the shape of the pediment perfectly. Yet the sculptor was not content with this decorative scheme. The pediment must also contain narrative elements. Therefore a number of smaller figures were added in the spaces left between or behind the main group. On either side are Medusa's children, Pegasus and Chrysaor, who will be born when Perseus decapitates her; the corners may have depicted Zeus and Poseidon battling Titans. The design of the pediment thus shows two conflicting purposes in uneasy balance. Soon, however, narrative will win out over heraldry.

It is a striking feature of Greek temples and other religious buildings that they were designed with sculpture in mind almost as soon as they began to be built of stone (see page 126). Indeed, early Greek architects such as Theodoros of Samos were often sculptors. Thus to a Greek, a temple would have seemed "undressed" without sculpture, which was usually designed at the same time as the structure itself. Architecture and sculpture became so closely linked that Greek architecture is highly sculptural and has the same organic quality as the figures that populate it. The sculpture, in turn, plays an important role in helping to articulate the structure and bring it to life.

Aside from the pediment, however, there were not many places that the Greeks found suitable for architectural sculpture. They might put freestanding figures (often of terra-cotta) above the ends and the center of the pediment to break the severity of its outline. And they often placed reliefs in the zone just below the pediment. In Doric temples such as that at Corfu (fig. 5-18), the relief consists of **triglyphs** (blocks with three vertical markings) alternating with **metopes**. The latter originally were empty spaces between the ends of the ceiling beams; hence they, like the pediment, could be filled with sculpture. In Ionic architecture, the triglyphs were omitted, and the frieze became a continuous band of painted or sculptured decoration. The Ionians would also sometimes support the roof of a porch with female statues instead of columns. This use is not very surprising, given the columnlike quality of the *"Hera"* from Samos (see fig. 5-13).

THE SIPHNIAN TREASURY, DELPHI. All these possibilities are combined in the Treasury (a miniature temple for storing votive gifts) built at Delphi shortly before 525 B.C. by the people of the Ionian island of Siphnos. Although the building no longer stands, we can get an idea of its appearance from the reconstruction in figures 5-19 and 5-20. Its chief feature was two female **caryatids,** or column-figures, supporting the architrave. It appears that

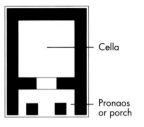

5-19. Plan of the Treasury of the Siphnians

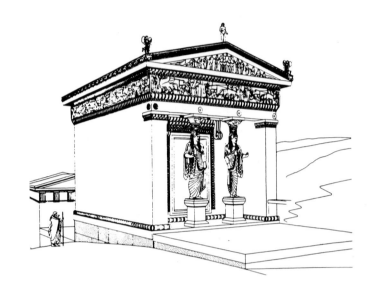

5-20. Reconstruction drawing of the Treasury of the Siphnians. Sanctuary of Apollo at Delphi. c. 525 B.C.

such figures were first used by the Syrians at Tell-Halaf some 300 years earlier, yet we know of no intervening examples. Hence their presence here must be considered novel.

The most impressive part of the treasury's sculptural décor is the splendid frieze. The detail shown here (fig. 5-21) depicts part of the battle of the Greek gods against the giants. At the far left, two lions who pull the chariot of the mother goddess Cybele are tearing apart an anguished giant. In front of them, Apollo and Artemis advance together, shooting their arrows. A dead giant, stripped of his armor, lies at their feet, while three others enter from the right.

The high relief, with its deep undercutting, recalls the Corfu pediment, but the Siphnian sculptor has taken full advantage of the spatial possibilities offered by this technique. The ledge at the bottom of the frieze is used as a stage on which he can place his figures in depth. The arms and legs of those nearest the viewer are carved in the round. In the second and third layers, the forms become shallower, yet even those farthest from us do not merge with the background. The result is a condensed but convincing space that permits a dramatic relationship between the figures never seen before in narrative reliefs. Compared with older examples (such as fig. 4-17), Archaic art has conquered a new dimension here, not only in the physical but also in the expressive sense.

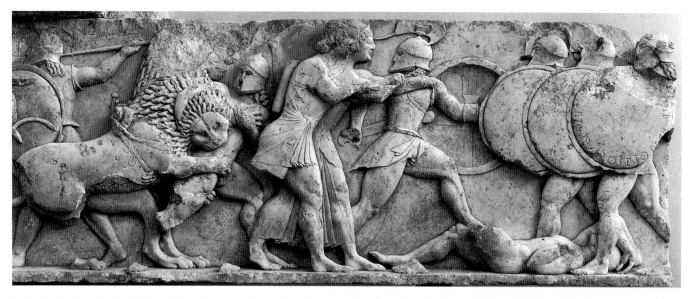

5-21. *Battle of the Gods and Giants,* from the north frieze of the Treasury of the Siphnians, Delphi. c. 530 B.C. Marble, height 26" (66 cm). Archaeological Museum, Delphi

THE TEMPLE OF APHAIA, AEGINA. Meanwhile, in pedimental sculpture, relief was abandoned altogether. Instead, we find statues placed side by side in dramatic groups designed to fit the triangular frame. The most ambitious ones were the pediments of the Temple of Aphaia at Aegina. The original east pediment was evidently destroyed by the Persians when they took the island in 490 B.C. The present one (fig. 5-22) was commissioned after their defeat at the battle of Salamis in 480 B.C. It shows the first sack of Troy by Herakles, who had completed his twelve labors, and Telamon, king of Salamis, who had fled Aegina after he and Peleus killed their half-brother. The west pediment, which dates from about 510–500 B.C., depicts the second siege of Troy (recounted in the *Iliad)* by Agamemnon, who was related to Herakles by descent from King Pelops, and Ajax, Telamon's son. The pairing of the subjects commemorates the important role played by the heroes of Aegina in both battles—and, by extension, at Salamis, where their navy helped win the day. This elevation of historical events to a universal plane through allegory was typical of the ancient Greek mentality.

The east pediment brings us to the final stage in the evolution of Archaic sculpture. The figures were found in pieces on the ground. Although the exact arrangement has been a matter of much debate, the relative position of each within the pediment can be determined with reasonable accuracy, since their height (but not their scale) varies with the sloping sides of the triangle (fig. 5-22). In the center the standing goddess Athena presides over the battle between Greeks and Trojans that rages to either side of her. The symmetrical arrangement of the poses on the two halves of the pediment creates a balanced design. Yet it also forces us to see the statues as elements in an ornamental pattern and thus deprives them of their individuality. They speak most strongly to us when viewed one by one. Among the most impressive are the fallen warrior from the left-hand corner (fig. 5-23) and the kneeling Herakles, who once held a bronze bow, from the right-hand half (fig. 5-24). Both are lean, muscular figures whose bodies seem marvelously functional and organic. That in itself, however, does not explain their great beauty, much as we may admire the artist's command of the

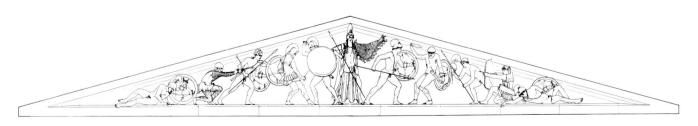

5-22. Reconstruction drawing of the east pediment of the Temple of Aphaia, Aegina (after Ohly)

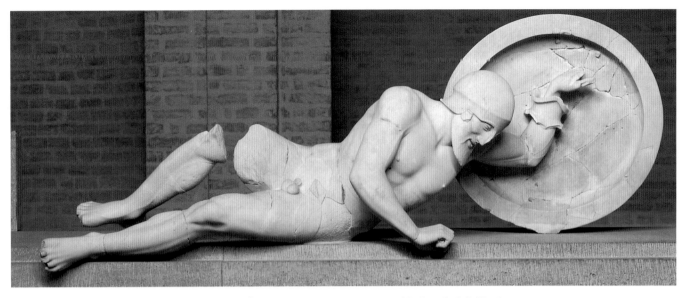

5-23. *Dying Warrior,* from the east pediment of the Temple of Aphaia. c. 480 B.C. Marble, length 6' (1.83 m). Staatliche Antikensammlungen und Glyptothek, Munich

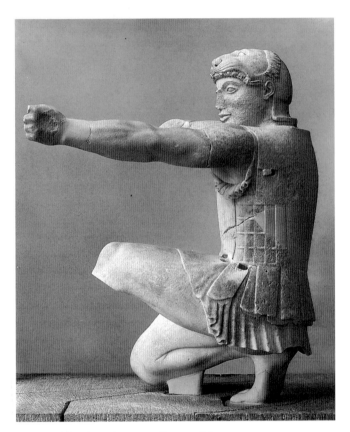

5-24. *Herakles,* from the east pediment of the Temple of Aphaia. c. 480 B.C. Marble, height 31" (78.7 cm). Staatliche Antikensammlungen und Glyptothek, Munich

human form in action. What really moves us is their nobility of spirit, whether in the agony of dying or in the act of killing. These men, we sense, are suffering—or carrying out—what fate has decreed, with extraordinary dignity and resolve. This spirit is conveyed in the very feel of the magnificently firm shapes themselves.

ARCHITECTURE

Temple Orders and Plans

Since Roman times, the Greek achievement in architecture has been identified with the three Classical **orders**: Doric, Ionic, and Corinthian. [See Primary Sources, no. 4, page 213.] Actually, there are only two, for the Corinthian is a variant of the Ionic. (The **dentils,** or toothlike blocks, of the Corinthian order are sometimes found in the Doric and Ionic orders as well.) The Doric, so named because its home is a region of the Greek mainland, may well be the primary order. It is older and more sharply defined than the Ionic, which developed on the Aegean Islands and the coast of Asia Minor.

What do we mean by an architectural "order"? By common agreement, the term is used only for Greek architecture (and its descendants); and rightly so, for none of the other architectural systems known to us produced anything like it. Perhaps the simplest way to make this point is to note that there is no such thing as "the Egyptian temple" or "the Gothic church." The individual buildings, however much they may have in common, are so varied that we cannot say that they represent a type. But "the Doric temple" is a real entity that forms in our minds as we study the monuments themselves.

We must be careful, of course, not to think of this abstraction as an ideal that permits us to measure the degree of perfection of any given Doric temple. It simply means that the elements of which a Doric temple is composed are extraordinarily constant in kind, in number, and in their relation to one another. As a result, Doric temples all belong to the same easily recognized family, just as Kouros statues do. And like Kouros statues, Doric temples show an internal consistency that gives them a unique organic unity. Nor is the similarity a coincidence. According to the Roman architect Vitruvius, no doubt basing himself on a well-established Greek tradition, "Without symmetry and proportion there can be no principles in the design of any temple; that is, if there is no

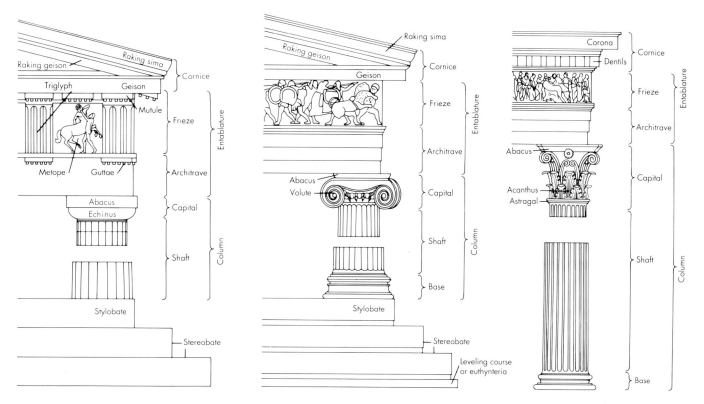

5-25. Doric, Ionic, and Corinthian orders, respectively

precise relation between its members, as in the case of a well-shaped man. [Like the face] the other bodily members have also their measured ratios, such as the great painters and master sculptors employed for attainment of great and boundless fame."

THE DORIC ORDER. The term *Doric order* refers to the standard parts, and their sequence, found on the exterior of any Doric temple. The order's general outlines are already familiar to us from the facade of the Temple of Artemis at Corfu (see fig. 5-18). The diagram in figure 5-25 shows the order in detail, along with the names of all its parts. To the nonspecialist, the detailed terminology of Greek architecture may seem something of a nuisance. Yet many of these terms have become part of our general architectural vocabulary. They remind us that analytical thinking, in architecture as in countless other fields, began with the Greeks.

Let us first look at the three main divisions: the stepped platform, the columns, and the entablature. The platform has a three-step combination of **stereobate** and **stylobate,** which supports the columns. The **Doric** column consists of the **shaft,** marked by 20 shallow vertical grooves known as **flutes,** and the **capital,** which is made up of the flaring, cushionlike **echinus** and a square tablet called the **abacus.** These bear a strict ratio to each other, although the proportions became taller over time. The entablature, which includes all the horizontal elements that rest on the columns, is the most complex of the three major units. It is subdivided into the **architrave** (a row of stone blocks directly supported by the columns); the **frieze,** made up of grooved triglyphs and flat or sculpted metopes; and a projecting horizontal cornice, or geison, which may include a gutter (sima). The architrave in turn supports the triangular **pediment** and the roof elements (the raking geison and raking sima).

The entire structure is built of stone blocks fitted together without mortar, so that they had to be shaped with great precision to achieve smooth joints. Where necessary, they were fastened together with metal dowels or clamps. Columns, with very rare exceptions, were composed of sections, called drums (see fig. 5-28). The shaft was fluted after the entire column was assembled and in position. The roof was made of terra-cotta tiles over wooden rafters, and wooden beams were used for the ceiling, so that the threat of fire was constant.

TEMPLE PLANS. The plans of Greek temples are not directly linked to the orders, which concern only the elevation. They may vary according to the size of the building or regional preferences. However, their basic features are so much alike that it is useful to study them from a "typical" plan (fig. 5-26). The nucleus is the **cella** or naos (the room in which the image of the deity was placed) and the porch (pronaos), with its two columns flanked by pilasters

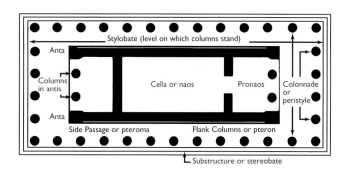

5-26. Ground plan of a typical Greek peripteral temple (after Grinnell)

(antae). The Siphnian Treasury shows this basic plan (see fig. 5-19). Often we find a second porch added behind the cella, to make the design more symmetrical. In the larger temples, the central unit of cella and porches is surrounded by a colonnade called the peristyle. The peristyle consists of six to eight columns at front and back, and usually 12–14 along the sides (the corner columns are counted twice, as part of each side); the structure is then known as peripteral. The very largest temples of Ionian Greece may even have a double colonnade. In most Greek temples the entrance faces east, toward the rising sun. This orientation reaches back to Stonehenge (see fig. 1-18) and is continued in Christian basilicas (see pages 232–233), which also face east but were entered from the west. Unlike Christian churches, however, Greek temples were built not to hold large numbers of worshipers, but rather to house the cult image of the deity.

Doric Temples

How did the Doric order originate? What factors shaped it? These questions can be answered only in part, for we have hardly any remains from the time when the system was being formed. The earliest stone temples were probably built north of Mycenae near Corinth, the leading cultural center of Greece during the late seventh century B.C. From there the idea spread across the isthmus that connects the Peloponnesus to the mainland and up the coast to Delphi and Corfu, then rapidly throughout the Hellenic world. The importance of this architectural revolution can be seen in the fact that soon thereafter the first Greek architects become known to us by name. Nor is it a coincidence that they began to write treatises on architecture—the first we know of. The oldest temples that have come down to us, such as Artemis at Corfu (see fig. 5-18), show that the main features of the Doric order were already well established soon after 600 B.C. But how they developed, individually and in combination, and why they came together into a system so quickly, remains a puzzle to which we have few reliable clues.

The early Greek builders in stone seem to have drawn upon three sources of inspiration: Egypt, Mycenae, and pre-Archaic Greek architecture in wood and mud brick. Of the three, Mycenae is the most obvious, although probably not the most important. The central unit of the Greek temple, the cella and porch, is clearly derived from the megaron (see fig. 4-20), either through tradition or by way of revival. There is something oddly symbolic about the fact that the Mycenaean royal hall should have been converted into the dwelling place of the Greek gods. The entire Mycenaean era had become part of Greek mythology (witness the Homeric epics), and the walls of the Mycenaean fortresses were thought to be the work of mythical giants, the Cyclopes. The awe the Greeks felt toward these remains also helps us to understand the link between the Lioness Gate relief at Mycenae (see fig. 4-19) and the sculptured pediments on Doric temples. Finally, the flaring, cushionlike capital of the Minoan-Mycenaean column is much closer to the Doric echinus and abacus than is any Egyptian capital. The shaft of the Doric column, on the other hand, tapers upward, not downward as does the Minoan-Mycenaean column, and this points to Egyptian influence.

Perhaps we will recall with some surprise the fluted half-columns in the funerary district of Djoser at Saqqara (see fig. 2-8). They look like the Doric shaft but are more than 2,000 years older. Moreover, the very notion that temples ought to be built of stone, and that they should have large numbers of columns, must have come from Egypt. It is true, of course, that the Egyptian temple is designed to be seen from the inside, while the Greek temple is arranged so that the exterior matters most. (People were allowed to see the cult statue in the dimly lit cella, but most religious rites took place at altars set up outdoors, with the temple facade as a backdrop.) A peripteral temple might be viewed as the columned court of an Egyptian sanctuary turned inside out. The Greeks must have gained many of their stonecutting and masonry techniques from the Egyptians. Also from Egypt came their knowledge of architectural ornament and the geometry needed to lay out temples and to fit the parts together. Yet we cannot say just how they went about all this, or exactly what they took over, technically and artistically. There can be little doubt, however, that they owed more to the Egyptians than to the Minoans or the Mycenaeans.

DOES FORM FOLLOW FUNCTION? We must consider a third factor: To what extent was the Doric order a reflection of wooden structures? Those historians of architecture who believe that form follows function—that an architectural form will always reflect its purpose—have pursued this approach at length, especially in trying to explain the details of the entablature. Up to a point, their arguments are convincing. It seems plausible that at one time the triglyphs did mask the ends of wooden beams. It also makes sense that the droplike shapes below, called **guttae** (see fig. 5-25), are the descendants of wooden pegs. Metopes evolved out of the boards that filled in the gaps between the triglyphs to guard against the weather. Likewise, **mutules** (flat projecting blocks) reflect the rafter ends of wooden roofs. It is more difficult to see the odd vertical subdivisions of the triglyphs as an echo of three half-round logs. And when we come to the flutings of the column, our doubts continue to rise. Were they really developed from adz marks on a tree trunk, or did the Greeks take them over ready-made from the "proto-Doric" stone columns of Egypt?

As a further test of the functional theory, we may ask how the Egyptians came to put flutes in their columns. They, too, had to translate architectural forms from impermanent materials into stone. Perhaps it was they who turned adz marks into flutes? But the predynastic Egyptians had so little timber that they seem to have used it only for ceilings. The rest of their buildings were made of mud brick, strengthened by bundles of reeds. And since the proto-Doric columns at Saqqara are not freestanding but are attached to walls, their flutings might be an abstract imitation of bundles of reeds. (There are also columns at Saqqara with convex rather than concave flutes that come much closer to the notion of a bundle of thin staves.) On the other hand, the Egyptians may have developed the habit of fluting without reference to any earlier building techniques. Perhaps they used it to disguise the horizontal joints between the drums and to stress the continuity of the shaft. Even the Greeks did not flute the shafts of their columns drum by drum, but waited until the entire column was assembled and in position. Be that as it may, fluting certainly enhances the

expressive character of the column. A fluted shaft looks stronger, more energetic and resilient, than a smooth one. This expressive quality, rather than how the habit began, surely accounts for its persistence.

Why did we enter into an argument that seems inconclusive? Mainly in order to suggest the complexity, as well as the limitations, of the technological approach to problems of architectural form. The question of how far stylistic features can be explained in terms of function will face us again and again. Obviously, the history of architecture cannot be fully understood if we view it only as an evolution of style and do not consider the purposes of building or its technical aspects. But we must likewise be prepared to accept the aesthetic impulse in its own right. At the very start, Doric architects certainly imitated in stone some features of wooden temples, if only because these features were deemed necessary in order to identify a building as a temple. When Greek architects made these ancient structural elements part of the Doric order, however, they did not do so from mere force of habit. The wooden forms had by now been so thoroughly transformed that they were an organic part of the stone structure.

TEMPLES AT PAESTUM. We can see the evolution of temples in two examples located near the southern Italian town of Paestum, where a Greek colony flourished during the Archaic period (fig. 5-27; fig. 5-28). They are both dedicated to the goddess Hera, wife of Zeus; however, the Temple of Hera II (foreground, fig. 5-27) was built almost a century after the Temple of Hera I (the so-called Basilica). (The former was previously thought to be a Temple of Poseidon, because Paestum was once named for the Greek god of the sea.) Both temples are Doric, but there are striking differences in their proportions. The Temple of Hera I seems low and sprawling—and not just because so much of the entablature is missing—while the Temple of Hera II looks tall and compact. Part of the difference is psychological and is produced by the outline of the columns. Those in the Temple of Hera I (fig. 5-28) are more strongly curved and are tapered to a relatively narrow top. This swelling effect, known as **entasis**, gives the feeling that the columns bulge with the strain of supporting the superstructure and that the slender tops, although aided by the widely flaring, cushionlike capitals, are just barely up to the task. The sense of strain has been explained on the grounds that Archaic architects were not fully familiar with their new materials and engineering procedures. Such a view, however, judges the building by the standards of later temples and overlooks the expressive vitality of the building—the vitality we sense in a living body.

In the Temple of Hera II the exaggerated curvatures have been modified. This change, combined with a closer spacing of the columns, brings the stresses between supports and weight into

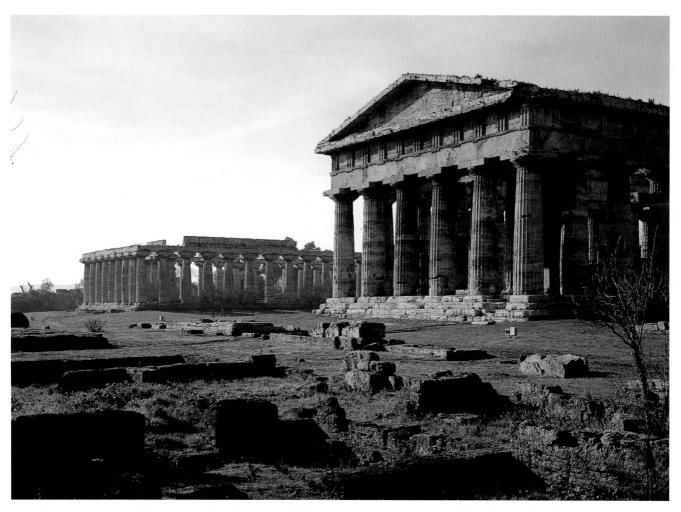

5-27. The Temple of Hera I ("Basilica"), c. 550 B.C., and the Temple of Hera II ("Temple of Poseidon"), c. 460 B.C. Paestum

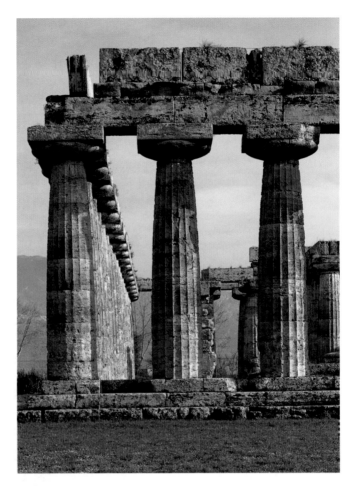

5-28. Corner of the Temple of Hera I, Paestum, Italy. c. 550 B.C.

more harmonious balance literally as well as expressively. Perhaps because the architect took fewer risks, the building is better preserved than the "Basilica." Its air of self-contained repose parallels developments in the field of Greek sculpture.

The Temple of Hera II (figs. 5-27 and 5-29) is among the best preserved of all Doric sanctuaries. Of special interest are the interior supports of the cella ceiling (fig. 5-29). The two rows of columns each support a smaller set of columns in a way that makes the tapering seem continuous despite the architrave in between. Such a two-story interior became a practical necessity in the larger Doric temples. It is first found at the Temple of Aphaia at Aegina around the beginning of the fifth century. That temple is shown here in a reconstruction drawing (fig. 5-30), which shows the structural system in detail.

ATHENS, PERIKLES, AND THE PARTHENON. In 480 B.C., shortly before their defeat by the Greeks, the Persians destroyed the temple and statues on the Akropolis (literally, "highest part of the city"), the sacred hill above Athens, which had been a fortified site since Mycenaean times. The rebuilding of the Akropolis under the leadership of Perikles during the later fifth century, when Athens was at the height of its power, was the most ambitious enterprise in the history of Greek architecture. This achievement is all the more surprising in light of the fact that, by today's standards, Athens was only a modest city, with no more than about 50,000 inhabitants. The Akropolis nevertheless represents the artistic climax of Greek art. Individually and collectively, these structures exemplify the Classical phase of Greek art in full maturity. The inspiration for such a complex can only have come from Egypt. So must Perikles' idea of treating it as a vast public works project, for which he spared no expense.

The greatest temple, and the only one to be completed before the onset of the Peloponnesian War in 431 B.C., is the Parthenon (fig. 5-31). It was dedicated to the virgin goddess Athena Parthenos (Athena the Virgin), the patron deity in whose honor Athens was named. Inside was a large cult statue of the goddess. The architects Iktinos, Kallikrates, and Karpion erected it in 448–432 B.C., an amazingly brief span of time for a project of this size. Built of gleaming white marble on the most prominent site along the southern flank of the Akropolis, it dominates the entire city and the surrounding countryside, a brilliant landmark against the backdrop of mountains to the north.

To meet the huge expense of building the largest and most lavish temple on the Greek mainland, Perikles used funds that had been collected from states allied with Athens for mutual defense against the Persians. He may have felt that the danger was no longer real and that Athens, the chief victim and victor of the Persian wars in 480–479 B.C., was justified in using the money to rebuild what the Persians had destroyed. His act weakened Athens' position, however, and contributed to the disastrous outcome of the

5-29. Interior, Temple of Hera II.
c. 500 B.C.

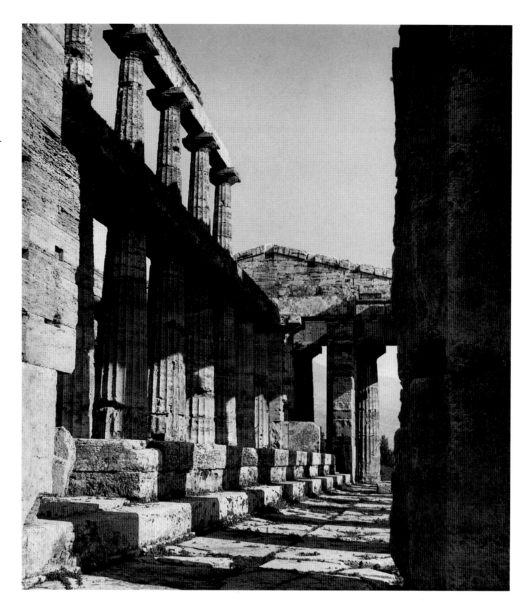

5-30. Sectional view (restored) of
the Temple of Aphaia, Aegina

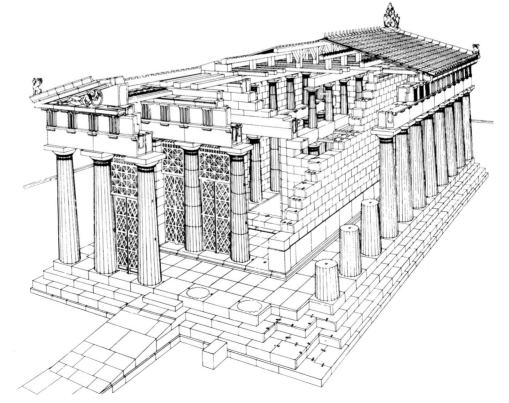

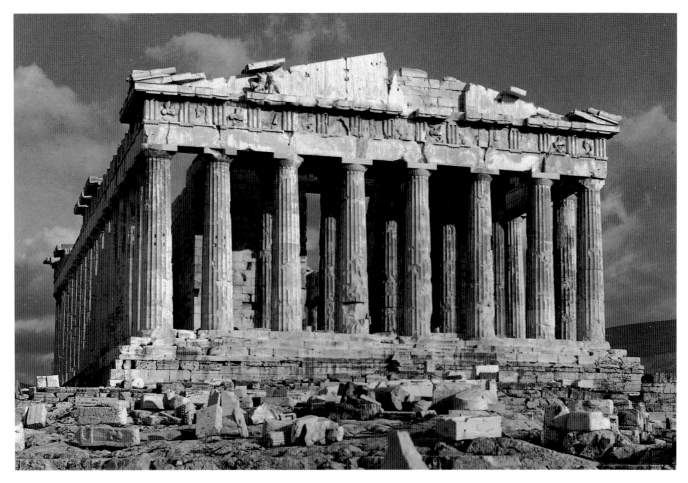

5-31. Iktinos, Kallikrates, and Karpion. The Parthenon (view from the west), Akropolis, Athens. 448–432 B.C.

Peloponnesian War. (Thucydides, who wrote a history of the war, reproached him for adorning the city "like a harlot with precious stones, statues, and temples costing a thousand talents.")

The Parthenon is unconventional in plan (see fig. 5-32). The cella is unusually wide and somewhat shorter than in other temples, so as to accommodate the large statue of Athena by the sculptor Pheidias and a second room behind it for storing ritual objects. The pronaos and its counterpart at the western end have almost disappeared. However, there is an extra row of columns in front of each entrance. The architrave above these columns is more Ionic than Doric, since it has no triglyphs and metopes but a continuous frieze that encircles the cella (see fig. 5-33).

As the perfect embodiment of Classical Doric architecture, the Parthenon makes an instructive contrast with the Temple of Hera II at Paestum (see fig. 5-27 right). Despite its greater size, the Parthenon seems far less massive. Instead, it creates an impression of festive, balanced grace within the austere scheme of the Doric order. This effect has been achieved by lightening and readjusting the proportions. The entablature is lower in relation to its width and to the height of the columns, and the cornice projects less. The proportions were determined by the fact that, as a matter of convenience as well as economic necessity, the architects reused numerous column drums from the unfinished first Parthenon, which had been burned by the Persians. The columns themselves are much more slender, their tapering and entasis less pro-

nounced, and the capitals are smaller and less flaring; yet the spacing of the columns is wider. We might say that the load carried by the Parthenon columns has decreased, and as a result the supports can fulfill their task with a new sense of ease.

THE PARTHENON'S REFINEMENTS. These and other intentional departures from the strict geometric regularity of the design are features of the Classical Doric style that can be seen in the Parthenon better than anywhere else. For example, the stepped platform and the entablature are not absolutely straight but are slightly curved, so that the center is a bit higher than the ends. Similarly, the columns lean inward; the space between the corner column and its neighbors is smaller than the standard interval adopted for the colonnade as a whole; and every capital of the colonnade is slightly distorted to fit the curving architrave.

A great deal has been written about these intentional departures from the strict regularity of design. That they are planned to create a deliberate effect is beyond doubt, but why did the architects go to the trouble of carrying them through, since they are not necessary? They used to be thought of as optical corrections designed to produce the illusion of absolutely straight horizontals and verticals. However, this functional explanation does not work. If it did, we would not be able to perceive the deviations except by careful measurement. Yet the fact is that, though unobtrusive, they are visible to the naked eye, even in photographs.

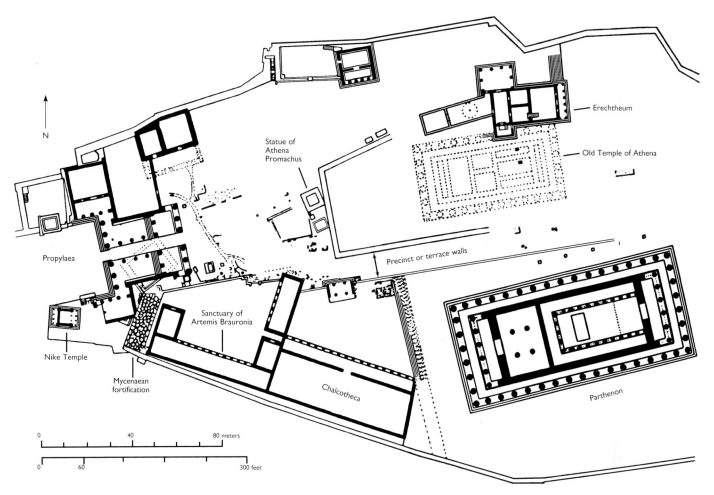

5-32. Plan of the Akropolis at Athens in 400 B.C. (after A. W. Lawrence)

N

Erechtheum

Old Temple of Athena

Statue of
Athena
Promachus

Precinct or terrace walls

Propylaea

Nike Temple

Mycenaean
fortification

Sanctuary of
Artemis Brauronia

Chalcotheca

Parthenon

0 40 80 meters

0 60 300 feet

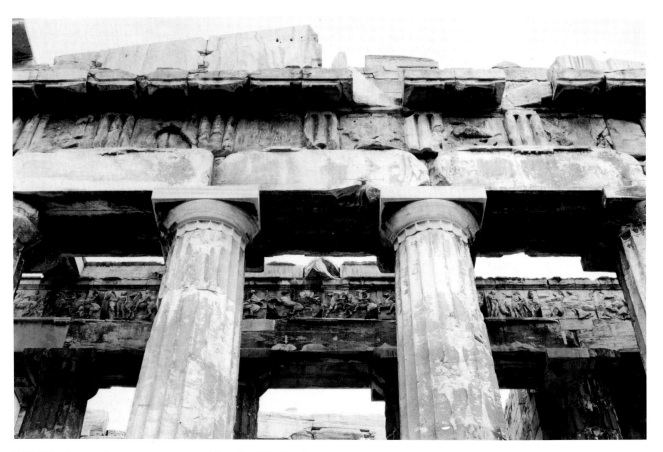

5-33. Frieze above the western entrance of the cella of the Parthenon

Moreover, in temples that do not have these refinements, the columns do not appear to be leaning outward, nor do the horizontal lines seem to sag. Plainly, then, these adjustments were built into the Parthenon for aesthetic reasons: they were thought to add to its beauty, and were meant to be noticed. They do contribute, in ways that are hard to define, to the harmonious quality of the structure. They give us visual reassurance that the points of greatest stress are supported and are provided with a counterstress as well.

These refinements nevertheless fail to account fully for the Parthenon's remarkable persuasiveness, which has never been surpassed. The Roman architect Vitruvius records that Iktinos based his design on carefully considered proportions. The ratio of spacing between the columns to their lower diameter (9:4) was used throughout the building. (This proportion was slightly greater than the multiples of two used by Libon of Elis in the Temple of Zeus at Olympia, the first Greek temple we know of to make such a systematic use of ratios.) But accurate measurements reveal that the system of the Parthenon is far from simple or rigid. There are many subtle adjustments, which give the temple its surprisingly organic quality. In this respect the Parthenon's design closely parallels the underlying principles of Classical sculpture (see pages 137–138). Indeed, with its sculpture in place the Parthenon must have seemed animated with the same inner life that informs the pediment figures, such as the *Three Goddesses* (see fig. 5-54).

THE PROPYLAEA. Soon after the completion of the Parthenon, Perikles commissioned another costly project. This was the monumental entry gate at the western end of the Akropolis, called the Propylaea (see plan, fig. 5-32). It was begun in 437 B.C. under the architect Mnesikles, who completed the main

part in five years; the remainder had to be abandoned because of the Peloponnesian War. Again, the entire structure was built of marble and included refinements similar to those of the Parthenon. It is fascinating to see how the elements of a Doric temple have been adapted to a totally different task, and to an irregular and steeply rising site. Mnesikles' design not only fits the difficult terrain but transforms it from a rough passage among rocks into a splendid entrance to the sacred precinct.

Of the two porches (or facades) at either end, only the northern one is in fair condition today (fig. 5-34). It resembles a Classical Doric temple front, except for the wide opening between the third and fourth columns. The eastern porch was flanked by two wings (fig. 5-35). The larger one to the north included a picture gallery (*pinakotheke*), the first known instance of a public room especially designed for the display of paintings. Along the central roadway that passes through the Propylaea, we find two rows of columns which are Ionic rather than Doric. Apparently, at that time, the trend in Athenian architecture was toward using Ionic elements inside Doric structures. (The Parthenon cella, we recall, has a continuous sculptured frieze; see fig. 5-33.)

Ionic Temples

Next to the Propylaea is the elegant little Temple of Athena Nike (fig. 5-36), which was probably built between 427 and 424 B.C. from a design prepared 20 years earlier by Kallikrates. It has the more slender proportions and the scroll capitals of the **Ionic order.** Not much is known about the previous history of this order, which first appeared about a half-century after the Doric. Of the huge Ionic temples that were erected in Archaic times—the Temple of

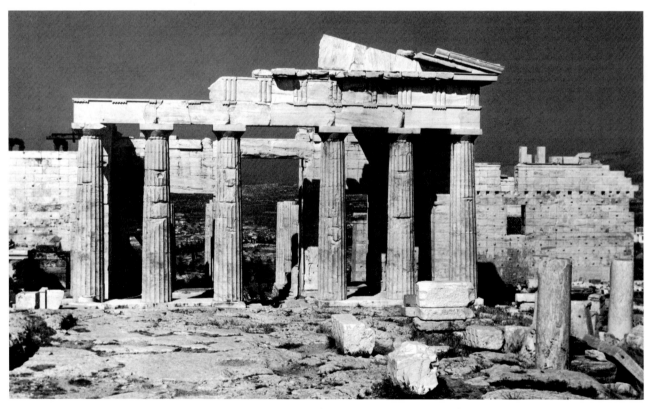

5-34. Mnesikles. The Propylaea, 437–432 B.C. Akropolis (view from the west, inside the grounds), Athens

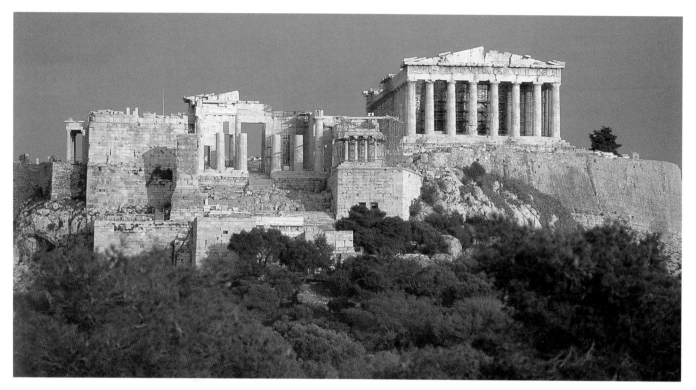

5-35. The Propylaea, 437–432 B.C.; with Temple of Athena Nike, 427–424 B.C., Akropolis (view from the west), Athens

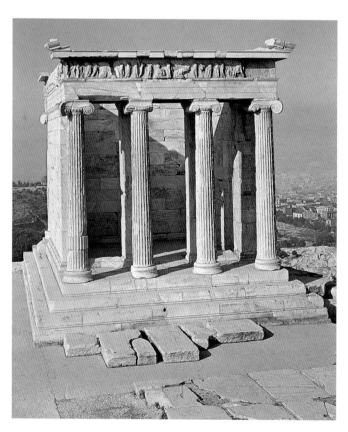

5-36. Temple of Athena Nike (view from the east), Akropolis, Athens, 421–405 B.C.

Hera, built around 575 B.C. by Theodoros of Samos according to Vitruvius, and the Temple of Artemis at Ephesus, designed some 15 years later by Chersiphon and his son Metagenes—little has survived except the plans. They are the earliest dipteral (double-colonnaded) temples we know of.

Athens, with its strong Aegean orientation, had been open to the eastern Greek style of building from the mid-fifth century B.C. on. In fact, the finest surviving examples of the Ionic order are on the Akropolis. In pre-Classical times, however, the only Ionic structures on the Greek mainland had been the small treasuries built by eastern Greek states at Delphi in their regional styles. Thus, when Athenian architects first used the Ionic order, about 450 B.C., they thought of it as suitable only for small temples with simple plans.

The Ionic style seems to have been fairly fluid, with strong links to the Near East (see figs. 3-26 and 3-27). It did not become an order in the strict sense until the Classical period. Even then it remained more flexible than the Doric order. Its most striking features are the continuous frieze, which lacks the alternating triglyphs and metopes of the Doric order, and the **Ionic** column, which differs from the Doric not only in body but also in spirit (see fig. 5-25). The Ionic column rests on an ornate base of its own, perhaps used at first to protect the bottom from rain. The shaft is more slender, and there is less tapering and entasis. The capital shows a large double scroll, or **volute,** below the abacus, which projects strongly beyond the width of the shaft.

When we turn from the diagram to an actual building (fig. 5-36) it becomes clear that the Ionic column is very different in character from the Doric column. How shall we define it? The Ionic column is lighter and more graceful. It lacks the muscular quality of its mainland cousin. Instead, it evokes a growing plant, something like a formalized palm tree. This vegetal analogy is not

5-37. Aeolian capital, from Larissa. c. 600 B.C. Archaeological Museum, Istanbul, Turkey

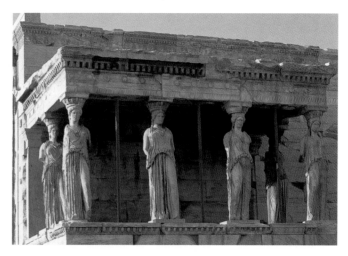

5-38. Porch of the Maidens, the Erechtheum, Akropolis, Athens. 421–405 B.C.

sheer fancy, for we have early ancestors, or relatives, of the Ionic capital that bear it out (fig. 5-37). If we were to pursue these plant-like columns back to their point of origin, we would find ourselves at Saqqara. There we see not only "proto-Doric" supports but also the papyrus half-columns of figure 2-8, with their flaring capitals. It may well be that the form of the Ionic column, too, had its source in Egypt. But instead of reaching Greece by sea, as we suppose the proto-Doric column did, it traveled a slow and tortuous path by land through Syria and Asia Minor.

THE ERECHTHEUM. The finest example of the Ionic order is the Erechtheum (see fig. 5-32), which is larger and more complex than the Temple of Athena Nike. Located on the northern edge of the Akropolis, opposite the Parthenon, it was built between 421 and 405 B.C., probably by Mnesikles. Like the Propylaea, it is well adapted to an irregular, sloping site. The area had various associations with the mythical founding of Athens, so that the Erechtheum served several religious functions at once. Apparently there were four rooms, as well as a basement on the western side. One held a statue of Erechtheus, a legendary king of Athens, who promoted the worship of Athena and for whom the building is named. The Erechtheum may have covered the spot where the contest between Athena and Poseidon, depicted on the east pediment of the Parthenon, was believed to have taken place (see box page 111). In addition to the olive tree given by Athena, it included the saltwater pool that sprang up where Poseidon threw his trident. The eastern room was dedicated to Athena Polias (Athena the City Goddess) and contained the old statue that had been replaced by Pheidias; the western room was dedicated to Poseidon.

Instead of a west facade, the Erechtheum has two porches attached to its flanks: a very large one facing north, which was the main entrance, and a small one toward the Parthenon. The latter is the famous Porch of the Maidens (fig. 5-38). Its roof is held up by six female **caryatids** on a high parapet, instead of by columns (compare fig. 5-20). Here the exquisite refinement of the Ionic order conveys what Vitruvius might have called a "feminine" quality, compared with the "masculinity" of the Parthenon. [See

Primary Sources, no. 4, page 213.] Apart from the caryatids, sculptural decoration on the Erechtheum was confined to the frieze, of which very little survives. The pediments remained bare, perhaps for lack of funds at the end of the Peloponnesian War. However, the carving on the bases and capitals of the columns, and on the frames of doorways and windows, is extraordinarily delicate and rich. According to the accounts inscribed on the building, it cost more than figure sculpture.

THE CORINTHIAN CAPITAL. Such emphasis on ornament became characteristic of Greek architecture from the late fifth century on, when the Doric increasingly lost favor to the Ionic. It was at this time, too, that the Corinthian capital was invented (by the metalworker Kallimachos, according to Vitruvius). The Corinthian capital was an elaborate substitute for the Ionic. (For a comparison of Doric, Ionic, and Corinthian capitals, see fig. 5-25.) Its shape is an inverted bell covered with the curly shoots and leaves of the acanthus plant, which seem to sprout from the top of the column shaft (fig. 5-39). At first, Corinthian capitals were used only in interiors of temples at Bassae and Delphi. Not until the fourth century B.C. do we find them replacing Ionic capitals on the exteriors.

The earliest known instance of a Corinthian capital on a facade is the **tholos** (a circular building with a conical roof) built

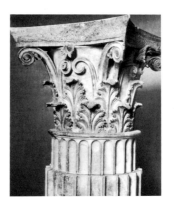

5-39. Corinthian capital, from the Tholos at Epidauros. c. 350 B.C. Museum, Epidauros, Greece

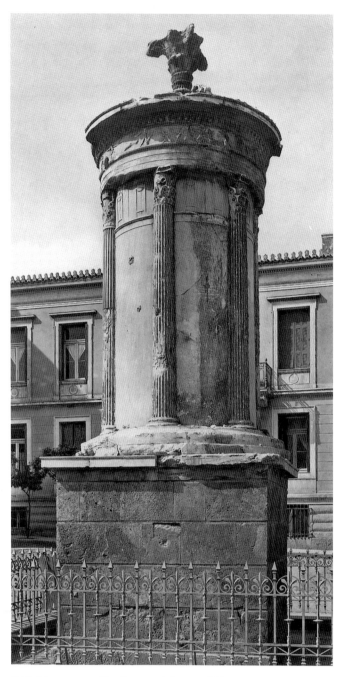

5-40. Monument of Lysikrates, Athens, c. 334 B.C.

around 375 B.C. at Delphi by Theodoros of Phocaea, whose book helped to popularize both. The spirited example in figure 5-39 comes from the slightly later tholos at Epidauros by Polykleitos the Younger, who is sometimes credited with having brought the Corinthian capital to maturity. The only intact example is the Monument of Lysikrates in Athens (fig. 5-40), built soon after 334 B.C. The round structure, resting on a tall base, is not really a building in the full sense of the term—the interior, though hollow, has no entrance—but an elaborate support for a tripod won by Lysikrates in a choral contest at the Athenian theater (see box page 114). The columns here are engaged rather than freestanding, to make the monument more compact. Soon after, the Corinthian capital came to be used on the exteriors of large buildings as well, and in Roman times it was the standard capital for almost any purpose.

TOWN PLANNING AND THEATERS. Temples, of course, were not the only buildings erected by the Greeks. The **stoa** was a colonnaded hall with a covered portico (porch). Such structures lined the *agora* (marketplace), the center of civic and commercial life. It was here that the *ekklesia* (general assembly of citizens) met. Other important types were the *boueleuterion,* where meetings of the town council *(boule)* were held; and the *prytaneion,* where the 50 members of the presiding council *(prytany)* sat. Yet in both technical and aesthetic terms, the architectural vocabulary remained the same as in the late fifth-century temples. It was around the middle of the century that town planning on a rectangular grid pattern, which had been introduced as early as the eighth century B.C., took on new importance. According to Aristotle, Hippodamos of Miletos used such a grid to lay out his hometown in 466 B.C. and the port city of Piraeus near Athens soon thereafter.

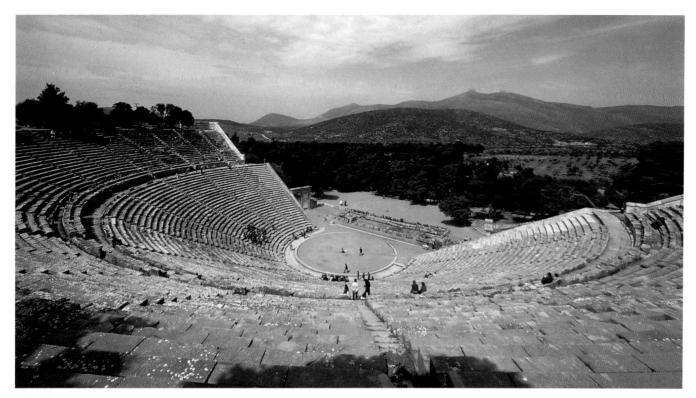

5-41. Theater, Epidauros. c. 350 B.C.

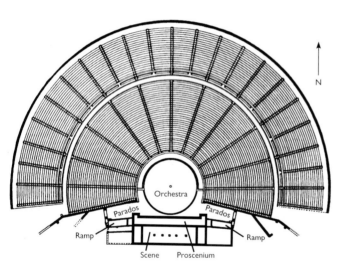

5-42. Plan of the Theater, Epidauros (after Picard-Cambridge)

During the three centuries between the end of the Peloponnesian War and the Roman conquest, Greek architecture showed little further development on the mainland. It is in the Greek cities of Asia Minor and the nearby Aegean islands of Rhodes and Kos where most building activity occurred. Even before the time of Alexander the Great, we see structures of a new kind. They often reveal Oriental influence, as in the huge Tomb of Mausolos at Halikarnassos (see figs. 5-65, 5-66, and 5-67) and the Great Pergamon Altar (see figs. 5-74, 5-75, and 5-76). But the main tendency was to make buildings, including private houses, larger and more ornate than before. There was also a trend to combine structures to create ever more elaborate complexes, which were as theatrical as the sculpture of the period. Such compounds served new commercial, educational, and athletic functions. An important addition was the gymnasium, the forerunner of today's schools of higher education. It was made up of a series of stoas around a central courtyard, and might include lecture rooms, a wrestling school (*palaestra*), and even a covered running track *(xystos)*. The largest religious precincts were the forerunners of the Roman Sanctuary of Fortuna Primigenia at Praeneste, near Rome (see fig. 7-7).

The basic forms of Greek architecture increased in only one respect: the open-air theater took on a regular shape. Before the mid-fourth century, the auditorium had been a natural slope, preferably curved, equipped with stone benches. Now the hillside was covered with concentric rows of seats, which had staircase-aisles at regular intervals, as at Epidauros (figs. 5-41 and 5-42). In the center was the orchestra, where most of the action took place.

THE CONTRIBUTION OF GREEK ARCHITECTURE. In the end, the greatest achievement of Classical Greek architecture was much more than just beautiful buildings. The Greeks tried to regulate their temples in accordance with nature's harmony by constructing them of measured units proportioned to be in perfect agreement. Greek temples look stable because they are governed by a strict logic. ("Perfect" was as significant an idea to the Greeks as "forever" was to the Egyptians.) Now architects could create organic unities, not by copying nature, not by divine inspiration, but by design. Their temples seem to be almost alive. They achieved this triumph chiefly by architectonics—expressing the structural forces and counterforces active in buildings, and creating a perfect balance among them. This is the real reason why,

in so many periods of Western history, the orders have been considered the only true basis for beautiful architecture. They are so perfect that they could not be surpassed, only equaled.

LIMITATIONS OF GREEK ARCHITECTURE. Why, then, did Greek architecture not grow much after the Peloponnesian War? After all, neither intellectual life nor the work of sculptors and painters show any tendency toward staleness during the last 300 years of Greek civilization. Are we perhaps misjudging the architecture of the Greeks after 400 B.C.? Or were there inherent limitations that prevented Greek architecture from continuing the pace of development it had maintained in Archaic and Classical times? A number of such limitations come to mind: the concern with exteriors at the expense of interior space, the focus on temples of one particular type, and the lack of interest in any structural system more advanced than the post-and-lintel (uprights supporting horizontal beams). Until the late fifth century B.C., these had all been advantages. Without them, the great works of the Periklean age would have been unthinkable. But the possibilities of the Doric temple were nearly exhausted by then, as can be seen in the attention given to expensive refinements.

What Greek architecture needed was a revival of the experimental spirit of the seventh century that would create an interest in new building materials, vaulting, and interior space. What prevented the breakthrough? Could it have been the architectural orders, or rather the cast of mind that produced them? One suspects that it was the very coherence and rigidity of these orders that made it impossible for Greek architects to break from them. What had been their great strength in earlier days became a tyranny. It remained for later ages to adapt the Greek orders to brick and concrete, arches and vaults. Such adaptation required violating the original character of the orders—something the Greeks, it seems, were unable to do.

CLASSICAL SCULPTURE
Free-Standing Sculpture

THE KRITIOS BOY. Among the many statues excavated from the debris the Persians had left behind after sacking the Akropolis in 480 B.C., there is one Kouros (fig. 5-43) that stands apart. This remarkable work, which must have been carved shortly before that fateful event, has sometimes been attributed to the Athenian sculptor Kritios and has therefore come to be known as the *Kritios Boy.* It differs in important ways from the Archaic Kouros figures we discussed above (see figs. 5-10 and 5-11). To begin with, it is the first statue we know that *stands* in the full sense of the word. Of course, the earlier figures also stand, but only in the sense that they are in an upright position instead of reclining, sitting, kneeling, or running. Their stance is really an arrested walk, with the weight of the body resting evenly on both legs. Thus early Greek statues have almost a military air, as if they were standing at attention.

The *Kritios Boy,* too, has one leg forward, yet we never doubt that he is standing still. Just as in military drill, this is simply a matter of allowing the weight of the body to shift. When we compare the left and right half of his body, we find that the symmetry of

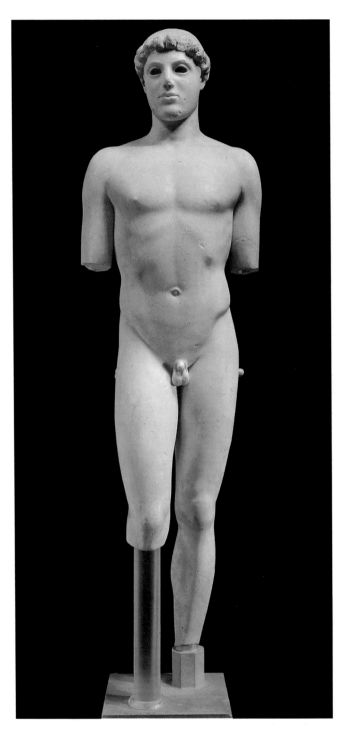

5-43. *Kritios Boy.* c. 480 B.C. Marble, height 46" (116.7 cm). Akropolis Museum, Athens

the Archaic Kouros has given way to a calculated nonsymmetry. The knee of the forward leg is lower than the other, the right hip is thrust down and in, and the left hip up and out. If we trace the axis of the body, we see that it is not a straight vertical line but a reversed S-curve. Taken together, these small departures from symmetry tell us that the weight of the body rests mainly on the left leg and that the right leg plays the role of a prop to help the body keep its balance.

In the *Kritios Boy,* however, we sense not only a new repose but also a vitality that recalls our experience of our own body. The use of contrapposto brings about all kinds of subtle curvatures. The bending of the free knee results in a slight swiveling of the pelvis, a compensating curvature of the spine, and an adjusting tilt of the shoulders. Like the refined details of the Parthenon, there adjustments have nothing to do with the statue's ability to stand erect. Rather, they serve to enhance its lifelike impression. In repose, it will still seem capable of movement; in motion, of maintaining its stability. The entire figure seems so alive that the Archaic smile, the "sign of life," is no longer needed. It has given way to a pensive expression characteristic of the early phase of Classical sculpture (or, as it is often called, the Severe style). Once the Greek statue was free to move, as it were, it became free to think, not merely to act. The two properties—movement and thought—are inseparable aspects of Greek Classicism. The forms, moreover, have a new naturalism and harmonious proportion that together provided the basis for the strong idealization characteristic of all subsequent Greek art.

POLYKLEITOS. Within half a century, the new articulation of the body that appears in the *Kritios Boy* reached its full development in the mature Classical style of the Periklean era. The most famous Kouros statue of that time, the *Doryphoros (Spear Bearer)* by Polykleitos (fig. 5-44), is known to us only through Roman copies, which must convey little of the beauty of the original. Still, it is instructive to compare this work with the *Kritios Boy.* Everything is a harmony of complementary opposites. The contrapposto is now much more emphatic. The differentiation between the halves of the body can be seen in every muscle. The turn of the head, barely hinted at in the *Kritios Boy,* is now pronounced. The "working" left arm is balanced by the "engaged" right leg in the forward position, and the relaxed right arm by the "free" left leg. This studied poise, the precise anatomical details, and, above all, the harmonious proportions of the figure made the *Doryphoros* renowned as the embodiment of the Classical ideal of beauty. The ideal here must be understood in a dual sense: as a perfect model and as a prototype. According to one ancient writer, the statue was known simply as the *kanon* (canon, meaning "rule" or "measure"). [See Primary Sources, no. 3, pages 211–13.]

The *Doryphoros* was more than an exercise in abstract geometry. It embodied not only *symmetria* (proportion, structure), but also *rhythmos* (composition, movement). Both were basic aspects of Greek aesthetics, derived from music and dance (see box pages 139–40). A faith in ratio can be found throughout Greek philosophy beginning with the Pythagoreans, who believed that the harmony of the universe, like musical harmony, could be expressed in mathematical terms. The Greeks were not the first to explore proportions, of course; the Egyptians had done so earlier. But the Greeks were more systematic in their study, thanks to their passion for abstract numbers. They were able to devise the algebraic formulas required for solving complex problems, something that was beyond the grasp of the Egyptians, who remained wedded to a practical approach (see page 50). Thus the Greeks easily solved problems that posed great difficulty for Egyptian mathematicians. There is considerable evidence that East Greeks living in Anatolia,

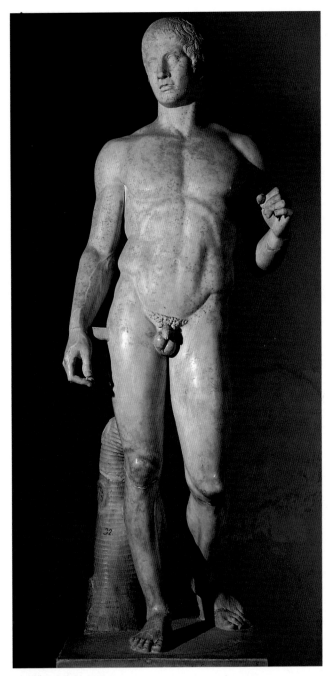

5-44. *Doryphoros (Spear Bearer).* Roman copy after an original of c. 450–440 B.C. by Polykleitos. Marble, height 6'6" (2 m). Museo Archeologico Nazionale, Naples

CONTRAPPOSTO. The *Kritios Boy,* then, not only stands, he stands at ease. The artist has masterfully observed the balanced nonsymmetry of this relaxed natural stance. To describe it, we use the Italian word *contrapposto* (counterpoise). The leg that carries the main weight is called the engaged leg; the other, the free leg. These terms are a useful shorthand, for from now on we shall often mention **contrapposto**. It was a very basic discovery. Only by learning how to represent the body at rest could the sculptor gain the freedom to show it in motion. But is there not plenty of motion in Archaic art? There is indeed, but it is somewhat mechanical (see figs. 5-17, 5-21, 5-23, and 5-24). We read it from the poses without really feeling it. It is portrayed in formulas that denote rather than depict motion.

Although the earliest surviving remnants of Greek culture can be traced back to the eighth century B.C., they must have been preceded by at least 400 years of development now lost to us. In the eighth century we find the earliest works of Greek sculpture, painting, and architecture, however primitive they may be; the beginnings of Greek philosophy at Miletos; and, above all, the creation of two epic poems, the *Iliad* and the *Odyssey* (which probably treat an actual war of about 1200 B.C.), out of preexisting material. Homer, to whom these poems are attributed, lived in Asia Minor and sang his poetry while playing a lyre. This unity of words and music was to be a constant feature of Greek poetry and theater. It was embodied by the legendary bard Orpheos, whose music, it was said, could move even animals and stones.

Early Greek music as sung by the bards was of a very rudimentary sort called *stithic*. Melodies consisted of only three or four notes sung repetitively in lines of simple rhythm and unchanging length. There was also a strophic form that could be closed (small, using a few basic meters, and clear in structure) or open (larger, more complex, with no fixed meter). Early Greek vocal music was accompanied by lyres having only a few strings ("lyric" poetry was sung to a lyre) or a primitive form of the aulos, an oboelike reed instrument that was always played in pairs. The harp, an import from Lydia and Ionia in Asia Minor, was preferred by the poetess Sappho of Lesbos (early sixth century B.C.) and remained chiefly an instrument for women.

We owe much of what we know about Greek harmonics to the Roman writer Vitruvius. Because it involved only four notes, early Greek music was organized in tetrachords. At first, it was governed by the "enharmonic" (in tune) genus. By the fifth century B.C., a second genus, chromaticism, began to gain favor because it was easier to play. Chromaticism virtually displaced the enharmonic genus toward the end of the fourth century B.C. Even easier was the diatonic genus, which was used for most late Greek music and has been for the vast majority of Western music since then. Two successive tetrachords were joined by a common note to form a seven-note scale, which gave rise to the standard seven-string kithara (lyre). Not until the early seventh century B.C. was the scale extended to the modern octave by Terpander.

These scales, with their varying intervals, were the basis of the so-called modes. Although the notes can be reconstructed readily enough, individual modes were associated with certain rhythms, meters, and melodies. Each had a distinctive character (*ethos*) that can only be guessed at. All that remains of Greek music is some 51, mostly late, fragments supplemented by a small but crucial body of theory. There were five standard modes. The Dorian mode was used for invocations, lamentations, tragedy, and choral songs. The Phrygian mode, introduced into Athens by Sophokles, could be cheerful and pious, according to the philosopher Plato (427?–347 B.C.), or wildly emotional (orgiastic) according to his pupil Aristotle (384–322 B.C.). The Lydian mode was a soft ("slack") mode used by the poet Anacreon (c. 570–c. 485 B.C.) at symposia that perhaps arose from the aulos airs composed by Olympos in the late eighth century B.C. The Mixolydian was a highly emotional mode used by Sappho and was deemed especially suitable for laments, which was the main tragic mode with the Dorian before the time of Sophokles. The Ionian was a soft mode that was derived from Asiatic laments and was therefore also appropriate for tragedy. All other modes were probably derived from these five. Their names attest to the fact that Greece was a vast melting pot both musically and ethnically. In fact, there were rival musical centers throughout Greece. Sparta and Lesbos were the leaders throughout the seventh century B.C. They were succeeded by Argos during the sixth century B.C. Around 450 B.C. Syracuse emerged as the capital of Greek music, though Thebes continued to reign supreme on the aulos.

The modes could be varied through modulations of genus, scale, key, and ethos. The growing complexity of music was spurred by the rise of instrumental music independent of singing. It began in Phrygia in the late eighth century B.C. with the first aulos player (*aulete*), variously considered to be Olympos or Hyagnis (Agnis). A piper's contest (*agones*) was held during the Phrygian games in 586 B.C., which was won by Sakada of Argos. The first kithara contest was added to the Phrygian games 28 years later. No longer tied to words, instrumental music was free to develop ever more novel, complex forms. It also underwent a change in character toward the ecstatic, serpentine music still found in the Near East today. By the mid-fifth century B.C., the emphasis was on virtuosity, which inevitably influenced vocal music as well. For example, Pindar (518?–c. 438 B.C.), the great composer of odes (music meant to be sung by a chorus), emphasized the intricacy and variety of his music. This trend reached its zenith in the late fifth century B.C. under Melanippides of Melos, a composer who created a more expressive singing style shaped to the words. *The Persians,* by his contemporary, Timotheos the Milesian, strikingly anticipated *The Battle of Issos* (see fig. 5-62) in its representation of the sounds and color of combat. These innovations, however, met with stiff resistance from conservatives, who lamented the loss of simplicity and dignity in favor of corrupt styles catering to popular taste.

(box continues on following page)

The Pistoxenos Painter. *Linos and Iphikles at Music Lesson.* c. 470 B.C. Attic red-figured drinking cup (*skyphos*). Staatliches Museum, Schwerin, Germany

It became essential to unify the scales after the invention in the sixth century B.C. of sophisticated lyres and auloi that could change modes without retuning. The first consistent system was devised in the fourth century B.C. by Aristoxenos of Tarentum, a pupil of Aristotle, on whom Vitruvius based his account of Greek music. His 13-note scale was eventually superseded by a 15-note "perfect system," although Ptolemy tried to reduce the number back to 7 in the second century B.C. Surprisingly, the great age of Greek music was soon over. By the early fourth century, composers were replaced by star performers, who relied for the most part on the music of the past.

Music was of great importance in ancient Greece. The word *music* derives from *muse*, the personification and inspiration of the nine branches of art and learning. Thus an educated person was a "musical" person. Music was closely linked to art through philosophy. The mathematician and philosopher Pythagoras (c. 582–c. 507 B.C.) believed that the universe was governed by numbers. He is generally credited with discovering that an octave is exactly half the length of the next lower one on a chord stretched over a graduated rule *(kanon)*. (However, it may have actually been the work of the fifth-century theorist Simos.) Also during the sixth century, Epigonos used a zither divided into quarter tones to determine the relationships between the modal scales. From then on, Greek aesthetics as a branch of philosophy was founded on the belief in harmonious proportion. Nevertheless, musical theory for the most part continued to be based on tonal intervals, which do not bear a simple mathematical relationship to each other. The importance of ratio was acknowledged by the great philosopher Plato, for whom the music of the spheres was made by eight Sirens representing the eight notes of the standard diatonic scale.

During the fifth century B.C., beauty itself was regarded as having inherent ethical associations and educative functions by Plato and his successor, Aristotle, who became the teacher of Alexander the Great. This concept, too, was rooted in music. It was first voiced in the 440s by Damon, Perikles' teacher, who spelled out a comprehensive theory of modes according to their expressive effect and impact on character. Damon warned against revolutions in music as bad for society. This idea was taken up as well by Plato, who had studied music under Damon's pupil Dracon. While it was challenged by the Epicurean philosophers in particular, the concept of musical ethos reached its height with Ptolemy, whose system of cosmic proportions was founded on his belief in the "tuning" of the soul.

along the coast of modern Turkey, gained their theoretical bent from Mesopotamia. In fact, Pythagoras' theorem $a^2 + b^2 = c^2$ had been solved a thousand years earlier, around the time of Hammurabi (see pages 79 and 81). Once they had acquired this taste for mathematics, the Greeks never lost it. Plato, too, made numbers the basis of his doctrine of ideal forms and acknowledged that the concept of beauty was commonly based on proportion, though he seems to have had little use for art. [See Primary Sources, no. 6, page 215.]

Polykleitos' faith in numbers also had a moral dimension often found in Classical Greek philosophy, including Plato's. Contemplation of harmonious proportions was equated with contemplation of the good. To the Greeks, pose and expression reflected character and feeling, which revealed the inner person and, with it, *arete* (excellence or virtue). Thus the lowered gaze of the *Doryphoros* may be seen as denoting modesty, a chief virtue to the Classical Greeks. Rather than being opposed to naturalism, this moral dimension was linked to a more careful treatment of form that makes the human figure appear more alive as well as more real. Classical Greek sculpture appeals to both the mind and the eye, so that human and divine beauty become one. No wonder that figures of victorious athletes have sometimes been mistaken for gods!

We can get some idea of what the *Doryphoros* might have looked like in its original bronze form from a pair of figures that created a sensation when they were found in the sea near Riace, Italy, in 1972 (figs. 5-45 and 5-46). They owe their importance to their fine workmanship and the extreme rarity of intact monumental bronze statues from ancient Greece. Miraculously, these statues still have their ivory and glass-paste eyes, bronze eyelashes, and copper lips. Combined with the detailed anatomy, they create an astonishingly lifelike presence. The pair challenges our understanding of Greek sculpture in many ways. What or whom do these statues represent? When and where were they made? What purpose did they serve? We do not yet have the answers to these questions. The stylistic and technical evidence suggests that they were made around the same time as the *Doryphoros*. Although they have sometimes been dated slightly earlier, the sculptor may well have been an older artist who was used to working in the Severe style and had not fully adapted to the new Classicism. (Compare the heads to the *Zeus* in fig. 5-48.)

A clue is provided by the statue in figure 5-46, which belongs to a widespread type. (In contrast, figure 5-45 does not conform to any known model.) Riace Warrior B, it seems, is a warrior rather than an athlete, in contrast to the *Doryphoros*. The extraordinary realism of the heads, so out of keeping with the idealization characteristic of Greek art, has yet to be explained. Were they meant to honor two heroes? It is tempting to think so. If that is the case, why were their names not recorded by ancient historians? Moreover,

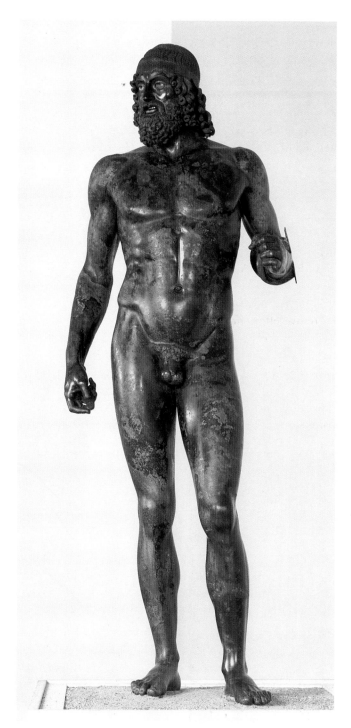

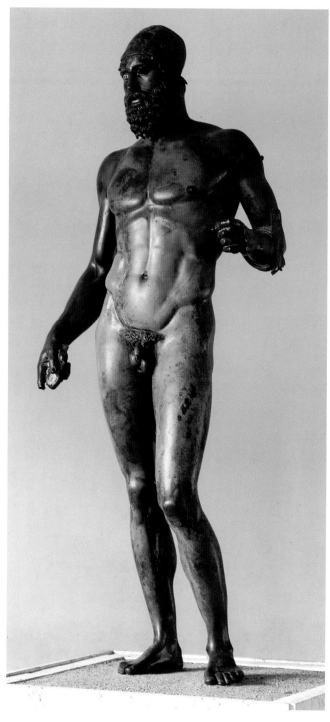

5 45. Riace Warrior A, found in the sea off Riace, Italy.
c. 450 B.C. Bronze, height 6'8" (2.03 m). Museo Archeologico,
Reggio Calabria, Italy

5-46. Riace Warrior B, found in the sea off Riace.
c. 450 B.C. Bronze, height 6'8" (2.03 m). Museo Archeologico,
Reggio Calabria

true portraits are unknown from this time. Perhaps, then, their features were varied to distinguish them from other members of a larger group, although freestanding groups of more than two figures are not recorded before the Late Classical era.

Conceptually, these figures are not altogether satisfying. The contrast between the individuality of the faces and the idealized treatment of the bodies is both fascinating and disturbing. Were there similar statues that we do not know of simply because they have not survived? Our view of Greek sculpture may be as distorted by the incomplete record as was that of the German poet Goethe (see box pages 682–683), who could not reconcile the Aegina statues with his understanding of Greek art.

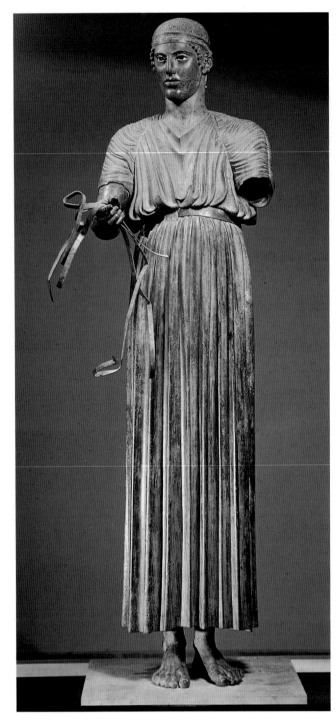

5-47. *Charioteer,* from the Sanctuary of Apollo at Delphi. c. 470 B.C.
Bronze, height 71" (180 cm). Archaeological Museum, Delphi

THE SEVERE STYLE. The *Charioteer* from Delphi (fig. 5-47), one of the earliest surviving large bronze statues in Greek art, shows why the period of Greek sculpture from about 480–450 B.C. is called the Severe style. It must have been made about a decade later than the *Kritios Boy*, as a votive offering after a race: the young victor originally stood on a chariot drawn by four horses. Despite the long, heavy garment, there is a hint of contrapposto in the body. The feet are differentiated so as to show that the left leg is the engaged one, and the shoulders and head turn slightly to the right. The garment is severely simple, yet compared with Archaic drapery the folds seem softer and more pliable. We feel, probably

for the first time in the history of sculpture, that they reflect the behavior of real cloth.

Not only the body but the drapery, too, reveals a new understanding of functional relationships. Every fold is shaped by the forces that act upon it: the pull of gravity, the shape of the body, and the belts or straps that constrict its flow. The face has the pensive look we saw in the *Kritios Boy*, but the colored inlay of the eyes and the slightly parted lips give it a more animated expression. The entire figure conveys the solemnity of the event it commemorates, for chariot races and similar contests were competitions for divine favor, not mere sporting events in the modern sense.

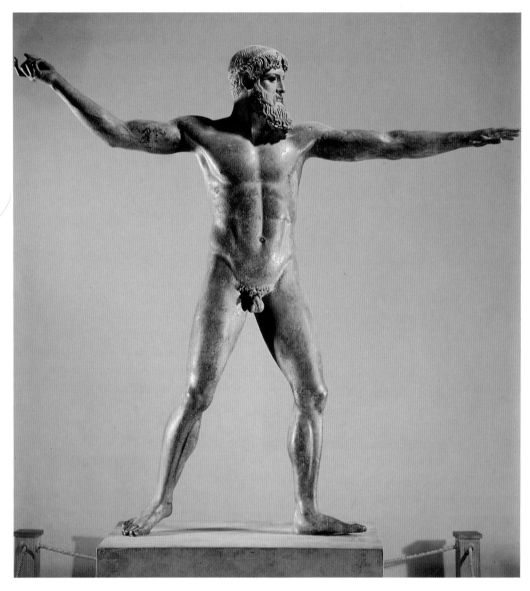

5-48. *Zeus.* c. 460–450 B.C. Bronze, height 6'10" (2.08 m). National Archaeological Museum, Athens

MOVEMENT IN STATUES. To infuse freedom of movement into genuinely freestanding statues was an enormous challenge to Greek sculptors. Not only did it run counter to an age-old tradition that denied mobility to these figures, but unfreezing them had to be done in such a way that their all-around balance and self-sufficiency would be preserved. The problem could not really be tackled until contrapposto was mastered. Then the solution no longer presented serious difficulties.

Large, freestanding statues in motion are the most important achievement of the Severe style. The finest figure of this kind was recovered from the sea near the coast of Greece (fig. 5-48): a mag-

nificent nude bronze, almost seven feet tall, of Zeus throwing a thunderbolt. Here stability in the midst of action becomes outright grandeur. The pose is not so much arrested motion as an awe-inspiring gesture that reveals the power of the god. Hurling a weapon thus becomes a divine attribute, rather than a specific act aimed at an adversary.

Some ten years after the *Zeus,* about 450 B.C., Myron created his bronze statue of the *Diskobolos (Discus Thrower),* which became as famous as the *Doryphoros.* It, too, is known to us only from Roman copies (fig. 5-49) [See Primary Sources, no. 3, pages 211–13.] Here the problem of how to condense a sequence of movements into a

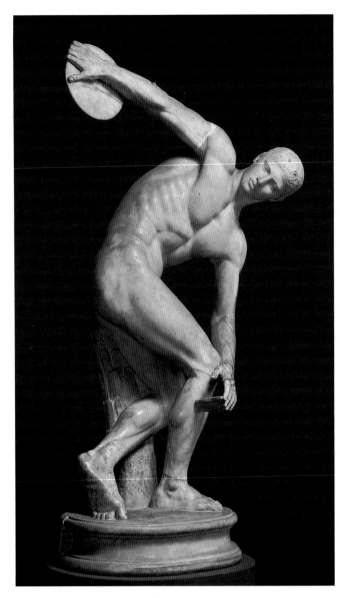

5-49. *Diskobolos (Discus Thrower).*
Roman marble copy after a bronze original of c. 450 B.C.
by Myron. Lifesize. Museo delle Terme, Rome

single pose without freezing it is much more complex. It involves a violent twist of the torso in order to bring the arms into the same plane as the legs. The pose conveys the essence of the action by presenting the coiled figure in perfect balance. (The copy makes the design seem harsher and less poised than it must have been in the original.)

Architectural Sculpture

THE TEMPLE OF ZEUS, OLYMPIA. Many of the original Greek sculptures that have survived to this day were part of ensembles created to ornament architecture. In fact, the greatest sculptural ensemble of the Severe style is the pair of pediments of the Temple of Zeus at Olympia. They were carved about 460 B.C., perhaps by Agelades of Argos, and have been reassembled in the local museum. The temple was paid for with spoils from the

victory of Elis over its neighbor Pisa in 470 B.C. (see also pages 128 and 130), which is reflected in the east pediment. The subject is Pelops's triumph over Oinomaos, the king of Pisa, in a chariot race for which the prize was the hand of the ruler's daughter, Hippodamia. Pelops (for whom the Pelopponesus is named) held a position of special importance to the Greeks, for he was thought to have founded the games at Olympia. But because he won by trickery, he and his descendants, which included Herakles and Agamemnon, were cursed. Hence his example also served as a warning to contestants as they paraded past the temple.

In the west pediment, the more mature of the two, we see the victory of the Lapiths over the Centaurs (fig. 5-50). Centaurs were the offspring of Ixion, king of the Lapiths, and a phantom of Hera, whom he tried to seduce while in Olympos. (Zeus had brought him there to be purified for having murdered his father-in-law in order to avoid paying for his bride.) In punishment for his impiety, Ixion was chained forever to a fiery wheel in Tartarus. Since they were the half-brothers of the Lapiths, the Centaurs were invited to the wedding of the Lapith king Peirithoös and Deidameia (who is sometimes also referred to as Hippodameia, though she was not related to her namesake on the other pediment). Because they were half-animals, the Centaurs became drunk and got into a brawl with the Lapiths, who subdued them with the aid of Peirithoös' friend Theseus.

At the center of the composition stands Apollo. His commanding figure is part of the drama and yet above it. The outstretched right arm and the strong turn of the head show his active role. He wills the victory but, as befits a god, does not physically help to achieve it. Still, there is a tenseness in this powerful body that makes its outward calm even more impressive.

The forms themselves are massive and simple, with soft contours and undulating surfaces. To the left of Apollo, we see another achievement of the Severe style in the Centaur king, Eurytion, who has seized Hippodameia. No Archaic artist would have known how to combine the two into a group so compact, so full of interlocking movements. Strenuous action had already been investigated, of course, in pedimental sculpture of the late Archaic period (see figs. 5-23 and 5-24). Here, however, the passionate struggle is expressed not only through action and gesture but through the emotions mirrored in the face of the Centaur, whose pain and desperate effort contrast vividly with the stoic calm on the face of the young woman.

The pediment makes a clear moral distinction in the contrast between the bestial Centaurs and the humans, who share Apollo's nobility. Thus it is Apollo, as the god of music and poetry, who is the real hero. In general, the pediment stands for the victory of humanity's rational and moral sides over its animal nature. It thus celebrates the triumph of Greek civilization over barbarianism as a whole—and the victory over the Persians in particular. (It may also have served as a gentle reminder to visitors at the Olympian games to behave in a dignified manner.)

Equally important are the metopes depicting the labors of Herakles, Pelops' great-grandson, who according to legend laid out the stadium at Olympia. Narrative scenes had been a feature of metopes since the early sixth century B.C., but it was not until a

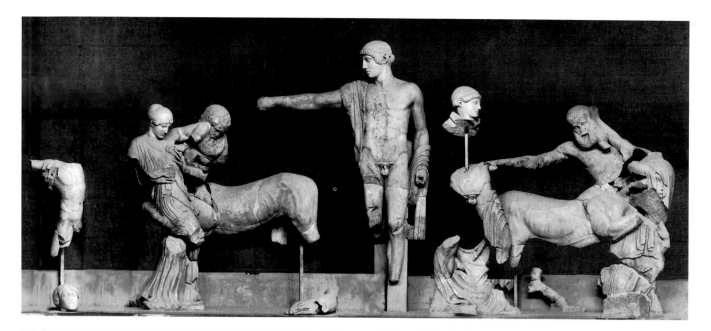

The confident yet self-questioning atmosphere which developed in the wake of the victory over the Persians also served to bring to maturity the dominant and most characteristic literary form of the fifth century B.C.—Athenian tragic drama. The dramas were public rites, performed at religious festivals by actors who were, in most cases at least, the fellow citizens of those who witnessed them. They were above all reflections of group-experience. The dramatic poet, whether reflecting the mentality of his time or seeking to shape it (or both), spoke to, and often for, society as a whole. It is therefore not surprising that the best dramas bring into focus simultaneously most of the intellectual and emotional preoccupations of the Early Classical period. . .

Sculptors and painters seem. . .actually to have borrowed some of the technical devices which had been developed in dramatic performances to convey character and narrative action—for example, the formal gestures of actors, the masks which were designed to express at once an individual character and a basic human type, and perhaps also a sense of dramatic timing. Nowhere is the attempt to adapt the themes, spirit, expressive power, and technical components of the great dramatic cycles. . .to the medium of the visual arts more successfully and grandly carried out than in the sculptures of the temple of Zeus at Olympia. . .

—J. J. Pollitt. *Art and Experience in Classical Greece.* Cambridge, England, and New York: Cambridge University Press, 1972, p. 27

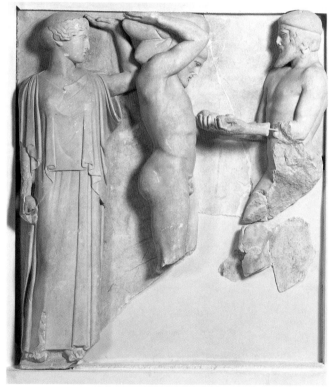

5-51. *Atlas Bringing Herakles the Apples of the Hesperides.* c. 456 B.C. Marble, height 63" (160 cm). Archaeological Museum, Olympia

hundred years later that they began to outgrow their crude beginnings. At Olympia the pictorial and dramatic possibilities are fully exploited for the first time. Our example, which was featured prominently over the entrance on the east side of the temple, shows Atlas returning with the apples of the Hesperides (fig. 5-51). During Atlas' absence, Herakles held the celestial globe on his shoulders with the seemingly effortless support of Athena. He looks on almost in astonishment as he tries to think of a way to trick Atlas into giving up the apples. In contrast to the grim combats featured in Archaic Greek art (see figs. 5-6, 5-7), Herakles takes on the more thoughtful air that is basic to the Classical spirit. The scene is

depicted with a wonderful economy of pose and expression that further serves to enhance the hero's stature. The carving is no less beautiful than those on the pediment and participates fully in the development of the Severe style.

THE CLASSICAL STYLE. The pedimental figures we have seen thus far, although technically carved in the round, are not freestanding. Rather, they are a kind of super-relief, designed to be seen against a background and from one direction only. By contrast, the *Dying Niobid* (fig. 5-52), a work of the 440s, is so three-dimensional and self-contained that we would hardly suspect she was carved for the pediment of a Doric temple. According to legend, Niobe had humiliated the mother of Apollo and Artemis by boasting of the numerical superiority of her seven sons and seven daughters. In revenge, the two gods killed all of Niobe's children. Our Niobid ("child of Niobe") has been shot in the back while running. Her strength broken, she sinks to the ground while trying to extract the fatal arrow. The violent movement of her arms has made her garment slip off. Her nudity is thus a dramatic device rather than a necessary part of the story.

The *Niobid* is the earliest known large female nude in Greek art. The artist's main goal was to display a beautiful female body

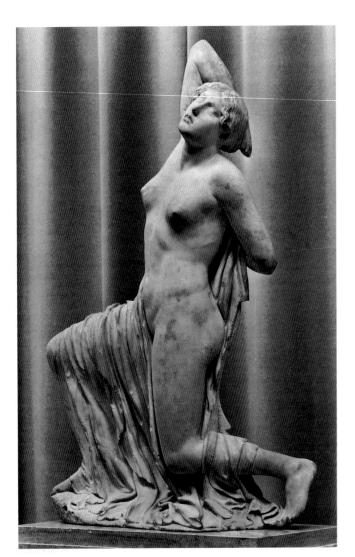

5-52. *Dying Niobid.* c. 450–440 B.C. Marble, height 59" (1.5 m). Museo delle Terme, Rome

in the kind of strenuous action that previously had been reserved for the male nude. Still, we must not misread the intent. It was not a detached interest in the physical aspect of the event alone but the desire to unite motion and emotion and thus to make the viewer experience the suffering of this victim of a cruel fate. In the *Niobid,* human feeling is for the first time expressed as eloquently in the features as in the rest of the figure.

A glance at the wounded warrior from Aegina (see fig. 5-23) will show us how differently the agony of death had been conceived only half a century before. What separates the *Niobid* from the world of Archaic art is summed up in the Greek word *pathos*. *Pathos* means suffering, but particularly suffering conveyed with nobility and restraint, so that it touches rather than horrifies us. Late Archaic art may approach it now and then, as in *Eos and Memnon* (see fig. 5-8). Yet the full force of pathos can be felt only in Classical works such as the *Dying Niobid.*

To measure the astonishing development of Greek sculpture in less than two centuries, let us compare the *Niobid* with the Gorgon from Corfu (see fig. 5-17). These two works, worlds apart as they may be, do in fact belong to the same artistic tradition. The *Niobid,* too, shows the pinwheel stance, even though its meaning is vastly different. Once we recognize the ancient origin of her pose, we understand why the *Niobid,* despite her suffering, remains so monumentally self-contained.

THE PARTHENON. The largest, as well as the finest, group of Classical sculptures that has come down to us are the remains of the marble decoration of the Parthenon. Unfortunately, a large number of these works are in battered and fragmentary condition. Many were removed between 1801 and 1803 by Lord Elgin; known as the Elgin Marbles, these are housed today in The British Museum, where they were over-cleaned and clumsily restored. The centers of both pediments are gone, and of the corner figures, only those from the east pediment are intact enough to convey something of the quality of the whole. They represent various deities, most in sitting or reclining poses, witnessing the birth of Athena from the head of Zeus (figs. 5-53 and 5-54). (The west pediment portrayed the struggle of Athena and Poseidon for Athens.)

Here, even more than in the case of the *Dying Niobid,* we marvel at the ease of movement even in repose. There is neither violence nor pathos in them—indeed, no specific action of any kind, only a deeply felt poetry of being. We find it equally in the relaxed muscular body of Dionysos and in the soft fullness of the three goddesses, enveloped in thin drapery that seems to share the qualities of water as it flows around the forms underneath. Although all are seated or half-reclining, the turning of the bodies under the folds of their costumes makes them seem anything but static. Indeed, the "wet" drapery unites them in one continuous action, so that they seem to be in the process of arising.

The figures are so freely conceived in depth that they create their own space. In fact, we find it hard to imagine them "shelved" upon the pediment. Evidently so did the sculptors who achieved such lifelike figures. The composition as a whole (fig. 5-55) treats the triangular field as a purely physical limit. For example, two horses' heads are placed in the sharp angles at the corners, at the feet of Dionysos and the reclining goddesses. They represent the

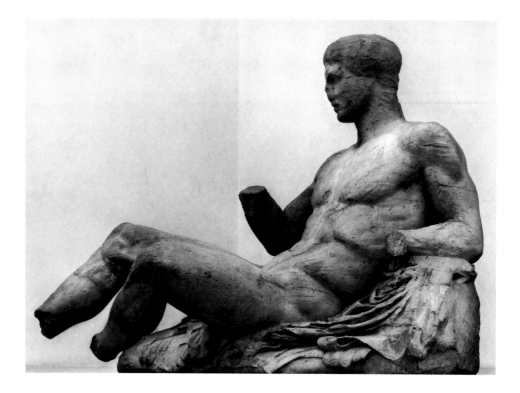

(RIGHT) 5-53. *Dionysos,* from the east pediment of the Parthenon. c. 438–432 B.C. Marble, over-life-size. The British Museum, London

(BELOW) 5-54. *Three Goddesses,* from the east pediment of the Parthenon. c. 438–432 B.C. Marble, over-lifesize. The British Museum, London

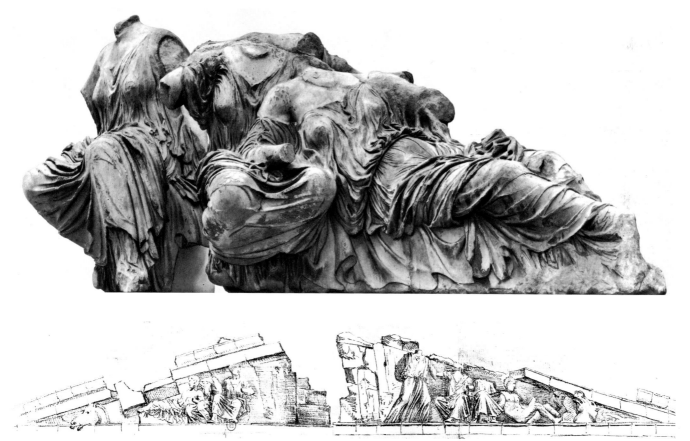

5-55. Jacques Carrey. Drawings of the east pediment of the Parthenon. 1674. Bibliothèque Nationale, Paris

chariots of the sun and the moon—one emerging into the pediment and the other dipping below it—to portray the lapsed time of a day. But visually the heads are merely two fragments cut off by the frame. Clearly we are approaching a time when the pediment will no longer be the focal point of Greek architectural sculpture. The sculptural decoration of later buildings tended to be placed in areas where the figures would seem less boxed in and be more readily visible.

The frieze of the Parthenon, a continuous band 525 feet long (see fig. 5-33), is of the same high quality as the pediment sculptures. In a different way it, too, suffered from subordination to its setting. Placed just below the ceiling, it must have been poorly lit and

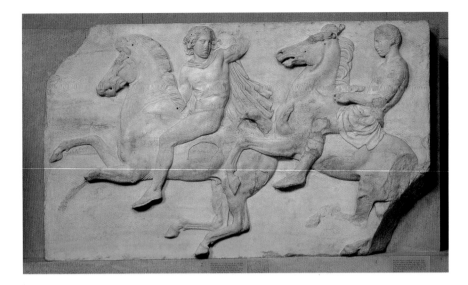

5-56. *Horsemen,* from the west frieze of the Parthenon. c. 488–432 B.C. Marble, height 43" (109.3 cm). The British Museum, London

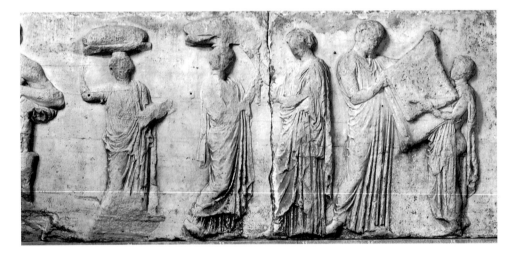

5-57. *The Sacrifice of King Erechtheus' Daughters* (?), from the east frieze of the Parthenon. c. 440 B.C. Marble, height 43" (109.3 cm). The British Museum, London

difficult to see. The concept of relief and depth of the carving are not radically different from the frieze of the Siphnian Treasury (see figs. 5-20 and 5-21). However, the illusion of space and of rounded form is now achieved with the greatest ease. The most noteworthy aspect of the Parthenon frieze is the rhythmic grace of the design, especially the spirited movement of the groups of horsemen (fig. 5-56).

The frieze is widely believed to depict a Panathenaic procession. Such events were held annually, with a greater one every four years, to honor Athena in the presence of the other Olympic gods. Although the figures and their groupings are typical of the participants in these processions, the account is an idealized one, unified thematically rather than in time and place. In addition, it has been argued that this is a "heroicized" representation that honors the 192 Athenians slain at the battle of Marathon. This argument is based on the grounds that the frieze originally had a like number of equestrian figures, although it cannot be proved. Their sacrifice was honored by the original Parthenon, which was begun soon after the battle but was burned by the Persians in 480 B.C. The battle was the subject of a famous painting by Polygnotos of Thasos in the Athenian stoa (see pages 135–136), as well as one in the pinakotheke at the entrance to the Akropolis itself.

The most problematic aspect of the relief is the detail in figure 5-57. According to one recent theory, this scene depicts not the folding of the new peplos for the Archaic statue of Athena but the sacrifice by King Erechtheus of his three daughters. Their death was demanded by the oracle at Delphi, in order to save Athens from its enemies; Erechtheus himself was to perish during his victory over Eumolpos, the son of Poseidon. The subject would have been especially significant to the city following its victory over the Persians, who had desecrated the old Temple of Athena. This theory, which is highly controversial, hinges in part on whether the younger figure to the right is indeed a girl instead of a boy, as some have suggested. Yet it has the advantage of integrating the frieze conceptually into the rest of the Parthenon and the Akropolis as a whole. Each of these three options is tempting, yet none accounts for every element. It is even possible that all three played a role. The issue, which may never be fully resolved, is typical of the problems that confront scholars in even the most familiar monuments.

The metopes, which date from the 440s, are very different from the rest of the sculpture on the Parthenon in showing violent action. We have met two of the subjects before: the combat of the gods and giants and the battle of Lapiths and Centaurs (see figs. 5-21 and 5-50). It is the other two subjects that provide the key to their meaning. They are the Sack of Troy by the Greeks, and Greeks fighting Amazons, who, according to legend, had once desecrated the Akropolis. The entire cycle forms an allegory of the Athenian victory over the Persians, who likewise had destroyed the Akropolis. But rather than presenting the war as historical

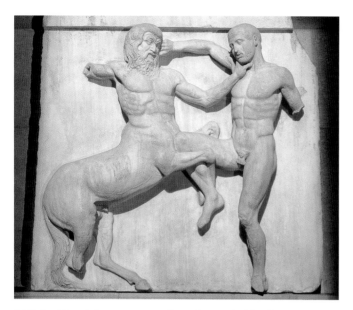

5-58. *Lapith and Centaur,* metope from the south side of the Parthenon. c. 440 B.C. Marble, height 56" (142.2 cm). The British Museum, London

fact, the Greek artist cloaked it in the guise of myth and legend in order to explain the outcome, as if preordained.

The metopes vary in quality and do not form a fully coherent program. However, the best of them, such as our scene of a Lapith fighting a Centaur (fig. 5-58), have a dramatic force that is still grounded in the pediment at Olympia of almost 20 years earlier (see fig. 5-50). The sculptor has been remarkably successful in overcoming the obstacles presented by the metope. Because it was placed high above the ground, where it could barely be seen, the figures fill as much of the field as possible and are carved deeply so as to appear nearly in the round. Although the action seems somewhat forced in both pose and expression when seen up close, it has been beautifully choreographed for maximum clarity and impact when seen from the ground.

PHEIDIAS. The Parthenon sculptures have long been associated with the name of Pheidias, who, according to the Greek biographer Plutarch, was the chief overseer of all the artistic projects sponsored by Perikles. [See Primary Sources, no. 5, pages 214–15.] Pheidias was famous for the huge ivory-and-gold statue of Athena that he made for the cella of the Parthenon, an equally large bronze sculpture of Athena that stood on the Akropolis facing the Propylaea, and another colossal figure for the Temple of Zeus at Olympia. The admiration they aroused may have been due to their size, the cost of the materials, and the aura of religious awe surrounding them. None of these works survives, and small-scale copies made in later times cannot convey the artist's style. Therefore we know very little about Pheidias' artistic personality. He may have been simply a very able supervisor, but more likely he was a genius, comparable to the Egyptian architect Imhotep (see page 53), who could give powerful expression to the ideas of his patron.

The Parthenon sculptures undoubtedly involved a large number of masters, since the two pediments and frieze were executed in less than ten years (c. 440–432 B.C.). The term *Pheidian style* is

nevertheless convenient, for it conveys an ideal that was not merely artistic but philosophical: it denotes a distinctive attitude in which the gods are aware of, yet aloof from, human affairs as they fulfill their cosmic roles. This outlook came to be widely shared among Greek philosophers, especially in the fourth century B.C.

It is hardly surprising that the Pheidian style should have dominated Athenian sculpture until the end of the fifth century and beyond, even though large-scale sculptural enterprises gradually came to a halt because of the Peloponnesian War. The last of these projects was the balustrade built around the small Temple of Athena Nike about 410–407 B.C. Like the Parthenon frieze, it shows a festive procession, but the participants are winged personifications of victory (*Nike* means "Victory") rather than citizens of Athens. One Nike (fig. 5-59) is taking off her sandals, in observance of an age-old tradition, indicating that she is about to step on holy ground (see page 50). Her wings—one open, the other closed—help her keep her balance, so that she performs this normally awkward act with consummate elegance and ease. Her figure is more strongly detached from the relief ground than are those on the Parthenon frieze, and her garments, with their deeply cut folds, cling to her body. We saw an earlier phase of this "wet" drapery in the *Three Goddesses* of the Parthenon (fig. 5-54).

5-59. *Nike,* from the balustrade of the Temple of Athena Nike. c. 410–407 B.C. Marble, height 42" (106.7 cm). Akropolis Museum, Athens

5-60. *Grave Stele of Hegeso.* c. 410–400 B.C. Marble, height 59" (150 cm). National Archaeological Museum, Athens

to place figures at various heights in a landscape setting and to depict women in transparent drapery. But, above all, he introduced the "representation of emotion and character [and the] use of patterns of composition," which became as central to Classical painting as they were to sculpture. A major advance came a hundred years later with the invention of shading by Apollodoros of Athens.

Painting reached its peak in the fourth century B.C., when it was recognized as one of the liberal arts. During this period, numerous rival schools emerged as paintings on wooden panels replaced wall painting. Among the leading artists mentioned by the Roman writer Pliny the Elder are Zeuxis of Herakleia, a master of texture, and Parrhasios of Ephesos, who "first gave proportion to painting . . . and was supreme in painting contour lines, which is the most subtle aspect of painting." Pliny also mentions Apelles of Kos, Alexander the Great's favorite artist and the most famous painter of his day, celebrated for his grace; and Nikomachos of Athens, renowned for his rapid brush. [See Primary Sources, no. 3, page 000.]

We get a tantalizing glimpse of Classical painting in *The Abduction of Proserpine* (fig. 5-61). This painting comes from one of several Macedonian tombs, including Phillip II's, at Vergina, of about 340–330 B.C. Discovered only in 1976, they are of great importance because they contain the only relatively complete Greek wall paintings to come to light. The subject is appropriate to the funereal setting. Proserpine, goddess of vegetation, was abducted by Hades, ruler of the underworld, to be his queen. Thanks to Zeus' intervention, she was allowed to return to earth

Also Pheidian, and also from the last years of the century, is the beautiful *Grave Stele of Hegeso* (fig. 5-60). Memorials of this kind were produced in large numbers by Athenian sculptors, and their export must have helped to spread the Pheidian style throughout the Greek world. Few of them, however, can match the harmonious design and the gentle melancholy of our example. The deceased is represented in a simple domestic scene that was a standard subject for sculptured and painted memorials of young women. She has picked a necklace from the box held by the girl servant and seems to be contemplating it as if it were a keepsake. The delicacy of the carving can be seen especially well in the forms farthest removed from the viewer, such as the servant's left arm supporting the lid of the jewel box, or the veil behind Hegeso's right shoulder. Here the relief merges with the background, so that the ground appears more like empty space than a solid surface. This novel effect was probably inspired by paintings. Indeed, the subject is similar to those found on white-ground lekythoi (oil jugs) of the same period (see fig. 5-63).

CLASSICAL PAINTING

Written sources tell us a great deal about how Classical painting evolved, but rarely in enough detail for us to know what it looked like. The great age of Greek painting began in the Early Classical period with Polygnotos of Thasos and his collaborator, Mikon of Athens, who were sculptors as well. Polygnotos was the first artist

5-61. *The Abduction of Proserpine.* Detail of a wall painting in Tomb I, Vergina, Macedonia. c. 340–330 B.C

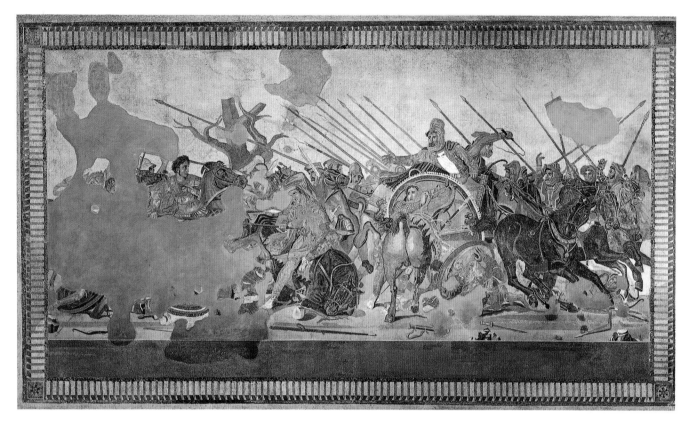

5-62. *The Battle of Issos* or *Battle of Alexander and the Persians*. c. 100 B.C. Mosaic copy from Pompeii of a Hellenistic painting of c. 315 B.C. 8'11" x 16'9½" (2.7 x 5.1 m). Museo Archeologico Nazionale, Naples

for six months of every year. Because of its rapid brushwork, the painting may well be based on a famous work by Nikomachos of Athens. The forceful expressiveness more than makes up for any technical deficiencies of the artist, who clearly was not of the first rank: the scene has a magnificent sweep that captures the frenzy of the moment. The technique reflects the main tradition of Greek painting, which gave primacy to line, although there was also a competing tendency that emphasized color.

We can gain a further idea of what Greek wall painting looked like from Roman copies and imitations, although their relation is problematic (see pages 205–208). According to Pliny, at the end of the fourth century Philoxenos of Eretria painted the victory of Alexander the Great over Darius III at Issos. The same subject is shown in an exceptionally large and technically masterful floor mosaic from a Pompeian house of about 100 B.C. (fig. 5-62). The scene, recently attributed to Apelles of Kos (see above), depicts Darius and the fleeing Persians on the right and, in the badly damaged left-hand portion, the figure of Alexander.

While there is no absolute reason to link this mosaic with Pliny's account (several others are recorded), we can hardly doubt that it is an excellent copy of a Hellenistic painting from the late fourth century B.C. The picture follows the four-color scheme (yellow, red, black, and white) that is known to have been widely used at that time. [See Primary Sources, no. 3, page 211.] The crowding, the air of frantic excitement, the powerfully modeled and foreshortened forms, and the precise shadows make the scene far more complicated and dramatic than any other known work of Greek art from the period. And for the first time it shows something that actually happened, without the symbolic overtones of the

Battle of the Lapiths and Centaurs (see figs. 5-50 and 5-58). In character and even in appearance, it is close to Roman reliefs commemorating specific historic events (see figs. 7-35–7-37). Yet there can be little doubt that the mosaic was created by a Greek, as this technique originated in Hellenistic times and remained a specialty of Greek artists to the end.

According to literary sources, Greek painters of the Classical period made a breakthrough in mastering illusionistic space. [See Primary Sources, no. 3, page 211, and no. 6, page 215.] This claim is supported in part by other murals found in Macedonia. By its very nature, vase painting was limited in its ability to make use of the new concept of pictorial space. Still, there are some exceptions to this rule. We find them mostly in the lekythoi (oil jugs) used as funerary offerings. These vases had a white coating on which painters could draw as freely and with the same spatial effect as if they were using pen and paper. The white ground is treated as empty space from which the forms seem to emerge—if the artist knows how to achieve this effect.

Only a few lekythos painters were able to create this illusion. Foremost among them is the unknown master, called the Achilles Painter, who drew the woman in figure 5-63. Although some 25 years older than the Hegeso stele, this vase shows a similar scene. There is the same mood of Pheidian reverie, as a woman (perhaps a poetess seeking inspiration) listens to the muse playing her lyre on Mount Helikon, accompanied by a nightingale. Our chief interest, however, is in the masterly draftsmanship. With a few lines, sure, fresh, and fluid, the artist not only creates a three-dimensional figure but reveals the body beneath the drapery as well. What persuades us that these shapes exist in depth rather

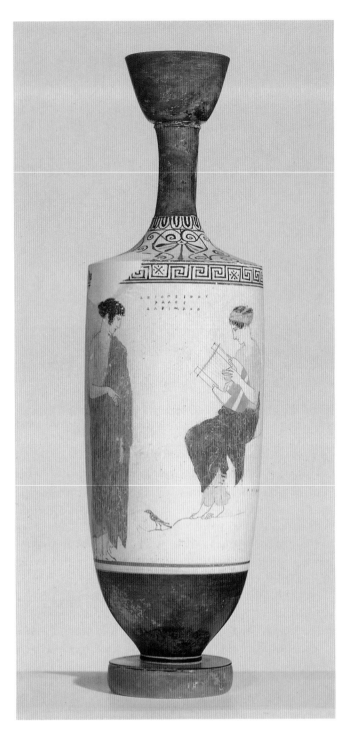

In view of its artistic advantages, we might expect wider use of the white-ground technique. Such, however, was not the case. Instead, from the mid-fifth century on, the impact of monumental painting gradually transformed vase painting into a satellite art. Vase painters tried to reproduce large-scale compositions in a kind of shorthand dictated by their limited technique. The result, more often than not, was spotty and overcrowded.

Even the finest examples suffer from this defect, as we can see in figure 5-64. This vase was produced near the end of the Classical period by an Athenian artist known as the Marsyas Painter. It shows Thetis, who is about to bathe in the sea, being abducted by Peleos as two of her maids flee in panic. The main figures are placed on a firm ground-line, with a bit of wavy water to suggest the setting. The others, intended to be farther away, seem to be suspended in midair. Although the turning poses also try to create the illusion of space, the effect remains flat and silhouette-like because of the black background.

In an attempt to enlarge the color range, the bodies of Thetis and of Eros crowning Peleos have been painted white. Thetis' dress has been filled in with green as well. However, the medium does not permit shading or modeling. Our artist must therefore rely on the network of lines to hold the scene together and create maximum excitement. And, being a good draftsman, he almost succeeds. Still, it is a success at second hand, for the composition must have been inspired by a mural or panel painting. The Marsyas Painter is, as it were, fighting for a lost cause. In effect, we have reached the end of Greek vase painting, which disappeared as a major form by the end of the century.

5-63. The Achilles Painter. *Muse and Maiden,* on an Attic white-ground lekythos. c. 440–430 B.C. Height 16" (40.7 cm). Staatliche Antikensammlungen, Munich

than merely on the surface of the vase? First of all, the use of foreshortening. But the "internal dynamics" of the lines are equally important. Their swelling and fading make some contours stand out while others merge with one another or disappear into the white ground. The effect is completed by the color, which is unusually elaborate for a lekythos: vermilion for the *himations* (loose outer garments) and the muse's head scarf, ocher for her *chiton.* The artist has made skillful use of the white ground to enliven the "empty" space by adding an inscription: "Axiopeithes, the son of Alkimachos, is beautiful."

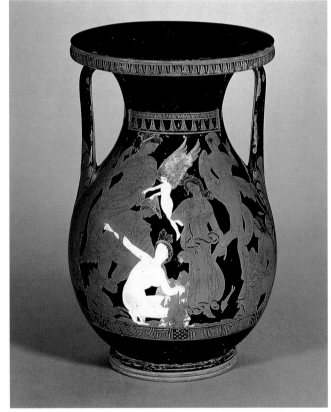

5-64. The Marsyas Painter. *Peleos and Thetis,* on a Kerch-style pelike. c. 340 B.C. Height 16¾" (42.5 cm). The British Museum, London

FOURTH-CENTURY SCULPTURE

The Pheidian style, so harmonious in both feeling and form, did not long survive the defeat of Athens by Sparta in the Peloponnesian War. Building and sculpture continued in the same tradition for another three centuries, but without the subtleties of the Classical age. Unfortunately, there is no single word, like *Archaic* or *Classical,* that we can use to designate this third and final phase in the development of Greek art, which lasted from about 400 to the first century B.C. The 75-year span between the end of the Peloponnesian War and the rise of Alexander the Great used to be called Late Classical. The remaining two centuries and a half were labeled Hellenistic, a term that was meant to convey the spread of Greek civilization southeastward to Asia Minor and Mesopotamia, Egypt, and the borders of India following Alexander's conquests between 333 and 323 B.C. The military incursions gave rise to a wave of migrations to the east, where new cities were founded, ruled by absolute monarchs, and rivaled the city-states of Greece in wealth, power, and culture. The most important of these were Alexandria, the city founded by Alexander in Egypt shortly before his death, Antioch, Pergamon, and Halikarnassos. At the same time, the island of Rhodes gained its independence and rose to become a major power.

It was natural to expect that these changes would bring about an equal artistic revolution. However, the history of style is not always in tune with political history. Although the center of Greek thought shifted to Alexandria, there was no decisive break in the tradition of Greek art at the end of the fourth century. The art of the Hellenistic era is the direct outgrowth of developments that occurred, not at the time of Alexander, but during the preceding 50 years.

Here, then, is our dilemma: Hellenistic is a concept so closely linked with the political and cultural effects of Alexander's conquests that we cannot extend it backward to the early fourth century. This difficulty holds true even though there is wide agreement that the art of the years 400 to 325 B.C. can be understood far better if we view it as pre-Hellenistic rather than as Late Classical. But until the right word is found and becomes widely accepted, we shall have to make do with Late Classical, always keeping in mind the continuity of the third phase that we are about to examine.

THE MAUSOLEUM AT HALIKARNASSOS. The contrast between Classical and Late Classical art is strikingly demonstrated by the only project of the fourth century that corresponds to the Parthenon in size and ambition. It is not a temple but a huge tomb designed by Pytheos of Priene and built at Halikarnassos in Asia Minor about 360 B.C. by Mausolos, the ruler of Caria, and his widow, Artemisia. From his name comes the term *mausoleum,* used ever since for large, above-ground funerary monuments. The structure itself has been destroyed, but its dimensions and appearance can be reconstructed on the basis of ancient descriptions and the remaining fragments, which include a good deal of sculpture. [See Primary Sources, no. 3, page 211.]

The drawing in figure 5-65 is not an exact reconstruction. We know, however, that the building rose in three stages to a height of about 160 feet. A tall rectangular base 117 feet wide and 82 feet deep supported a colonnade of Ionic columns 40 feet tall. Above

5-65. Reconstruction drawing of the Mausoleum at Halikarnassos. 359–351 B.C.

this was a pyramid crowned by an enormous quadriga (four-horse chariot) with statues of Mausolos and Artemisia. There were two long friezes showing Greeks battling Persians and Greeks fighting Amazons, each as long as the Parthenon frieze. Between them was a row of Greek and Persian figures. Along the colonnade were 36 large statues of Mausolos' family, and on the roof was a row of carved guardian lions.

The commemorative character of the monument, based on the idea of life as a glorious struggle or chariot race, is entirely Greek. Yet we immediately notice the un-Greek way in which it has been carried out. The vast size of the tomb and the pyramid form are derived from Egypt. They imply an exaltation of the ruler far beyond ordinary human status. His kinship with the gods may have been hinted at also. Apparently Mausolos took the view of himself as a divinely ordained sovereign from the Persians, whom he served as a satrap; they in turn had inherited it from the Assyrians and Egyptians. However, he seems to have wanted to glorify his personality as much as his office. The structure must have struck his contemporaries as impressive and monstrous at the same time, with its multiple friezes and a pyramid instead of pediments above the colonnade.

SKOPAS. According to Pliny, the sculpture on each of the four sides of the monument was done by a different master, chosen from among the best of the time. Bryaxis did the north side, Timotheos the south, Leochares the west, and Skopas, the most famous, the main one on the east. [See Primary Sources, no. 3, page 211.] Skopas' dynamic style has been recognized in some parts of the Amazon frieze, such as the portion in figure 5-66. The Parthenon style can still be felt here, but its harmony and rhythmic flow have been replaced by an un-Classical violence, physical as well as emotional, which is conveyed through strained movements and passionate expressions, heightened by the deep-set eyes that are a hallmark of Skopas' style. His sweeping, impulsive gestures require a lot of elbow room. What the composition lacks in continuity, it more than

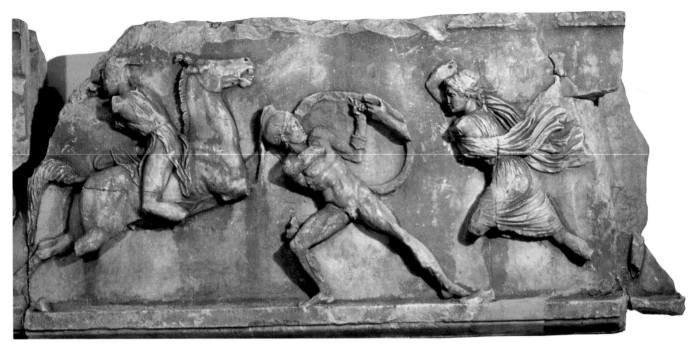

5-66. Skopas (?). *Battle of the Greeks and Amazons,* from the east frieze of the Mausoleum, Halikarnassos. 359–351 B.C. Marble, height 35" (88.9 cm). The British Museum, London

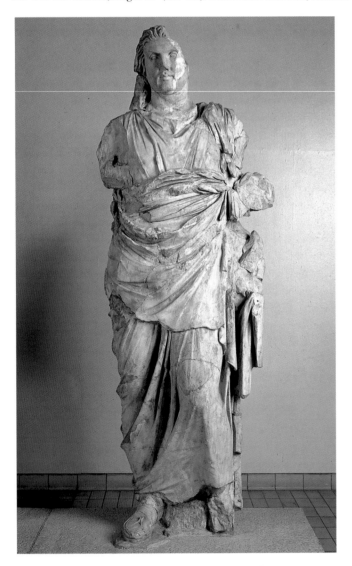

5-67. *"Mausolos,"* from the Mausoleum at Halikarnassos. c. 360 B.C. Marble, height 9'10" (3.1 m). The British Museum, London

makes up for in boldly innovative inventions, such as the Amazon seated backward on her horse. In a sense, Skopas turned back as well—to the scenes of violent action so popular in the Archaic period. We recognize the ancestor of this scene in the Siphnian *Battle of the Gods and Giants* (see fig. 5-21). But he clearly also learned from the example of the Parthenon metopes (see fig. 5-58).

The Late Classical flavor is even more pronounced in one of the statues from the colonnade, sometimes presumed to portray Mausolos himself (fig. 5-67). The figure must be the work of a man younger than Skopas and even less tied to Classical standards, probably Bryaxis, the master of the north side. Through Roman copies, we know of some Greek portraits of Classical times, but they seem to represent types rather than individuals. Such is probably the case here. The figure is a distinctly non-Greek sort. Not until Hellenistic times did physical likenesses become important. Still, the head has a surprisingly personal character, with its heavy jaws and small, sensuous mouth—features later found in the Hellenistic portrait head from Delos (see fig. 5-79). The thick neck and fleshy body seem equally individual. The massiveness of the forms is emphasized by the stiff drapery, which encases, rather than merely clothes, the body. The great volumes of folds across the abdomen and below the left arm seem designed for picturesque effect more than for functional clarity.

THE DEMETER OF KNIDOS. Some aspects of the Mausoleum sculpture are found in other important statues of the period. Foremost among them is the seated figure of the goddess Demeter from her temple at Knidos on the western coast of Ionia (fig. 5-68). Here again the drapery, although more finely textured, has an impressive volume of its own. Motifs such as the S-curve of folds across the chest form a counterpoint to the shape of the body beneath. The deep-set eyes gaze into the distance with an intensity that suggests the influence of Skopas. The modeling of the head,

however, has a softness that points to a different source: Praxiteles, the master of feminine grace and sensuous rendering of flesh.

PRAXITELES. The Demeter is probably only slightly later than Praxiteles' most famous statue, an Aphrodite of about 340–330 B.C. (fig. 5-69). That work was purchased by the island of Knidos, while a clothed version was acquired, so Pliny tells us, by the people of Kos. [See Primary Sources, no. 3, page 211.] Hence the sculptor who carved the Demeter would have had no difficulty giving his own work some Praxitelean qualities. Unlike many free-standing Classical Greek sculptures, the *Knidian Aphrodite* was done in marble, which Praxiteles adopted in preference to bronze early in his career. She achieved such fame that she is often referred to in ancient literature as a synonym for perfection. (According to one account, Alexander the Great's mistress, Phryne, posed for the statue.) She was to have countless descendants in Hellenistic and Roman art. To what extent her fame was based on her beauty is difficult to say, for the statue is known to us only through Roman copies that can be no more than pale reflections

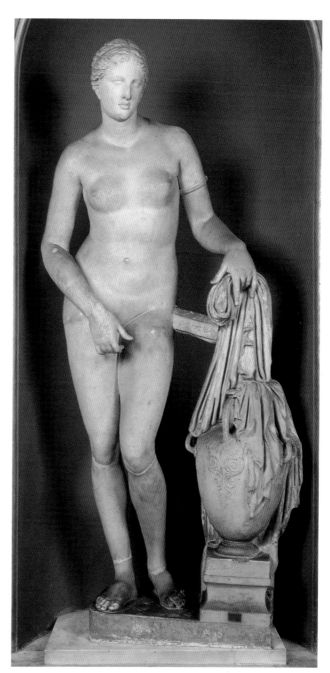

5-69. *Knidian Aphrodite*. Roman copy after an original of c. 340–330 B.C. by Praxiteles. Marble, height 6'8" (2 m). Musei Vaticani, Museo Pio Clementino, Gabinetto delle Maschere, Città del Vaticano, Rome

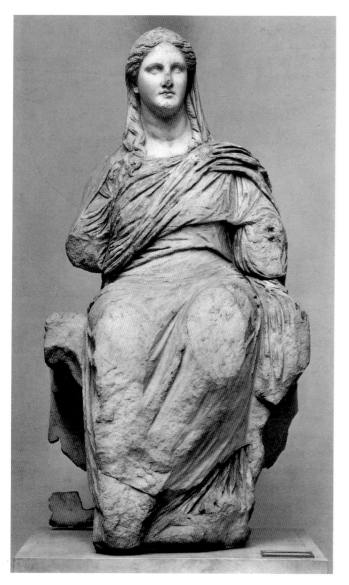

5-68. *Demeter,* from Knidos. c. 330 B.C. Marble, height 60" (152.3 cm). The British Museum, London

of the original. Her reputation rested at least as much on the fact that she was (so far as we know) the first completely nude monumental cult statue of a goddess in Greek art. She was placed in an open-air shrine in such a way that the viewer "discovered" her in the midst of bathing; yet through her self-contained pose and expression, she maintains a modesty so chaste that it could not fail to disarm even the sternest critic.

A more faithful example of Praxitelean beauty is the group of Hermes with the infant Bacchos (fig. 5-70). Pausanias mentions seeing such a statue by Praxiteles at the Temple of Hera at Olympia, where this marble was found in 1877. It is of such high quality that it was long regarded as a late work by Praxiteles. Now, however, most scholars believe it to be a very fine Greek copy of

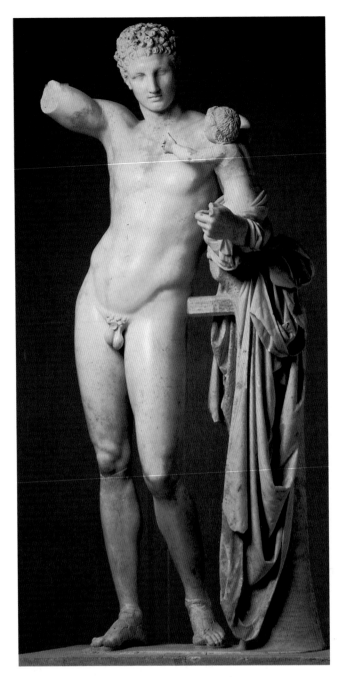

5-70. *Hermes*. Roman copy after an original of c. 320–310 B.C. by Praxiteles. Marble, height 7'1" (2.16 m). Archaeological Museum, Olympia

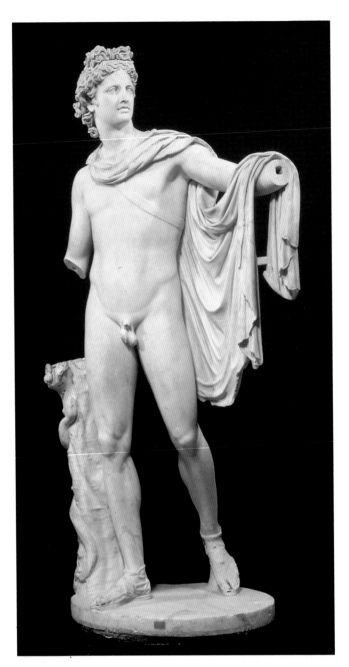

5-71. *Apollo Belvedere*. Roman marble copy, probably of a Greek original of the late 4th century B.C. Height 7'4" (2.3 m). Musei Vaticani, Museo Pio Clementino, Cortile Ottagono, Città del Vaticano, Rome

the first century B.C. because of the strut support and unfinished back. The dispute emphasizes the fact that we do not have a single undisputed original work by any of the famous sculptors of Greece. Still, the *Hermes* is the most Praxitelean statue we know. The sensuousness, the lithe proportions, the curve of the torso, the play of gentle curves, the sense of complete relaxation (enhanced by the use of an outside support for the figure to lean against), all agree with the character of the *Knidian Aphrodite*. We also find many refinements here that are usually lost in a copy. They include the caressing treatment of the marble, the faint smile, and the soft, "veiled" modeling of the features. Even the hair, left rough for contrast, shares the silky feel of the rest of the work. Here, for the first time, is an attempt to give a statue a less stony look by creating the illusion of a surrounding atmosphere.

THE APOLLO BELVEDERE. The same qualities recur in many other statues, all of them Roman copies of Greek works in a more or less Praxitelean vein. The best known is the *Apollo Belvedere* (fig. 5-71), sometimes attributed to Leochares. This work was extremely popular during the eighteenth and nineteenth centuries. The antiquarian Johann Winckelmann, Goethe, and other leaders of the Greek Revival movement of the eighteenth century saw it as the perfect exemplar of Classical beauty. Plaster casts or copies of it were found in all museums, art academies, and liberal arts colleges. Generations of students grew up with the belief that it embodied the Greek spirit. This enthusiasm tells us a good deal, not about the qualities of the *Apollo Belvedere* but about the character of the Greek Revival. Our own time takes a less enthusiastic view of the statue.

LYSIPPOS. Besides Skopas and Praxiteles, there is another great name in pre-Hellenistic sculpture: Lysippos. This sculptor's career may have begun as early as about 370 B.C. and continued almost to the end of the century. The main features of his style, however, are difficult to grasp, because of the contradictory evidence of Roman copies. Ancient authors praised him for replacing the canon of Polykleitos with a new set of proportions that produced a more slender body and a smaller head. [See Primary Sources, no. 3, pages 211–13.] He was famous, too, for his realism: he is said to have had no master other than nature. But these statements describe little more than a general trend toward the end of the fourth century. Certainly the proportions of Praxiteles' statues are "Lysippic" rather than "Polykleitan." Nor could Lysippos have been the only artist of his time to conquer new aspects of reality.

Even in the case of the *Apoxyomenos* (fig. 5-72), the statue most often linked with his name, the evidence is far from conclusive. It shows a young athlete cleaning himself with a scraper, a frequent subject in Greek art from Classical times on. Unlike all other versions, here the arms are extended in front of the body. This bold thrust into space, although it obstructs the view of the torso, is a major feat, whether or not we credit it to Lysippos. It endows the figure with a new capacity for three-dimensional movement. A similar freedom is suggested by the diagonal line of the free leg. Even the unruly hair reflects the new trend toward spontaneity.

HELLENISTIC SCULPTURE

We know very little about the development of Greek sculpture during the first hundred years of the Hellenistic era. Even after that, we have few fixed points of reference. No more than a small fraction of the many works that have survived can be firmly identified as to date and place of origin. Moreover, Greek sculpture was now being produced throughout such a vast territory that the interplay of local and international currents must have formed a complex pattern, of which we can trace only isolated strands. Hellenistic sculpture is nevertheless quite different from that of the Classical era. It generally has a more pronounced realism and expressiveness. Drapery and pose show greater variety, and are sometimes marked by considerable torsion. These changes should be seen as a valid, even necessary, attempt to extend the subject matter and dynamic range of Greek art in accordance with a new outlook.

THE DYING TRUMPETER. This new, more human conception is seen in the sculpture groups dedicated by Attalos I of Pergamon (a city in northwestern Asia Minor) between about 240 and 200 B.C. These works celebrated his victories over the Celts, who repeatedly raided the Greek states from Galatia, the area around present-day Ankara, until Attalos forced them to settle down. The bronze statues were copied in marble for the Romans, who had their own troubles with Celtic tribes in northwestern Europe (see page 270). A number of these copies of have survived. Some are of such high quality that they may well be originals. Among them is the famous *Dying Trumpeter* (fig. 5-73), which is mentioned in Pliny's *Natural History* as by Epigonos of Pergamon.

The sculptor must have known the Celts well, for the ethnic type is carefully rendered in the facial structure and in the bristly

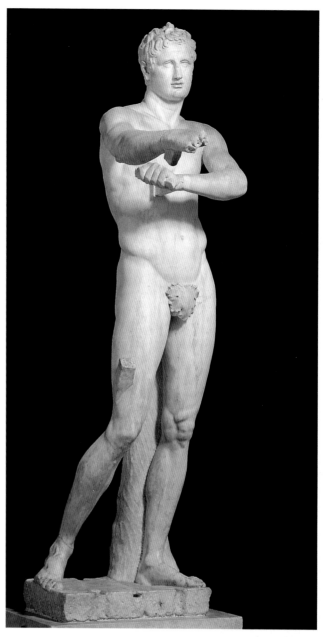

5-72. *Apoxyomenos (Scraper)*. Roman marble copy, probably after a bronze original of c. 330 B.C. by Lysippos. Height 6'9" (2.1 m). Musei Vaticani, Museo Pio Clementino, Gabinetto dell'Apoxyomenos, Città del Vaticano, Rome

shock of hair. The torque worn around the neck is another Celtic feature. Otherwise, the trumpeter shares the heroic nudity of Greek warriors, such as those on the Aegina pediments (see fig. 5-23). Although his agony seems much more realistic in comparison, it still has a great deal of dignity and pathos. Clearly, the Celts were considered worthy foes. "They knew how to die, barbarians though they were," is the idea conveyed by the statue. Yet we also sense something else, an animal quality that had never before been part of Greek images of men. Death, as we witness it here, is a very concrete physical process. No longer able to move his legs, the trumpeter puts all his waning strength into his arms, as if to prevent a tremendous invisible weight from crushing him against the ground.

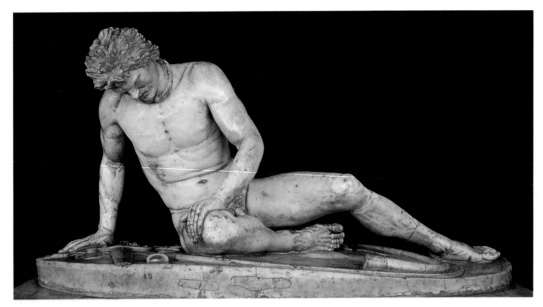

5-73. Epigonos of Pergamon (?). *Dying Trumpeter.* Perhaps a Roman copy after a bronze original of c. 230–220 B.C., from Pergamon, Turkey. Marble, life-size. Museo Capitolino, Rome

(BELOW) 5-74. The west front of the Great Pergamon Altar (restored). Staatliche Museen zu Berlin, Preussischer Kulturbesitz, Antikensammlung

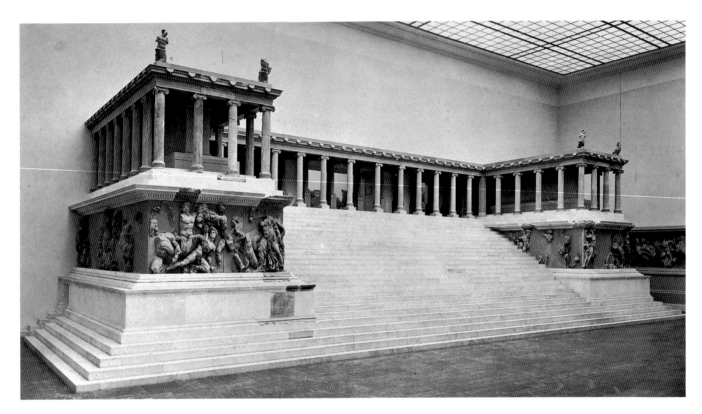

THE PERGAMON ALTAR. Several decades later, we find a second sculptural style flourishing at Pergamon. About 180 B.C., Eumenes II, the son and successor of Attalos I, had an enormous altar built on a hill above the city to commemorate the victory of Rome and her allies over Antiochos the Great of Syria eight years before (a conquest that had given him much of the Seleucid empire). A large part of the sculptural decoration has been recovered by excavation, and the entire west front of the monument, with the great flight of stairs leading to its entrance, has been reconstructed in Berlin (fig. 5-74). The altar itself is at the center of a rectangular court surrounded by an Ionic colonnade, which rises on a tall base about 100 feet square (fig. 5-75). Altars of such great size seem to have been an Ionian tradition since Archaic

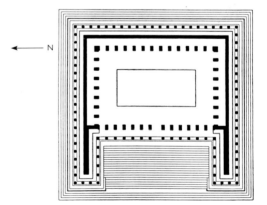

5-75. Plan of the Great Pergamon Altar (after J. Schrammen)

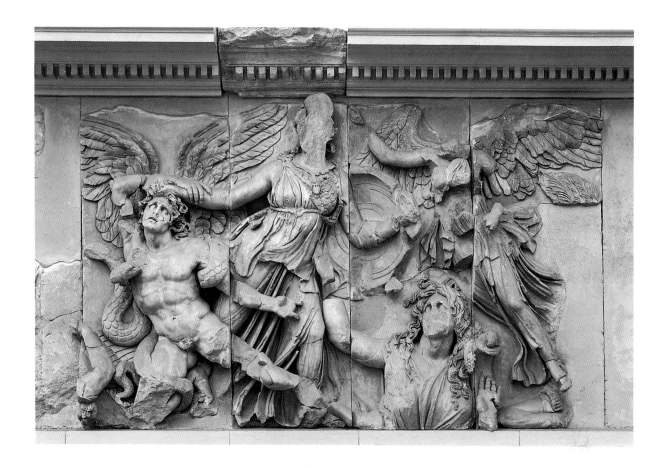

5-76 *Athena and Alkyoneus,* from the east side of the Great
Frieze of the Great Pergamon Altar. c. 166–156 B.C. Marble,
height 7'6" (2.29 m). Staatliche Museen zu Berlin, Preussicher
Kulturbesitz, Antikensammlung

*Eumenes II, who succeeded Attalos, erected a great altar to Zeus at
Pergamon itself in the first half of the second century B.C. For sheer
skill in carving, for the size of the figures, and for the quantity of
sculpture it is unsurpassed—and when one considers the technical
knowledge and the thought that must have been devoted to it the
result is pitiable. It is like a mythological dictionary: all the facts
are there, but it is empty of life; and this, since almost every figure
is in violent action, is not a little surprising. Lack of belief is the rea-
son. For artists of the Archaic period, the beings depicted were real;
in the Classical period there might have been some suspension of
belief, but the scenes had at least some symbolic meaning and were
essentially if not literally true. Now even this seems to have evapo-
rated: the events depicted, though with dramatic bravura, have
clearly never taken place: the beings have never existed.*

—H. A. Groenewegen-Frankfort and Bernard Ashmole
Art of the Ancient World. New York:
Harry N. Abrams, Inc., 1975, pp. 359, 363.
Originally published in 1971

H. A. GROENEWEGEN-FRANKFORT (born 1896) was an eminent
Dutch scholar of ancient art, especially the art of the ancient Near East. She
and her husband, Henri Frankfort (see page 000), spearheaded The Oriental
Institute of the University of Chicago's archaeological expeditions in
Mesopotamia. Her 1951 book, *Arrest and Movement,* is a classic interpretation
of meaning.

BERNARD ASHMOLE (1894–1988) was one of the twentieth century's
most distinguished authorities on Greek and Roman art. He was known best
as a scholar of Greek sculpture. His career as professor, curator, and adviser
included years at The British Museum as Keeper of Greek and Roman Antiq-
uities and an early adviser to J. Paul Getty while he began to acquire the Getty
Museum's distinguished collection of ancient sculpture. The powerful charac-
terization of the three main styles of Greek sculpture, given above, does not
hide their preference for Archaic and Classical art.

times, but the Pergamon Altar is the most elaborate of all. It is also the only one of which considerable portions have survived. Its boldest feature is the frieze covering the base, which is 400 feet long and over 7 feet tall. The huge figures, cut so deep that they seem almost detached from the background, have the scale and weight of pedimental statues, but they have been freed from the confining triangular frame and placed in a frieze. This unique blend of two traditions brings the development of Greek architectural sculpture to a thundering climax (fig. 5-76).

The carving of the frieze, although not very subtle, has tremendous dramatic force. The muscular bodies rush at each other, and the high relief creates strong accents of light and dark. The beating wings and windblown garments are almost overwhelming in their dynamism. A writhing movement pervades the entire design, down to the last lock of hair, and links the figures in a single continuous rhythm. This sense of unity restrains the violence of the struggle and keeps it—but just barely—from exploding its architectural frame. Indeed, the action spills out onto the stairs, where several figures are locked in combat.

The subject, the battle of the gods and giants, is a traditional one for Ionic friezes. (We saw it before on the Siphnian Treasury, see fig. 5-21.) At Pergamon, however, it has a novel significance. It promotes Pergamon as a new Athens—the patron goddess of both cities was Athena, who has a prominent place in the great frieze. Moreover, it almost surely incorporates a cosmological program, whose exact meaning, however, is disputed. Finally, the victory of the gods is meant to symbolize Eumenes' own victories. Such translations of history into mythology had been common in Greek art for a long time (see pages 148–149). But to place Eumenes in analogy with the gods themselves implies an exaltation of the ruler that is Oriental rather than Greek. The analogy was reinforced by a second frieze, entirely different in character, along the interior wall of the altar, which depicted the life of Telephos, the legendary founder of Pergamon and the son of Herakles, who was born of Zeus.

After the time of Mausolos, who may have been the first to introduce the idea of divine kingship on Greek soil, the concept was adopted by Alexander the Great and the lesser sovereigns who divided his realm, including the rulers of Pergamon. It later became central to Imperial Rome from Augustus onward (see pages 190–192).

NIKE OF SAMOTHRACE. Equally dramatic is another victory monument of the early second century B.C., the *Nike of Samothrace* (fig. 5-77). This sculpture probably commemorates the naval victory of Eudamos of Rhodes over Antiochos the Great in 190 B.C. The style is Rhodian and the statue may well have been carved by the island's leading sculptor, Pythokritos. The goddess has just descended to the prow of a ship. Her great wings spread wide, she is still partly airborne by the powerful head wind against which she advances. The invisible force of onrushing air here becomes a tangible reality. It not only balances the forward movement of the figure but also shapes every fold of the wonderfully animated drapery. As a result, there is an active relationship between the statue and the space around it such as we have never

seen before. By comparison, all earlier examples of active drapery seem inert. This is true even of the three goddesses from the Parthenon (see fig. 5-54), whose wet drapery responds not to the atmosphere around it but to an inner impulse that is independent of motion. Nor shall we see its like again for a long time to come. The *Nike of Samothrace* deserves her fame as the greatest masterpiece of Hellenistic sculpture.

LAOCOÖN. Until the *Nike* was discovered over 100 years ago, the most admired work of Hellenistic sculpture had been a group showing the death of Laocoön and his two sons (fig. 5-78). [See Primary Sources, no. 7, pages 215–16.] Found in Rome in 1506 in excavations at Nero's Golden House, it made a tremendous impression on Michelangelo and many others. The history of its fame is like that of the *Apollo Belvedere*. The two were treated as complementary: the *Apollo* exemplified harmonious beauty and the *Laocoön* sublime tragedy. (Laocoön was the priest who was punished by the gods for telling the Trojans not to admit the Greeks' wooden horse into the city. His warning went unheeded, which led to the Trojans' defeat.) Today we tend to find the pathos of the group somewhat calculated, and its surface finish strikes us merely as a display of virtuoso technique.

In style, including the relieflike spread of the three figures, it clearly descends from the Pergamon frieze. Here, though, the dynamism has become rather self-conscious. The *Laocoön* was long thought to be a Greek original and was identified with a group by Agesander, Athenodoros, and Polydoros of Rhodes that the Roman writer Pliny mentions as being in the palace of the emperor Titus. [See Primary Sources, no. 6, page 215.] We now know that these sculptors were skilled copyists who were active just before or after the birth of Jesus. The subject must have held a special meaning for the Romans. Laocoön's fate forewarned Aeneas of the fall of Troy and prompted him to flee in time. Since Aeneas was believed to have come to Italy and to have been the ancestor of Romulus and Remus, the death of Laocoön could be viewed as the first link in a chain of events that ultimately led to the founding of Rome.

Just how far back the legend of Laocoön goes is uncertain, but it does not seems to predate the *Aeneid* by the Roman poet Virgil (70–19 B.C.). This epic poem was written mainly to justify the emperor Augustus' lineage and claim to the throne, which occupies the middle chapters of the book. It is, in effect, a lengthy, highly entertaining piece of literary propaganda cast as a successor to Homer's *Iliad*.

(OPPOSITE) 5-77. Pythokritos of Rhodes (?).
Nike of Samothrace. c. 190 B.C. Marble, height 8' (2.44 m).
Musée du Louvre, Paris

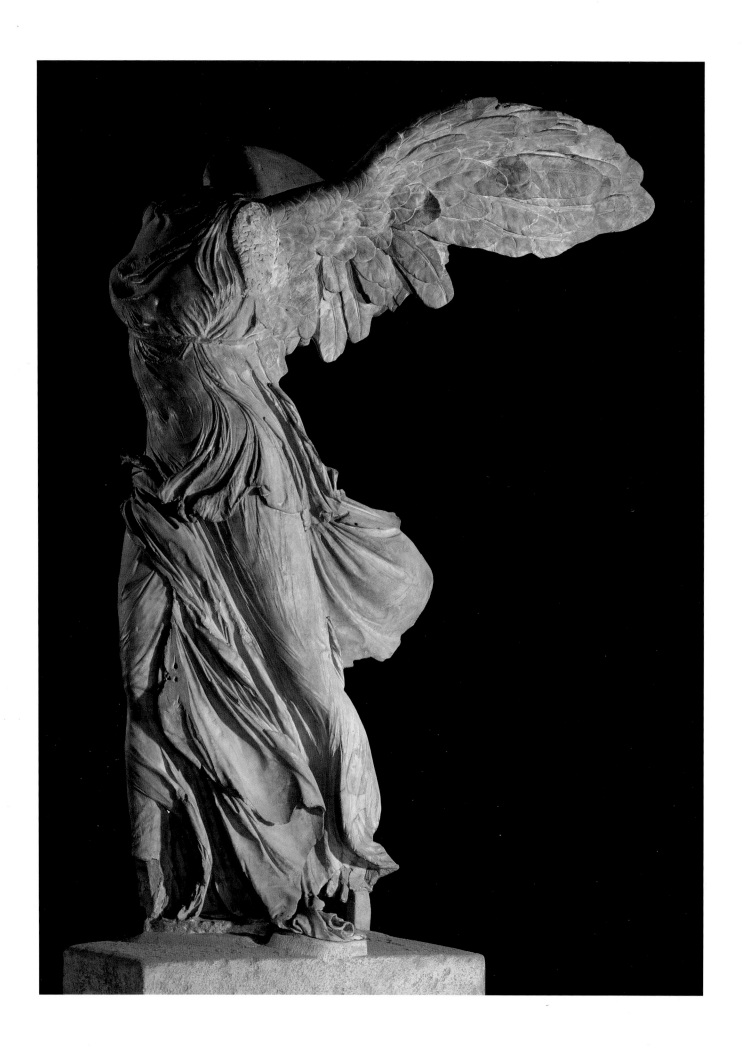

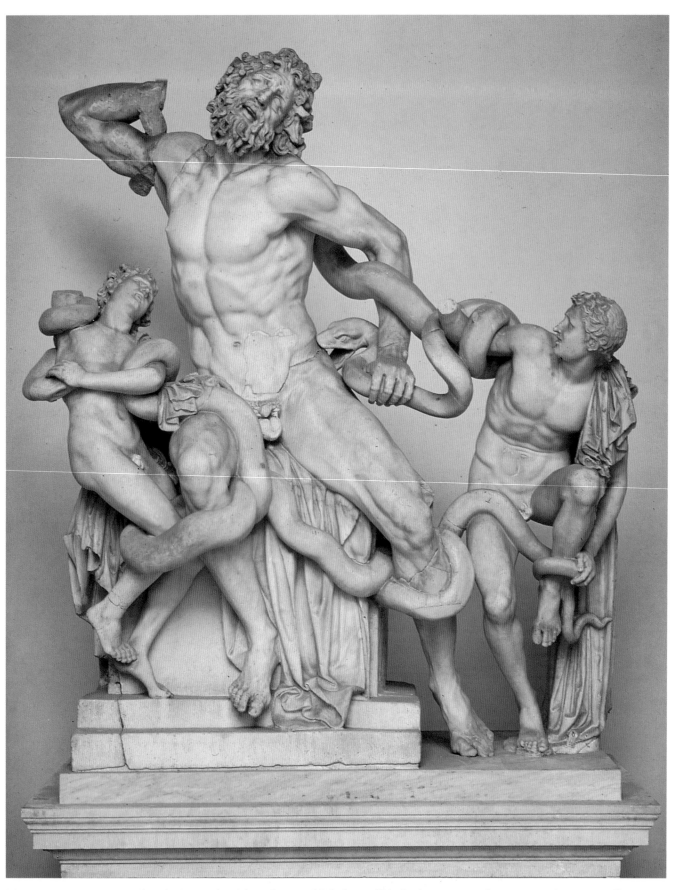

5-78. *The Laocoön Group.* Perhaps by Agesander, Athenodoros, and Polydoros of Rhodes (present state, former restorations removed). 1st century B.C. Marble, height 7' (2.1 m). Musei Vaticani, Museo Pio Clementino, Cortile Ottagono, Città del Vaticano, Rome

5-79. *Portrait Head,* from Delos. c. 80 B.C. Bronze, height 12¾" (32.4 cm). National Archaeological Museum, Athens

5-80. *Veiled Dancer.* c. 200 B.C.? Bronze statuette, height 8⅛" (20.6 cm). The Metropolitan Museum of Art, New York

BEQUEST OF WALTER C. BAKER, 1971

PORTRAITS. Individual likenesses were unknown in Classical art, which sought a timeless ideal. [See Primary Sources, no. 8, page 216.] Only in the mid-fourth century, did portraiture become a major branch of Greek sculpture, and it continued to flourish in Hellenistic times. Its achievements, however, are known to us only indirectly, for the most part through Roman copies. One of the few originals is a vivid bronze head from Delos, a work of the early first century B.C. (fig. 5-79). It was not made as a bust but rather, in accordance with Greek custom, was part of a full-length statue. The man's identity is not known, but whoever he was, we get an intensely private view of him that captures the character of the age. His likeness has been fused with a distinctive Hellenistic type (compare the face of Alkyoneos in figure 5-76) and the distant stare of the *"Mausolos"* (see fig. 5-67) has been replaced by a trou-

bled look. The fluid modeling of the somewhat flabby features, the uncertain mouth, and the unhappy eyes under furrowed brows reveal an individual beset by doubts and fears—a very human, unheroic personality. There are echoes of pathos in these features, but it is a pathos translated into psychological terms. People who felt such inner turmoil had certainly existed earlier in the Greek world, just as they do today. Yet it is significant that their complex personality could be conveyed in art only when Greek independence came to an end, culturally and politically under Rome in 146 B.C.

STATUETTES. Before we leave Hellenistic sculpture, we must look briefly at another aspect of it, represented by the enchanting statuette of a veiled dancer (fig. 5-80). She introduces us to the

wide variety of small-scale works—many in terra-cotta, others in bronze, like our example—produced for private ownership. These works form a special category, often called Tanagra figures after the site where many have been found. Such pieces were collected in much the same way as painted vases had been in earlier times. Like vase paintings, they show a broad range of subjects. Besides the familiar mythological themes, we find everyday subjects: beggars, street entertainers, peasants, young ladies of fashion. The grotesque, the humorous, the picturesque—rarely found in Greek monumental art—are prominent. Most of these figurines are routine pieces that were mass-produced in clay or bronze. But at their best, they have a freedom that is rarely matched on a larger scale. The bold spiral twist of the veiled dancer, reinforced in the diagonal folds of the drapery, creates a variety of interesting views that practically force the viewer to turn the statuette in his hands. No less remarkable is the interplay of concave and convex forms, and the contrast between the compact silhouette of the figure and the mobility of the body within.

COINS

We rarely think of coins as works of art, and the majority of them are not. The study of coins, known as numismatics, offers many rewards, but visual delight is often the least of these. If many Greek coins are exceptions to this rule, it is not simply because they are the earliest. (The idea of stamping metal pellets of standard weight with an identifying design originated in Ionian Greece sometime before 600 B.C.) After all, the first postage stamps were not more works of art than stamps are today. The reason, rather, is the individualism of Greek political life. Every city-state had its own coinage, with its own emblem, and the designs were changed often so as to take account of treaties, victories, or other occasions for local pride. As a result, the number of coins struck at any one time was relatively small, while the number of coinages was large.

The constant demand for new designs produced highly skilled specialists who took such pride in their work that they sometimes signed it. Greek coins thus are not only a valuable source of historical knowledge but an authentic expression of the changing Greek sense of form. They illustrate the development of Greek sculpture from the sixth to the second century B.C. as faithfully as the larger works we have discussed. And since they form a continuous series, with the place and date of almost every item well established, they reflect this development more fully in some respects than do the works of monumental art.

Some of the finest coins of Archaic and Classical Greece were produced not by the most powerful states such as Athens, Corinth, or Sparta, but by the lesser ones. Our first example (fig. 5-81), from the Aegean island of Peparethos, reflects the origin of coinage: a square die embedded in a rather shapeless pellet, like an impression in sealing wax. The winged god, whose pinwheel stance is so perfectly adapted to the frame, is a summary-in-miniature of Archaic art, down to the smile (see fig. 5-17). On the coin from Naxos in Sicily (fig. 5-82), almost half a century later, the die fills the entire area of the coin. The surprisingly monumental figure shows the articulation and organic vitality of the Severe style (compare fig. 5-50). Our third coin (fig. 5-83) was struck in the Sicilian town of Catana toward the end of the Peloponnesian War. It is signed with the name of its maker, Herakleidas, and it deserves to be, for it is one of the true masterpieces of Greek coinage. Who would have thought it possible to give such plasticity to a full-face view of a head in low relief? This radiant image of Apollo has the swelling roundness of the mature Classical style. Its grandeur completely transcends the limitations of the tiny scale of a coin.

From the time of Alexander the Great onward, coins began to show profile portraits of rulers. At first the successors of Alexander put his features on their coins to stress their link with him. Such a piece is shown in figure 5-84. Alexander displays the horns that identify him with the ram-headed Egyptian god Amun. His "inspired" expression, conveyed by the half-open mouth and the upward-looking eyes, is characteristic of the emotionalism of Hellenistic art, as are the fluid modeling of the features and the agitated, snakelike hair. As a likeness, this head can have only a slight relation to the way Alexander actually looked. Yet this idealized image of the deified conqueror projects the flavor of the new era more eloquently than do the large-scale portraits of Alexander.

Once the Hellenistic rulers started putting themselves on their coins, the likenesses became more individual. Perhaps the most notable of these (fig. 5-85) is the head of Antimachos of Bactria (present-day Afghanistan), which stands at the opposite end of the scale from the Alexander-Amun. Its mobile features show a man of sharp intelligence and wit, a bit skeptical perhaps about himself and others, and, in any event, without any desire for self-glorification. This penetratingly human portrait seems to point the way to the bronze head from Delos (see fig. 5-79), which appeared a hundred years later. It has no counterpart in the monumental sculpture of its own time and thus helps to fill an important gap in our knowledge of Hellenistic portraiture.

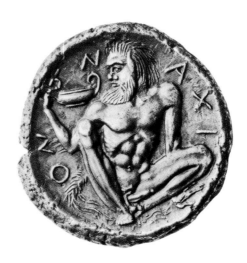

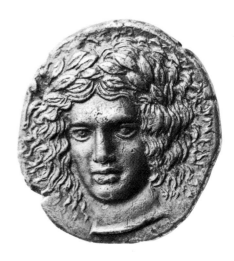

-81. *Winged God.* Silver coin from Peparethos. 500 B.C. Diameter 1½" (3.7 cm). The British Museum, London

5-82. *Silenus.* Silver coin from Naxos, Sicily. c. 460 B.C. Diameter 1¼" (3.3 cm). The British Museum, London

5-83. *Apollo.* Silver coin from Catana. c. 415–400 B.C. Diameter 1⅛" (3 cm). The British Museum, London

-84. *Alexander the Great with Amun Horns.* Four-drachma silver coin issued by Lysimachos. 297–281 B.C. Diameter 1⅛" (3 cm)

5-85. *Antimachos of Bactria.* Silver coin. c. 185 B.C. Diameter 1¼" (3.3 cm). The British Museum, London

Etruscan Art

The Italian peninsula did not emerge into the light of history until fairly late. The Bronze Age, which dawned first in Mesopotamia about 4000 B.C., came to an end in the Italian peninsula only around 1000 B.C. At that time the Villanovans, who had migrated to the peninsula from central Europe, established an early Iron Age culture near Bologna that had strong ties to central Europe. They were succeeded by the Etruscans in the eighth century B.C., at about the time the Greeks first began to settle along the southern shores of Italy and in Sicily. Interestingly, the Classical Greek historian Herodotos believed that the Etruscans (*Tyrrhenoi* to the Greeks) had left their homeland of Lydia in Asia Minor about 1200 B.C. According to him, they had settled in the area between Florence and Rome, called Rasenna by the Etruscans, Etruria by the Romans, and now known as Tuscany. Herodotos' claim was already disputed in Roman times by the Greek historian Dionysius of Halikarnassos. It is likely that the Etruscans were actually descended through the Villanovans from the Bronze Age peoples who had occupied central Italy since about 3000 B.C.

In any case, the Etruscans had strong cultural links with both Asia Minor and the ancient Near East. Yet they also show many traits that are not found anywhere else. The sudden flowering of Etruscan civilization resulted in large part from the influx of Greek culture. For example, the Etruscans borrowed their alphabet from the Greeks toward the end of the eighth century. Nevertheless, their language is unlike any other. The only Etruscan writings that have come down to us are brief funerary inscriptions and a few somewhat longer texts relating to religious ritual. However, Roman authors, notably the emperor Claudius, tell us that a rich Etruscan literature once existed, of which not even a trace remains. In fact, we would know almost nothing about the Etruscans at first hand were it not for their tombs. They were not disturbed when the Romans destroyed or rebuilt Etruscan cities, and have survived intact until modern times.

Italian Bronze Age burials, like those elsewhere in prehistoric Europe, were modest. The remains of the deceased, contained in a pottery vessel or cinerary urn, were placed in a simple pit along with the equipment they required in an afterlife: weapons for men, jewelry and household tools for women. In Mycenaean

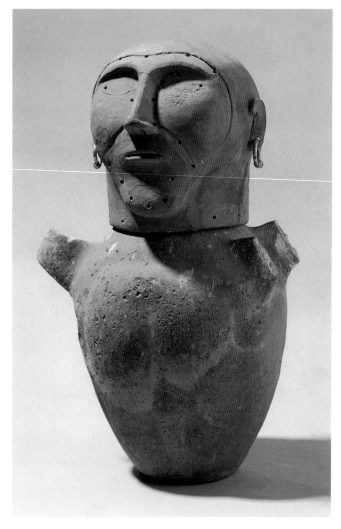

6-1. Human-headed cinerary urn. c. 675–650 B.C. Terra-cotta, height 25½" (64.7 cm). Museo Etrusco, Chiusi, Italy

Greece, this primitive cult of the dead became more elaborate under Egyptian influence, as shown by the monumental beehive tombs. Something very similar happened eight centuries later in Tuscany during the Orientalizing phase of Etruscan art, which

lasted from roughly 750 B.C. to 575 B.C. Toward 700 B.C., Etruscan tombs began to imitate in stone the interiors of dwellings. Covered by great conical mounds of earth, these tumulus tombs could be roofed by vaults or corbeled domes built of horizontal, overlapping courses of stone blocks, as was the Treasury of Atreus at Mycenae (see fig. 4-14).

At the same time, the pottery urns gradually took on human shape. The lid grew into the head of the deceased, and body markings appeared on the vessel itself (fig. 6-1). Sometimes the urn was placed on a sort of throne, possibly to indicate high rank. The style, primitive though it may be, has much in common with that of north Syrian sculpture of the ninth century B.C. at Tell Halaf. It was in Syria, too, that the funerary meal, a frequent theme in Etruscan art, probably originated. Like the Greeks, Etruscan sailors made the Syrian city of Al Mina a port of call.

Alongside the modest beginnings of funerary sculpture, we find sudden evidence of great wealth in the form of goldsmiths' work. These objects were probably made by the Phoenicians, with whom the Etruscans forged trade agreements and peace treaties. They were decorated with motifs like those on the orientalizing Greek vases of the same period (see fig. 5-4). Also found in the tombs were precious objects imported from the ancient Near East.

In the seventh and sixth centuries B.C. the Etruscans reached the height of their power. Their cities rivaled those of the Greeks; their fleet dominated the western Mediterranean and protected a vast commercial empire that competed with the Greeks and Phoenicians; and their territory extended as far as Naples in the south and the lower Po Valley in the north. But the Etruscans, like the Greeks, never formed a unified nation. They were no more than a loose federation of individual city-states that were given to quarreling among themselves and were slow to unite against a common enemy. The Etruscan fleet was defeated by the navy of its archrival, Syracuse, in 474 B.C. And during the later fifth and fourth centuries B.C., one Etruscan city after another fell to the Romans. By 270 B.C., all of them had lost their independence, although many continued to prosper, if we are to judge by the richness of their tombs during the period of political decline.

Tombs and Their Decoration

The flowering of Etruscan civilization coincides with the Archaic age in Greece. During this period, especially near the end of the sixth and early in the fifth century B.C., Etruscan art showed its greatest vigor. Greek Archaic influence displaced the orientalizing tendencies. (Many of the finest Greek vases have been found in Etruscan tombs of that time.) But Etruscan artists did not simply imitate their Hellenic models. Working in a very different cultural setting, they retained their own clear-cut identity.

One might expect the Etruscan cult of the dead to have waned under Greek influence. On the contrary, Etruscan tombs and their equipment grew more elaborate as the skills of the sculptor and painter increased. The deceased could be shown full length, reclining on the lids of sarcophagi shaped like couches, as if they were participants in a festive event similar to the Greek symposium (see page 116). The Etruscans, however, made such feasts into family affairs instead of restricting them to men. (When women do appear in Greek banquet scenes, it is on red-figured pots with amorous subjects.) The example in figure 6-2 shows a husband and wife side

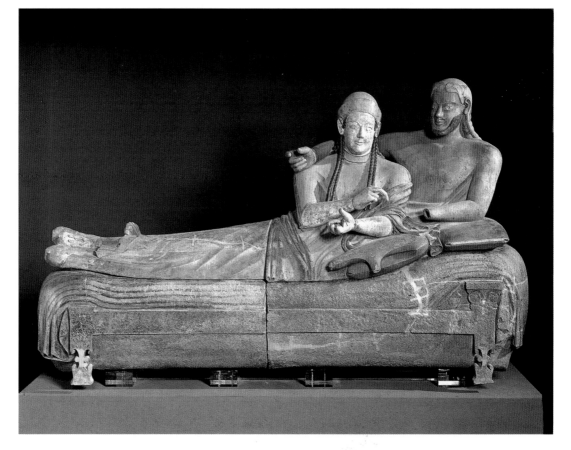

6-2. Sarcophagus, from Cerveteri. c. 520 B.C. Terra-cotta, length 6'7" (2 m). Museo Nazionale di Villa Giulia, Rome

by side on a Greek bed, an Archaic smile on their lips, so that they seem gay and majestic at the same time. A wineskin cushions the woman's left elbow, but the position of the hands suggests that the pair were not drinking. Rather the wife appears to have been applying funereal oil from a missing alabastron in her right hand onto her husband's left hand—a typical Etruscan rite. This tenderness in depicting a married man and woman is also uniquely Etruscan; we shall meet it again (see fig. 6-12). The entire work is of terra-cotta and was once painted in bright colors, which have been revealed more clearly in a recent cleaning. The rounded forms reveal the Etruscan sculptor's preference for modeling in soft materials, in contrast to the Greek love of stone carving. There is less formal discipline here but an extraordinary directness and vivacity that are characteristic of Etruscan art.

EARLY FUNERARY BELIEFS. We do not know exactly what ideas the Archaic Etruscans held about the afterlife. Effigies such as our reclining couple, which for the first time in history show the deceased as alive and enjoying themselves, suggest that they regarded the tomb as a home not only for the body but also for the soul. (In contrast, the Egyptians thought that the soul roamed freely; their funerary sculpture therefore was "inanimate.") How else are we to understand the purpose of the wonderfully rich array of murals in these tombs? Since nothing of the sort has survived in Greek territory, they are uniquely important not only as an Etruscan achievement but also as a possible reflection of Greek wall painting.

THE TOMB OF HUNTING AND FISHING. Perhaps the most remarkable murals are found in the Tomb of Hunting and Fishing at Tarquinia of about 520 B.C. Figure 6-3 shows a marine panorama at one end of the low chamber. In this vast expanse of water and sky, the fishermen seem to play only an incidental part. Exekias' *Dionysos in a Boat* (see fig. 5-5) is the closest Greek counterpart to our scene. (In the myth, the dolphins were Etruscan sailors.) The differences, however, are as revealing as the similarities. One wonders if any Greek Archaic artist knew how to place human figures in a natural setting as effectively as the Etruscan painter did. Could the mural have been inspired by Egyptian scenes of hunting in the marshes, such as the one in figure 2-18?

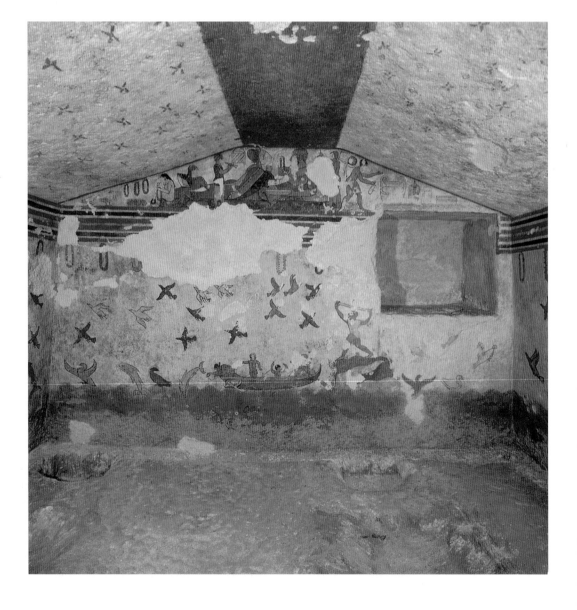

6-3. Tomb of Hunting and Fishing, Tarquinia, Italy. c. 520 B.C.

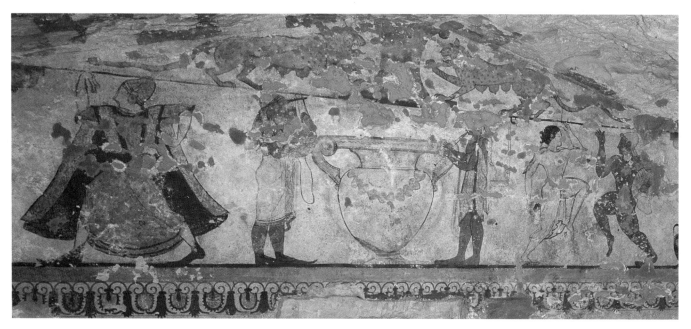

6-4. *Musicians and Two Dancers.* Detail of a wall painting. c. 470–460 B.C. Tomb of the Lionesses, Tarquinia, Italy

They seem the most likely precedent for our subject. If so, the Etruscan artist has brought the scene to life, just as the reclining couple in figure 6-2 has been brought to life compared with Egyptian funerary statues.

The free, rhythmic movement of birds and dolphins also reminds us of Minoan painting of a thousand years earlier (see fig. 4-5). So far as we know, the Minoans were the only people before the Etruscans to paint murals devoted solely to landscape. How are we to account for this apparent debt to Egyptian and Minoan art of so many centuries earlier amid the obvious Greek influences? Perhaps the contact came through the Etruscan navy, which roamed throughout the Mediterranean, reaching Egypt—where, we recall, Minoan-style frescoes could also be seen (see page 59). The mystery may never be cleared up, however.

Despite the air of enchantment, the scene has ominous overtones. The giant hunter with a slingshot, from whom the birds flee in all directions, is very likely a demon of death, closely related to another masked demon named Phersu who sometimes appears in Etruscan murals. This dualism is continued in the niche above: we see a couple on a couch enjoying a last meal. (By contrast, paintings of the final supper found at the entrances to Egyptian tombs show only the deceased seated at a table.) Thus the purpose of the mural is essentially commemorative, ushering the deceased into the next life.

The man and woman in the mural are flanked by a musician and servants, one of whom is drawing wine from a large mixing bowl, or krater, while another is making wreaths. From the Greeks, the Etruscans adopted the cult of Dionysos, whom they called Fufluns or Pachies (from Bacchos [Latin, Bacchus], his other Greek name; see box page 111). Besides being the god of wine, he was the god of vegetation and hence of death and resurrection, like Osiris. Thus the painting has a funereal content whose full meaning escapes us. In this context, for example, the couple may be seen as counterparts to Bacchus and Ariadne (known as Ariatha to the Etruscans). These two figures recline in eternal love on the pediment of a late Etruscan temple, where they serve as symbols of regeneration.

THE TOMB OF THE LIONESSES. The importance of Dionysos can be seen in other tombs as well. A somewhat later example from another tomb in Tarquinia (fig. 6-4) shows a pair of ecstatic dancers beside an immense krater. The passionate energy of their movements again is uniquely Etruscan rather than Greek in spirit. Of particular interest is the transparent garment of the woman, which lets the body shine through. In Greece, this treatment appears only a few years earlier, during the final phase of Archaic vase painting. The contrasting body color of the two figures continues a practice that was begun by the Egyptians more than 2,000 years before (see fig. 2-15) and was carried on by the Greeks. The dancers are descended from Greek depictions of satyrs and maenads, thereby establishing a link to the cult of Dionysos. And, as we have seen, the Minoan-looking dolphins also had Dionysian associations.

Yet the meaning of the mural as a whole remains obscure. What are we to make of the lactating lionesses? They are kin to ancient Sumerian depictions of the mother goddess in leonine form. These and other images from the Near East first appeared in the orientalizing style. Lions were also linked to Dionysos. Here the lionesses are evidently seen in their dual guise as givers of life and dispensers of death, thus suggesting regeneration in a life beyond. The motif reappears in a later Etruscan funerary relief, executed in a curiously Syrian manner, of a lioness nursing a youth. This lioness may be a forerunner of the she-wolf that, according to legend, suckled Romulus and Remus (see below).

LATER FUNERARY BELIEFS. During the fifth century, the Etruscan view of the hereafter must have become a good deal more complex and less festive. We notice the change immediately

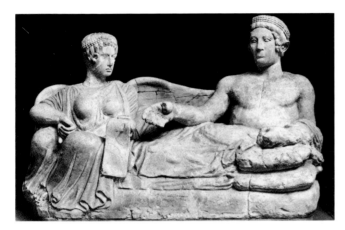

6-5. *Youth and Demon of Death*. Cinerary container. Early 4th century B.C. Stone (*pietra fetida*), length 47" (119.4 cm). Museo Archeologico Nazionale, Florence

if we compare the group in figure 6-5, a cinerary container made of soft local stone soon after 400 B.C., with its predecessor in figure 6-2. The woman now sits at the foot of the couch, but she is not the wife of the young man. Her wings show that she is the demon of death, and the scroll in her left hand records the fate of the deceased. The young man is pointing to it as if to say, "Behold, my time has come." The thoughtful, melancholy air of the two **carved** figures may be due, to some extent, to the influence of Classical Greek art, which pervades the style of our group (compare fig. 5-60). A new mood of uncertainty and regret is felt. Human destiny is in the hands of inexorable supernatural forces. Death is now the great divide rather than a continuation, albeit on a different plane, of life on earth.

In later tombs, the demons of death gain an even more fearful aspect. Other, more terrifying demons enter the scene. Often they are shown battling against benevolent spirits for possession of the soul of the deceased—a prefiguration of the Last Judgment in medieval art (see fig. 10-24). One of these demons appears in the center of figure 6-6, a tomb of the third century B.C. at Cerveteri, richly decorated with stucco reliefs rather than paintings. The entire chamber, cut into the rock, imitates the interior of a house, including the beams of the roof, for it is a family burial site. The sturdy pilasters (note the capitals, which recall the Aeolian type from Asia Minor in fig. 5-37), as well as the wall surfaces between the niches, are covered with exact reproductions of weapons, armor, household implements, small domestic animals, and busts of the deceased. In such a setting, the snake-legged demon and his three-headed hound (whom we recognize as Cerberus, the guardian of hell) are particularly disquieting.

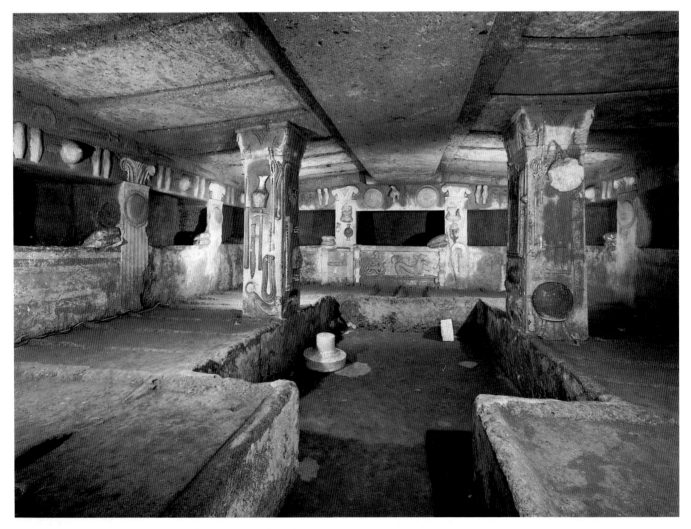

6-6. Burial chamber. Tomb of the Reliefs, Cerveteri, Italy. 3rd century B.C.

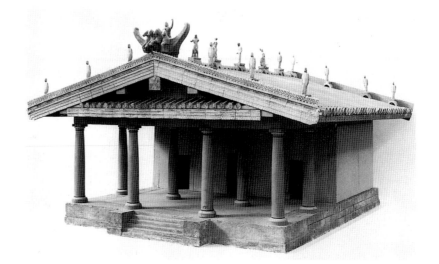

6-7. Reconstruction of an Etruscan temple, as described by Vitruvius. Museo delle Antichità Etrusche e Italiche, Università di Roma "La Sapienza"

(RIGHT) 6-8. *Apollo,* from Veii. c. 510 B.C. Terra-cotta, height 5'9" (1.75 m). Museo Nazionale di Villa Giulia, Rome

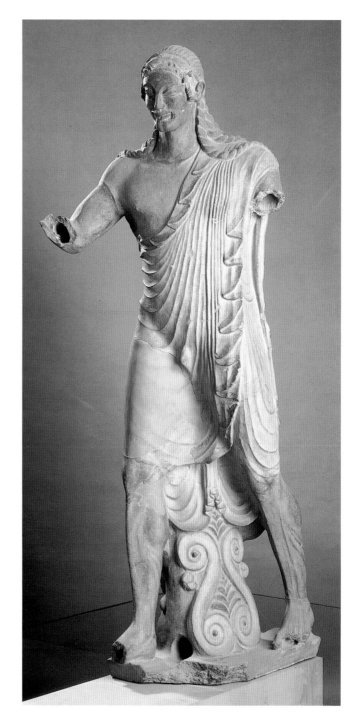

Temples and Their Decoration

Only the stone foundations of Etruscan temples have survived, since the buildings themselves were built of wood. Apparently the Etruscans, although they were masters of masonry construction, rejected the use of stone in temple architecture for religious reasons. The design of their sanctuaries bears a general resemblance to the simpler Greek temples (fig. 6-7). Nevertheless they also have several distinctive features, some of which were later adopted by the Romans. The entire structure rests on a tall base, or podium, that is no wider than the cella and has steps only on the south side. The steps lead to a deep porch, supported by two rows of four columns each, and to the cella beyond. Because Etruscan religion was dominated by a triad of gods who were the predecessors of the Roman Juno, Jupiter, and Minerva, the cella is generally subdivided into three compartments. The shape of Etruscan temples, then, must have been squat and squarish compared to the graceful lines of Greek sanctuaries, and was more closely linked with domestic architecture. Needless to say, it provided no place for stone sculpture. The decoration usually consisted of terra-cotta plaques that covered the architrave and the edges of the roof. Only after 400 B.C. do we occasionally find large-scale terra-cotta groups designed to fill the pediment above the porch.

VEII. We know, however, of one earlier attempt—and an astonishingly bold one—to find a place for monumental sculpture on the exterior of an Etruscan temple. The so-called Temple of Apollo at Veii, not far north of Rome, was a structure of the standard type. However, it had four life-size terra-cotta statues on the ridge of its roof. (Similar examples appear in the reconstruction model, fig. 6-7). They formed a dramatic group of the sort we might expect in Greek pedimental sculpture: the contest of Hercules and Apollo for the sacred hind (female deer), in the presence of other deities.

The best preserved of these figures is the Apollo (fig. 6-8), acknowledged to be the masterpiece of Etruscan Archaic sculpture.

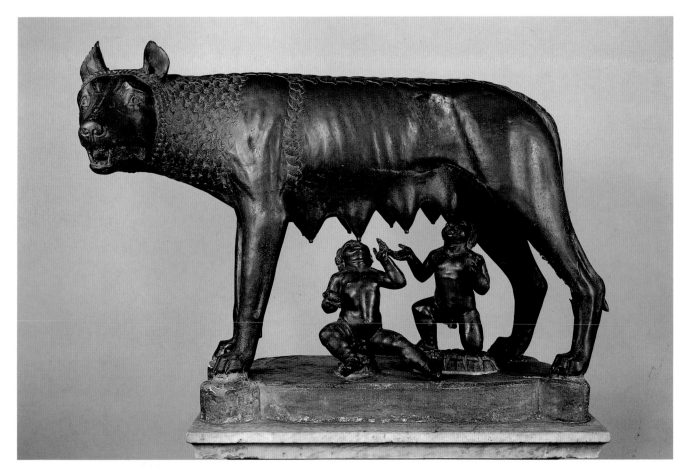

6-9. *She-Wolf.* c. 500 B.C. Bronze, height 33½" (85 cm). Museo Capitolino, Rome

His massive body, revealed beneath the ornamental treatment of the drapery; the sinewy, muscular legs; the hurried, purposeful stride—all these possess an expressive force that has no counterpart in freestanding Greek statues of the same date, even given the fact that the medium of terra-cotta allows greater freedom for the sculptor to experiment with poses.

That Veii was indeed a sculptural center at the end of the sixth century seems to be confirmed by the Roman tradition that the last of the Etruscan rulers of the city called on a master from Veii to make the terra-cotta image of Jupiter for the temple on the Capitoline Hill. This image has been lost, but an even more famous one, **cast** in bronze, is still in existence (fig. 6-9). According to a myth promulgated by Virgil, Livy, and others during the time of Augustus to legitimize his reign, Rome was founded in 753 B.C. by Romulus and Remus. These two brothers, descendants of refugees from Troy in Asia Minor (see page 166), were said to have been nourished by a she-wolf after being abandoned. [See Primary Sources, no. 9, page 216.] (The two babies beneath the wolf were added during the Renaissance.) The early history of the statue is unclear, and some scholars have even suspected it of being a medieval work. Nevertheless, it is almost surely an Etruscan Archaic original, for the wonderful ferocity of expression and the physical power of the body and legs have the same awesome quality that we sense in the Apollo from Veii. Furthermore, the she-

wolf has strong links with Etruscan mythology, in which wolves seem to have played an important part from very early times.

Portraiture and Metalwork

The Etruscan concern with images of the deceased might lead us to expect an early interest in portraiture. Yet the features of funerary images such as those in figures 6-2 and 6-5 are impersonal. Only toward 300 B.C., under the influence of Greek portraiture, did individual likenesses begin to appear in Etruscan sculpture. The finest of them are not funerary portraits, which tend to be rather crude and indifferent, but the heads of bronze statues. *Portrait of a Boy* (fig. 6-10) is a masterpiece of its kind. The firmness of modeling lends a special poignancy to the sensitive mouth and the gentle, melancholy eyes.

No less impressive is the high quality of the casting and finishing, which bears out the ancient Etruscans' fame as metalworkers. This ability was of long standing, for the wealth of Etruria was founded on the exploitation of copper and iron deposits. From the sixth century on, they produced large numbers of bronze statuettes, mirrors, and the like, both for export and for domestic use. The backs of mirrors were often engraved with scenes taken from Etruscan versions of Greek myths devoted to the loves of the gods. Such amorous subjects were entirely appro-

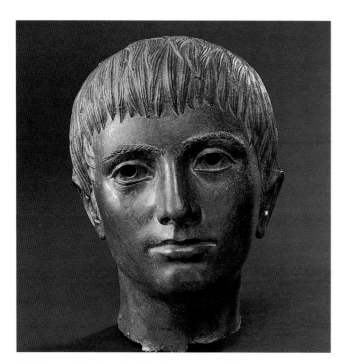

6-10. *Portrait of a Boy.* Early 3rd century B.C. Bronze, height 9" (23 cm). Museo Archeologico Nazionale, Florence

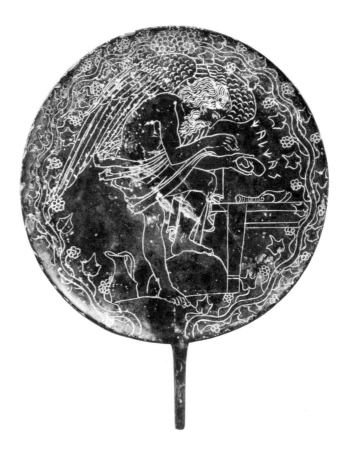

6-11. Engraved back of a mirror. c. 400 B.C. Bronze, diameter 6" (15.3 cm). Musei Vaticani, Museo Gregoriano Etrusco, Città del Vaticano, Rome

priate to an object used for self-admiration. (We recall the myth of Narcissus, the beautiful youth who fell in love with his reflection in a pool.)

The design on the back of a mirror done soon after 400 B.C. (fig. 6-11) shows another aspect of mirrors. Within an undulating wreath of vines, we see a winged old man, identified as the seer Khalchas (a reference to the Greek seer Kalchas from Homer's *The Iliad*), examining a roundish object. The draftsmanship is so beautifully balanced and assured that we are tempted to assume that Classical Greek art was the direct source of inspiration.

DIVINATION. So far as the style of our piece is concerned, this may well be the case, but the subject is uniquely Etruscan, for the winged genius is gazing at the liver of a sacrificial animal. We are seeing a practice that loomed as large in the lives of the Etruscans as the care of the dead: the search for omens or portents. The Etruscans believed that the will of the gods was expressed through signs in the natural world, such as thunderstorms or the flight of birds. By reading these signs, people could find out whether the gods approved or disapproved of their acts. The priests who knew the secret language of these signs enjoyed great prestige. Even the Romans consulted them before any major public or private event. Divination (as the Romans called the art of interpreting omens)

can be traced back to ancient Mesopotamia, and the practice was not unknown in Greece, but the Etruscans carried it further. As the Roman philosopher and statesman Seneca wrote: "This is the difference between us and the Etruscans. . . . Since they attribute everything to divine agency, they are of the opinion that things do not reveal the future because they have occurred, but that they occur because they are meant to reveal the future." The Etruscans put special trust in the livers of sacrificial animals, on which they thought the gods had inscribed the hoped-for message. In fact, they viewed the liver as a sort of microcosm, divided into sections that corresponded to the 16 regions of the sky. Mirrors, too, were valued for their ability to reveal the future, which is why this scene is represented here.

Strange and irrational as they were, these practices became part of our cultural heritage. True, we no longer try to tell the future by watching the flight of birds or examining animal livers, but tea leaves and horoscopes are still prophetic to many people. And we speak of auspicious events or events which indicate a favorable future, unaware that *auspicious* originally referred to a favorable flight of birds. Perhaps we do not believe very seriously that four-leaf clovers bring good luck and black cats or broken mirrors bad luck, yet a surprising number of us admit to being superstitious.

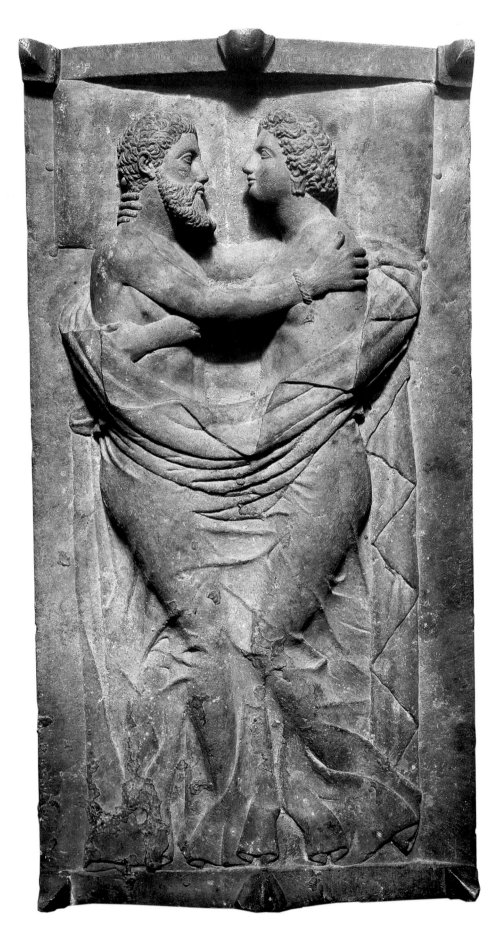

6-12. Sarcophagus lid of Larth Tetnies and Thanchvil Tarnai. c. 350–300 B.C. Marble, length 7' (2.13 m). Museum of Fine Arts, Boston

Late Sculpture

THE SARCOPHAGUS OF LARTH TETNIES AND THANCHVIL TARNAI. Even as the Romans were conquering one Etruscan city after another, Etruscan sculpture continued to flourish under Greek influence. A unique pair of sarcophagi discovered near Vulci in southern Etruria show a man and woman in a tender embrace under the sheet of their marital bed. In the finer of the two (fig. 6-12) the couple displays a remarkable affection that harks back to the terra-cotta sarcophagus from Cerveteri (fig. 6-2). The hairdos and beard reflect Greek fashion, and the sculptor himself may have been Greek, since the sides show Greek battle scenes. However, slight deviations from Late Classical and Hellenistic norms lead us to suspect that the artist was actually an Etruscan working in a thoroughly Greek style to satisfy the taste of his patrons. In any case, it is an object of extraordinary beauty and expressiveness that was only rarely equaled in later Etruscan art.

The Architecture of Cities

According to Roman writers, the Etruscans were masters of architectural engineering, town planning, and surveying. There is little doubt that the Romans learned a good deal from them. But it is difficult to say how much the Etruscans contributed to Roman architecture, since very little Etruscan or early Roman architecture is still standing. Ongoing excavations at the town of Marzabotto seem to confirm that the Etruscans used a grid as an organizing principle in town planning. Roman temples certainly retained many Etruscan features. The atrium, the central hall of the Roman house (see fig. 7-21), also originated in Etruria. In town planning and surveying, too, the Etruscans have a good claim to priority over the Greeks.

The original homeland of the Etruscans, Tuscany, was too hilly for geometric town schemes. However, when they colonized the flatlands south of Rome in the sixth century B.C., they laid out their newly founded cities as a network of streets centering on the intersection of two main thoroughfares, the *cardo* (which ran north and south) and the *decumanus* (which ran east and west). The four quarters thus obtained could be further subdivided or expanded, according to need. This system, which the Romans adopted for the new cities they were to found throughout Italy, western Europe, and North Africa, may have been derived from the plan of Etruscan military camps. Yet it also seems to reflect the religious beliefs that made the Etruscans divide the sky into regions according to the points of the compass and place their temples along a north-south axis. The Etruscans must also have taught the Romans how to build fortifications, bridges, drainage systems, and aqueducts, although hardly anything remains of these works.

Roman Art

Roman civilization is far more accessible to us than any other of the ancient world. We know a great deal about its history, thanks to its vast literary legacy, from poetry and philosophy to inscriptions recording everyday events. The Romans also built vast numbers of monuments throughout their empire. Yet there are few questions more difficult to answer than "What is Roman art?" The Roman genius, so clearly recognizable in everything else, is much harder to define in the fine arts.

Why is this so? The most obvious reason is the Romans' admiration for Greek art. They imported originals by the thousands and had them copied in even greater numbers. In addition, their own works were clearly based on Greek sources, and many, if not most, of their artists, from Republican times (510–44 B.C.) to the end of the empire (44 B.C.–476 A.D.), were of Greek origin. Roman authors tell us a good deal about the development of Greek art as described in Greek writings. They also discuss Roman art during the early days of the Republic, of which not a trace survives today. However, they show little concern with the art of their own time. And except for Vitruvius, whose treatise on architecture is of great importance for later eras (see pages 426, 429, and 653), the Romans never developed a rich literature on the history and theory of art such as had existed among the Greeks.

We might be tempted to conclude, therefore, that the Romans viewed the art of their time as being in decline compared with the Greek past. This attitude also prevailed among scholars until not very long ago. Roman art, they claimed, is Greek art in its final phase—Greek art under Roman rule. Hence there is no such thing as Roman style, only Roman subject matter. Yet the fact remains that, as a whole, Roman art looks distinctly different from Greek art. Otherwise the "problem" would not have arisen. If we insist on judging this difference by Greek standards, it will appear as decline. If, on the other hand, we interpret it as expressing different aims, we are likely to see it in a more positive light.

Rome, after all, was not simply an outgrowth of Greece. According to legend, it was founded in 753 B.C. by Romulus, who chose the site after slaying his brother, Remus, although in fact the location had been inhabited for about 250 years. Rapid expansion took place during the following century under a series of kings, some of whom probably came from the nearby Sabine mountains.

This openness was to become a hallmark of Roman civilization as a whole. In fact, Rome was ruled by able Etruscan kings for about a century, until the last was overthrown as a despot in 509 B.C., and the Republic was established. The Etruscan kings threw the first defensive wall around the seven hills, drained the swampy plain of the Forum, and built the original temple on the Capitoline Hill, thus making a city out of what had been little more than a group of villages consisting of primitive huts. Equally important, they established the foundations for its future greatness by providing Rome with its early institutions and introducing the latest techniques of warfare. These Etruscan influences, as well as native Latin and Sabine traditions, made Roman civilization quite distinct from that of the Greeks. (See also box page 207.)

Under the Republic, the king was replaced by two magistrates, or consuls. They were advised by the Senate, made up of the patricians (aristocrats), who monopolized power and resources, although in theory the people were sovereign. A series of popular uprisings lasting over 200 years, from 494 to 287 B.C., ended with the plebeians (ordinary citizens), many of whom were subsistence farmers, being granted the right to pass laws in their own military and civil assemblies. Rome and its ally, the Latin League (founded in 493 B.C.), succeeded in conquering Etruria in 396 B.C., when Etruria's capitol, Veii, was destroyed. Rome itself was sacked in 390 B.C. by the Gauls, who left after receiving a large ransom. More than 40 years later, the Latin cities lost their independence, and by 275 B.C. Rome ruled all of Italy, including the Greek colonies. It soon launched the first of the three Punic (Latin for Phoenician) Wars against the north African city of Carthage, which ended finally with its razing in 146 B.C. During the second century all of Greece and Asia Minor fell to the Romans as well.

Despite these victories, Rome became bitterly divided between the Senate and the Popular Assembly. Following a brief civil war, Sulla emerged as dictator in 82 B.C., the general preparing the way for Roman emperors (beginning with Julius Caesar in 46 B.C.) who ruled Rome for the next four centuries. The decisive period came after Julius Caesar's murder two years later. His heir, Octavius, gradually vanquished his three rivals—Brutus, Cassius, and Marcus Antonius—until he was named Augustus Caesar in 27 B.C. Although his reign ushered in a period of peace and

prosperity that was marked by good relationships with both the Senate and the Assembly, his means of ascending the throne set the precedent for battles of succession that afflicted the empire virtually until its end in 476 A.D. (see page 270).

In the Roman empire, national or regional traits were absorbed into the pattern set by the capital, the city of Rome. From the very start Roman society proved remarkably tolerant of non-Roman traditions. It was able to make room for them all, so long as they did not threaten the security of the state. The populations of newly conquered provinces were not forced to change their ways but rather were put into a fairly low-temperature melting pot. Law and order, and respect for the symbols of Roman rule, were imposed on them. At the same time, their gods and sages were hospitably received in the capital, and eventually they themselves would be given the rights of citizenship. Roman civilization and Roman art thus integrated not only the heritage of the Greeks but also, to a lesser extent, the cultures of the Etruscans, Egyptians, and Near Eastern peoples as well. All this made for a complex and open society that was uniform and diverse at the same time.

Under such conditions, we cannot expect Roman art to show a consistent style such as we found in Egypt, or the clear-cut evolution that distinguishes the art of Greece. Its development consists of a set of tendencies that may exist side by side, even within a single monument, none of which is dominant. The "Roman-ness" of Roman art must be found in this complex pattern, rather than in a single, consistent quality of form—and that is precisely its strength.

Once we acknowledge that Roman art had important un-Greek aspects, we cannot say that it forms the final phase of Greek art, no matter how many artists of Greek origin we may find in Roman records. Actually, the Greek names of these men do not mean much. Most of the artists, it seems, were fully Romanized. In any event, most Roman works of art are unsigned, and their makers, for all we know, may have come from any part of the far-flung Roman domains.

ARCHITECTURE

While the originality of Roman sculpture and painting has been questioned, there is no such doubt about Roman architecture, which is a creative feat of extraordinary importance. From the very start, its growth reflected a distinctly Roman way of public and private life. Greek models, although much admired, could not accommodate the sheer numbers of people in large public buildings required by the empire. And when it came to supplying citizens with everything they needed, from water to entertainment on a grand scale, new forms had to be invented, and cheaper materials and quicker methods had to be used.

We cannot imagine the growth of Rome without the **arch** and the **vault** systems derived from it: the **barrel vault** (a half-cylinder); the **groin vault** (two barrel vaults that intersect at right angles); and the **dome** (see figs. 7-1 and 8-33). True arches are constructed of wedge-shaped blocks, called **voussoirs**, each pointing toward the center of the semicircular opening. Such an arch is strong and self-sustaining, in contrast to the "false" arch made up of horizontal courses of masonry or brickwork (like the opening above the lintel of the Lioness Gate at Mycenae, fig. 4-19). The true arch, as well as its extension, the barrel vault, had been discovered in Egypt as early as about 2700 B.C. But the Egyptians had used it mainly in underground tombs and in utilitarian buildings, never in temples. Apparently they did not think it was suited to monumental architecture. In Mesopotamia the true arch was used for city gates and perhaps other purposes as well, but to what extent we cannot determine for lack of preserved examples. The Greeks knew the principle of the true arch from the fifth century B.C. on, but they confined its use to underground structures or simple gateways, and refused to combine it with the architectural orders.

No less vital to Roman architecture was concrete, a mixture of mortar and gravel with rubble (small pieces of building stone and brick). Concrete construction had been invented in the Near East more than a thousand years earlier, but the Romans made it their chief building technique. The advantages of concrete are obvious: it is strong, cheap, and adaptable. Concrete made possible the vast architectural works that are the chief reminders of "the grandeur that was Rome." The Romans hid the unattractive concrete surface by adding a facing of brick, stone, marble, or plaster. Today this decorative skin has disappeared from most Roman buildings, leaving the concrete core exposed and depriving these ruins of the appeal that those of Greece have for us.

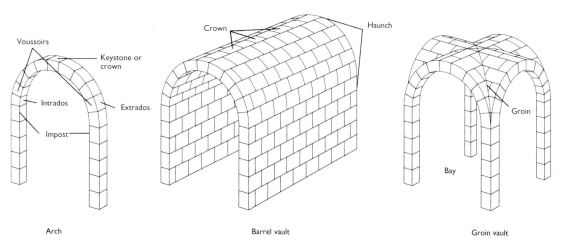

7-1. Arch, barrel vault, and groin vault

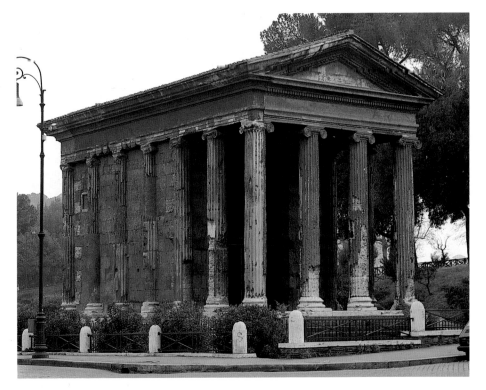

7-2. "Temple of Fortuna Virilis," Rome. Late 2nd century B.C.

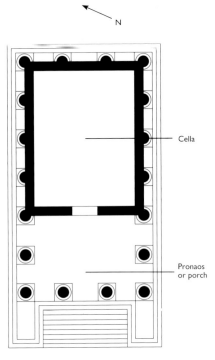

7-3. Plan of the "Temple of Fortuna Virilis"

Republican Religious Architecture

THE "TEMPLE OF FORTUNA VIRILIS." Any elements borrowed from the Etruscans or Greeks were soon marked with an unmistakable Roman stamp. These links with the past are strongest in the temple types developed during the Republican period (510–44 B.C.), the heroic age of Roman expansion. The delightful little "Temple of Fortuna Virilis," built in Rome during the last years of the second century B.C., is the oldest well-preserved example of its kind (fig. 7-2). (The name is sheer fancy, for it seems to have been dedicated to the Roman god of harbors, Portunus.) The elegant proportions of its Ionic columns and entablature suggest the wave of Greek influence following the Roman conquest of Greece in 146 B.C. Yet it is not simply a copy of a Greek temple. We recognize a number of Etruscan elements: the high podium, the deep porch, and the wide cella. However, the cella is no longer subdivided into three compartments, as it had been under the Etruscans, but now encloses a single space (fig. 7-3) and uses engaged columns instead of a true peristyle.

The "Temple of Fortuna Virilis" represents a new type of temple designed for Roman needs, not a haphazard cross of Etruscan and Greek elements. It was to have a long life. Numerous examples of it, usually large and with Corinthian columns, can be found as late as the second century A.D., both in Italy and in the provincial capitals of the empire. The Romans needed spacious temple interiors, since they used them not only for the image of the god but also for the display of trophies brought back by their armies (see fig. 7-35).

THE TEMPLE OF THE SIBYL. Another type of Republican temple is seen in the so-called "Temple of the Sibyl" at Tivoli (figs. 7-4 and 7-5), built a few decades later than the "Temple of Fortu-

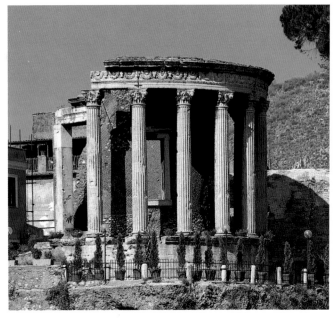

7-4. "Temple of the Sibyl," Tivoli. Early 1st century B.C.

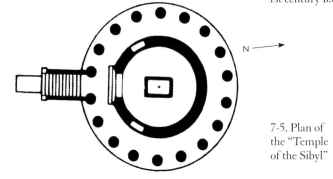

7-5. Plan of the "Temple of the Sibyl"

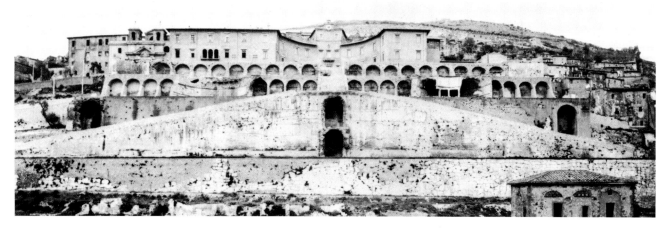

7-6. Sanctuary of Fortuna Primigenia, Praeneste (Palestrina). Early 1st century B.C.

na Virilis." It, too, merges two traditions. Its original ancestor was a building in the center of Rome which housed the sacred flame of the city. This type at first had the round shape of the traditional peasant huts in the Roman countryside. Later it was redesigned in stone under the influence of the Greek tholos (see pages 134–135), and thus became the model for the round temples of late Republican times. Here again we find the high podium, with steps only at the entrance, and a Greek-inspired exterior. As we look closely at the cella, we note that while the door and window frames are of cut stone, the wall is built in concrete, which can be seen now that the marble facing is gone.

THE SANCTUARY OF FORTUNA PRIMIGENIA. Roman buildings characteristically speak to us through their massive size and bold conception. The oldest monument in which these qualities are fully seen is the Sanctuary of Fortuna Primigenia at Palestrina, in the foothills of the Apennines east of Rome (fig. 7-6), dating from the early first century B.C. Here, in what was once an important Etruscan stronghold, a strange cult had been established since early times, dedicated to Fortuna (Fate) as a mother deity and combined with a famous oracle, a person through whom the deity was believed to have spoken. Its size and shape were almost completely hidden by the medieval town that had been built over it. In 1944, however, a bombing attack destroyed most of the later houses and revealed the ancient temple precinct.

The site originally had a temple at the foot of the hill (fig. 7-7). Behind the ramp, a series of staircases led up to two terraces. The first terrace was a broad colonnade marked by semicircular porticoes, while the second had arched recesses framed by engaged columns and architraves. The openings were covered by barrel vaults, another typical feature of Roman architecture. At the top of the entire sanctuary was a great colonnaded court, with a large semicircular exedra. (The tholoslike structure above it is much later in date.) Except for one niche that still has the original columns and entablature on the lower terrace (center right), all the surfaces now visible are of concrete, like the cella of the round temple at Tivoli. Indeed, it is hard to imagine how such a huge complex could have been constructed otherwise.

What makes the sanctuary at Palestrina so imposing, however, is not merely its scale but the superb way it fits the site. An entire hillside, comparable to the Akropolis of Athens in its commanding position, has been transformed. The architectural forms seem to grow out of the rock, as if human beings had simply completed a design laid out by nature itself. Such a molding of open spaces had never been possible, or even desired, in the Classical Greek world. The only comparable projects are found in Egypt (see fig. 2-25). Nor did the Palestrina sanctuary express the spirit of the Roman Republic. Significantly, the sanctuary dates from the time of Sulla, whose brief dictatorship (82–79 B.C.) marked the transition from

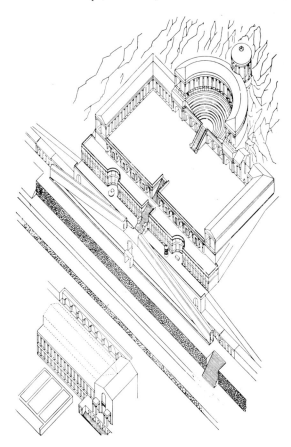

7-7. Axonometric reconstruction of the Sanctuary of Fortuna Primigenia, Praeneste

Republican government to the one-man rule of Julius Caesar and the emperors who followed him. Because Sulla had won a great victory against his enemies in the civil war at Palestrina, it is tempting to think that he personally ordered the complex built, both as an offering to Fortuna and as a monument to his own fame.

FORUMS. Julius Caesar sponsored a project on a similar scale in Rome itself: the Forum Julium. Built near the end of his life, it was a great architecturally framed square adjoining the Temple of Venus Genetrix, the mythical ancestress of Caesar's family. Here the merging of religious cult and personal glory is even more obvious. The Forum of Caesar set the pattern for all the later imperial forums, which were linked to it by a common major axis to form the most magnificent architectural sight of the Roman world (fig. 7-8). Unfortunately, nothing is left of the forums today but a field of ruins that conveys little of their original splendor.

Republican Secular Architecture

The arch and vault, as we saw at Palestrina, were an essential part of Roman monumental architecture. They also formed the basis of construction projects such as sewers, bridges, and aqueducts, which were designed for efficiency rather than beauty. The first structures of this kind were built in Rome as early as the end of the fourth century B.C., but only traces of them survive today. There are, however, many others of later date throughout the empire. An excellent example is the well-preserved aqueduct at Nîmes in southern France known as the Pont du Gard (fig. 7-9). Its clean, rugged lines spanning the wide valley are a tribute not only to the high caliber of Roman engineering but also to the sense of order and permanence that inspired these efforts. It is these qualities, one may argue, that underlie all Roman architecture and define its unique character.

THE COLOSSEUM. They impress us again in the Colosseum, the huge amphitheater for gladiatorial games in the center of Rome (figs. 7-10 and 7-11). Completed in 80 A.D., the Colosseum, was in terms of sheer mass, one of the largest single buildings anywhere: it stood 159 feet high, 616 feet 9 inches long, and 511 feet 11 inches wide, and could hold more than 50,000 spectators. The concrete core, with its miles of stairways and corridors, is an outstanding feat of engineering, designed to ensure the smooth flow of traffic to and from the arena. It uses both the familiar barrel vault and a more complex form, the groin vault (see fig. 7-1). On the top is evidence that huge canvas sheets could be rigged by sailors to provide shade during the hottest days. The exterior, dignified and monumental, reflects the interior organization of the structure, but clothes and accentuates it in cut stone. There is a fine balance between vertical and horizontal elements in the framework of engaged columns and entablatures that contains the endless series of arches. The three Classical orders are superimposed according to their "weight": Doric, the oldest and most severe, on the ground floor, followed by Ionic and Corinthian. The lightening of the proportions, however, is barely noticeable, for the Roman versions of the orders are almost alike. Structurally they have become ghosts, yet they still serve an important aesthetic function. It is through them that this enormous facade is related to the human scale.

Imperial Religious Architecture

Arches, vaults, and concrete permitted the Romans to create huge, uninterrupted interior spaces for the first time in the history of architecture. The potential of all three was explored especially in the great baths, or *thermae*, which were major centers of social life in imperial Rome. The experience gained there could then be applied to more traditional types of buildings, sometimes with revolutionary results.

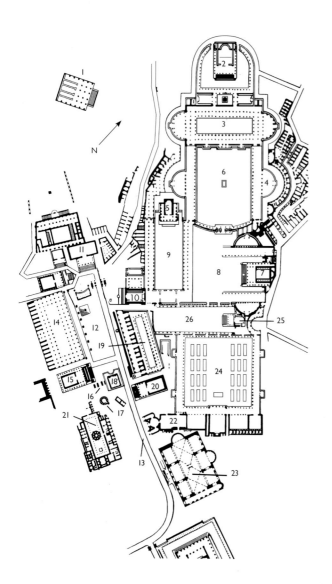

(LEFT) 7-8. Plan of the Forums, Rome:
(1) Temple of Capitoline Jupiter; (2) Temple of Trajan; (3) Basilica Ulpia; (4) Market of Trajan; (5) Temple of Venus Genetrix; (6) Forum of Trajan; (7) Temple of Mars Ultor; (8) Forum of Augustus; (9) Forum of Julius Caesar; (10) Senate Chamber; (11) Temple of Concord; (12) Roman Forum; (13) Sacred Way; (14) Basilica Julia; (15) Temple of Castor and Pollux; (16) Arch of Augustus; (17) Temple of Vesta; (18) Temple of Julius Caesar; (19) Basilica Aemilia; (20) Temple of Antoninus and Faustina; (21) House of the Vestal Virgins; (22) Temple of Romulus; (23) Basilica of Maxentius and Constantine; (24) Forum of Vespasian; (25) Temple of Minerva; (26) Forum of Nerva

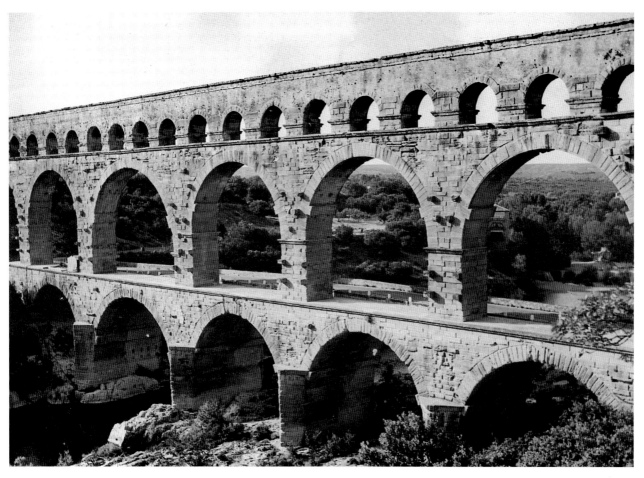

7-9. Pont du Gard, Nîmes, France. Early 1st century A.D.

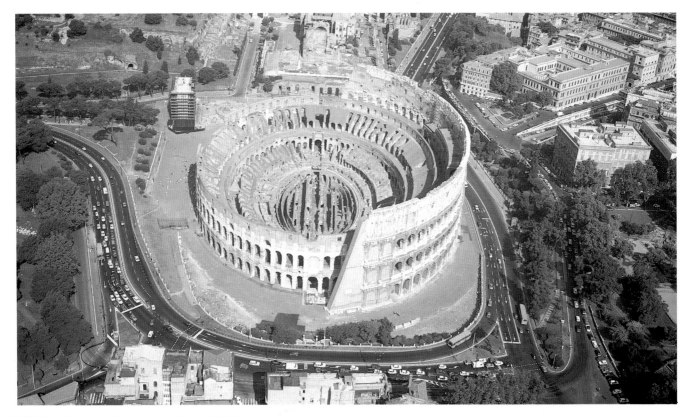

7-10. The Colosseum (aerial view), Rome. 72–80 A.D.

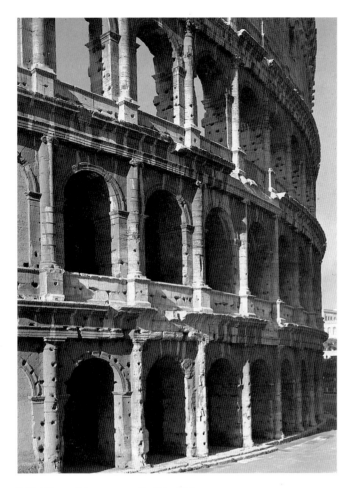

7-11. View of the outer wall of the Colosseum

The impact of the great domed interior—awe-inspiring and harmonious at the same time—is impossible to convey in photographs. Even the painting in figure 7-12 fails to do it justice.

The dome is a true hemisphere of ingenious design. The interlocking ribs form a structural cage that permits the use of relatively lightweight **coffers** (recessed panels) arranged in five rings. (Such coffers were first used above the porches and side passages in Greek temples.) The circular opening in its center (called the oculus, or eye) admits an ample and even flow of light. The height from the floor to the oculus is 143 feet, which is also the diameter of the dome's base and the interior (see fig. 7-14). The dome and drum are likewise of equal height, so that all the proportions are in exact balance. This equilibrium could not be achieved on the exterior, despite its fine proportions, because the outward thrust of the dome had to be contained by making the base much heavier than the top. (The thickness of the dome increases downward from 6 feet to 20 feet.)

The weight of the dome does not rest uniformly on the drum but is concentrated on the eight wide pillars (see fig. 7-13). Between them are seven niches hollowed out of the massive concrete. Although they are closed in back, the screen of columns creates a sense of open space that makes the walls seem less thick

THE PANTHEON. The most striking example of this process is the famous **Pantheon** in Rome. This large circular temple of the early second century A.D. is one of the best preserved, as well as the most impressive, of any Roman structure (figs. 7-12, 7-13, 7-14, and 7-15). There had been round temples long before this time (see figs. 7-4 and 7-5), but they are so different from the Pantheon that it could not have been derived from them.

On the outside (fig. 7-15), the cella of the Pantheon appears as a plain cylindrical **drum**, surmounted by a gently curved dome. The entrance is emphasized by a deep porch of the kind familiar to us from Roman temples of the "Fortuna Virilis" type (see figs. 7-2 and 7-3). (The inscription above the columns refers to Marcus Agrippa, who built the first temple on the site toward the end of the first century B.C.) The junction of these two elements seems rather abrupt, but we no longer see the building raised high on a podium as it was meant to be seen. Today the level of the surrounding streets is a good deal higher than it was in antiquity, so that the steps leading up to the entrance are now submerged. Moreover, the porch was part of a rectangular, colonnaded forecourt, which must have had the effect of detaching it visually from the rotunda.

The heavy plainness of the exterior wall suggests that the architects did not have an easy time with the problem of supporting the huge dome. Nothing on the outside, however, gives any hint of the interior. Indeed, its airiness and elegance are completely different from what the severe exterior would lead us to expect.

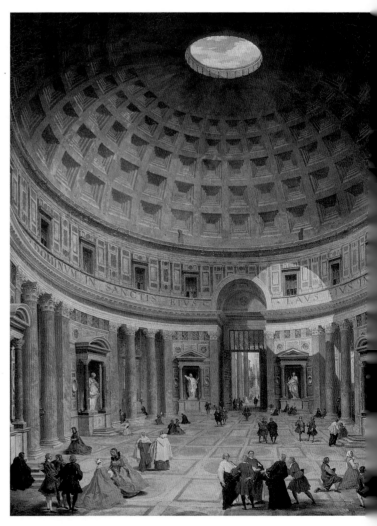

7-12. Giovanni Paolo Panini. *The Interior of the Pantheon.* c. 1740. Oil on canvas, 50½ x 39" (128.2 x 99.1 cm). National Gallery of Art, Washington, D.C. Samuel H. Kress Collection

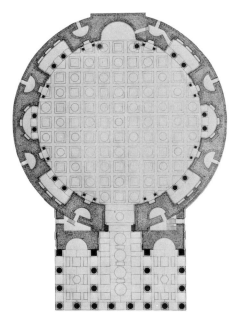

7-13. Plan of the Pantheon

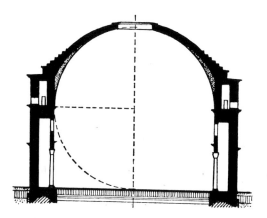

7-14. Transverse section of the Pantheon

7-15. The Pantheon, Rome. 118–25 A.D.

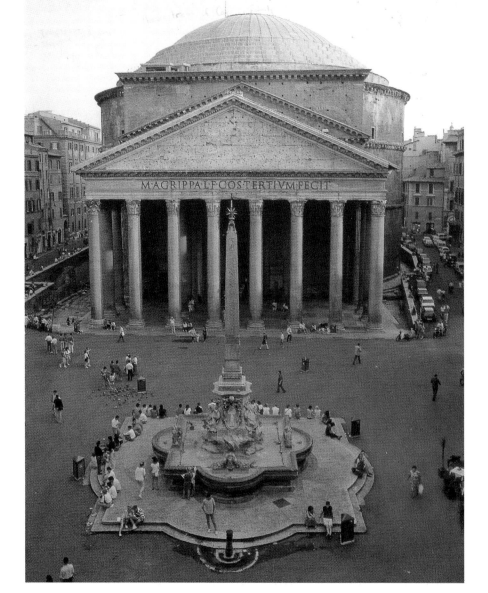

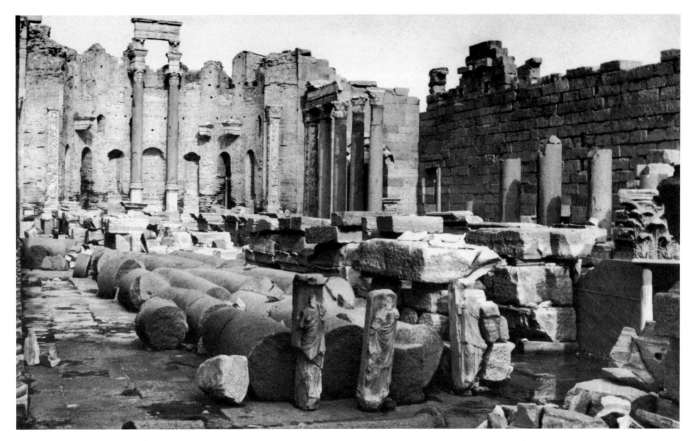

7-16. Basilica, Leptis Magna, Libya. Early 3rd century A.D.

and the dome much lighter than they actually are. The columns, the colored marble paneling of the wall surfaces, and the floor remain largely as they were in Roman times. Originally, however, the coffers were **gilded** (overlaid with a thin layer of gold).

As its name suggests, the Pantheon was dedicated to all the gods or, more precisely, to the seven planetary gods. (The sculptures of the seven planetary gods that fill the seven niches in our illustration date from the Baroque era.) It is therefore likely that the golden dome represented the Dome of Heaven. Yet this solemn structure grew from rather humble beginnings. Vitruvius, writing more than a century earlier, describes the domed steam chamber of a bath that foreshadows (on a much smaller scale) the basic features of the Pantheon: a hemispherical dome, a proportional relationship of height and width, and a circular opening in the center, which could be closed by a bronze shutter on chains to adjust the temperature of the steam room.

BASILICAS. Basilicas, long halls used for civic purposes, had first been developed in Hellenistic Greece toward the end of the third century B.C. (In ancient Greek, *basilica* meant "royal house," from *basileus,* "king.") Roman basilicas, whose origins can be traced back to 184 B.C., eventually became a standard feature of every major town. One of their chief functions was to provide a dignified setting for the courts of law that dispensed justice in the name of the emperor. According to Vitruvius, their placement and proportions followed set principles, although they never actually conformed to a single type and varied from region to region. [See Primary Sources, no. 4, page 213.] These basilicas had wooden ceil-

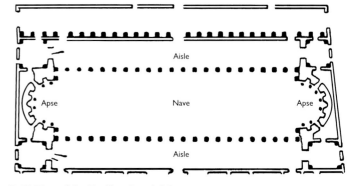

7-17. Plan of the Basilica, Leptis Magna

ings instead of masonry vaults, for reasons of convenience and tradition rather than necessity. Thus they were often destroyed by fire. Rome itself had a number of basilicas, but very little remains of them today. Those in the provinces have fared somewhat better. Ruined though it is, the one at Leptis Magna in North Africa (figs. 7-16 and 7-17) is among the best-preserved examples. It has most of the features of the imperial type. The long center tract, or nave, has a semicircular apse at either end. It had a two-story colonnade to provide access to the side aisles, which were lower than the nave to permit clerestory windows in the upper part of the wall.

The Basilica of Constantine (figs. 7-18, 7-19, and 7-20) was a daring attempt to create a new, vaulted type of basilica derived from thermae. Actually begun by Constantine's predecessor, Maxentius, it was based on the main halls of the public baths built by

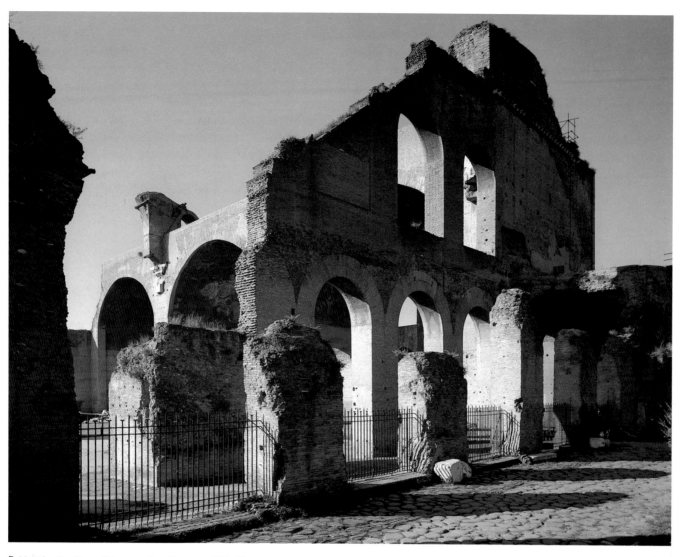

7-18. The Basilica of Constantine, Rome. c. 307–20 A.D.

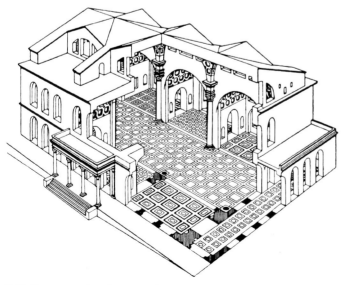

7-19. Reconstruction drawing of the Basilica of Constantine (after Huelsen)

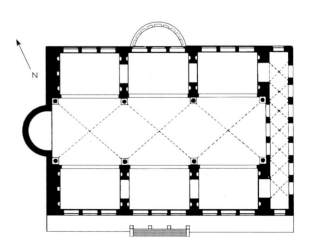

7-20. Plan of the Basilica of Constantine

two earlier emperors, Caracalla and Diocletian. However, it is on an even grander scale and must have been the largest roofed interior in all of Rome. The building was entered through a narthex (vestibule) at the east end. At the opposite end was an apse where a colossal statue of Constantine was found (see fig. 7-45). Probably to make room for his cult statue, Constantine modified the basilica by adding a second entrance to the south and a second apse opposite it where he could sit as emperor.

Today only the north aisle, consisting of three huge barrel-vaulted compartments, is still standing (fig. 7-18). The nave was covered by three groin vaults (figs. 7-19 and 7-20) and rose a good deal higher. Since a groin vault, like a canopy, has its weight and thrust concentrated at the four corners (see fig. 7-1), the upper walls of the nave could be pierced by a large clerestory. As a result, the interior of the basilica must have had a light and airy quality despite its enormous size. Despite its obvious advantages, the type seems to have met with little favor. Perhaps people felt that it lacked dignity because of its resemblance to the public baths. Whatever the reason, the Christian basilicas of the fourth century were modeled on the older, wooden-roofed type (see fig. 8-6). Not until 700 years later did vaulted basilican churches become common in western Europe.

Imperial Domestic Architecture

One of the delights in studying Roman architecture is that it includes not only great public buildings but also a wide variety of dwellings, from imperial palaces to the homes of the urban poor. If we disregard these two extremes, we are left with two basic house types that account for most of the domestic architecture that has survived. The *domus* is a single-family house based on ancient Italic tradition. Its distinctive feature is the **atrium**, a square or oblong central hall lit by an opening in the roof, around which the other rooms are grouped. In Etruscan times, it had been a rural dwelling, but the Romans "citified" it to create the typical home of the well-to-do, discussed at length by Vitruvius. [See Primary Sources, no. 4, page 213.]

Many examples of the domus have been excavated at Herculaneum and Pompeii, the two towns that were buried under volcanic ash during an eruption of Mount Vesuvius in 79 A.D. As we enter the House of the Silver Wedding at Pompeii (fig. 7-21), the atrium, seen here from the vestibule along the main axis of the domus, has become a room of impressive size. (The house received its nickname when the king and queen of Italy visited the site during their silver anniversary in 1893.) The four Corinthian columns at the corners of the opening in the roof give it the quality of an enclosed court. There is a shallow basin in the center to catch the rainwater. (The roof slants inward.) The atrium was the traditional place for keeping portraits of ancestors. At its far end, to the right, we see a recess for keeping family records (the *tablinum*). Beyond it is the garden, surrounded by a colonnade (the **peristyle**). In addition to the rooms around the atrium, there may be rooms attached to the back of the house. The domus is shut off from the street by windowless walls. Obviously, privacy and self-sufficiency were important to the wealthy Roman. Yet the domus was also a public space shared with favored guests, who were entertained lavishly amid sumptuous decorations—stucco, wall paintings, and mosaics—that testified to the family's wealth, status, and good taste.

Less elegant than the domus, and urban from the start, is the **insula**, or city block, which we find mainly in Rome itself and in Ostia, the ancient port near the mouth of the Tiber River. The insula has many features of the modern apartment house. It is a good-sized concrete-and-brick building (or a chain of buildings) around a small central court. On the ground floor are shops and taverns open to the street; above it are living quarters for numerous families. Some insulae had as many as five stories, with balconies above the second floor (fig. 7-22). The daily life of the artisans and shopkeepers who lived in them was oriented toward the street, as it still largely is in modern Italy. The privacy of the domus was reserved for the few who could afford it.

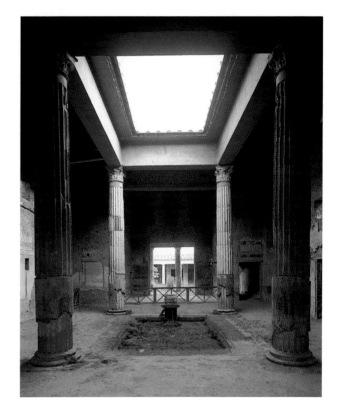

7-22. Insula of the House of Diana, Ostia. c. 150 A.D.

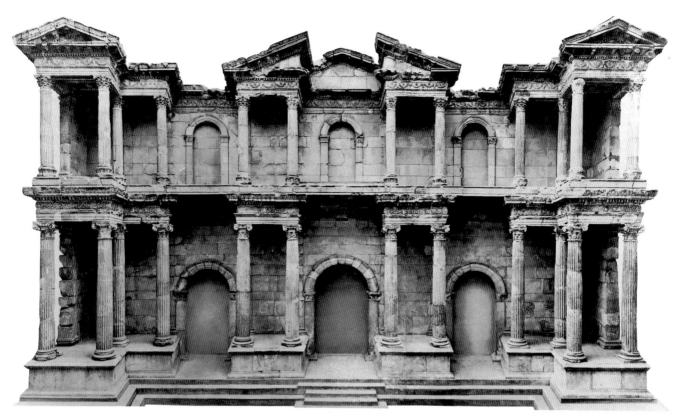

7-23. Market Gate from Miletus (restored). c. 160 A.D. Staatliche Museen zu Berlin, Preussischer Kulturbesitz, Antikensammlung

Late Roman Architecture

In discussing the new forms of construction, we noted the Romans' loyalty to the Classical Greek orders. While they no longer relied on them in the structural sense, they remained faithful to their spirit by continuing to use the post-and-lintel system as an organizing principle. Column, architrave, and pediment might be merely superimposed on a vaulted brick-and-concrete core, but their shapes, as well as their relationships to each other, were still determined by the original orders.

This orthodox attitude toward the architectural vocabulary of the Greeks prevailed from the Roman conquest of Greece until the end of the first century A.D. After that, we find a growing taste for imaginative transformations of the Greek vocabulary. Just when and where this tendency began is still unclear. There is some evidence that it may go back to late Hellenistic times in the Near East, since it certainly was most pronounced in the Asiatic and African provinces of the empire. A characteristic example is the Market Gate from Miletus of about 160 A.D. (rebuilt in the state museum in Berlin; fig. 7-23). One might refer to it as display architecture in terms of both its effect and its ancestry. The facade, with its alternating recesses and projections, is derived from the architectural stage backgrounds of the Roman theater. The continuous in-and-out rhythm even appears in the pediment above the central doorway, which is broken into three parts.

By the late third century, the trend had become so well established that the traditional grammar of the Greek orders was dissolving everywhere. Nowhere is this better seen than at the Palace of Diocletian at Spalato (fig. 7-24) overlooking the Adriatic Sea, built after Diocletian abdicated in 305. Still remarkably well preserved, it is essentially a fortified castle, with defensive walls and towers. It was organized somewhat like a military camp: as an enormous rectangle (about 650 by 500 feet) divided into four major blocks by two intersecting colonnaded streets leading to three gates. The main gate led ultimately to the audience hall. At the end of this peristyle, the architrave between the two center columns supporting the pediment (sometimes referred to as the Pediment of Glorification) is curved to create a novel effect by echoing the arch of the doorway below. The pediment may have been crowned by a statue, perhaps of the victorious emperor in a quadriga. It was here that the former emperor made his public appearances. Behind this grand entrance was a vestibule, which opened on to the audience hall, where Diocletian sat like a god. The idea of the divine ruler was Eastern in origin, and Eastern influences abound throughout the vast complex.

On the long sides of the peristyle we see an even more revolutionary device: a series of arches resting directly on columns. A few arcades of this sort can be found as early as Augustan times, but it was only now, on the eve of the victory of Christianity, that the marriage of arch and column was fully accepted. This union, indispensable to the future development of architecture, seems so natural to us that we can hardly understand why it was ever opposed.

To the left was an equally novel feature: a huge octagonal mausoleum, which became one of the prototypes of Christian martyria, burial places of martyred saints (see page 232). We can just make out the large entrance hall behind the first three bays in our illustration. Later, the mausoleum was converted into a Christian cathedral.

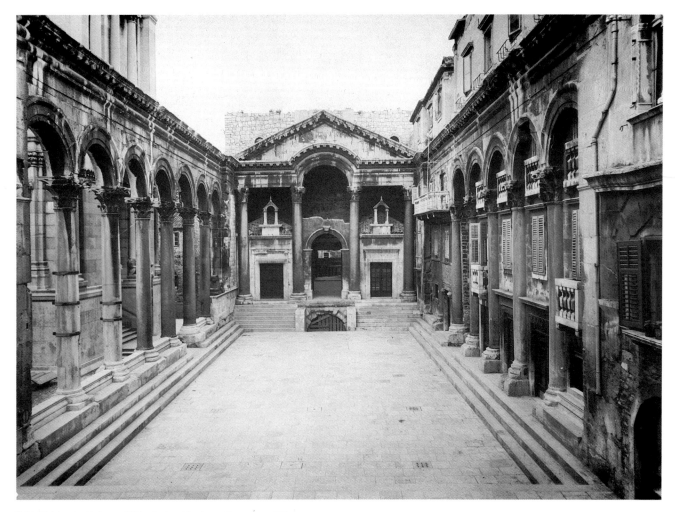

7-24. Peristyle, Palace of Diocletian, Spalato, Croatia. c. 300 A.D.

SCULPTURE

The debate over the question "Is there such a thing as a Roman style?" has centered largely on sculpture, and for good reason. Even if we discount the importing and copying of Greek originals, the reputation of the Romans as imitators seems to be borne out by large numbers of works that are probably based on Greek models. While the Roman demand for sculpture was tremendous, much of it may be attributed to a taste for antiquities and for sumptuous interior decoration. On the other hand, there can be no doubt that some kinds of sculpture had important functions in ancient Rome. These works represent the living sculptural tradition. We shall concern ourselves here with two aspects of Roman sculpture that are rooted in Roman society: portraiture and narrative relief.

Republican Sculpture

We know from literary accounts that great political or military leaders were honored by having their statues put on public display. This custom began in early Republican times and continued until the end of the empire a thousand years later. It may have been derived from the Greek custom of placing votive statues of athletes and other important individuals in the precincts of the Akropolis and in such sanctuaries as Delphi and Olympia (see fig.

5-47). Unfortunately, the first 400 years of this Roman tradition are a closed book. Not a single Roman portrait has come to light that can be securely dated before the first century B.C. How were those early statues related to Etruscan or Greek sculpture? Did they have any specifically Roman qualities? Were they individual likenesses, or were their subjects identified only by pose, costume, attributes, and inscriptions?

L'ARRINGATORE. Our sole clue is the lifesize bronze sculpture of an orator called *L'Arringatore* (fig. 7-25). It was once assigned to the second century B.C. but now is generally placed in the early years of the first. The statue comes from southern Etruscan territory and bears an Etruscan inscription that includes the name Aule Metele (Aulus Metellus in Latin), presumably the name of the person it represents. He must have been a Roman, or at least an official appointed by the Romans. The workmanship is evidently Etruscan, as indicated by the inscription. But the gesture, which denotes both address and salutation, is found in hundreds of Roman statues of the same sort. The costume, an early kind of toga, is Roman. Our sculptor tried to conform to an established Roman type of portrait statue, not only in these features but in style as well. We see very little of the Hellenistic flavor of the later Etruscan tradition. What makes the figure remarkable is its serious, factual quality, down to the neatly tied shoelaces.

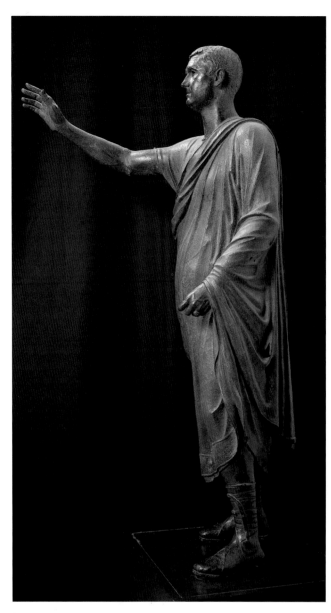

7-25. *Aulus Metellus (L'Arringatore)*. Early 1st century B.C. Bronze, height 71" (280 cm). Museo Archeologico Nazionale, Florence

PORTRAITS. It appears that a clearly Roman portrait style was not achieved until the time of Sulla, when Roman architecture, too, came of age (see pages 179–80). It arose from an ancient custom. Upon the death of the male head of the family, a wax image was made of his face, which was then preserved in a special shrine or family altar. At funerals, these ancestral images were carried in the procession. The patrician (aristocratic) families of Rome clung tenaciously to this kind of ancestor worship well into imperial times. The desire to have these perishable wax likenesses reproduced in marble may have come about because the patricians felt that their traditional position of leadership was threatened and they wanted to make a greater public display of their ancestors in order to stress their ancient noble lineage.

ANCESTOR PORTRAITS. Such display is certainly the purpose of the statue in figure 7-26. It shows an unknown Roman holding two busts of his ancestors, presumably his father and grandfather. The impressive heads of the two ancestors are copies

of the lost originals. (Differences in the style and in the shape of the busts indicate that the original of the head on the left is about 30 years older than that of the one on the right.) The somber face and grave demeanor of this dutiful Roman are strangely affecting and indeed seem to project a spirit of patriarchal dignity that was probably not present in the original wax portraits. Thus the process of

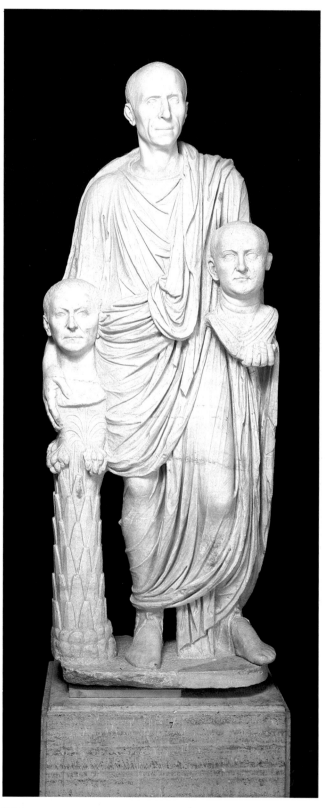

7-26. *A Roman Patrician with Busts of His Ancestors.*
Late 1st century B.C. Marble, life-size. Museo Capitolino, Rome

translating ancestor portraits into marble not only made the images permanent but monumentalized them in the spiritual sense as well.

What mattered, however, was the face itself, not the style of the artist who recorded it. For that reason, these portraits have a serious, prosaic quality. The word *uninspired* suggests itself—not as a criticism but as a way to describe the difference in attitude of the Roman artist from those of Greek or even Etruscan portraitists. That seriousness was a positive value becomes clear when we compare the right-hand ancestral head in our group with the Hellenistic portrait from Delos in figure 5-79. It would be hard to imagine a greater contrast. Both are persuasive likenesses, yet they seem worlds apart. Whereas the Hellenistic head impresses us with its grasp of the sitter's psychology, the Roman bust may strike us at first glance as no more than a detailed record of the face's topogra-

phy, in which the sitter's character appears only incidentally. And yet this is not really the case. The features are true to life, no doubt, but the carver has emphasized them selectively to bring out a specifically Roman personality: stern, rugged, devoted to duty. It is a father image of frightening authority, and the facial details are like individual biographical data that distinguish it from others.

Imperial Sculpture

PORTRAITS. As we approach the reign of the emperor Augustus (27 B.C.–14 A.D.), we find a new trend in Roman portraiture, which reaches its climax in the images of Augustus himself. At first glance, we may not be certain whether his statue from Primaporta (fig. 7-27) represents a god or a human being. This doubt is

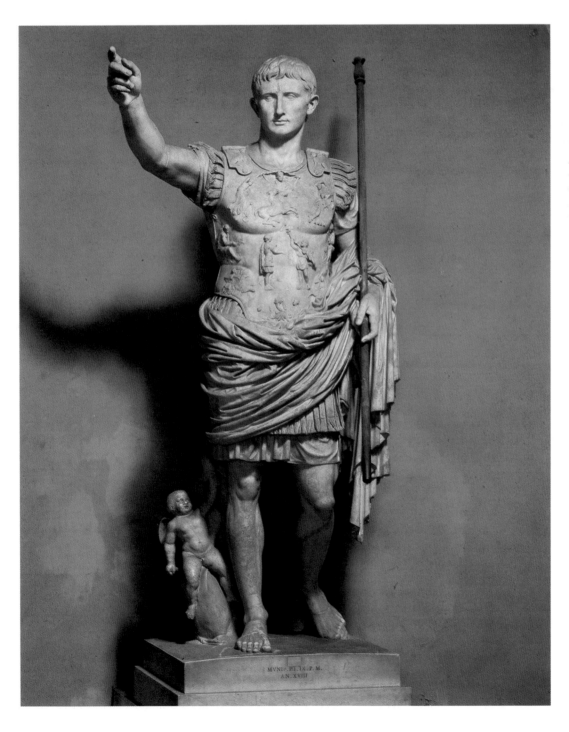

7-27. *Augustus of Primaporta*. Roman copy of c. 20 A.D. of a Roman original of c. 15 B.C. Marble, height 6'8" (2.03 m). Musei Vaticani, Braccio Nuovo, Rome

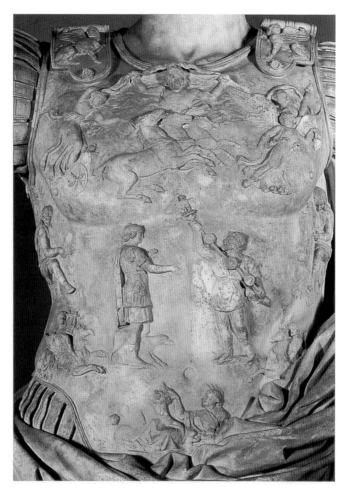

7-28. *Augustus of Primaporta*. Detail of breastplate

entirely appropriate, for the figure is meant to be both and may be read as a form of political propaganda. Here we meet a concept familiar to us from Egypt and the ancient Near East: the divine ruler. It had entered the Greek world in the fourth century B.C. (see page 154). Alexander the Great adopted it, as did his successors, who modeled themselves after him. They, in turn, transmitted it to Julius Caesar and the Roman emperors, who at first encouraged the worship of themselves only in the eastern provinces, where belief in a divine ruler was a tradition.

The idea of giving the emperor divine stature to enhance his authority soon became official policy. While Augustus did not carry it as far as later emperors, the Primaporta statue clearly shows him enveloped in an air of divinity. (He also was the chief priest of the state religion; see fig. 7-32.) The idealized body is clearly derived from the *Doryphoros of Polykleitos* (see fig. 5-44), while the Cupid at his feet suggests the infant Bacchus in Praxiteles' *Hermes* (see fig. 5-70). The head is idealized, or better yet Hellenized. Small details are omitted, and the focus on the eyes creates something like the inspired look we find in portraits of Alexander the Great (compare fig. 5-84). However, the statue has an unmistakably Roman flavor. The emperor's gesture is familiar from *Aulus Metellus* (see fig. 7-25). And the face is a definite likeness, idealized yet clearly individual, as we know from many other portraits of Augustus. All Romans would have recognized it immediately, for

they knew it from coins and countless other representations. In fact, the emperor's image soon came to play the symbolic role of a national flag.

Although it was found in the villa of Augustus's wife, Livia, the Primaporta statue may be a later copy of a lost original. The bare feet indicate that he has been deified, so that the sculpture was perhaps made after his death. (However, the emperor Hadrian had a statue erected of himself as a nude god while he was still alive.) Myth and reality are blended in order to glorify the emperor. The little Cupid on a dolphin serves both to support the heavy marble figure and to remind viewers of the claim that the Julian family was descended from Venus. The Cupid has also been seen as representing Gaius Caesar, Augustus's nephew and designated successor who died early in life, although this proposal seems unlikely.

The costume's surface texture conveys the actual feel of cloth, metal, and leather. The breastplate (fig. 7-28) illustrates Augustus' victory over the Parthians in 39–38 B.C., which avenged a Roman defeat at their hands nearly 15 years earlier. Characteristically, however, the event is shown as an allegory. The presence of gods and goddesses raises it to cosmic significance, while the symbolic aspects of the work proclaim that this triumph, which Augustus viewed as pivotal, began an era of peace and plenty. Representing their respective armies, a Parthian returns a captured military standard to a Roman. Are they personifications, as seems likely, or

are they historical figures—Phraates IV and either Augustus himself or his stepson and successor Tiberius? (According to the historian Suetonius, Tiberius was Augustus' intermediary and would have benefited from this bit of visual propaganda.) The issue may never be resolved.

If we regard the Republican ancestral images and the Greek-inspired *Augustus of Primaporta* as two extremes, we can find almost any kind of mixture of the two. Vast numbers of portraits were made, and the range of types and styles mirrors the ever more complex nature of Roman society. The head of the emperor Vespasian, of about 75 A.D., is a case in point (fig. 7-29). He was the first of the Flavian emperors, which included his sons Titus (see below) and Domitian. A military man, he assumed the throne soon after the infamous emperor Nero was overthrown in 68 A.D. Vespasian must have been skeptical about the idea of emperor worship. When he was dying, he is reported to have said, "Alas, it seems I am about to become a god." His humble origin and simple tastes may be reflected in the Republican flavor of his portrait. The soft, veiled quality of the carving, on the other hand, with its emphasis on texture, is so Greek that it recalls the technique of Praxiteles and his school (compare fig. 5-70). More classical still is the wonderful head of Trajan (fig. 7-30). Its rounded forms recall the *Augustus of Primaporta*, as does the commanding look of the eyes under strongly projecting brows. The face, however, has an

7-30. *Trajan*. c. 100 A.D. Marble, lifesize. Museum, Ostia

emotional intensity that is difficult to define—a kind of Greek pathos translated into Roman nobility (compare fig. 5-79).

NARRATIVE RELIEFS. Imperial art was not confined to portraiture. The emperors also commemorated their achievements in narrative reliefs on monumental altars, **triumphal arches**, and columns. Similar scenes are familiar to us from the ancient Near East (see figs. 3-13 and 3-28) but not from Greece. Historical events—that is, events which occurred only once, at a specific time and place—had not been shown in Classical Greek sculpture. If a victory over the Persians was to be commemorated, for instance, it had to be portrayed as a mythical event outside any space-time context: a combat of Lapiths and Centaurs or Greeks and Amazons (see figs. 5-58 and 5-66). This attitude continued into Hellenistic times, although not quite as absolutely. When Attalos I of Pergamon celebrated his victories over the Celts, the latter were represented faithfully (see fig. 5-73), but in typical poses of defeat rather than in the framework of a particular battle.

Greek painters, on the other hand, had depicted historical subjects such as the Battle of Salamis as early as the mid-fifth century B.C., although we do not know how specific these pictures were in detail. As we have seen, the mosaic from Pompeii showing the Battle of Issos (see fig. 5-62) probably reflects a famous Hellenistic painting of about 315 B.C. representing the defeat of the Persian king Darius by Alexander the Great. Historic events had been portrayed in Rome, too, from the third century B.C. on. A victorious military leader would have his deeds painted on panels that were carried in his triumphal procession or shown in public places. These pictures seem to have had the fleeting nature of posters

7-29. *Vespasian*. c. 75 A.D. Marble, lifesize, with damaged chin repaired. Museo delle Terme, Rome

advertising the hero's achievements; none has survived. Sometime during the late years of the Republic, such images began to take on a more monumental and permanent form. They were no longer painted, but carved and attached to permanent structures. They proved a ready tool for glorifying imperial rule, and the emperors used them on a large scale.

THE ARA PACIS. Augustus preferred to be represented as the "Prince of Peace" than as the all-conquering military hero. The most important of his monuments was the Ara Pacis (Altar of Peace), voted by the Roman Senate in 13 B.C. and completed four years later. This richly carved structure (fig. 7-31) recalls the Pergamon Altar, although on a much smaller scale (compare fig. 5-74). On the wall that screens the altar itself, a monumental frieze depicts allegorical and legendary scenes, as well as a solemn procession led by the emperor himself.

Here the "Hellenic" style we found in the *Augustus of Prima-porta* reaches its fullest expression. Yet if we compare the Ara Pacis

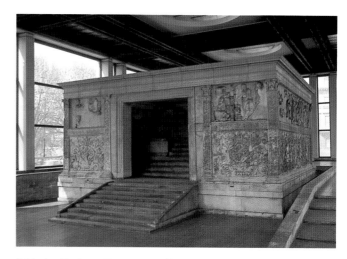

7-31. Ara Pacis. c. 13–9 B.C. Marble, width of altar approx. 35' (10.7 m). Museum of the Ara Pacis, Rome

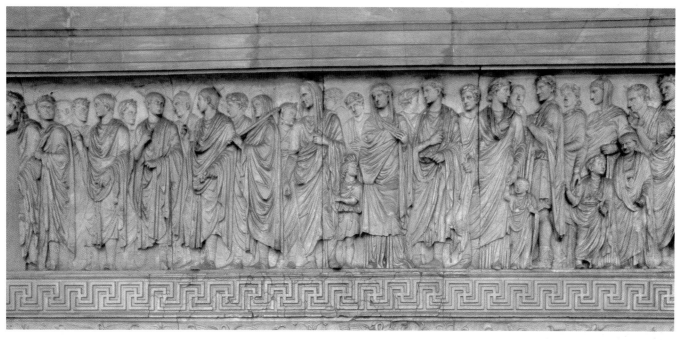

7-32. *Imperial Procession,* a portion of the frieze of the Ara Pacis. 13–9 B.C. Marble, height 63" (1.6 m)

7-33. *Procession,* a portion of the east frieze, Parthenon. c. 440 B.C. Marble, height 43" (109.3 cm). Musée du Louvre, Paris

procession (fig. 7-32) with that on the Parthenon (figs. 5-33 and 7-33), we see how different they really are, despite the many surface similarities. The Parthenon frieze belongs to an ideal, timeless world. What holds it together is the formal rhythm of the ritual itself, not its details. The Ara Pacis, in contrast, celebrates a recent event—probably the founding of the altar in 13 B.C. It has been idealized to evoke the solemn air that surrounds the Parthenon procession, yet it is filled with the concrete details of a remembered occasion. The participants, at least those belonging to the imperial family, are meant to be portraits, although all are idealized as well. To the left are Augustus, wearing a shroud as Pontifex Maximus, the chief priest of the state religion; his wife, Livia; and his son-in-law, Agrippa, who served as his chief advisor. The children, dressed in miniature togas, are too young to grasp the significance of what is happening: the little boy in the center is tugging at the

mantle of the young man in front of him, while the somewhat older child to his left seems to be telling him to behave. The Roman artist also shows more concern with spatial depth than Classical Greek artists. The softening of the background, which we first saw in the *Grave Stele of Hegeso* (see fig. 5-60), has been carried so far that the figures farthest away seem partly immersed in the stone. Note, for example, the woman on the left, whose face appears behind the shoulder of the young mother in front of her.

The same interest in space appears even more strongly in the allegorical panel in figure 7-34, showing a personification of Mother Earth or perhaps Italy flanked by two personifications of winds. She not only embodies human, animal, and plant fertility, but also serves as a symbol of Augustus' reign that reflects a time of peace and plenty. Here the figures are placed in a landscape setting of rocks, water, and vegetation. The blank background clearly stands for the empty sky. Whether this treatment of space is a Hellenistic or Roman invention is unclear. There can be no question, however, about the Hellenistic look of the three personifications. They represent not only a different level of reality but also a different, and less distinctly Roman, style from the imperial procession. The acanthus ornament on the pilasters and the lower part of the wall, on the other hand, does not occur in Greek art, although the acanthus motif itself derives from Greece. The plant forms are graceful and alive and, once again, symbols of peace and prosperity. Yet the design as a whole, with its emphasis on symmetry, never violates the discipline of surface decoration. It thus serves as a foil for the spatial treatment in the reliefs above.

THE ARCH OF TITUS. The treatment of space in Roman relief carving reached its greatest development in the two large narrative panels on the triumphal arch erected in 81 A.D. to com-

7-34. Allegorical and ornamental panels of the Ara Pacis

memorate the victories of the emperor Titus. One of them (fig. 7-35) shows part of the procession celebrating the conquest of Jerusalem in 70 A.D. The booty includes a seven-branched menorah

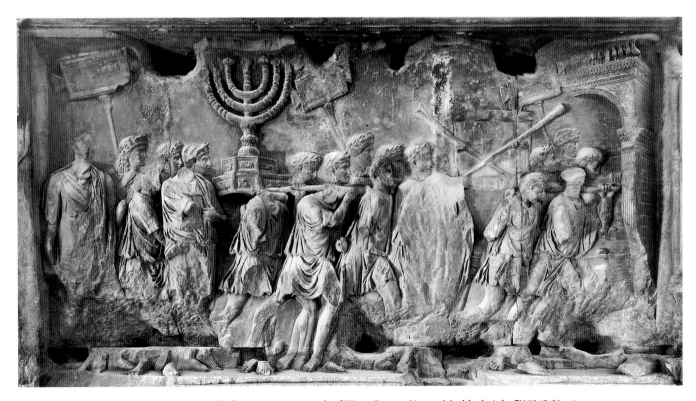

7-35. *Spoils from the Temple in Jerusalem.* Relief in passageway, Arch of Titus, Rome. 81 A.D. Marble, height 7'10" (2.39 m)

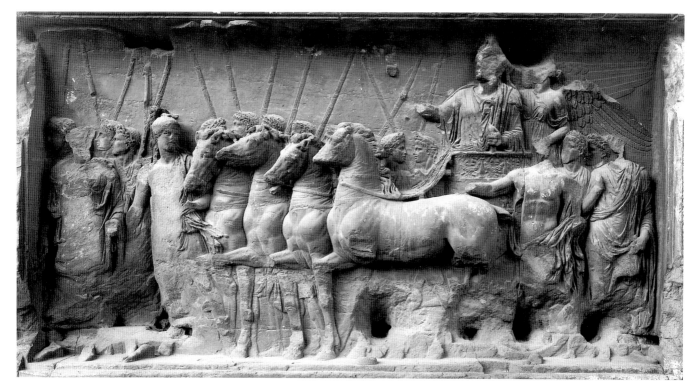

7-36. *Triumph of Titus.* Relief in passageway, Arch of Titus

(candlestick) and other sacred objects. The movement of a crowd of figures in depth is conveyed with striking success, despite the damaged surface. On the right, the procession turns away from us and disappears through a triumphal arch, which is placed obliquely to the background plane so that only the nearer half actually emerges from the background—a radical but effective compositional device that creates an illusion of spatial reality.

The other panel (fig. 7-36) avoids such experiments, although the number of relief layers is equally great. Its design has a static quality. Since this scene is part of the same procession, the difference must be due to the subject: the emperor in his chariot, crowned by the winged Victory behind him. The sculptor's main concern was to display this set image, rather than to keep the procession moving. Once we try to read the figures and objects in terms of real space, we become aware of how contradictory the spatial relationships are. Four horses, shown in profile, move in a direction parallel to the bottom edge of the panel, but the chariot is not where it ought to be if they were really pulling it. Moreover, the emperor and most of the other figures are shown in frontal view, rather than in profile. These seem to be fixed conventions for representing the triumphant emperor which the artist felt must be respected, even though they conflicted with the desire to create movement in space.

THE COLUMN OF TRAJAN. The conflict between the narrative or symbolic purposes of imperial art and the desire for realistic treatment of space becomes fully evident in the Column of Trajan. The column was erected between 106 and 113 A.D. to celebrate the emperor's victorious campaigns against the Dacians (the inhabitants of what is now Romania). Freestanding columns had been used as commemorative monuments from Hellenistic times on; their source may have been the obelisks of Egypt. The Column of Trajan is distinguished not only by its great height (125 feet, including the base) but also by the continuous spiral band of relief (fig. 7-37), which recounts in epic breadth and obsessive detail the history of the Dacian wars. The column was crowned by a statue of the emperor (destroyed in the Middle Ages), and the base served as a burial chamber for his ashes. [See Primary Sources, no. 11, page 217.] The design is often credited to Apollodorus of Damascus, who served as Trajan's military architect during the wars.

If we could unwind the relief band on the column, it would be 656 feet long, two-thirds the combined length of the three friezes of the Mausoleum at Halikarnassos. In terms of the number of figures and the density of the narrative, however, our relief is by far the most ambitious **frieze** composition up to that time. It is also the most frustrating, for viewers must "run around in circles like a circus horse" (as one scholar put it) if they want to follow the narrative. Moreover, details above the fourth or fifth turn can hardly be seen without binoculars. One wonders for whose benefit this elaborate pictorial account was intended. In Roman times, the monument formed the center of a small court flanked by libraries at least two stories tall within the Forum of Trajan, but even that arrangement does not answer our question.

Let us take a closer look at the scenes in figure 7-37. In the center of the bottom strip, we see the upper part of a large river god, the Roman descendent of Poseidon, representing the Danube. To the left are some riverboats loaded with supplies, and a Roman town on the rocky bank. To the right, the Roman army crosses the river on a pontoon bridge. The second strip shows Trajan

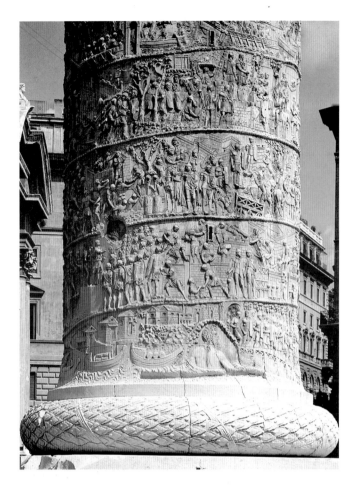

7-37. Lower portion of the Column of Trajan, Rome. 106–13 A.D. Marble, height of relief band approx. 50" (127 cm)

speaking to his soldiers (to the left), and the building of fortifications. The third depicts the building of a garrison camp and bridge as the Roman cavalry sets out on a reconnaissance mission (on the right). In the fourth strip, foot soldiers are crossing a stream (center); to the right, the emperor addresses his troops in front of a Dacian fortress. These scenes are a fair sampling of the events on the column. Among the more than 150 episodes, actual combat occurs only rarely. The geographic, logistic, and political aspects of the campaign receive more attention, much as they do in Julius Caesar's famous account of his conquest of Gaul.

We have seen this matter-of-fact portrayal of military operations in Egyptian and Assyrian reliefs. Is there an indirect link between them? And, if so, of what kind? The question is difficult to answer, especially since none of the panels showing Roman military conquests that were carried in triumphal processions have survived (see pages 192–193). They may have been of perishable materials. Nor have the scrolls recording the Dacian wars, which may have been illustrated. Egypt, of course, had long been part of the empire. Trajan himself actually conquered Assyria and the western part of the Parthian empire, but only after the column had been erected. He died on his way back, and the territory was quickly given up by his successor, Hadrian. Could Apollodorus, who came from the outer rim of the former Assyrian empire, have known reliefs such as that in figure 3-19?

At any rate, the spiral frieze on the Column of Trajan was a new and demanding framework for historic narrative, which imposed a number of difficult conditions upon the sculptor. Since there could be no inscriptions, the pictorial account had to be as clear as possible. The spatial setting of each episode therefore had to be worked out with great care. Visual continuity had to be preserved without destroying the coherence of each scene. And the carving had to be much shallower than in reliefs such as those on the Arch of Titus. Otherwise, the shadows cast by the projecting parts would make the scenes unreadable from below.

The artist has solved these problems with great success, but at a price. Landscape and architecture become "stage sets," and the ground on which the figures stand is tilted upward. These devices had already been used in Egyptian and Assyrian narrative reliefs (compare figs. 2-35 and 3-19). Here they appear once more, in spite of a more recent tradition of **foreshortening** and **perspective** space. Perhaps we are judging the Roman artist too harshly. Despite the testimony of literary sources that Greek Classical painters made great strides in treating illusionistic space (see page 151–153), there is no direct evidence that they did so on the scale found here. Seen in this light, the Roman conquest of landscape and architectural space is a striking achievement, whatever its shortcomings. This method of pictorial description was to become dominant in another 200 years, at the dawn of medieval art. In this respect, the relief band on the Column of Trajan foretells both the end of one era and the beginning of the next.

THE APOTHEOSIS OF SABINA. Trajan, who restored imperial prestige, hailed from Spain—the first Roman emperor to come from the provinces. His successor and cousin, Hadrian, was also Spanish-born but was educated in Athens. Hadrian led a Classical revival upon becoming emperor. He abandoned the age-old Roman custom of being clean-shaven and adopted the Greek fashion of wearing a beard as a sign of his admiration for the Hellenic heritage. Hadrianic reliefs relied on allegory for largely personal reasons. First Hadrian proclaimed the beautiful youth Antinous a god and erected cult statues of him as Apollo throughout the empire. (One is depicted in a medallion on the Arch of Constantine, which was taken from a Hadrianic monument; see fig. 7-47, right). Then he had his wife, Sabina, deified. She was not the first Roman woman to be so honored. That distinction belonged to Livia, the wife of Augustus, whose portraits show her as a moral paragon, although, thanks to Suetonius, she is remembered chiefly for her intrigues. (She was only proclaimed a goddess twelve years after her death by Claudius I.) In any event, the relief in figure 7-38 is the first of its kind. We see the deceased empress, wearing the crown of a goddess, borne to heaven from her funeral pyre by the female genius of Eternity, who is identified by her torch. Hadrian and the personification of the Campus Martius, where the royal cremation took place, witness the event to make it official. It is a strange sight, yet it is made plausible by the Classical style, which permits allegory and reality to mingle with surprising ease.

MELEAGER SARCOPHAGUS. The *Apotheosis of Sabina* signifies a major change in the attitude toward death that occurred in the time of Hadrian. Sarcophagi quickly replaced cinerary urns

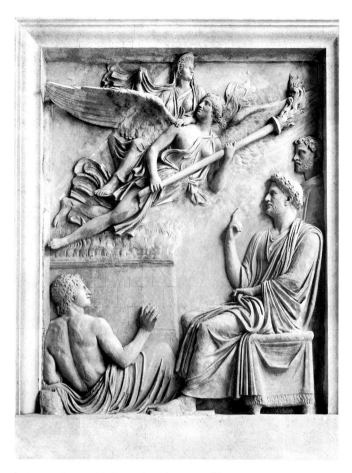

7-38. *Apotheosis of Sabina*. 136–38 A.D. Marble.
Museo dei Conservatori, Rome

as part of a new belief in an afterlife. In response to the sudden demand for sarcophagi, patterns for decorating them were based at first on Greek examples. New designs were soon passed from shop to shop, probably in pattern books of some kind. Preferences changed over time. For example, under Marcus Aurelius battle sarcophagi were favored. Later, in the third century, biographical and historical scenes projected the deceased's ideal of life, often with moral overtones. But the most popular scenes were taken from Classical mythology. Since these occur only on sarcophagi, they must have symbolic significance and not just antiquarian interest. Their purpose seems to have been to glorify the deceased through visual analogy to the legendary heroes of the past.

Here, too, Hadrian took the lead. A second medallion on the Arch of Constantine (see fig. 7-47, left) shows him slaying a wild boar. This relief is testimony not simply to his love of the chase but also to his courage in battle, for which hunting serves as a metaphor. A third medallion on the other side showing a sacrifice to Hercules equates great deeds with victory over death (see fig. 7-46, far right). Roman fondness for such heroic analogies explains the prevalence of Meleager on sarcophagi. In Homer's account, Meleager saved Calydon from a huge boar that had been sent by Artemis to ravage his father's land, but then died in the battle over its pelt. He thus served as an example of noble *virtus,* or virtue, a concept akin to the Greek arete (see box page 112). For his heroism and death in the service of country, Meleager earned immortality. Figure 7-39 illustrates the finest example of the type. (The top shows the fallen Meleager being carried from the field of combat.) Its style is indebted, however distantly, to Skopas (see fig. 5-66), but now the poses are a bit stiff and the expressions filled with the exaggerated pathos of Hellenistic sculpture. Typical of Roman reliefs is the crowding of the entire surface with figures (compare fig. 7-32).

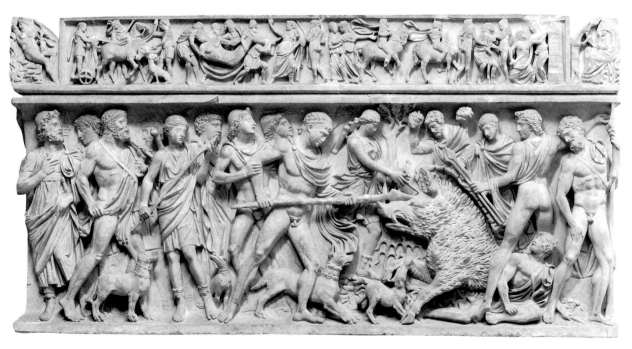

7-39. *Meleager Sarcophagus.* c. 180 A.D. Marble. Galleria Doria Pamphili, Rome

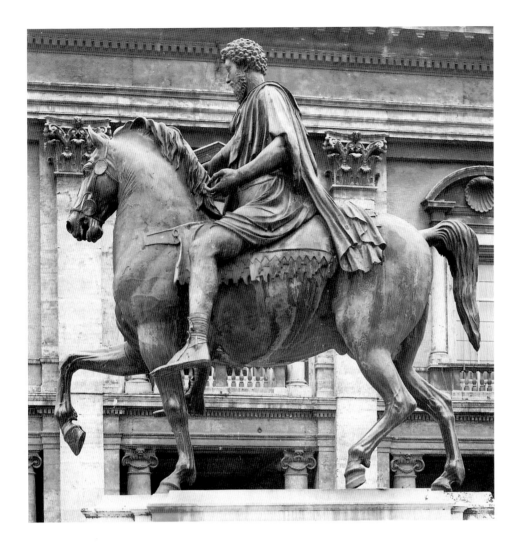

7-40. *Equestrian Statue of Marcus Aurelius*. 161–80 A.D. Bronze, over-lifesize. Piazza del Campidoglio, Rome

LATER IMPERIAL PORTRAITS. A strong classicistic trend, often cool and formal, was continued in sculpture under Marcus Aurelius, who, like Hadrian, was a private man interested in Greek philosophy. We can sense this quality in his famous equestrian bronze statue (fig. 7-40), which is notable not only as the sole survivor from antiquity of its kind, but also as one of the few Roman statues that remained on public view throughout the Middle Ages. The image showing the mounted emperor as the all-conquering lord of the earth had been an established tradition ever since Julius Caesar permitted an equestrian statue of himself to be erected in the forum that he built. Marcus Aurelius, too, was meant to be seen as ever victorious. According to medieval accounts, a small figure of a bound barbarian chieftain once crouched beneath the horse's right front leg. The powerful and spirited horse expresses this martial spirit. But the emperor himself is a model of stoic calm. Without weapons or armor, Marcus Aurelius appears as a bringer of peace rather than a military hero, for this is how he saw himself and his reign (161–180 A.D.).

A portrait of Marcus Aurelius's wife, Faustina the Younger (fig. 7-41), is cast in the same neo-Augustan mold as her husband's. Although it is a clear likeness, her features have been subtly ideal-

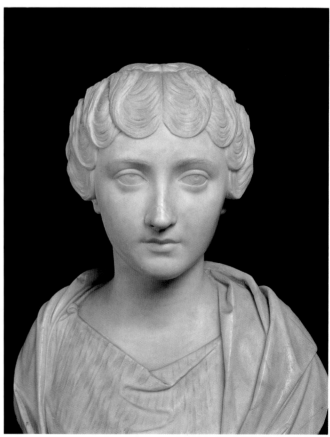

7-41. *Faustina the Younger*. c. 147–48 A.D. Marble, height 23⅝" (60 cm). Museo Capitolino, Rome

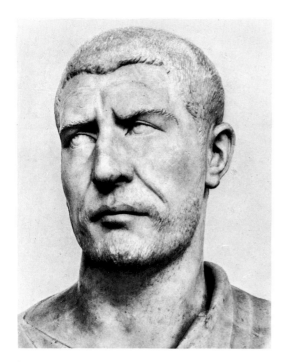

7-42. *Philippus the Arab.* 244–49 A.D.
Marble, lifesize. Musei Vaticani, Braccio Nuovo,
Città del Vaticano, Rome

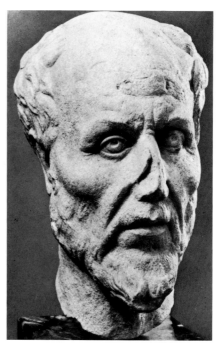

7-43. *Portrait Head* (probably Plotinus).
Late 3rd century A.D. Marble, lifesize.
Museum, Ostia

ized in accordance with Greek sculpture, right down to the coiffure (compare the head of the *Dying Niobid* in fig. 5-52). In this way, the bust acclaims her as a model of Roman womanhood. Besides bearing him two sons, Faustina accompanied Marcus Aurelius on his military campaigns, which earned her the title Mother of the Camps. Her life embodied the feminine virtues that were important to the Romans, and for which her husband later consecrated her a goddess: devotion to home and family, affection, respect, and piety, as well as beauty, grace, fertility, modesty, and fidelity. The tunic and cloak worn by Faustina are signs of the modesty befitting a Roman matron. The sculpture harks back to portraits of Livia, for it was during Augustus' reign that these virtues were defined, along with the legal status of women, although they were deeply rooted in Roman society. The portrait thus contains a flattering comparison to her great predecessor. Female members of the aristocracy may have been subordinate to men, but they had a great deal of influence and sometimes independence as well. None had more power than the empress, who served as a model for other women and often determined matters of taste in fashion.

The reign of Marcus Aurelius was the calm before the storm. A period of chaos was ushered in by his decadent son Commodus, who was finally murdered in 192 A.D. The reforms of the short-lived Severan dynasty (193–235 A.D.) gave way to almost constant crisis, which plagued the Roman empire for the most of the remainder of the third century. Barbarians threatened the frontiers while internal conflicts undermined the authority of the emperor, which was not restored until the reign of Diocletian (284–305 A.D.). Retaining the throne became a matter of naked force, succession by murder a regular habit. The "soldier emperors," who were mercenaries from the outlying provinces of the realm, followed one another at brief intervals. The portraits of

some of these men, such as Philippus the Arab (fig. 7-42; see also fig. 3-30), who reigned from 244 to 249 A.D., are among the most powerful likenesses in all of art. Their realism is as exact as anything in Republican portraiture, but its aim is expressive rather than documentary. All the dark passions of the human mind—fear, suspicion, cruelty—are revealed here, with a directness that is almost unbelievable. The face of Philippus mirrors all the violence of the time. There is a psychological nakedness about it that recalls a cornered animal. Clearly, the agony of the Roman world was not only physical but spiritual. That Roman art could create an image that reflects this crisis is a tribute to its continued vitality.

The portrait reminds us of the head from Delos (see fig. 5-79) but uses new techniques for achieving its impact. The expression now centers on the eyes, which seem to gaze at some unseen threat. The engraved outline of the iris and the hollowed-out pupils, devices that do not appear in earlier portraits so emphatically, serve to fix the direction of the glance. The hair, too, is rendered in un-Classical fashion as a close-fitting, textured cap. The beard has been replaced by a stubble created by roughing up the surfaces of the jaw and mouth with short chisel strokes.

A somewhat later portrait, probably of the Greek philosopher Plotinus, suggests a different side of the third-century crisis (fig. 7-43). Plotinus' thinking—abstract, speculative, and strongly tinged with mysticism—marked a retreat from concern with the beauty of the outer world, which he viewed as mere "images, traces, shadows." Instead, he favored "beautiful ways of life" that would bring one nearer to god, an attitude that seems closer to the Middle Ages than to the Classical tradition of Greek philosophy. [See Primary Sources, no. 12, page 217.] This new frame of mind sprang from the same mood that, on a more popular level, was expressed in the spread of Oriental mystery cults throughout the Roman empire. It is hard to say how close a likeness this head

represents. The ascetic features, the intense eyes and tall brow, may well portray inner qualities more accurately than outward appearance. According to his biographer, Plotinus was so contemptuous of the physical world that he refused to have any portrait made of himself. The body, he maintained, was an awkward enough likeness of the true, spiritual self. Why bother to make an even more awkward "likeness of a likeness"?

This view signals the end of portraiture as we have known it so far. If a physical likeness is worthless, a portrait becomes meaningful only as a visible symbol of the spiritual self. It is in these terms that we must view the statue of the Tetrarchs from about 300 A.D., who jointly ruled the four corners of the Roman empire for a decade (fig. 7-44). To emphasize their equality, all are identical: they are the same height, wear the same clothes, and bear the same features, nominally those of the emperor Diocletian, who conceived this unique form of government, which had its roots, however, in the very beginnings of the empire (see page 176). Each bearded Augustus embraces his Caesar, or junior partner, who was his designated successor and son-in-law. The sculpture is made of porphyry, an extremely hard Egyptian stone reserved for imperial portraits because of its "royal" purple color. Yet the effect is hardly one of sovereign majesty and solidarity. Instead the figures appear huddled together, as if seeking strength against the turbulent times, to which they lent some measure of stability.

Stranger still is the head of Constantine the Great, the first Christian emperor and reorganizer of the Roman state, who was

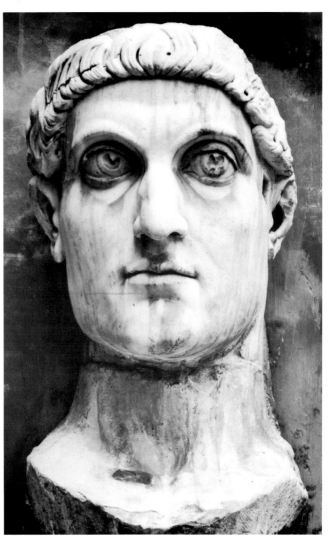

7-45. *Constantine the Great.* Early 4th century A.D. Marble, height 8' (2.4 m). Museo dei Conservatori, Rome

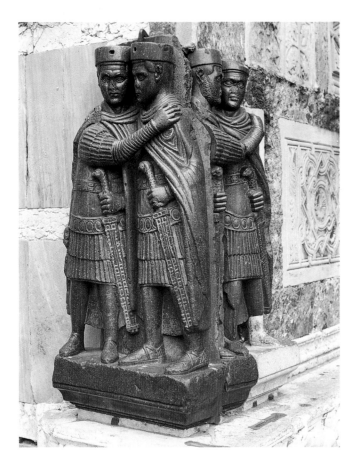

7-44. *The Tetrarchs.* c. 305 A.D. Porphyry, height 51" (129.5 cm). St. Mark's, Venice

named a tetrarch in 307 but became sole ruler only in 324 (fig. 7-45). Although the head shows more individuality than those of the Tetrarchs, its face is not a true portrait. In fact, the head is one of several fragments of a huge statue from the apse of Constantine's basilica (see fig. 7-18). Although full-figure imperial portraits, including other colossal statues of the period, generally show the ruler standing, this one probably depicted him seated nude in the manner of Jupiter, with a mantle draped across his legs. It is probably the large statue mentioned by Bishop Eusebius, Constantine's friend and biographer, that held a cross-scepter, called a *labarum*, in its right hand. After Constantine's conversion in 312, this imperial device, originally a Roman military standard, became a Christian symbol through the addition of the Chi Rho insignia within a wreath. (Chi and Rho are the first two letters of Christ's name in Greek.) Thus the colossal statue represented Constantine as a Christian ruler of the world, although the surviving hand points straight up. (The other hand most likely held an orb.) At the same time, it served as a cult statue to the emperor himself.

The portrait seems superhuman. The head alone is eight feet tall. Everything is so out of proportion to the scale of ordinary people that we feel crushed by its enormous size. The impression of

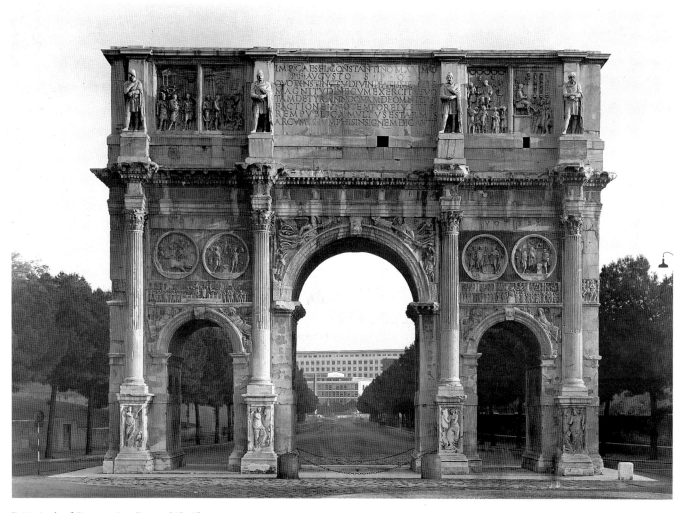

7-46. Arch of Constantine, Rome. 312–15 A.D.

being in the presence of some unimaginable power is reinforced by the massive, immobile features out of which the huge eyes stare with hypnotic intensity. Instead of the Greek beard that had been in vogue since Hadrian's time, the face has the clean-shaven look of Trajan. For the rest of the fourth century, Roman emperors followed Constantine's example as the ideal Christian ruler (except for one, who briefly sought a return to paganism). All in all, the colossal head conveys little of Constantine's appearance, but it tells us a great deal about his view of himself and his exalted office.

THE ARCH OF CONSTANTINE. Constantine's conception of his role is further reflected in his triumphal arch (fig. 7-46), which was erected near the Colosseum between 312 and 315 A.D. One of the largest and most elaborate of its kind, it is decorated for the most part with sculpture taken from earlier monuments. This approach has often been viewed as due to haste and to the poor state of the sculptural workshops of Rome at that time. These factors may have played a role, but there appears to be a conscious plan behind the way the earlier pieces were chosen. All of them come from a related group of monuments dedicated to Trajan, Hadrian, and Marcus Aurelius, and the portraits of these emperors have been reworked into likenesses of Constantine. This program con-

veys Constantine's view of himself as the restorer of Roman glory, the heir of the "good emperors" of the second century, who chose their successors based on merit rather than kinship.

The arch also contains a number of reliefs made especially for it, such as the friezes above the side portals. These show the new Constantinian style in full force. If we compare the medallions of figure 7-47, carved in Hadrian's time, with the relief just below them, they seem to belong to two different worlds. The scene depicts Constantine, after his entry into Rome in 312 A.D., speaking to the Senate and the people from the **rostrum** in the Forum.

The first thing we notice is the absence of the many devices developed since the fifth century B.C. for creating depth. We find no oblique lines, no foreshortening, and almost no movement in the listening crowds. The architecture has been flattened out against the background, which becomes a solid, impenetrable surface. The rostrum and the people on or beside it form an equally shallow layer: the second row of figures appears as a series of heads above the first. The figures themselves are oddly doll-like. The heads are very large, while the bodies seem not only flat but also dwarfish because of their stubby legs. Contrapposto has largely disappeared, so that many of these figures no longer stand freely but seem to dangle from invisible strings.

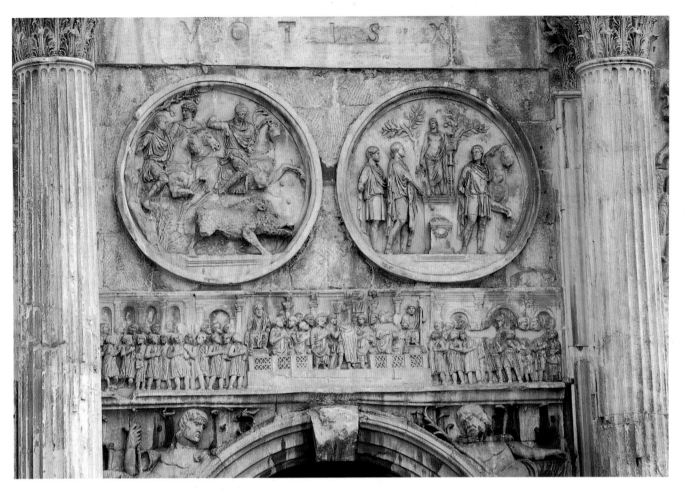

7-47. Medallions (117–38 A.D.) and frieze (early 4th century), Arch of Constantine

Judged by Classical standards, these features are negative. Worse, they seem to represent the loss of many hard-won gains—a throwback to more primitive levels of expression. Yet this approach does not help us understand the new style. Constantine's panel cannot be explained by a lack of ability, for it is far too consistent to be regarded as simply a clumsy attempt to imitate earlier Roman reliefs. Nor can it be viewed as a return to Archaic art, since there is nothing in pre-Classical times that looks like it. No, the sculptor must have had a positive new purpose. Perhaps we can approach it best by stressing the main feature of our relief: its sense of self-sufficiency.

The scene fills the available area completely. (All the buildings are the same height.) Any suggestion that it continues beyond the frame is avoided. It is as if the artist had asked, "How can I get this entire ceremony into my panel?" In order to do so, an abstract order has been imposed on the subject. The middle third of the strip is given over to the rostrum with Constantine and his entourage, the rest to the listeners and the buildings that identify the Roman Forum as the setting. They are all recognizable, even though their scale and proportions have been drastically adjusted. The symmetrical design also makes clear the special status of the emperor. Constantine not only occupies the exact center, he is shown full-face. (His head, unfortunately, has been knocked off.) All the other figures turn their heads toward him to express their dependence on him. That the frontal pose is reserved for sovereigns, human or

divine, is shown by the seated figures at the corners of the rostrum, the only ones besides Constantine to face us directly. These figures are statues of the same "good emperors" we see elsewhere on the arch, Hadrian and Marcus Aurelius. Seen in this way, the relief is a bold and original creation. It foreshadows a new vision that will become basic to the development of Christian art.

PAINTING

We know infinitely less about Roman painting than we do about Roman architecture or sculpture. Almost all the surviving works are wall paintings, and most of these come from Pompeii, Herculaneum, and other towns buried by the eruption of Mount Vesuvius in 79 A.D., or from Rome and its environs. Their dates cover a span of less than 200 years, from the end of the second century B.C. to the late first century A.D. What happened before then is largely a matter of guesswork, but after that time Roman painting seems to have declined. And since we have only a few Greek wall paintings in Macedonian tombs from Alexander's time, it is far more difficult to single out the Roman element in painting than in sculpture or architecture.

ROMAN ILLUSIONISM. Based partly on Vitruvius' discussion, four phases of Roman wall painting have been distinguished. However, the differences among them are not always clear, and

there seems to have been a great deal of overlap in their sequence. [See Primary Sources, no. 4, page 213.] The earliest phase, known from a few examples dating to the late second century B.C., must have been widespread in the Hellenistic world, since examples of it have also been found in the eastern Mediterranean. Unfortunately, it is not very informative for us, as it consists entirely of imitations of colored marble paneling. About 100 B.C., this so-called First Style began to be displaced by a far more ambitious one that sought to open up flat wall surfaces by painting architectural perspectives and "window effects," including landscapes and figures.

The architectural vistas typical of the Second Style are represented by the fresco in figure 7-48. Our artist is clearly a master of modeling and surface textures. The forms framing the vista—the richly decorated columns, moldings, and mask at the top—have an extraordinary degree of three-dimensionality. They set off the distant view of buildings, which are flooded with light to convey a sense of open space. But as soon as we try to enter this architectural maze, we become lost. The structures cannot be disentangled from each other, and their size and relationship are hard to determine. We quickly realize that the painter has no systematic grasp of spatial depth. The perspective is haphazard and inconsistent within itself. We were never intended to enter this architectural maze. Like a promised land, it remains forever beyond us.

ODYSSEY LANDSCAPES. When landscape takes the place of architectural vistas, foreshortening becomes less important. Now the virtues of the Roman painter's approach outweigh its drawbacks. This advantage can be seen most clearly in the Odyssey Landscapes, in which a continuous stretch of landscape is subdivided into eight compartments by a framework of pilasters. Each section illustrates an adventure of Odysseus (Ulysses). Vitruvius tells us that such cycles were common. [See Primary Sources, no. 4, pages 213–214.] However, the narrative has large gaps, which suggests that the scenes have been taken from a larger cycle. In the battle with the Laestrygonians (fig. 7-49, page 204), the bluish tones create a feeling of light-filled space that envelops all the forms in this warm Mediterranean fairyland, including the figures, which seem to play a minor role. Only upon reflection do we realize how frail the illusion of consistency is. If we tried to map this landscape, we would find it just as ambiguous as the architectural perspective discussed above. Its unity is not structural but poetic.

VILLA OF LIVIA. We find another approach to nature in the paintings from a room of the Villa of Livia at Primaporta (fig. 7-50, page 204). Their only antecedent lies in Aegean art (compare fig. 4-9). Here the architectural framework has been replaced by a view of a delightful garden full of flowers, fruit trees, and birds. These charming details have the same reality of color and texture as the architectural framework of figure 7-48. Their apparent distance from the beholder is also about the same: they seem to be within arm's reach. At the bottom is a low trellis, beyond it a narrow strip of lawn with a tree in the center, then a low wall. Immediately after that, the garden itself begins. However, we cannot enter it. Behind the front row of trees and flowers lies an opaque mass of greenery that shuts off our view as effectively as a dense hedge. This garden, then, is another promised land made only for

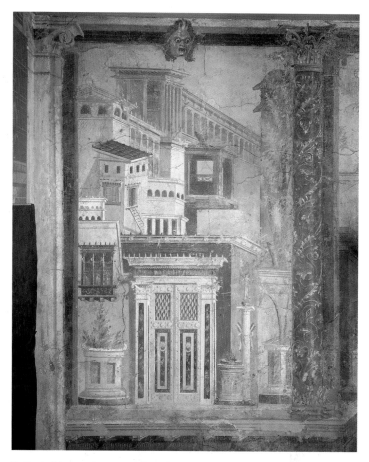

7-48. *Architectural View.* Wall painting from a villa at Boscoreale, near Naples. 1st century B.C. The Metropolitan Museum of Art, New York.
ROGERS FUND, 1903

looking. The wall has not really been opened up but merely pushed back a few feet and replaced by a wall of plants. It is this limited depth that gives the mural its coherence.

THE VILLA OF THE MYSTERIES. Like the garden view from the Villa of Livia, the great frieze in one of the rooms in the Villa of the Mysteries just outside Pompeii (fig. 7-51, page 205) dates from the latter part of the first century B.C., when the Second Style was at its height. As far as the treatment of the wall surface is concerned, the two works have more in common with each other than with other Second Style murals. Both are conceived in terms of rhythmic continuity and shallow depth. The frieze nevertheless has a grandeur and coherence that is nearly unique in Roman painting. The figures have been placed on a narrow ledge of green against a regular pattern of red panels separated by strips of black, so as to create a kind of running stage on which they perform their strange rite. Who are they, and what is the meaning of the cycle? Many details remain puzzling, but the frieze as a whole depicts various rites of the Dionysiac mysteries, a semi-secret cult of very ancient origin that had been brought to Italy from Greece. The rituals are performed, perhaps as part of an initiation into womanhood or marriage, in the presence of Dionysos and Adriadne, with their train of satyrs and sileni. Thus human and mythical realities merge into one. As a result all the figures have certain qualities in common: their dignity of bearing and expression, the

7-49. *The Laestrygonians Hurling Rocks at the Fleet of Odysseus.* Wall painting from the Odyssey Landscapes series in a house on the Esquiline Hill, Rome. Late 1st century B.C. Biblioteca Apostolica Vaticana, Città del Vaticano, Rome

7-50. *View of a Garden.* Wall painting from the Villa of Livia at Primaporta. c. 20 B.C. Museo delle Terme, Rome

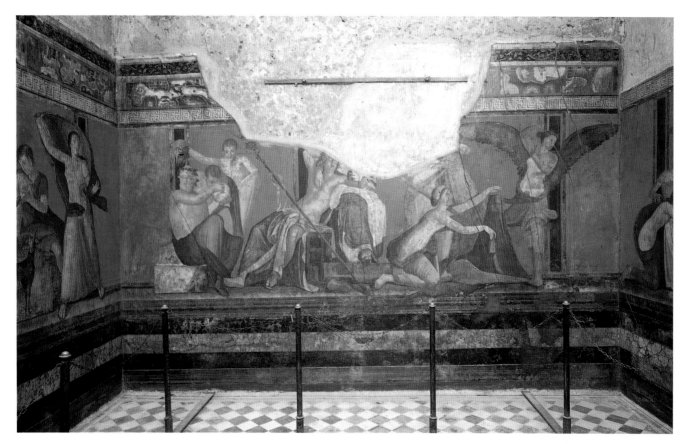

7-51. *Scenes of a Dionysiac Mystery Cult.* Mural frieze. c. 50 B.C. Villa of the Mysteries, Pompeii

firmness of body and drapery, and the rapt intensity with which they participate in the drama of the ritual.

LATE ROMAN PAINTING. The Third Style, from about 20 B.C. until at least the middle of the first century A.D., abandoned illusionism in favor of decorative surfaces with broad planes of intense color that were sometimes relieved by imitation panel paintings. By contrast, the Fourth Style, which prevailed at the time of the eruption of Mount Vesuvius in 79 A.D., was the most intricate of all. It united aspects of all three preceding styles to create an extravagant effect. The result is a somewhat disjointed compilation of **motifs** from various sources. The Ixion Room in the House of the Vettii at Pompeii (fig. 7-52, page 206) combines imitation marble paneling, framed mythological scenes that give the effect of panel pictures set into the wall, and fantastic architectural vistas seen through make-believe windows. This architecture has a strangely unreal and picturesque quality that is thought to reflect the architectural backdrops of the theaters of the time. It anticipates effects seen in the Market Gate of Miletus (see fig. 7-23), which shares the same source.

A unique feature of Roman mural decoration is the **still life** that sometimes appears within the architectural schemes of the Fourth Style. These usually take the form of imaginary niches or cupboards, so that the objects, which are often displayed on two levels, remain close to us. Our example (fig. 7-53) is noteworthy for its rendering of the glass jar half filled with water. The reflections

are so carefully observed that we feel the painter must have copied them from an actual jar that was lit in just this way. However, we cannot determine the source and direction of the light, because the shadows cast by the various objects are not consistent with each other. Nor do we have the impression that the jar stands in a stream of light. Instead, the light seems to be trapped within the jar.

Clearly the Roman artist, despite striving for illusionistic effects, is no more systematic in the approach to light than in the handling of perspective. However real the details may seem, the work nearly always lacks overall unity. In the finest examples, however, other qualities compensate for this deficiency. The absence of a consistent view of the visible world should be thought of instead as a fundamental characteristic of Roman painting.

Greek Sources

There is no doubt that Greek designs were copied and that Greek paintings as well as artists were imported. It is tempting to link Roman paintings with lost Greek works recorded by Pliny, Vitruvius, and others. *The Battle of Issos* (see fig. 5-62) is, however, one of the rare cases in which such a connection can be clearly demonstrated. For the most part, Roman painting appears to have been a specifically Roman development. Despite the fact that the characters' names are given in Greek, there is no reason to assume a Greek origin for the Odyssey Landscapes any more than for the *View of a Garden* from the Villa of Livia. Likewise, the still lifes

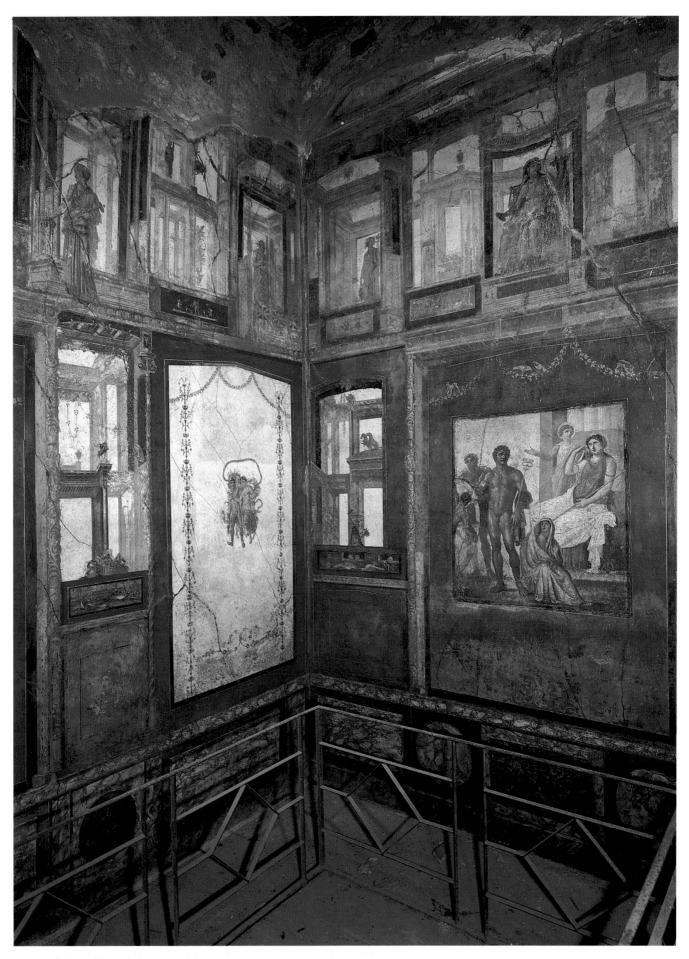

7-52. The Ixion Room, House of the Vettii, Pompeii. 63–79 A.D.

According to contemporary sources, the Romans adopted Greek music, including its system of modes, with little modification. Judging from its wide range of instruments, however, Rome was a melting pot in music as it was in everything else. Many of these instruments were known to the Greeks as well. If the lyre and aulos were preferred by the Greeks, the trumpet and horn were the most characteristic instruments of the Romans. They were widely used in military campaigns, public parades, and festivals (compare fig. 7-35). Certain instruments were associated with particular cults, which thrived throughout the realm and were imported to Rome itself, such as that of Cybele, the Great Mother Goddess of Anatolia. The most common combination for celebrating rituals in Roman religions was flute-drum-cymbals.

Roman theater was very different in many respects from that of Greece, for its origins lay more in the region of Etruria. Tarquin the Elder, the Etruscan ruler of Rome between about 616 and 578 B.C., established the religious festivals known as *ludi Romani* (Roman games) to honor Jupiter each September. Plays were part of the program from the beginning and were always associated with religious festivals. He also introduced the Etruscan taste for spectacle and built the first Circus Maximus for horse races and similar events. Most Roman theater, in fact, fell into the category of modern carnival and circus acts, called *mimus,* or mime. The Roman writer Livy (59 B.C.–17 A.D.) states that the first theater performances were held in 364 B.C., when musicians and dancers were imported from Etruria to appease the gods during a plague. A late form of popular theater was pantomime (all mime)—introduced from Greece in 22 B.C.—which involved a single dancer who acted out all the roles of a tragedy by changing masks.

Serious drama began in 240 B.C., when Livius Andronicus, a freed Greek slave from south Italy, produced a Latin translation of two Greek plays for the *ludi Romani* and became the first writer of Greek-style tragedies in Latin. Because Roman tragedies reflected the stringent moral values of Republican Rome, they gradually died out during the Empire. The greatest author of comedies was Caecilius Statius (c. 219–168 B.C.) but, as with Livius Andronicus, none of his works is left. During the first century B.C., Roman comic theater was taken over by the Fabula Atellana (named for the town of Atella near Naples). It was a coarse variety of farce accompanied by music that relied

Scene from New Comedy (traveling musicians). 2nd century B.C. Mosaic from Pompeii, Villa of Cicero, 17 x 16⅛" (43.2 x 41 cm). Archaeological Museum, Naples

on stock subjects with happy endings in the manner of late Greek comedy.

All that remains of Roman theater are 21 comedies by Plautus (c. 254–184 B.C.), six comedies by the freed African slave Terence (190–156 B.C.), and nine tragedies by Seneca (4 B.C.–65 A.D.), the teacher of the emperor Nero, which may never have been performed. These writers exercised enormous influence on sixteenth-century Elizabethan theater by providing models of plot and style that were used by William Shakespeare and Christopher Marlowe. Roman playwrights have fallen into unjust neglect today, especially Seneca, whose powerful dramas feature penetrating characterizations revealed in soliloquies that are fully the equal of Shakespeare's.

The architect and historian Vitruvius, writing in the late first century B.C., has left us a detailed account of Roman theater practices. He suggests that Roman architectural backdrops and painted scenery were considerably more elaborate than those of Greece. We can get a good idea of their probable appearance from the illusionistic treatment of architecture in Roman wall paintings (see fig. 7-52).

that sometimes appear within the architectural schemes of the Fourth Style are distinctively Roman, even though still-life painting began in Greece and certain Classical Greek motifs were taken over by the Romans. Finally, the illusionistic tendencies that gained the upper hand in Roman murals during the first century B.C. represent a dramatic breakthrough that had no precedent in Greek art as far as we know.

The issue is more complex when it comes to narrative painting. Although very little of it exists, we can hardly doubt that Greek painting continued to evolve after the Classical era. However, narrative painting underwent a decline in the late Hellenistic period, when earlier panels were highly prized by collectors, in the way Old Master paintings are today. It was revived, Pliny tells us, around the middle of the first century B.C. by Timomachus of Byzantium, who "restored its ancient dignity to the art of painting." [See Primary Sources, no. 3, page 211.] This rebirth came around the same time as the frescoes in the Villa of the Mysteries, which provide a test case of what is Roman in Roman painting. Many of the poses and gestures are taken from Classical Greek art, yet they lack the self-conscious quality of Classicism. An artist of

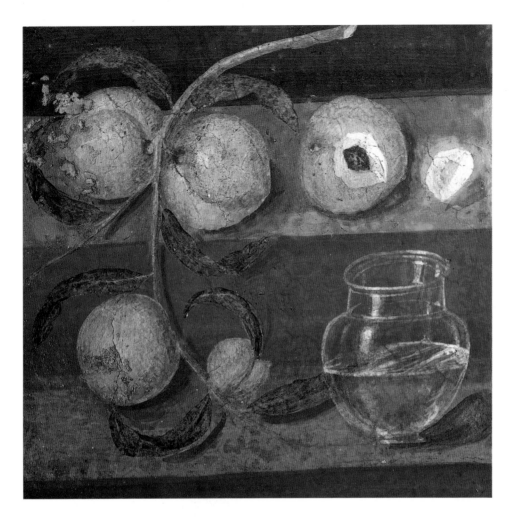

7-53. *Peaches and Glass Jar.*
Wall painting from Herculaneum.
c. 50 A.D. Museo Archeologico
Nazionale, Naples

great vision has filled these forms with new life. He was the legitimate heir of the Greeks in the same sense that the finest Latin poets were the legitimate heirs to the Greek poetic tradition.

Roman painting as a whole shows the same genius for adapting Greek examples to Roman needs as do sculpture and architecture. This is true even of seemingly reproductive or imitative works. The mythological panels that occur like islands in the Third and Fourth Styles (see fig. 7-52) sometimes give the impression of being copies after Hellenistic originals. In several cases, however, we have more than one variant of the same composition derived ultimately from the same, presumably Greek, source. The differences between examples attest to how readily the original was copied and changed. Moreover, a closer look shows that such panels, too, evolved in ways that reflect the changing taste of Roman artists and their patrons. Figures were freely altered and rearranged, often in very different settings, suggesting that they could be found in pattern books much like those for sarcophagi (see page 197). Thus, whatever their relation to the masterpieces of Greece that are lost to us forever, scenes such as Hermes overseeing the punishment of Ixion in figure 7-52 represent the eclectic Roman approach to painting, and it is likely that most were of recent vintage as well.

These pictures often have a rather disjointed character because they combine motifs from diverse sources. An example is the picture of Hercules discovering his infant son, Telephus, in Arcadia (fig. 7-54). This scene, from the basilica at Herculaneum, may reflect a painting made in Pergamon, since a similar composition occurs in fragmentary form on the Great Altar (see pages 159–60). What shows that this scene is the work of a Roman painter is its unstable style. Almost everything has the look of a quotation. Not only the forms, but even the brushwork, vary from one figure to the next. Thus the personification of Arcadia, seated in the center, seems as immobile and tightly modeled as a statue. Although his pose is equally statuesque, Hercules has a broader and more luminous technique. And the mischievously smiling young Pan in the upper left-hand corner is composed of feathery brushstrokes that have an entirely different character. Or compare the precise outlines of the doe and the child with the Nemean Lion, emblem of Hercules, and the eagle of Jupiter, his father, which are painted in sketchy dabs. The sparkling highlights on the basket of fruit are derived from yet another source: still lifes such as figure 7-53. We recognize the same uniquely Roman principle at work here as in the shifting system of the Fourth Style as a whole, with its ambivalent perspective and inconsistent light.

PORTRAITS. Portrait painting, according to Pliny, was an established custom in Republican Rome. It served the ancestor cult, as did portrait busts (see pages 189–90). None of these panels has survived, and the few portraits found on the walls of Roman houses in Pompeii may derive from a different, Hellenistic tradition. The only coherent group of painted portraits that has come down to us is from the Faiyum district in Lower Egypt. The

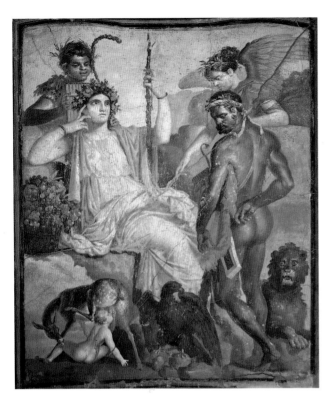

7-54. *Hercules and Telephus.* Wall painting from Herculaneum.
c. 70 A.D. Museo Archeologico Nazionale, Naples

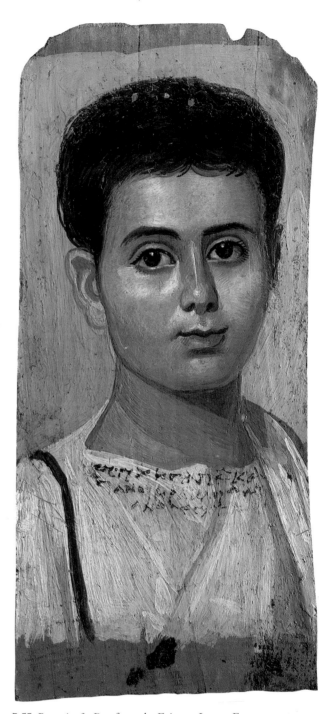

7-55. *Portrait of a Boy,* from the Faiyum, Lower Egypt.
2nd century A.D. Encaustic on panel, 15⅜ x 7½" (39.1 x 19.1 cm).
The Metropolitan Museum of Art, New York

GIFT OF EDWARD S. HARKNESS, 1918

earliest of them seem to date from the second century A.D. We owe them to the survival (or revival) of the ancient Egyptian custom of attaching a portrait of the deceased to the wrapped, mummified body. Originally, these portraits had been sculpted (compare fig. 2-29), but in Roman times they were replaced by painted ones such as the very fine wooden panel that is shown in figure 7-55.

The amazing freshness of its colors is due to the fact that it was done in a very durable medium called **encaustic**, which uses pigments suspended in hot wax. The mixture can be opaque and creamy, like oil paint, or thin and translucent. At their best, these portraits have an immediacy and a sureness of touch that have rarely been surpassed, thanks to the need to work quickly before the hot wax set. Our dark-haired boy is as solid and lifelike as anyone might wish. The style of the picture—and it does have style, otherwise we could not tell it from a snapshot—becomes apparent only when we compare it with other Faiyum portraits. Since they were produced quickly and in large numbers, they tend to have many elements in common. These include the emphasis on the eyes, the placing of the highlights and shadows, and the angle from which the face is seen. Over time, these components stiffened into a fixed type, but here they provide a flexible mold for an individual likeness. In this happy instance the intent was only to recall the personality of a beloved child. This way of painting was revived four centuries later in the earliest Byzantine icons, which were considered portraits of the Madonna and Child, Christ, and the saints.

Primary Sources for Part One

The following is a selection of excerpts, in modern translations, from original texts by historians or writers from Egyptian times through the Roman era. These readings supplement the main text and are keyed to it. Their full citations are given in the Credits section at the end of the book.

1
The Book of the Dead

This text is an incantation from Plate III of the Papyrus of Ani in the British Museum, from the latter half of Dynasty XVIII. It accompanies the weighing of the soul illustrated in the closely related Book of the Dead *of Hunefer (see fig. 2-31).*

Saith Thoth the righteous judge of the cycle of the gods great who are in the presence of Osiris: Hear ye decision this. In very truth is weighed the heart of Osiris, is his soul standing as a witness for him; his sentence is right upon the scales great. Not hath been found wickedness [in] him any; not hath he wasted food offering in the temples; not hath he done harm in deed; not hath he let go with his mouth evil things while he was upon earth.

Saith the cycle of the gods great to Thoth [dwelling] in Hermopolis [the god's cult-center along the Nile in Upper Egypt]: Decreed is it that which cometh forth from thy mouth. Truth [and] righteous [is] Osiris, the scribe Ani triumphant. Not hath he sinned, not hath he done evil in respect of us. Let not be allowed to prevail Amemet [Ammut, the devourer of souls] over him. Let there be given to him cakes, and a coming forth in the presence of Osiris, and a field abiding in Sekhet-hetepu [Field of Peace] like the followers of Horus.

2
From *Cylinder A of Gudea*

Gudea's rebuilding of the temple, called Eninnu, to the god Ningirsu was recounted on three inscribed clay cylinders of about 2125 B.C. Cylinder A describes the construction of the temple. Gudea is presented as the architect, helped by Nidaba (goddess of writing, here representing the use of written sources) and Enki (god of builders).

For . . . Gudea . . . did Nidaba open
the house of understanding,
did Enki put right

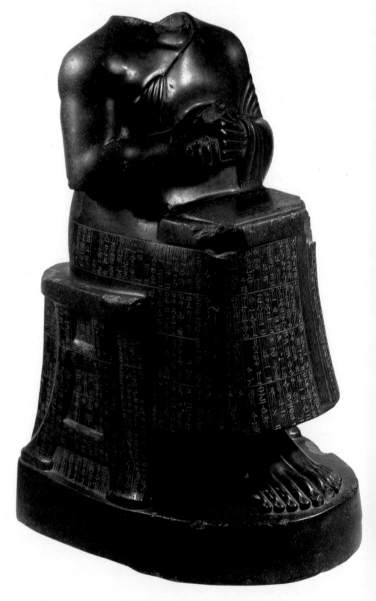

PS-2. *Gudea with Architectural Plan,* from Lagash (Telloh), Iraq. c. 2150 B.C. Diorite, height 29" (73.7 cm). Musée du Louvre, Paris

the design of the house.
To the house . . . did Gudea pace from south
to north on the fired [purified] mound, . . .
laid the measuring cord down
 on what was a true acre,
put in pegs at its sides,
 verified them himself.
It was cause of rejoicing
 for him. . . .
In the brick-mold shed he performed
 the pouring of water,
and the water sounded to the ruler
 as cymbals and *alu* lyres playing for him;
on the brick pit and its bricks
 he drenched the top layer,
hoed in honey, butter, and sweet princely oil; . . .
into the brick mold Gudea put the clay,
made "the proper thing" appear,
was establishing his name,
making the brick of the house appear. . . .
He placed the brick, paced off
 the house,
laid out the plan of the house,
(as) a very Nidaba knowing the inmost
 (secrets) of numbers,
and like a young man
 building his first house,
sweet sleep came not unto his eyes;
like a cow keeping an eye on its calf,
he went in constant worry to the house—
like a man who eats food sparingly
he tired not from going. . . .
Gudea made Ningirsu's house
come out like the sun from the clouds,
had it grow to be like sparkling foothills;
like foothills of white alabaster
he had it stand forth to be marveled at . . .
the house's stretching out
 along (substructure) walltops,
was like the heights of heaven
 awe-inspiring;
the roofing of the house, like a white cloud,
 was floating in the midst of heaven.
Its gate through which the owner entered
was like a lammergeier [vulture]
 espying a wild bull,
its curved gateposts standing
 at the gate
were like the rainbow
 standing in the sky. . . .
It (the house) kept an eye on the country;
no arrogant one could walk
 in its sight,
awe of Eninnu
covered all lands like a cloth.

3
PLINY THE ELDER (23–79 A.D.)
Natural History

The earliest preserved history of art appears in the work of the Roman naturalist and historian Pliny, who lived at the beginning of the Roman Imperial period and died in the eruption of Mount Vesuvius that destroyed Pompeii. Pliny says nothing about vase painting. For him the great era of painting began in the fifth century B.C., and its high point came in the fourth century B.C. Pliny lists the names and works of many artists who are otherwise unknown today. His anecdotes reveal the primacy placed on illusionism by Greeks and Romans. Pliny's work influenced Renaissance writers of art history, including Ghiberti and Vasari.

from Book 35 (on Greek painting)

The origin of painting is obscure. . . . All, however, agree that painting began with the outlining of a man's shadow; this was the first stage, in the second a single colour was employed, and after the discovery of more elaborate methods this style, which is still in vogue, received the name of monochrome. . . .

Four colours only—white from Melos, Attic yellow, red from Sinope on the Black Sea, and the black called 'atramentum'—were used by Apelles, Aetion, Melanthios and Nikomachos in their . . . works; illustrious artists, a single one of whose pictures the wealth of a city could hardly suffice to buy. . . .

Apollodoros of Athens [in 408–405 B.C.] was the first to give his figures the appearance of reality. [He] opened the gates of art through which Zeuxis of Herakleia passed [in 397 B.C.]. The story runs that Parrhasios and Zeuxis entered into competition, Zeuxis exhibiting a picture of some grapes, so true to nature that the birds flew up to the wall of the stage. Parrhasios then displayed a picture of a linen curtain, realistic to such a degree that Zeuxis, elated by the verdict of the birds, cried out that now at last his rival must draw the curtain and show his picture. On discovering his mistake he surrendered the prize to Parrhasios, admitting candidly that he had deceived the birds, while Parrhasios had deluded himself, a painter. . . .

Apelles of Kos [in 332–329 B.C.] excelled all painters who came before or after him. He of himself perhaps contributed more to painting than all the others together; he also wrote treatises on his theory of art. . . .

Nikomachos' . . . pupils were his brother Ariston, his son Aristeides and Philoxenos of Eretria, who painted for king Kassander the battle between Alexander and Dareios, a picture second to none [compare fig. 5-62].

from Book 34 (on bronze)

Besides his Olympian Zeus, a work which has no rival, Pheidias made in ivory the Athena at Athens, which stands erect in the Parthenon. . . . He is rightly held to have first revealed the capabilities of sculpture and indicatd its methods.

Polykleitos . . . made an athlete binding the diadem about his head, which was famous for the sum of one hundred talents which it realized. This . . . has been described as 'a man, yet a boy': the . . . spear-bearer [see fig. 5-44] as 'a boy, yet a man.' He also made the statue which sculptors call the 'canon,' referring to it as to a standard from which they can learn the first rules of their art. He is the only man who is held to have embodied the principles of his art in a single work. . . . He is considered to have brought the scientific knowledge of statuary to perfection, and to have system-

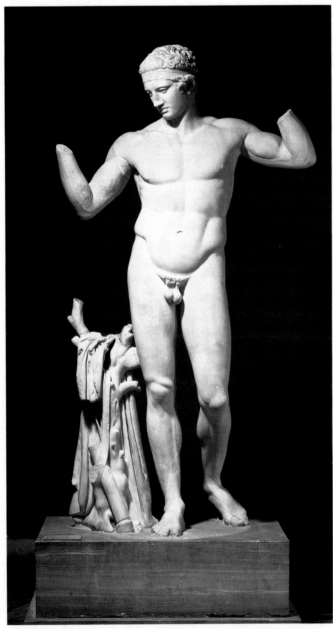

PS-3. Polykleitos. *Diadoumenos.* Roman marble copy (1st century B.C.) after bronze Greek original of c. 430 B.C., height 6'5" (1.95 m). Archeological Museum, Athens

atized the art of which Pheidias had revealed the possibilities. It was his peculiar characteristic to represent his figures resting their weight on one leg; . . .

Myron . . . [made an] athlete hurling the disk [see fig. 5-49], a Perseus, . . . and the Herakles which is near the great Circus in the temple of the great Pompeius. . . . He was more productive than Polykleitos, and a more diligent observer of symmetry. Still he too only cared for the physical form, and did not express the sensations of the mind. . . .

Lysippos produced more works than any other artist, possessing, as I have said, a most prolific genius. Among them is the man scraping himself [see fig. 5-72]. . . . In this statue the Emperor Tiberius took a marvellous delight, . . . he could not refrain from having the statue removed into his private chamber, substituting another in its place. . . . His chief contributions to the art of sculpture are said to consist in his vivid rendering of the hair, in making the heads smaller than older artists had done, and the bodies slimmer and with less flesh, thus increasing the apparent height of his figures. There is no word in Latin for the canon of symmetry which he was so careful to preserve, bringing innovations which had never been thought of before into the square canon of the older artists, and he often said that the difference between himself and them was that they represented men as they were, and he as they appeared to be. His chief characteristic is extreme delicacy of execution even in the smallest details.

from Book 36 (on marble)

The art of [marble] sculpture is much older than that of painting or of bronze statuary, both of which began with Pheidias. . . .

Praxiteles . . . outdid even himself by the fame of his works in marble. . . . Famous . . . throughout the whole world, is the Aphrodite which multitudes have sailed to Knidos to look upon [see fig. 5-69]. He had offered two statues of Aphrodite for sale at the same time, the second being a draped figure, which for that reason was preferred by the people of Kos with whom lay the first choice; the price of the two figures was the same, but they flattered themselves they were giving proof of a severe modesty. The rejected statue, which was bought by the people of Knidos, enjoys an immeasurably greater reputation. King Nikomedes subsequently wished to buy it from them, offering to discharge the whole of their public debt, which was enormous. They, however, preferred to suffer the worst that could befall, and they showed their wisdom, for by this statue Praxiteles made Knidos illustrious. . . .

Bryaxis, Timotheos, and Leochares were rivals and contemporaries of Skopas, and must be mentioned with him, as they worked together on the Mausoleion [figs. 5-65 and 5-66]. This is the tomb erected by Artemisia in honour of her husband Mausolos, . . . and its place among the seven wonders of the world is largely due to these great sculptors. The length of the south and north sides is 163 feet; the two facades are shorter, and the whole perimeter is 440 feet; its height is 25 cubits [37½ feet], and it has thirty-six columns. . . . The sculptures of the eastern front are carved by Skopas, those on the north by Bryaxis, on the south by Timotheos, and on the west by Leochares. . . . Above the colonnade is a

pyramid, of the same height as the lower structure, consisting of twenty-four retreating steps rising into a cone. On the apex stands a chariot and four horses in marble made by Pythis. . . .

In the case of certain masterpieces the . . . number of the collaborators is an obstacle to their individual fame, since neither can one man take to himself the whole glory, nor have a number so great a claim to honour. This is the case with the Laokoon in the palace of the Emperor Titus, a work superior to all the pictures and bronzes of the world [compare fig. 5-78]. Out of one block of marble did the illustrious artists Hagesander, Polydoros, and Athanodoros of Rhodes, after taking counsel together, carve Laokoon, his children, and the wondrous coils of the snakes.

from Book 35 (on Roman painting)

Timomachos of Byzantium, in the period when Caesar was dictator [46–44 B.C.], painted an *Ajax* and a *Medea,* which were placed by Caesar, after he bought them for 80 talents, in the temple of Venus *Genetrix.* . . . Works by Timomachos which are equally praised are his *Orestes*, his *Iphigeneia among the Taurians,* his picture of *Lekythion* the trainer in agility, a family portrait of well-known people, and his picture of two men in Greek cloaks, whom he has painted as about to speak, one standing and the other seated. His art seems to have been exceptionally successful, however, in his painting of a *Gorgon*.

Women too have been painters: . . . Iaia of Kyzikos, who remained single all her life, worked at Rome. . . . She painted chiefly portraits of women, and also a large picture of an old woman at Naples, and a portrait of herself, executed with the help of a mirror. No artist worked more rapidly than she did, and her pictures had such merit that they sold for higher prices than those of [other] well-known contemporary painters, whose works fill our galleries.

4

VITRUVIUS (1ST CENTURY B.C.)
On Architecture

Vitruvius, like Pliny, was a Roman writer who admired the achievements of the Greeks. He was an architect under Julius Caesar and Augustus, and his treatise on architecture (c. 35–25 B.C.) reflects the classicizing taste of his time. Vitruvius' work was a principal source for Renaissance architects seeking the revival of antiquity. His account of the origin of the Greek orders is partly mythic, partly rational conjecture (see fig. 5-25).

from Book IV
(on the Doric and Corinthian orders)

For in Achaea and over the whole Peloponnese, Dorus . . . was king; by chance he built a temple . . . at the old city of Argos, in the sanctuary of Juno. . . . Afterwards [Greeks in Ionia] . . . established

a temple as they had seen in Achaea. Then they called it Doric because they had first seen it built in that style. When they wished to place columns in that temple, not having their proportions, . . . they measured a man's footstep and applied it to his height. Finding that the foot was the sixth part of the height in a man, they applied this proportion to the column. Of whatever thickness they made the base of the shaft they raised it along with the capital to six times as much in height. So the Doric column began to furnish the proportion of a man's body, its strength and grace. . . .

But the third order, which is called Corinthian, imitates the slight figure of a maiden; because girls are represented with slighter dimensions because of their tender age, and admit of more graceful effects in ornament. Now the first invention of that capital is related to have happened thus. A girl, a native of Corinth, already of age to be married, was attacked by disease and died. After her funeral, the goblets which delighted her when living, were put together in a basket by her nurse, carried to the monument, and placed on the top. That they might remain longer, exposed as they were to the weather, she covered the basket with a tile. As it happened the basket was placed upon the root of an acanthus. Meanwhile about spring time, the root of the acanthus, being pressed down in the middle by the weight, put forth leaves and shoots. The shoots grew up the sides of the basket, and, being pressed down at the angles by the force of the weight of the tile, were compelled to form the curves of volutes at the extreme parts. . . .

Workmen of old, . . . when they had put beams reaching from the inner walls to the outside parts, built in the spaces between the beams. . . . Then they cut off the projections of the beams, as far as they came forward, to the line and perpendicular of the walls. But since this appearance was ungraceful, they fixed tablets shaped as triglyphs now are, against the cut-off beams, and painted them with blue wax, in order that the cut-off beams might be concealed so as not to offend the eyes. Thus in Doric structures, the divisions of the beams being hidden began to have the arrangement of the triglyphs, and, between the beams, of metopes. Subsequently other architects in other works carried forward over the triglyphs the projecting rafters, and trimmed the projections. . . . In the Doric style the detail . . . of the triglyphs . . . arose from this imitation of timber work.

from Book V (on public buildings)

The sites of basilicas ought to be fixed adjoining the fora in as warm a quarter as possible, so that in the winter, business men may meet there without being troubled by the weather. And their breadth should be fixed at not less than a third, nor more than half their length, unless the nature of the site is awkward and forces the proportions to be changed. When the site is longer than necessary, the committee rooms are to be placed at the end of the basilica. . . . The columns of basilicas are to be of a height equal to the width of the aisle. The aisle is to have a width one third of the nave.

from Book VI (on private buildings)

We must go on to consider how, in private buildings, the rooms belonging to the family, and how those which are shared with

visitors, should be planned. For into the private rooms no one can come uninvited, such as the bedrooms, dining-rooms, baths and other apartments which have similar purposes. The common rooms are those into which, though uninvited, persons of the people can come by right, such as vestibules, courtyards, peristyles and other apartments of similar uses. Therefore magnificent vestibules and alcoves and halls are not necessary to persons of a common fortune, because they pay their respects by visiting among others, and are not visited by others. . . . The houses of bankers and farmers of the revenue should be more spacious and imposing and safe from burglars. . . . For persons of high rank who hold office and magistracies, and whose duty it is to serve the state, we must provide princely vestibules, lofty halls and very spacious peristyles, plantations and broad avenues finished in a majestic manner.

from Book VII (on fresco wall painting)

For other apartments, that is, those used for spring, autumn, and summer, and also in atriums and peristyles, clearly defined principles for depicting objects were derived by the ancients from prototypes which really existed in nature. For a picture is an image of something which either really exists or at least can exist—for instance, men, actual buildings, ships, and other things from whose clearly defined and actually existent physical forms pictorial representations are derived by copying. Following this principle, the ancients, who first undertook to use polished wall surfaces, began by imitating different varieties of marble revetments in different positions, and then went on to imitate cornices, hard stones, and wedges arranged in various ways in relation to one another.

Later they became so proficient that they would imitate the forms even of buildings and the way columns and gables stood out as they projected from the background; and in open spaces, such as exedrae, because of the extensiveness of the walls, they depicted stage facades in the tragic, comic, or satyric style. Their walks, because of the extended length of the wall space, they decorated with landscapes of various sorts, modeling these images on the features of actual places. In these are painted harbors, promontories, coastlines, rivers, springs, straits, sanctuaries, groves, mountains, flocks, and shepherds. In places there are some designs done in the megalographic style representing images of the gods or narrating episodes from mythology, or, no less often, scenes from the Trojan war, or the wanderings of Odysseus over the landscape backgrounds, and other subjects, which are produced on the basis of similar principles from nature as it really is.

But these, which are representations derived from reality, are now scorned by the undiscriminating tastes of the present. For now there are monstrosities painted on stucco walls rather than true-to-life images based on actual things—instead of columns the structural elements are striated reeds; instead of gables there are ribbed appendages with curled leaves and volutes. Candelabra are seen supporting figures of small shrines, and, above the gables of these, many tender stalks with volutes grow up from their roots and have, without it making any sense whatsoever, little seated figures upon them. Not only that, but there are slender stalks which have little half-figures, some with human heads and some with beasts' heads [compare fig. 7-52].

Such things do not exist, nor could they exist, nor have they ever existed. Consequently it is the new tastes which have brought about a condition in which bad judges who deal with incompetent art have the power to condemn real excellence in the arts. For to what extent can a reed actually sustain a roof or a candelabrum the ornaments of a gable, or a tender, soft stalk support a seated figure, or at one time flowers and at another time half-figures be produced from roots and stalks? And yet upon seeing these false images they do not disapprove of them, but on the contrary they delight in them, nor do they give any attention to the question of whether any of these things could really exist or not. Minds obscured by weak powers of criticism are not able to make a valid judgment, with authority and with a rational understanding of what is proper, about what can exist. For pictures should not be given approbation which are not likenesses of reality; even if they are refined creations executed with artistic skill, they still should not, simply on the basis of these facts, immediately be judged as correct, unless their subjects demonstrate conceptual principles which are based on reality and are put into practice without deviations. . . .

But it will not be beyond the scope of our discussion to explain why a false method wins out over the truth. The reason is that what the ancients sought to achieve by laborious, painstaking diligence in their arts, the present age seeks to attain by colors and their alluring effect; and the impressiveness which the subtle skill of the artist used to contribute to works is now brought about by lavish expenditure on the part of the client, lest loss of subtlety be noted.

5

PLUTARCH (c. 46–AFTER 119 A.D.)
Parallel Lives of Greeks and Romans, from the lives of Perikles and Fabius Maximus

A Greek author of the Roman period, Plutarch wrote Parallel Lives *to show that ancient Greece matched or exceeded Rome in its great leaders. Comparing Perikles (d. 429 B.C.) with Fabius Maximus (died 203 B.C.), he concludes that Perikles' buildings surpass all the architecture of the Romans. Plutarch is the only ancient source to say that Pheidias was the overseer of Perikles' works.*

But that which brought most delightful adornment to Athens, and the greatest amazement to the rest of mankind; that which alone now testifies for Hellas that her ancient power and splendour, of which so much is told, was no idle fiction—I mean his construction of sacred edifices. . . . For this reason are the works of Perikles all the more to be wondered at; they were created in a short time for all time. Each one of them, in its beauty, was even then and at once antique; but in the freshness of its vigour it is,

even to the present day, recent and newly wrought. Such is the bloom of perpetual newness, as it were, upon these works of his, which makes them ever to look untouched by time, as though the unfaltering breath of an ageless spirit had been infused into them.

His general manager and general overseer was Pheidias, although the several works had great architects and artists besides. Of the Parthenon, for instance, with its cella of a hundred feet in length, Callicrates and Ictinus were the architects. . . .

By the side of the great public works, the temples, and the stately edifices, with which Perikles adorned Athens, all Rome's attempts at splendour down to the times of the Caesars, taken together, are not worthy to be considered, nay, the one had a towering pre-eminence above the other, both in grandeur of design, and grandeur of execution, which precludes comparison.

6

PLATO (c. 427–347 B.C.)
The Republic, from Book X

At the end of his treatise on the ideal state, the philosopher Plato attacks poets and painters. He claims that painters are only imitators of appearances, rather than of essences (forms or ideas), and therefore dishonest; he concludes that they must be banished from the state. Implicit in this argument is a condemnation of the new illusionistic practices in Greek art. The treatise is written in Socratic dialogue form, which consists of a series of questions designed to elicit clear and rational answers.

"Could you tell me what imitation in general is? . . . We are, presumably, accustomed to set down some one particular form for each of the particular 'manys' to which we apply the same name. Or don't you understand?"

"I do."

"Then let's now set down any one of the 'manys' you please; for example, if you wish, there are surely many couches and tables."

"Of course."

"But as for *ideas* for these furnishings, there are presumably two, one of couch, one of table.

"Yes." . . .

"You could fabricate them quickly, . . . if you are willing to take a mirror and carry it around everywhere; quickly you will make the sun and the things in heaven; quickly, the earth; and quickly, yourself and the other animals and implements and plants. . . . "

"Yes," he said, "so that they look like they *are;* however, they surely *are* not the truth."

"Fine," I said, "and you attack the argument at just the right place. For I suppose the painter is also one of these craftsmen, isn't he?"

"Of course he is."

"But I suppose you'll say that he doesn't truly make what he makes. And yet in a certain way the painter too does make a couch, doesn't he?"

"Yes," he said, "he too makes what looks like a couch." . . .

"There turn out, then, to be these three kinds of couches: one that *is* in nature, which we would say, I suppose, a god produced. . . . And then one that the carpenter produced."

"Yes," he said.

"And the one that the painter produced, isn't that so?" . . .

"Now consider this very point. Toward which is painting directed in each case—toward imitation of the being as it is or toward its looking as it looks? Is it imitation of looks or of truth?"

"Of looks," he said.

"Therefore, imitation is surely far from truth; and, as it seems, it is due to this that it produces everything—because it lays hold of a certain small part of each thing, and that part is itself only a phantom. For example, the painter, we say, will paint for us a shoemaker, a carpenter, and the other craftsmen, although he doesn't understand the arts of any one of them. But, nevertheless, if he is a good painter, by painting a carpenter and displaying him from far off, he would deceive children and foolish human beings into thinking that it is truly a carpenter."

7

ARISTOTLE (384–322 B.C.)
The Politics, from Book VIII

The Politics is a counterpart to Plato's Republic, a treatment of the constitution of the state. Books VII and VIII discuss the education prescribed for good citizens. Drawing is included as a liberal art—that is, a skill not only useful but also conducive to higher activities. Yet painting and sculpture are said to have only limited power to move the soul.

There is a sort of education in which parents should train their sons, not as being useful or necessary, but because it is liberal or noble. . . . Further, it is clear that children should be instructed in some useful things—for example, in reading and writing—not only for their usefulness, but also because many other sorts of knowledge are acquired through them. With a like view they may be taught drawing, not to prevent their making mistakes in their own purchases, or in order that they may not be imposed upon in the buying or selling of articles [works of art], but perhaps rather because it makes them judges of the beauty of the human form. To be always seeking after the useful does not become free and exalted souls. . . .

The habit of feeling pleasure or pain at mere representations is not far removed from the same feeling about realities; for example, if any one delights in the sight of a statue for its beauty only, it necessarily follows that the sight of the original will be pleasant to him. The objects of no other sense, such as taste or touch, have any resemblance to moral qualities; in visible objects there is only a little, for there are figures which are of a moral character, but only to a slight extent, and all do not participate in the feeling about them. Again, figures and colours are not imitations, but signs, of character, indications which the body gives of states of feeling. The

connexion of them with morals is slight, but in so far as there is any, young men should be taught to look . . . at [the works] of Polygnotus, or any other painter or sculptor who expresses character.

8

VERGIL (70–19 B.C.)
The Aeneid, from Book II

Vergil was the greatest Latin poet and the chief exponent of the Augustan age in literature. The Aeneid *is an epic poem about the hero Aeneas, who fled Troy when it was destroyed by the Greeks and settled in Italy. Book II tells of the fall of Troy, including the punishment by Minerva of Laocoön for trying to warn the Trojans against the trick wooden horse. The sculptural rendition of Laocoön shown in figure 5-78 closely resembles Vergil's description. The Vatican Vergil (see fig. 8-19) contains the complete* Aeneid *as well as other poetry by Vergil.*

Laocoön, by lot named priest of Neptune,
was sacrificing then a giant bull
upon the customary altars, when
two snakes with endless coils, from Tenedos
strike out across the tranquil deep. . . .
They lick their hissing jaws with quivering tongues.
We scatter at the sight, our blood is gone.
They strike a straight line toward Laocoön.
At first each snake entwines the tiny bodies
of his two sons in an embrace, then feasts
its fangs on their defenseless limbs. The pair
next seize upon Laocoön himself,
who nears to help his sons, carrying weapons.
They wind around his waist and twice around
his throat. They throttle him with scaly backs;
their heads and steep necks tower over him.
He struggles with his hands to rip their knots,
his headbands soaked in filth and in dark venom,
while he lifts high his hideous cries to heaven,
just like the bellows of a wounded bull.

9

LIVY (59 B.C.–17 A.D.)
From the Founding of the City, from Book I

Livy, a historian, was a contemporary of Vitruvius and Vergil and also moved in the circle of the emperor Augustus. His history of Rome begins with Aeneas and includes the legend of the she-wolf that suckled Romulus and Remus (compare fig. 6-9).

The Vestal [Virgin, Rhea Silvia] was ravished, and having given birth to twin sons, named Mars as the father of her doubtful offspring. . . . But neither gods nor men protected the mother herself or her babes from the king's cruelty; the priestess he ordered to be manacled and cast into prison, the children to be committed to the river. . . . The story persists that when the floating basket in which the children had been exposed was left high and dry by the receding water, a she-wolf, coming down out of the surrounding hills to slake her thirst, turned her steps towards the cry of the infants, and with her teats gave them suck so gently, that the keeper of the royal flock found her licking them with her tongue. . . . He carried the twins to his hut and gave them to his wife Larentia to rear.

10

POLYBIUS (c. 200–c. 118 B.C.)
Histories, from Book VI

Polybius was a Greek historian active during the Roman conquest of his homeland. His Histories *recount the rise of Rome from the third century B.C. to the destruction of Corinth in 146 B.C. In Book VI he considers cultural and other factors explaining Rome's success.*

Whenever any illustrious man dies, . . . they place the image of the departed in the most conspicuous position in the house, enclosed in a wooden shrine. This image is a mask reproducing with remarkable fidelity both the features and complexion of the deceased. On the occasion of public sacrifices they display these images, and decorate them with much care, and when any distinguished member of the family dies they take them to the funeral, putting them on men who seem to them to bear the closest resemblance to the original in stature and carriage. These representatives wear togas, with a purple border if the deceased was a consul or praetor, whole purple if he was a censor, and embroidered with gold if he had celebrated a triumph or achieved anything similar. They all ride in chariots preceded by the fasces, axes, and other insignia . . . and when they arrive at the rostra they all seat themselves in a row on ivory chairs. There could not easily be a more ennobling spectacle for a young man who aspires to fame and virtue. For who would not be inspired by the sight of the images of men renowned for their excellence, all together and as if alive and breathing? . . . By this means, by this constant renewal of the good report of brave men, the celebrity of those who performed noble deeds is rendered immortal. . . . But the most important result is that young men are thus inspired to endure every suffering for the public welfare in the hope of winning the glory that attends on brave men.

11
JOSEPHUS (37/8–c. 100 A.D.)
The Jewish War, from Book VII

The Jewish soldier and historian Josephus Flavius was born Joseph Ben Matthias in Jerusalem. He was named commander of Galilee during the uprising of 66–70 A.D. against the Romans in the reign of Nero. After surrendering, he won the favor of the general Titus Flavius Sabinus Vespasian and took the name Flavius as his own. Josephus moved to Rome, where he wrote an account of the war (75–79 A.D.) and Antiquities of the Jews (93 A.D.), which was later illustrated by Jean Fouquet (see fig. 15-18). The following passage from his history of the rebellion describes the triumphal procession into Rome following the Sack of Jerusalem in 70 A.D., which is depicted on the Arch of Titus (figs. 7-35, 7-36).

It is impossible to give a worthy description of the great number of splendid sights and of the magnificence which occurred in every conceivable form, be it works of art, varieties of wealth, or natural objects of great rarity. For almost all the wondrous and expensive objects which had ever been collected, piece by piece, from one land and another, by prosperous men—all this, being brought together for exhibition on a single day, gave a true indication of the greatness of the Roman Empire. For a vast amount of silver and gold and ivory, wrought into every sort of form, was to be seen, giving not so much the impression of being borne along in a procession as, one might say, of flowing by like a river. Woven tapestries were carried along, some dyed purple and of great rarity, others having varied representations of living figures embroidered on them with great exactness, the handiwork of Babylonians. Transparent stones, some set into gold crowns, some displayed in other ways, were borne by in such great numbers that the conception which we had formed of their rarity seemed pointless. Images of the Roman gods, of wondrous size and made with no inconsiderable workmanship, were also exhibited, and of these there was not one which was not made of some expensive material. . . .

The rest of the spoils were borne along in random heaps. The most interesting of all were the spoils seized from the temple of Jerusalem: a gold table weighing many talents, and a lampstand, also made of gold, which was made in a form different from that which we usually employ. For there was a central shaft fastened to the base; then spandrels extended from this in an arrangement which rather resembled the shape of a trident, and on the end of each of these spandrels a lamp was forged. There were seven of these, emphasizing the honor accorded to the number seven among the Jews. The law of the Jews was borne along after these as the last of the spoils. In the next section a good many images of Victory were paraded by. The workmanship of all of these was in ivory and gold. Vespasian drove along behind these and Titus followed him; Domitian rode beside them, dressed in a dazzling fashion and riding a horse which was worth seeing.

12
PLOTINUS (205–270 A.D.)
Enneads, from Book I.6, "On Beauty"

A Greek philosopher who taught in Rome, Plotinus was a Neoplatonist, the last great pagan expositor of the thought of Plato. Mystical in outlook, he conceived the cosmos as a hierarchical descent from the ineffable One (God) to matter. His reference to "images, traces, shadows" is a clear echo of Plato's argument in The Republic *and indicates his distrust of images. As the lowest form of existence in his scheme, matter could not be the site of true beauty. Plotinus' teachings were Christianized and transmitted to the Middle Ages by writers such as Pseudo-Dionysius.*

Beauty is mostly in sight, but it is to be found too in things we hear, in combinations of words and also in music . . . and for those who are advancing upwards from sense-perception ways of life and actions and characters and intellectual activities are beautiful, and there is the beauty of virtue. . . .

How can one see the "inconceivable beauty" which . . . does not come out where the profane may see it? Let him who can . . . leave . . . the sight of his eyes. . . . When he sees the beauty in bodies he must not run after them; we must know that they are images, traces, shadows, and hurry away to that which they image. For if a man runs to the image and wants to seize it as if it was the reality . . . [he] will, . . . in soul, . . . sink down into the dark depths where intellect has no delight, and stay blind in Hades. . . . Shut your eyes, and change to and wake another way of seeing, which everyone has but few use. . . .

First of all . . . look at beautiful ways of life: then at beautiful works, not those which the arts produce, but the works of men who have a name for goodness: then look at the souls of the people who produce the beautiful works.

	35,000–3500 B.C.	3500–3000 B.C.	3000–2500 B.C.
HISTORY AND POLITICS	c. 35,000 First Paleolithic societies c. 4000 Predynastic period in Egypt	c. 3500–3000 Sumerian civilization, Mesopotamia c. 3100 Narmer unites the Upper and Lower Kingdoms of Egypt. Beginning of Old Kingdom in Egypt (dynasties 1–6, until c. 2190); divine kingship of the pharaoh c. 3000 Rise of early Aegean civilizations: Cretan, Cycladic, and Helladic periods	
RELIGION			

> **PYRAMIDS AND POWER** The pyramids, built in Egypt during the Old Kingdom, are artworks in which the connection of public architecture to political power, religious ideology, and the development of high technology is particularly clear. Intentionally grandiose, they were designed to impress the viewer with their monumentality and to represent the might and wealth of the pharaohs who built them. The newly centralized government placed power directly in the hands of the monarch, administered by an efficient bureaucracy able to mobilize tens of thousands of workers and apply accurate astronomical calculations and the latest in surveying techniques (such as the plumb line and the A-frame). The pyramids display a high degree of skill in their precise architecture and fine masonry. Built in as little as 30 years as tombs for Egypt's rulers, they and their attendant temples and sculptures express on a grand scale the contemporary idea of the divinity of the pharaoh.

Woman of Willendorf, c. 25,000–20,000 B.C.

Cave painting, Altamira, c. 15,000–10,000 B.C.

Female Head, Uruk, c. 3500–3000 B.C.

Inlay panel, Ur, c. 2600 B.C.

	35,000–3500 B.C.	3500–3000 B.C.	3000–2500 B.C.
MUSIC, LITERATURE, AND PHILOSOPHY			c. 3000–2500 *Epic of Gilgamesh,* early Sumerian heroic tale
SCIENCE AND TECHNOLOGY	c. 8000 Husbandry and farming develop in the Near East	c. 3500–3000 Wheeled carts in Sumer c. 3500 Sailboats used on the Nile c. 3300–3000 Invention of writing by Sumerians; use of potter's wheel and organic dyes	

2500–2000 B.C.	2000–1500 B.C.	1500–1000 B.C.	
Sargon of Akkad, Akkadian ruler (ruled 2340–2305), unifies Mesopotamian region and organizes first empire, encompassing land in Persia, Africa, and the Aegean c. **2125** Gudea rules in Mesopotamia; c. 2060–1950, Third Dynasty of Ur comes to power in Sumeria, ushering in a period of great cultural development **2040–1674** Middle Kingdom in Egypt. After a period of chaos, Egyptian pharaohs strengthen the country, institute a centralized government, and conquer neighboring Nubia (present-day Ethiopia)	c. **2000–750** Bronze Age in Europe c. **1760–1600** Babylonian Empire, founded by Hammurabi, flourishes	c. **1500–1145** New Kingdom in Egypt (dynasties 18–20) **1478–1458** Queen Hatshepsut rules Egypt c. **1450** Mycenaean forces conquer the Minoan city of Knossos on Crete c. **1350** Assyrian Empire founded in Mesopotamia by Ashuruballit I; empire endures until 612 **Pharaoh Akhenaten (ruled 1348–1336/5)** attempts radical alteration of Egyptian society. Deposed by Tutankhamen (ruled 1336/5–1327) c. **1319–1145** Ramesside period in Egypt (Dynasty 19), epitomized by Pharaoh Ramesses II, whose frequent wars against invaders bring about great expansion of Egyptian territory and influence c. **1250 (traditional)** Moses and Israelites flee to Palestine from Egypt to escape persecution **1184 (traditional)** Attack on Troy in Asia Minor by united Greek armies under Agamemnon	HISTORY AND POLITICS
		c. **1345** Akhenaten institutes a new monotheistic religion in Egypt c. **1000** Hebrews in Palestine accept monotheism	RELIGION

The Great Sphinx, Egypt, c. 2570–2544 B.C.

Inanna-Ishtar, Mesopotamia, c. 2025–1763 B.C.

Stonehenge, England, c. 2000 B.C.

(TOP) *"The Toreador Fresco,"* Crete, c. 1500 B.C.
(BOTTOM) *Sety I in a Chariot Charging the Libyans,* from the temple of Amun-Re at Karnak, Thebes, c. 1280 B.C.

2500–2000 B.C.	2000–1500 B.C.	1500–1000 B.C.	
c. **2350** *The Pyramid Texts,* early religious writings found on walls of Egyptian tombs	c. **1900** *The Story of Sinuhe,* a Middle Kingdom Egyptian tale c. **1760** Code of Hammurabi, first known legal document, carved on a stone monolith for the Babylonian king	c. **1500** The Book of the Dead, first manuscripts (on papyrus), encapsulating Egyptian religious thought	MUSIC, LITERATURE, AND PHILOSOPHY
	c. **2000** Iron used for tools and weapons in Asia Minor c. **1725** Hyksos tribes introduce horse-drawn vehicles into Egypt c. **1700** Babylonian mathematics flourish under Hammurabi: use of whole numbers, fractions, and square roots	c. **1500** Chinese develop silk production c. **1400** First Greek writing, known as Linear B, in general use in the Aegean	SCIENCE AND TECHNOLOGY

	1000–600 B.C.	600–200 B.C.	200 B.C–1 A.D.
HISTORY AND POLITICS	c. **1000–961** Israelite kingdom established by King David. Reign of his son, Solomon (961–922), is a time of legendary peace, justice, and stability **753 (traditional)** Founding of Rome by Romulus and Remus **By 700 (traditional)** Theseus unifies Athenian state **Nebuchadnezzar, Neo-Babylonian king (ruled 605–562).** Under his rule the empire, based in Babylon, reaches its greatest extent, conquering Egypt (605) and Jerusalem (586)	**539** Persians conquer Babylonian Empire and Egypt (525). Expansion of Persian Empire **510** Roman Republic established c. **510–508** Greece establishes the first government based on democratic principles c. **499** Persians invade Greece; 490, defeated by Athenians at the Battle of Marathon **431–404** Peloponnesian War pits Greek city-states against one another; Athens is defeated by Sparta and its fleet destroyed at Syracuse **356–323** Alexander the Great leads Greek army in conquest of Egypt (323), Palestine, Phoenicia, and Persia (331) **264–201** Punic Wars waged between Rome and North Africa. Carthaginian general Hannibal marches from Spain and invades Italy (218), threatening Rome (211). He is defeated, and Roman expansion continues; Rome annexes Spain (201), by 147 dominates Asia Minor, Syria, Egypt, and Greece (146). Carthage destroyed (146)	**82–79** Sulla becomes first dictator of Roman state. Institutes substantial legal and legislative reforms **73–71** Slave rebellion led by the ex-gladiator Spartacus in Rome **51–30** Cleopatra, descendant of the Ptolemys, rules in Egypt **49–44** Julius Caesar (c. 101–44), Roman general, becomes dictator of Rome after a military career in the provinces. Assassinated by a group of senators who fear his usurpation of power **31** Sea battle of Actium, on the western coast of Greece, in which Julius Caesar's cousin Octavian defeats Marc Antony, a rival, and consolidates the Roman Empire under his control. Octavian takes the name Augustus Caesar and rules with Imperial powers, 27 B.C.–14 A.D. Golden Age of Rome, the *Pax Romana.* Henceforth Roman emperors are hereditary, although the senate retains some powers
RELIGION	**776** First Olympic Games, established as a religious festival in Olympia, Greece	c. **563** Siddhartha (Gautama Buddha), founder of Buddhism, born in Nepal c. **250** Mithraism, worship of an ancient Persian warrior hero, grows in Roman Empire	**4** Birth of Jesus Christ, crucified c. 30 A.D.

Detail of *Ashurnasirpal II Killing Lions,* from the Palace of Ashurnasirpal II, Nimrud, Iraq, c. 850 B.C.

(LEFT) Marsyas Painter, red-figured pelike, Greece, c. 340 B.C.
(RIGHT) *Nike of Samothrace,* c. 200–190 B.C.

Imperial Procession, from the Ara Pacis, Rome, c. 13–9 B.C.

	1000–600 B.C.	600–200 B.C.	200 B.C–1 A.D.
MUSIC, LITERATURE, AND PHILOSOPHY	c. **750–700 (traditional)** Homer composes the epics *Iliad* and *Odyssey*	**Confucius (551–c. 479),** Chinese philosopher **Pythagoras (c. 520),** Greek philosopher c. **500–400** Greek drama: Aeschylus (523–456), Sophocles (496–406), Euripides (480–406), Aristophanes (c. 448–385) c. **450–300** Classical Greek philosophy: Socrates (470–399), Plato (c. 427?–c. 347), Aristotle (384–322) **Demosthenes** (384–322), Greek philosopher and orator	**Cicero (106–43),** Roman statesman and orator **Vergil (70–19),** Roman author of *The Aeneid,* epic poem narrating the mythic origins of the Romans **Livy (59 B.C.–17 A.D.),** author of *From the Founding of the City,* a history of Rome c. **50 Commentaries,** by Julius Caesar, details the progress of his wars in France **Ovid (43 B.C.–17 A.D.),** poet of *The Metamorphoses,* amorous and mythological tales
SCIENCE AND TECHNOLOGY	c. **800** Adoption of the Phoenician alphabet, ancestor of modern European languages, by Greeks c. **700–600** Phoenician sailors circumnavigate African continent; c. 700, horseshoes invented in Europe by Celtic tribes c. **650** Coins for currency imported from Asia Minor to Greece	c. **500** Greek advances in metalworking; invention of metal-casting and ore-smelting techniques c. **300** Euclid, geometrician in Alexandria, writes *Elements,* fundamental text of mathematics and reasoning **Pytheas,** Greek explorer, travels the Atlantic coast of Europe, reaching points beyond Britain **Archimedes (287–212),** Greek mathematician	c. **200** Standing army maintained by the Romans; development of the professional soldier; use of concrete as building material in the Roman Empire c. **100** Earliest waterwheels **Vitruvius'** *On Architecture,* late-first-century B.C. manual of classical building methods and styles **46** Julius Caesar establishes the Julian calendar, in use until the 16th century A.D.

Claudius (ruled 41–54), reluctant emperor of Rome, reconquers Britain

In the reign of the emperor Nero (ruled 54–68), a fire destroys most of Rome, which is soon rebuilt; first persecutions of Christians

79 Eruption of Mount Vesuvius in southern Italy; destruction of cities of Pompeii and Herculaneum by lava and ash

Emperor Trajan (ruled 98–117) brings the Roman Empire to its greatest expansion, venturing into Persian territory and northern Germany. The city of Rome has an estimated population of one million

132–35 Jewish Diaspora begins; Jews expelled from Jerusalem

Marcus Aurelius, emperor of Rome (ruled 161–80), repulses the growing flood of Goth and Hun invaders from northern Europe

285 Emperor Diocletian (ruled 284–305) divides Roman Empire among four emperors in separate zones. Beginning of Roman decline, loss of territories, economic troubles, and political dissent

POMPEII The sudden destruction of Pompeii by lava from Mount Vesuvius in 79 B.C. preserved intact an entire city. Private houses, public buildings, shops, plumbing systems, and even bits of furniture were encased in lava and mud. Pompeii was a town of modest importance in first-century Rome; it thus affords a remarkable view of daily life—both high and low—in the Empire. Grooves in paved streets mark the passage of carts and chariots. On the walls of fine villas are brightly colored paintings; on those of cheaper lodgings are scrawled political slogans and graffiti. Among the finest wall paintings, otherwise rare, are those of the luxurious villas of wealthy Pompeiians decorated lavishly with complex architectural scenes, figures, and landscape vistas. With ornate mosaic floors and elegant architecture, the Pompeiian villas illustrate the refinement of aristocratic Roman life.

c. 45–50 St. Paul spreads Christianity in Asia Minor and Greece

St. Peter (died c. 64), first bishop of Rome

c. 130–68 Dead Sea Scrolls written; early manuscripts of Judaism and Christianity

c. 250–302 Widespread persecution of Christians in Roman Empire

Spoils from the Temple in Jerusalem, from the Arch of Titus, Rome, 81 A.D.

Pantheon, Rome, 118–125 A.D.

Fayyum Portrait of a Boy, Egypt, 2nd century A.D.

Seneca (4 B.C.–65 A.D.), prominent Roman Stoic philosopher and adviser to Emperor Nero

Plutarch (c. 46–after 119), Greek essayist, author of *Parallel Lives of Greeks and Romans*

c. 47–49 Epistles of St. Paul, written during his missionary work in Asia Minor

Tacitus (55–118), Roman historian and political commentator

Plotinus (205–70), Neo-Platonic Greek philosopher and author of the *Enneads,* teaches in Rome

c. 77 Pliny the Elder (23–79) writes his *Natural History,* an encyclopedic history, including a history of art

Ptolemy (85–160), influential geographer and astronomer in Alexandria, popularizes the theory that the earth is at the center of the universe

c. 100 Early glass-blowing techniques developed in Syria

Galen (c. 130–200), Greek physician whose writings form the foundation of the study of human physiology

By 200 More than 50,000 miles of paved roads built by Romans

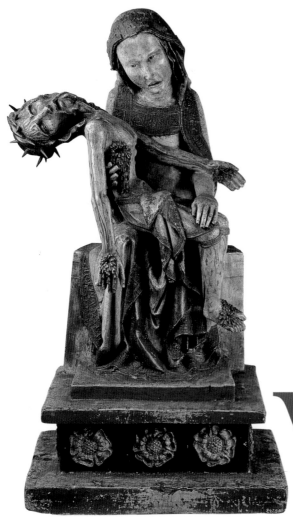

E TEND TO THINK OF THE GREAT
WESTERN CIVILIZATIONS OF THE
PAST IN TERMS OF THE MONUMENTS
THAT HAVE COME TO SYMBOLIZE THEM:
the pyramids of Egypt, the ziggurats of Babylon, the Parthenon of Athens, the Colosseum of Rome.
The Middle Ages would be represented by a Gothic cathedral—Notre-Dame in Paris, perhaps, or the
cathedral of Chartres in France, or Salisbury Cathedral in England. We have many to choose from,
but whichever one we pick, it will be well north of the Alps (although in an area that was once part of
the Roman empire). And if we were to spill a bucket of water in front of the cathedral of our choice,
this water would eventually make its way to the English Channel rather than to the Mediterranean
Sea. Here, then, we have perhaps the most important single fact about the Middle Ages—the center
of gravity of European civilization has shifted to what had been the northern boundaries of the Roman
world. The Mediterranean, which for so many centuries bound together all the lands along its shores,
has become a border zone.

How did this dramatic shift come about? In 323 A.D. Constantine the Great made a fateful decision,
the consequences of which are still felt today. He resolved to move the capital of the Roman empire to
the Greek town of Byzantium, which came to be known as Constantinople and today as Istanbul. Six

The Middle Ages

years later, after a major building campaign, the transfer was officially completed. In taking this step, the emperor acknowledged the growing strategic and economic importance of the eastern provinces. The new capital also symbolized the new Christian basis of the Roman state, since it was in the heart of the most fully Christianized part of the empire.

Constantine could hardly have foreseen that moving the seat of imperial power would split the empire. Less than 75 years later, in 395, the division of the realm into the Eastern and Western empires was complete when they were divided between the sons of Theodosius I. Eventually that separation led to a religious split as well.

By the end of the fifth century, the bishop of Rome, who derived his authority from St. Peter, regained independence from the emperor. He then reasserted his claim as the pope, the head of the Christian Church. This claim to supremacy, however, was soon disputed by his Eastern counterpart, the patriarch of Constantinople. Differences in doctrine began to emerge and eventually the division of Christendom into a Western, or Catholic, and an Eastern, or Orthodox, Church became all but final. The differences between them went very deep. Roman Catholicism maintained its independence from state authority and became an international institution, reflecting its character as the Universal Church. The Orthodox Church, on the other hand, was based on the union of spiritual and secular authority in the person of the emperor, who appointed the patriarch. It thus remained dependent on

the power of the State, requiring a double allegiance from the faithful. This tradition did not die even with the fall of Constantinople to the Ottoman Turks in 1453. The czars of Russia claimed the mantle of the Byzantine emperors, Moscow became "the third Rome," and the Russian Orthodox Church was as closely tied to the State as the Byzantine church had been.

Under Justinian (ruled 527–65), the Eastern (or Byzantine) empire reached new power and stability after riots in 532 nearly deposed him. In contrast, the Latin West soon fell prey to invading Germanic peoples: Visigoths, Vandals, Franks, Ostrogoths, and Lombards. By the end of the sixth century, the last vestige of centralized authority had disappeared, even though the emperors at Constantinople did not give up their claim to the western provinces. Yet these invaders, once they had settled in their new lands, accepted the framework of late Roman, Christian civilization, however imperfectly. The local kingdoms they founded—the Vandals in North Africa, the Visigoths in Spain, the Franks in Gaul, the Ostrogoths and Lombards in Italy—were all Mediterranean-oriented, provincial states on the edges of the Byzantine empire. They were subject to the pull of the empire's military, commercial, and cultural power. As late as 630, after the Byzantine armies had recovered Syria, Palestine, and Egypt from the Sassanid Persians, the reconquest of the western provinces remained a serious possibility as well. Ten years later, the chance had ceased to exist, for an unforeseen new force—Islam—had made itself felt in the East.

Under the banner of Islam, the Arabs overran the African and Near Eastern parts of the empire. By 732, a century after Mohammed's death, they had absorbed Spain and threatened to conquer southwestern France as well. In the eleventh century, the Turks occupied much of Asia Minor. Meanwhile the last Byzantine lands in the West (in southern Italy) fell to the Normans, from northwestern France. The Eastern empire, with its domain reduced to the Balkan peninsula, including Greece, held on until 1453, when the Turks conquered Constantinople.

In the East, Islam created a new civilization stretching to the Indus Valley (now Pakistan). That civilization reached its highest point far more rapidly than did that of the medieval West. Baghdad, on the Tigris, was the most important city of Islam in the eighth century. Its splendor rivaled that of Byzantium. Islamic art, learning, and crafts were to have great influence on the European Middle Ages, from arabesque ornament, the manufacture of paper, and Arabic numerals to the transmission of Greek philosophy and science through the writings of Arab scholars. (The English language records this debt in words such as *algebra*.)

It would be difficult to exaggerate the impact of the rapid advance of Islam. The Byzantine empire, deprived of its western Mediterranean bases, focused on keeping Islam at bay in the East. In the

West, it retained only a tenuous foothold on Italian soil. The European shore of the western Mediterranean, from the Pyrenees to Naples, was exposed to Arabic raiders from North Africa and Spain. Western Europe was thus forced to develop its own resources—political, economic, and spiritual.

The process was slow and difficult, however. The early medieval world was in a state of constant turmoil and therefore presents a constantly shifting picture. Not even the Frankish kingdom, which was ruled by the Merovingian dynasty from about 500 to 751, and then by the Carolingians, beginning with King Pepin III, was able to impose lasting order. As the only international organization of any sort, Christianity was of critical importance in promoting a measure of stability. Yet it, too, was divided between the papacy, whose influence was limited, and the monastic orders that spread quickly throughout Europe but remained largely independent of the Church in Rome.

This rapid spread of Christianity, like that of Islam, cannot be explained simply in institutional terms, for the Church did not perfectly embody Christian ideals. Moreover, its success was hardly guaranteed. In fact, its position was often precarious under Constantine's Latin successors. Instead, Christianity must have been extremely persuasive, in spiritual as well as moral terms, to the masses of people who heard its message. There is no other way to explain the rapid conversion of northern Europe. (Heathen gods were as terrifying as those of the ancient Near East, reflecting the violent life of a warrior society.)

Church and State gradually discovered that they could not live without each other. What was needed, however, was an alliance between a strong secular power and a united church. This link was forged when the Catholic church, which had now gained the allegiance of the religious orders, broke its last ties with the East and turned for support to the Germanic North. There the leadership of Pepin III's son Charlemagne and his descendants—the Carolingian dynasty—made the Frankish kingdom into the leading power during the second half of the eighth century. Charlemagne usurped the territory of his brother, Carloman, from his heirs. He then conquered most of Europe from the North Sea to Spain and as far south as Lombardy. When Pope Leo III appealed to him for help in 799, Charlemagne went to Rome, where on Christmas Day 800 the pope bestowed on him the title of emperor—something that Charlemagne neither sought nor wanted.

In placing himself and all of Western Christianity under the protection of the king of the Franks and Lombards, Leo did not merely solemnize the new order of things. He also tried to assert his authority over the newly created Catholic emperor. He claimed that the emperor's legitimacy depended on the pope, based on the forged Donation of Constantine. (Before then it had been the other way around: the emperor in Constantinople had ratified the newly elected pope.) Although Charlemagne did not subordinate himself to the pope, this interdependence of spiritual and political authority, of Church and State, was to distinguish the West from both the Orthodox East and the Islamic South. Its outward symbol was the fact that although the emperor was crowned in Rome, he did not live there. Charlemagne built his capital at the center of his power, in Aachen, located in what is now Germany and close to France, Belgium, and the Netherlands.

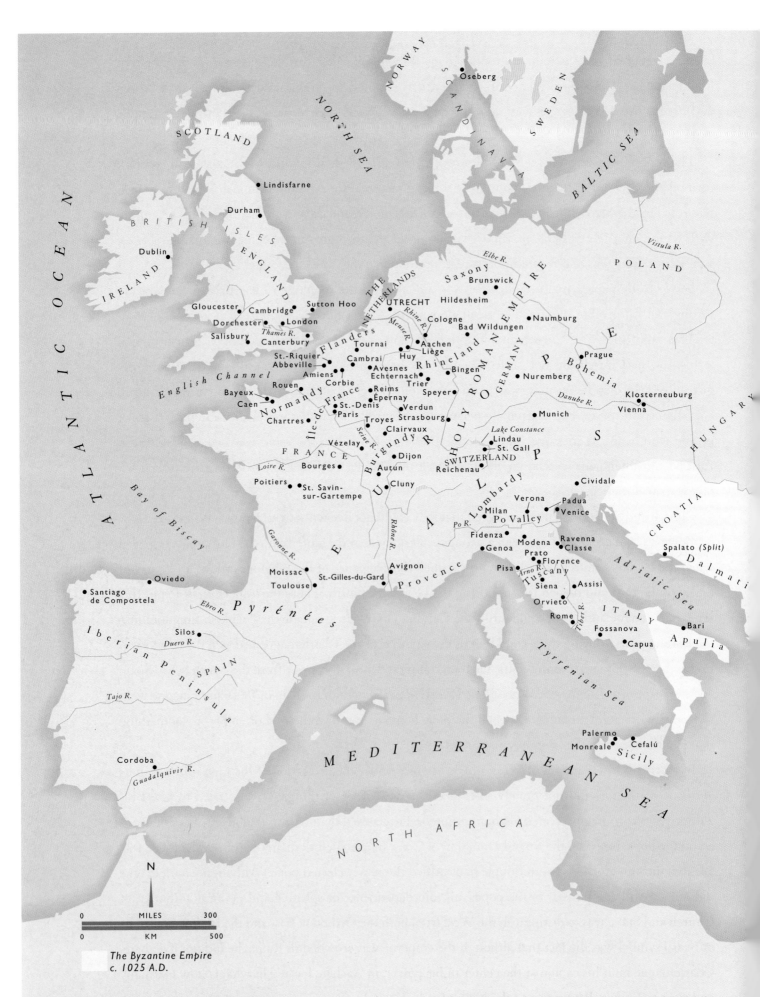

ATLANTIC OCEAN

NORWAY

• Oseberg

SCANDINAVIA

SWEDEN

NORTH SEA

BALTIC SEA

POLAND

Vistula R.

SCOTLAND

• Lindisfarne

• Durham

BRITISH ISLES

IRELAND

• Dublin

ENGLAND

Elbe R.

Saxony • Brunswick

THE NETHERLANDS

• UTRECHT • Hildesheim

Rhine R. • Cologne • Naumburg

Bad Wildungen

HOLY ROMAN EMPIRE

E

Prague

• Gloucester • Cambridge • Sutton Hoo

• Dorchester • London

• Salisbury Thames R. • Canterbury

Flanders • Tournai

St.-Riquier • Cambrai

Abbeville • Avesnes

Amiens • Corbie

Rouen

Bayeux

Caen Normandy

Chartres Île-de-France

Meuse R.

Huy • Aachen • Liège

Echternach Rhineland

Trier

Reims • Speyer

Épernay

St.-Denis Verdun

Paris

Troyes Strasbourg

Clairvaux

• Bingen

GERMANY • Nuremberg

Bohemia

ALPS

Danube R.

• Munich

Klosterneuburg

• Vienna

HUNGARY

English Channel

Seine R.

Vézelay

FRANCE

Burgundy

Dijon

Autun

Lake Constance

Lindau

St. Gall

SWITZERLAND

Reichenau

CROATIA

Bourges

Loire R.

Poitiers • St. Savin-
sur-Gartempe

Cluny

Cividale

Po R. Lombardy Verona Padua

Milan • Venice

Po Valley

Fidenza

Genoa Modena Ravenna

Prato Classe

Pisa Florence

Arno R. Tuscany • Siena • Assisi

Orvieto

Rome Tiber R. ITALY

Fossanova

• Capua

Bari

Apulia

Spalato (Split)

Dalmati

Adriatic Sea

Garonne R.

Moissac

Toulouse

St.-Gilles-du-Gard

Avignon

Provence

• Oviedo

Santiago
de Compostela

Ebro R.

Pyrénées

RHÔNE R.

• Silos

Duero R.

Iberian Peninsula

SPAIN

Tajo R.

• Cordoba

Guadalquivir R.

MEDITERRANEAN SEA

NORTH AFRICA

Tyrrenian Sea

Palermo
Monreale • Cefalú
Sicily

Bay of Biscay

N

MILES 300

KM 500

The Byzantine Empire
c. 1025 A.D.

THE MIDDLE AGES

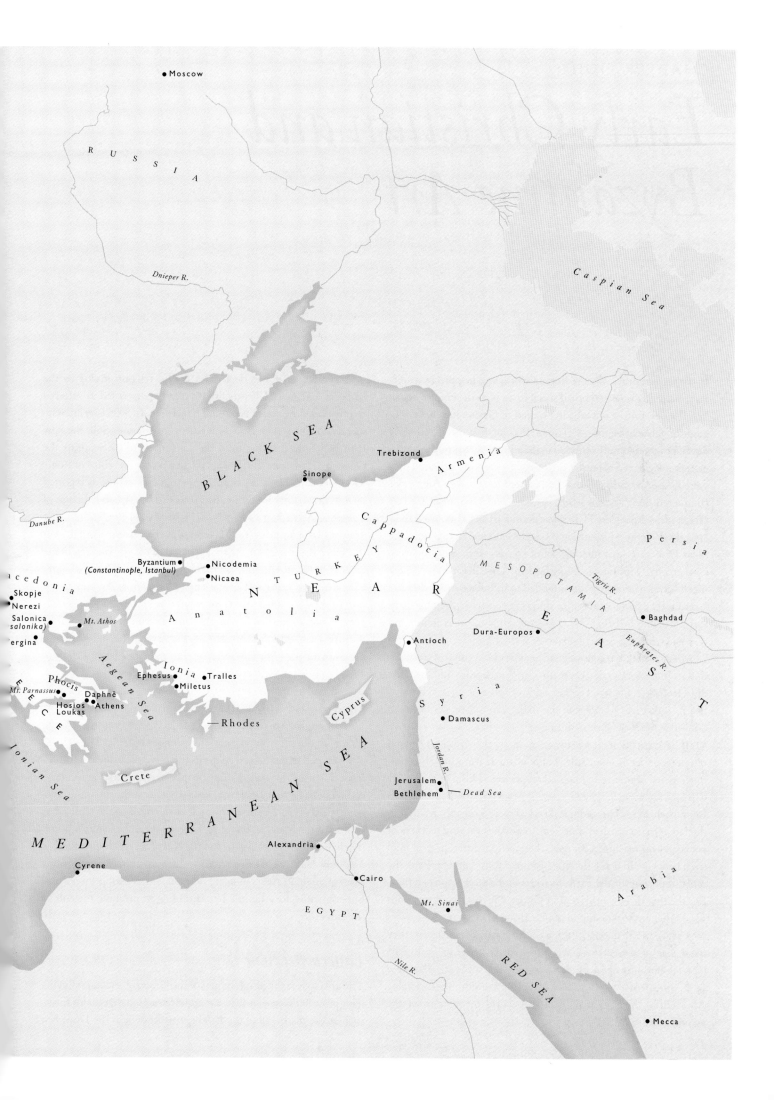

Moscow

RUSSIA

Dnieper R.

Caspian Sea

Danube R.

BLACK SEA

Trebizond

Sinope

Armenia

Cappadocia

Byzantium
(Constantinople, Istanbul)

Nicodemia

Nicaea

Persia

acedonia

NEAR

TURKEY

MESOPOTAMIA

Tigris R.

Skopje

Nerezi

Anatolia

Baghdad

Salonica
salonika)

Mt. Athos

Dura-Europos

E

Euphrates R.

ergina

A

Antioch

S

Ionia

Ephesus Tralles

Aegean Sea

Miletus

Syria

T

Phocis

Cyprus

Mt. Parnassus

Daphnē

Hosios
Loukas

Athens

Rhodes

Damascus

Ionian Sea

Crete

MEDITERRANEAN SEA

Jordan R.

Jerusalem

Bethlehem

Dead Sea

Alexandria

Cyrene

Cairo

Arabia

EGYPT

Mt. Sinai

Nile R.

RED SEA

Mecca

Early Christian and Byzantine Art

In the third century A.D. the Roman world was gripped by a spiritual crisis that reflected broad social turmoil as the empire began to fall apart. One result was the spread of Oriental mystery religions of various origins—Egyptian, Persian, Semitic. Their early development naturally centered in their home territory, the southeastern provinces and border regions of the empire. Although they were based on traditions that had existed long before Alexander conquered these ancient lands, the cults had been influenced by Greek ideas during the Hellenistic period. In fact, they owed their appeal to a blend of Oriental and Greek elements. At that time, the Near East was a vast melting pot of creeds—including Judaism, Christianity, Mithraism, Manichaeism, Gnosticism, and many more. These competing faiths tended to influence each other. As a result, they had a number of things in common. Among them were a claim to being the one true religion, an emphasis on revealed truth, the hope of salvation, a chief prophet or messiah, a belief in a cosmic struggle of good against evil, a ritual of purification or initiation (such as baptism), and, except for Judaism, the duty to seek converts. The last faith of this type to develop was Islam, which was founded in the sixth century, and continues to dominate the Near East to this day.

It is difficult to trace the growth of the Graeco-Oriental religions under Roman rule. Many of them were underground movements that have left behind few traces. This is true of early Christianity as well. The Gospels of Mark, Matthew, Luke, and John (their likely chronological order) were probably written in the later first century and present somewhat varying pictures of Jesus and his teachings. In part, these reflect differences in doctrine between St. Peter, the first bishop of Rome, and St. Paul, the most important of the early converts and a tireless proselytizer. For the first three centuries after Christ, Christian congregations were reluctant to worship in public. Instead, their simple services took place in the houses of the wealthier members. At best, they made use of altars; there were few implements or vestments (special clothing worn by those conducting services). The new faith spread first to the Greek-speaking communities, notably Alexandria, then reached the Latin world by the end of the second century.

Even before it was declared a lawful religion in 261 by the emperor Gallienus, Christianity was rarely persecuted. It suffered chiefly under the tyrant Nero and Diocletian. In 309 Galerius, who succeeded Diocletian, issued an edict of toleration. Still, the new faith had little standing until the conversion of Constantine the Great in 312, despite the fact that by then nearly one-third of Rome was Christian. The story of the emperor's conversion, as reported by him much later in his life, was recorded by Bishop Eusebius of Caesarea. According to Eusebius, on the eve of the fateful battle against Constantine's rival Maxentius at the Milvian Bridge over the Tiber River in Rome, there appeared in the sky the sign of the cross with the inscription, "In this sign, conquer." The next night, Christ himself came to Constantine in a dream and commanded him to copy a symbol which must have been the Chi Rho monogram. Constantine had the insignia inscribed on his helmet and on the military standards of his soldiers. Victory in battle followed, and the emperor responded by accepting the faith, if he had not done so already, although he was baptized only on his deathbed. The next year, he and his fellow emperor, Licinius, issued the Edict of Milan, which proclaimed freedom of religion throughout the empire.

Although Constantine never made Christianity the official state religion, it enjoyed special status under his rule. The emperor promoted it and helped shape its theology, partly in an effort to settle doctrinal disputes. Unlike the pagan emperors, Constantine could not be deified, but he did claim that his authority was granted by God. Thus he placed himself at the head of the Church as well as of the State. In doing so, he adapted an ancient tradition: the divine kingship of Egypt and the Near East. Although there is no doubt that Constantine's faith was sincere, he set a pattern for future Christian rulers in using religion for his own personal and imperial ends, for example by continuing to promote the cult of the emperor.

Eastern Religions

The area where the development of the Graeco-Oriental religions took place has seen so much war and destruction that major finds, such as the discovery of the Essene texts known as the Dead Sea

Scrolls in 1947, are very rare. There is enough evidence, however, to indicate that the new faiths gave birth to a new style in art, and that this style blended Graeco-Roman and Oriental elements.

MITHRAS. *Mithras Slaying the Sacred Bull* (fig. 8-1) shows an early stage in this process. It depicts the central myth of the cult: the god Mithras captures and sacrifices the bull, which was associated with spring. He thus releases its vital life-giving forces to the snake, symbol of earth; the scorpion, the astrological sign of autumn, is shown sapping the bull's strength. Originally a minor figure in the pantheon of the Persian prophet Zoroaster (Zarathustra; c. 628–c. 551 B.C.), Mithras emerged as the chief deity of Persia. Mithraism spread from there and became the leading mystical sect of the Roman Empire during the second century, when our relief was carved. The image contains the main features of the religion: the struggle of good against evil, and the triumph of life over death. These dualistic forces were represented by light and darkness, portrayed by the Roman sun-god Helios to the left and the moon goddess Luna (now missing) at the right.

The composition is indebted to Late Classical reliefs, in which similar Persian figures appear in hunting scenes and battles against the Greeks. Indeed, Helios is surprisingly like the head of the *Apollo Belvedere* (see fig. 5-71). Yet the relief has an exotic character that is unmistakably Oriental. This is evident not only in the subject and costume, but also in the composition itself. The juxtaposition of hero and beast has an ancient history in the Near East. The clear layout, with its symbolic significance, also has roots in the same region (compare figs. 3-9 and 3-20). So, too, does the sympathetic portrayal of the splendid bull in its death throes, which is echoed in the struggling cows on the *Vaphio Cups* (see figs. 4-17 and 4-18).

The refined technique and classical style indicate that the Mithraic relief was carved in Rome itself, where it was found. It is nevertheless exceptional. For the most part, the people who wrestled with the task of creating images to express the new faiths were not very gifted. They were provincial artists of modest ambition who drew upon whatever visual sources were available, adapting and combining them as best they could. Their efforts are often clumsy, yet it is here that we find the beginnings of a tradition that was to become basic to the development of medieval art.

DURA-EUROPOS. The most important examples of this new compound style have been found in the Mesopotamian town of Dura-Europos on the upper Euphrates river. This Roman frontier station was captured by the Persians under Shapur I about 256 A.D. (see page 89) and abandoned soon afterward. Its ruins have yielded the remains of sanctuaries of several religions, including Mithraism, Judaism, and Christianity. They are decorated with murals, all of which show essentially the same Graeco-Oriental

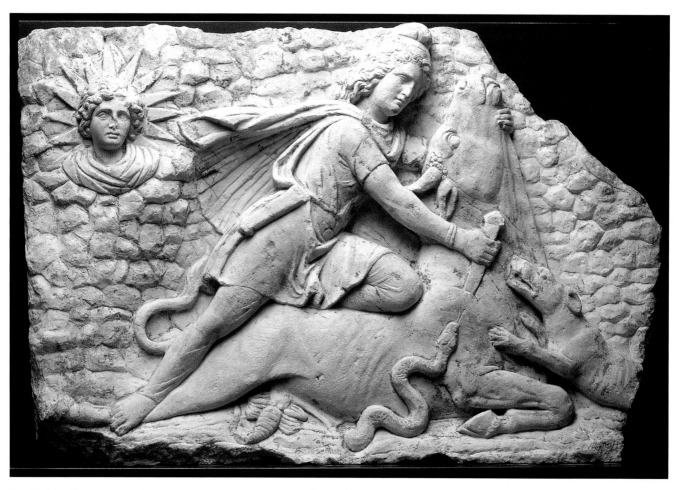

8-1. *Mithras Slaying the Sacred Bull.* c. 150–200 A.D. Limestone, 24⅝ x 37½" (62.5 x 95.2 cm). Cincinnati Art Museum

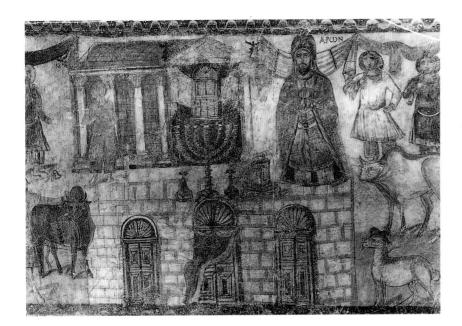

8-2. *The Consecration of the Tabernacle and Its Priests,* from the Assembly Hall of the Synagogue at Dura-Europos. 245–56 A.D. Mural, 4'8¼" x 7'8¼" (1.4 x 2.3 m). National Museum, Damascus, Syria

character. The finest and best preserved are those from the assembly hall of a synagogue, painted about 250 A.D. They have numerous compartments; the one shown here (fig. 8-2) depicts the consecration of the tabernacle.

It is characteristic of the melting-pot conditions at the time that even Judaism was affected by them. The age-old injunction against images was relaxed, so that the walls of the assembly hall could be covered with a detailed visual account of the history of the Chosen People and their Covenant with the Lord. The new attitude seems to have been linked with a tendency to change Judaism from a national to a universal faith by missionary activity among the non-Jewish population, the gentiles. (Interestingly, some of the inscriptions on the murals, such as the name Aaron in figure 8-2, are in Greek.) In any event, we may be sure that the artists who designed these pictures faced an unfamiliar task, just as did the painters who worked for the earliest Christian communities. They had to cast into visible form what had before been expressed only in words. How did they go about it?

Let us take a closer look at our illustration. We can read the details—animals, human beings, buildings, cult objects—without trouble, but their relationship to one another is not clear. There is no action, no story, only an assembly of forms and figures that we are expected to link together. The frieze in the Villa of the Mysteries (see fig. 7-51) presents a similar problem. There, too, the viewer is supposed to know what is represented. Yet it is much less puzzling, for the eloquent gestures and expressions make the figures meaningful even though we may not understand the content of the scenes.

If the synagogue painter is less persuasive, is it simply because of a lack of ability, or are there other reasons as well? The question is rather like the one we faced in the Constantinian relief (see fig. 7-47), which resembles the synagogue mural in a number of ways. The synagogue painting shows the same sense of self-sufficiency by condensing the design for the sake of completeness, but the subject is far more demanding. The mural had to depict an event of great religious importance: the consecration of the tabernacle and its priests, which began the reconciliation of humanity and God, as

described in the Holy Scriptures. At the same time, it had to suggest that this was a timeless, recurring ritual. Thus the content is far greater and more rigidly defined than in the Dionysiac frieze or the Constantinian relief. But there was no tradition of Jewish religious painting that could help the artist visualize the scene.

No wonder our painter has made use of a sort of symbolic shorthand composed of images borrowed from older traditions. The **tabernacle** itself, for instance, is shown as a Classical temple simply because the artist could not imagine it as a tentlike structure of poles and goat's-hair curtains. The attendant and the red heifer in the lower left-hand corner are derived from Roman scenes of animal sacrifice; hence they show remnants of foreshortening that are not found among the other figures. Other echoes of Roman painting appear in the perspective view of the altar table next to the figure of Aaron. They can also be seen in the indifferent modeling and in the shadows attached to some of the figures. These seem to be empty gestures, since the rest of the picture reveals no awareness of either light or space in the Roman sense. Even the overlapping of some of the forms appears to be largely accidental.

The sequence of things in space is conveyed by other means. The seven-branched candlestick, or menorah, the two incense burners, the altar, and Aaron are to be seen as behind, rather than on top of, the wall in vertical perspective. Their size, however, is based on their importance, not on their position in space. Aaron, as the main figure, is not only larger than the attendants but also more abstract. Because of its ritual meaning, his costume is shown in detail, at the cost of the body underneath. The attendants, on the other hand, still show some mobility and three-dimensional form. Their garments, surprisingly enough, are Persian, a sign not only of the odd mixture of civilizations in this border area but of possible artistic influences from Persia.

The synagogue mural, then, combines—not very skillfully— a variety of elements which share only the religious message of the whole. In the hands of a great artist, this message might have been a stronger unifying force. Even then, however, the shapes and colors would have been an imperfect embodiment of the spiritual truth they were meant to serve. That, surely, was the outlook of

the authorities who conceived the program of the mural cycle. These pictures can no longer be understood in the framework of ancient art. They express an attitude that seems far closer to the Middle Ages.

EARLY CHRISTIAN ART

We do not know when and where the first Christian works of art were produced. None of the surviving examples can be dated earlier than about 200 A.D. In fact, we know little about Christian art before the reign of Constantine the Great, because little remains from the third century. Few traces survive of the large Christian communities that existed in the great cities of North Africa and the Near East, such as Alexandria and Antioch. The only Christian house found at Dura-Europos has murals that are far less extensive or developed than the synagogue frescoes. The painted decorations of the Roman **catacombs,** the underground burial places of the Christians, are the only sizable body of material, but they are only one of several kinds of Christian art that may have existed.

The Catacombs

The catacomb paintings tell us a good deal about the spirit of the communities that sponsored them, even though the lack of material from the eastern provinces of the empire makes it difficult to judge their role in the development of Christian art. The burial rite and safeguarding the tomb were of vital concern to the early Christians, whose faith rested on the hope of eternal life in heaven. In the painted ceiling in figure 8-3, the imagery clearly expresses this otherworldly outlook. The forms are still based on pre-Christian murals, and the division of the ceiling into compartments is a highly simplified echo of the architectural schemes in Pompeian painting. The modeling of the figures, as well as the landscape settings, are also descended from Roman designs, although they have become debased by endless repetition. However, the catacomb painter has little interest in the original meaning of the forms, which he has used to convey a new, symbolic content. Even the geometric framework shares in this task, for the great circle suggests the Dome of Heaven, inscribed with the Cross, the main symbol of the faith. In the central medallion, or circle, we see a youthful shepherd with a sheep on his shoulders in a pose that can be traced back as far as Greek Archaic art (compare fig. 5-12). He stands for Christ the Savior, the Good Shepherd who gives his life for his flock.

The semicircular compartments tell the story of Jonah. On the left he is cast from the ship, and on the right he emerges from the whale. At the bottom he is safe again on dry land, where he is meditating on the mercy of the Lord. This Old Testament miracle, often juxtaposed with supernatural events from the New Testament, enjoyed great favor in Early Christian art as proof of the

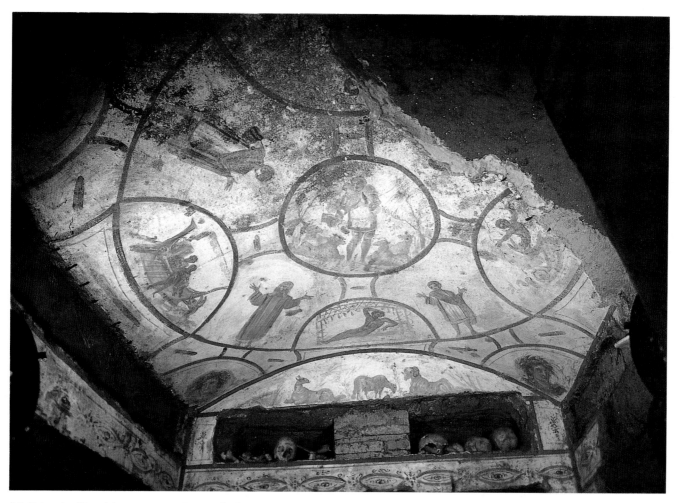

8-3. Painted ceiling. 4th century A.D. Catacomb of SS. Pietro e Marcellino, Rome

Lord's power to rescue the faithful from the jaws of death. The standing figures with their hands raised in prayer (known as orants) may represent members of the Church. The entire scheme, though small in scale and unimpressive in execution, has a consistency and clarity that set it apart from its Graeco-Roman ancestors, as well as from the synagogue murals of Dura-Europos (see fig. 8-2). Here we have at least the promise of a monumental new form (compare fig. 8-49).

Architecture

Constantine's decision to make Christianity a legal religion of the Roman Empire had a profound impact on Christian architecture. Before then, the Church (ecclesia) was simply the congregation. (We will recall that the Greek word ekklesia originally meant the assembly of citizens; see page 135.) Now, almost overnight, an impressive setting had to be created for the faith, so that the Church might be visible to all. To do so, however, involved rethinking the meaning of the Church itself. It now became identified with its expression in architecture, something which we take for granted but for which there had been no need before. To meet the challenge, church leaders adapted existing types to new ends. Constantine devoted the full resources of his office to this task, and within a few years an astonishing number of large, imperially sponsored churches were built, not only in Rome but also in Constantinople, the Holy Land, and other important centers.

THE CHRISTIAN BASILICA. The most important structures were of a new type, now called the Early Christian basilica, which provided the basic model for the development of church architecture in western Europe. Although this type of building has features of an assembly hall, temple, and private house, it cannot be wholly explained in terms of its sources. The Early Christian basilica as we know it owes its essential features—the long nave flanked by aisles and lit by clerestory windows, the apse, and the wooden roof—to the imperial basilicas built during the previous hundred years, such as that at Leptis Magna (see figs. 7-16 and 7-17). The Roman-style basilica was not unique to Christianity, however. It had already been used by pagan cults and Judaism. It was nevertheless a suitable model for Constantinian churches, since it combined the spacious interior needed to accommodate a large congregation with imperial associations that proclaimed the privileged status of Christianity. But a church had to be more than an assembly hall. In addition to serving as a meeting place for the faithful, it was the sacred House of God, literally the Heavenly Jerusalem. It was the Christian successor to the temples of old. But the basilica had to be redesigned. Therefore the plan of the Early Christian basilica was given a new focus, the altar, which was placed in front of the semicircular apse, normally at the eastern end of the nave. The entrances, which in earlier basilicas had usually been on the flanks, were shifted to the western end. The Early Christian basilica was thus arranged along a single, longitudinal axis that is indebted to the layout of Greek temples, except that the latter faced eastward to greet the rising sun (compare fig. 5-32).

Unfortunately, none of the early Christian basilicas has survived in its original form. However, the plan of the greatest Constantinian church, Old St. Peter's in Rome, is known with a good deal of accuracy (figs. 8-4 and 8-5). (It was torn down and replaced by the present church in the sixteenth and seventeenth centuries; see figs. 13-10 and 17-15.) Moreover, its appearance is preserved in an album from 1619 of detailed drawings with annotations by Jacopo Grimaldi that copy earlier ones, some of which also survive (fig. 8-6). The church, begun as early as 319 and finished by 329, was built on the Vatican hill next to a pagan burial ground. It stood directly over the grave of St. Peter, which was marked by a shrine covered with a **baldacchino** placed on a platform and attached to the apse itself. [See Primary Sources, no. 15, page 384.] As such, St. Peter's served mainly as a martyrium of the apostle. (Martyr originally meant "witness" in Greek and only later came to denote those who died for their faith.) It was also a cemetery for the faithful who were buried along the nave. Funeral banquets, which the Romans had inherited from the Etruscans (see figs. 6-2 and 6-3), became Christianized and were held until the

THE LITURGY OF MASS

The central rite of many Christian churches is the Eucharist or communion service, a ritual meal that reenacts Jesus' Last Supper. In the Catholic Church and in a few Protestant churches, this service is known as the Mass (from the Latin words Ite, missa est, "Go, [the congregation] is dismissed" at the end of the Latin service). The Mass was first codified by Pope Gregory the Great about 600. Each Mass consists of the "ordinary"—those prayers and hymns that are the same in all Masses—and the "proper," the parts that vary, depending on the occasion. In addition to a number of specific prayers, the "ordinary" consists of five hymns: the Kyrie Eleison (Greek for "Lord have mercy on us"); the Gloria in Excelsis (Latin for "Glory in the highest"); Credo (Latin for "I believe," a statement of faith also called the Creed); Sanctus (Latin for "Holy");

and Agnus Dei (Latin for "Lamb of God"). The "proper" of the Mass consists of prayers, two readings from the New Testament (one from the Epistles and one from the Gospels); a homily, or sermon, on these texts; and hymns, all chosen specifically for the day.

Musical settings for the five "ordinary" hymns (also called a Mass) have been a major compositional form from 1400 into the twentieth century. However, these masses follow no set tradition and have considerable variety. Many of the greatest composers have written masses, including Josquin Des Prés, Bach, Haydn, Mozart, Beethoven, Verdi, Stravinsky, Britten, and Bernstein. These works often depart rather freely from liturgical requirements of the Mass, as they were written for special occasions, such as the Requiem Mass for the dead, the Nuptial Mass for weddings, and the Coronation Mass.

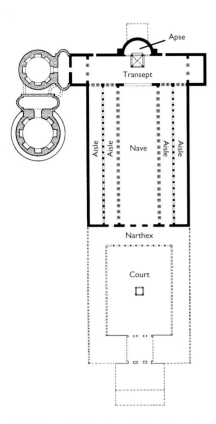

8-4. Plan of Old St. Peter's (after Frazer)

(ABOVE RIGHT) 8-5. Jacopo Grimaldi.
Facade of St. Peter's, Rome. 1619.
Drawing, Ms.: Barbarini Lat. 2733 fol. 133v.
Vatican Library, Rome

(BELOW RIGHT) 8-6. Jacopo Grimaldi.
Interior of Old St. Peter's, Rome. 1619.
Drawing, Ms.: Barbarini Lat. 2733 fols.
104v–105r. Vatican Library, Rome

end of the fourth century. Other rituals were conducted from a portable altar placed before the shrine, using gold and silver implements donated by the emperor himself.

The basic plan follows the precedent set by the basilica of S. Giovanni in Laterano, Constantine's first major church, begun about 313 as the cathedral of the bishop of Rome. However, the apse in Old St. Peter's was at the west, not the east, end of the church. Before entering the church itself, we cross a colonnaded court, the atrium (a feature derived from the domus; see fig. 7-21), which was added toward the end of the fourth century. Only when we step from the entrance hall, the narthex, through the nave portal do we gain the view presented in figure 8-6. The steady rhythm of the nave arcade pulls us toward the **triumphal arch** at the western end, which frames the shrine of St. Peter and the apse beyond. As we come closer, we see that the shrine stands in the transept, a separate space that was placed at right angles to the nave and aisles to form a cross. This feature is often left out in

early basilican churches and only later became standard. Here it was sunken, perhaps to isolate the shrine from the rest of the church. Pairs of columns were used to create additional compartments of unknown purpose at each end.

CENTRAL PLAN CHURCHES. Another type of structure entered the tradition of Christian architecture in Constantinian times: round or polygonal buildings crowned with a dome. Known as **central-plan churches**, they developed out of Roman baths. (The design of the Pantheon, we will recall, was derived from the same source; see pages 182–184.) Similar structures had been built by Roman emperors such as Augustus and Hadrian to serve as monumental tombs, or mausoleums. In the fourth century, this type of building was given a Christian meaning in the baptisteries (where the bath became the sacred rite of baptism) and in the funerary chapels (where the hope for eternal life was expressed) that were connected with basilican churches. (St. Peter's was next to a

second-century circular tomb, and an imperial mausoleum was attached to the south transept of the church around 400 A.D.) Because of these symbolic associations, central-plan churches were widely adopted. Most were derived from a handful of sacred sites, such as the Church of the Holy Sepulcher in Jerusalem, built by Constantine. But these served only as a point of departure, so that many liberties were taken with their design. The sense of geometry was surprisingly loose. The shape could be round or polygonal. Only one or two major features and measurements were needed to link a building with its model. Symbolism also played an important role in the number of elements and their arrangement. For example, octagons, which had been used in imperial mausoleums of the early fourth century, among them Diocletian's and Galerius', were favored because the number eight was a symbol of

resurrection: it signified the eighth day, the day of the new creation when the blessed shall attain the Heavenly Jerusalem. This free approach was typical of Early Christian architecture as a whole. Thus we find wide variation from building to building—not only among domed structures but among basilican churches as well.

The finest surviving example of a central-plan church is Sta. Costanza (figs. 8-7, 8-8, and 8-9), the mausoleum of Constantine's daughter Constantia. It was originally attached to the now-ruined Roman church of St. Agnes Outside the Walls. In contrast to earlier examples, it shows a clear articulation of the interior space. A domed cylindrical core lit by clerestory windows—the counterpart of the nave of a basilican church—is surrounded by a ring-shaped aisle, or ambulatory, covered by a barrel vault. The mosaic decoration plays an important role. The motifs in the ambu-

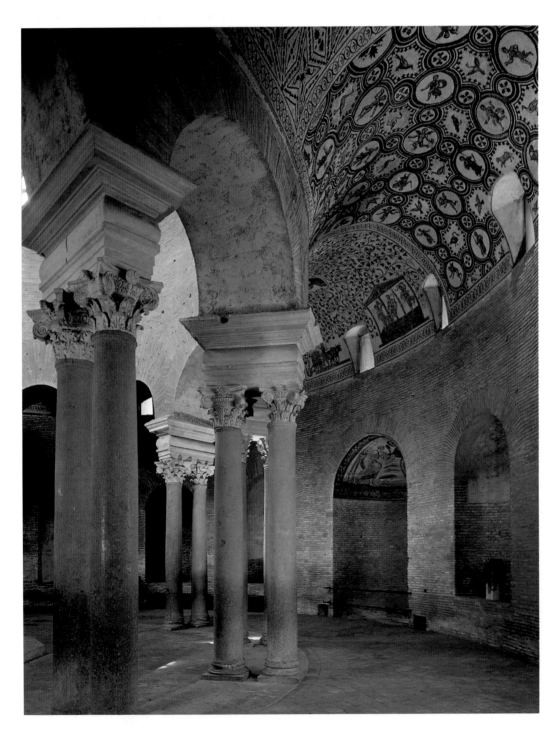

8-7. Interior,
Sta. Costanza, Rome.
c. 350 A.D.

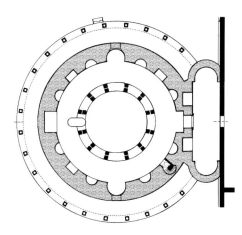

8-8. Plan of Sta. Costanza

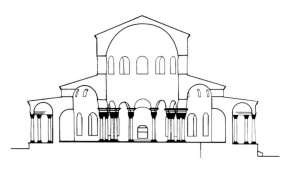

8-9. Section of Sta. Costanza

latory are secular, but those in the two chapels are Christian. This striking contrast attests to how long the two forms coexisted. The distinction is blurred in the grape harvest above the entrance to the chapel in our illustration. It refers not only to the wine of the Eucharist (Jesus said, "I am the true vine"), but also to the tree of life; thus it signifies the victory of eternal life over death for the Christian faithful.

SAN LORENZO MAGGIORE. One building stands out for its daring originality: S. Lorenzo Maggiore in Milan (figs. 8-10, 8-11, and 8-12). Several dates have been proposed for the church (which received its name long after it was completed), from the mid-fourth century into the fifth. Given its location just outside the city walls, however, it was most likely built as a palace church in 388–391, when the Eastern emperor Theodosius the Great resided in Milan after defeating the Western usurper Maximus—the last time the Roman empire was united under one ruler. Although they later squabbled over issues of power and responsibility, Theodosius had already found Bishop Ambrose a willing ally during the ecumenical council of 381. (At that council the Nicene Creed was established as official Catholic dogma against the Arian "heresy," which taught that Jesus was not equal to God or made of the same substance, but a supernatural creature who was neither human nor divine.) At the time, Milan occupied a very important position. After Constantine moved his capital to Byzantium in

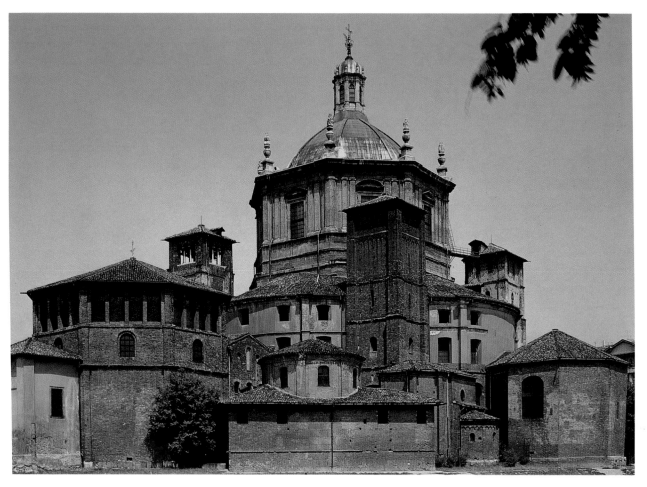

8-10. S. Lorenzo Maggiore, Milan, exterior from the southeast. c. 388–91 A.D.

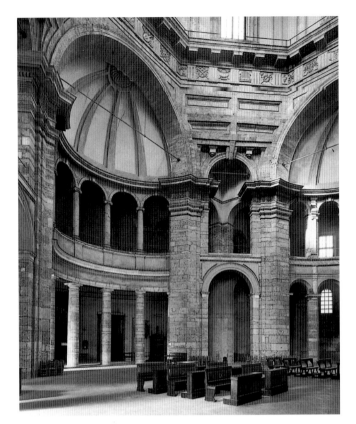

8-11. Interior, S. Lorenzo Maggiore

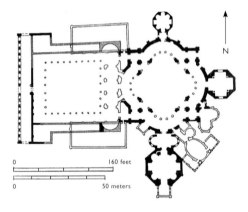

8-12. Plan of S. Lorenzo Maggiore (after Krautheimer)

323, Milan served as the capital of the western empire for a while. It was also the religious center of northern Italy, rivaling Rome.

S. Lorenzo is unlike any other church built in Milan or the entire Latin realm at the time, even though all of its elements can be traced to late Roman architecture. (The conch-shaped imperial niches are similar to the apse of the basilica at Leptis Magna; see figs. 7-16 and 7-17.) The plan is a quatrefoil in a double shell, with four corner towers. The two octagonal structures on the east and south ends seem to have been intended as a royal mausoleum and a martyrium. Like most Early Christian buildings, it was heavily altered in later times, and the facade now looks very different, although the walls are original. The towers were reworked during the Middle Ages, while the dome was rebuilt as an octagon in the sixteenth century, when much of the marble-and-stucco facing of the interior was replaced. The large court, too, is missing.

Nevertheless, the complex molding of space and the refined proportions of the noble interior suggest that S. Lorenzo was designed by an architect called from the east, probably by Theodosius himself. The building is thus of great importance in perhaps giving us a glimpse of the great churches built by Constantine and his successors in Byzantium, none of which stand today.

Mosaics

The sixth-century Church of S. Apollinare in Classe, near Ravenna (figs. 8-13, 8-14, and 8-15), is the best-preserved of the Early Christian basilicas. (St. Apollinarus was the first bishop of Ravenna; Classe is the seaport of Ravenna.) Our view, taken from the west, shows the narthex but not the atrium, which was torn down long ago. The church is similar in plan to Old St. Peter's, except that it has single aisles and the transept was omitted, as it was in many early churches. (The round bell tower, or campanile, is a medieval addition.)

S. Apollinare in Classe shows another essential aspect of Early Christian religious architecture: the contrast between exterior and interior. The plain brick facade is merely a shell whose shape reflects the space it encloses—the opposite of the Classical temple. This antimonumental treatment of the exterior gives way to the utmost richness as we enter the nave. Having left the everyday world behind, we find ourselves in a shimmering realm of light and color where precious marble surfaces and glittering mosaics evoke the spiritual splendor of the Kingdom of God. The steady rhythm of the nave arcade pulls us toward the great "triumphal" arch at the eastern end, which frames the altar and the vaulted apse beyond.

The rapid growth of Christian architecture on a large scale had a revolutionary effect on Early Christian art. All of a sudden, huge wall surfaces had to be covered with images worthy of their monumental framework. Who was equal to this challenge? Certainly not the humble artists who had decorated the catacombs. They were replaced by masters of greater ability—probably recruited by officials of the empire, as were the architects of the new basilicas. Unfortunately, so little of the decoration of fourth-century churches has survived that its history cannot be traced in detail.

WALL MOSAICS. Out of this process emerged a great new art form, the Early Christian wall mosaic, which to a large extent replaced the older and cheaper medium of mural painting. Mosaics—designs composed of small pieces of colored material set in plaster—had been used by the Sumerians as early as the third millennium B.C. to decorate architectural surfaces. The Hellenistic Greeks and the Romans, using small cubes of marble called **tesserae**, had refined the technique to the point that it could be used to copy paintings, as seen in *The Battle of Issos* (see fig. 5-62). But these were mostly floor mosaics, and the color scale, although rich in gradations, lacked brilliance, since it was limited to the kinds of colored marble found in nature. The Romans also produced wall mosaics occasionally, but only for special purposes and on a limited scale.

The extensive and complex wall mosaics of Early Christian art are thus essentially without precedent. The same is true of their material. They consist of tesserae made of colored glass, which the

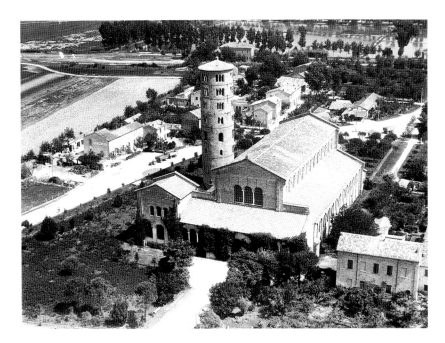

8-13. S. Apollinare in Classe, Ravenna, Italy. 533–49 A.D.

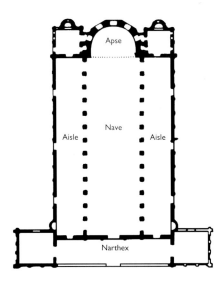

8-14. Plan of S. Apollinare in Classe
(after De Angelis d'Ossat)

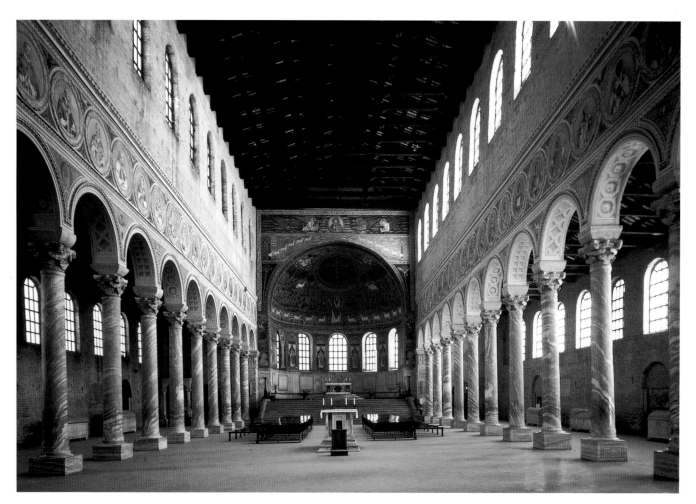

8-15. Interior (view toward the apse), S. Apollinare in Classe, Ravenna. 533–49 A.D.

Romans had known but never fully exploited. Glass tesserae offered colors, including gold, of far greater range and intensity than marble tesserae, though they lacked the fine gradations in tone needed to imitate painted pictures. Moreover, the shiny, slightly irregular faces of glass tesserae act as tiny reflectors, so that the overall effect is like a glittering, immaterial screen rather than a solid, continuous surface. All these qualities made glass mosaic the ideal material for the new architectural aesthetic of Early Christian basilicas.

The guiding principle of Graeco-Roman architecture had been to express a balance of opposing forces, rather like the balance within the contrapposto of a Classical statue. The result was a muscular display of active and passive members. In comparison, Early Christian architecture seems strangely inexpressive, and unimpressive. The material structure is subservient to the creation of immaterial space. Walls and vaults seem like weightless shells, their actual thickness and solidity hidden rather than emphasized. The brilliant color, the brightness of gold, the severe geometric order of the mosaic cycle at S. Apollinare in Classe (fig. 8-15)—all fit the spirit of these interiors to perfection. One might say, in fact, that Early Christian and Byzantine churches demand mosaics the way Greek temples *demand* architectural sculpture.

EARLY SOURCES. The challenge of inventing a body of Christian imagery produced an extraordinary creative outpouring, and by 500 A.D. the process was largely complete. It took less than two centuries to lay the foundation for a new artistic tradition—a remarkably short time indeed! The progress of Christian imagery was interwoven with the development of architecture. The earliest church decorations probably consisted of ornamental designs in marble, plaster, stucco, or even gold. Soon, however, great pictorial cycles of subjects selected from the Old and New Testaments were spread over the nave walls, the triumphal arch, and the apse, first in painting, then in mosaic. Much of the initial development seems to have occurred during the fifth century. These cycles must have drawn on sources that reflected the whole range of Graeco-Roman painting as well as the artistic traditions that surely had developed in the Christian communities of North Africa and the Near East. Paintings in the orientalizing style of the synagogue murals at Dura-Europos (see fig. 8-2) may have decorated the walls of Christian places of worship in Syria and Palestine. Moreover, during the first or second century A.D., Alexandria, the home of a large, Hellenized Jewish colony, may have produced illustrations of the Old Testament similar in style to the Pompeian murals. We meet echoes of such scenes in Christian art later on, but we cannot be sure when or where they originated, or how they entered the Christian tradition. The importance of Judaic sources for Early Christian art is hardly surprising: the earliest Christian congregations were formed by dissident members of the Jewish community. The new faith also incorporated many aspects of the Jewish service into its own liturgy. These included hymns, which later formed the basis of medieval chants.

The heritage of the past was not only absorbed but also transformed physically as well as spiritually. A characteristic example is the *Good Shepherd* mosaic (fig. 8-16) in the so-called mausoleum of Galla Placidia. (Galla Placidia was the sister of the emperor Honorius, who sponsored the first major building program in Ravenna. However, the building was probably originally intended as a chapel dedicated to the Spanish martyr Saint Vincent.) The figure of the shepherd seated in a landscape expands the central subject of our catacomb painting (see fig. 8-3) by being treated both more elaborately and more formally. In accordance with the preference of the time, Christ is portrayed as a young man in the familiar pose of a philosopher. (We shall meet him again as a youthful philosopher in the *Sarcophagus of Junius Bassus;* see fig. 8-21.) The rest of his attributes, however, have been adapted from

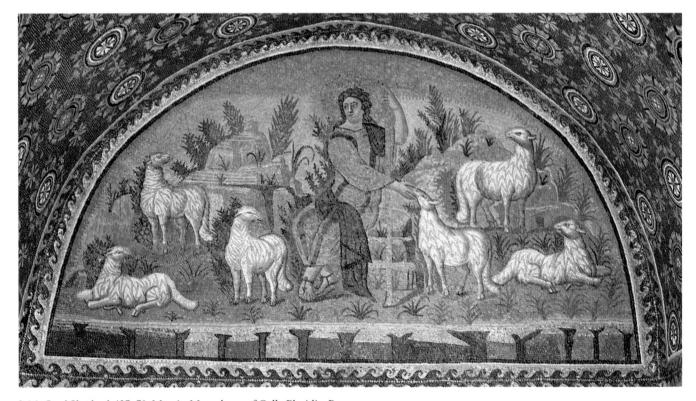

8-16. *Good Shepherd*. 425–50. Mosaic. Mausoleum of Galla Placidia, Ravenna

Imperial art, which provided a ready supply of motifs that was mined heavily in the early fifth century, when Christian imagery underwent intensive development. The halo, for example, was taken from representations of the emperor as sun-king, and even the cross had been an Imperial device.

CONTRASTS WITH GRAECO-ROMAN PAINTING. Roman mural painting used illusionistic devices to suggest a reality beyond the surface of the wall. Early Christian mosaics also denied the flatness of the wall surface, but their goal was to achieve an "illusion of unreality," a luminous realm filled with celestial beings or symbols. In Early Christian narrative scenes we see the illusionistic tradition of ancient painting being transformed by new content.

The Parting of Lot and Abraham (fig. 8-17) is a scene from the oldest and most important surviving mosaic cycle of this kind. It was done about 432–40 in the church of Sta. Maria Maggiore in Rome. In the left half of the scene, Abraham, his son Isaac, and the rest of his family depart for the land of Canaan. On the right, Lot and his clan, including his two small daughters, turn toward the city of Sodom. The artist who designed this scene faced the same task as the sculptors of the Column of Trajan (see fig. 7-37). They needed to condense complex actions into a form that could be read at a distance. In fact, many of the same shorthand devices are employed, such as the formulas for house, tree, and city, or the trick of showing a crowd of people as a grape-cluster of heads.

In the Trajanic reliefs, these devices could be used only to the extent that they allowed the artist to re-create actual historical events. The mosaics in Sta. Maria Maggiore, by contrast, depict the history of salvation. They begin with Old Testament scenes along the nave (in this instance from Genesis 13) and end with the life of Jesus as the Messiah on the arch across the nave. The scheme is not only a historical cycle but a symbolic program that presents a higher reality—the Word of God. Hence the artist need not be concerned with the details of historical narrative. Glances and gestures are more important than movement or three-dimensional form. The symmetrical composition, with its gap in the center, makes clear the significance of this parting. The way of righteousness is represented by Abraham, while the way of evil is signified by the city of Sodom, which was destroyed by the Lord.

S. APOLLINARE NUOVO, RAVENNA. The earliest cycle of mosaics to survive intact (preceded by others in Rome) are those in S. Apollinare Nuovo in Ravenna. Originally a naval station on the Adriatic, Ravenna had become the capital first of the West Roman emperors in 402, when the emperor Honorius was forced to withdraw from Milan, and then of Theodoric, king of the Ostrogoths at the end of the century. Although Theodoric's Arian beliefs were later considered heretical, his tastes were formed in Constantinople, where he had spent a decade as a young man. Under Justinian, Ravenna became the main stronghold of Byzantine rule in Italy.

S. Apollinare Nuovo was built around 500 by Theodoric as his palace church. It received its present name only in the mid-ninth century, when the saint's relics were moved from S. Apollinare in Classe (see page 236). About 560 it was confiscated by Bishop

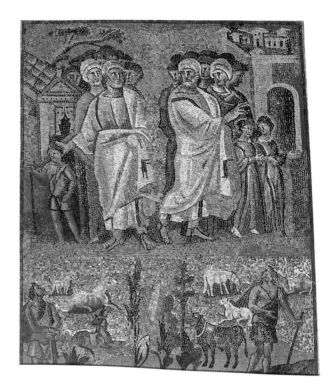

8-17. *The Parting of Lot and Abraham.* c. 432–40 A.D. Mosaic. Sta. Maria Maggiore, Rome

Agnellus, with Justinian's blessing, and rededicated to St. Martin, a champion of orthodoxy. St. Martin replaced Theodoric at the head of the row of male martyrs leading from the palace at the west of the nave toward the enthroned Christ near the apse. A similar row of female martyrs ending in the Virgin Enthroned may also have been reworked at that time. The prophets, patriarchs, and apostles between the windows were left untouched, however.

It is the scenes depicting the ministry of Christ and the Passion that interest us. Although they have been placed on a narrow band above the clerestory, they are of great historical importance. The selection of subjects is somewhat unusual, perhaps reflecting Theodoric's Arian persuasion, but they generally center on events in which Jesus revealed his divinity through miracles and other acts—a reminder of the dual meaning of *martyr* (see page 232). In *The Betrayal of Christ* (fig. 8-18, page 240) he is "revealed" by the kiss of Judas. We immediately recognize the kinship with *The Parting of Lot and Abraham* at Sta. Maria Maggiore (fig. 8-17); the figures betray their Graeco-Roman ancestry as well (compare figs. 7-32 and 7-33). Yet we are struck not by any debt to the past but by the newness of the scene, which has no precedent in Greek or Roman art. Its originality lies not so much in the details as in the approach. The drama has a clarity that is surprisingly intense. Jesus and Judas are isolated between two equal groups of soldiers and disciples, so that we are forced to focus on the central event and, above all, its meaning. So persuasive is the result that the scene became classic in its own right: it is the ancestor of countless others not only in Byzantium but also in the West, from Giotto through El Greco and Van Dyck.

The word "bible" is derived from the Greek word for books, since it was originally a compilation of a number of sacred texts. Over time, the books of the Bible came to be regarded as a unit, and thus the Bible is now generally considered a single book.

There is considerable disagreement between Christians and Jews, and among various Christian and Jewish sects, over which books should be considered canonical—that is, accepted as legitimate parts of the biblical canon, the standard list of authentic texts. However, every version of the Bible includes the Hebrew Torah, or the Law (also called the Pentateuch, or Books of Moses), as the first five books. Also universally accepted by both Jews and Christians are the books known as the Prophets (which include texts of Jewish history as well as prophecy). There are also a number of other books known simply as the Writings, which include history, poetry (the Psalms and the Song of Songs), prophecy, and even folktales, some universally accepted, some accepted by one group, and some accepted virtually by no one. Books of doubtful authenticity are known as apocryphal books or, simply, Apocrypha, from a Greek word meaning obscure. The Jewish Bible or Hebrew Canon—the books that are accepted as authentic Jewish scripture—was agreed upon by Jewish scholars sometime before the beginning of the Christian era.

The Christian Bible is divided into two major sections, the Old Testament and the New Testament. The Old Testament contains many, but not all, of the Jewish scriptures, while the New Testament, originally written in Greek, is specifically Christian. It contains four gospels—each written in the first century A.D. by one of the Early Christian missionaries known as the four evangelists, Mark, Matthew, Luke, and John. The Gospels tell, from slightly different points of view, the story of the life and teachings of Jesus of Nazareth. They are followed by the Epistles, letters written by Paul and a few other Christian missionaries to various congregations of the church. The final book is the Apocalypse, by John the Divine, also called the Book of Revelation, which foretells the end of the world.

Jerome (342–420), the foremost scholar of the early Church, selected the books considered canonical for the Christian Bible from a large body of Early Christian writings. It was due to his energetic advocacy that the Church accepted the Hebrew scriptures as representing the Word of God as much as the Christian texts, and therefore worthy to be included in the Bible. Jerome then translated the books he had chosen from Hebrew and Greek into Latin, the spoken language of Italy in his time. This Latin translation of the Bible was—and is—known as the Vulgate because it was written in the vernacular (Latin *vulgaris*) language. The Vulgate remained the Church's primary text for the Bible for more than a thousand years. It was regarded with such reverence that in the fourteenth century, when early humanists first translated it into the vernacular languages of their time, they were sometimes suspected of heresy for doing so. The writings rejected for inclusion in the New Testament by Jerome are known as Christian Apocrypha. Although not canonical, some of these books, such as the Life of Mary and the Gospel of James, were nevertheless used by artists and playwrights during the Middle Ages as sources for stories to illustrate and dramatize.

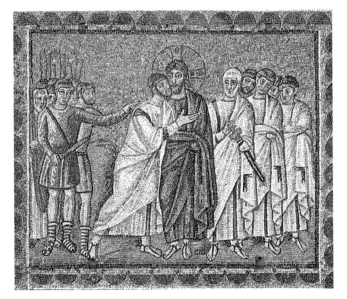

8-18. *The Betrayal of Christ.* c. 500 A.D. Mosaic.
S. Apollinare Nuovo, Ravenna

Roll, Book, and Illustration

What were the sources of the mosaic compositions at Sta. Maria Maggiore and S. Apollinare Nuovo? They were certainly not the first to depict scenes from the Bible (see box below). For certain subjects, models could have been found among the catacomb murals but others may have come from illustrated manuscripts. Because they were portable, manuscripts have been assigned an important role by art historians in spreading religious imagery. In some cases there is no doubt that manuscript illustrations served as models for wall paintings. In others, however, it is clear that murals must have been derived ultimately from frescoes, especially when the similarities between two pictures point to a common source.

Because it was founded on the Word of God as revealed in the Bible, the early Christian Church must have sponsored duplication of the sacred text on a large scale. Every copy was handled with a reverence quite unlike the treatment of any Greek or Roman book. But when did these copies become works of art as well? And what did the earliest Bible illustrations look like?

Because books are frail things, we have only indirect evidence of their history in the ancient world. It begins in Egypt with scrolls made from the papyrus plant, which is is like paper but more brittle (see pages 66–67; fig. 2-31). Papyrus scrolls were produced

throughout antiquity. Not until the second century B.C., in late Hellenistic times, did a better material become available. This was parchment, or vellum (thin, bleached animal hide), which lasts far longer than papyrus. It was strong enough to be creased without breaking and thus made possible the kind of bound book we know today, technically called a **codex**, which appeared sometime in the late first century A.D.

Between the second and the fourth centuries A.D., the vellum codex gradually replaced the roll. This change had an important effect on book illustration. Scroll illustrations seem to have been mostly line drawings, since layers of pigment would soon have cracked and come off during rolling and unrolling. Only the **vellum** codex permitted the use of rich colors, including gold. Hence it could make book illustration—or, as we usually say, manuscript illumination—the small-scale counterpart of murals, mosaics, and panel pictures. Some questions are still unanswered. When, where, and how quickly did book illumination develop? Were most of the subjects biblical, mythological, or historical? How much of a carryover was there from roll to codex?

THE VATICAN VERGIL. The earliest illuminations, whether Christian, Jewish, or classical, were undoubtedly influenced strongly by the illusionism of Hellenistic-Roman painting of the sort we met at Pompeii. One of the oldest illustrated manuscript books known, the *Vatican Vergil,* reflects that tradition, although the miniatures are far from inspired (fig. 8-19). The book was probably made in Italy about the time of the Sta. Maria Maggiore mosaics, to which it is closely linked in style. The picture, separated from the rest of the page by a heavy frame, is like a window, and in the landscape we find the remains of deep space, perspective, and the play of light and shade. In striking contrast to earlier images, which are largely or completely independent of text, such manuscript illuminations are clearly subordinate to the written word. This approach was well suited to Christianity, which was based on the authority of sacred texts. Pictures took on a new role: to serve as illustrations or commentaries. This is the reason that manuscripts are unlikely sources for early Christian paintings and mosaics.

THE VIENNA GENESIS. The oldest illustrated Bible manuscripts discovered thus far appear to date from the early sixth century, except for one fragment of five leaves related to the *Vatican Vergil* that is probably a hundred or so years earlier. They, too, contain echoes of the Hellenistic-Roman style, which has been adapted to religious narrative but often has a Near Eastern flavor that at times recalls the Dura-Europos murals (see fig. 8-2). The most important example, the *Vienna Genesis,* nearly abandons the classical style of the *Vatican Vergil.* This Greek translation of the first book of the Bible has a richness similar to the mosaics we have seen. It is written in silver (now turned black) on purple vellum and decorated with brilliantly colored miniatures. (Since Roman times, purple was the royal color reserved for the imperial court.) Our page (fig. 8-20) shows a number of scenes from the story of Jacob. (In the center foreground, for example, we see him wrestling with the angel, then receiving the angel's blessing.) Hence the picture does not show a single event but a whole sequence. The scenes take place along a single U-shaped path, so that progression in space

8-19. Miniature, from the *Vatican Vergil.* Early 5th century A.D. Biblioteca Apostolica Vaticana, Rome

becomes progression in time. This method, known as continuous narration, goes back as far as ancient Egypt and Mesopotamia. Its appearance in miniatures such as this may reflect earlier illustrations made for books in roll rather than book form. The picture certainly looks like a frieze turned back upon itself.

For manuscript illustration, continuous narrative makes the most economical use of space. The painter can pack a maximum of scenes into a small area. The artist thought of the picture as a running account to be read like lines of text, rather than as a window that required a frame. The painted forms are placed directly on the purple background that holds the text, making the entire page a unified field.

Sculpture

Compared with painting and architecture, sculpture played a secondary role in Early Christian art. The biblical prohibition of graven (carved) images in the Second Commandment was thought to apply particularly to large cult statues, the idols that were worshiped in pagan temples. [See Primary Sources, no. 13, page 384.] To escape any hint of idolatry, religious sculpture had to avoid lifesize representations of the human figure. It therefore developed away from the monumental size and fullness of Graeco-Roman sculpture toward small-scale forms and lacelike surface decoration.

The earliest works of Christian sculpture are marble sarcophagi. They evolved from the pagan examples that replaced cinerary urns in Roman society around the time of Hadrian (see pages 196–197). From the middle of the third century on, these stone coffins were also made for the more important members of the Christian Church. Before the time of Constantine, they were decorated mainly with themes that are familiar from catacomb murals—the Good Shepherd, Jonah and the Whale, and the

BIBLICAL, CHURCH, AND CELESTIAL BEINGS

Much of Western art deals with biblical persons and celestial beings. Their names appear in titles of paintings and sculpture and in discussions of subject matter. Following is a brief guide to some of the most commonly encountered persons and beings in Christian art.

PATRIARCHS. Literally, heads of families, or rulers of tribes. The Old Testament patriarchs are Abraham, Isaac, Jacob, and Jacob's 12 sons. *Patriarch* may also refer to the bishops of the five chief bishoprics of Christendom: Alexandria, Antioch, Constantinople, Jerusalem, and Rome.

PROPHETS. In Christian art, *prophets* usually means the Old Testament figures whose writings were seen to foretell the coming of Christ. The so-called major prophets are Isaiah, Jeremiah, and Ezekiel. The minor prophets are Hosea, Joel, Amos, Obadiah, Jonah, Micah, Nahum, Habakkuk, Zephaniah, Haggai, Zechariah, and Malachi.

TRINITY. Central to Christian belief is the doctrine that One God exists in Three Persons: Father, Son (Jesus Christ), and Holy Spirit. The Holy Spirit is often represented as a dove.

HOLY FAMILY. The infant Jesus, his mother Mary, and his foster father Joseph constitute the Holy Family. Sometimes Mary's mother, St. Anne, appears with them.

JOHN THE BAPTIST. The precursor of Jesus Christ, John is regarded by Christians as the last prophet before the coming of the Messiah, Jesus. John was an ascetic who baptized his disciples in the name of the coming Messiah; he recognized Jesus as that Messiah when he saw the Holy Spirit descend on Jesus when he came to John to be baptized.

EVANGELISTS. There are four: Matthew, John, Mark, and Luke—each an author of one of the Gospels. The first two were among Jesus' 12 apostles. The latter two wrote in the second half of the first century.

APOSTLES. The apostles are the 12 disciples Jesus asked to convert nations to his faith. They are Peter (Simon Peter), Andrew, James the Greater, John, Philip, Bartholomew, Matthew, Thomas, James the Less, Jude (or Thaddaeus), Simon the Canaanite, and Judas Iscariot. After Judas betrayed Jesus, his place was taken by Matthias. St. Paul (though not a disciple) is also considered an apostle.

DISCIPLES. See Apostles.

ANGELS AND ARCHANGELS. Beings of a spiritual nature, angels are spoken of in the Old and New Testaments as having been created by God to be heavenly messengers between God and human beings, Heaven and earth. Spoken of first by the apostle Paul, archangels, unlike angels, have names: Michael, Gabriel, and Raphael.

CHERUBIM AND SERAPHIM. The celestial hierarchy devised by Pseudo-Dionysius about 500 A.D. had cherubim (with four wings) and seraphim (six wings) at the peak, encircling the throne of God. After the Middle Ages, a cherub came to be represented as a rosy-cheeked, plump, and winged child.

SAINTS. Persons are declared saints only after death. The pope acknowledges sainthood by canonization, a process based on meeting rigid criteria of authentic miracles and beatitude. He ordains a public cult of the new saint throughout the Catholic Church. A similar process is followed in the Orthodox Church.

MARTYRS. Originally, martyrs (witnesses) referred to all the apostles. Later, it signified those persecuted for their faith. Still later, the term was reserved for those who died in the name of Christ.

POPE. Meaning "father," the term refers to the bishop of Rome, the spiritual head of the Roman Catholic Church. Today, the pope dwells in and heads an independent state, Vatican City, within the city of Rome. Throughout most of Christian history, the pope ruled a large territory that occupied much of central Italy. His chief attribute is a shepherd's staff; he dresses in white.

CARDINALS. Priests or higher religious officials chosen to help the pope administer the Church. They are of two types: those who live in Rome (the Curia) and those who remain in their dioceses. Together they constitute the Sacred College. One of their duties is to elect a pope after the death or removal of a sitting pope. They wear a red cassock (robe) and, depending on the occasion, one of three ceremonial hats.

DIOCESE. A territorial unit administered in the Western church by a bishop and in the Eastern Church by a patriarch. A cathedral is the diocese church and the seat of the bishop.

BISHOPS AND ARCHBISHOPS. A bishop is the highest order of minister in the Catholic Church, with his administrative territory being the diocese. Bishops are ordained by archbishops, who also have the authority to consecrate kings. Bishops carry an elaborately curved staff called a crozier and, on ceremonial occasions, wear a three-pointed hat.

PRIESTS AND PARISHES. Priests did not exist in the early Church because only bishops were authorized to offer the Eucharist and receive confession. As the Church grew, church officials called presbyters (elders), or priests, were designated by bishops to perform the Eucharist and ablutions in smaller administrative units, called parishes.

ABBOTS AND ABBESSES. Heads of large monasteries (called abbeys) and convents (nunneries).

MONKS AND NUNS. Men and women living in religious communities who have taken vows of poverty, chastity, and obedience to the rules of their orders.

CANONS AND CANONESSES. Men and women who live in religious communities but under less rigorous rules than monks and nuns.

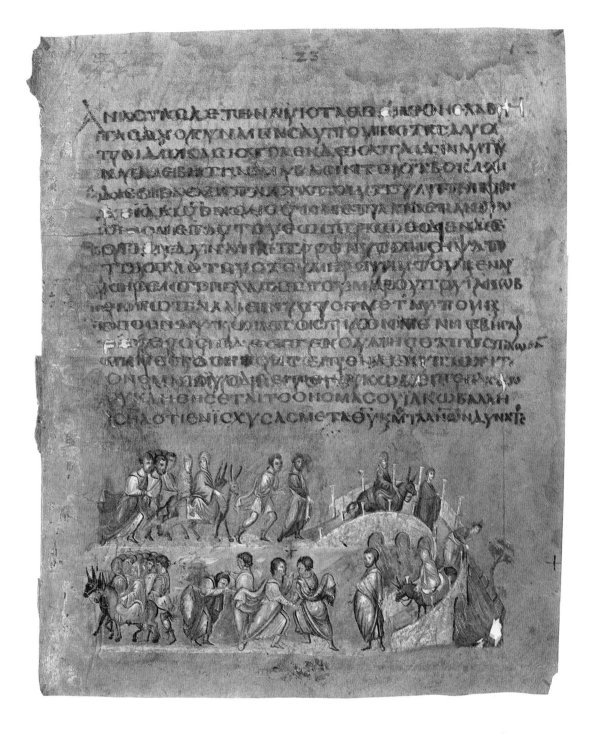

8-20. Page with *Jacob Wrestling the Angel,* from the *Vienna Genesis.* Early 6th century A.D. Tempera and silver on dyed vellum, 13¼ x 9½" (33.6 x 24.1 cm). Österreichische Nationalbibliothek, Vienna

like—but within a framework borrowed from pagan art. Not until a century later do we find a much broader range of subject matter and forms.

THE SARCOPHAGUS OF JUNIUS BASSUS. The finest Early Christian sarcophagus is the richly carved *Sarcophagus of Junius Bassus,* made for a prefect of Rome who died in 359 (fig. 8-21). The front, divided by columns into ten square compartments, shows a mixture of Old and New Testament scenes. In the upper row we see (from left to right) the Sacrifice of Isaac, St. Peter Taken Prisoner, Christ Enthroned between Sts. Peter and Paul, and Christ before Pontius Pilate (two compartments). In the lower row are the Misery of Job, the Temptation of Adam and Eve, Christ's Entry into Jerusalem, Daniel in the Lions' Den, and St. Paul Led to His Martyrdom. This choice, which may seem somewhat strange

to the modern viewer, is characteristic of the Early Christian way of thinking, which stressed the divine rather than the human nature of Christ. Hence his suffering and death are merely hinted at. He appears before Pilate as a youthful, long-haired philosopher expounding the true wisdom. (Note the scroll.) The martyrdom of the two apostles is shown in the same discreet fashion.

The two central scenes are devoted to Jesus (see box pages 246–47). Enthroned above Jupiter as the personification of the heavens, he dispenses the Law to Sts. Peter and Paul. Below, he enters Jerusalem as Conquering Savior (compare fig. 7-40). Adam and Eve, the original sinners, signify the burden of guilt redeemed by Christ. The Sacrifice of Isaac is an Old Testament prefiguration of Christ's sacrificial death and resurrection. Job and Daniel carry the same message as Jonah in the catacomb painting (see fig. 8-3): they fortify the hope of salvation.

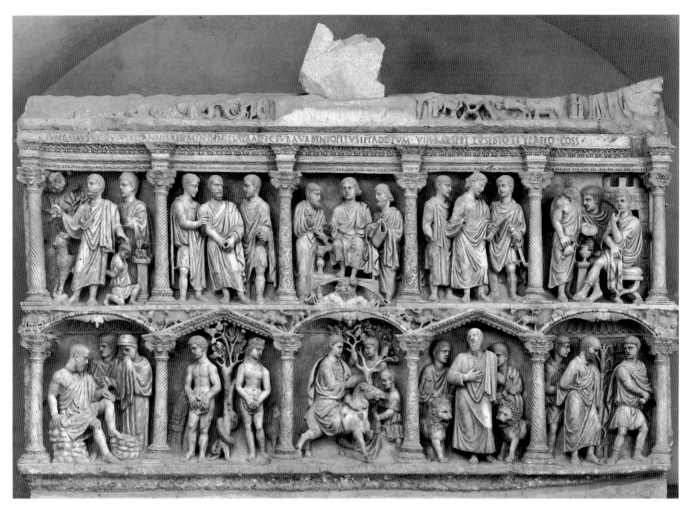

8-21. *Sarcophagus of Junius Bassus.* c. 359 A.D. Marble, 3'10½" x 8' (1.2 x 2.4 m). Museo Storico del Capitolino di S. Pietro, Rome

Compared with the frieze on the Arch of Constantine, carved almost half a century before (see fig. 7-47), the *Sarcophagus of Junius Bassus* retains an element of classicism. The figures in their deep niches recall the dignity of Greek and Roman sculpture. (Compare Eve to the *Knidian Aphrodite* of Praxiteles, fig. 5-69). Yet beneath this veneer we see a resemblance to the Constantinian style in the doll-like bodies and large heads. Moreover, the events and figures are no longer intended to tell their own story but to call to mind a larger symbolic meaning that unites them. Hence the passive air of scenes that would otherwise seem to call for dramatic action.

CLASSICISM. Classicizing tendencies of this sort seem to have recurred in Early Christian sculpture from the mid-fourth to the early sixth century. Their causes have been explained in various ways. During this period paganism still had many important followers who may have fostered such revivals as a kind of rear-guard action. Recent converts (including Junius Bassus, who was not baptized until shortly before his death) often remained loyal to values of the past. Some Church leaders also sought to reconcile Christianity with the heritage of classical antiquity with good reason: early Christian theology depended a great deal on Greek and Roman philosophers, not only recent ones such as the Neo-Platonist Plotinus (see fig. 7-43) but also Plato, Aristotle, and earlier thinkers. The imperial courts, both East and West, remained aware of their

links with pre-Christian times. They collected large numbers of original Greek works and Roman copies, so that they became centers for classicizing tendencies. Whatever its roots in any given case, classicism remained important during this time of transition.

IVORY DIPTYCHS. This lingering tradition is found especially in a class of objects whose artistic importance far exceeds its physical size: ivory panels and other small-scale reliefs in precious materials. Designed for private ownership and meant to be enjoyed at close range, they often mirror a collector's taste. Such a refined aesthetic sense is not found among the large works sponsored by Church or State. The ivory in figure 8-22 forms the right half of a hinged two-leaved tablet, or **diptych**, that was carved about 390–400. It was probably made for a wedding between the Nicomachi and Symmachi, two aristocratic Roman families. (The other half is poorly preserved.) The conservatism of this piece is reflected not only in the pagan subject (a priestess of Bacchus and her assistant before an altar of Jupiter) but also in the design, which harks back to the era of Augustus (compare fig. 7-32). At first glance, we might well mistake it for a much earlier work. But we soon realize, from such details as the priestess's right foot overlapping the frame, that these forms are quotations from earlier examples. Although they have been reproduced with loving care, they are no longer fully understood. It is noteworthy that the

pagan theme did not prevent the panel from being incorporated into the shrine of a saint many centuries later. Its cool perfection must have still had an appeal in the Middle Ages.

PORTRAITURE. Monumental sculpture, although discouraged by the Church, retained the support of the State, at least for a while. Emperors, consuls, and high officials erected portrait statues of themselves in public places as late as the reign of Justinian (527–65), and sometimes later than that. (The last recorded case is in the late eighth century.) During the latter half of the fourth century and the early years of the fifth, there was a revival of pre-Constantinian types and a renewed interest in individual appearances. From about 450 on, however, the outward likeness gives way to the image of a spiritual ideal. Sometimes these images were highly expressive, but they became increasingly impersonal. There were no more portraits in the Graeco-Roman sense for almost a thousand years.

The process can be seen in the head of Eutropios from Ephesus (fig. 8-23), among the most striking of its kind. It reminds us of the sorrowful countenance of "Plotinus" and the colossal head of Constantine (see figs. 7-43 and 7-45). But both of these have a concreteness that seems almost overwhelming compared to Eutropios. Here the face is frozen in visionary ecstasy, as if the sitter were a hermit saint. He looks, in fact, more like a specter than a being of flesh and blood. Solid volumes are avoided to such an extent that the features are indicated for the most part only by thin ridges or shallow lines. Their smooth curves emphasize the elongated oval of the head and reinforce its abstract, otherworldly character. Neither the individual person nor the human body have tangible reality here—and with that the Greek tradition of sculpture in the round has reached the end of the road.

BYZANTINE ART
Early Byzantine Art

It is the religious, even more than the political, separation of East and West that makes it impossible to discuss the development of Christian art in the Roman empire under a single heading.

8-22. *Priestess of Bacchus.* Leaf of a diptych. c. 390–400 A.D. Ivory, 11¾ x 5½" (30 x 14 cm). Victoria & Albert Museum, London

8-23. *Portrait of Eutropios.* c. 450 A.D. Marble, height 12½" (31.7 cm). Kunsthistorisches Museum, Vienna

Early Christian does not, strictly speaking, designate a style. It refers, rather, to any work of art produced by or for Christians during roughly the first five centuries after the birth of Jesus. *Byzantine*, on the other hand, designates not only the art of the eastern Roman empire after the Orthodox Church split from the Catholic Church, but also its specific culture and style, which was linked to the imperial court of Constantinople. Hence the terms are by no means equivalent. Yet there is no clear-cut line between Early Christian and Byzantine art. East Roman and West Roman—or, as some scholars prefer to call them, Eastern and Western Christian—traits are difficult to separate before the sixth century. Until that time, both areas contributed to the development of Early Christian art, but as the West declined, the leadership tended to shift to the East. This process was completed during the reign of

THE LIFE OF JESUS

Events in the life of Jesus, from his birth through his ascension to Heaven, are traditionally grouped in cycles, each with numerous episodes. The scenes most frequently depicted in European art are presented here.

INCARNATION CYCLE AND THE CHILDHOOD OF JESUS These episodes concern Jesus' conception, birth, infancy, and youth.

ANNUNCIATION. The archangel Gabriel tells Mary that she will bear God's son. The Holy Spirit, shown usually as a dove, represents the Incarnation, the miraculous conception.

VISITATION. The pregnant Mary visits her older cousin, Elizabeth, who is to bear John the Baptist and who is the first to recognize the divine nature of the baby Mary is carrying.

NATIVITY. At the birth of Jesus, the Holy Family—Mary, his foster father Joseph, and the child—is usually depicted in a stable or, in Byzantine representations, in a cave.

ANNUNCIATION TO THE SHEPHERDS AND ADORATION OF THE SHEPHERDS. An angel announces the birth of Jesus to shepherds in the field at night. The shepherds then go to the birthplace to pay homage to the child.

ADORATION OF THE MAGI. The Magi, wise men from the East (called the three kings in the Middle Ages), follow a bright star for 12 days until they find the Holy Family and present their precious gifts to the Infant Jesus.

PRESENTATION IN THE TEMPLE. Mary and Joseph take the baby Jesus to the Temple in Jerusalem, where Simeon, a devout man, and Anna, a prophetess, foresee Jesus' messianic (savior's) mission and martyr's death.

MASSACRE OF THE INNOCENTS AND FLIGHT INTO EGYPT. King Herod orders all children under the age of two in and around Bethlehem killed to preclude his being murdered by a rival newborn king. The Holy Family flees to Egypt.

PUBLIC MINISTRY CYCLE

BAPTISM. John the Baptist baptizes Jesus in the Jordan River, recognizing Jesus' incarnation as the Son of God. This marks the beginning of Jesus' ministry.

CALLING OF MATTHEW. A tax collector, Matthew, becomes Jesus' first disciple (apostle) when Jesus calls to him, "Follow me."

JESUS WALKING ON THE WATER. During a storm, Jesus walks on the water of the Sea of Galilee to reach his apostles in a boat.

RAISING OF LAZARUS. Jesus brings his friend Lazarus back to life four days after Lazarus' death and burial.

DELIVERY OF THE KEYS TO PETER. Jesus names the apostle Peter his successor by giving him the keys to the kingdom of Heaven.

TRANSFIGURATION. As Jesus' closest disciples watch, God transforms Jesus into a dazzling vision and proclaims him to be his own son.

CLEANSING THE TEMPLE. Enraged, Jesus clears the Temple of moneychangers and animal traders.

PASSION CYCLE

The Passion (from *passio,* Latin for suffering) cycle relates Jesus' death, resurrection from the dead, and ascension into Heaven.

ENTRY INTO JERUSALEM. Welcomed by crowds as the Messiah, Jesus rides an ass into Jerusalem.

LAST SUPPER. At the Passover seder, Jesus tells his disciples of his impending death and lays the foundation for the Christian rite of the Eucharist: the taking of bread and wine in remembrance of Christ. (Strictly speaking, Jesus is called Jesus until he leaves his earthly physical form, after which he is called Christ.)

JESUS WASHING THE DISCIPLES' FEET. Following the Last Supper, Jesus washes the feet of his disciples to demonstrate humility.

AGONY IN THE GARDEN. In Gethsemane, the disciples sleep while Jesus wrestles with his mortal dread of suffering and dying.

BETRAYAL (ARREST). Disciple Judas Iscariot takes money to identify Jesus to Roman soldiers. Jesus is arrested.

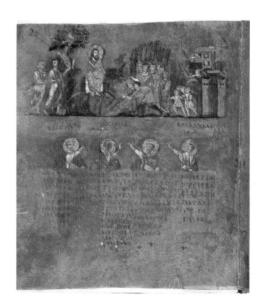

The Entry into Jerusalem, from the Codex Purpureus. 6th century. Illuminated parchment fol. 11. Diocesan Museum of Sacred Art, Duomo Rossano, Italy

Justinian, who ruled the Eastern empire from 527 to 565. Under the patronage of Justinian, Constantinople became the artistic as well as political capital of the empire. Justinian himself was a man of strongly Latin orientation, and he almost succeeded in reuniting Constantine's domain. The monuments he sponsored have a grandeur that justifies the claim that his era was a golden age. They also exhibit an inner stylistic unity that links them more strongly with the future development of Byzantine art than with the art of the past.

The political and religious differences between East and West became an artistic division as well. In western Europe, Celtic and Germanic peoples fell heir to the civilization of late antiquity, of which Early Christian art had been a part, and transformed it into the art of the Middle Ages. The East, in contrast, experienced no such break. Late antiquity lived on in the Byzantine Empire, although Greek and Oriental elements came increasingly to the fore at the expense of the Roman heritage. This sense of tradition played a central role in the development of Byzantine art.

S. VITALE, RAVENNA. The finest early Byzantine monuments (526–726 A.D.) survive not in Constantinople, where much has been destroyed, but in the town of Ravenna, the main stronghold of Byzantine rule in Italy under Justinian. The most important church of that time, S. Vitale (figs. 8-24–8-27, page 248), was begun by Bishop Ecclesius in 526, just before the death of king Theodoric. It was continued under Bishop Ursicinus and Bishop Victor, but was built chiefly in 540–47 under Bishop Maximianus, who also consecrated S. Apollinare in Classe two years later (see figs. 8-13, 8-14, and 8-15). A martyrium (see above), S. Vitale is dedicated to a minor figure whose body had been rediscovered at Bologna by Saint Ambrose. Its structure is of a type derived mainly from Constantinople. The plan shows only the barest remnants of the longitudinal axis of the Early Christian basilica. Toward the east is a cross-vaulted compartment for the altar, backed by an apse. On the other side is a narthex, whose odd, nonsymmetrical placement has never been fully explained. Otherwise the plan is octagonal with a circular dome (figs. 8-26 and 8-27), which makes it a descendant of the mausoleum of Sta. Costanza in Rome (see figs. 8-7, 8-8, and 8-9). However, the intervening development seems to have taken place in the East, where domed churches of various kinds had been built during the previous century.

When we recall S. Apollinare in Classe (see figs. 8-13, 8-14, and 8-15), built at the same time on a straightforward basilican plan with funds from the same donor, we are struck by how different S. Vitale is. How did it happen that the East favored a type of church building so different from the basilica? A number of reasons have been suggested: practical, religious, political. All of them may be relevant, but none is fully persuasive. After all, the design of the basilica had been backed by the authority of Constantine; yet it was never as popular in the East as it had been in the West since early Imperial times. Moreover, it was Constantine who built the first central-plan churches in Constantinople, thereby helping to establish the preference for the type in the East. In any case, domed, central-plan churches were to rule the world of Orthodox Christianity as thoroughly as the basilican plan dominated the architecture of the medieval West.

Compared to Sta. Costanza (fig. 8-7), S. Vitale is larger in scale and much richer in its spatial effect (fig. 8-27). The circular nave is ringed by an aisle, or ambulatory. Below the clerestory, this central space turns into a series of semicircular niches that penetrate into the aisle, linking it to the nave in a new way. The aisle itself has a second story: the galleries, which may have been reserved for women. The interior is flooded with light from large windows on

DENIAL OF PETER. As Jesus predicted, Peter, waiting outside the High Priest's palace, denies knowing Jesus three times, as Jesus is being questioned by the high priest, Caiaphas.

JESUS BEFORE PILATE. Jesus is questioned by the Roman governor Pontius Pilate regarding whether he calls himself King of the Jews. Jesus does not answer. Pilate reluctantly condemns him.

FLAGELLATION (SCOURGING). Jesus is whipped by Roman soldiers.

JESUS CROWNED WITH THORNS (THE MOCKING OF CHRIST). Pilate's soldiers mock Jesus by dressing him in robes, crowning him with thorns, and calling him King of the Jews.

CARRYING OF THE CROSS (ROAD TO CALVARY). Jesus carries the wooden cross on which he will be executed from Pilate's house to the hill of Golgotha, "the place of the skull."

CRUCIFIXION. Jesus is nailed to the cross by his hands and feet and dies after great physical suffering.

DESCENT FROM THE CROSS (DEPOSITION). Jesus' followers lower his body from the cross and wrap it for burial. Also present are the Virgin, the apostle John, and, in some accounts, Mary Magdalen.

LAMENTATION (*PIETÀ* OR *VESPERBILD*). The grief-stricken followers gather around Jesus' body. In the *Pietà,* his body lies in the lap of the Virgin.

ENTOMBMENT. The Virgin and others place the wrapped body in a sarcophagus, or a rock tomb.

DESCENT INTO LIMBO (HARROWING OF HELL OR *ANASTASIS* IN THE ORTHODOX CHURCH). Christ descends to Hell, or limbo, to free deserving souls who have not heard the Christian message—the prophets of the Old Testament, the Kings of Israel, and Adam and Eve.

RESURRECTION. Christ rises from the dead on the third day after his entombment.

THE MARYS AT THE TOMB. As terrified soldiers look on, Christ's female followers (the Virgin Mary, Mary Magdalen, and Mary, mother of the apostle James) discover the empty tomb.

***NOLI ME TANGERE*, SUPPER AT EMMAUS, DOUBTING OF THOMAS.** In three episodes during the 40 days between his resurrection and ascent into Heaven, Christ tells Mary Magdalen not to touch him *(Noli me tangere)*; shares a supper with his disciples at Emmaus; and invites the apostle Thomas to touch the lance wound in his side.

ASCENSION. As his disciples watch, Christ is taken into Heaven from the Mount of Olives.

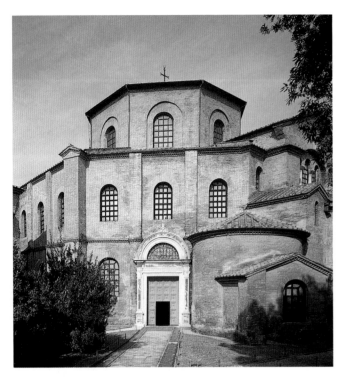

8-24. S. Vitale, Ravenna. 526–47 A.D.

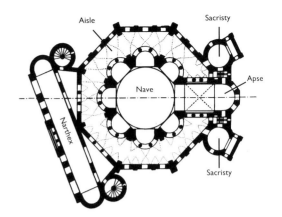

8-25. Plan of S. Vitale

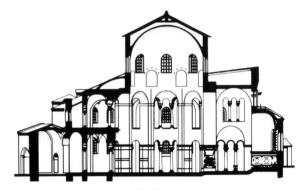

8-26. Transverse section of S. Vitale

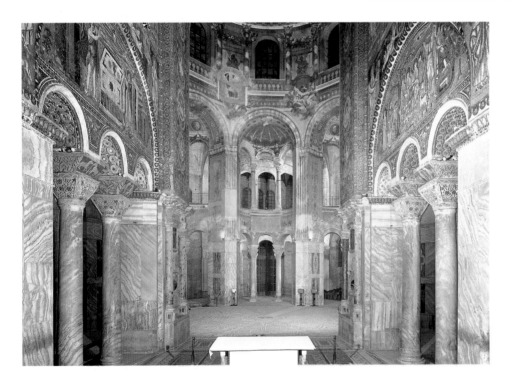

8-27. Interior (view from the apse into the choir), S. Vitale

every level, which was made possible by a new economy in the construction of the vaulting. The complexity of the interior is matched by its lavish decoration.

S. Vitale's link with the Byzantine court can be seen in the two famous mosaics flanking the altar (figs. 8-28 and 8-29). They depict Justinian and his empress, Theodora, accompanied by officials, the local clergy, and ladies-in-waiting, about to enter the church from the atrium at the beginning of the Byzantine liturgy (the Little Entrance). Although they did not attend the actual event, the royal couple is shown as present at the consecration of S. Vitale. The purpose is to demonstrate their authority over Church and State, as well as their support for their archbishop, Maximianus, who at first was unpopular with the citizens of Ravenna. In these large panels, whose design most likely came from an imperial workshop, we find an ideal of beauty that is very different from the squat, large-headed figures we met in the art of the fourth and fifth centuries.

We have caught a few glimpses of this new ideal (see figs. 8-3 and 8-22), but only now do we see it complete. The figures are tall

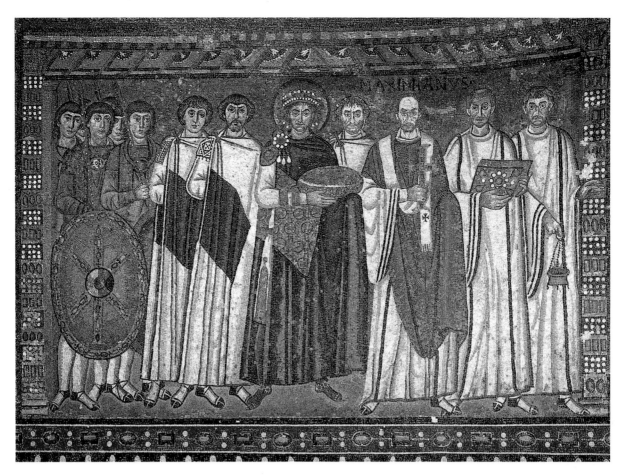

8-28. *Emperor Justinian and His Attendants*. c. 547 A.D. Mosaic. S. Vitale

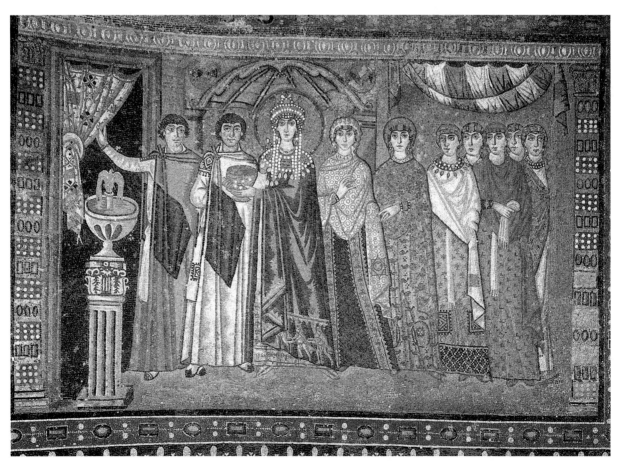

8-29. *Empress Theodora and Her Attendants*. c. 547 A.D. Mosaic. S. Vitale

and slim, with tiny feet and small almond-shaped faces dominated by huge eyes. They seem capable only of making ceremonial gestures and displaying magnificent costumes. There is no hint of movement or change. The dimensions of time and earthly space have given way to an eternal present in the golden setting of Heaven. Hence the solemn, frontal images seem to belong to a celestial rather than a secular court. This union of political and spiritual authority reflects the "divine kingship" of the Byzantine emperor. Justinian and Theodora are portrayed as analogous to Christ and the Virgin. Justinian (fig. 8-28) is flanked by 12 companions—the equivalent of the 12 apostles. (Six are soldiers, crowded behind a shield with the monogram of Christ). The embroidery on the hem of Theodora's mantle (fig. 8-29) shows the three Magi carrying their gifts to Mary and the newborn King. The exact meaning is not clear: it may refer to the Eucharist or the Second Coming, but most likely it honors the royal couple as donors of the church.

Justinian, Theodora, and their neighbors—especially Maximianus and Julianus Argentarius, the banker who underwrote the building—were surely meant to be individual likenesses. Their features are differentiated to some degree, but the courtly ideal has molded the faces as well as the bodies, so that they all resemble one another. We shall meet the same large, dark eyes under curved brows, the same small mouths and long, narrow noses countless times from now on in Byzantine art. As we turn from these mosaics to the interior space of S. Vitale (see fig. 8-27), we come to realize that it, too, shares the quality of dematerialized, soaring slenderness that endows the figures with an air of mute exaltation.

HAGIA SOPHIA, ISTANBUL. Among the surviving monuments of Justinian's reign in Constantinople, the most important by far is Hagia Sophia (Church of Holy Wisdom). The architectural masterpiece of its era, Hagia Sophia is one of the great creative triumphs of any age (figs. 8-30–8-35). The first church, begun by Constantine II and finished in 360, was destroyed during rioting in 404. Its replacement, built by Theodosius II within a decade, suffered the same fate in the riots of 532 that almost deposed Justinian, who immediately rebuilt it. Completed in only five years, Hagia Sophia achieved such fame that the names of the architects, too, were remembered: Anthemius of Tralles, an expert

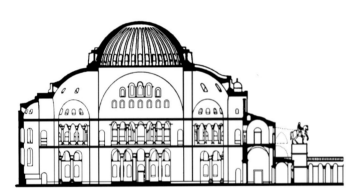

8-30. Section of Hagia Sophia (after Gurlitt)

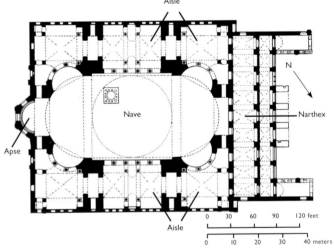

8-31. Plan of Hagia Sophia (after v. Sybel)

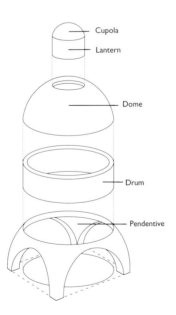

8-32. Parts of a dome

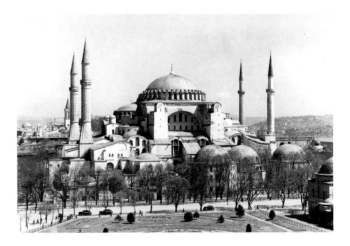

8-33. Anthemius of Tralles and Isidorus of Miletus. Hagia Sophia, Istanbul, Turkey. 532–37 A.D.

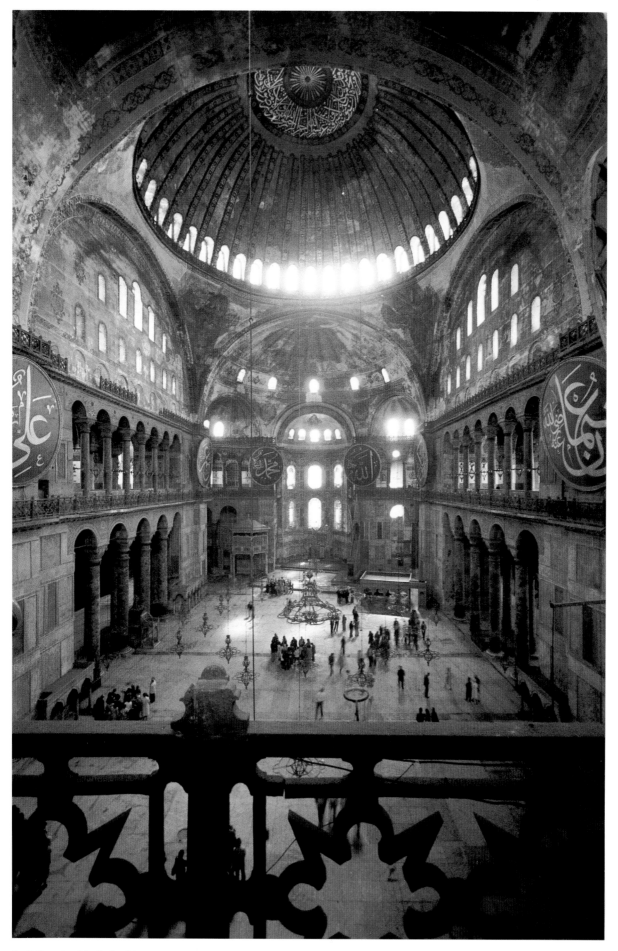

8-34. Interior, Hagia Sophia

8-35. Capital, Hagia Sophia

in geometry and the theory of statics and kinetics, and Isidorus of Miletus, who taught physics and wrote on vaulting techniques. The dome collapsed in the earthquake of 558, and a new, taller one was built in four years from a new design by Isidorus' nephew. After the Turkish conquest in 1453, the church became a mosque (the four minarets and extra **buttresses** were added then), and the mosaic decoration was largely hidden under whitewash. Some of the mosaics were uncovered in the twentieth century, after the building was turned into a museum (see fig. 8-40).

The design of Hagia Sophia presents a unique combination of elements. It has the longitudinal axis of an Early Christian basilica, but the central feature of the **nave** is a vast, square space crowned by a huge **dome**. At either end are half-domes, so that the nave has the form of a great ellipse. Attached to the half-domes are semicircular **apses** with open **arcades**, similar to those in S. Vitale. One might say, then, that the domed central space of Hagia Sophia has been inserted between the two halves of a divided central-plan church. The dome rests on four arches that carry its weight to the large piers at the corners of the square. Thus the walls below the arches have no supporting function at all. The transition from the square formed by the arches to the circular rim of the dome is achieved by spherical triangles called **pendentives** (see fig. 8-32). Hence we speak of the entire unit as a dome on pendentives. This device, along with a new technique for building domes using thin bricks embedded in mortar, permits the construction of taller, lighter, and more economical domes than the older method (seen in the Pantheon, Sta. Costanza, and S. Vitale) of placing the dome on a round or polygonal base. Where or when the dome on pendentives was invented we do not know. Hagia Sophia is the earliest example we have of its use on a monumental scale, and it had a lasting impact. It became a basic feature of Byzantine architecture and, somewhat later, of Western architecture as well.

There is still another element that entered into the design of Hagia Sophia. The plan, the buttressing of the main piers, and the huge scale of the whole recall the Basilica of Constantine (see figs. 7-18, 7-19, and 7-20), the most ambitious achievement of imperial Roman vaulted architecture and the greatest monument associated with a ruler for whom Justinian had particular admiration. Hagia Sophia thus unites East and West, past and future, in a single overpowering synthesis. Its massive exterior, firmly planted upon the earth like a great mound, rises by stages to a height of 184 feet—41 feet taller than the Pantheon—and therefore its dome, although its diameter is somewhat smaller (112 feet), stands out far more boldly. The dome improves on the Pantheon's, to which it is obviously indebted: the thinnest of ribs radiate from an oculus, which has been closed in, while the extremely lightweight construction made it possible to dispense with the rings altogether and to insert a row of windows around the base.

Once we are inside, all sense of weight disappears, as if the solid aspects of the structure had been banished to the outside. Nothing remains but a space that inflates, like so many sails, the apses, the pendentives, and the dome itself. Here the architectural aesthetic we saw taking shape in Early Christian architecture (see pages 232–36) has achieved a new dimension. Even more than before, light plays a key role. The dome seems to float—"like the radiant heavens," according to a contemporary description—because it rests upon a closely spaced row of windows. The nave walls are pierced by so many openings that they have the transparency of lace curtains. The golden glitter of the mosaics must have completed the "illusion of unreality." Its purpose is clear. As Procopius, the court historian to Justinian, wrote: "Whenever one enters this church to pray, he understands at once that it is not by any human power or skill, but by the influence of God, that this work has been so finely turned. And so his mind is lifted up toward God and exalted, feeling that He cannot be far away, but must especially love to dwell in this place that He has chosen." [See Primary Sources, no. 16, page 384.]

We can sense the new aesthetic even in ornamental details such as moldings and capitals (fig. 8-35). The scrolls, acanthus leaves, and the like are motifs derived from classical architecture, but their effect is very different. Instead of actively cushioning the impact of heavy weight on the shaft of the column, the capital has become like an openwork basket whose delicate surface pattern belies the strength and solidity of the stone.

IVORIES. Beyond architectural decorations and some sarcophagi, early Byzantine sculpture consists mainly of reliefs in ivory and silver, which survive in considerable numbers. The ivory in figure 8-36 looks back to earlier classical ivories (compare fig. 8-22), but it has rightly been dated to the time of Justinian and may have been paired with a panel showing the emperor himself. (The inscription above has the prayer, "Receive these gifts, and having learned the cause. . . ," which would probably have continued on the missing leaf with a plea to forgive the owner's sins.) In any event, it must have been done around 520–30 by an imperial workshop in Constantinople. Here classicism has become an eloquent vehicle for Christian content. The majestic archangel is a descendant of the winged Victories of Graeco-Roman art, down to the rich drapery (see fig. 5-59). The power he heralds is not of this world, nor does he inhabit an earthly space. The niche has lost all three-dimensional

the sides), and John the Baptist flanked by the four evangelists (on the front). They are embedded in strips of the most luxurious ornamentation—covered with lacy foliage, including clusters of grapes, and inhabited by lions, stags, peacocks, and other exotic creatures.

Considering its size, it is likely that the throne was the work of several people of outstanding ability who had been summoned by the court to Constantinople from around the Empire. It was probably a gift from Justinian to Maximianus, the archbishop of Ravenna, upon the dedication of S. Vitale. We are assured that it was made at the Byzantine court not only by its quality but also by the style of the Baptist and his companions. It echoes the classicism of *The Archangel Michael* yet also conforms to the aristocratic ideal of the S. Vitale mosaics (see figs. 8-28 and 8-29) with their flattened forms. The arcade with frontal figures, derived from sarcophagi, was to have a long life: it is found on nearly all metal reliefs and ivory carvings (especially book covers) through the Romanesque era.

The last vestiges of classicism can be seen in the beautifully carved diptych of *Justinian As Conqueror,* from about the same time as the throne, which celebrates Justinian's victories in Italy, North

8-36. *The Archangel Michael.* Leaf of a diptych.
Early 6th century A.D. Ivory, 17 x 5½" (43.3 x 14 cm)
The British Museum, London

reality. Its relationship to him is purely symbolic and ornamental, so that he seems to hover rather than to stand. (Notice the position of the feet on the steps.) It is this disembodied quality, conveyed through harmonious forms, that makes his presence so compelling. He might appear more concrete if the panel retained its original colors and gilding, which many, if not most, antique, Early Christian, and Byzantine ivories originally had.

Not surprisingly, many ivories share traits with the capitals at Hagia Sophia, as we can see from the *Throne of Maximianus* (fig. 8-37). This magnificent episcopal chair *(cathedra)* is covered with ivory panels (some are later replacements), which depict the infancy of Christ (on the backrest), the story of Joseph in Egypt (on

8-37. *Throne of Maximianus.* c. 547.
Ivory over wood, 59 x 23½" (149.8 x 59.7 cm).
Archiepiscopal Museum, Ravenna

8-38. *Justinian As Conqueror.*
c. 525–50 A.D. Ivory,
13½ x 10½" (34.2 x 26.8 cm).
Musée du Louvre, Paris

Africa, and Asia (fig. 8-38). The subject restates the allegorical scene on the breastplate of the *Augustus of Primaporta* in Christian terms (see fig. 7-28). The figure of Victory appears twice: above the emperor, to his right, and as a statuette held by the Roman general at the left, who no doubt was mirrored in the missing panel at the right. Scythians, Indians, even lions and elephants offer gifts and pay homage, while a figure personifying Earth supports Justinian's foot to signify his dominion over the entire world. His role as triumphant general and ruler of the empire is blessed from heaven (note the sun, moon, and star) by Christ, whose image is carried in a medallion by two heraldically arranged angels. Despite their ancestry, the stubby figures are hardly classical in style. They remind us of Constantinian reliefs (compare fig. 7-47), but with an Oriental cast derived from the eastern provinces. The large head and bulging features of Justinian brim with the same energy as his charging steed. He is a far cry from the calm philosopher portrayed on the equestrian statue of Marcus Aurelius (fig. 7-40) from which the image is derived.

ICONS. In the late sixth century icons began to compete with relics as objects of personal, then public, veneration. Icons are paintings of Christ, the Enthroned Madonna, or saints. From the

beginning they were considered portraits, and understandably so, for such pictures had developed in Early Christian times out of Graeco-Roman portrait panels. One of the chief arguments in their favor was the claim that Christ had appeared with the Virgin to St. Luke and permitted him to paint their portrait, and that other portraits of Christ or of the Virgin had miraculously appeared on earth by divine command. These "true" sacred images were considered to have been the sources for the later, man-made ones. Little is known about the origins of icons, for examples from before the Iconoclastic Controversy are extremely scarce (see page 257), but they undoubtedly developed in part from pagan icons, since both began to be painted around 200 A.D.

Of the few early examples, the most revealing is the *Virgin and Child Enthroned between Saints and Angels* (fig. 8-39). Like late Roman murals (see pages 203–08), it is painted in several styles. Its link with Graeco-Roman portraiture is clear not only from the use of encaustic (which was not used after the Iconoclastic Controversy) but also from the gradations of light and shade in the Virgin's face, which is similar in treatment to the little boy's in our Faiyum portrait (see fig. 7-55). She is flanked by two warrior saints, probably Theodore on the left and George (or Demetrios?) to the right, who recall the stiff figures that accompany Justinian in S. Vitale

(see fig. 8-28). Typical of early icons, however, their heads are too large for their doll-like bodies. Behind them are two angels who come out of Roman art (compare the personification of Arcadia in fig. 7-54), although their lumpy features show that classicism is no longer a living tradition. Clearly these figures are quotations from different sources, so that the painting marks an early stage in the development of icons. Yet it is typical of the conservative icon tradition that the artist has tried to remain faithful to his sources, in order to preserve the likenesses of these holy figures.

This icon, though not impressive in itself, is worthy of our attention because it is the earliest representation we have of the Madonna and Child. The motif itself was probably taken from the cult of Isis, which was popular in Egypt at the time of the Faiyum portraits. The regal Christ child probably evolved from images of the infant Dionysos. We note the stiff formality of the pose. To the Byzantines the Madonna was the regal mother, or bearer, of god (*Theotokos*), while Jesus is no mere infant but god in human form (*Logos*). [See Primary Sources, no. 18, page 385.] Only later did she acquire the gentle maternal presence of the Virgin that is so familiar in Italian art (compare fig. 12-49).

Icons functioned as living images to instruct and inspire the worshiper. Because the actual figure—be it Christ, Mary, a saint, or an angel—was thought to reside in the image, as it had in antique sculpture, icons were believed able to work miracles and to intercede on behalf of the faithful. In describing an icon of the archangel Michael, the sixth-century poet Agathias writes: "The

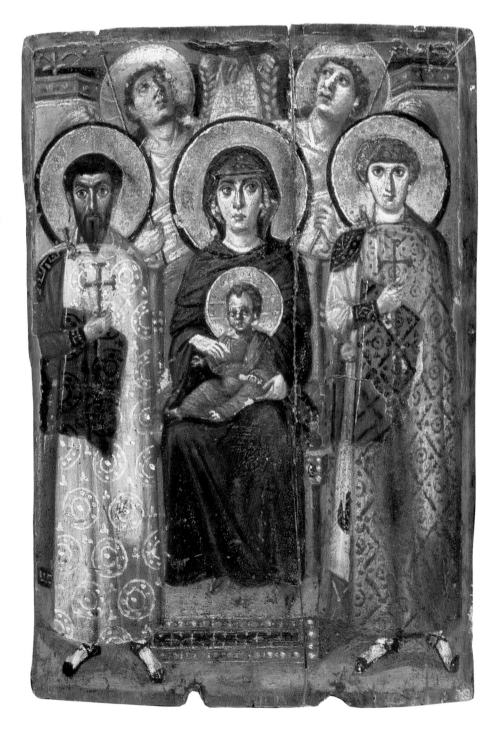

8-39. *Virgin and Child Enthroned between Saints and Angels.* Late 6th century A.D. Encaustic on panel, 27 x 19 3/8" (68.5 x 49.2 cm). Monastery of St. Catherine, Mount Sinai, Egypt

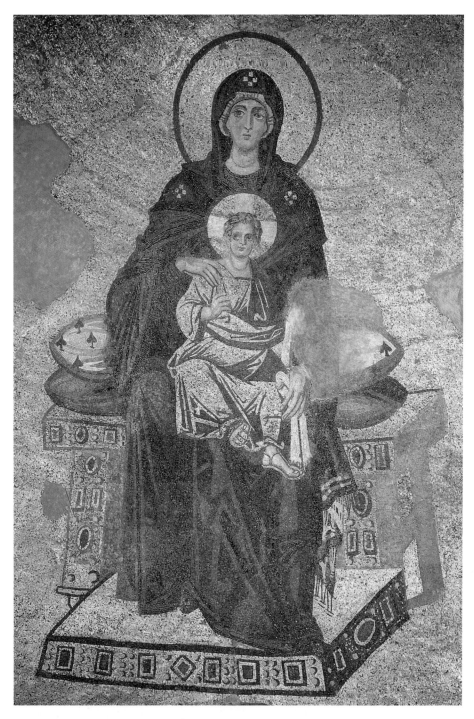

8-40. *Virgin and Child Enthroned*. c. 843–67. Mosaic. Hagia Sophia, Istanbul

wax remarkably has represented the invisible. . . .The viewer can directly venerate the archangel [and] trembles as if in his actual presence. The eyes encourage deep thoughts; through art and its colors the innermost prayer of the viewer is passed to the image."

Middle Byzantine Art

ICONOCLASTIC CONTROVERSY. After the time of Justinian, the development of Byzantine art—not only painting and sculpture but architecture as well—was disrupted by the Iconoclastic Controversy. The conflict, which began with an edict promulgated by the Byzantine emperor Leo III in 726 prohibiting

religious images, raged for more than a hundred years between two hostile groups. The image-destroyers (Iconoclasts), led by the emperor and supported mainly in the eastern provinces, insisted on a literal interpretation of the biblical ban against graven images as leading to idolatry. They wanted to restrict religious art to abstract symbols and plant or animal forms. Their opponents, the Iconophiles, were led by the monks and were particularly centered in the western provinces, where the imperial edict was not effective. The strongest argument in favor of icons was Neo-Platonic: because Christ and his image are inseparable, the honor given to the image is transferred to him. [See Primary Sources no. 17, page 385.] The roots of the argument went very deep. On the plane of

theology, they involved the basic issue of the relationship of the human and the divine in the person of Christ. Moreover, icons had come to replace the Eucharist as the focus of lay devotion, because of the screen *(templon)* hung with icons, which separated the altar from the worshipers in Orthodox churches (see fig. 8-43). Socially and politically, the conflict was a power struggle between Church and State, which in theory were united in the figure of the emperor. It came during a low point in Byzantine power, when the empire had been greatly reduced in size by the rise of Islam. Iconoclasm seemed justified by Leo's victories over the Arabs, who were themselves Iconoclasts. The controversy also caused an irreparable break between Catholicism and the Orthodox faith, although the two churches remained officially united until 1054, when the pope excommunicated the Eastern patriarch for heresy.

If the edict had been enforced throughout the empire, it might well have dealt Byzantine religious art a fatal blow. It did succeed in greatly reducing the production of sacred images, but failed to wipe them out entirely. The most direct proof of the survival of the Byzantine artistic tradition during the early eighth to mid-ninth century is the mosaic of the *Virgin and Child Enthroned* in Hagia Sophia (fig. 8-40). We know it was made sometime between 843 (the year of the victory of the Iconophiles under the empress Theodora which marked the end of the Iconoclastic Controversy) and 867 (when it was unveiled to celebrate the triumph of Orthodoxy). It conforms to the earliest icon of the same subject (see fig. 8-39), and its subtle modeling and color are in the best tradition of early Byzantine art. However, there is a new human quality, not seen before, in the fullness of the figures, the more relaxed poses, and the more natural expressions. Hence there was a fairly rapid

recovery after the victory of the Iconophiles in 843 under the empress Theodora. Spearheaded by Basil I the Macedonian, a revival of Byzantine artistic traditions that lasted from the late ninth to the eleventh century followed the years of iconoclasm.

MONASTIC ARCHITECTURE. Byzantine architecture never produced another structure to match the scale of Hagia Sophia, not even the Nea (New Church) completed by Basil I in Constantinople by 880, the largest since Justinian times, which set the pattern for those that followed it. The churches built after the Iconoclastic Controversy were initially modest in size and monastic in spirit. Most were built for small groups of monks living in isolated areas, although later monasteries erected in Constantinople under imperial patronage were much larger and served social purposes as schools and hospitals.

The two churches at the Monastery of Hosios Loukas (St. Luke of Stieris) in Greece are typical (figs. 8-41, 8-42, and 8-43). (Saint Luke of Stieris was a much-venerated local hermit saint who died in 953.) The smaller of the two, the Panaghia Theotokos (All-Holy Mother of God), was built around 990 to replace the saint's martyrium. It served as the monastery's main church *(katholikon)* until the present one (on the left in figs. 8-41 and 8-42) was erected early in the next century. They are joined at the hip, so to speak, in order to include St. Luke's grave. Both churches follow the usual Middle Byzantine plan of a Greek cross (which has arms of equal length) contained in a square, with a narthex added on one side and an apse (sometimes with flanking chapels, as in the Panaghia) on the other. The central feature of such churches is a dome on a square base. It often rests on a cylindrical or octagonal

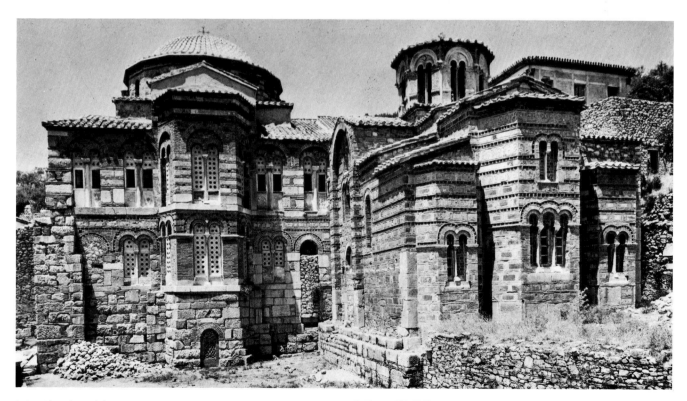

8-41. Churches of the Monastery of Hosios Loukas (St. Luke of Stiris), Greece. Early 11th century

8-42. Plan of churches of the Monastery of Hosios Loukas (after Diehl)

drum with tall windows, which raises it high above the rest of the building. The monastery churches at Hosios Loukas also show other features of later Byzantine architecture. One is a tendency toward more elaborate exteriors, in contrast to the severity of S. Vitale (compare fig. 8-24). Another is a preference for elongated proportions, which was established by the Nea. The full impact of this verticality, however, strikes us fully only when we enter the church (fig. 8-43 shows the interior of the Katholikon). The tall, narrow compartments produce both an unusually active space and a sense almost of compression. This feeling is dramatically relieved as we raise our glance toward the luminous pool of space beneath the dome, which was filled with mosaics that disintegrated long ago. (Note, too, the huge icons on the *templon* which screens the altar.)

Byzantine art had managed somehow to preserve biblical subjects from Early Christian times. In the eleventh century they enjoyed a revival, which thoroughly explored their narrative and pictorial potential, along with a wider range of themes and feelings. The *Nativity* in figure 8-44 from Hosios Loukas is more complex than any previous example. Instead of focusing simply on the Virgin and Child, the mosaicist uses continuous narrative. The scene includes not only midwives bathing the newborn infant but also a host of angels, the Adoration of the Magi, and the

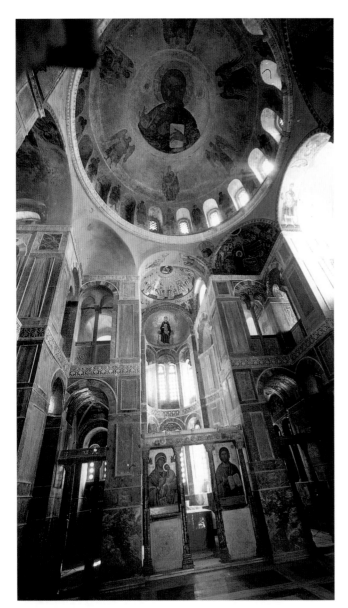

8-43. Interior, Katholikon, Hosios Loukas

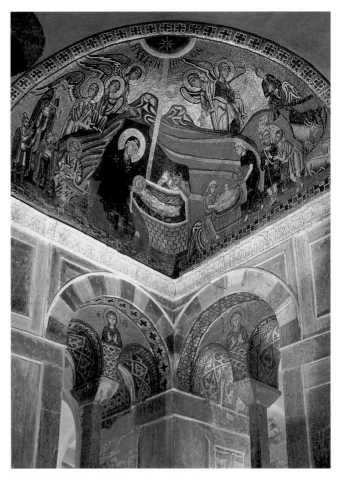

8-44. *Nativity*. Early 11th century. Mosaic. Monastery of Hosios Loukas

8-45. St. Mark's (aerial view), Venice. Begun 1063

Annunciation to the Shepherds. The great variety of poses and expressions lends the scene a heightened sense of drama. Despite its schematic rendering, the mountainous landscape shows a new interest in illusionistic space as well.

ST. MARK'S, VENICE. The largest and most lavishly decorated church of the period that still survives is St. Mark's in Venice, begun in 1063. The present structure replaced two earlier churches of the same name on the site; it is modeled on the Church of the Holy Apostles in Constantinople, which had been rebuilt by Justinian after the riot of 532 and was later destroyed. The Venetians had long been under Byzantine rule, and they remained artistically dependent on the East long after they had become politically and commercially powerful in their own right. St. Mark's has a Greek-cross plan inscribed within a square, but here each arm of the cross is emphasized by a dome of its own (figs. 8-45 and 8-46). These domes are not raised on drums. Instead, they have been encased in bulbous wooden helmets covered by gilt copper sheeting and topped by ornate lanterns, so that they appear taller and more visible at a distance. (They make a splendid landmark for seafarers.) The spacious interior, which is famous for its mosaics, shows that it was meant for the people of a large city rather than a small monastic community such as Hosios Loukas.

ST. BASIL, MOSCOW. Byzantine architecture spread to Russia, along with the Orthodox faith. There the basic type of the Byzantine church was transformed through the use of wood as a structural material. The most famous example of this native trend

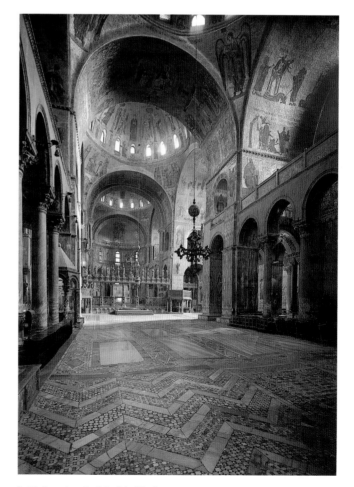

8-46. Interior, St. Mark's, Venice

8-47. Cathedral of St. Basil, Moscow. 1554–60

(OPPOSITE) 8-48. *David Composing the Psalms*, from the *Paris Psalter.* c. 900 A.D. 14⅛ x 10¼" (36 x 26 cm). Bibliothèque Nationale, Paris

Biblical imagery is deeply rooted in classical art, from the point of view not only of style, but, to a considerable extent, of content. Wherever possible the Christian artist adapted a classical figure or, if he could, a whole scene with few changes or none at all. The figure of Christ is a most striking example: as a lamb carrier the form is taken from a bucolic context and the idea from a representation of Philanthropy [see fig. 8-3]; as a teacher he is surrounded by disciples, as are philosophers [see fig. 8-21]; as a divine being he may be associated with Helios or Orpheus [or similarly, David as in figure 8-48]; and, seated on a jewel-studded throne, he poses like an emperor. Many scenes from the Old and New Testaments are based on parallels from classical mythology: the Creation of Adam on man's creation by Prometheus; Jonah under the gourd on the sleeping Endymion; Samson on Heracles, and so forth.

—Kurt Weitzmann, ed. *Age of Spirituality.* New York: The Metropolitan Museum of Art, 1977, p. xxiii.

KURT WEITZMANN (1904–1993) was a German-born, Berlin-educated American Byzantinist based at Princeton University for most of his career—from 1935 until after his retirement in 1972. He headed the university's exploration of the remote Byzantine Monastery of Saint Catherine at Mount Sinai from 1956 to 1965, publishing his most important book, *The Monastery of Saint Catherine at Mount Sinai,* in 1972. Weitzmann's penetrating scholarship in the relationship between the art of the West and that of the Byzantine East helped reshape art history's view of the flow of influences in the Early Christian and Byzantine traditions. The excerpt above is typical of Weitzmann's richly informative scholarship.

is the Cathedral of St. Basil adjoining the Kremlin in Moscow (fig. 8-47). Built during the reign of Ivan the Terrible, it seems as unmistakable as that extraordinary ruler himself. The numerous domes have become fantastic structures as vividly patterned as the rest of the building. The total effect is extremely colorful. The church nevertheless conveys a sense of the miraculous that is derived from the more austere miracles of Byzantine architecture.

CLASSICAL REVIVAL. After Basil I reopened the university in Constantinople, there was a revival of classical learning, literature, and art. Much of it occurred in the early tenth century under Constantine VII. Emperor in name only for most of his life, he devoted his energies instead to art and scholarship. This renewed interest helps to explain the reappearance of Late Classical motifs in Middle Byzantine art. *David Composing the Psalms* (fig. 8-48) is one of eight full-page scenes in the *Paris Psalter.* Illustrating David's life, they introduce the Psalms, which David was thought to have composed. The psalter was probably illuminated about 900, although the temptation to date it earlier is almost irresistible. Not only do we find a landscape that recalls Pompeian

murals, but the figures, too, are clearly derived from Roman models. David himself could well be mistaken for Orpheus charming the beasts with his music. His companions are even more surprising, since they are allegorical figures that have nothing to do with the Bible. The young woman next to David is Melody, the one coyly hiding behind a pillar is Echo, and the male figure with a tree trunk personifies the mountains of Bethlehem. The late date of the picture is evident only from certain qualities of style such as the abstract zigzag pattern of the drapery covering Melody's legs.

DAPHNÉ. The *Paris Psalter* shows an almost antiquarian enthusiasm for the traditions of classical art. Such a direct revival, however, is unusual. More often classicism is merged with the spiritualized ideal of human beauty we saw in the art of Justinian's reign. The *Crucifixion* mosaic in the Greek monastery church at Daphné (fig. 8-49) enjoys special fame. Its classical qualities are more deeply felt than in the *Paris Psalter,* yet they are also completely Christian. There is no attempt to create a realistic spatial setting, but the composition has a balance and clarity that are truly monumental.

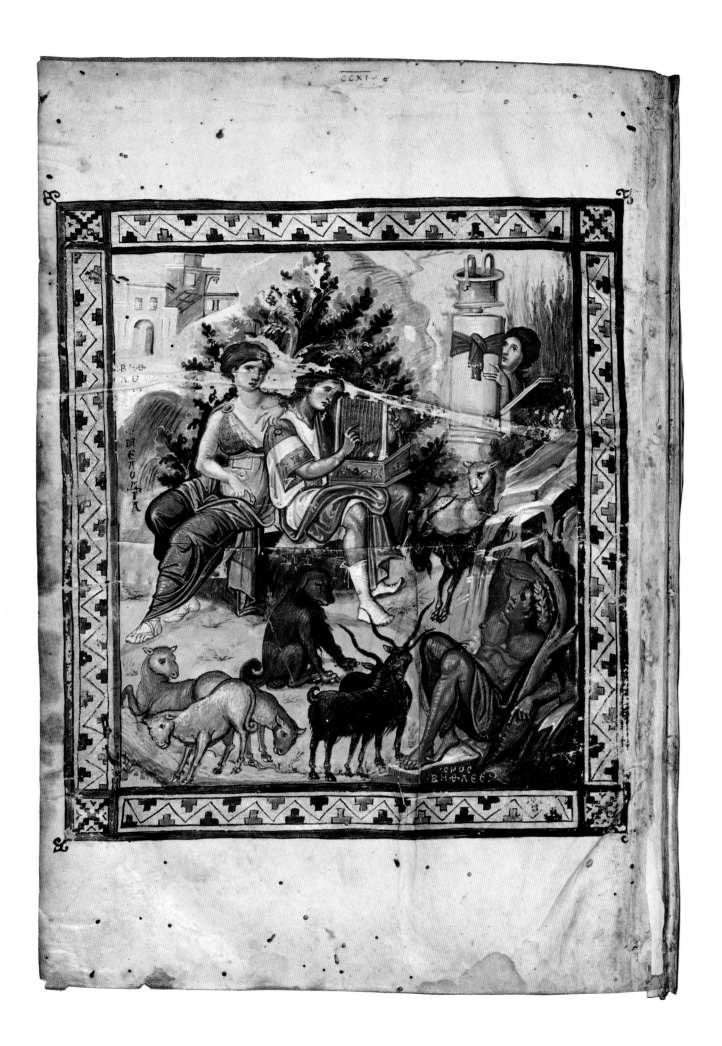

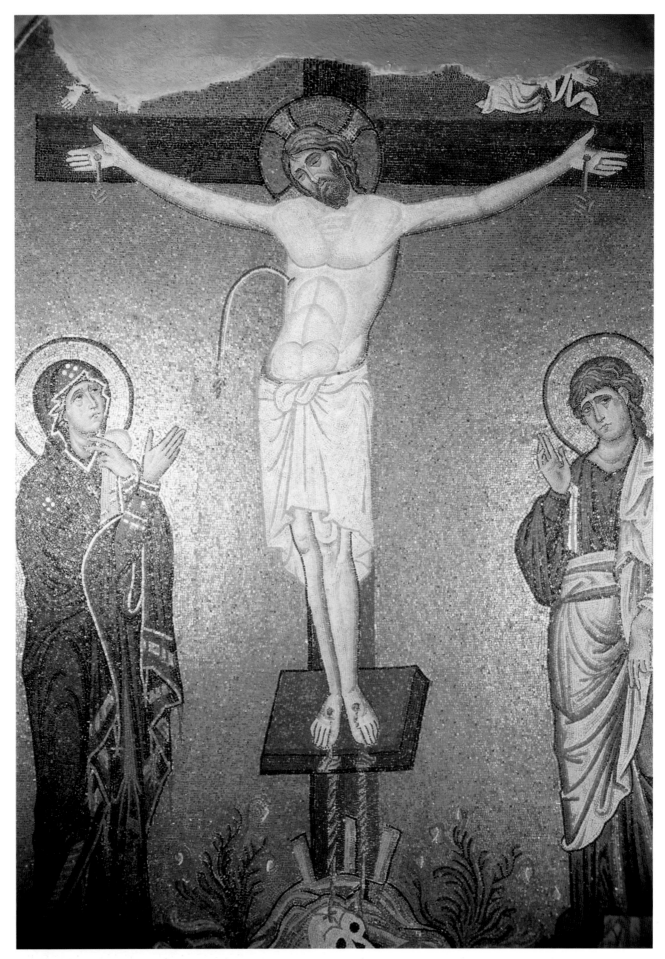

8-49. *The Crucifixion*. 11th century. Mosaic. Monastery Church, Daphné, Greece

8-50. Dome mosaics. 11th century. Monastery Church, Daphné, Greece

Classical, too, is the heroic nudity of Christ, which emphasizes the Incarnation of the Logos. [See Primary Sources, no. 18, page 385.] The statuesque dignity of the figures makes them seem extraordinarily organic and graceful compared to the stiff poses in the Justinian mosaics at S. Vitale (see figs. 8-28 and 8-29).

The most important aspect of the classical heritage, however, is emotional rather than physical. The gestures and facial expressions convey a restrained and noble suffering like the pathos we first met in Greek art of the fifth century B.C. (see pages 146–48). We cannot say when and where this human interpretation of the Savior first appeared, but it seems to have developed in the wake of the Iconoclastic Controversy and reached its height during the Ducas (1059–81) and Komnene dynasties (1081–1185). There are, to be sure, a few earlier examples of it, but none of them appeals to the emotions of the viewer so powerfully as the Daphné *Crucifixion*. To have introduced this compassionate view of Christ into sacred art was the greatest achievement of Middle Byzantine art.

Early Christian art had been quite devoid of this quality. It stressed the Savior's divine wisdom and power rather than his sacrificial death. Hence the Crucifixion was depicted only rarely and without pathos, though with a like simplicity. Alongside the new emphasis on the Christ of the Passion, however, the image of the Pantocrator (the Ruler of the Universe, the All-Holder who contains everything) retained its importance. We recall this image from the *Sarcophagus of Junius Bassus* and above the apse of S. Apollinare in Classe (see figs. 8-21 and 8-15). Staring down from the center of the dome at Daphné is an awesome (though heavily restored) mosaic image of Christ the Pantocrator against a gold background (fig. 8-50). Its huge scale is emphasized by the much smaller figures of the 16 Old Testament prophets between the windows. Although the type descends from images of Zeus, the mature, bearded face of Jesus was first defined during the sixth century. It appeared in the Mandylion, a "true portrait" on cloth that, according to legend, Jesus sent to King Agbar. Later the Mandylion was the basis for the miraculous image that appeared on the veil *(sudarium)* of St. Veronica (from *vera icona,* "true image") when she wiped his face on the way to Calvary. Because of its supposed historical authenticity, the bearded Christ quickly replaced the youthful philosopher in art.

In the corners of the dome are four scenes that reveal the divine and human natures of Christ. The Annunciation (bottom left) is followed in counterclockwise order by the Birth, Baptism, and Transfiguration. The entire cycle (similar to that in Hosios Loukas; see figs. fig. 8-43 and 8-44) represents a theological program that is in perfect harmony with the geometric relationship of the images. A strict order also governs the distribution of subjects throughout the rest of the interior. The basic scheme probably dates back to the time of Basil I (ruled 867–886), founder of the Macedonian dynasty that endured until 1056, who built the Nea and ordered decorations added to Constantine's Church of the Holy Apostles, in Constantinople (both now destroyed). It was also at this time that Middle Byzantine imagery was defined. It was organized loosely along the lines of the Twelve Great Feasts of the Orthodox church, which celebrate major events from the lives of Jesus and the Madonna. [See Primary Sources, no. 18, pages 385–86.] Taken together, they illustrate the Orthodox belief in the Incarnation as the redemption of original sin and the triumph over death.

NEREZI. The emphasis on human emotions reaches its climax in the paintings at the church of St. Panteleimon in Nerezi,

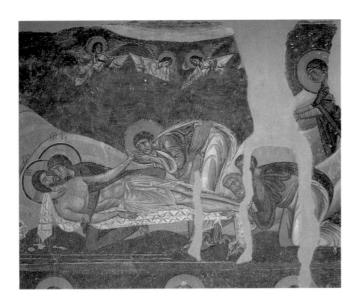

8-51. *Lamentation over the Dead Christ.* 1164. Fresco.
Monastery of St. Panteleimon, Nerezi, Macedonia.

. . .[T]here is clear evidence of a new emotional approach, with vio-
lently agitated drapery, flickering highlights, and strange elongation
of forms. In the tense curves of the Deposition and above all in the
Lamentation over the Dead Christ, *the agony of grief is made
manifest in this new phase of Byzantine art. The Virgin, her face dis-
torted with sorrow, sways to the left in a squatting position and
embraces the dead Christ, whose pale form is partially framed by the
dark blue robes of the Virgin; the Apostles are bent in paroxysms of
grief; and from the sky emerge half-figures of wailing angels.*

—John Beckwith and Richard Krautheimer.
Early Christian and Byzantine Art. Pelican History of
Art Series. New Haven: Yale University Press, 1992, p. 271.
Originally published in 1970 by Penguin Books.

JOHN BECKWITH (1918–1991) spent most of his career at the Victoria
and Albert Museum in London, where he was eventually named Keeper of the
Department of Architecture and Sculpture. A specialist in sculpture, he lectured
and wrote widely about Early Medieval and Early Christian and Byzantine art. Of
his many publications, the finest is his book in the Pelican History of Art series,
which is a summation of everything he had learned in a lifetime of scholarship
and intimate association with works of art. His persuasive passage on the Nerezi
Lamentation from that book is an eloquent and moving description of a work
that almost defies analysis.

Macedonia. It was built by members of the Byzantine fam-
ily and decorated by a team of artists from Constantinople. From
the beginning of Byzantine art in the sixth century, mural paint-
ing had served as a less expensive alternative to mosaic, which
was preferred whenever possible. The two were closely linked,
however, since mosaics were laid out in paint on fresh plaster
each day before the tesserae were added. Thus the best painters
participated fully in the new style and, in some cases, introduced
innovations of their own. The artist responsible for the *Lamentation
over the Dead Christ* (fig. 8-51) was a great master who expanded on
the latest advances. The gentle sadness of the Daphné *Crucifixion*

has been replaced by a grief of almost unbearable intensity. The
style remains the same, but its expressive qualities have been
emphasized by subtle adjustments in the proportions and fea-
tures. The subject seems to have been invented recently, for it
does not occur in earlier Byzantine art. Even more than the
Daphné *Crucifixion,* its origins lie in Classical art: in composition
and mood, it echoes *Eos and Memnon* by Douris (fig. 5-8). Yet
nothing prepares us for the Virgin's anguish as she clasps her dead
son or the deep sorrow of St. John holding Christ's lifeless hand.
Their grief is echoed by the helpless angels overhead. We have
entered a new realm of religious feeling that was to be explored
further in the West.

MONREALE. The Byzantine manner was soon transmitted to
Italy, where it was called the "Greek style" and had a decisive
impact on Gothic painting (see pages 361–62). Sometimes it was
carried by miniature mosaic diptychs from Constantinople, but
most often it was brought directly by visiting Byzantine artists. It
first appeared in Sicily, a former Byzantine holding which was
taken from the Muslims in 1091 by the Normans and united with
southern Italy. The new style is seen throughout the magnificent
churches and monasteries built in Palermo, the island's capital.

The Norman kings considered themselves the equals of the
Byzantine emperors. They called in teams of mosaicists from Con-
stantinople to decorate their splendid religious buildings. The
mosaics at the Cathedral of Monreale, the last to be executed, are
in a thoroughly up-to-date Byzantine style, although the selection
and distribution of the subjects are largely Western. *Christ in the
Garden of Gethsemane* (fig. 8-52) shows Christ being comforted by
the angel of the Lord. Below, Christ admonishes Peter and the
sleeping disciples, who appear enclosed by the mountain behind
them in order to present the two events in a single image. Even
more important than the striking composition is the attention paid
to the figures, each of which is far more individualized than ever
before. The artist's growing ability to investigate subtleties of char-
acterization and pose marks the progress of Byzantine art.

IVORIES. Monumental sculpture, as we saw earlier (page 242),
tended to disappear completely from the fifth century on. In
Byzantine art, large-scale statuary died out with the last imperial
portraits, and stone carving was confined almost entirely to archi-
tectural ornament (see fig. 8-35). But small-scale reliefs, especially
in ivory and metal, continued to be produced in large numbers.

Their extraordinary variety of content, style, and purpose is
suggested by the two examples shown here, both of which date
from the tenth century. One is *The Harbaville Triptych,* a portable
shrine with two hinged wings of the kind a high official might
carry for his private worship while traveling (fig. 8-53). In the
upper half of the center panel we see Christ Enthroned. On either
side are St. John the Baptist and the Virgin, who plead for divine
mercy on behalf of humanity. Below is John the Baptist, flanked
by the four apostles arranged in strictly frontal view. Only in the
upper tier of each wing is this formula relaxed. There we find an
echo of Classical contrapposto in the poses of the two inner mili-
tary saints. The exquisite refinement of this icon-in-miniature
recalls the style of the Daphné *Crucifixion* (see fig. 8-49).

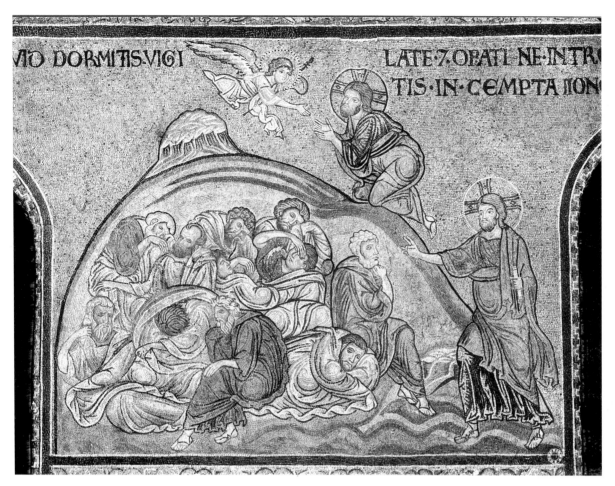

8-52. *Christ in the Garden of Gethsemane.* c. 1183. Mosaic. Cathedral, Monreale, Italy

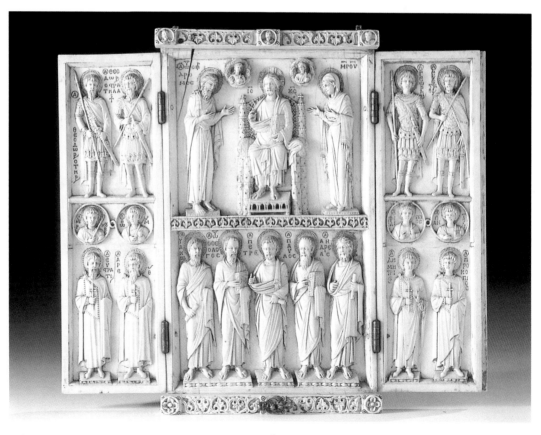

8-53. *The Harbaville Triptych.* Late 10th century. Ivory, 9½ x 11" (24.1 x 28 cm). Musée du Louvre, Paris

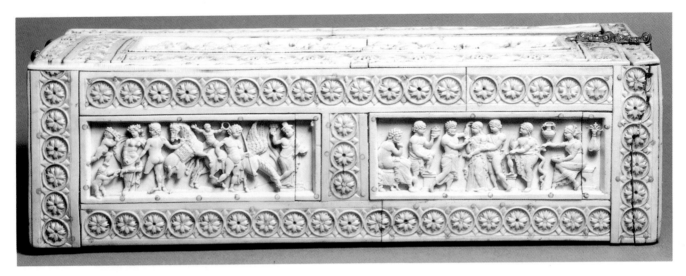

8-54. *The Veroli Casket.* 10th century. Ivory.

Our second example, slightly later in date, is the *Veroli Casket* (fig. 8-54), which was a wedding gift. Rather surprisingly, it is decorated with scenes of Greek mythology. Even more than the miniatures of the *Paris Psalter,* it reveals the antiquarian aspects of Byzantine classicism after the Iconoclastic Controversy. The subjects in the left panel—Helen and Castor, and Belerophon and the Nymph of Peirene—come from the world of mythology. The Sacrifice of Iphigenia in the right panel was derived from a famous drama by the Greek playwright Euripides (see box pages 114–115; Greek Theater). The panel shows a major change in style that features deep undercutting of the relief. But the composition nevertheless remains curiously shallow, and probably comes from an illustrated manuscript. Although quoted from ancient art, these knobby little figures, with their distinctive grape-cluster hair, are drained of all tragic emotion and reduced to a level of ornamental playfulness reflecting courtly taste.

Late Byzantine Painting

In 1204 Byzantium suffered an almost fatal defeat when the armies of the Fourth Crusade captured and sacked the city of Constantinople, instead of warring against the Turks. For more than 50 years, the core of the Eastern Empire remained in Western hands. Byzantium, however, survived this catastrophe. In 1261 it regained its independence under Michael VII, who established the Palaeologue dynasty, which lasted until the Turkish conquest in 1453. The fourteenth century saw a last flowering of Byzantine painting under these enlightened rulers.

ICONS. The Crusades decisively changed the course of Byzantine art through contact with the West. The impact can be seen in the *Madonna Enthroned* (fig. 8-55), which unites elements of both, so that its authorship has been much debated. Because of the

COVENANTS OLD AND NEW

By convention Western history is divided into two epochs separated by the birth of Jesus: B.C. (Before Christ) and A.D. (*Anno Domini,* "year of our Lord"), also called C.E. (Christian Era). To Christians, these periods correspond to the Old and New Testaments. Consequently they are also known as the Old Dispensation, which is the Covenant of the Ark, and the New Dispensation, the covenant represented by the cup of wine at the Last Supper, when Jesus said, "This is my blood of the new testament, which is shed for many." The Christian era is often termed the time of grace *(tempus gratia),* in contrast to the time of God's law as received by Moses *(tempus legem).*

The Covenant of the Ark bound the Israelites to worship Yaweh as their only god in exchange for being his chosen people. The ark consisted of the two tablets containing the Ten Commandments given to Moses on Mount Sinai; hence the Covenant of the Ark is also called the Covenant of Sinai. The ark resided at Shiloh in Canaan, the Promised Land, until it was brought by King David to Jerusalem, where it was later placed inside the tabernacle of the temple built by King Solomon. To many Christians, Jesus was the sacrificial lamb whose death atoned for the violation of the old covenant by the Jews, which it therefore replaced. To Muslims, Islam adds the Last Covenant, made between Muhammad and God, as revealed in the Koran.

(OPPOSITE) 8-55. *Madonna Enthroned.* Late 13th century. Tempera on panel, 32⅛ x 19⅜" (81.9 x 49.3 cm). National Gallery of Art, Washington, D.C.

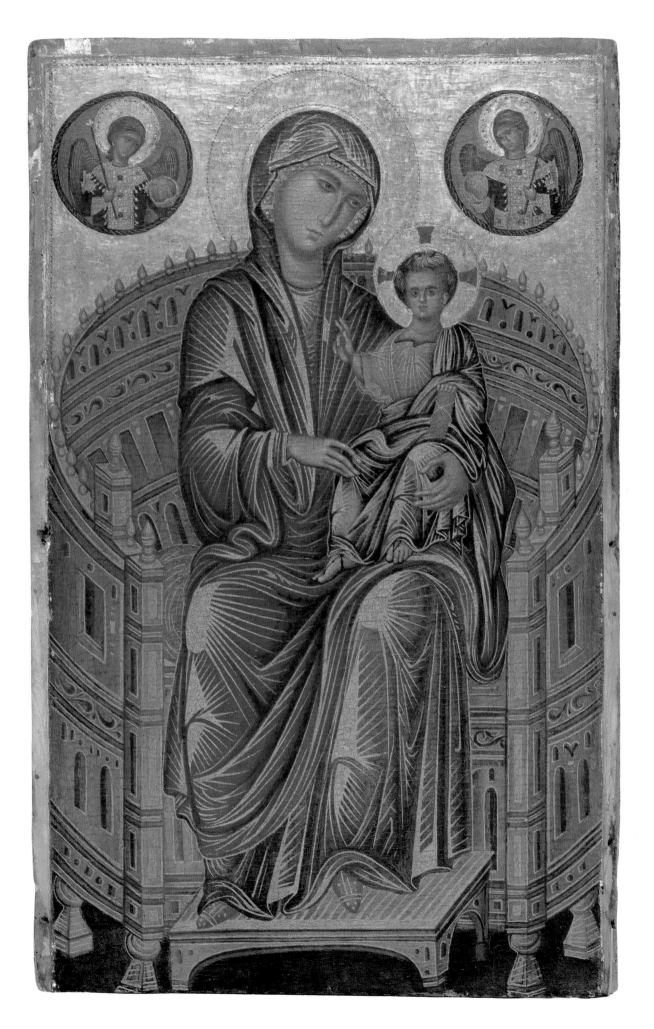

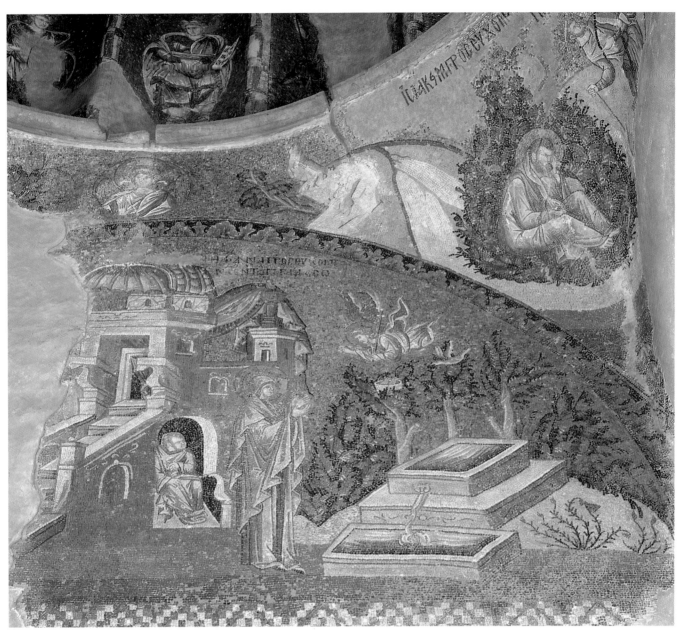

8-56. *Elizabeth at the Well*. c. 1310. Mosaic. Kariye Camii (Church of the Savior in the Chora Monastery), Istanbul

veneration in which they were held, icons had to conform to strict rules, with fixed patterns repeated over and over again. As a result, most of them are noteworthy more for exacting craftsmanship than artistic inventiveness. Although painted at the end of the thirteenth century, our example reflects a much earlier type. There are echoes of Middle Byzantine art in the graceful pose, the play of drapery folds, and the tender melancholy of the Virgin's face. But these elements have become abstract, reflecting a new taste and style. The highlights on the drapery resemble sunbursts, in contrast to the soft shading of hands and faces. The total effect is neither flat nor spatial but transparent, so that the shapes look as if they were lit from behind. Indeed, the gold background and highlights are so brilliant that even the shadows never seem wholly opaque. This all-pervading radiance, we will recall, first appears in Early Christian mosaics. Panels such as this may therefore be viewed as the aesthetic equivalent of mosaics, and not simply as the descendants of the panel-painting tradition. In fact, some of the most precious

Byzantine icons are miniature mosaics attached to panels, and our artist may have been trained as a mosaicist rather than as a painter.

The style, then, is Late Byzantine, but with an Italian overlay—for example in the treatment of the faces—that is hard to explain. The elaborate throne, which looks like a miniature replica of the Colosseum (see fig. 7-10), no longer functions as a three-dimensional object, despite the foreshortening. The panel must have been painted by a Byzantine artist, not simply a Westerner trained in that tradition. However, this master may have worked for a Western patron or in a Byzantine center under European control. (Cyprus, then ruled by the French, has been suggested.) Most likely, our painter had visited Italy or been active there, perhaps in Rome or Tuscany, where a neo-Byzantine style was well established (see page 364). Whatever position we adopt points to a profound shift in the relation between the two traditions: after 600 years of borrowing from Byzantium, Western art for the first time began to contribute something in return.

MOSAICS AND MURAL PAINTING. The finest surviving cycles of Late Byzantine mosaics and paintings are found in Istanbul's Kariye Camii, the former Church of the Savior in the Chora Monastery. (*Chora* means "land" or "place"; *camii* denotes a mosque, although the site is now a museum.) They represent the climax of the humanism that emerged in Middle Byzantine art. Like Constantine VII, Theodore Metochites, prime minister to the emperor Andronicus II, was a scholar and poet, who restored the church and paid for its decorations. *Elizabeth at the Well* (fig. 8-56) shows the growing Byzantine fascination with storytelling. The legend, a prefiguration of the Annunciation (see box page 246), is one of many that arose around this time about the lives of the Virgin, Jesus, and their family. Here the angel of the Lord informs the mother of John the Baptist, Mary's kinswoman, that she will bear a child. As part of this lively narrative, the setting has blossomed into a full landscape, complete with illusionistic architecture. The scene revives a landscape style that had flourished in sixth-century secular mosaics and then was all but lost. Its illusionism, familiar to us from Pompeian painting, had somehow been preserved in manuscripts of the classical revival of the tenth century (compare fig. 8-48).

Equally impressive are the paintings in the mortuary chapel attached to Kariye Camii. Because of the empire's greatly reduced resources, murals often took the place of mosaics, but at Kariye Camii they exist on an even footing and may even have been designed by the same artist. Figure 8-57 shows the *Anastasis* (Resurrection) in the mortuary chapel. (The term means both "to rise" and "to raise.") To either side are Resurrection miracles: The Raising of the Widow's Son on the left and The Raising of the Daughter of Jairus to the right. The main scene depicts the traditional Byzantine image of the Anastasis, which Western Christians call Christ's Descent into Limbo, or the Harrowing of Hell. Surrounded by a radiant mandorla, the Savior has vanquished Satan and battered down the gates of Hell. (Note the bound Satan at his feet, in the midst of a profusion of hardware; the two kings to the left are David and Solomon.) What amazes us about the central group of Christ raising Adam and Eve from the dead is its dramatic force, a quality we would not expect from what we have seen of Byzantine art so far. Christ here moves with extraordinary physical energy, tearing Adam and Eve from their graves, so that they appear to fly through the air—a magnificently expressive image of divine triumph. Such dynamism had been unknown in the earlier Byzantine tradition. This style, which was related to slightly earlier developments in manuscript painting, was indeed revolutionary. Coming in the fourteenth century, it shows that eight hundred years after Justinian, when the subject first appeared, Byzantine art still had all its creative powers.

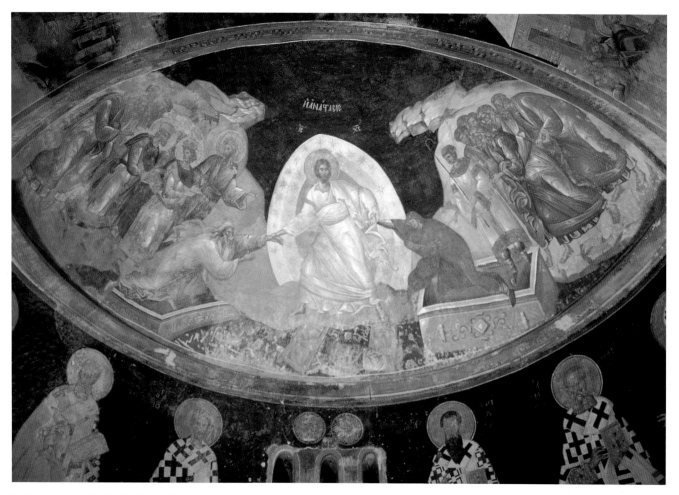

8-57. *Anastasis.* c. 1310–20. Fresco. Kariye Camii (Church of the Savior in the Chora Monastery), Istanbul

CHAPTER NINE
Early Medieval Art

Once established, the labels used for historical periods are almost impossible to change, even though they may no longer be suitable. The humanists who coined the term *Middle Ages* thought of the entire thousand years from the fifth to the fifteenth century as an age of darkness: an empty interval between classical antiquity and its rebirth, the Renaissance in Europe (see pages 222–225). Since then, our view of this period has changed completely. We now think of it as a time of great cultural change and creative activity. During the 200 years between the death of Justinian and the reign of Charlemagne, the center of gravity of European civilization shifted northward from the Mediterranean Sea. At the same time, the economic, political, and spiritual framework of the Middle Ages began to take shape. These two centuries also gave rise to some important artistic achievements.

The Celtic-Germanic Style

THE ANIMAL STYLE. The Germanic kingdoms that rose to power after the fall of the Roman empire in 476 A.D. were the result of widespread migrations during the previous 100 years. The period after Constantine's death in 337 saw the gradual erosion of imperial power in the West, although stability was briefly restored under Valentinian (364–375). In 376 the Huns, who had advanced beyond the Black Sea from Central Asia, became a serious threat to Europe. They pushed the Germanic Visigoths westward into the Roman empire from the Danube. Then, in 451, under Attila (died 453), they invaded Gaul, homeland of the Celts in southwest Germany and eastern France. A year later they attacked Rome, which had been sacked by the Visigoths in 410. The last Western emperor, Romulus Augustus, was overthrown by the German king Odoacer only 66 years later. Also in the fifth century, the Angles and Saxons from today's Denmark and northern Germany invaded the British Isles, which had been colonized for centuries by Celts (see page 47). The Germanic peoples carried with them, in the form of nomads' gear, the artistic tradition known as the animal style (see pages 84–86). The animal style merged with the intricate ornamental metalwork of the Celts, which had previously been affected by it (see fig. 1-22). Out of this union came Celtic-Germanic art, with its unique combination of abstract and organic shapes, of formal discipline and imaginative freedom.

An excellent example of this "heathen" style is the gold-and-enamel purse cover (fig. 9-1) from the ship burial at Sutton Hoo on the east coast of England of an Anglian king (almost certainly Raedwald, who died around 625). On it are four pairs of symmetrical motifs. Each has its own distinctive character, an indication that they were assembled from different sources. One, the standing man between facing animals, has a very long history indeed. We first saw it in Mesopotamian art more than 3,200 years earlier (see fig. 3-9), and it is even older than that. The eagles pouncing on ducks brings to mind similar pairings of carnivore and victim in ancient bronzes. The design above them, at the center, is of more recent origin. It consists of fighting animals whose tails, legs, and jaws are elongated into bands that form a complex interweaving pattern. The fourth, on the top left and right, uses interlacing bands as an ornamental device. This motif occurs in Roman and Early Christian art, especially along the southern shore of the Mediterranean. However, the combination of these bands with the animal style, as shown here, seems to be an invention of Celtic-Germanic art not long before our purse cover.

The chief medium of the animal style had been metalwork, in a variety of materials and techniques and sometimes of exquisitely refined craftsmanship. Such articles, small, durable, and eagerly sought after, account for the rapid diffusion of its repertory of forms. They spread not only geographically but also artistically: from metal into wood, stone, and even paint. We also know from literary accounts that gold objects were plentiful. Since nothing else like it from the same period has been found elsewhere in England, it is far from clear whether the Sutton Hoo purse was made locally or, like Scythian gold (see page 86), was of foreign origin, as were most of the luxury goods from the same mound.

Ship burials like those at Sutton Hoo and nearby Snape first began in Scandinavia, where the animal style flourished longer than anywhere else and where most wooden items have been found. The splendid animal head of the early ninth century in figure 9-2 is the decorated end of a post recovered from a buried Viking ship at Oseberg in southern Norway. Snarling monsters

9-1. Purse cover, from the Sutton Hoo ship burial. 625–33 A.D. Gold with garnets and enamels, length 8" (20.3 cm). The British Museum, London

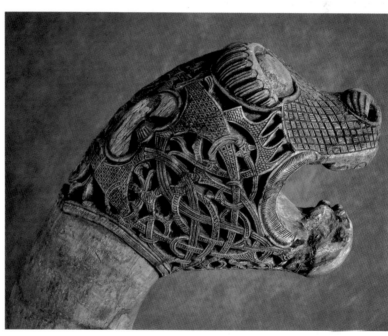

9-2. *Animal Head,* from the Oseberg ship burial. c. 825 A.D. Wood, height approx. 5" (12.7 cm). Institute for Art History and Classical Archaeology, University of Oslo, Norway

such as this used to rise from the prows of Viking ships, which gave them the character of mythical sea dragons. Like the Sutton Hoo purse cover, it is composed of different motifs. The basic shape of the head is surprisingly realistic, as are such details as the teeth, gums, and nostrils. But the surface is covered with interlacing and geometric patterns derived from metalwork.

The Hiberno-Saxon Style

During the early Middle Ages, the Irish (Hibernians) were the spiritual and cultural leaders of western Europe. In fact, the period from 600 to 800 A.D. deserves to be called the Golden Age of

Ireland. Unlike their English neighbors, the Irish had never been part of the Roman empire. Thus the missionaries who carried the Gospel to them from England in the fifth century found a Celtic society that was barbarian by Roman standards. The Irish readily accepted Christianity, which brought them into contact with Mediterranean civilization. However, they adapted what they had received in a spirit of vigorous local independence.

Because it was essentially urban, the institutional framework of the Roman Church was poorly suited to the rural Irish way of life. Irish Christians preferred to follow the example of the desert saints of Egypt and the Near East, who had left the temptations of the city to seek spiritual perfection in the solitude of the wilder-

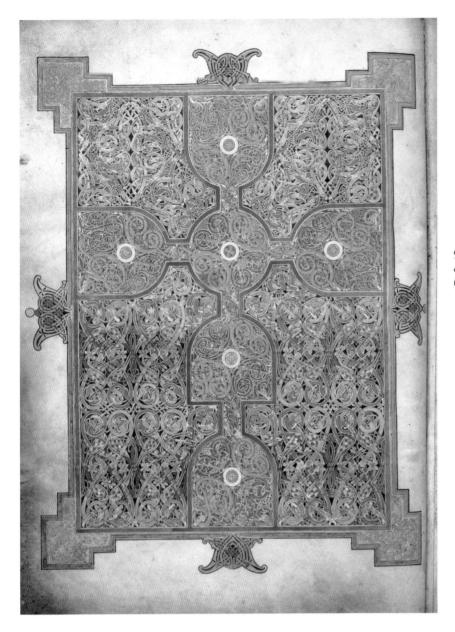

9-3. Cross page, from the *Lindisfarne Gospels*. c. 700 A.D. Tempera on vellum, 13½ x 9¼" (34.3 x 23.5 cm). The British Library, London

ness, where groups of them founded the earliest monasteries (see pages 299–300). By the fifth century, monasticism had spread as far north as western Britain, but only in Ireland did the monks take over the leadership of the Church from the bishops.

Irish monasteries, unlike their Egyptian models, soon became centers of learning and the arts. In the words of the historian Thomas Cahill, they saved civilization by taking up "the great task of copying all of Western literature—everything they could lay their hands on," except for those volumes available only in Byzantium. They also sent monks to preach to the heathen and to found monasteries not only in northern Britain but also on the European mainland, from present-day France to Austria. These Irish monks speeded the conversion of Europe north of the Alps to Christianity. Furthermore, they made the monastery a cultural center throughout the European countryside. The monasteries on the Continent were soon taken over by the monks of the Benedictine order, who were advancing north from Italy during the seventh and eighth centuries. Even so, Irish influence was felt in medieval civilization for several hundred years.

MANUSCRIPTS AND BOOK COVERS. In order to spread the Gospel, the Irish monasteries had to produce copies of the Bible and other Christian books in large numbers. Their **scriptoria** (writing workshops) also became artistic centers. A manuscript containing the Word of God was looked upon as a sacred object whose beauty should reflect the importance of its contents. Irish monks must have known Early Christian illuminated manuscripts, but here, too, they developed an independent tradition instead of simply copying their models. While pictures illustrating biblical events held little interest for them, they devoted much effort to abstract decoration. The finest of these manuscripts belong to the Hiberno-Saxon style—a Christian form that evolved from heathen Celtic-Germanic art and flourished in the monasteries founded by Irishmen in Saxon England.

Thanks to a later colophon (inscription), we know a great deal about the origin of the *Lindisfarne Gospels,* including the names of the translator and the scribe, who presumably painted the illuminations as well. [See Primary Sources, no. 19, page 386.] The Cross page (fig. 9-3) is a creation of breathtaking complexity. Working

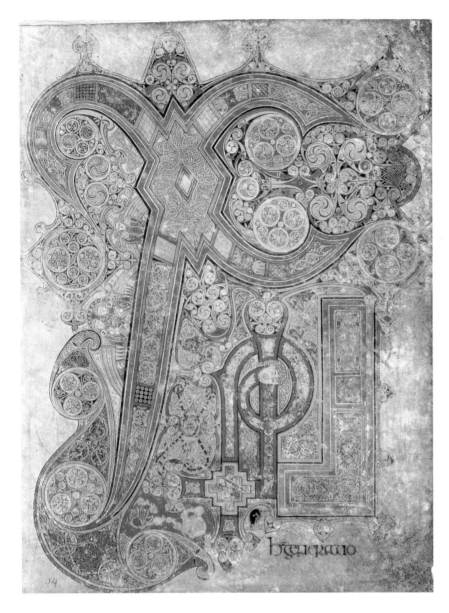

9-4. Chi Rho page, from the *Book of Kells*.
c. 800 A.D.? 13 x 9½" (33 x 24.1 cm).
Trinity College Library, Dublin

with the precision of a jeweler, the miniaturist has poured into the geometric frame an animal interlace so dense and yet so full of movement that the fighting beasts on the Sutton Hoo purse cover seem simple in comparison. It is as if these biting and clawing monsters had been subdued by the power of the Cross. In order to achieve this effect, our artist had to work within a severe discipline by exactly following "rules of the game." These rules demand, for instance, that organic and geometric shapes be kept separate. Within the animal compartments, every line must turn out to be part of an animal's body. There are other rules concerning symmetry, mirror-image effects, and repetitions of shapes and colors. Only by working these out through intense observation can we enter into the spirit of this mazelike world.

What was the origin of this complex style? From the beginning, Celtic art had favored a form of organic abstraction based mainly on plant motifs. This vocabulary was greatly enlarged during the later fourth century B.C. by Etruscan and other Italian artisans working for Celtic patrons. Many of the new forms were derived from Classical Greece. The vegetal style spread rapidly throughout the Celtic realm, where it became thoroughly integrated with existing motifs. It was subjected to a strict discipline using the compass, which continued to be employed in Britain long after it was abandoned on the Continent. Yet nothing in earlier Celtic art prepares us for the elaboration found in Hibernian manuscripts, despite the persistence of plantlike forms.

The Irish manuscript style reached its climax a hundred years after the *Lindisfarne Gospels* in the *Book of Kells,* the most elaborate codex of Celtic art. Once called "the chief relic of the Western world," it was made at the monastery on the island of Iona and left incomplete when the island was invaded by Vikings between 804 and 807. Its many pages reflect a wide array of influences from the Mediterranean to the English Channel. The famous Chi Rho monogram (standing for Christ; fig. 9-4) has much the same swirling design as the Cross page from the *Lindisfarne Gospels*. But now the rigid geometry has been relaxed somewhat and, with it, the ban on images of humans. The top of the X-shaped Chi sprouts a thoroughly recognizable face, while along its shaft are three winged angels. And in a touch of enchanting fantasy,

the tendril-like P-shaped Rho ends in a monk's head. More surprising still is the introduction of the natural world. Nearly hidden in the ornamentation, as if playing a game of hide-and-seek, are cats and mice, butterflies, even otters catching fish. No doubt they perform some symbolic function in order to justify their presence. Their appearance here is nevertheless astounding.

Of the images in Early Christian manuscripts, the Hiberno-Saxon illuminators retained only the symbols of the four evangelists, since they could be readily translated into their ornamental style. These symbols—the man (St. Matthew), the lion (St. Mark), the ox (St. Luke), and the eagle (St. John)—were derived from the Revelation of St. John the Divine and assigned to the evangelists by St. Augustine. The lion of St. Mark in the *Echternach Gospels* (fig. 9-5), sectioned and patterned like the enamel inlays of the Sutton Hoo purse cover, is "animated" by the same curvilinear sense of movement we saw in the Chi Rho page. Here again we see the masterly balance between the shape of the animal and the geometric framework (which includes the inscription *imago leonis*, "image of lion"). Thus tamed, as if caged within the manuscript page, he is a worthy successor to the magnificent beasts in Assyrian lion hunts (compare fig. 3-20).

However, Celtic and Germanic artists showed little interest in the human figure for a long time. The bronze plaque of the *Crucifixion* (fig. 9-6), probably made for a book cover, emphasizes flat patterns, even when dealing with images of men. Although the composition is Early Christian in origin, the artist has treated the human form as a series of ornamental compartments. The figure of Jesus is disembodied in the most literal sense: the head, arms, and feet are all separate elements joined to a central pattern of whorls, zigzags, and interlacing bands. Most fascinating of all are the faces: they hardly differ from those found on Celtic bronzes of fully 1,200 years earlier! Clearly there is a wide gulf between the Celtic-Germanic and the Mediterranean traditions, a gulf that the Irish artist who modeled the Crucifixion saw no need to bridge. The situation was much the same in the rest of Europe during the early Middle Ages. Even the French and the Lombards in northern Italy did not know what to do with human images. The problem was finally solved by Carolingian artists drawing on the Byzantine tradition, with its roots in classical art.

The Lombard Style

The Germanic sculptor who carved the marble balustrade relief in the Cathedral Baptistery at Cividale (fig. 9-7) was just as perplexed as the Irish by the problem of representation. The evangelists' symbols are strange creatures indeed. All four of them consist of nothing but head, wings, spidery legs, and (except for the

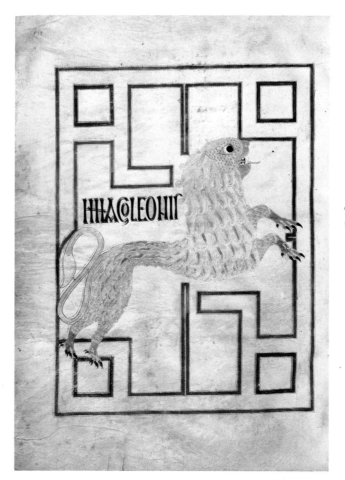

9-5. *Symbol of St. Mark*, from the *Echternach Gospels*. c. 690 A.D. 12¾ x 10⅜" (32.4 x 26.4 cm). Bibliothèque Nationale, Paris

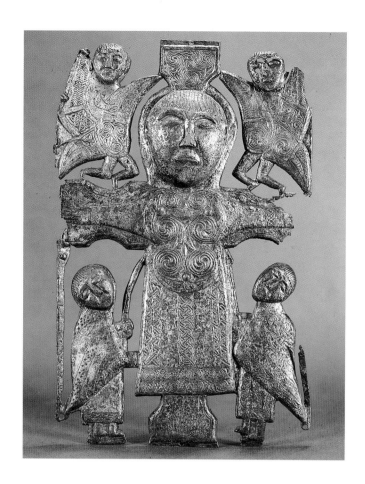

9-6. *Crucifixion,* plaque from a book cover (?). 8th century A.D. Bronze, height 8¼" (21 cm). National Museum of Ireland, Dublin

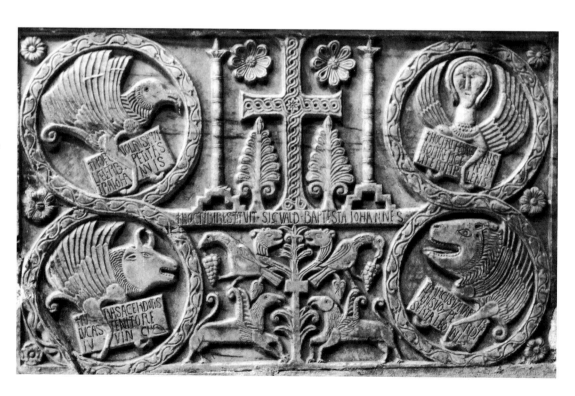

9-7. Balustrade relief inscribed by the Patriarch Sigvald (762–76 A.D.), probably carved c. 725–50 A.D. Marble, approx. 36 x 60" (91.3 x 152.3 cm). Cathedral Baptistery, Cividale, Italy

angel) a little spiral tail. Apparently the artist did not mind forcing them into their circular frames to create this bit of visual shorthand. On the other hand, the panel has a well-developed sense of ornament. The flat, symmetrical pattern is an effective piece of decoration, rather like an embroidered cloth. It may, in fact, have been derived in part from Oriental or Byzantine textiles.

CAROLINGIAN ART

The cultural achievements of Charlemagne's reign have proved far more lasting than his empire, which began to fall apart even before his death in 814. Indeed, this very page is printed in letters whose shapes are derived from the script in Carolingian manuscripts. The fact that these letters are known today as Roman rather than Carolingian recalls another aspect of the cultural reforms sponsored by Charlemagne: the collecting and copying of ancient Roman literature. The oldest surviving texts of many classical Latin authors are found in Carolingian manuscripts, which were long mistakenly considered Roman. Hence their lettering, too, was called Roman.

This interest in preserving the classics was part of a larger reform program to improve the education of the court and the clergy. Charlemagne's goals were to improve the administration of his realm and the teaching of Christian truths. He summoned the best minds to his court, including Alcuin of York, the most learned scholar of the day, to restore ancient Roman learning and to establish a system of schools at every cathedral and monastery. The emperor, who could read but not write, took an active hand in this renewal, which went well beyond mere antiquarianism. He wanted to model his rule after the empire under Constantine and Justinian—not their pagan predecessors. To a great extent he succeeded. Thus the Carolingian revival may be termed the first, and in some ways most important, phase of a fusion of the Celtic-Germanic spirit with the heritage of the Mediterranean world.

Architecture

The word *architect* is derived from the Greek word for master builder and was defined in its modern sense of designer and theoretician by the Roman writer Vitruvius during the first century A.D. In the Middle Ages, however, it came to have different meanings. During the eighth century the distinction between design and construction—between theory and practice—became blurred. As a result, the term had nearly disappeared in northern Europe by the tenth century, and was replaced by a new vocabulary, in part because the building trades were strictly separated under the guild system. When it was used, architect could apply not only to masons, carpenters, and even roofers, but also to the person who commissioned or supervised a building. We know that in some instances the head abbot of a community of monks was the actual designer. As a result, the design of churches became increasingly subordinate to liturgical and practical considerations. Their actual appearance, however, was largely determined by an organic construction process. Roman architectural principles and construction techniques, such as the use of cement, had been largely forgotten. They were recovered only through cautious experimentation by builders, who were inherently conservative. Thus vaulting remained simple and was limited to short spans, mainly over aisles, if it was used at all.

Not until about 1260 did the theologian Thomas Aquinas revive Aristotle's definition of an architect as the person who leads, as opposed to the artisan who makes. In doing so, he acknowledged a change that had occurred over the previous 150 years. During that time, the concept of *architectus* had been rediscovered, thanks to the widespread copying of Vitruvius' ten books on architecture. However, it now had a different meaning, since architecture itself remained in the hands of master builders. The stimulus may have been provided by the Crusades, which brought Westerners into contact with Byzantium, with its great libraries, as well as with Saracen architects, then among the most advanced in the world. Within a century the term *architect* was used by the humanist Petrarch to refer to the artist in charge of a project. He thus acknowledged what had become established practice in Florence, where first the painter Giotto and then the sculptors Andrea Pisano and Francesco Talenti were placed in charge of Florence Cathedral (see page 343).

GUILDS: MASTERS AND APPRENTICES

In the Middle Ages, the word "master" (Latin, *magister*) was a title conferred by a trade organization, or guild, on a member who had achieved the highest level of skill in the guild's profession or craft. In each city, trade guilds virtually controlled commercial life by establishing quality standards, setting prices, defining the limits of each guild's activity, and overseeing the admission of new members. The earliest guilds were formed in the eleventh century by merchants. Soon, however, craftsmen also organized themselves in similar professional societies, whose power continued well into the sixteenth century. Most guilds admitted only men, but some, such as the painters guild of Bruges, occasionally admitted women as well. Guild membership established a certain level of social status for townspeople, who were neither nobility, clerics (people in religious life), nor peasantry.

A boy would begin as an apprentice to a master in his chosen guild, and after many years might advance to the rank of journeyman. In most guilds this meant that he was then a full member of the organization, capable of working without direction, and entitled to receive full wages for his work. Once he became a master, the highest rank, he could direct the work of apprentices and manage his own workshop, hiring journeymen to work with him.

In architecture, the master mason (sometimes called master builder) generally designed the building, that is, acted in the role of architect. In church-building campaigns, teams of masons, carpenters (joiners), metalworkers, and glaziers (glassworkers) labored under the direction of the master builder.

THE PALACE CHAPEL, AACHEN. The achievement of Charlemagne's Palace Chapel (figs. 9-8, 9-9, and 9-10) is all the more spectacular when seen in this light. On his visits to Italy, beginning with his son Pepin's baptism by Pope Hadrian in 781, Charlemagne had become familiar with the monuments erected by Constantine in Rome and Justinian in Ravenna. Charlemagne felt that his new capital at Aachen (Aix-la-Chapelle; the site was chosen for its mineral baths) must convey the majesty of empire through buildings of an equally imposing kind. To signify Charlemagne's position as a Christian ruler, his palace complex was modeled on the Lateran Palace in Rome, which had been given by Constantine to the pope. Charlemagne's palace included a basilica, the Royal Hall, which was linked to the Palace Chapel. The chapel itself was inspired in equal measure by the Lateran baptistery and S. Vitale (see figs. 8-24–8-27). The debt to the latter is especially clear in cross section (compare fig. 9-10 to fig. 8-26). To construct such a building on Northern soil was a difficult undertaking, which was supervised by Einhard, Charlemagne's trusted adviser and biographer. Columns and bronze gratings had to be imported from Italy, and expert stonemasons must have been hard to find.

The design is by Odo of Metz (probably the earliest architect north of the Alps known to us by name). It is by no means a mere echo of S. Vitale but a vigorous reinterpretation. The piers and vaults have an impressive massiveness, while the geometric clarity of the spatial units is very different from the fluid space of the earlier structure. These features, which are found in French buildings of the previous century, are a distinctly Northern variant of Roman architecture.

Equally important is Odo's scheme for the western entrance, now largely obscured by later additions and rebuilding (see fig. 9-8). At S. Vitale, the entrance consists of a broad, semidetached narthex with twin stair turrets, placed at an odd angle to the main axis of the church (see fig. 8-25). At Aachen, these elements have been molded into a tall, compact unit, in line with the main axis and attached to the chapel itself. This monumental structure, known as a **westwork** (from the German *Westwerk*), makes one of its first appearances here. It was originally flanked by a pair of round towers, thus anticipating the facade found on so many later medieval churches (compare fig. 9-21).

Charlemagne's throne was placed in the tribune, as the gallery of the westwork is often called, behind the great opening (later glassed in) above the entrance; there he could emerge into the view of people assembled in the atrium below. The throne faced an altar dedicated to Christ, who blesses the emperor from the dome mosaic. Thus, although contemporary documents say very little about its function, the westwork seems to have served initially as a royal loge or chapel. However, both here and elsewhere, it may have been used for other purposes as the need arose.

CORVEY. An even more elaborate westwork formed part of the greatest basilican church of Carolingian times, that of the monastery of St.-Riquier (also called Centula), near Abbeville in northeastern France. Named for a monk who died in 645, it was established in 790 by Abbot Angilbert, a poet and scholar close to Charlemagne whose nickname at the court was Homer. The monastery has been

9-8. Entrance, Palace Chapel of Charlemagne, Aachen, Germany. 792–805 A.D.

destroyed, but its design is known from drawings and descriptions. Several innovations in the church became of basic importance for the future. The westwork led into a vaulted **narthex**, which was in effect a western **transept**. Its crossing (the area where the transept intersects the nave) was crowned by a tower, as was the **crossing** of the eastern transept. Both transepts, moreover, featured a pair of round stair towers. The church, one of three within the monastery, had several altars that were used at different stages of the worship service, as described by Angilbert himself. [See Primary Sources, nos. 20–21, page 387, and accompanying illustration.] The monks followed *The Rule* established by St. Benedict of Nursia. [See Primary Sources, no. 22, page 387.]

St.-Riquier was widely imitated in other Carolingian monastery churches, but these, too, have been destroyed or rebuilt in later times. The best preserved is the abbey church at Corvey (figs.

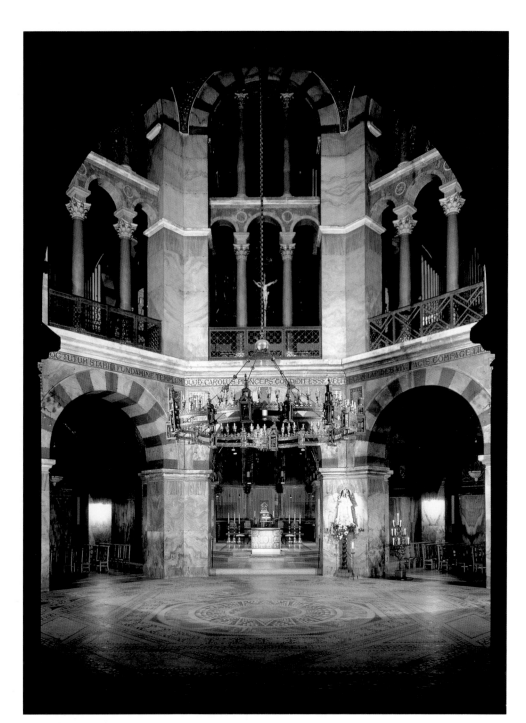

9-9. Interior of the Palace Chapel of Charlemagne, Aachen

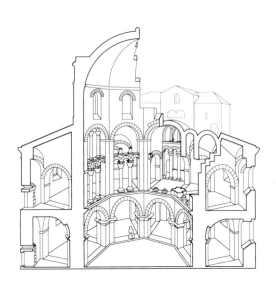

9-10. Cross section of the
Palace Chapel of Charlemagne (after Kubach)

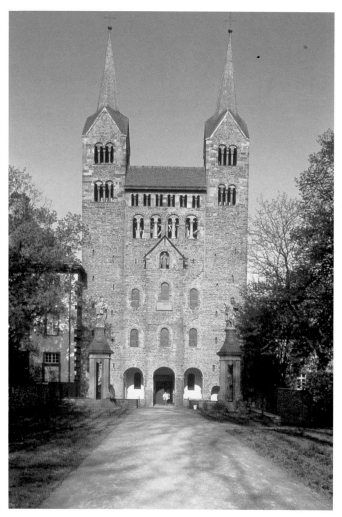

9-11. Facade, Abbey Church, Corvey, Germany.
Late 9th century A.D., with later additions

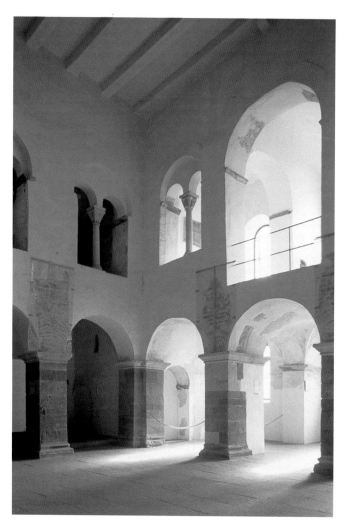

9-12. Western Tribune, Abbey Church, Corvey

9-11 and 9-12), built in 873–85. Except for the upper stories, which date from around 1146, the westwork retains much of its original appearance. Even without these additions, it provided a suitably regal entrance. It is impressive not only because of its height but also because of its plain surfaces, which emphasize the clear geometry and powerful masses of the exterior. This wonderful simplicity is continued inside the church. Our view of the tribune shows the understated eloquence of Carolingian architecture at its finest. The east end of the church, now much changed, is also important for anticipating the apses with **radiating chapels** and **ambulatories** found on Romanesque churches (compare fig. 10-1).

PLAN OF A MONASTERY, ST. GALL. The importance of monasteries and their close link with the imperial court are suggested by a unique document of the period, a large drawing on five sheets of vellum of a plan for a monastery that is preserved in the chapter library at St. Gall in Switzerland (fig. 9-13, page 280). Its basic features seem to have been determined at a council held near Aachen in 816–17 that established the Benedictines as the official

order under the Carolingians. This copy was then sent by Abbot Haito of Reichenau, an island in Lake Constance, to Gozbert, the abbot of St. Gall, for "you to study only" in rebuilding the monastery. We may therefore regard it as a standard plan, intended to be altered to meet local needs.

The monastery plan shows a complex, self-contained unit filling a rectangle about 500 by 700 feet. The main path of the entrance, from the west, passes between stables and a hostelry toward a gate. Here the visitor is admitted to a colonnaded semicircular **portico** (porch) flanked by two round towers—an early example of a westwork—that would have loomed above the low outer buildings. The plan emphasizes the church as the center of the monastic community. The church is a basilica, with an apse at each end. The nave and aisles, which contain many other altars, do not form a single continuous space but are subdivided into compartments by screens. There are numerous entrances: two beside the western apse, others on the north and south flanks.

This arrangement reflects the functions of a monastery church, which was designed for the liturgical needs of the monks

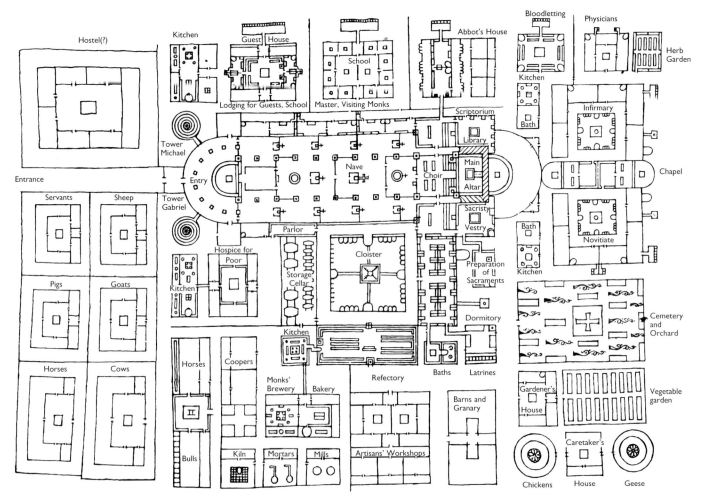

Hostel(?)

Kitchen

Guest House

School

Abbot's House

Bloodletting

Physicians

Herb Garden

Lodging for Guests, School

Master, Visiting Monks

Kitchen

Entrance

Tower Michael

Scriptorium

Infirmary

Library

Nave

Main Altar

Choir

Chapel

Entry

Tower Gabriel

Servants

Sheep

Sacristy

Vestry

Bath

Parlor

Cloister

Preparation of Sacraments

Novitiate

Hospice for Poor

Kitchen

Storage Cellar

Pigs

Goats

Kitchen

Dormitory

Cemetery and Orchard

Horses

Cows

Horses

Coopers

Kitchen

Monks' Brewery

Bakery

Refectory

Baths

Latrines

Gardener's House

Vegetable garden

Bulls

Kiln

Mortars

Mills

Artisans' Workshops

Barns and Granary

Caretaker's House

Chickens

House

Geese

9-13. Plan of a monastery. Redrawn, with inscriptions translated into English from the Latin, from the original of c. 820 A.D. Red ink on parchment, 28 x 44⅛" (71.1 x 112.1 cm). Stiftsbibliothek, St. Gall, Switzerland

rather than for a lay congregation. Adjoining the church to the south is an arcaded **cloister,** around which are grouped the monks' dormitory (on the east side), a refectory (dining hall) and kitchen (on the south side), and a cellar. The three large buildings north of the church are a guest house, a school, and the abbot's house. To the east are the infirmary, a chapel and quarters for novices (new members of the community), the cemetery (marked by a large cross), a garden, and coops for chickens and geese. On the south side are workshops, barns, and other service buildings. There is no monastery exactly like this plan anywhere—even in St. Gall the design was not carried out as drawn. Yet the plan gives us a good idea of the layout of monasteries throughout the Middle Ages. [See Primary Sources, no. 22, page 387.]

SPAIN. Outside of Germany, most early medieval churches were small in size, simple in plan, and provincial in style. The best examples, which are in Spain, owe their survival to their remote locations. Sta. Maria de Naranco (fig. 9-14) was built by Ramiro I about 848 as part of his palace near Oviedo. Like Charlemagne's Palace Chapel, it is an audience hall and chapel (it even included baths) but on a much more modest scale. Remarkably, it features a tunnel vault along the upper story and arcaded loggias at either

end that were clearly inspired by the interior of the Palace Chapel (see fig. 9-9). The construction, however, is more primitive. It was built of crudely carved, irregular blocks instead of the dressed masonry (called ashlar) found at Aachen. We need only glance at S. Apollinare in Classe (see fig. 8-13) to realize how much of the architectural past had been lost in only 300 years.

Manuscripts and Book Covers

THE GOSPEL BOOK OF CHARLEMAGNE. The fine arts played an important role in Charlemagne's cultural program from the very start. We know from literary sources that Carolingian churches contained murals, mosaics, and relief sculpture, but these have disappeared almost entirely. Illuminated manuscripts, carved ivories, and goldsmiths' work, on the other hand, have survived in considerable numbers. They demonstrate the impact of the Carolingian revival even more strikingly than the architectural remains of the period. The former Imperial Treasury in Vienna contains a Gospel Book said to have been found in the Tomb of Charlemagne and, in any case, closely linked with his court at Aachen. Looking at the picture of St. Matthew from that manuscript (fig. 9-15), we can hardly believe that such a work could have

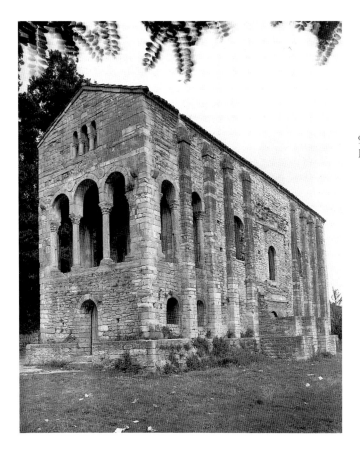

9-14. Sta. Maria de Naranco, Oviedo, Spain.
Dedicated 848 A.D.

9-15. *St. Matthew,* from the *Gospel Book
of Charlemagne.* c. 800–10 A.D.
Ink and colors on vellum, 13 x 10" (33 x 25.4 cm).
Kunsthistorisches Museum, Vienna

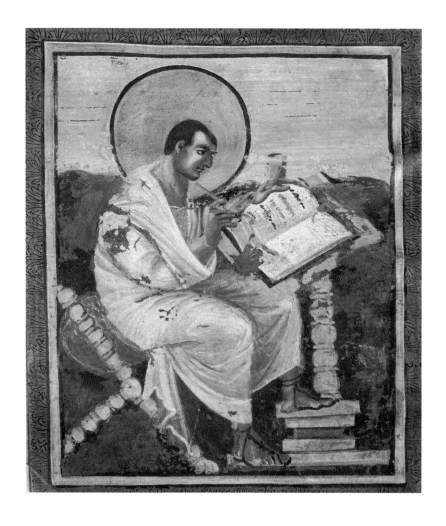

been executed in northern Europe about the year 800. Were it not for the large golden halo, the evangelist might almost be mistaken for the portrait of a classical author, like the one of Menander (fig. 9-16) painted at Pompeii almost eight centuries earlier. Whether Byzantine, Italian, or Frankish, the artist clearly knew the Roman tradition of painting, down to the acanthus ornament on the wide frame, which emphasizes the "window" treatment of the picture.

THE GOSPEL BOOK OF ARCHBISHOP EBBO. This *St. Matthew* represents the first and most conservative phase of the Carolingian revival. It is comparable to a copy of a classical text. More typical is a miniature of St. Mark painted some three decades later for the *Gospel Book of Archbishop Ebbo of Reims* (fig. 9-17), which shows the classical model translated into Carolingian terms. It must have been based on an evangelist's portrait of the same style as the *St. Matthew,* but now the picture is filled with a vibrant energy that sets everything into motion. The drapery swirls about the figure, the hills heave upward, and the vegetation seems to be tossed about by a whirlwind. Even the acanthus pattern on the frame has a flamelike character. The evangelist has been transformed from a Roman author setting down his thoughts into a man seized with the frenzy of divine inspiration—

9-16. *Portrait of Menander*. c. 70 A.D. Wall painting. House of Menander, Pompeii

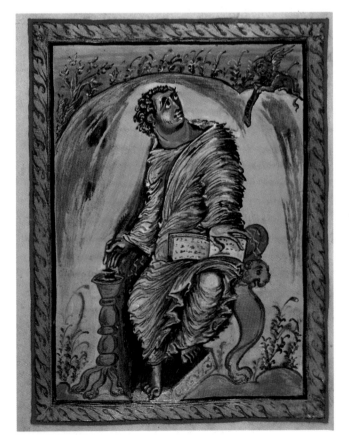

9-17. *St. Mark,* from the *Gospel Book of Archbishop Ebbo of Reims*. 816–35 A.D. Ink and colors on vellum, 10¼ x 8³⁄₁₆" (26 x 20.8 cm). Bibliothèque Municipale, Épernay, France

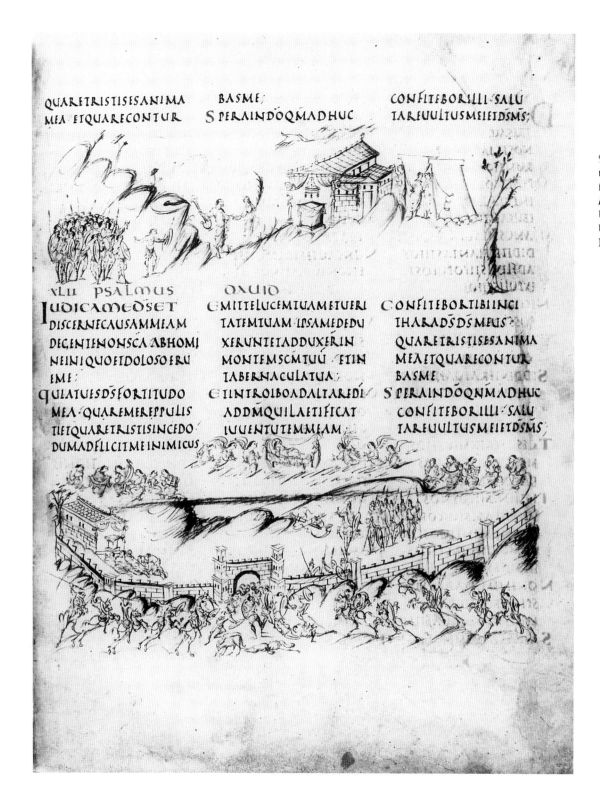

QUARETRISTISESANIMA
MEA ETQUARECONTUR

BASME;
SPERAINDOQMADHUC

CONFITEBORILLI·SALU
TAREUULTUSMEIETDSMS;

XLII PSALMUS OXUIO
IUDICAMEDSET
DISCERNECAUSAMMEAM
DEGENTENONSCA ABHOMI
NEINIQUOETDOLOSOERU
EME;
QUIATUESDSFORTITUDO
MEA·QUAREMEREPPULIS
TIETQUARETRISTISINCEDO·
DUMADELLCITMEINIMICUS

EMITTELUCEMIUAMETUERI
TATEMTUAM·IPSAMEDEDU
XERUNTETADDUXERIN
MONTEMSCMTUU ETIN
TABERNACULATUA;
ETINTROIBOADALTAREDI
ADDMQUILAETIFICAT
IUUENTUTEMMEAM;

CONFITEBORTIBIINCI
THARADSDSMEUS
QUARETRISTISESANIMA
MEAETQUARECONTUR
BASME
SPERAINDOQNMADHUC
CONFITEBORILLI·SALU
TAREUULTUSMEIETDSMS;

9-18. Illustrations to Psalms 43 and 44, from the *Utrecht Psalter*. c. 820–32 A.D. University Library, Utrecht, the Netherlands

a vehicle for recording the Word of God. His gaze is fixed not upon his book but upon his symbol (the winged lion with a scroll), which transmits the sacred text. This dependence on the Word, so powerfully expressed here, shows the contrast between the classical and medieval images of humanity. But the *means* of expression—the dynamism of line that distinguishes our miniature—recalls the passionate movement in the ornamentation of Irish manuscripts (see figs. 9-3 and 9-4).

THE UTRECHT PSALTER. The Reims School also produced the most extraordinary of all Carolingian manuscripts, the *Utrecht Psalter* (fig. 9-18). It displays the style of the *Ebbo Gospels* in an even more energetic form, since the entire book is illustrated with pen drawings. That the artist has followed a much older model is indicated by the architectural and landscape settings of the scenes, which recall the Column of Trajan (see fig. 7-37). It can also be seen in the use of Roman capital lettering, which had gone

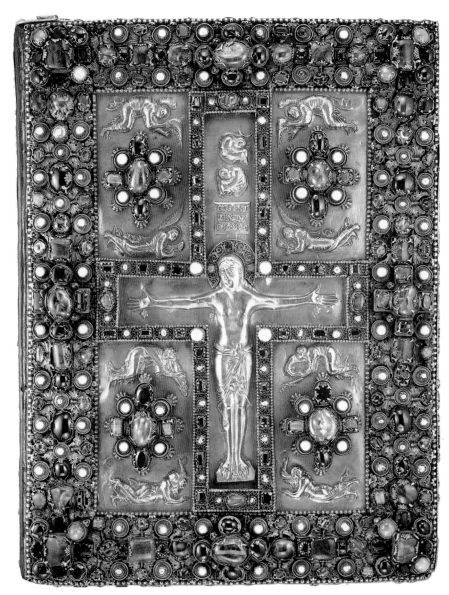

9-19. Front cover of binding, *Lindau Gospels*. c. 870 A.D.
Gold and jewels, 13¾ x 10½" (35 x 26.7 cm).
The Pierpont Morgan Library, New York

out of general use several centuries before. The wonderfully rhythmic quality of the draftsmanship, however, gives these sketches an expressive unity that could not have been present in the earlier pictures. Without it, the drawings of the *Utrecht Psalter* would carry little conviction, for the poetic language of the Psalms does not lend itself to illustration in the same sense as the narrative portions of the Bible.

The Psalms can be represented only by taking each phrase literally and then by visualizing it in some way. Thus the top of the page illustrates, "Let them bring me unto thy holy hill, and to thy tabernacles." Toward the bottom of the page, we see the Lord reclining on a bed, flanked by pleading angels. (The image is based on the words, "Awake, why sleepest thou, Oh Lord?") On the left, the faithful crouch before the Temple ("for . . . our belly cleaveth unto the earth"), and at the city gate in the foreground they are killed ("as sheep for the slaughter"). In the hands of a less imaginative and skillful artist, this procedure could well have turned into a tiresome game. Here it has the force of a great drama.

THE LINDAU GOSPELS COVER. The style of the Reims School can still be felt in the reliefs on the front cover of the *Lindau Gospels* (fig. 9-19). This masterpiece of the goldsmith's art,

dating from the third quarter of the ninth century, shows how splendidly the Celtic-Germanic metalwork tradition was adapted to the Carolingian revival. The clusters of semiprecious stones are not mounted directly on the gold ground. Instead, they are raised on claw feet or arcaded turrets, so that the light can penetrate from beneath them to bring out their full brilliance. The crucified Jesus betrays no hint of pain or death. He seems to stand rather than to hang, his arms spread out in a solemn gesture. To endow him with the signs of human suffering was not yet conceivable for the Carolingian artists, even though the means were at hand, as we can see from the expressions of grief among the small figures in the surrounding compartments.

OTTONIAN ART

Upon the death of Charlemagne's son, Louis I, in 843, the empire built by Charlemagne was divided into three parts by his grandsons: Charles the Bald, the West Frankish king, who founded the French Carolingian dynasty; Louis the German, the East Frankish king, who ruled an area roughly that of today's Germany; and Lothair I, who inherited the middle kingdom and the title of Holy Roman Emperor. By distributing the king's domain among his heirs, the Carolingian dynasty made the same fatal mistake as its predecessors, the Merovingians. Charlemagne had tried to impose unified rule by placing his friends in positions of power throughout the realm, but they became increasingly independent over time. During the late ninth and early tenth centuries this loose arrangement gave way to the decentralized political and social system known today as feudalism, mainly in France and Germany, where it had deep historical roots. Knights (originally cavalry officers) held fiefs, or feuds, as their land was called. In return, they gave military and other service to their lords, to whom they were linked through a complex system of personal bonds—termed *vassalage*—that extended all the way to the king. The land itself was worked by the large class of generally downtrodden peasants (serfs and esnes), who were utterly powerless.

The Carolingians finally became so weak that Continental Europe once again lay exposed. The Moslems attacked in the south. Slavs and Magyars advanced from the east, and Vikings from Scandinavia ravaged the north and west. The Vikings (the Norse ancestors of today's Danes and Norwegians) had been raiding Ireland and Britain by sea from the late eighth century on. Now they invaded northwestern France and occupied the area that ever since has been called Normandy. They soon adopted Christianity and Carolingian civilization, and their leaders were recognized as dukes nominally subject to the king of France. During the eleventh century, the Normans played a major role in shaping the political and cultural destiny of Europe. The duke of Normandy, William the Conqueror, became king of England following the invasion of 1066, while other Norman nobles expelled the Arabs and the Byzantines from Sicily and southern Italy.

In Germany the center of political power shifted north to Saxony after the death of the last Carolingian monarch in 911. Beginning with Henry I, the Saxon kings (919–1024) reestablished an effective central government. The greatest of them, Otto I, revived the imperial ambitions of Charlemagne. After marrying the widow of a Lombard king, he extended his rule over most of Italy. In 962 he was crowned emperor by Pope John XII, at whose request he conquered Rome and whom he later deposed for conspiring against him. From then on the Holy Roman Empire was to be a German institution. Perhaps we ought to call it a German dream, for Otto's successors were unable to maintain their sovereignty south of the Alps. Yet this claim had important effects, since it led the German emperors into centuries of conflict with the papacy and local Italian rulers. North and South thus were linked in a love-hate relationship that is still felt today.

Sculpture

THE GERO CRUCIFIX. During the Ottonian period, from the mid-tenth century to the beginning of the eleventh, Germany was the leading nation of Europe, artistically as well as politically. German achievements in both areas began as revivals of Carolingian traditions but soon developed original traits. The change is readily apparent if we compare the Christ on the cover of the *Lindau Gospels* with *The Gero Crucifix* (fig. 9-20, page 286). (It was carved for Archbishop Gero of Cologne). The two works are separated by little more than a hundred years, but the contrast between them suggests a far greater span. In *The Gero Crucifix* we meet an image of the crucified Savior that is new to Western art. It is monumental in scale, carved in powerfully rounded forms, and filled with deep feeling for the suffering of the Lord. Particularly striking is the forward bulge of the heavy body, which makes the physical strain on the arms and shoulders seem almost unbearable. The face, with its deeply incised, angular features, has turned into a mask of agony from which all life has fled.

How did the Ottonian sculptor arrive at this bold conception? *The Gero Crucifix* was clearly influenced by Middle Byzantine art, which had created the compassionate view of Christ on the Cross (see fig. 8-49). Byzantine influence was strong in Germany at the time, for Otto II had married a Byzantine princess, thereby linking the two imperial courts. Yet, that source alone is not enough to explain the results. It remained for the Ottonian artist to translate the Byzantine image into large-scale sculptural terms and to replace its gentle pathos with the expressive realism that has been the main strength of German art ever since.

The size and intensity of the figure on *The Gero Crucifix* signal an important religious development at the time. The individual was given a greater role in salvation, not merely through baptism and celebration of the Eucharist but through a personal union with Christ and identification with his sacrifice. The result was a rift between theology and mysticism that was not reconciled until a century later by St. Anselm of Canterbury.

Architecture

ST. PANTALEON. Cologne was connected with the imperial house through its archbishop, Bruno, the brother of Otto I, who left a strong mark on the city through the many churches he built or rebuilt. His favorite among these, the Benedictine abbey of St.

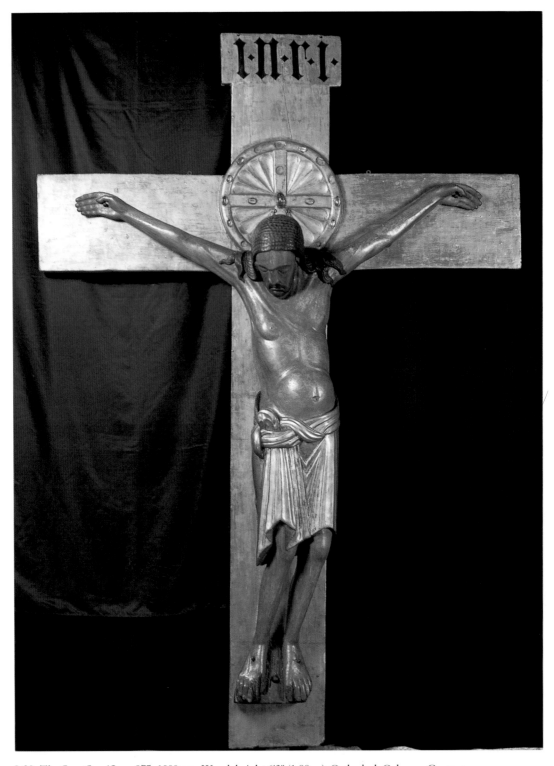

9-20. *The Gero Crucifix*. c. 975–1000 A.D. Wood, height 6'2" (1.88 m). Cathedral, Cologne, Germany

Pantaleon, became his burial place as well as that of the wife of Otto II. Only the monumental westwork (fig. 9-21) remains essentially unchanged. It is a massive and well-proportioned successor to Carolingian westworks, with the characteristic tower over the crossing of the western transept and a deep porch flanked by tall stair turrets [see illustration in Primary Sources no. 20, page 387].

ST. MICHAEL'S, HILDESHEIM. Judged in terms of surviving works, the most ambitious patron of architecture and art in the Ottonian age was Bernward, who became bishop of Hildesheim after having been court chaplain and a tutor of Otto III during the regency of the empress Theophano. His chief monument is another Benedictine abbey church, St. Michael's (figs. 9-22, 9-23, and 9-24). The plan is descended from St.-Riquier [see illustration,

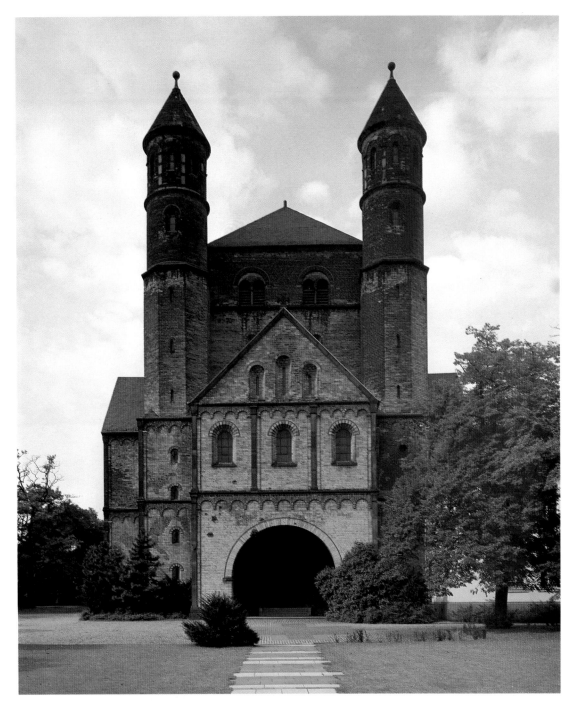

9-21. Westwork, St. Pantaleon, Cologne. Consecrated 980 A.D.

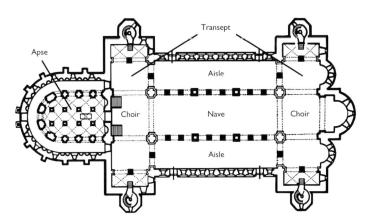

9-22. Reconstructed plan, Hildesheim Cathedral (St. Michael's), Germany. 1001–33 A.D. (after Beseler)

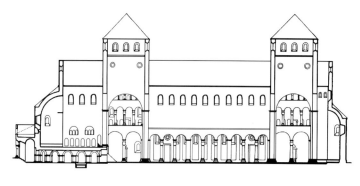

9-23. Reconstructed longitudinal section, Hildesheim Cathedral (after Beseler)

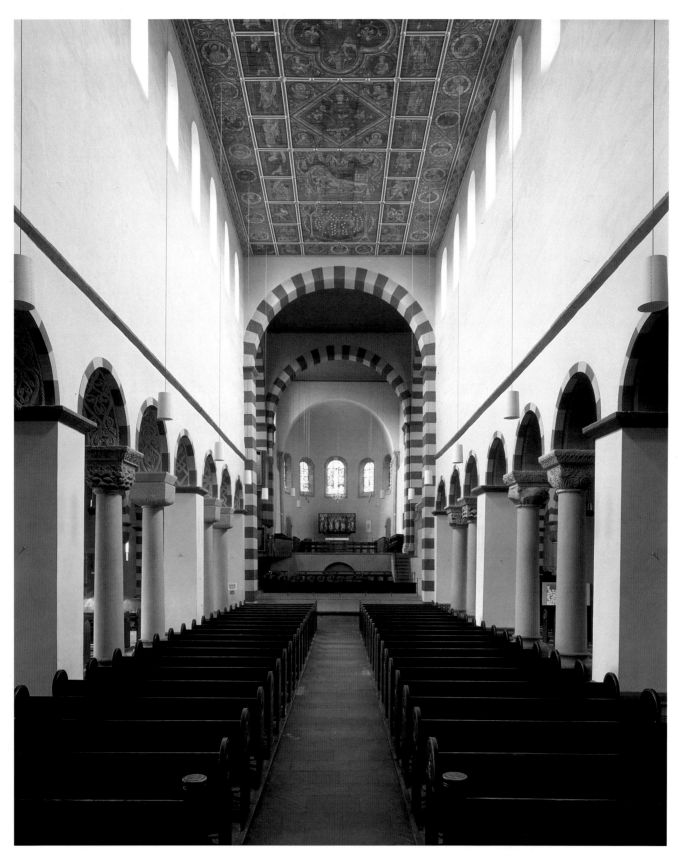

9-24. Interior (view toward the apse, after restoration of 1950–60), Hildesheim Cathedral

Primary Sources, no. 19, page 386]. But with its two choirs and side entrances, it also recalls the monastery church of the St. Gall plan (see fig. 9-13). However, in St. Michael's the symmetry is carried much further. Not only are there two identical transepts, with crossing towers and stair **turrets** (figs. 9-22 and 9-23), but the supports of the nave **arcade**, instead of being uniform, consist of pairs of columns separated by square piers (see fig. 9-24). This alternating system divides the arcade into three equal units, called **bays**, each with three openings. These units are equal in length to the width of the transepts, which are separated into three compartments to emphasize the choirs. Moreover, the first and third bays correspond with the entrances. And since the aisles and nave are unusually wide in relation to their length, the architect's intention must have been to achieve a harmonious balance between the longitudinal and horizontal axes throughout the structure.

The exterior (fig. 9-23) as well as the choirs of Bernward's church have been disfigured by rebuilding. However, the restoration of the interior of the nave (fig. 9-24), with its great expanse of wall space between the arcade and **clerestory**, retains the majestic feeling of the original design. (The capitals of the columns date from the twelfth century, the painted wooden ceiling from the thirteenth.) The western choir, as reconstructed in our plan, is especially interesting. Its floor was raised above the level of the rest of the church to make room for a half-buried basement chapel, or **crypt**. The crypt (apparently a special sanctuary of St. Michael) could be entered both from the transept and from the west. It was roofed by groin vaults resting on two rows of columns, and its walls were pierced by arched openings that linked it with the ∪-shaped corridor, or ambulatory, wrapped around it. The ambulatory must have been visible above ground, where it enriched the exterior of the choir, since there were windows in its outer wall. Such crypts with ambulatories, usually housing the venerated tomb of a saint, had been introduced into Western church architecture during Carolingian times. But the design of St. Michael's stands out for its large scale and its careful integration with the rest of the building.

Metalwork

THE BRONZE DOORS OF BISHOP BERNWARD.

We can gauge the importance Bernward himself attached to the crypt at St. Michael's from the pair of richly sculptured bronze doors he commissioned. They were probably meant for the two entrances leading from the transept to the ambulatory (fig. 9-25, page 290) and were finished in 1015, the year the crypt was consecrated. According to his biographer, Thangmar of Heidelberg, Bernward excelled in the arts and crafts. The idea for the doors may have come to him as a result of his visit to Rome, where he could have seen ancient Roman (and perhaps Byzantine) doors of bronze or wood. Bernward's doors, however, differ from earlier ones: they are divided into broad horizontal fields rather than vertical panels, and each field contains a biblical scene in high relief. The subjects, taken from Genesis (left door) and the Life of Christ (right door), depict the origin and redemption of sin.

Our detail (fig. 9-26, page 291) shows Adam and Eve after the Fall. Below it, in inlaid letters notable for their classical Roman character, is part of the inscription, with the date and Bernward's name. The figures here have none of the monumental spirit of *The Gero Crucifix*. They seem far smaller than they actually are, so that one might mistake them for a piece of goldsmith's work such as the *Lindau Gospels* cover (compare fig. 9-19). The composition must have been derived from a manuscript illumination, since very similar scenes are found in medieval Bibles. Even the stylized bits of vegetation have some of the twisting movement we recall from Irish miniatures. Yet this is no mere imitation. The story is conveyed with splendid directness and expressive force. The accusing finger of the Lord, seen against a great void, is the focal point of the drama. It points to a cringing Adam, who passes the blame to Eve, who in turn passes it to the serpent at her feet.

Manuscripts

THE GOSPEL BOOK OF OTTO III.

The same intensity is found in Ottonian manuscript painting. Here Carolingian and Byzantine elements are blended into a new style of extraordinary scope and power. The most important center of manuscript illumination at that time was the Reichenau Monastery, located on an island in Lake Constance, on the borders of modern-day Germany and Switzerland. Perhaps its finest achievement—and one of the great masterpieces of medieval art—is the *Gospel Book of Otto III*. Two full-page miniatures from it are reproduced here (figs. 9-27 and 9-28).

The scene of Jesus washing the feet of St. Peter (fig. 9-27, page 292) contains strong echoes of ancient painting, transmitted through Byzantine art. (The subject is found in a mosaic at Hosios Loukas.) The soft pastel hues of the background recall the illusionism of Graeco-Roman landscapes (see figs. 7-49 and 7-50), and the architectural frame around Jesus is a late descendant of the kind of architectural perspectives we saw in the mural from Boscoreale (see fig. 7-48). The Ottonian artist has put these elements to a new use. What was once an architectural vista now becomes the Heavenly City, the House of the Lord, filled with golden celestial space in contrast with the atmospheric earthly space outside.

The figures have also been transformed. In ancient art this composition had been used to depict a doctor treating a patient. Now St. Peter takes the place of the patient, and Jesus of the physician. (Jesus is still represented as a beardless young philosopher.) As a result, the emphasis has shifted from physical to spiritual action. This new kind of action is not only conveyed through glances and gestures, but also governs scale. Jesus and St. Peter, the most animated figures, are larger than the rest, and Jesus' "active" arm is longer than his "passive" one. The eight apostles, who merely watch, have been compressed into a tiny space, so that we see little more than their eyes and hands. Even the fanlike Early Christian crowd from which this group is derived (see fig. 8-17) is less disembodied. The scene straddles two eras. On the one hand, the nearly perfect blend of Western and Byzantine elements represents the culmination of the early medieval manuscript tradition. On the other, the expressive distortions look forward to Romanesque art, which incorporated them in heightened form.

The other miniature is a symbolic image of overwhelming grandeur, despite its small size (fig. 9-28, page 293). Unlike

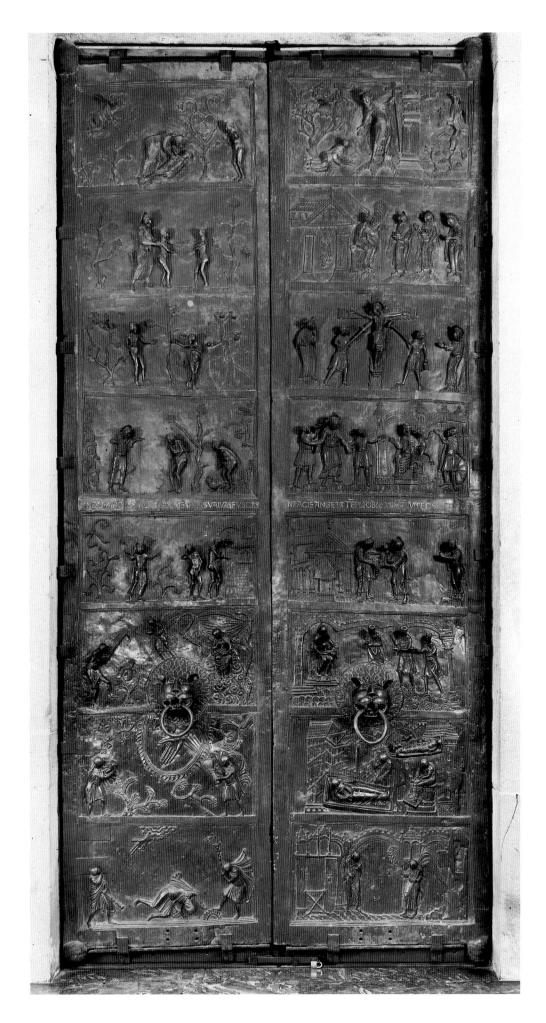

(OPPOSITE) 9-25. Doors of Bishop Bernward. 1015 A.D.
Bronze, height approx. 16' (4.8 m). Hildesheim Cathedral

(ABOVE) 9-26. *Adam and Eve Reproached by the Lord,*
from the Doors of Bishop Bernward.
Bronze, approx. 23 x 43" (58.3 x 109.3 cm)

...The impressive thing about St. Bernward's doors is not so much their relationship in scheme and composition with miniatures like those of the Vienna Genesis [see fig. 8-20], as [it is] a kind of perspective-modelling—in the treatment of the ground, for example, with its suggestive difference in relief between the clods of earth round the roots of the trees and the short grass a little farther off, and this is still more marked in the various volumes of the figures, whose heads detach themselves entirely from the background and are frankly treated in the round. The same characteristic is no less manifest in the famous column, a diminutive relation of Trajan's column [see fig. 7-37], adorned with a spiral band of very compact compositions; the scale of values here extends from something close to that of a medal to that of high relief....

—Henry Focillon. *The Art of the West in the Middle Ages.*
Edited and with an Introduction by Jean Bony. Vol. 1,
Romanesque Art. Ithaca: Cornell University Press, 1980, p. 46.
Originally published in English in 1963 by Phaidon Press, Inc.

French art historian **HENRI FOCILLON** (1881–1943) inspired a generation of art historians with his fresh insights on a number of great artistic traditions, including East Asian art, but most notably European art of the Middle Ages. A formalist, Focillon traced evolutionary patterns of style through formal analysis. His best-known work, the eloquent *The Art of the West in the Middle Ages* excerpted here, was originally published in 1938 as *Art d'Occident* and is still fundamental reading for art historians. He was celebrated as an exciting teacher both in France and at Yale University, where he was on the faculty from 1934 until his death.

Carolingian evangelists (see figs. 9-15 and 9-17), St. Luke is not shown writing. Instead, his Gospel lies completed on his lap. Enthroned on two rainbows, he holds aloft an awesome cluster of clouds from which tongues of light radiate in every direction. Within it we see his symbol, the ox, surrounded by five Old Testament prophets and an outer circle of angels. At the bottom, two lambs drink the life-giving waters that spring from beneath his feet. The key to the design is in the inscription: *Fonte patrum ductas bos agnis elicit undas*—"From the source of the fathers the ox brings forth a flow of water for the lambs." St. Luke makes the prophets' message of salvation explicit for the faithful. The Ottonian artist has truly "illuminated" the meaning of this terse phrase.

9-27. *Jesus Washing the Feet of Peter,* from the *Gospel Book of Otto III.* c. 1000 A.D. Tempera on vellum, 13 x 9⅜" (33 x 23.8 cm). Staatsbibliothek, Munich

9-28. *St. Luke,* from the *Gospel Book of Otto III.* c. 1000 A.D. Tempera on vellum, 13 x 9⅜" (33 x 23.8 cm). Staatsbibliothek, Munich

(BELOW) 9-29. *Moses Receiving the Law* and *The Doubting of Thomas*. Early 11th century. Ivory, each 9⅝ x 4" (24.5 x 10.2 cm). Staatliche Museen zu Berlin, Preussischer Kulturbesitz, Museum für Spätantike und Byzantische Kunst

IVORY DIPTYCHS. Closely related in style to the *Gospel Book of Otto III* is an ivory diptych with *Moses Receiving the Law* in the left panel and *The Doubting of Thomas* in the right (fig. 9-29). These two panels, which may have come from the abbey of Kues on the Mosel River, were probably made in nearby Trier, then a leading art center. It is certain that the artist was familiar with Byzantine ivories, among them the diptych of *Justinian As Conqueror* (see fig. 8-38), which was brought to Trier as early as the seventh century. Yet the artist, a great master, avoids the Byzantine influences that continued to find favor in Ottonian art. Instead, he prefers the physical distortions, fluid drapery, and architectural treatment seen in *Jesus Washing the Feet of Peter*. These devices are used to squeeze an amazing amount of action into the two scenes, which adopt the format but not the classicism of *The Archangel Michael* (see fig. 8-36). They also lend an impressive power to both panels that makes us feel the full force of the confrontation between mortal and God in both divine and human form: the awestruck Moses strains to receive the Ten Commandments from Heaven, and Thomas stretches to touch the wound of Christ.

CHAPTER TEN

Romanesque Art

Up to this point, almost all of our chapter headings and subheadings might serve equally well for a general history of civilization. Some are based on technology (for example, the Old Stone Age); others on geography, ethnology, or religion. Whatever the source, they have been borrowed from other fields, even though they are also used to designate artistic styles. There are only two important exceptions: Archaic and Classical are mainly stylistic terms that refer to qualities of form. Why don't we have more words of this sort? We do, as we shall see, but only for the art of the past 900 years.

Those writers who first thought of viewing the history of art as an evolution of styles began with the belief that ancient art evolved toward a single climax: Greek art from the age of Perikles to that of Alexander the Great. This style they called Classical (that is, perfect). Everything that came before was labeled Archaic, to indicate that it was still old-fashioned and tradition bound; it was not yet Classical but striving in the right direction. The style of post-Classical times, on the other hand, did not deserve a special term, since it had no positive qualities of its own—it was merely an echo or a decline of Classical art.

The early historians of medieval art followed a similar pattern. To them, the great climax was the Gothic style, from the thirteenth to the fifteenth centuries. For whatever was not-yet-Gothic they adopted the label *Romanesque,* which was first introduced in 1871. They were thinking mainly of architecture. Pre-Gothic churches, they noted, were round-arched, solid, and heavy, compared to the pointed arches and the soaring lightness of Gothic structures. It was rather like the ancient Roman style of building, and the word *Romanesque* was meant to convey just that quality. The term is actually quite misleading. In one sense, all of medieval art before 1200 could be called Romanesque insofar as it shows any link with Roman tradition. Strictly speaking, however, it applies only to a small group of modest churches in northern Italy, southern France, and northern Spain. These structures do seem to be part of a revival around 950–1060 of the Early Christian style under Constantine and Justinian, although the effect is rather superficial (compare figs. 8-13 and 8-24). This "First Romanesque," as it is sometimes known, was too limited and provincial, however, to account for the Romanesque itself. The same decorative vocabulary, moreover, had already been used on Ottonian churches (see fig. 9-21). What distinguishes the Romanesque proper is its amazing diversity and inventiveness, bespeaking a new spirit that is expressed most fully in monumental architecture.

Carolingian art was brought about by Charlemagne and his circle as part of a conscious classical revival. Even after his death it remained linked with his court. Ottonian art had a similarly narrow sponsorship. The Romanesque, in contrast, sprang up all over western Europe at about the same time. It consists of a large variety of regional styles, distinct yet closely related in many ways. In this respect, it resembles the art of the early Middle Ages rather than the Carolingian and Ottonian court styles. Its sources, however, include those styles, along with Late Classical, Early Christian, and Byzantine elements, as well as the Celtic-Germanic heritage and some Islamic influence.

What welded these components into a coherent style during the second half of the eleventh century was not any single force but a variety of factors that led to an upsurge of vitality throughout the West. The millennium came and went without the Apocalypse (described in the Book of Revelation of St. John the Divine) that many had predicted. Christianity had at last triumphed everywhere in Europe. The Vikings, still largely heathen in the ninth and tenth centuries when their raids terrorized the British Isles and the Continent, had entered the Catholic fold, not only in Normandy but in Scandinavia as well. In 1031 the Caliphate of Cordova had broken up into many small Muslim states, thus opening the way for the reconquest of the Iberian Peninsula, and the Magyars had settled down in Hungary.

There was a growing spirit of religious enthusiasm that could be seen in the greatly increased numbers of people making pilgrimages to sacred sites and in the Crusades against the Muslims. Equally important was the reopening of Mediterranean trade routes by the navies of Venice, Genoa, Amalfi, Pisa, and Rimini. The revival of trade and travel linked Europe commercially and culturally, and urban life flourished as a result. The new pace of religious and secular life is vividly described in pilgrim guides of the time. [See Primary Sources, no. 23, page 388.]

These changes were made possible by technological advances in agriculture, such as better iron plows and improved milling machinery. Although modest, these changes allowed farmers to grow more food than they needed for themselves for the first time since the fall of Rome. As a result of this increased productivity,

they became hired laborers, not simply serfs, which enhanced their status and gradually improved their lot. Vast areas of land were cleared for more farmland over the next 300 years to support a growing population, especially in towns and cities, which underwent an explosive growth.

During the turmoil of the early Middle Ages, the towns of the West Roman empire had shrunk greatly. (The population of Rome, about one million in 300 A.D., fell to less than 50,000 at one point.) Some cities were deserted altogether. From the eleventh century on, however, they began to regain their former importance. New towns sprang up everywhere. Like the cities, they gained their independence thanks to a new middle class of artisans and merchants which established itself between the peasantry and the landed nobility and became an important factor in medieval society.

In many ways, then, western Europe between 1050 and 1200 became a great deal more "Roman-esque" than it had been since the sixth century. It recaptured some of the trade patterns, the urban quality, and the military strength of ancient imperial times. To be sure, there was no central political authority. Even the empire of Otto I did not extend much farther west than modern Germany does. The monasteries of the Cistercians and Benedictines rivaled the wealth and power of kings (see box pages 299–300). To some extent, the central spiritual authority of the pope acted as a unifying force. The papacy was concerned mainly with combating the heresies that grew throughout the Catholic realm. Its claim of supremacy in dogma led to the final break (known as the Great Schism) with the Byzantine Orthodox church in 1054. However, the pope's influence extended to the temporal realm, where he came to exercise considerable control. Indeed, it was now the pope who sought to unite Europe into a single Christian realm. In 1095 Pope Urban II called for the First Crusade to liberate the Holy Land from Muslim rule and to aid the Byzantine emperor against the advancing Turks. The army of Crusaders was far larger than anything a secular ruler could have raised for the purpose.

This First Crusade managed to win Jerusalem after three years, but later ones were generally disasters. The Second Crusade (1147–49), which was called for by St. Bernard of Clairvaux (see box pages 299–300) after the fall of Edessa to the Turks, succeeded only in capturing Lisbon from the Arabs, while the Third Crusade, begun in 1189, failed to reconquer Jerusalem from the sultan Saladin, who had taken it two years earlier. The Fourth and final major Crusade did little to hinder the advance of Islam; its sole result was the fall of Constantinople in 1204. (There were five later ones, ending in 1270.) The Crusades, however, gave rise to that uniquely medieval institution: military orders of Christian knights, which enjoyed great power and prestige throughout Europe and often operated independently of royal or papal authority.

ARCHITECTURE

The most striking feature of Romanesque architecture is the amazing increase in building activity. An eleventh-century monk, Raoul Glaber, summed it up well when he exclaimed that the world was putting on a "white mantle of churches." These churches were not only more numerous than those of the early Middle Ages, they were also larger, more richly articulated, and more "Roman-looking." Their naves now had stone vaults instead of wooden roofs. Unlike previous churches, their exteriors were decorated with both architectural ornament and sculpture. Romanesque monuments of the first importance are distributed over an area that might well have represented the world—the Catholic world, that is—to Raoul Glaber: from northern Spain to the Rhineland, from the Scottish-English border to central Italy. If we add to this group the buildings, since destroyed or disfigured, whose original designs are known through archaeological research, we have a wealth of architectural invention unmatched by any previous era.

Southwestern France

ST.-SERNIN, TOULOUSE. The richest examples, the greatest variety of regional types, and the most adventurous ideas are to be found in France. St.-Sernin, in the southern French town of Toulouse (figs. 10-1–10-3, pages 296–97), is one of a group of great churches of the pilgrimage type, so called because they were built along the roads leading to the pilgrimage center of Santiago de Compostela in northwestern Spain and because they share many features. [See Primary Sources, no. 23, page 388.] The plan is much more complex and more integrated than in earlier structures such as Corvey (see fig. 9-11) or St. Michael's at Hildesheim (see figs. 9-22–9-24). It is an emphatic Latin cross, with the center of gravity at the eastern end (the dotted lines in the ambulatory groin vault). Clearly this church was designed not only to serve a monastic community but also, like Old St. Peter's in Rome (see fig. 8-4), to accommodate large crowds of lay worshipers in its long nave and transept.

The nave is flanked by two aisles on each side. The inner aisle continues around the arms of the transept and the apse. This ambulatory circuit is anchored to the two towers of the west facade, which was never completed as planned. The ambulatory, we will recall, had been a feature of the crypts of earlier churches such as St. Michael's. Now it is above ground, where it is linked with the aisles of the nave and transept. Chapels radiate from the apse and continue along the eastern face of the transept. (The apse, ambulatory, and apsidal chapels form a unit known as the pilgrimage choir.) The plan also shows that the aisles of St.-Sernin are groin-vaulted throughout. The use of vaulting imposes a high degree of regularity on the design. The aisles are made up of square bays, which serve as a basic module for the other dimensions. The nave and transept bays equal two such units, the crossing and the facade towers four units. The harmony conveyed by the repetition of these modules is perhaps the most notable feature of the pilgrimage church.

On the exterior, the relationship of elements is enhanced by the different roof levels, which set off the nave and transept against the inner and outer aisles, the apse, the ambulatory, and the **radiating chapels**. The effect is increased by the **buttresses**, which reinforce the walls between the windows to contain the outward thrust of the vaults. The windows and portals are further emphasized by decorative framing. The crossing tower was completed later, in Gothic times, and is taller than originally intended. The two facade towers, unfortunately, were never finished and remain stumps.

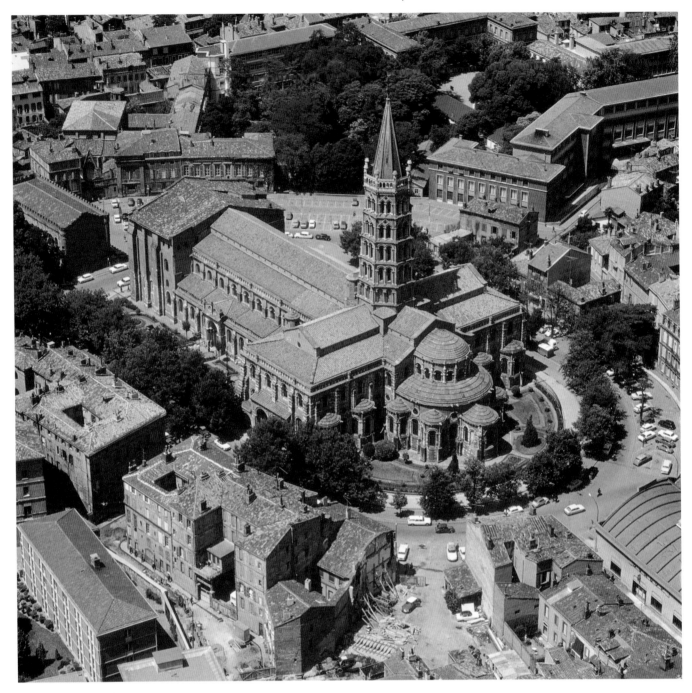

10-1. St.-Sernin, Toulouse, France (aerial view). c. 1070–1120

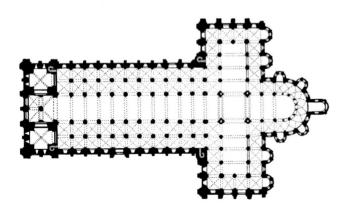

10-2. Plan of St.-Sernin (after Conant)

Inside the nave, the tall proportions, the elaboration of the walls, and the indirect lighting create a sensation very different from the ample and serene interior of St. Michael's, with its simple and clearly separated blocks of space (see figs. 9-22–9-24). While the nave walls of St. Michael's look Early Christian (see fig. 8-6), those of St.-Sernin seem more akin to the Colosseum (see fig. 7-11). The vocabulary and syntax of ancient Roman architecture—vaults, arches, engaged columns, and pilasters, all firmly knit together into a coherent order—have been recaptured here to a remarkable degree. Yet the forces expressed in the nave of St.-Sernin are no longer the physical, muscular forces of Graeco-Roman architecture but spiritual forces of the kind we have seen governing the human body in Carolingian and Ottonian miniatures. To a Roman viewer, the half-columns running the entire height of the nave wall would appear just as unnaturally drawn

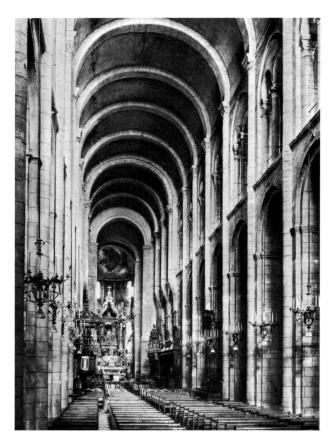

10-3. Nave and choir, St.-Sernin

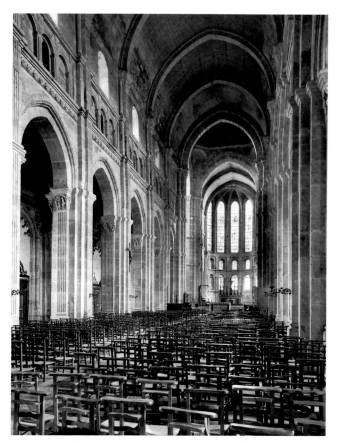

10-4. Nave wall, Autun Cathedral, France. c. 1120–32

out as the arm of Jesus in figure 9-27. The columns seem to be driven upward by some tremendous, unseen pressure, as if hastening to meet the transverse arches that subdivide the barrel vault of the nave. Their insistently repeated rhythm propels us toward the eastern end of the church, with its light-filled apse and ambulatory (now obscured by a huge altar of later date).

Beauty and engineering are inseparable in achieving this effect. Clearly the effort required the kind of detailed, systematic planning that only an architect in the proper sense of the term could provide (see page 276). Vaulting the nave to eliminate the fire hazard of a wooden roof was not only a practical aim, it also provided a challenge to make the House of the Lord grander. Since a vault becomes more difficult to sustain the farther it is from the ground, every resource had to be strained to make the nave as tall as possible. However, for safety's sake there is no clerestory. Instead, **galleries** were built over the inner aisles to counterbalance the lateral pressure of the nave vault in the hope that enough light would filter through them into the central space. St.-Sernin reminds us that architecture, like politics, is the art of the possible. Its success, here as elsewhere, is measured by how far the architect has explored the limits of what seemed possible, both structurally and aesthetically, under those particular conditions.

Burgundy and Western France

AUTUN CATHEDRAL. The builders of St-Sernin would have been the first to admit that their answer to the problem of the nave vault was not the final one. The architects of Burgundy arrived at

a more elegant solution, which can be seen in the Cathedral of Autun (fig. 10-4). The church was dedicated to Lazarus, the dead man revived by Christ, whose bones it came to house. It was begun by Bishop Étienne de Bage of the Cluniac order (see "Monasticism and Christian Monastic Orders," pages 299–300) and consecrated in 1132. Here the galleries are replaced by a blind arcade (called a *triforium,* since it often has three openings per bay) and a clerestory. This three-story elevation was made possible by the use of the pointed arch for the nave vault. The pointed arch probably reached France from Islamic architecture, where it had been used for some time. By eliminating the center part of the round arch, which responds the most to the pull of gravity, the two halves of a pointed arch brace each other. Because the pointed arch exerts less outward pressure than the semicircular arch, not only can it be made as steep as possible, but the walls can be pierced. (For reasons of harmony, it also appears in the nave arcade, where it is not needed for further support.) The advances that grew out of this discovery were to make possible the soaring churches of the Gothic period (see, for example, figs. 11-5, 11-13, and 11-17). Like St.-Sernin, Autun comes close to straining the limits of the possible. The upper part of the nave wall shows a slight outward lean under the pressure of the vault—a warning against any further attempts to increase the height of the clerestory or to enlarge the windows.

CLUNY. The largest structure ever built in Romanesque Europe was the third abbey church at Cluny. The order's rapid growth (see box pages 299–300) can be seen in the fact that this great church, begun in 1088, was a replacement for the ample one finished

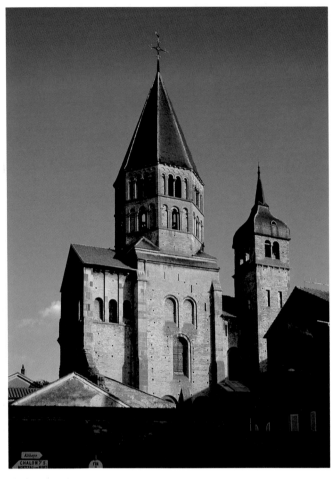

10-5. South Transept, Cluny III, 1088–1130

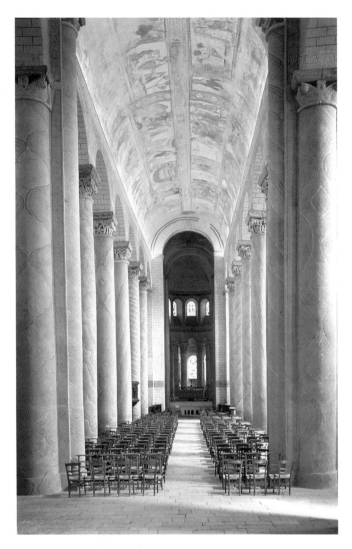

10-6. Choir (c. 1060–75) and nave (1095–1115), St.-Savin-sur-Gartempe, France

only about 75 years earlier, which itself had been built beside the original wooden basilica of about 910. Unfortunately Cluny III, as it is known, was destroyed after the French Revolution. Only the south transept and its octagonal tower remain from what was once the most impressive massing of towers in all of Europe (fig. 10-5). They indicate the huge scale of the church as a whole, which was not surpassed until the Gothic. We can get a good idea of the interior if we combine the nave elevation of Autun with the barrel vault and apse of St.-Sernin, except that there was a second triforium in place of the clerestory.

HALL CHURCHES. A third type, called a hall church, appears first in the west of France. At St.-Savin-sur-Gartempe (fig. 10-6), the nave vault lacks the reinforcing arches, since it was designed to offer a continuous surface for murals (see fig. 10-36 for this cycle, the finest of its kind). Its weight rests directly on the nave arcade, which is supported by a majestic set of columns. Yet the nave is fairly well lit, for the two aisles are carried almost to the same height, and their outer walls have generous windows. At the eastern end of the nave, there is a pilgrimage choir beyond the crossing tower.

The nave and aisles of hall churches are covered by a single roof, as at St.-Savin. The west facade, too, tends to be low and wide, and may become richly sculptured. Notre-Dame-la-Grande at Poitiers (fig. 10-7), due west from St.-Savin, is notable in this

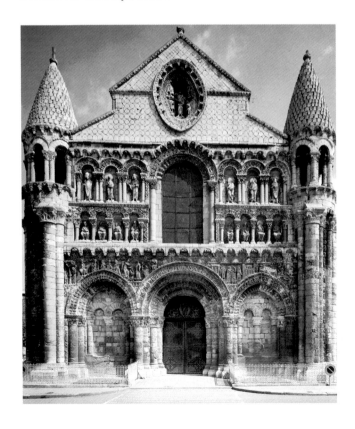

10-7. West facade, Notre-Dame-la-Grande, Poitiers, France. Early 12th century

MONASTICISM AND CHRISTIAN MONASTIC ORDERS

People of many times, places, and religious faiths have renounced the world and devoted themselves entirely to a spiritual way of life. Some have chosen to live alone as hermits, often in isolated places, where they have led harsh, ascetic existences. Others have come together in religious communities known as monasteries to share their faith and religious observance. Hermits have been especially characteristic of Hinduism, while the monastic life has been more common in Buddhism. Among the Jews of the first century B.C., there were both hermits, or anchorites (John the Baptist was one of these), and a kind of monasticism practiced by a sect known as the Essenes. Both forms are found in Christianity throughout most of its history as well. Their basis can be found in Scripture. On the one hand, Jesus urged giving up all earthly possessions as the road to salvation. On the other, the Book of Acts in the Bible records that his followers came together in their faith after the Crucifixion.

The earliest monasticism practiced by Christians was the hermit's life. It was chosen by a number of pious men and women who lived alone in the Egyptian desert in the second and third centuries A.D. This way of life was to remain fundamental to the Eastern Church, especially in Syria. But early on, communities emerged when colonies of disciples—both men and women—gathered around the most revered of the hermits, such as St. Anthony (fourth century), who achieved such fame as a holy man that he was pursued by people asking him to act as a divine intercessor on their behalf.

Monasteries soon came to assume great importance in early Christian life. (They included communities for women, which are often called convents or nunneries.) The earliest known monastery was founded by Pachomius along the Nile around 320, a community that blossomed into nine monasteries and two nunneries by the time of his death a quarter century later. Similar ones quickly followed in Syria, where monachism (monasticism) flourished until the 638 conquest by the Arabs. Syrian monasteries were for the most part sites along pilgrimage routes leading to the great monastery at Telanessa (present-day Qal'at Sim'ân), where Simeon Stylites (born 390) spent the last 30 years of his long life atop a tall column in almost ceaseless prayer.

Eastern monasticism was founded by Basil the Great (c. 330–379), bishop of Caesarea in Asia Minor. A remarkable man, he was the brother of Gregory of Nyssa and St. Macrina, successor to Eusebius as bishop of Caesarea. Along with his close friend Gregory Nazianzen, he was one of the four Fathers of the Greek Church. Basil's rule for this life established the basic characteristics of Christian monasticism: poverty, chastity, and humility. It emphasized prayer, scriptural reading, and work, not only within the monastery but also for the good of lay people in the world beyond its walls; as a result, monasticism now assumed a social role. One of the oldest rules in the West is that of St. Augustine of Hippo (354–430). He spread monasticism to Africa, where it proved short-lived due to the Vandal conquests.

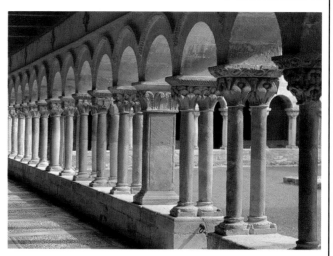

The cloister at Sto. Domingo de Silos Monastery, Spain. c. 1085–1100

Monasticism had been brought even earlier to France by St. Martin of Tours (c. 316–397) around the middle of the fourth century and to Ireland by St. Patrick (c. 385–461) in the fifth century. Ireland wholeheartedly adopted a harsh form of anchoritism during the sixth century. Monasticism was established in England by St. Augustine (died 604), first archbishop of Canterbury (not to be confused with the church doctor of the same name mentioned above), who went there in 597 at the request of Gregory the Great and enjoyed remarkable success in turning the country to Christianity.

The most important figure in Western monasticism was Benedict of Nursia (c. 480–c. 553), the founder of the abbey at Monte Cassino in southern Italy. His rule, which was patterned after Basil's, divided the monk's day into periods of private prayer, communal ritual, and labor and also required a moderate form of communal life, which was strictly governed. This was the beginning of the Benedictine order, the first of the great monastic orders (or societies) of the Western church. The Benedictines thrived with the strong support of Pope Gregory the Great, himself a former monk, who codified the Western liturgy and the forms of Gregorian chant (see pages 328–329).

Because of their organization and continuity, monasteries were considered ideal seats of learning and administration under the Frankish kings of the eighth century. They were supported even more strongly by Charlemagne and his heirs, who gave them land, money, and royal protection. As a result, they became rich and powerful, even exercising influence on international affairs. Monasteries and convents provided a place for the younger children of the nobility, and even talented members of the lower classes, to pursue challenging, creative, and useful lives as teachers, nurses, writers, and artists—opportunities that generally would have been closed to them in secular life (see box page 318). Although they had considerable independence at first, the various orders eventually gave their loyalty to Pope Gregory the Great. They thereby became a major source of power for the papacy in return for its protection. Through these

(box continues on following page)

linkages, Church and State over time became linked institutionally, to their mutual benefit, thereby promoting greater stability.

Besides the Benedictines, the other important monastic orders of the West included the Cluniacs, the Cistercians, the Carthusians, the Franciscans, and the Dominicans. The Cluniac order (named after its original monastery at Cluny, in France) was founded as a renewal of the original Benedictine rule in 909 by Berno of Baume and 12 brethren on farmland donated by William of Aquitaine. It quickly emerged as the leading international force in Europe, thanks to its unique charter, which made it answerable only to the papacy, then at a low ebb in its power. The order also enjoyed close connections to the Ottonian rulers. Indeed, under the abbots Odilo (ruled 994–1049) and Hugh of Semur (ruled 1049–1109), its authority became so great that it could determine papal elections and influence imperial policy. It also called for crusades and the reconquest of Spain.

Partly in reaction to the wealth and secular power of the Cluniac order and other Church institutions, the Cistercian order was founded in 1098 by Robert of Molesme as a return to the Benedictine rule. This order, headquartered at Cîteaux, reached its height under St. Bernard (1090–1153). His abbey in Clairvaux, settled with 12 brethren, overtook Cluny in population and power by the time of his death. Cistercian monasteries were deliberately located in remote places, where the monks would come into minimal contact with the outside world, and the rules of daily life were particularly strict. In keeping with this austerity, the order developed an architectural style known as Cistercian Gothic, recognizable by its geometric simplicity and lack of ornamentation (see pages 337 and 341).

The Carthusian order was founded by Bruno, an Italian monk, in 1084. Carthusians are in effect hermits, each monk or nun living alone in a separate cell, vowed to silence and devoted to prayer and meditation. The members of each house come together only for religious services and for communal meals several times a year. Because of the extreme austerity and piety of

this order, several powerful dukes in the fourteenth and fifteenth centuries established Carthusian houses (charterhouses; French, *chartreuses*), so that the monks could pray perpetually for the souls of the dukes after they died. The most famous of these was the Chartreuse de Champmol, built in 1385 near Dijon, France, as the funerary church of Philip the Bold of Burgundy (see page 354) and his son, John the Fearless.

Eventually the conflict between poverty and work led to the creation of two orders of wandering friars: the Franciscans and the Dominicans. Founded with the blessing of Pope Innocent III, to whom they swore obedience, both orders became arms of papal policy. They grew with astonishing rapidity until they became rivals, due partly to their contrasting missions. The Franciscans were devoted to spiritual reform by living example, while the purpose of the Dominicans was to combat heresy. The Franciscan order was founded in 1209 by St. Francis of Assisi (c. 1181–1226) as a preaching community. Francis, who was perhaps the most saintly character since Early Christian times, insisted on a life of complete poverty, not only for the members personally but for the order as a whole. The Poor Clares, established by Francis and his friend St. Clare (1194–1253) near Assisi, was an order of nuns that followed the ascetic life while ministering to the sick. It, too, underwent spectacular growth, especially in Spain, where it was sponsored by the royal house. Franciscan monks and nuns were originally mendicant—that is, they begged for a living. This rule was revised in the fourteenth century.

The Dominican order was established in 1220 by St. Dominic (c. 1170–1221), a Spanish monk who had been a member of the Cistercians. Besides preaching, the Dominicans devoted themselves to the study of theology. They were considered the most intellectual of the religious orders in the late Middle Ages and the Early Renaissance. The Dominicans were well organized from the start. However, the Franciscan community did not become a formal order until a papal bull of 1230. It attained its greatest prominence under St. Bonaventure (1221–1274), who was, with the Dominican St. Thomas Aquinas (1225–1274), one of the great doctors (theologians) of the Church. The two even taught together at the University of Paris during the early 1250s.

respect. The sculptural program is an exposition of Christian doctrine that is a feast for the eyes as well as the mind. The elaborately bordered arcades house large seated or standing figures. Below them a wide band of relief carving stretches across the facade. Essential to the rich sculptural effect is the doorway, which is deeply recessed and framed by a series of arches resting on stumpy columns. Taller bundles of columns enhance the turrets. Their conical helmets nearly match the height of the gable in the center, which rises above the actual height of the roof behind it.

Normandy and England

The next major development took place farther north, in Normandy, and for good reason. The duchy had been ruled by a series

of weak Carolingians before being ceded to the Danes by the aptly nicknamed Charles the Simple in 911. By the middle of the eleventh century, however, it developed into the most dynamic force in Europe under the Capetian dynasty, which was established when Hugh Capet was elected king in 987 and which ruled France for almost 350 years. Although it came late, Christianity was strongly supported by the Norman dukes and barons, who actively promoted monastic reform and founded numerous abbeys. Thus Normandy soon became a cultural center of international importance.

ST.-ÉTIENNE, CAEN. The architecture of southern France merged with local traditions to produce a new Norman school that evolved in an entirely different direction. The west facade of the

structural engineering, which took place in England, where William started to build as well. Durham Cathedral (fig. 10-9–10-11), begun in 1093, is among the largest churches of medieval Europe. Its nave is one-third wider than St.-Sernin's, and its overall length (400 feet) is also greater. The nave may have been designed to be vaulted from the start. The vault over its eastern end had been completed by 1107, a remarkably short time, and the rest of the nave was finished by 1130. The choir was heavily damaged by a fire and was rebuilt in 1174–84 by Guillaume de Sens and, after he left because of an injury, William the Englishman.

This vault is of great interest. As the earliest systematic use of a ribbed groin vault over a three-story nave, it marks a basic advance beyond Autun. Looking at the plan (fig. 10-10), we see that the aisles consist of the usual groin-vaulted compartments approaching a square. The bays of the nave, separated by strong transverse arches, are oblong and groin-vaulted so that the ribs form a double-X design. The vault thus is divided into seven sections rather than the usual four. Since the nave bays are twice as long as the aisle bays, the transverse arches occur only at the odd-numbered piers of the nave arcade. The piers therefore alternate in size. The larger ones are of compound shape (that is, they have bundles of column and pilaster shafts attached to a square or oblong core), while the others are cylindrical.

The easiest way to visualize the origin of this system is to imagine that the architect started out by designing a barrel-vaulted nave, with galleries over the aisles and without a clerestory, as at St.-Sernin, but with the transverse arches spaced more widely. The realization suddenly dawned that putting groin vaults over

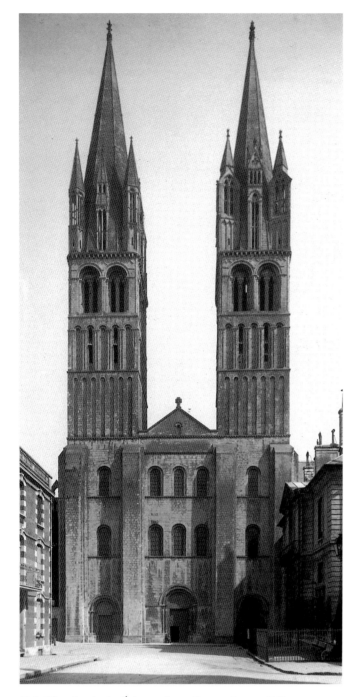

10-8. West facade, St.-Étienne, Caen, France. Begun 1068

abbey church of St.-Étienne at Caen (fig. 10-8), founded by William the Conqueror a year or two after his invasion of England in 1066, offers a striking contrast with Notre-Dame-la-Grande (fig. 10-7). The westwork proclaims this an imperial church. Its closest ancestors are Carolingian churches built under royal patronage, such as Corvey (see fig. 9-11). Like them, it has a minimum of decoration. Four huge buttresses divide the front of the church into three vertical sections. The vertical thrust continues in the two towers, whose height would be impressive even without the tall Early Gothic helmets. St.-Étienne is cool and composed: its refined proportions are meant to be appreciated by the mind rather than the eye.

DURHAM CATHEDRAL. The thinking that went into Norman architecture is responsible for the next great breakthrough in

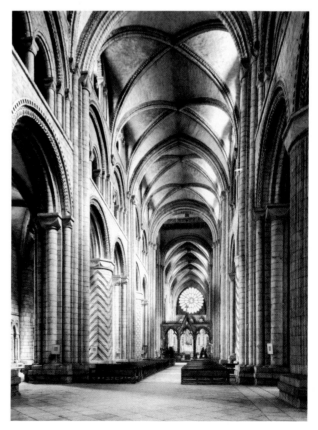

10-9. Nave (looking east), Durham Cathedral, England. 1093–1130

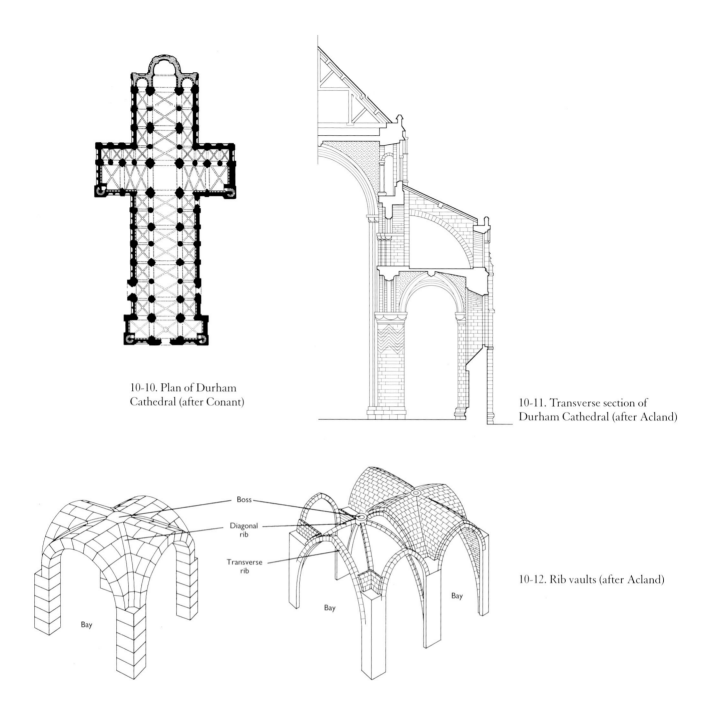

10-10. Plan of Durham
Cathedral (after Conant)

10-11. Transverse section of
Durham Cathedral (after Acland)

Boss

Diagonal
rib

Transverse
rib

Bay

Bay

Bay

10-12. Rib vaults (after Acland)

the nave as well as the aisles would produce a semicircular area at the ends of each transverse vault which could be broken through to make a clerestory, because it had no essential supporting functions (fig. 10-12, left). Each nave bay is intersected by two transverse barrel vaults of oval shape, so that it contains a pair of Siamese-twin groin vaults that divide it into seven compartments. The outward thrust and weight of the whole vault are concentrated at six securely anchored points on the gallery level. The ribs were needed to provide a stable skeleton for the groin vault, so that the curved surfaces between them could be filled in with masonry of minimum thickness. Thus both weight and thrust were reduced. (They were carried downward to the outer wall of the aisles by flying buttresses; see fig. 10-11.) We do not know whether this ingenious scheme was actually invented at Durham, but it could not have been devised much earlier, for it is still in an experimental stage. While the transverse arches at the crossing are

round, those to the west of it are slightly pointed, indicating an ongoing search for improvements.

This system had other advantages as well. From an aesthetic standpoint, the nave at Durham is among the finest in all Romanesque architecture. The wonderful sturdiness of the alternating piers makes a splendid contrast with the dramatically lit, sail-like surfaces of the vault. This lightweight, flexible system for covering broad expanses of great height with fireproof vaulting, while retaining the ample lighting of a clerestory, marks the culmination of the Romanesque and the dawn of the Gothic.

ST.-ÉTIENNE, CAEN. Let us turn now to the interior of St.-Étienne at Caen (fig. 10-13). It seems that the nave had been planned to have galleries and a clerestory, with a wooden ceiling. After the experience of Durham, it became possible in the early twelfth century to build a groined nave vault instead, with only

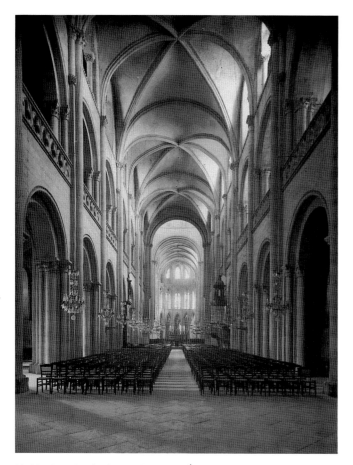

10-13. Nave (vaulted c. 1115–20), St.-Étienne, Caen

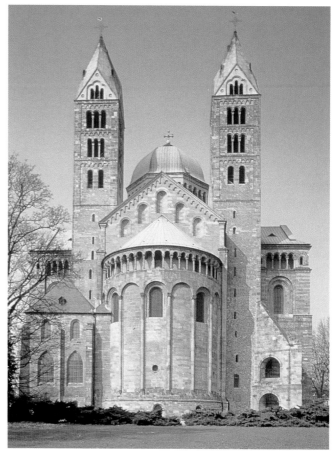

10-14. Speyer Cathedral, Germany, from the east. Begun 1030

slight changes in the wall design. But the bays of the nave here are approximately square. The double-X rib pattern therefore could be replaced by a single X with an additional transverse rib (see fig. 10-12, right), which produced a groin vault with six sections instead of seven. These vaults are no longer separated by heavy transverse arches but by simple ribs. The result is another saving in weight that also gives a stronger sense of continuity to the nave vault as a whole and makes for a less emphatic alternation of piers. Compared to Durham, the nave of St.-Étienne has an airy lightness similar in quality to the Gothic choir that was added in the thirteenth century. In structural terms, too, we have here reached the point where Romanesque merges into Early Gothic.

Germany

SPEYER CATHEDRAL. German Romanesque architecture, centered in the Rhineland, was highly conservative. As an imperial church, Speyer Cathedral reflects the Carolingian-Ottonian tradition. Begun about 1030, it was not completed until more than a century later. Speyer has a westwork (now covered by a modern reconstruction) and an equally monumental eastern grouping of crossing tower and paired stair towers (fig. 10-14). The effect reminds us of St. Pantaleon in Cologne, as do the tall proportions (compare fig. 9-21). The scale is so great as to dwarf every other church of the period. The nave, one-third taller and wider than that of Durham, has a large clerestory, since it was planned for a

wooden roof. Only in the early twelfth century was it divided into square bays and covered with heavy, unribbed groin vaults. These, however, are closer to the Lombard rather than the Norman type. The architectural detail, although similar to St. Pantaleon's, is also related to the First Romanesque (see below) in Lombardy, long a focus of German imperial ambitions.

Lombardy

We might have expected central Italy, which had been part of the heartland of the Roman Empire, to have produced the noblest Romanesque of them all, since surviving classical originals were close at hand. There were a number of factors that prevented this development. All of the rulers who sought to revive "the grandeur that was Rome," with themselves in the role of emperor, were in northern Europe. The spiritual authority of the pope, reinforced by large territorial holdings, made imperial ambitions in Italy difficult to achieve. New centers of prosperity and commerce, whether arising from seaborne trade or local industries, tended to consolidate a number of small principalities. They competed among themselves, or aligned themselves from time to time with the pope or the German emperor if it seemed politically profitable. Since Early Christian churches were as readily accessible as classical Roman buildings, the Tuscans were content to continue what were basically Early Christian forms, but they added decorative features inspired by pagan architecture.

S. AMBROGIO, MILAN. Instead, the lead in developing the Romanesque in Italy was taken by Lombardy, where ancient cities had once again grown large and prosperous. At the time when the Normans and Anglo-Normans were constructing their earliest ribbed-groined nave vaults, the same problem was being explored in and around Milan, which had devised a rudimentary system of barrel vaulting during the so-called First Romanesque in the late ninth century. Lombard Romanesque architecture was both nourished and hindered by a building tradition that reached back to Roman and Early Christian times and included the monuments of Ravenna. This background lies behind S. Ambrogio in Milan (figs. 10-15 and 10-16). The site had been occupied by a church since the fourth century. The present building was begun in the late eleventh century, except for the apse and southern tower, which date from the tenth. The brick exterior, although more ornate and more monumental, follows the First Romanesque in recalling the proportions and the geometric simplicity of the Ravenna churches (see S. Apollinare in Classe and S. Vitale; figs. 8-13 and 8-24).

Upon entering the atrium (fig. 10-15), we encounter a handsome facade with deeply recessed arcades. Just beyond it are two bell towers, separate structures just touching the outer walls of the church. We have seen a round tower of this kind on the north side of S. Apollinare in Classe, probably the earliest surviving example, of the ninth or tenth century. Most later ones are square, but the tradition of the freestanding bell tower, or **campanile**, remained so

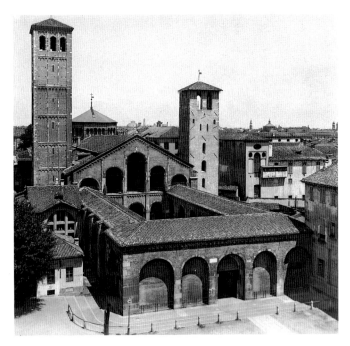

10-15. S. Ambrogio, Milan. Late 11th and 12th centuries

strong in Italy that they hardly ever became an integral part of the church itself.

The nave of S. Ambrogio (fig. 10-16) is low and broad. (It is some ten feet wider than that of Durham). It consists of four

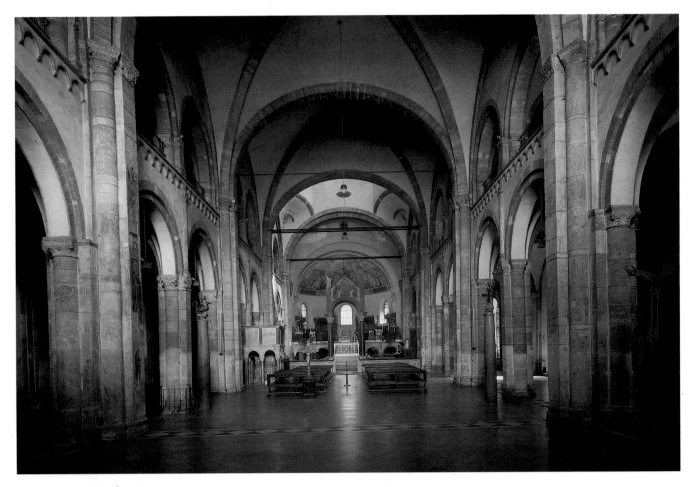

10-16. Interior, S. Ambrogio

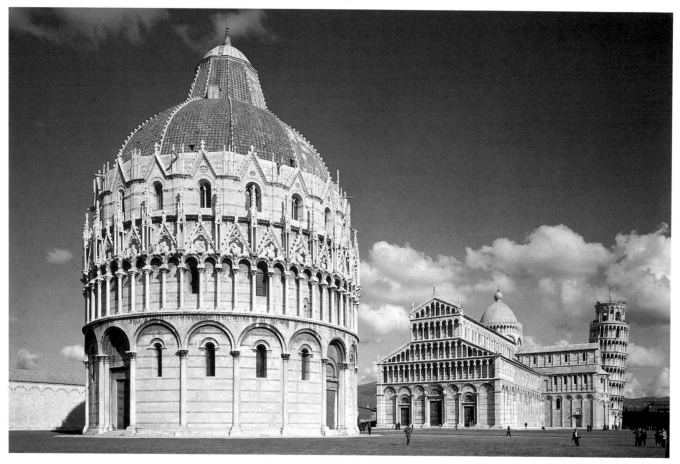

10-17. Pisa Baptistery, Cathedral, and Campanile (view from the west). 1053–1272

square bays separated by strong transverse arches. There is no transept, but the easternmost nave bay carries an octagonal, domed lantern. This feature was an afterthought, but we can easily see why it was added. The nave has no clerestory, and the windows of the lantern provide badly needed light. As at Durham and Caen, there is a system of alternating piers, since the length of each nave bay equals two aisle bays. The aisles are groin-vaulted, like the first three nave bays, and support galleries. The nave vaults are quite different from those of northern churches. Made of brick and rubble using a technique reminiscent of Roman groin vaults such as those in the Basilica of Constantine (see fig. 7-17), they are a good deal heavier. The diagonal ribs form true half-circles (at Durham and Caen they are flattened), so that the vaults rise to a point high above the transverse arches. Apart from increasing the height of the vault, this shape creates a domed effect and gives each bay the appearance of a separate unit.

On a smaller scale the architect might have attempted a clerestory instead of galleries. But the span of the nave was determined by the width of the tenth-century apse. Moreover, Lombardy had a taste for broad interior proportions, like those of Early Christian basilicas (compare fig. 8-15), instead of the height and light favored in contemporary Norman churches. Hence there was no reason to experiment with more economical shapes and lighter construction. As a result, the ribbed groin vault in Lombardy never approached the proto-Gothic.

Tuscany

PISA CATHEDRAL. The most famous monument of the Tuscan Romanesque owes its fame to an accident. Because of poor foundations, the Leaning Tower of Pisa, designed by the sculptor Bonanno Pisano (active 1174–86), began to tilt even before it was completed (fig. 10-17). The tower is the campanile of Pisa Cathedral, which includes the church itself and the circular, domed baptistery to the west. The baptistery was begun in 1153 by Dioti Salvi but everything above the arcaded first level is by the sculptor Nicola Pisano (see page 355) a century later. This ensemble, built on an open site north of the city, reflects the wealth and pride of the city-republic of Pisa after its naval victory at Palermo in 1062.

Tuscany remained conscious of its classical heritage throughout the Middle Ages. Pisa Cathedral is closely related in scale and shape to St.-Sernin in Toulouse (fig. 10-1) by way of northern Italy. However, the essential features are still much as at S. Apollinare in Ravenna (fig. 8-13). The basic plan is that of an Early Christian basilica, but it has been transformed into a Latin cross by the addition of transept arms that resemble small basilicas with apses of their own. The crossing is marked by a dome. The rest of the church is wooden-roofed except for the aisles (four in the nave, two in the transept arms), which have groin vaults. The interior (fig. 10-18) has somewhat taller proportions than an Early Christian basilica, because there are galleries over the aisles as well as a

clerestory. Yet the classical columns supporting the nave and aisle arcades still recall S. Apollinare in Classe (see fig. 8-15).

The only deliberate revival of the antique Roman style in Tuscan architecture was in the use of a multicolored marble "skin" on the exteriors of churches. Little of this inlay is left in Rome because much of it was literally "lifted" to decorate later buildings. However, the interior of the Pantheon still gives us some idea of it (see fig. 7-12). The revival of polychromy is a feature of religious architecture in Tuscany built largely during the benevolent, eventful reign of Countess Matilde (c. 1070–1115). Pisa Cathedral and its companions are covered in white marble inlaid with horizontal stripes and ornamental patterns in dark-green marble. This decorative scheme is combined with blind arcades and galleries. The result is a richness very different from austere Early Christian exteriors.

THE BAPTISTERY OF S. GIOVANNI, FLORENCE. In Florence, which was to outstrip Pisa commercially and artistically, the greatest achievement of the Tuscan Romanesque is the baptistery (fig. 10-19), opposite Florence Cathedral, which was to play an important role in the Renaissance. It is a domed, octagonal structure of impressive size. The green-and-white marble paneling is typical of the Florentine Romanesque in its severely geometric lines. The blind arcades, with their triumphal-arch motif, are extraordinarily classical in proportion and detail. Although largely from the thirteenth century, parts of it date to the early fourteenth century or even later. The entire building has such a classical air that by the time of Dante around 1300, the Florentines believed it to have first been a temple of Mars; in fact, it was originally built in the fifth century, though what we see today dates from almost a thousand years later.

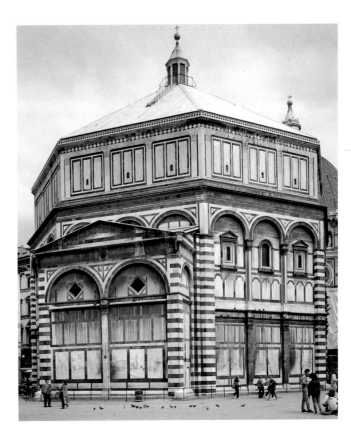

10-19. Baptistery of S. Giovanni, Florence. c. 1060–1150

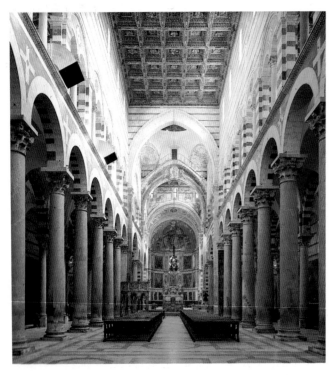

10-18. Interior, Pisa Cathedral

SCULPTURE

The revival of monumental stone sculpture is even more surprising than the architectural achievements of the Romanesque era, since neither Carolingian nor Ottonian art had shown any such inclination. Freestanding statues all but disappeared from Western art after the fifth century. Stone relief survived only in the form of architectural ornament or surface decoration, with the depth of the carving kept to a minimum. Thus the only continuous sculptural tradition in early medieval art was that of sculpture-in-miniature: small reliefs, and occasional statuettes in metal or ivory. In works such as the bronze doors of Bishop Bernward (see fig. 9-25), Ottonian art had enlarged the small scale of this tradition but had not changed its spirit. Moreover, its truly large-scale sculptural efforts, such as *The Gero Crucifix* (fig. 9-20), were limited almost entirely to wood. What little stone carving there was in western Europe before the mid-eleventh century hardly went beyond the artistic and technical level of the Sigvald relief (fig. 9-7).

Southwestern France

Fifty years later, the situation had changed dramatically. We do not know exactly when and where the revival of stone sculpture began, but the earliest surviving examples are found in southwestern France and northern Spain, along the pilgrimage roads leading to Santiago de Compostela. The link with the pilgrimage traffic seems logical enough. Architectural sculpture, especially on the exterior of a church, is meant to appeal to lay worshipers rather than to the members of a closed monastic community.

ST.-SERNIN, TOULOUSE. As in Romanesque architecture, the rapid development of stone sculpture shortly before 1100 coincides with the growth of religious fervor in the decades before the First Crusade. St.-Sernin at Toulouse contains several important examples probably carved about 1090, including the *Apostle* in figure 10-20. (This panel is now in the ambulatory; its original location is not certain, but it may have decorated the front of an altar.) Where have we seen its like before? The solidity of the forms has a strongly classical air, indicating that our artist must have had a close look at late Roman sculpture, of which there are numerous remains in southern France. But the solemn frontality of the figure and its placement in the architectural frame show that the design must be derived from a Byzantine source, probably an ivory panel descended from the *Archangel Michael* in figure 8-36.

In enlarging such a miniature, the carver of this relief has also reinflated it. The niche is a real cavity; the hair a round, close-fitting cap; the body severe and blocklike. Our *Apostle* has, in fact, much the same dignity and directness as the sculpture of Archaic Greece.

The figure, which is somewhat more than half-lifesize, was not meant to be viewed only at close range. Its impressive bulk and weight carry over a considerable distance. This emphasis on massive volume hints at what may have been the main inspiration behind the revival of large-scale sculpture. A stone-carved image, being solid and three-dimensional, is far more "real" than a painted one. To the mind of a cleric steeped in abstract theology, this might seem irrelevant or even dangerous. For unsophisticated lay worshipers, however, large sculpture had something of the effect of an idol, and it was this quality that gave it such great appeal.

ST.-PIERRE, MOISSAC. Another important early center of Romanesque sculpture was the abbey at Moissac, farther north of Toulouse along the Garonne River. In figure 10-21 we see the magnificent **trumeau** (the center post supporting the lintel) and the western **jamb** (the side of the doorway) of the south portal. (The parts of typical medieval portals are shown in fig. 10-22.) Both have a scalloped profile—apparently a bit of Moorish influence. The shafts of the half-columns applied to the jambs and **trumeau** also follow this pattern, as if they had been squeezed from a giant pastry tube. Human and animal forms are treated with the same flexibility, so that the spidery prophet on the side of the trumeau

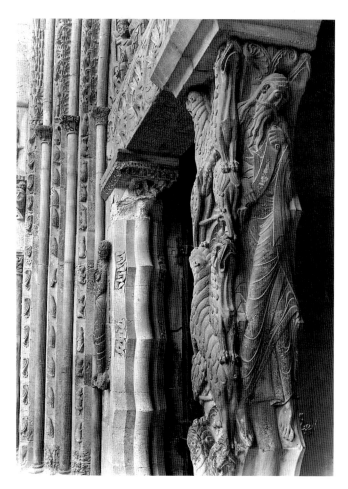

10-21. South portal (portion), St.-Pierre, Moissac, France. Early 12th century

10-20. *Apostle*. c. 1090. Stone. St.-Sernin, Toulouse

seems perfectly adapted to his precarious perch. (Notice how he, too, has been fitted into the scalloped outline.) He even remains free to cross his legs in a dancelike movement and to turn his head toward the interior of the church as he unfurls his scroll.

But what of the crossed lions that form a symmetrical zigzag on the face of the trumeau—do they have a meaning? So far as we know, they simply "animate" the shaft, just as the interlacing beasts of Irish miniatures (from which they are descended) enliven the compartments they inhabit. In manuscript illumination, this tradition had never died out. Our sculpture has undoubtedly been influenced by it, just as the agitated movement of the prophet originated in miniature painting (see fig. 10-34). The crossed lions reflect another source as well. We can trace them through textiles to Persian metalwork, although not in this towerlike formation. They descend ultimately from the heraldically arranged animals of ancient Near Eastern art (see figs. 3-9 and 4-19). Yet we cannot fully account for their presence at Moissac in terms of their effectiveness as ornament alone. They belong to an extensive family of savage or monstrous creatures in Romanesque art that retain their demoniacal vitality even though they are forced, like these lions, to perform a supporting function. (A similar example may be seen in fig. 10-27.) Their purpose is thus not only decorative but expressive. They embody dark forces that have been domesticated into guardian figures or banished to a position that holds them fixed for all eternity, however much they may snarl in protest.

The south portal at Moissac shows a richness of invention that St. Bernard of Clairvaux condemned in a letter of 1127 to Abbot William of St-Thierry concerning the sculpture of Cluny. [See Primary Sources, no. 24, page 389.] The pictorial representation of Christian themes was often justified by a famous saying: *Quod legentibus scriptura, hoc idiotis... pictura*. Translated freely, it means that painting conveys the Word of God to the unlettered. [See Primary Sources, no. 14, page 384.] Although he did not object specifically to the teaching role of art, St. Bernard had little use for church decoration. He would surely have disapproved of the Moissac portal's excesses, which were clearly meant to appeal to the eye—as his grudging admiration for the cloister at Cluny attests.

In front of the portal at Moissac is a deep porch with lavishly sculptured sides. Within the arcade on the east flank (fig. 10-23), we see the *Annunciation* and *Visitation,* as well as the *Adoration of the Magi*. Other events from the early life of Christ are shown on the frieze above. Here we find the same thin limbs and eloquent gestures we saw in the prophet on the trumeau. (Note the wonderful play of hands in the *Visitation* and *Annunciation*.) Only the proportions of the bodies and the size of the figures vary with the architectural context. What matters is the vividness of the narrative, rather than consistency of treatment.

Burgundy

AUTUN CATHEDRAL. The **tympanum** (the lunette above the lintel) of the main portal of Romanesque churches usually holds a composition centering on the Enthroned Christ. Most often it shows the Apocalyptic Vision, or the Last Judgment, the most awesome scene in Christian art. At Autun Cathedral this subject has been treated with extraordinary force by Giselbertus (fig. 10-24), who probably based his imagery on a contemporary account rather than on the Revelation of St. John the Divine. The apostles, at the viewer's left, observe the weighing of souls, shown at the right. Four angels in the corners sound the trumpets of the Apocalypse. At the bottom, the dead rise from their graves in fear

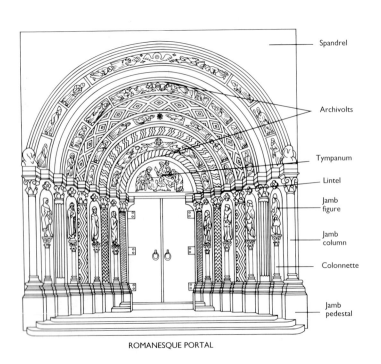

ROMANESQUE PORTAL

Spandrel

Archivolts

Tympanum

Lintel

Jamb figure

Jamb column

Colonnette

Jamb pedestal

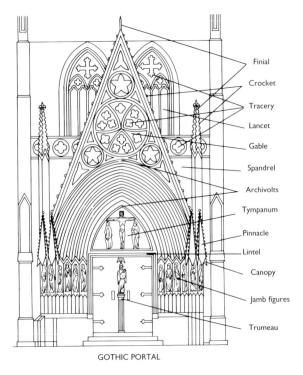

GOTHIC PORTAL

Finial

Crocket

Tracery

Lancet

Gable

Spandrel

Archivolts

Tympanum

Pinnacle

Lintel

Canopy

Jamb figures

Trumeau

10-22. Romanesque and High Gothic portal ensembles

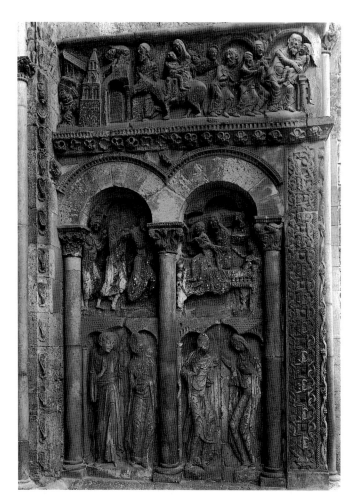

and trembling; some are already beset by snakes or gripped by huge, clawlike hands. Above, their fate quite literally hangs in the balance, with devils yanking at one end of the scales and angels at the other. The saved souls cling like children to the angels for protection before their ascent to the Heavenly Jerusalem (far left), while the condemned, seized by grinning devils, are cast into the mouth of Hell (far right). These devils betray the same nightmarish imagination we saw in the Romanesque animal world. They are human in general outline but they have birdlike legs, furry thighs, tails, pointed ears, and savage mouths. No visitor, having "read in the marble" here (to quote St. Bernard of Clairvaux), could fail to enter the church in a chastened spirit.

The emergence of distinct artistic personalities in the twelfth century is rarely acknowledged, perhaps because it contradicts the widespread notion that all medieval art is anonymous. Giselbertus is not the only or even the earliest case. He is one of several Romanesque sculptors who are known to us by name, and not by accident. Their highly individual styles made theirs the first names worthy of being recorded since Odo of Metz more than three hundred years earlier.

Giselbertus is distinguished from his contemporaries by the unusually wide range of his work. As at Moissac, it varies according to subject and location. His *Eve* (fig. 10-25) is as whimsical as the *Last Judgment* is terrifying. She is delicately plucking the apple from

(LEFT) 10-23. East flank, south portal, St.-Pierre, Moissac (the angel of the *Annunciation,* bottom left, is modern)

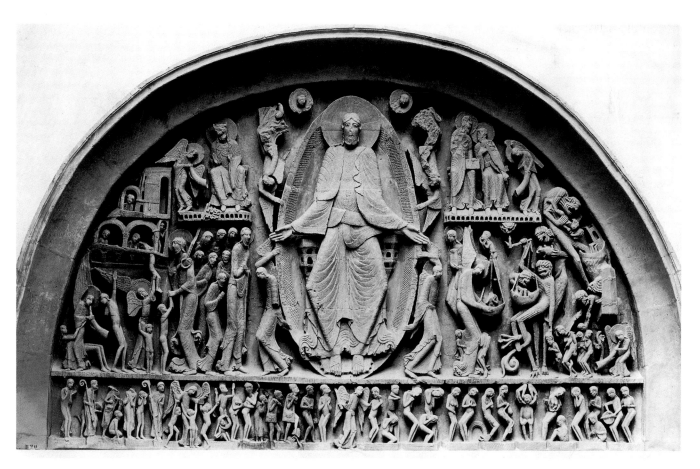

10-24. Giselbertus. *Last Judgment,* west tympanum, Autun Cathedral. c. 1130–35

the Tree of Knowledge with an irresistible come-hither look at the missing Adam, who no doubt faced her. The languid pose, necessitated by the door lintel she adorns, allows Giselbertus to model her figure with captivating—and surprisingly sensual—beauty

STE.-MADELEINE, VÉZELAY. Giselbertus began his career at Cluny (see pages 297–298). There he may have served as chief assistant to the unknown master who created the tympanum at Ste. Madeleine in Vézelay, not far from Autun (fig. 10-26), perhaps

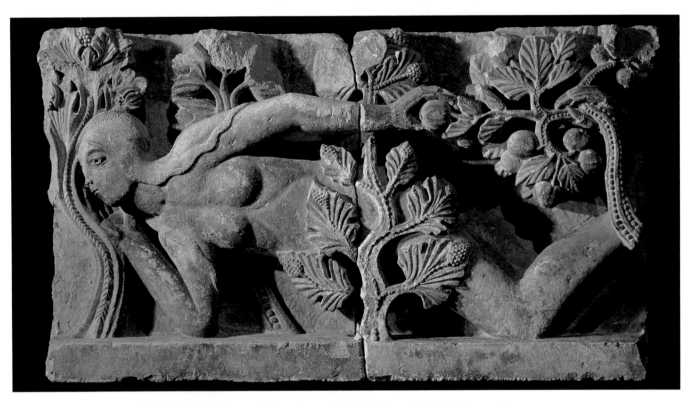

10-25. Giselbertus. *Eve,* right half of lintel, north portal from Autun Cathedral, France. 1120–1132. 28½ x 51" (72.4 x 129.5 cm). Musée Rolin, Autun

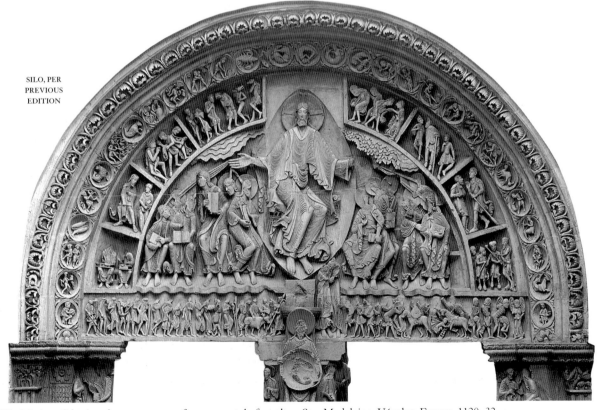

SILO, PER PREVIOUS EDITION

10-26. *The Mission of the Apostles,* tympanum of center portal of narthex, Ste.-Madeleine, Vézelay, France. 1120–32

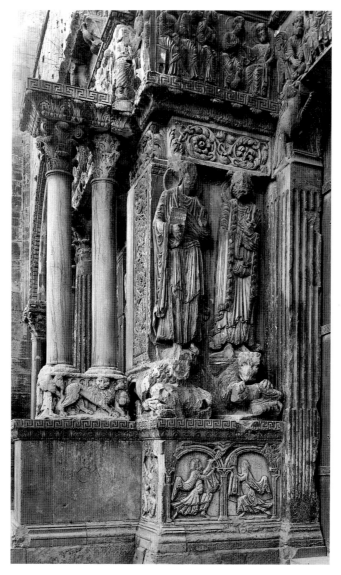

10-27. North jamb, center portal, St.-Gilles-du-Gard, France.
Second quarter of the 12th century

the most beautiful in all Romanesque art. [See Primary Sources, no. 23, page 388.] Its subject, the Mission of the Apostles, had a special meaning for the age of Crusades, since it proclaims the duty of every Christian to spread the Gospel to the ends of the earth. From the hands of the majestic ascending Christ we see the rays of the Holy Spirit pouring down upon the apostles, all of whom hold copies of the Scriptures in token of their mission. The lintel and the compartments around the central group are filled with representatives of the heathen world, an encyclopedia of medieval anthropology which includes all sorts of legendary races. On the **archivolt** (the arch framing the tympanum) are the signs of the zodiac and the labors appropriate to every month of the year, to indicate that the preaching of the Faith is as unlimited in time as it is in space.

Romanesque Classicism

PROVENCE. The portal sculpture at Moissac, Autun, and Vézelay, although varied in style, has many qualities in common: intense expression, unbridled fantasy, and a nervous agility that

owes more to manuscript illumination and metalwork than to the sculpture of antiquity. The *Apostle* from St.-Sernin, in contrast, impressed us with its distinctly Roman flavor. The influence of classical monuments was particularly strong in Provence, the coastal region of southeastern France. This area had been part of the Graeco-Roman world far longer than the rest of the country and is full of Roman remains. Perhaps for that reason, the Romanesque style persisted longer here than anywhere else.

Looking at the center portal of the church at St.-Gilles-du-Gard (fig. 10-27), one of the great masterpieces of Romanesque art, we are struck immediately by the classical flavor of the architectural framework, with its freestanding columns, meandering patterns, and acanthus ornament. The two large statues, carved almost in the round, have a weight and volume that reminds us of the *Apostle* from St.-Sernin. Being half a century later, however, they also display the rich detail we have seen at Autun and Vézelay. The pair stand on brackets supported by crouching beasts of prey that show a Roman massiveness, while the small figures on the base (Cain and Abel) recall the style of Moissac.

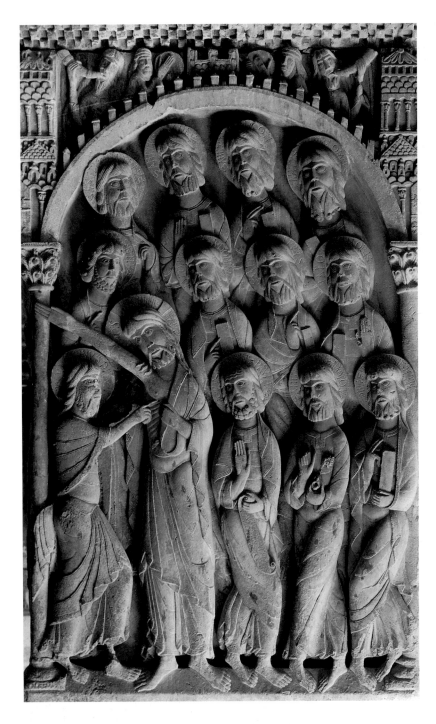

10-28. *The Doubting of Thomas.*
c. 1130–40. Marble.
Cloister, Sto. Domingo de Silos, Spain

Spain and Italy

STO. DOMINGO DE SILOS. The French style soon spread to Spain, first to Santiago de Compostela, where the sculpture has unfortunately been much rearranged, then to Sto. Domingo de Silos, which became an important destination in its own right, even though it lies some 60 miles off the pilgrimage route. Among the reliefs in the cloister of Sto. Domingo, which were probably carved in the second quarter of the twelfth century, is the superb *Doubting of Thomas* in figure 10-28. The composition, with apostles who all appear to have been cut from the same mold, is indebted to Ottonian art (compare fig. 9-29). The subtle carving owes something to France as well, in particular the corner piers of the cloister at Moissac. It shares other features found in Romanesque sculpture outside Spain: the elongated forms, angular poses, and emphatic gestures. Yet we cannot account for the appearance of this work solely in terms of external influences. *The Doubting of Thomas* is, in fact, highly original, for there is nothing like it elsewhere. Its unaffected plainness is both enchanting and deceptive—the stylization gives the scene an expressiveness that is as moving as it is direct. Like the Gregorian chants for which Silos is known, this relief is an eloquent testimony to faith. They share similar formal means as well: both rely on the repetition of unadorned motifs in simple cadence for their effect.

WILIGELMO. Although the French style quickly became international, it was modified through interaction with local tradition. We see this process in the work of Wiligelmo, whose reliefs from

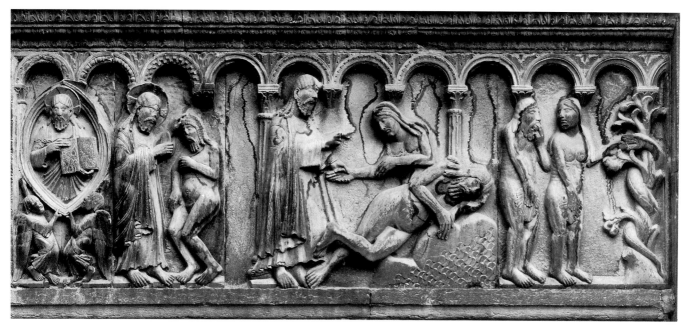

10-29. Wiligelmo. *Scenes from Genesis*. c. 1106–20. Marble, height approx. 36" (91.5 cm). Cathedral, Modena, Italy

Genesis (fig. 10-29) on the facade of Modena Cathedral founded Romanesque sculpture in Italy. The scenes show a surprising kinship to the doors of Bishop Bernward at Hildesheim (fig. 9-25). The resemblance suggests that Wiligelmo perhaps came from Germany, where he may have been trained as a goldsmith under the name Wilhelm. If so, he must also have been familiar with the Romanesque style then emerging in Burgundy, as a glance at the frieze depicting the early life of Christ along the porch at Moissac attests (see fig. 10-23). Nevertheless, the figures show a knowledge of the nude that can have been gained only in Italy itself. Moreover, they have a massiveness derived from Early Christian ivory panels done in Italy that seems all the more surprising if we compare them to the spindly Adam and Eve at Hildesheim, from which they descend. This solidity gives the scenes a solemn dignity, in contrast to the drama seen on Bernward's doors (compare fig. 9-26). The artist was proud of his work, and justly so. An inscription boasts, "Among sculptors, your work shines through, Wiligelmo." It is not surprising that Italian sculpture was revived by a German. The Italian sculptural tradition had all but died out by the middle of the eighth century, while northern Italy remained in the hands of German rulers, who also acted as protectors of the papacy in Rome.

BENEDETTO ANTELAMI. The budding classicism of Wiligelmo reached its height toward the end of the twelfth century in the figure of King David from the facade of Fidenza Cathedral in Lombardy (fig. 10-30), by Benedetto Antelami, the greatest sculptor of Italian Romanesque art. As we have seen, artists' signatures are far from rare in Romanesque times. What sets Antelami apart is the fact that his work shows much more individuality than other artists'. For the first time since the ancient Greeks, we can begin to speak (although with some hesitation) of a personal style. Unlike Wiligelmo, Antelami was at heart a monumental sculptor, not a relief carver. Thus his *King David* comes closer to the ideal of the freestanding statue than any medieval work we have seen

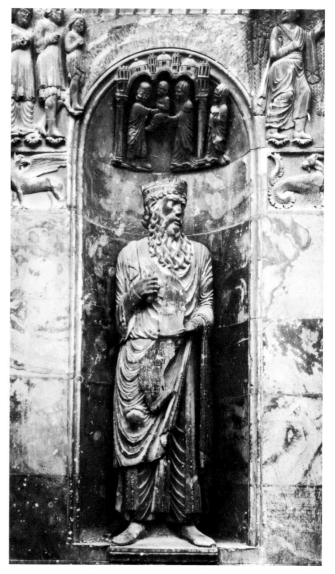

10-30. Benedetto Antelami. *King David*. c. 1180–90. West facade, Fidenza Cathedral, Italy

so far. Whereas the *Apostle* from St.-Sernin is fixed to its niche, Antelami's *King David* stands physically free and even shows an attempt at classical contrapposto. To be sure, he would look awkward if placed on a pedestal in isolation. He demands the architectural framework for which he was made, but far less than the two statues at St.-Gilles-du-Gard, to which he is otherwise related (fig. 10-27). Unlike the St.-Sernin *Apostle* (fig. 10-20), he is not part of a series of figures; his only companion is a second statue in a niche on the other side of the portal. We note, too, that the figure is lost in thought. Indeed, such expressiveness, new to Romanesque sculpture, is typical of Antelami's work. We shall meet it again in the statues of Donatello (compare fig. 12-2). The *King David* is an extraordinary achievement, especially if we consider that less than a hundred years separate it from the beginnings of the sculptural revival.

The Meuse Valley

The revival of individuality also took place in the valley of the Meuse River, which runs from northeastern France into Belgium and Holland. Here again it is linked with the influence of ancient art, although this influence did not lead to works on a monumental scale. This region had been the home of the classicizing Reims style in Carolingian times (see figs. 9-17 and 9-18), and an awareness of classical sources pervades its art (called Mosan) during the Romanesque period.

Mosan Romanesque sculptors excelled in metalwork. The baptismal font of 1107–18 in Liège (fig. 10-31) was done by the earliest artist of the region whose name we know: Renier of Huy. The vessel rests on 12 oxen (symbols of the 12 apostles), like Solomon's basin in the Temple at Jerusalem as described in the Bible. The reliefs are about the same height as those on Bernward's doors (see fig. 9-26). Instead of the rough expressive power of the Ottonian panel, however, we find a harmonious balance of design, a subtle control of the sculptured surfaces, and an understanding of organic structure that, in medieval terms, are amazingly classical. The figure seen from the back (beyond the tree on the left), with its graceful movement and Greek-looking drapery, might almost be taken for an ancient work. The scene was, in fact, adapted from Byzanine art, which helps to explain its classical quality.

Germany

THE LION MONUMENT. The only monumental freestanding statue of Romanesque art that has survived is the lifesize bronze lion on top of a tall shaft that Duke Henry the Lion of Saxony had placed in front of his palace at Brunswick in 1166 (fig. 10-32). The ferocious animal personifies the duke, or at least the aspect of his personality that earned him his nickname. It brings to mind the lion of St. Mark from the *Echternach Gospels* (fig. 9-5), and with good reason. Both are descended from the miniature beasts that decorate a Hallstatt bronze cauldron and from the monsters of Celtic art, which are derived from the Near East. We are also reminded of the archaic bronze she-wolf of Rome (see fig. 6-9). Perhaps the resemblance is not a coincidence.

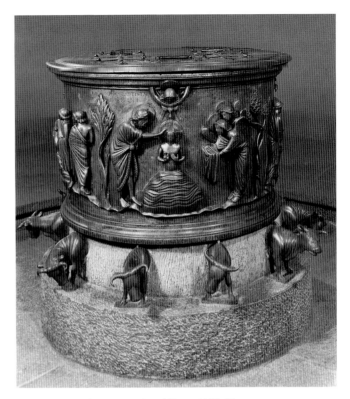

10-31. Renier of Huy. Baptismal Font. 1107–18. Bronze, height 25" (63.5 cm). St.-Barthélemy, Liège, Belgium

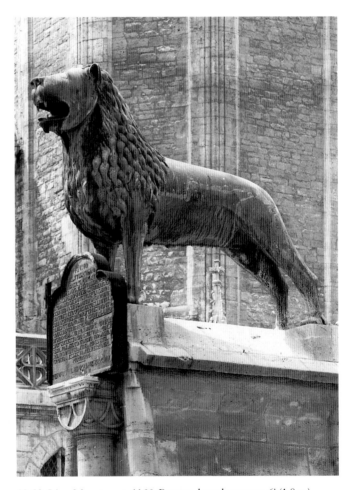

10-32. Lion Monument. 1166. Bronze, length approx. 6' (1.8 m). Cathedral Square, Brunswick, Germany

The she-wolf was on public view in Rome at that time and must have had a strong appeal for Romanesque artists.

The more immediate relatives of the Brunswick lion, however, are the bronze water ewers in the shape of lions, dragons, griffins, and the like that came into use in the twelfth century for the ritual washing of the priest's hands during Mass. These vessels, another instance of monsters serving the Lord, were of Near Eastern inspiration. The beguiling example in figure 10-33 betrays its descent from the winged beasts of Persian art (compare fig. 3-29), which were transmitted to the West through trade with the Islamic world.

PAINTING AND METALWORK

Unlike architecture and sculpture, Romanesque painting shows no revolutionary developments that set it apart from Carolingian or Ottonian art. Nor does it look more Roman than Carolingian or Ottonian painting. This does not mean, however, that in the eleventh and twelfth centuries painting was any less important than it had been during the earlier Middle Ages. The lack of dramatic change merely emphasizes the greater continuity of the pictorial tradition, especially in manuscript illumination.

France

THE GOSPEL BOOK, CORBIE. Soon after the year 1000 we find the beginnings of a painting style that corresponds to—and often anticipates—the monumental qualities of Romanesque sculpture. It can be seen in the *St. Mark* (fig. 10-34) from a Gospel

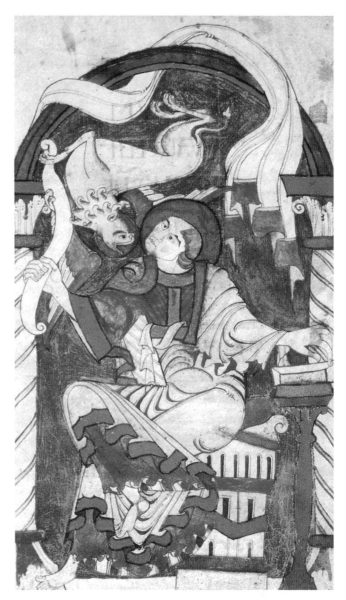

10-34. *St. Mark,* from a Gospel Book produced at Corbie. c. 1050. Bibliothèque Municipale, Amiens, France

10-33. Ewer. Mosan. c. 1130. Gilt bronze, height 7¼" (18.5 cm). Victoria & Albert Museum, London

Book probably done toward 1050 at the monastery of Corbie in northern France. The twisting movement of the lines, not only in the figure of St. Mark but also in the winged lion, the scroll, and the curtain, recalls Carolingian miniatures of the Reims School such as the *Ebbo Gospels* (see fig. 9-17). This very resemblance helps us see the differences between them as well. In the Corbie manuscript, every trace of classical illusionism has disappeared. The fluid modeling of the Reims School, with its suggestion of light and space, has been replaced by firm contours filled in with bright, solid colors. As a result, the three-dimensional aspects of the picture are reduced to overlapping planes. Even Ottonian painting (see figs. 9-27 and 9-28) seems illusionistic in comparison. Yet by sacrificing the last remnants of modeling in terms of light and shade, the Romanesque artist has given his work a clarity and precision that had not been possible in Carolingian or Ottonian times. Only now can we truly say that the representational, the symbolic, and the decorative elements of the design are fully united.

10-35. *The Battle of Hastings.* Detail of the *Bayeux Tapestry.* c. 1073–83. Wool embroidery on linen, height 20" (50.7 cm). Centre Guillaume le Conquérant, Bayeux, France

This style avoids all pictorial effects—not only tonal values but the textures and highlights still found in Ottonian painting. For that very reason, however, it gains a new universality of scale. The evangelists of the *Ebbo Gospels,* the drawings of the *Utrecht Psalter,* and the miniatures in the *Gospel Book of Otto III* are made up of open, spontaneous flicks and dashes of brush or pen that have an intimate, handwritten flavor. They would look strange if copied on a larger scale or in another medium. The Corbie miniature, on the contrary, might be translated into a mural, a stained-glass window, a tapestry, or a relief panel without losing any of its essential qualities.

THE BAYEUX TAPESTRY. This monumentality is found again in the *Bayeux Tapestry,* an embroidered frieze 230 feet long illustrating William the Conqueror's invasion of England. In our detail (fig. 10-35) depicting the Battle of Hastings, the designer has integrated narrative and ornament with complete ease. The main scene is framed by two border strips. The upper tier with birds and animals is purely decorative, but the lower one is full of dead warriors and horses and forms part of the story. Although it does not use the pictorial devices of classical painting, such as foreshortening and overlapping (see fig. 5-62), the tapestry gives us a vivid and detailed account of warfare in the eleventh century. The massed forms of the Graeco-Roman scene are gone, replaced by a new kind of individualism that makes each figure a potential hero, whether by force or by cunning. (Note how the soldier who has

fallen from the horse with its hind legs in the air is, in turn, toppling his foe by yanking at the saddle girth of his mount.) The kinship with the Corbie manuscript can be seen in the lively somersaults of the horses, so like the pose of the lion in the miniature.

ST.-SAVIN-SUR-GARTEMPE. The firm outlines and strong sense of pattern found in the English Channel region are equally characteristic of Romanesque wall painting in southwestern France. *The Building of the Tower of Babel* (fig. 10-36) is part of the most impressive surviving cycle, which appears on the nave vault of the church at St.-Savin-sur-Gartempe (compare fig. 10-6). It is an intensely dramatic design, crowded with strenuous action. The Lord himself, on the far left, participates directly in the narrative as he addresses the builders of the huge structure. He is counterbalanced, on the right, by the giant Nimrod, the leader of the project, who frantically hands blocks of stone to the masons atop the tower, so that the entire scene becomes a great test of strength between God and human. The heavy, dark contours and the emphatic gestures make the composition easily readable from the floor below. Yet the same qualities occur in the illuminated manuscripts of the region, which can be equally monumental despite their small scale.

S. ANGELO IN FORMIS. Where did the idea come from to cover such a vast area with murals? Surely not from France itself, which had no tradition of monumental painting. It must have

10-36. *The Building of the Tower of Babel.* Detail of painting on the nave vault, St.-Savin-sur-Gartempe, France. Early 12th century

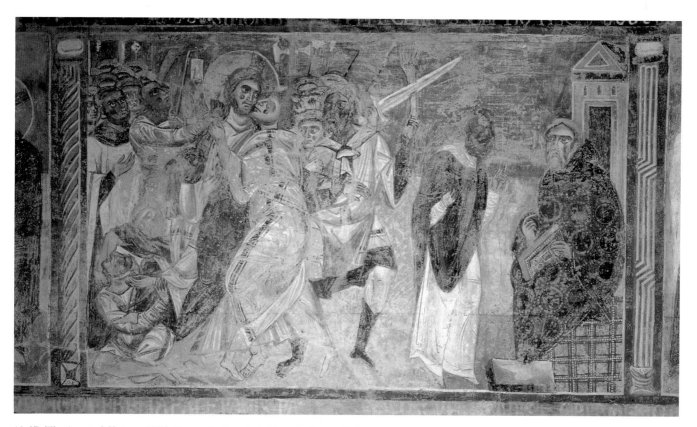

10-37. *The Arrest of Christ.* c. 1085. Fresco. S. Angelo in Formis, Capua, Italy

come from Byzantium (see fig. 8-57)—probably by way of Italy, which had strong ties to the East (see pages 236–240). Toward the end of the eleventh century, Greek artists decorated the newly constructed basilican church of the Benedictine monastery at Monte Cassino with mosaics at the invitation of Abbot Desiderius (later Pope Victor III). Although they have been lost, their impact can be seen in the frescoes painted a short time later in the church

of S. Angelo in Formis near Capua, also built by Desiderius. *The Arrest of Christ,* along the nave (fig. 10-37), is a counterpart to the mosaics and murals of Early Christian basilicas, whose splendor Desiderius sought to recapture. The painting shows its Byzantine heritage, but it has been adapted to Latin liturgical requirements and taste. What it lacks in sophistication, this monumental style more than makes up for in expressive power. That quality appealed

The late tenth through the twelfth centuries witnessed the unprecedented rise of women, first as patrons of art and then as artists. This remarkable development began with the Ottonian dynasty, which forged an alliance with the Church by placing members of the ruling family in prominent positions. Thus Mathilde, Otto I's granddaughter, became abbess of the Holy Trinity convent at Essen in 974. Later, the sister, daughters, and granddaughter of Otto II also served as abbesses of major convents. Hardly less important, though not of royal blood, were Hrosvitha, canoness at the monastery of Gandersheim, who was the first woman dramatist we know of, and the two abbesses of Niedermünster, both named Uota. They paved the way for Herrad of Hohenberg (died 1195), author of *The Garden of Delights,* an encyclopedia of knowledge and history compiled for the education of her sisters.

Most remarkable of all was the Benedictine abbess Hildegard of Bingen (1098–1179). Among the most brilliant women in history, she corresponded with leaders throughout Europe. In addition to a musical drama in Latin, the *Ordo Virtutum,* about the struggle between the forces of good and evil, she composed almost 80 vocal works that rank with the finest of the day. For her, musical harmony reflected the harmony of the universe. She also wrote some 13 books on theology, medicine, and science. She is known above all for her books of visions, which made her one of the great spiritual voices of her day. Although one *(To Know the Ways of God)* is now known only in facsimile (it was destroyed in 1945) and the other *(The Book of Divine Works)* in a later reproduction, it seems likely that the originals were executed under her direct supervision by nuns in her con-

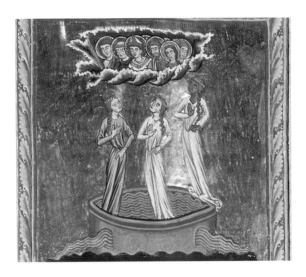

"The Fountain of Life," detail from *Liber divornum operum.* Vision 8. fol. 132r. 13th century. Tempera on vellum, 13⅛ x 5⅝" (33.3 x 14 cm). Biblioteca Statale di Lucca, Italy

vent on the Rhine. It has also been argued that they were produced by monks at nearby monasteries.

That there were women artists from the twelfth century on is certain, although we know only a few of their names. [See Primary Sources, no. 39, page 395.] In one instance, an initial in a manuscript includes a nun bearing a scroll inscribed "Guda, the sinful woman, wrote and illuminated this book"; another book depicts Claricia, evidently a lay artist, swinging as carefree as any child from the letter Q she has decorated. Without these author portraits, we might never suspect the involvement of women illuminators.

to Western artists, as it was in keeping with the vigorous art that emerged at the same time in the *Bayeux Tapestry.*

By the middle of the twelfth century, Byzantine influence could be seen everywhere, from Italy and Spain in the south to France, Germany, and England in the north. How did it spread? Most likely through the Benedictine order, then at the height of its power. A Byzantine style must have been a major feature of the decorations in the abbey church at Cluny, the seat of Benedictine monasticism in France. The Cluniac style is echoed in the early-twelfth-century frescoes at nearby Berzé-la-Ville, which have distinct Byzantine overtones that relate them directly to the paintings at S. Angelo in Formis.

The Channel Region

Although Romanesque painting, like architecture and sculpture, developed a wide variety of regional styles, its greatest achievements emerged from the monastic **scriptoria** of northern France, Belgium, and southern England. The works from this area are so closely related in style that at times we cannot be sure on which side of the English Channel a given manuscript was produced.

THE GOSPEL BOOK OF ABBOT WEDRICUS. The style of the miniature of St. John (fig. 10-38) has been linked with both Cambrai, France, and Canterbury, England. Here the abstract linear draftsmanship of the Corbie manuscript (see fig. 10-34) has been influenced by Byzantine art. (Note the ropelike loops of drapery, whose origin can be traced back to such works as the *Crucifixion* at Daphné in fig. 8-49 and, even further, to the ivory leaf in fig. 8-36.) The energetic rhythm of the Corbie style has not been lost entirely, however. The controlled dynamics of every contour, both in the main figure and in the frame, unite the varied elements of the composition. This quality of line betrays its ultimate source: the Celtic-Germanic heritage.

If we compare our miniature with one from the *Lindisfarne Gospels* (fig. 9-3), we see how much the interlacing patterns of the early Middle Ages have contributed to the design of the St. John page. The drapery folds and the clusters of floral ornament have an impulsive yet disciplined liveliness that echoes the intertwined snakelike monsters of the animal style, even though the foliage is derived from the classical **acanthus,** and the human figures are based on Carolingian and Byzantine models. The unity of the page is conveyed not only by the forms but by the content as well.

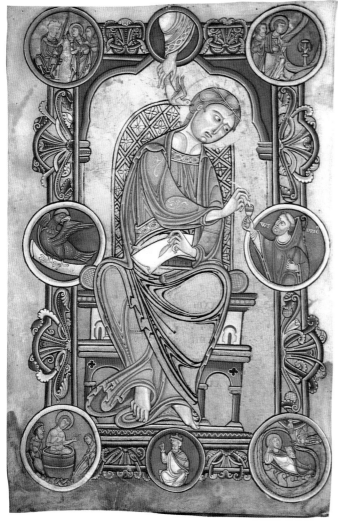

10-38. *St. John the Evangelist,* from the *Gospel Book of Abbot Wedricus.* c. 1147. Tempera on vellum, 14 x 9½" (35.5 x 24.1 cm). Société Archéologique et Historique, Avesnes-sur-Helpe, France

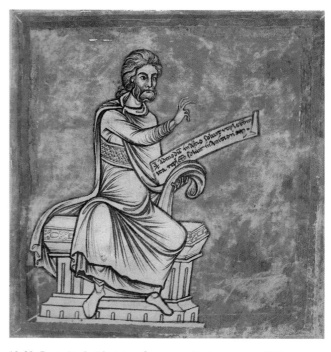

10-39. *Portrait of a Physician,* from a medical treatise. c. 1160. The British Museum, London

St. John inhabits the frame so thoroughly that we could not remove him from it without cutting off his ink supply (offered by the donor of the manuscript, Abbot Wedricus), his source of inspiration (the dove of the Holy Spirit in the hand of God), or his symbol (the eagle). The other medallions, less closely linked with the main figure, show scenes from the life of St. John.

PORTRAIT OF A PHYSICIAN. Soon after the middle of the twelfth century, there was an important change in Romanesque painting on both sides of the English Channel. *The Portrait of a Physician* (fig. 10-39), from a medical manuscript of about 1160, is quite different from the St. John miniature, although it was produced in the same region. Instead of abstract patterns, we find lines that describe three-dimensional forms. The drapery folds no longer lead an ornamental life of their own but suggest the rounded volume of the body underneath. There is even a renewed interest in foreshortening. At last, then, we see an appreciation for the achievements of antiquity that is missing in the murals at S. Angelo in Formis and St.-Savin-sur-Gartempe. Here again, the lead was taken by Cluny, which was a major center of manuscript production.

This style, too, stemmed from Byzantine art, which saw a revival of classicism during the tenth and eleventh centuries. It may have been transmitted through Germany, where Byzantine elements had long been present in manuscript painting (compare figs. 9-15 and 9-27). The physician, seated in the pose of Christ as philosopher, will remind us of David from the *Paris Psalter* (see fig. 8-48), but he has been utterly transformed. The sharp, deliberate lines look as if they had been engraved in metal, rather than drawn with pen or brush. Thus our miniature is the pictorial counterpart of the classicism we saw in the baptismal font of Renier of Huy at Liège (see fig. 10-31). In fact, it was probably done at Liège, too.

NICHOLAS OF VERDUN. That a new way of painting should have originated in metalwork is not as strange as it might seem: the style's essential qualities are sculptural rather than pictorial. Metalwork (which includes not only cast or embossed sculpture but also engraving, enameling, and goldsmithing) had been a highly developed art in the Meuse Valley area since Carolingian times, which had derived them from Byzantium. Its greatest practitioner after Renier of Huy was Nicholas of Verdun.

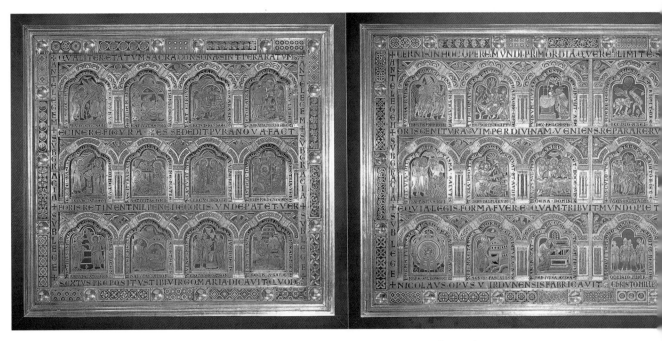

10-40. Nicholas of Verdun. *Klosterneuburg Altar.* 1181. Gold and enamel, height approx. 28" (71.1 cm). Klosterneuburg Abbey, Austria

In his work, the classicizing, three-dimensional style of draftsmanship reaches full maturity.

The Klosterneuburg Altar, which he completed in 1181 for provost Wernher, consists of numerous engraved and enameled plaques (fig. 10-40). Originally this work took the form of a **pulpit**, but after a fire in 1330 it was rearranged as a **triptych,** with the scenes laid out side by side like a series of manuscript illuminations from the Old and New Testaments. The plaques' brilliance recalls, on a miniature scale, the glittering play of light across mosaics (compare fig. 8-49). *The Crossing of the Red Sea* (fig. 10-41) clearly belongs to the same tradition as the Liège miniature. Here we meet the pictorial counterpart of the classicism that we saw earlier in the baptismal font by Renier of Huy (see fig.10-31). The lines have suddenly regained their ability to describe three-dimensional forms instead of abstract patterns. The figures, clothed in "wet" draperies familiar to us from Classical statues, have achieved such a high degree of organic structure and freedom of movement that we tend to think of them as forerunners of Gothic art rather than as the final phase of the Romanesque. Whatever we choose to call it, the style of the Klosterneuburg Altar had a profound impact on both painting and sculpture during the next 50 years (see figs. 11-75 and 11-45).

Equally revolutionary is the new expressiveness of the scene. All the figures, even the little dog perched on the bag carried by one of the men, are united through the exchange of glances and gestures within the tightly knit composition. Not since late Roman times have we seen such concentrated drama, although its intensity is unique to medieval art (compare fig. 8-17). Indeed, the astonishing humanity of Nicholas of Verdun's art is linked to an appreciation of ancient art, classical literature, and mythology.

CARMINA BURANA. The reawakening of interest in humanity and the natural world throughout northwestern Europe sometimes was expressed as the enjoyment of sensuous experience. This eagerness is reflected in poetry, such as the well-known *Carmina Burana,* composed during the later twelfth century by many of the leading poets of the day and preserved in an illuminated manuscript of the early thirteenth century that was produced at a Benedictine monastery in Upper Bavaria. That a collection of verse devoted largely, and at times very frankly, to the delights

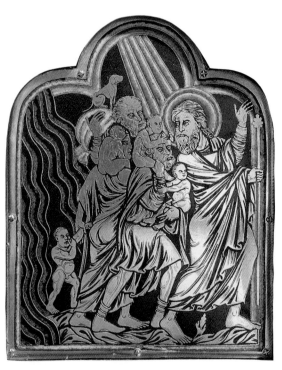

10-41. Nicholas of Verdun. *The Crossing of the Red Sea,* from the *Klosterneuburg Altar.* 1181. Enamel on gold plaque, height 5½" (14 cm). Klosterneuburg Abbey

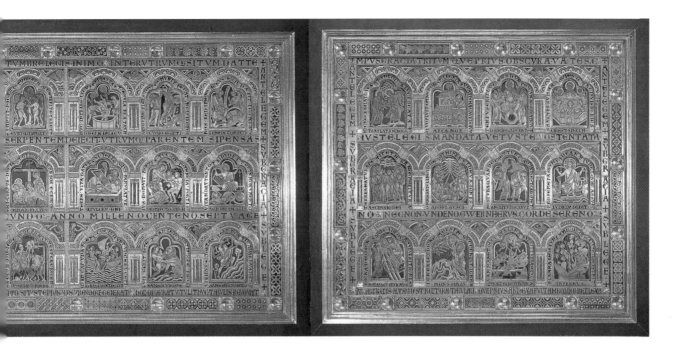

of nature, love, and drinking should have been embellished with illustrations is significant in itself. (It also includes biting moral and satirical poems, as well as liturgical dramas.) We are even more surprised, however, to find that one of the miniatures (fig. 10-42), coupled with a poem praising summer that was also set to music, represents a landscape—the first, so far as we know, to appear in Western art since Late Classical times.

Echoes of ancient landscape painting, derived from Early Christian and Byzantine sources, can be found in Carolingian art (see figs. 9-17 and 9-18), but there they serve only as a background for the human figure. Later on, these remnants were reduced still further, even when the subject required a landscape setting. For example, the Garden of Eden on Bernward's doors (see fig. 9-26) is no more than a few twisted stems and bits of foliage. Thus the illustrator of the *Carmina Burana* must have been perplexed by how to depict the life of nature in summertime. The problem has been solved in the only way possible at the time: by filling the page with a sort of anthology of Romanesque plant ornament interspersed with birds and animals.

The trees, vines, and flowers are so abstract that we cannot identify a single species. The birds and animals, probably copied from a zoological treatise, are far more realistic. Yet the plants have an uncanny vitality of their own. They seem to sprout and unfold as if the growth of an entire season were compressed into a few frantic moments. These giant seedlings convey the exuberance of early summer, of stored energy suddenly released, far more intensely than any normal vegetation could. Our artist has created a fairytale landscape, but this enchanted world evokes an underlying reality that shows a new appreciation of life in nature.

10-42. Page with *Summer Landscape,* from a manuscript of *Carmina Burana.* Early 13th century. 7 x 4⁷⁄₈" (17.8 x 12.5 cm). Bayerische Staatsbibliothek, Munich

CHAPTER ELEVEN
Gothic Art

Time and space, we have been taught, are interdependent. Yet although we tend to think of events as unfolding in time, we are not as aware of their unfolding in space. We visualize history as a stack of chronological layers, or periods, with each one having a specific depth that corresponds to its length. For the more remote past, when our information is scanty, this simple image works reasonably well. It becomes less satisfactory as we draw closer to the present and our knowledge is greater.

By the time we reach the Gothic era, this model is altogether inadequate. Thus we cannot define the age in terms of time alone—we must consider its changing surface area as well. At the start, about 1140, this area was small indeed. It included only the province known as the Île-de-France (Paris and vicinity), the royal domain of the French kings. A hundred years later, most of Europe had adopted the Gothic style, from Sicily to Iceland. Through the Crusaders the new style was even carried to the Near East. Around 1450, the Gothic area began to shrink. (It no longer included Italy.) By about 1550, it had disappeared almost entirely, except in England. The Gothic layer, then, has a rather complicated shape. Its depth ranges from close to 400 years in some places to 150 in others. Moreover, this shape is not the same in all the visual arts.

The term *Gothic* was first coined for architecture, and it is in architecture that the style is most recognizable, although we also speak of Gothic sculpture and painting. For a century—from about 1150 to 1250, during the Age of the Great Cathedrals—architecture played the dominant role. Gothic sculpture was at first severely architectural in spirit but became more independent after 1200; its greatest achievements are between the years 1220 and 1420. Painting, in turn, reached a peak between 1300 and 1350 in central Italy. North of the Alps, it became the leading art form from about 1400 on. Thus we find a gradual shift of emphasis from architectural to pictorial qualities. Early Gothic sculpture and painting both reflect the discipline of their monumental setting, while Late Gothic architecture and sculpture strive for picturesque effects.

Overlying this broad pattern is another one: international diffusion as against regional independence. Gothic art, as it spread from the Île-de-France to the rest of France and then all of Europe, came to be known as *opus modernum* or *opus francigenum* (modern or French work). In the course of the thirteenth century,

the new style gradually lost its imported flavor, and regional variety began to appear. Toward the middle of the fourteenth century, there was a growing tendency for these regional styles to influence each other until an "International Gothic" style prevailed almost everywhere around 1400. Shortly thereafter, this unity broke apart. Italy, with Florence in the lead, created the radically new art of the Early Renaissance. North of the Alps, Flanders took the lead in developing Late Gothic painting and sculpture. Finally, a century later the Italian Renaissance became the basis of another international style.

This development roughly parallels what happened in the political arena, for the Gothic was a distinctive period not only artistically but politically. Aided by advances in cannons and the iron crossbow, princes and kings were able to conquer increasingly large territories, which were administered for them by vassals, who in turn raised taxes to support armies and navies. In France, the Capetian line (see page 300) at first ruled only the Île de France, the fertile territory near Paris, but by 1300 had added Bourges, Tours, and Amiens—all of which were to become sites of important Gothic cathedrals. They also acquired Normandy from England, which had been conquered in 1066 by William the Conqueror of Normandy, the first to call himself king in the modern sense. This gave rise to the conflicting claims over the kingship of France known as the Hundred Years War (1339–1453), which consolidated the growing sense of nationalism on both sides of the English Channel; although the fighting was only occasional, the war was finally settled by the defeat of the English at Castillon in 1453. Germany remained a collection of independent city-states ruled by electors, who were responsible, among other things, for choosing kings. The powers of German kings were therefore severely limited, as were the claims of the Holy Roman Emperor to Italy, until the emergence of the house of Hapsburg in 1273, when Rudolf I was elected King. He gave Austria and Styria to his two sons. Later, through a series of astute marriages, the Hapsburgs acquired Burgundy when Emperor Maximilian I married the daughter of Duke Charles the Bold in 1477; Hungary and Bohemia in 1526; Spain in 1504 and once and for all in 1516. Until then, Spain was largely divided between Castile and Aragon, although the marriage of Ferdinand

of Aragon and Isabella of Castile in 1479 helped unite the country to expel the Moors altogether. Italy remained divided among a welter of independent cities and republics, of which Lombardy in the North was the most powerful. However, Venice, Genoa, and Pisa all emerged as major mercantile powers through trade with the East, while Florence became the leading banking center. Each had its own form of government, which gave rise to almost endless internal strife, as well as war with their neighbors.

Supported by shifting alliances with the papacy, the kings of France and England emerged as the leading powers at the expense of the Germans in the early thirteenth century, which was generally a time of peace and prosperity. Under these ideal conditions the new Franciscan and Dominican orders were established (see box pages 299–300), and Catholicism found St. Thomas Aquinas, its greatest intellect since St. Augustine and St. Jerome some 850 years earlier. After 1290, however, the balance of power quickly broke down. Finally, in 1305 the French pope Clement V moved the papacy to Avignon, France, where it remained for more than 70 years, during what the humanist Petrarch called "the Babylon Captivity of the Papacy."

ARCHITECTURE

France

ST.-DENIS AND ABBOT SUGER. We can pinpoint the origin of the Gothic style with uncommon accuracy. It was born between 1137 and 1144 in the rebuilding by Abbot Suger of the royal Abbey Church of St.-Denis just outside the city of Paris. To understand how Gothic architecture arose at this particular spot, we must consider the relationship between St.-Denis, Suger, and the French monarchy. The kings of France derived their authority from the Carolingian tradition, although they belonged to the Capetian line. However, they had less power than the nobles who, in theory, were their vassals. The only area they ruled directly was the Île-de-France, and their authority was often challenged even there. Not until the early twelfth century did the royal power begin to expand. As chief adviser to Louis VI, Suger helped to shape this process. It was he who forged the alliance between the monarchy and the Church. This union brought the bishops of France (and the cities under their authority) to the king's side; the king, in turn, supported the papacy in its struggle against the German emperors.

Suger also engaged in spiritual politics. By giving the monarchy religious significance and glorifying it as the strong right arm of justice, he sought to rally the nation behind the king. The **abbey** of St.-Denis was a key element in his plan. The church, founded in the late eighth century, enjoyed a dual prestige. It was both the shrine of St.-Denis, the Apostle of France and protector of the realm, and the chief memorial of the Carolingian dynasty. Both Charlemagne and his father, Pepin, had been consecrated as kings there. It was also the burial place of Charles Martel, Pepin, and Charles the Bald. Suger wanted to make the abbey the spiritual center of France, a pilgrimage church that would outshine all others and provide a focal point for religious as well as patriotic emotion. To achieve this goal, the old structure had to be enlarged

and rebuilt. The great abbot himself wrote two accounts of the church and its rebuilding which tell us a great deal, although they are incomplete. [See Primary Sources, nos. 25 and 26, pages 399–91.] Unfortunately, the west facade is badly mutilated (see discussion page 346), while the choir at the east end, which Suger saw as the most important part of the church, retains its original appearance only in the ambulatory (figs. 11-1 and 11-2).

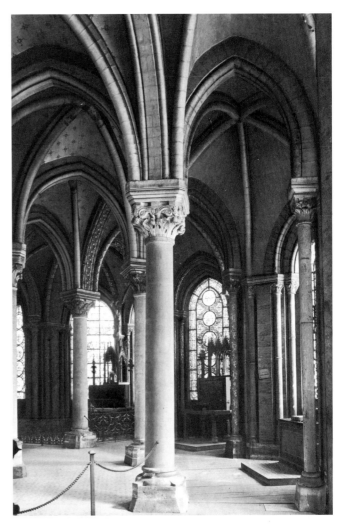

11-1. Ambulatory, Abbey Church of St.-Denis, Paris. 1140–44

11-2. Plan of the choir and ambulatory of St.-Denis (Peter Kidson)

The ambulatory and radiating chapels surrounding the arcaded apse are familiar elements from the Romanesque **pilgrimage choir** (compare fig. 10-2), but they have been integrated in a new way. Instead of being separate, the chapels are merged to form, in effect, a second ambulatory. Ribbed groin vaulting based on the pointed arch is used throughout. (In the Romanesque pilgrimage choir, only the ambulatory had been groin-vaulted.) As a result, the entire plan is held together by a new kind of geometric order. It consists of seven nearly identical wedge-shaped units fanning out from the center of the apse. (The central chapel, dedicated to the Virgin, and its neighbors on either side are slightly larger, presumably because of their greater importance.) We experience this double ambulatory not as a series of individual compartments but as a continuous (though clearly defined) space, whose shape is outlined for us by the network of slender arches, ribs, and columns that sustains the vaults.

What distinguishes this interior from earlier ones is its lightness, in both senses of the word. The architectural forms seem graceful, almost weightless, compared to the massive solidity of the Romanesque. In addition, the windows have been enlarged to the point that they are no longer openings cut into a wall—they themselves become translucent walls. What makes this abundance of light possible? The outward pressure of the vaults is contained by heavy buttresses jutting out between the chapels. In the plan, they look like stubby arrows pointing toward the center of the apse. (For the structural system of Gothic architecture, see fig. 11-19.) No wonder, then, that the interior appears so airy, since the heaviest parts of the structural skeleton are outside. The impression would be even more striking if we could see all of Suger's choir, for the upper part of the apse, rising above the double ambulatory, had very large, tall windows. The effect from the nave must have been similar to that of the somewhat later choir of Notre-Dame in Paris (see fig. 11-5).

SUGER AND GOTHIC ARCHITECTURE. In describing Suger's choir, we have also described the essentials of Gothic architecture. Yet none of the elements that make up its design is really new. The pilgrimage choir plan, the pointed arch, and the ribbed groin vault can be found in regional schools of the French and Anglo-Norman Romanesque. However, they were never combined in the same building until St.-Denis. The Île-de-France had not developed a Romanesque tradition of its own, so Suger (as he himself tells us) had to bring together artisans from many different regions for his project. We must not conclude, however, that Gothic architecture was merely a synthesis of Romanesque traits. Otherwise we would be hard pressed to explain the new spirit that strikes us so forcibly at St.-Denis in the emphasis on geometric planning and the quest for luminosity. Suger's account of the rebuilding of his church stresses both of these features as the highest values achieved in the new structure. Harmony (that is, the perfect relationship among parts in terms of mathematical proportions or ratios) is the source of all beauty, since it exemplifies the laws by which divine reason made the universe. Thus, it is suggested, the "miraculous" light that floods the choir through the "most sacred" windows becomes the Light Divine, a revelation of the spirit of God.

This symbolic interpretation of light and numerical harmony was well established in Christian thought. It derived in part from the writings of a fifth-century Greek theologian who, in the Middle Ages, was believed to have been Dionysius the Areopagite, an Athenian disciple of St. Paul. Because of this identification, the works of another fifth-century writer, known as the Pseudo-Dionysius, gained great authority. In Carolingian France, moreover, Dionysius the disciple of St. Paul was identified both with the author of the Pseudo-Dionysian texts and with St.-Denis. Although these writings were available to Suger at St.-Denis, his debt to them seems rather general at best. Suger was not a scholar, but he was a man of action who was mostly conventional in his thinking. He probably consulted the contemporary theologian Hugh of St.-Victor, who was steeped in Dionysian thought, especially for the most obscure part of his program at the west end of the church.

This does not mean that Suger's own writings are simply a justification after the fact. On the contrary, he clearly knew his own mind. What, then, was he trying to achieve? For Suger, the material realm was the stepping stone for spiritual contemplation. Thus the actual experience of dark, jewel-like light filtering through the stained-glass windows that disembodies the material world lies at the heart of Suger's mystical intent: to be transported to "some strange region of the universe which neither exists entirely in the slime of earth nor entirely in the purity of Heaven."

SUGER AND THE MEDIEVAL ARCHITECT. The success of the choir design at St.-Denis is proved not only by its inherent qualities but also by its extraordinary impact. Every visitor, it seems, was overwhelmed by the achievement, and within a few decades the new style had spread far beyond the Île-de-France. The how and why of Suger's success are a good deal more difficult to explain. They involve a controversy we have met several times before—that of form versus function. To the advocates of the functionalist approach, Gothic architecture was the result of advances in engineering, which made it possible to build more efficient vaults, to concentrate their thrust at a few critical points, and thus to eliminate the solid walls of the Romanesque church. Suger, they argue, was fortunate in having an architect who understood the principles of ribbed groin vaulting better than anybody else at that time. If the abbot chose to interpret the resulting structure as symbolic of Dionysian theology, he was simply expressing his enthusiasm in the abstract language of the churchman, so that his account does not help us to understand the origin of the new style.

As the integration of its parts suggests, the choir of St.-Denis is more rationally planned and constructed than any Romanesque church. The pointed arch (which can be "stretched" to reach any desired height regardless of the width of its base) has become an integral part of the ribbed groin vault. As a result, these vaults are no longer restricted to square or near-square compartments. They have a new flexibility that allows them to cover areas of almost any shape, such as the trapezoids and pentagons of the ambulatory. The buttressing of the vaults, too, is more fully mastered than before.

How could Suger's ideas have led to these technical advances unless he was a professionally trained architect? (Actually, archi-

tectural training as we know it did not exist at the time.) Since he was not, can he claim any credit for the style of what he so proudly calls "his" new church? Oddly enough, there is no contradiction here. As we have seen (page 276), the term *architect* had a very different meaning from the modern one, which derives from Greece and Rome by way of the Italian Renaissance. To the medieval mind, the overall leader of the project, not the master builder responsible for its construction, was the architect. As Suger's account makes abundantly clear, he shared this view, which is why he remains so silent about his helper.

Perhaps this is a chicken-and-egg question. The function of a church, after all, is not merely to enclose a maximum of space with a minimum of material but also to convey the religious ideas that lie behind it. For the master who built the choir of St.-Denis, the technical problems of vaulting must have been inseparable from issues of form, as well as such ideas as beauty, harmony, and the like. As a matter of fact, the design includes elements that express function without actually performing it, which we call architec-

tonics. An example is the slender shafts (called **responds)** that seem to carry the weight of the vaults to the church floor.

In order to know what concepts to convey, the medieval architect needed the guidance of religious authority. At a minimum, such guidance might be a simple directive to follow some established model. In Suger's case, however, it amounted to a more active role. It seems that he began with one master builder at the west end but was disappointed with the results and had it torn down. This fact not only shows that Suger was actively involved in the design process but also confirms his position as the architect of St.-Denis in the medieval sense. Suger's views no doubt guided his choice of a second master of Norman background to translate them into the kind of structure he wanted, not simply as a matter of design preference. This great artist must have been singularly responsive to the abbot's objectives. Together they created the Gothic style. We have seen this kind of close collaboration between patron and architect before: it occurred between Djoser and Imhotep, Perikles and Pheidias, just as it does today.

CONSTRUCTING ST.-DENIS. Building St.-Denis was an expensive and complex task that required the combined resources of Church and State. Suger used stone from quarries near Pontoise for the ambulatory columns and lumber from the forest of Yveline for the roof. Both had to be transported by land and river over great distances, a slow and costly process. The master builder probably employed several hundred stonemasons and two or three times that many laborers. He was aided by advances in technology spurred by warfare. Especially important were better cranes powered by windlasses or treadwheels that used counterweights and double pulleys for greater efficiency. These devices were easily put up and taken down, allowing for lighter scaffolding suspended from the wall instead of resting on the ground. Such developments made possible the construction techniques illustrated in figure 11-3 and were essential to building the new rib vaults.

NOTRE-DAME, PARIS. St.-Denis was an abbey, but the future of Gothic architecture lay in the towns rather than in rural monastic communities. There had been a vigorous revival of urban life, we will recall, since the early eleventh century. This development continued at a rapid pace, and the growth of the cities was felt not only economically and politically but in countless other ways as well. Bishops and the city clergy rose to new importance. Cathedral schools and universities took the place of monasteries as centers of learning. And the artistic efforts of the age culminated in the great cathedral churches. (A cathedral is the seat of a bishopric, or see.)

Notre-Dame ("Our Lady," the Virgin Mary) at Paris, begun in 1163, reflects the main features of Suger's St.-Denis more directly than does any other church (figs. 11-4–11-8). The plan, with its

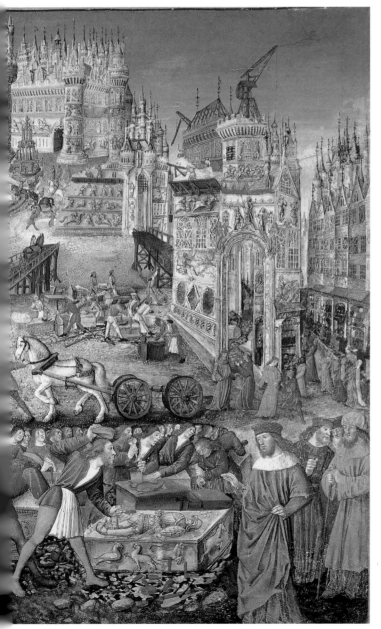

11-3. Jean Colombe. *King Priam Rebuilding Troy* (detail), detached miniature from *Histoire de la destruction de Troie la Grande,* after 1490. Tempera on vellum, 19⅝ x 13" (51 x 33 cm). Kupferstichkabinett, Pergamon Museum, Berlin, Preussischer Kulturbesitz

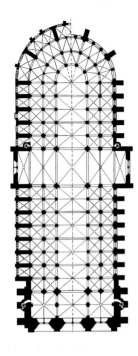

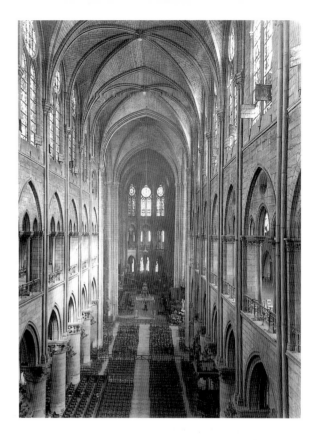

(Left) 11-4. Plan of Notre-Dame, Paris. 1163–c. 1250

(Right) 11-5. Nave and choir, Notre-Dame

(Below) 11-6. Notre-Dame (view from the southeast)

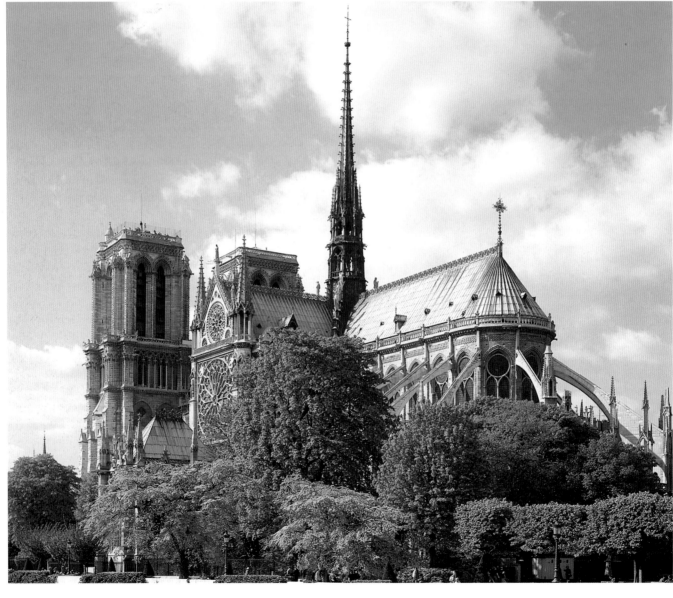

emphasis on the longitudinal axis, is extraordinarily compact and unified compared to other major Romanesque churches (fig. 11-4). The double ambulatory of the choir continues directly into the aisles, and the stubby transept barely exceeds the width of the facade. The six-part nave vaults over squarish bays, although not identical with the "Siamese-twin" groin vaulting in Durham Cathedral (see fig. 10-9), continue the kind of structural experimentation that was begun by the Norman Romanesque.

Inside we find other echoes of the Norman Romanesque in the galleries above the inner aisles and the columns of the nave arcade (fig. 11-5). Here the pointed ribbed arches, pioneered in the western bays of the nave at Durham, are used throughout the building. Yet the large clerestory windows and the light and slender forms, create the weightless effect that we associate with Gothic interiors and make the nave walls seem amazingly thin. The vertical emphasis of the interior is also Gothic. It depends less on the actual proportions of the nave—some Romanesque naves are equally tall in relation to their width—than on the constant accentuation of the verticals and the apparent ease with which the sense of height is attained. By contrast, Romanesque interiors such as St.-Sernin (fig. 10-3) emphasize the great effort required in supporting the weight of the vaults.

In Notre-Dame, as in Suger's choir, the buttresses (the heavy bones of the structural skeleton) cannot be seen from the inside. (The plan shows them as massive blocks of masonry that stick out from the building like a row of teeth.) Above the aisles, these piers turn into flying buttresses—arched bridges that reach upward to the critical spots between the clerestory windows where the outward thrust of the nave vault is concentrated (fig. 11-6). This method of anchoring vaults, so characteristic of Gothic architecture, certainly owed its origin to functional considerations (fig. 11-5). Yet even the flying buttress soon became aesthetically important. Its shape could express support (apart from actually providing it) in a variety of ways, according to the designer's sense of style (fig. 11-7).

The most monumental aspect of the exterior of Notre-Dame is the west facade (fig. 11-8). It retains its original appearance, except for the sculpture, which was badly damaged during the French Revolution and is for the most part restored. The design reflects St.-Denis, which was derived from Norman Romanesque facades. If we compare Notre-Dame with St.-Étienne at Caen (see fig. 10-8), we see that they share some basic features. These include the pier buttresses that reinforce the corners of the towers and divide the facade into three main parts, the placing of the portals, and the three-story arrangement. The rich sculptural decoration,

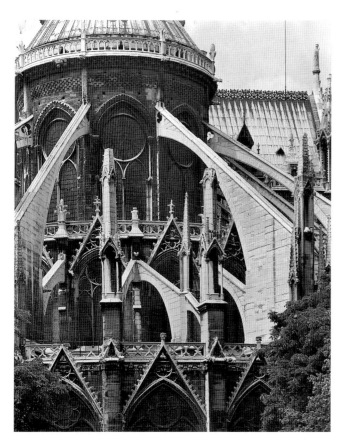

11-7. Flying arches and flying buttresses, Notre-Dame

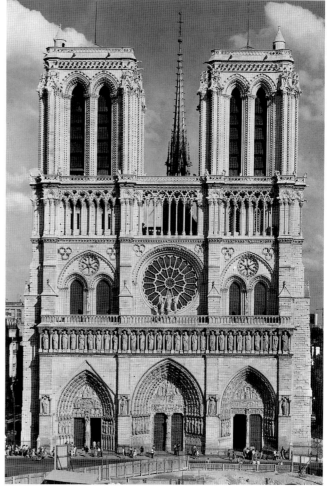

11-8. West facade, Notre-Dame

MEDIEVAL MUSIC AND THEATER

As in ancient Greece, music and theater were intimately connected during the Middle Ages. In fact, medieval theater was largely a direct outgrowth of music. The only musical texts that survive from the Middle Ages before the late eleventh century are religious. Like Early Christian visual art, they bring together Roman, Greek, Jewish, and Syrian elements. Early medieval pieces, or chants, were in the form of plainsong, a single, unaccompanied line of melody in free rhythm. Plainsong continued many of the features of the ancient Greek modes (see pages 139–40), thanks mainly to the philosopher Boethius (c. 480–524). His musical theories, set down around 500, were based on those of Pythagoras and other ancient Greek writers who are now mostly lost to us. By that time, however, Greek music was no longer a living tradition and had been modified by the Romans, so that its theories were adopted in different form.

One of the most important early medieval composers was Ambrose, a fourth-century bishop of Milan, who introduced an early variety of plainsong now known as Ambrosian chant. (He also converted the music-loving St. Augustine of Hippo to Catholicism.) Over the next two centuries, Ambrosian chant was developed further, especially by the choir of the papal chapel in Rome. Around 600, Pope Gregory the Great (590–604) codified the Church's liturgy (the prescribed form for various worship services and other rites), including the music to be sung in each kind of service and the prayer hours to be observed by the monastic orders. The plainsong style in use in Rome at the time, which is still sung in many Catholic services, is popularly known as Gregorian chant.

At first, medieval chant was sung in unison, one word to a note, but gradually more notes were added for some syllables. Eventually some of these multinote passages were developed into long musical phrases (melismas), until there were so many notes for each word that additional, often unrelated, texts could be inserted into the work. These interpolated texts (tropes, from the Latin tropus, for "added melody") ultimately developed into medieval drama. The introduction of dramatic elements was also an outgrowth of the interplay between two choruses (antiphons), or between a soloist and a choir (responses).

The growing complexity of medieval music gave rise to a new body of music theory—an organized code of rules comparable to the grammar of a spoken language. This effort reached its climax in the thirteenth century, when a system for musical notation was perfected. The development of this body of theory may also be compared to the evolution of architectural principles

Maître aux Bouqueteaux. *Guillaume de Machaut in His Study (Amour Presenting Him to His Three Children).* 1370. A miniature from an illuminated manuscript page of Machaut's works, fol. D. Bibliothèque Nationale, Paris

during the Romanesque and Gothic eras, when musicians sought a comprehensive structure for their work. Of the many centers of chant, the most important was the Cathedral of Notre-Dame in Paris, where a new type of polyphonic music (music in parts), called organum, developed from the late ninth to the thirteenth century. Organum might have two or more voices, which sang the same words and melody a set interval apart, often with a plainsong underpinning (cantus firmus). During the late twelfth century, these pieces became increasingly complex under Master Léonin and his pupil Master Pérotin, the first Western composers whose names and works we know. Eventually, around 1200 each voice was assigned its own text and melodic line. The resulting multivoiced composition, sometimes with instrumental accompaniment, was called a motet (from French mot, "word"). The motet had such appeal that it was quickly secularized by substituting vernacular verses (chiefly love poems) for religious texts.

Like Gothic architecture, the Notre-Dame style quickly spread throughout Europe. Although it lasted until about 1400 in some places, it was gradually replaced after 1325 by a new musical style. Called *ars nova* (new art), it featured polyphony and rhythms of ever-greater complexity and subtlety. Despite its name, *ars nova,* like the Gothic paintings of Giotto, remained rooted in the past while looking to the future. The greatest composer of *ars nova* was Guillaume de Machaut (c. 1300–1377). A cleric who served the kings of Bohemia and France, he was also considered the finest poet of his day. Thus he was a perfect blend of religious and secular talents characteristic of the Gothic era as a whole. Guillaume de Machaut was a new figure in European culture: the professional composer. During the twelfth and thirteenth centuries, courtly music had been composed by aristocratic amateurs (called *trouvères,* troubadours, or *Minnesingers*). They wrote songs chiefly on the theme of courtly love, but often

however, recalls the facades of western France (see fig. 10-7) and the carved portals of Burgundy, such as that at Vézelay (see 10-26).

Much more important are the qualities that distinguish Notre-Dame's facade from its Romanesque ancestors. Foremost among these is the way all the details have been integrated into a coherent whole. Here the meaning of Suger's emphasis on harmony, geo-

metric order, and proportion becomes even more evident than at St.-Denis itself. This formal discipline can also be seen in the sculpture, which no longer shows the spontaneous (and often uncontrolled) growth typical of the Romanesque. Instead, it has been assigned a precise role within the architectural framework. At the same time, the cubic solidity of the facade of St.-Étienne at

left the actual performance to minstrels, or *jongleurs*. Because of its sophistication, however, *ars nova* increasingly required professional musicians to compose and play it. The elaborate style of *ars nova* paralleled the rich ornamentation of Late Gothic architecture. It may also be seen as a musical counterpart to that late medieval blend of theology and philosophy known as Scholasticism.

Because of its pagan associations, theater was regarded as sinful by early Christianity. Actors were forbidden to become members of the Church or to receive the sacraments, although Theodora, the wife of the Byzantine emperor Justinian, had been a mime actress. Gradually, however, theater became associated with the great religious feasts, such as Christmas and Easter, although it, too, came eventually to rely on vernacular texts. Liturgical drama flourished at many of the same monasteries and churches that contributed to the development of medieval art and music, such as St. Gall in Switzerland. Theater and music shared many of the same subjects, such as the Passion cycle. The close relation between them is illustrated by the career of such composer–playwrights as Hildegard of Bingen (see box page 318). Another link of the two performing arts to religious life was architectural: music and drama were presented exclusively inside churches before 1200. Religious plays, acted by the priests and choirboys, often involved intricate self-contained architectural sets called *mansions*. In the early thirteenth century, performances became so elaborate and independent that they were moved outdoors to the churchyards, where they were taken over by civic institutions. At the same time, secular plays and farces illustrating moral lessons began to develop out of religious drama.

During the late Middle Ages, theater flourished as towns grew prosperous and the major guilds began to shoulder the costs of staging religious pageants. The dramas best known today date from the fourteenth century and later. They include the vast Corpus Christi cycle performed at York, England, the great Passion plays, and morality plays such as *Everyman*. These were community affairs, mounted in town squares, in which guild members assumed all the roles. Hence there was no clear distinction between religious and popular theater. The medieval tradition of music and theater continued well into the Renaissance, especially in the North. It culminated in Hans Sachs (1494–1576), the head of the shoemakers guild in Nuremberg. A master singer and composer, he wrote thousands of songs, fables, verses, religious plays, and secular farces. Sachs was immortalized by Richard Wagner in his nineteenth-century German opera *Der Meistersinger.*

Caen has been dissolved. Lacelike arcades and huge portals and windows break down the continuity of the wall surfaces, so that the total effect of the west front of Notre-Dame is of a weightless openwork screen.

How rapidly this tendency advanced during the first half of the thirteenth century can be seen by comparing the facade of Notre-Dame with the somewhat later south transept, visible in the center of figure 11-6. In the west facade, the rose window in the center is still deeply recessed. As a result, the stone tracery that subdivides the opening is clearly set off against the surrounding wall. On the transept, we can no longer distinguish the **rose window** from its frame, because a network of tracery covers the entire area.

CHARTRES CATHEDRAL. Toward 1145 the bishop of Chartres, who befriended Abbot Suger and shared his ideas, began to rebuild his cathedral in the new style with the help of the faithful. [See Primary Sources, no. 27, page 391.] Fifty years later a fire destroyed all but the west facade, which provided the main entrance, and the east crypt. A second rebuilding was begun in 1194 (fig. 11-9), and as the result of a huge campaign it was largely complete within the astonishingly brief span of 26 years.

The basic design is so unified that it must have been planned by a single master builder. However, because the construction proceeded in stages and was never entirely finished, the harmony of the result is evolutionary rather than systematic. For example, the two west towers, though similar, are by no means identical. Moreover, their **spires** are very different: the north spire on the left dates from the early sixteenth century, nearly 300 years later than the other one.

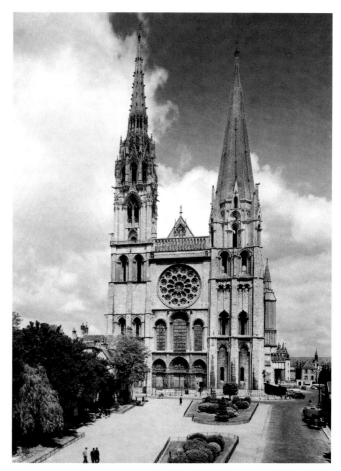

11-9. West facade, Chartres Cathedral
(north spire is from 16th century). 1145–1220

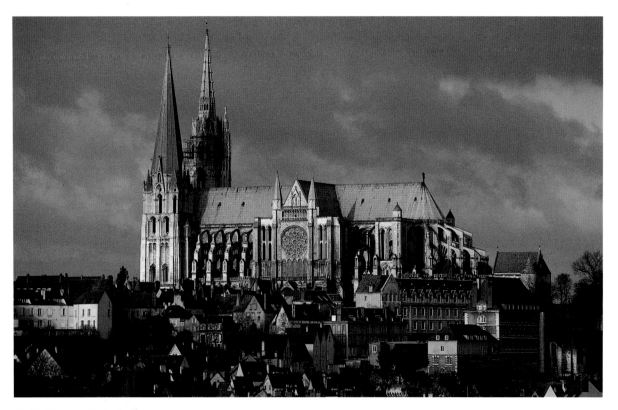

11-10. Chartres Cathedral

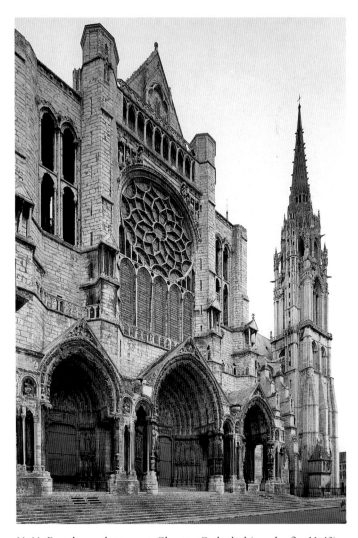

The church was built on the highest point in town, and the spires can be seen for miles in the surrounding farmland (fig. 11-10). If the seven other spires had been completed as planned, Chartres would not have such strong directionality. Both arms of the transept have three deeply recessed portals lavishly decorated with sculpture and an immense rose window over five smaller lancets (fig. 11-11). Perhaps the most striking feature of the flanks is the flying buttresses. They lend a powerfully organic presence to the apse at the east end, with its seven subsidiary chapels (figs. 11-10 and 11-12).

The west facade, divided into units of two and three, is a model of clarity that plays an important role in molding our expectations about the interior. The shape of the doors tells us that we will first enter a low chamber. As soon as we go into the narthex (the covered anteroom), we have left the temporal world behind. It takes some time for our eyes to adjust to the darkness of the interior. The noise of daily life has been shut out as well. At first sounds are eerily muffled, as if swallowed up with the light by the void. Once we recover from this disorienting effect, we become aware of a glimmering light, which guides us into the cavernous church.

Designed one generation after the nave of Notre-Dame in Paris, the rebuilt nave (fig. 11-13) is the first masterpiece of the mature, or High Gothic, style. The openings of the pointed nave arcade are taller and narrower (see fig. 11-5) than before. They are joined to a clerestory of the same height by a short triforium

11-11. Portals, north transept, Chartres Cathedral (see also fig. 11-43)

screening the galleries, which has been reduced to a narrow wall. Responds have been added to the columns to stress the continuity of the vertical lines and guide our eye upward to the vaults, which appear as diaphanous webs stretched across the slender ribs. Because there are so few walls, the vast interior space appears at first to lack clear boundaries. It seems even larger because of the disembodied sound. The effect is so striking that it may well have been planned from the beginning with music in mind—both antiphonal choirs and large pipe organs, which had been in use for more than two centuries in some parts of Europe.

An alternating sequence of round and octagonal piers extends down the nave toward the apse, where the liturgy is performed. Beneath the apse is the crypt, which houses Chartres' most important possession: remnants of a robe said to have been worn by the Virgin Mary, to whom the cathedral is dedicated. The relic, which miraculously survived the great fire of 1194, drew pilgrims from all over Europe. To provide room for large numbers of visitors without disturbing worshipers, there is a wide aisle running the length of the nave and around the transept. It is joined at the choir by a second aisle, forming an ambulatory that connects the apsidal chapels (see plan, fig. 11-14).

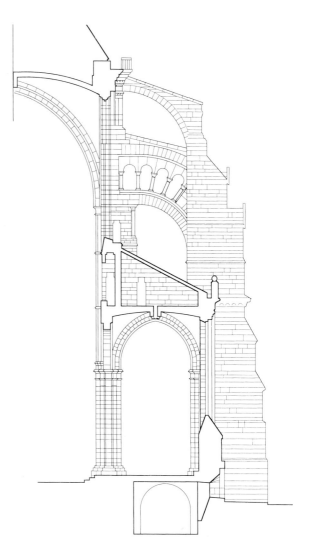

11-12. Transverse section of Chartres Cathedral (after Acland)

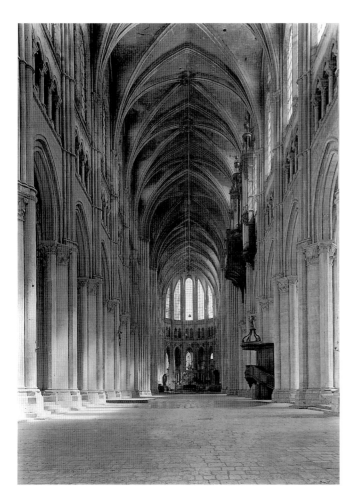

11-13. Nave and choir, Chartres Cathedral

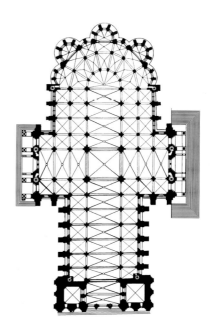

11-14. Plan, Chartres Cathedral

11-15. Triforium wall of the nave, Chartres Cathedral

Alone among all major Gothic cathedrals, Chartres still retains most of its more than 180 original stained-glass windows (see fig. 11-67). The magic of the jewel-like light from the clerestory is unforgettable to anyone who has experienced it (fig. 11-15). The windows admit far less light than one might expect. They act mainly as diffusing filters that change the quality of daylight, giving it the poetic and symbolic values so highly praised by Abbot Suger. The sensation of ethereal light dissolves the physical solidity of the church and, hence, the distinction between the temporal and the divine realms. The "miraculous light" creates the intense-ly mystical experience that lies at the heart of Gothic spirituality. (The aisles are darker because the stained-glass windows on the outer walls, although relatively large, are smaller and located at ground level, where they let in less light.)

AMIENS CATHEDRAL. The High Gothic style defined at Chartres reaches its climax a generation later in the interior of Amiens Cathedral (figs. 11-16 and 11-17). Breathtaking height is the dominant aim both technically and aesthetically. (The relatively swift progression toward verticality in French Gothic

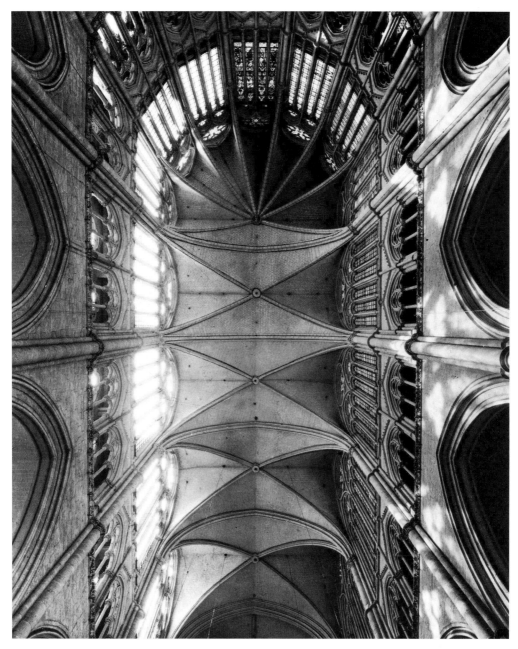

11-16. Choir vault, Amiens Cathedral. Begun 1220

cathedral architecture is clearly seen in figure 11-18. Figure 11-19 shows how both height and large expanses of window were achieved.) At Amiens, skeletal construction is carried to its limits. The vaults are as taut and thin as membranes, and the expanded window area now includes the **triforium**, so that the entire wall above the nave arcade becomes a clerestory in effect.

REIMS CATHEDRAL. The same emphasis on verticality and translucency can be traced in the development of the High Gothic facade. The most famous one, at Reims Cathedral (fig. 11-20,

page 335), makes an instructive contrast with Notre-Dame in Paris, even though it is only about 30 years later. Reims, as the Coronation Cathedral of the kings of France, was closely linked to Paris. The two share many elements, but they have been reshaped into a very different ensemble. The portals, instead of being recessed, project forward as gabled porches, with windows in place of tympanums above the doorways. The **gallery** of royal statues, which in Paris forms a horizontal band between the first and second stories, has been raised until it merges with the third-story arcade. Every detail except the rose window has become taller and

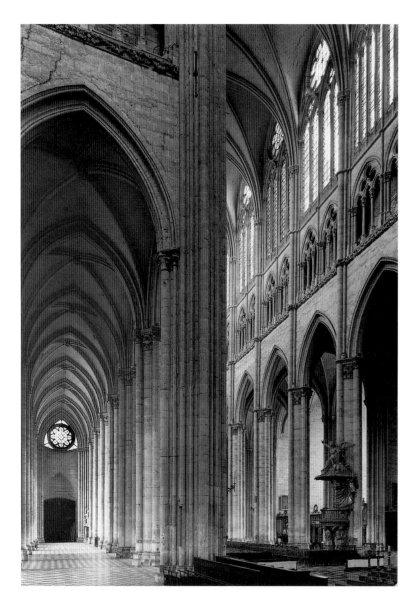

11-17. Nave and side aisle,
Amiens Cathedral

11-18. Comparison of nave elevations in same scale
(after Grodecki)
(1) Notre-Dame, Paris
(2) Chartres Cathedral
(3) Reims Cathedral
(4) Amiens Cathedral

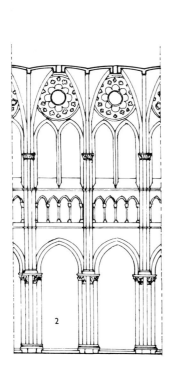
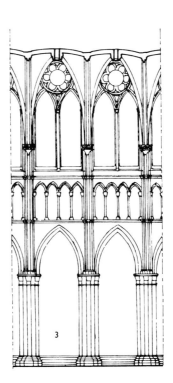
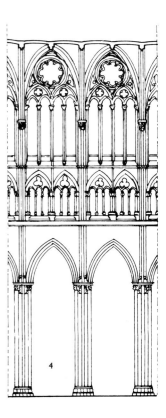

narrower than before. **Pinnacles** everywhere accentuate the restless upward movement. The sculptural decoration, by far the most lavish of its kind (see figs. 11-46 and 11-47), no longer remains in clearly marked-off zones. It has now spread to so many new perches, not only on the facade but on the flanks as well, that the exterior begins to look like a dovecote for statues.

LATER THIRTEENTH-CENTURY GOTHIC. The High Gothic cathedrals of France represent a concentrated effort rarely seen before or since. They are truly national monuments. Their huge cost was borne by donations collected all over the country and from all classes of society. They express the merging of religious and patriotic fervor that had been Abbot Suger's goal. By the middle of the thirteenth century, this wave of enthusiasm had passed its crest. Work on the vast structures begun during the first half of the century now proceeded at a slower pace. New projects were fewer and generally far less ambitious. As a result, the highly organized teams of masons and sculptors that had formed at the

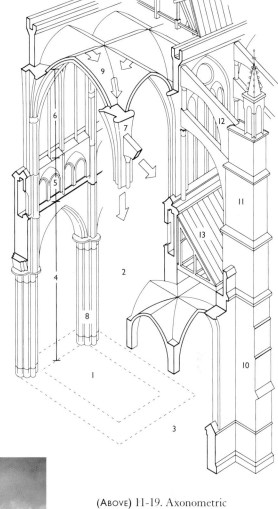

(ABOVE) 11-19. Axonometric projection of a High Gothic cathedral (after Acland)
(1) Bay
(2) Nave
(3) Side aisle
(4) Nave arcade
(5) Triforium
(6) Clerestory
(7) Pier
(8) Compound pier
(9) Sexpartite vault
(10) Buttress
(11) Flying buttress
(12) Flying arch
(13) Roof

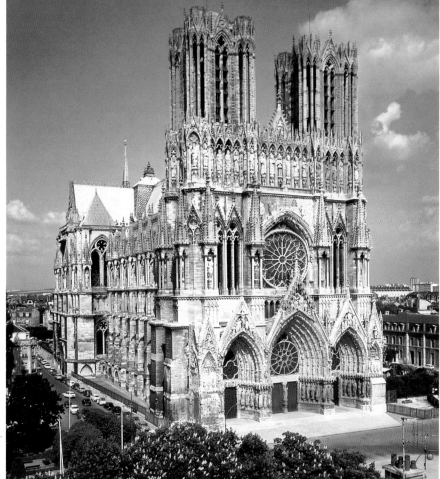

11-20. West facade, Reims Cathedral. c. 1225–99

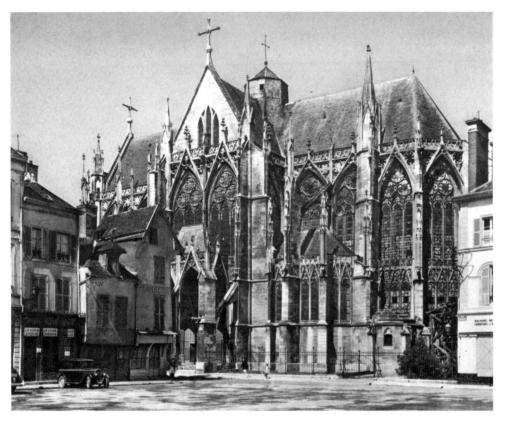

11-21. St.-Urbain, Troyes, France. 1261–75

sites of the great cathedrals during the preceding decades gradually broke up into smaller units.

St.-Urbain in Troyes (figs. 11-21 and 11-22), built during the later years of the thirteenth century, leaves no doubt that the heroic age of the Gothic style is past. Refinement of detail, rather than monumentality, has become the chief concern. By eliminating the triforium and simplifying the plan, the designer has created a delicate glass cage. (The choir windows begin only ten feet above the floor.) It is supported by flying buttresses so thin as to be hardly noticeable. The same spiny elegance can be felt in the architectural ornament.

FLAMBOYANT GOTHIC. In some ways St.-Urbain anticipates the Late, or Flamboyant, phase of Gothic architecture. The beginnings of the style do seem to go back to the late thirteenth century, but its growth was delayed by the Hundred Years' War (1338–1453) with England. Hence we do not meet any full-fledged examples of it until the early fifteenth century. Its name, which means flamelike, refers to the undulating curves that are a main feature of Late Gothic tracery. Structurally, Flamboyant Gothic shows no significant developments of its own. What distinguishes St.-Maclou (fig. 11-23) from St.-Urbain in Troyes is its profuse ornament. The church was built largely between 1434 and

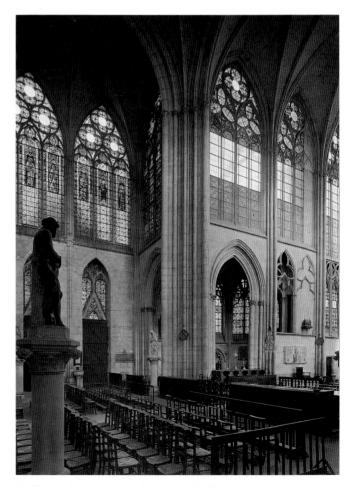

11-22. Interior toward northeast, St.-Urbain

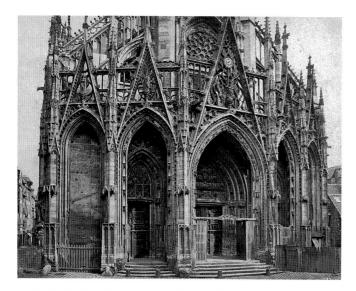

11-23. St.-Maclou, Rouen, France. Begun 1434

1470 by Pierre Robin; the facade was added by Ambroise Havel in 1500–14. The architect has covered the structural skeleton with a web of decoration so dense and fanciful as to hide it almost completely. It becomes a fascinating game of hide-and-seek to locate the bones of the building within this picturesque tangle of lines.

SECULAR ARCHITECTURE. Since our account of medieval architecture is mainly concerned with the development of style, we have confined our attention to churches, which were the most ambitious as well as the most representative efforts of the age. Secular building reflects the same general trends, but they are often obscured by the diversity of types, ranging from bridges and fortifications to royal palaces, from barns to town halls. Moreover, social, economic, and practical factors play a more important part here than in church design, so that the useful life of the buildings is apt to be much briefer and their chances of surviving lower. (Fortifications, for example, are often made obsolete by even minor advances in the technology of warfare.) As a result, our knowledge of secular structures of the pre-Gothic Middle Ages is fragmentary, and most of the surviving examples from Gothic times belong to the latter half of the period. This fact, however, is significant in itself. Nonreligious architecture, both private and public, became far more elaborate during the fourteenth and fifteenth centuries than before.

The history of the Louvre in Paris provides a striking example. The original building, erected about 1200, followed the functional plan of the castles of that time. It consisted mainly of a stout tower (the donjon or **keep**) surrounded by a heavy wall. In the 1360s, King Charles V built a new one as a royal residence. Although this second Louvre, too, has now disappeared, we know what it looked like from a miniature painted in the early fifteenth century (see fig. 11-94). There is still a defensive outer wall, but the structure behind it is much more like a palace than a fortress. Symmetrically laid out around a square court, it provided comfortable quarters for the royal household (note the countless chimneys), as well as lavishly decorated halls for state occasions.

The Spread of Gothic Architecture

The "royal French style of the Paris region" was enthusiastically received abroad. Even more remarkable was its ability to adapt to a variety of local conditions. In fact, the Gothic monuments of England and Germany have become objects of such intense national pride since the early nineteenth century that Gothic has been claimed as a native style in both countries. A number of factors contributed to the rapid spread of Gothic art. Among them were the skill of French architects and stone carvers and the prestige of French centers of learning, such as the Cathedral School of Chartres and the University of Paris. Also important was the influence of the Cistercians, the reformed monastic order energized by St. Bernard of Clairvaux (see box pages 299–300).

In keeping with Bernard's ideals, Cistercian abbey churches were of a distinctive, severe type. Decoration of any sort was held to a minimum, and a square choir took the place of apse, ambulatory, and radiating chapels. For that very reason, however, Cistercian architects put special emphasis on harmonious proportions and exact craftsmanship. Their "anti-Romanesque" outlook (see pages 307–308) also led them to adopt certain basic features of the Gothic style, even though Cistercian churches remained strongly Romanesque in appearance. During the latter half of the twelfth century, as the reform movement gathered momentum, this austere Cistercian Gothic came to be known throughout western Europe.

Still, one wonders whether any of these explanations really go to the heart of the matter. The basic reason for the spread of Gothic art seems to have been the persuasive power of the style itself. It kindled the imagination and aroused religious feeling even among people far removed from the cultural climate of the Île-de-France.

England

That England was especially receptive to the new style is not surprising. Yet the English Gothic did not grow directly from the Anglo-Norman Romanesque. Rather, it emerged from the Gothic of the Île-de-France, which was introduced in 1175 by the French architect who rebuilt the choir of Canterbury Cathedral, and from the architecture of the Cistercians. Within less than 50 years, it developed a well-defined character of its own, known as the Early English style, which dominated the second quarter of the thirteenth century. Although there was a great deal of building during those decades, it consisted mostly of additions to Anglo-Norman structures. Many English cathedrals had been begun about the same time as Durham (see figs. 10-9–10-11) but remained unfinished. They were now completed or enlarged. As a result, we find few churches that are designed in the Early English style throughout.

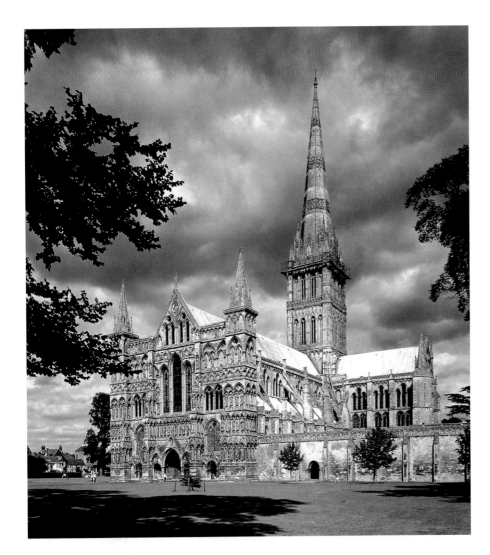

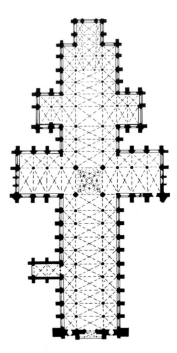

11-25. Plan of Salisbury Cathedral

SALISBURY CATHEDRAL. The exception is Salisbury Cathedral (figs. 11-24, 11-25, and 11-26). We see immediately how different the exterior is from French Gothic churches—and how futile it would be to judge it by the same standards. Compactness and verticality have given way to a long, low, sprawling look. (The crossing tower, which provides a dramatic unifying accent, was built a century later than the rest and is much taller than originally planned.) Since height is not the main goal, flying buttresses are used only as an afterthought. The west facade has become a screen wall, wider than the church itself and divided into horizontal bands of ornament and statuary. The towers have shrunk to stubby **turrets**. The plan, with its double transept, retains the segmented quality of the Romanesque, but the square east end derives from Cistercian architecture.

As we enter the nave (fig. 11-26), we recognize the same elements familiar to us from French interiors of the time, such as Chartres (see fig. 11-13). However, the English interpretation produces a very different effect. As on the facade, horizontal divisions are emphasized at the expense of the vertical. Hence we see the nave wall not as a succession of bays but as a series of arches and supports. These supports, carved of dark marble, stand out against the rest of the interior. This method of stressing their special function is one of the hallmarks of the Early English style. Another is the steep curve of the nave vault. The ribs rise all the way from the triforium

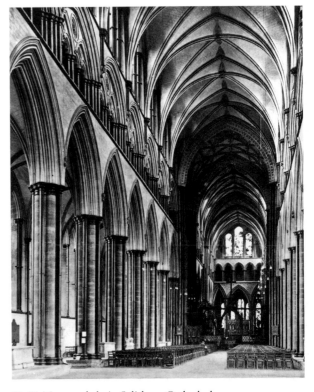

11-26. Nave and choir, Salisbury Cathedral

level. As a result, the clerestory gives the impression of being tucked away among the vaults. At Durham, more than a century earlier, the same treatment had been a technical necessity (compare figs. 10-10 and 10-11). Now it has become a matter of style, in keeping with the character of English Early Gothic as a whole. This character might be described as conservative in the positive sense. It accepts the French system but tones down its revolutionary aspects to maintain a strong sense of continuity with the Anglo-Norman past.

THE PERPENDICULAR STYLE. The contrast between the bold upward thrust of the crossing tower and the leisurely horizontal progression throughout the rest of Salisbury Cathedral suggests that English Gothic had developed in a new direction during the intervening hundred years. The change becomes very clear if we compare the interior of Salisbury with the choir of Gloucester Cathedral, built in the second quarter of the next century (fig. 11-27). Gloucester is an outstanding example of English Late Gothic, also called the Perpendicular style. The name certainly fits, since we now find the dominant vertical accent that is absent in the Early English style. (Note the responds running in an unbroken line from the vault to the floor.) In this respect, Perpendicular Gothic is much closer to French sources, but it includes so many uniquely English features that it would look out of place on the Continent. The repetition of small uniform tracery panels recalls the bands of statuary on the west facade at Salisbury. The square end repeats the apses of earlier English churches, and the upward curve of the vault is as steep as in the nave of Salisbury.

The ribs of the vaults, on the other hand, have taken on a new role. They have been multiplied until they form an ornamental network that screens the boundaries between the bays and thus makes the entire vault look like one continuous surface. This effect, in turn, emphasizes the unity of the interior space. Such elaboration of the classic four-part vault is characteristic of the Flamboyant style on the Continent as well (see pages 336–337), but the English started it earlier and carried it much further. The climax is reached in the amazing pendant vault of Henry VII's Chapel at Westminster Abbey, built in the early years of the sixteenth century (figs. 11-28 and 11-29). With its lanternlike knobs hanging from conical "fans," this chapel merges ribs and tracery patterns in a dazzling display of architectural pageantry.

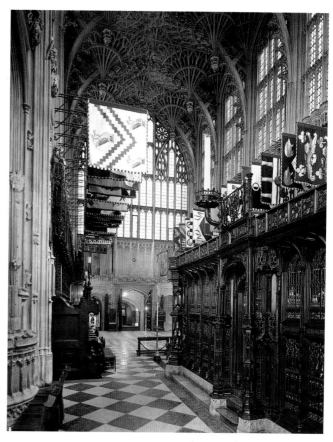

11-28. Chapel of Henry VII (view toward west), Westminster Abbey, London. 1503–19

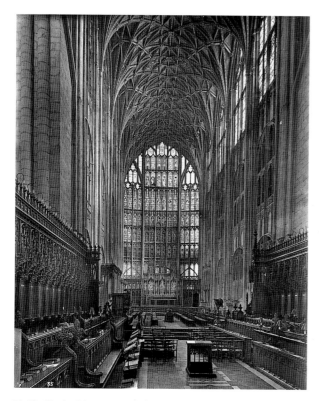

11-27. Choir, Gloucester Cathedral, England. 1332–57

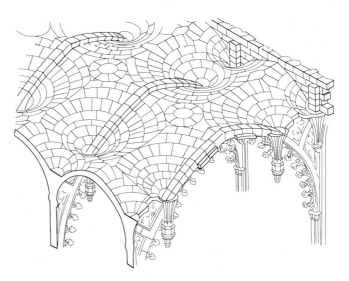

11-29. Diagram of vault construction, Chapel of Henry VII, Westminster Abbey (after Swaan)

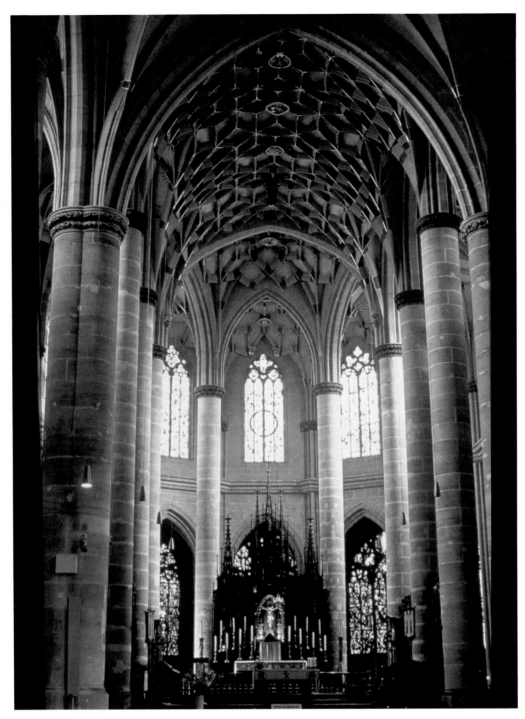

11-30. Choir, Heiligenkreuz, Schwäbish-Gmünd, Germany. After 1351

Germany

In Germany, Gothic architecture took root a good deal more slowly than in England. Until the mid-thirteenth century, the Romanesque tradition, with its persistent Ottonian elements, remained dominant, despite the growing acceptance of Early Gothic features. From about 1250 on, however, the High Gothic of the Île-de-France had a strong impact on the Rhineland. Cologne Cathedral (begun in 1248) is an ambitious attempt to carry the full-fledged French system beyond the stage of Amiens.

However, it was not completed until modern times. Nor were any others like it ever built.

HALL CHURCHES. Especially characteristic of German Gothic, although also found in France, is the hall church, or *Hallenkirche*. Such churches, with aisles and nave of the same height, stem from Romanesque architecture (see fig. 10-6). Although also found in France, the type was favored in Germany, where its possibilities were explored fully. Heiligenkreuz (Holy Cross) in Schwäbish-Gmünd (fig. 11-30) is one of many examples

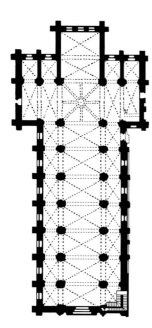

11-31. Plan of the Abbey Church of Fossanova

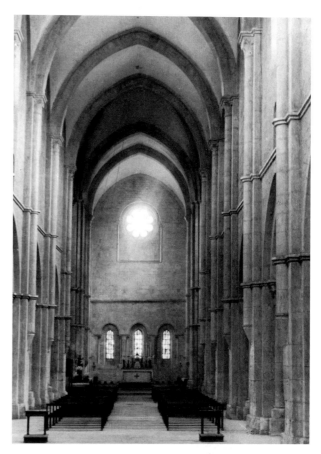

11-32. Nave and choir, Abbey Church of Fossanova, Italy. Consecrated 1208

from central Germany. The space has a fluidity and expansiveness that enfolds us as if we were standing under a huge canopy. There is no clear sense of direction to guide us. And the unbroken lines of the pillars, formed by bundles of shafts that diverge as they turn into lacy ribs covering the vaults, seem to echo the continuous movement that we feel in the space itself.

Italy

Italian Gothic architecture stands apart from that of the rest of Europe. Judged by the standards of the Île-de-France, most of it hardly deserves to be called Gothic at all. Yet the Gothic in Italy produced beautiful and impressive monuments that cannot be viewed simply as continuations of the local Romanesque. Instead, they present a blend of Gothic qualities and Mediterranean tradition. It was the Cistercians, rather than the cathedral builders of the Île-de-France, who provided the chief models for Italian architects. As early as the end of the twelfth century, Cistercian abbeys sprang up in both northern and central Italy, their designs patterned directly after those of the order's French monasteries.

ABBEY CHURCH, FOSSANOVA. One of the finest buildings is at Fossanova, some 60 miles south of Rome. It was

consecrated in 1208 (figs. 11-31 and 11-32). Without knowing its location, we would be hard put to decide where to place it on a map—it might as well be Burgundian or English. The plan looks like a simplified version of Salisbury. There are no facade towers, only a **lantern** over the crossing, in keeping with the ideal of severity prescribed by St. Bernard. The finely proportioned interior strongly resembles Cistercian abbeys of the French Romanesque and Gothic eras. The groin vaults, while based on the pointed arch, have no diagonal ribs. The windows are small, and the architectural detail has a Romanesque solidity. Still, the flavor of the whole is unmistakably Gothic.

Churches such as the one at Fossanova made a deep impression upon the Franciscans, the monastic order founded by St. Francis of Assisi in the early thirteenth century (see box page 299–300). As mendicant friars dedicated to poverty, simplicity, and humility, they were the spiritual kin of St. Bernard. The severe beauty of Cistercian Gothic must have seemed to express an ideal closely related to theirs. Thus, from the first, Franciscan churches reflected Cistercian influence and played a leading role in establishing Gothic architecture in Italy.

STA. CROCE, FLORENCE. Sta. Croce in Florence, begun about a century after Fossanova, may well claim to be the greatest

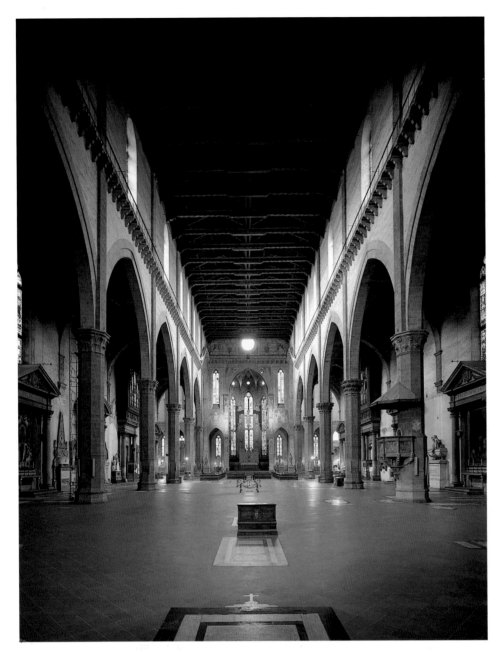

11-33. Nave and choir, Sta. Croce, Florence. Begun c. 1295

of all Franciscan structures (figs. 11-33 and 11-34). It is also a masterpiece of Gothic architecture, even though it has wooden ceilings instead of groin vaults, except in the choir. There can be no doubt that this was a matter of deliberate choice, rather than of technical or economic necessity. The decision was made not simply on the basis of local practice. (Wooden ceilings had been a feature of the Tuscan Romanesque.) It may also have sprung from a desire to evoke the simplicity of Early Christian basilicas and thus link Franciscan poverty with the traditions of the early Church. The plan, too, combines Cistercian and Early Christian features. However, it shows no trace of the Gothic structural system, except for the groin-vaulted apse. Hence, in contrast to Fossanova, there are no buttresses, since the wooden ceilings do not require them. The walls provide continuous surfaces. Indeed, Sta. Croce owes part of its fame to its murals. (Some of these can be seen on the transept and apse in our illustration.)

11-34. Plan of Sta. Croce

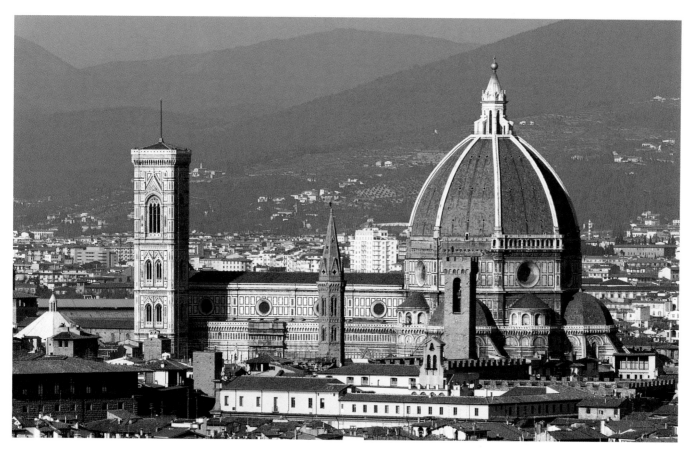

11-35. Florence Cathedral (Sta. Maria del Fiore). Begun by Arnolfo di Cambio, 1296; dome by Filippo Brunelleschi, 1420–36

Why, then, do we speak of Sta. Croce as Gothic? Surely the use of the pointed arch is not enough to justify the term. Yet the interior creates an effect fundamentally different from that of either Early Christian or Romanesque architecture. The nave walls have the weightless, transparent quality we saw in northern Gothic churches, and the dramatic massing of windows at the eastern end emphasizes the role of light as forcefully as Abbot Suger's choir at St.-Denis. Judged in terms of its emotional impact, Sta. Croce is Gothic beyond doubt. It is also profoundly Franciscan—and Florentine—in its monumental simplicity.

FLORENCE CATHEDRAL. Sta. Croce was probably designed by the sculptor Arnolfo di Cambio (c. 1245–c. 1310), who was responsible for the original design of Florence Cathedral, begun slightly later, since they have strikingly similar naves (compare fig. 11-33 with fig. 11-38). At Sta. Croce the architect's main concern was an impressive interior. In contrast, Florence Cathedral was planned as a landmark to civic pride towering above the city (fig. 11-35). Arnolfo's design is not known in detail. Although somewhat smaller than the present building, it probably had the same basic plan (fig. 11-36). The building as we know it is based largely on a design by Francesco Talenti (active 1325–69), who took over about 1343 and dramatically extended it to the east. The most striking feature is the octagonal dome with its subsidiary half-domes, which can be traced to late Roman times (see figs. 7-13,

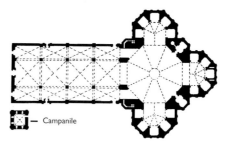

11-36. Plan of Florence Cathedral and Campanile

7-14, and 8-7–8-9). At first it may have been thought of as an oversize dome above the crossing of nave and transept, but it soon grew into a huge central pool of space that makes the nave look like an afterthought. The basic features of the dome were set by a committee of leading painters and sculptors in 1367. Because it posed enormous problems, however, the actual construction belongs to the early fifteenth century (see page 422).

Typical of Italy, a separate campanile takes the place of the facade towers of northern Gothic churches. It was begun by the great painter Giotto (see pages 367–371), who managed to finish only the first story, and continued by the sculptor Andrea Pisano (see page 359), who was responsible for the niche zone. The rest is the work of Talenti, who completed it by about 1360.

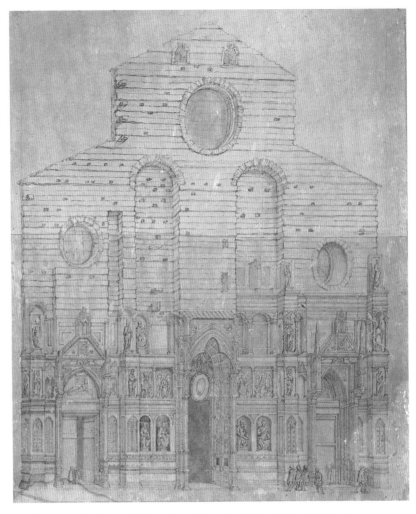

11-37. Bernardino Poccetti. Drawing of Arnolfo di Cambio's unfinished design for the facade of Florence Cathedral. c. 1587. Brown ink on canvas, 28⅜ x 22½" (72 x 57 cm). Museo dell'Opera di S. Maria del Fiore, Florence

The west facade, so dramatic a feature in French cathedrals, never achieved the same importance in Italy. In fact, it is remarkable how few Italian Gothic facades were ever finished before the Renaissance. (Those of Sta. Croce and Florence Cathedral both date from the nineteenth century.) Fortunately, Arnolfo's design for the exterior is preserved in a drawing made by Bernardino Poccetti just before the facade was destroyed in 1587 (fig. 11-37). Only the bottom half is shown in detail, but it gives a good idea of what an Italian Gothic facade would have looked like (although with some later alterations). Arnolfo devised an ornate scheme of pilasters and niches with sculptures, which was further decorated with mosaics. The effect must have been a dazzling fusion of sculpture and architecture, of classical severity and Gothic splendor.

Apart from the windows and the doorways, there is nothing Gothic about the exterior of Florence Cathedral. (Flying buttresses to sustain the nave vault may have been planned but proved unnecessary.) The solid walls, decorated with geometric marble inlays, are a perfect match for the Romanesque Baptistery nearby (see fig. 10-19). Although the interior directly recalls Sta. Croce, the dominant impression is one of solemnity rather than lightness and grace (fig. 11-38). The ribbed groin vault of the nave rests

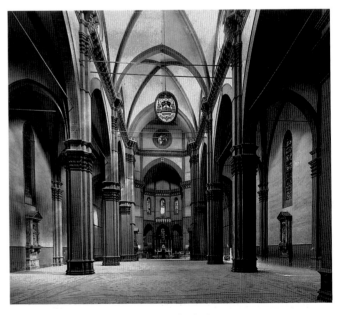

11-38. Nave and choir, Florence Cathedral

both to withstand armed assault and to proclaim the owner's importance. The Palazzo Vecchio, while larger and more elaborate than any private house, follows the same pattern. Behind its fortified walls, the city government could feel protected from angry crowds. The tall tower not only symbolizes civic pride but has a practical purpose: dominating Florence as well as the surrounding countryside, it served as a lookout against enemies from inside and outside the city.

Among Italian cities, Venice alone was ruled by a merchant aristocracy so firmly established that there was little internal conflict. As a result, Venetian palazzi were not required to serve as fortresses but instead developed into graceful, ornate structures. The Ca' d'Oro (fig. 11-40) was built in the early fifteenth century for the merchant Marino Contarini, who spared no expense. It received its name ("house of gold") from the lavish gold leaf that once adorned the front facing the Grand Canal. The odd design in part reflects the different functions of the building. The ground floor was used as a shipping center and warehouse, while the second story is devoted mainly to a large reception hall, with several smaller ones to the right. Private quarters are found mainly on the upper floor. There is a touch of the Orient in the delicate latticework on the facade, even though most of the decorative vocabulary derives from the Late Gothic of northern Europe. Its rippling patterns, designed to be seen against their own reflection in the water of the Grand Canal, have the same fairy-tale quality we recall from the exterior of St. Mark's (see fig. 8-46).

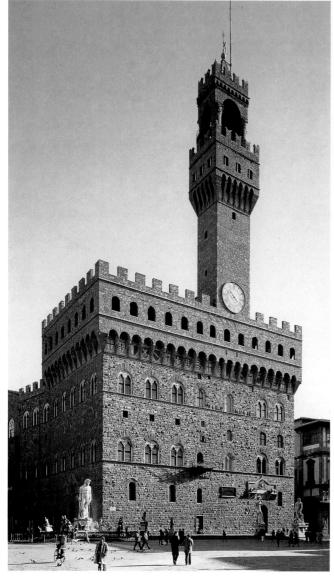

11-39. Palazzo Vecchio, Florence. Begun 1298

directly on the arcade, and the detail has a massive solidity that recalls Chartres (see fig. 11-13).

SECULAR ARCHITECTURE. The secular buildings of Gothic Italy also have a distinct local flavor. There is nothing in the cities of northern Europe to match the impressive grimness of the Palazzo Vecchio (fig. 11-39), the town hall of Florence. It, too, is sometimes thought to be the work of Arnolfo di Cambio, who put his stamp on much of medieval Florence. This fortresslike structure reflects the strife among political parties, social classes, and prominent families in the Italian city-states. It was begun in 1298, shortly after the antipapal Ghibelline faction was ousted by the Guelphs, but was given a slightly skewed shape in order not to intrude on the property of a family who briefly held power in the middle of the century.

The wealthy man's home (or palazzo, a term that denotes any large urban house) was quite literally his castle. It was designed

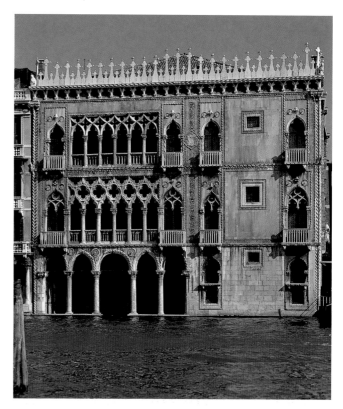

11-40. Ca' d'Oro, Venice. 1422–c. 1440

SCULPTURE

France

Abbot Suger must have attached considerable importance to the sculptural decoration of St.-Denis, although his account of the church does not discuss it at length. The three portals of his west facade were far larger and more richly carved than on any Norman Romanesque church. Unhappily, the **trumeau** figure of St.-Denis and the jamb statue-columns were removed in 1770–1 when the central portal was enlarged; worse still, the heads of the remaining figures were attacked by a mob during the French Revolution, and the metal doors melted down. As a result of these ravages and a series of clumsy restorations undertaken during the eighteenth and nineteenth centuries, we can gain only a general view of Suger's ideas about the role of sculpture at St.-Denis.

CHARTRES CATHEDRAL, WEST PORTALS. Suger's concept prepared the way for the splendid west portals of Chartres Cathedral (fig. 11-41), which were begun about 1145 under the influence of St.-Denis but were even more ambitious. They may well be the oldest full-fledged example of Early Gothic sculpture.

Compared to a Romanesque portal (see fig. 10-22), they show a new sense of order. It is as if all the figures, conscious of their responsibility to the architectural framework, had suddenly come to attention. The dense crowding and frantic movement of Romanesque sculpture have given way to symmetry and clarity. The figures on the lintels, archivolts, and tympanums are no longer entangled but are separate entities. As a result, the design carries visually much further than that of previous portals.

Especially striking is the novel treatment of the jambs (fig. 11-42), which are lined with tall figures attached to columns. Such figures had occurred on the jambs or trumeaux of Romanesque portals (see figs. 10-21 and 10-27), but they were reliefs carved from the masonry of the doorway. The Chartres jamb figures, in contrast, are essentially statues, each with its own axis. They could, in theory at least, be detached from their supports. Here, then, we witness a development of truly revolutionary importance: the beginning of the reconquest of monumental sculpture in the round since the end of classical antiquity. (Only Benedetto Antelami, we will recall, had made such an attempt during the Romanesque era; see fig. 10-30.) Apparently this step could be taken only by borrowing the cylindrical shape of the column for the human figure,

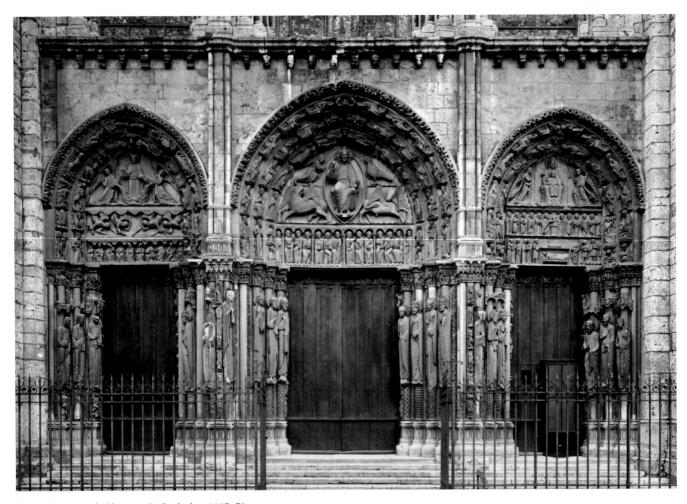

11-41. West portal, Chartres Cathedral. c. 1145–70

Realism is, of course, a relative term whose meaning varies according to circumstances. On the Chartres west portals, it appears to spring from a reaction against the fantastic and demoniacal aspects of Romanesque art. This response may be seen in the solemn spirit of the figures and their increased physical bulk. (Compare the Christ of the center tympanum with his counterpart at Vézelay, fig. 10-26.) It also appears in the discipline of the symbolic program underlying the entire scheme. While an understanding of the subtler aspects of this program requires a knowledge of the theology of the Chartres Cathedral School, its main elements can be readily understood.

The **jamb** statues form a continuous sequence linking all three portals (see fig. 11-41). Together they represent the prophets, kings, and queens of the Bible. Their purpose is to acclaim the rulers of France as the spiritual descendants of Old Testament royalty and to stress the harmony of spiritual and secular rule, of priests (or bishops) and kings—ideals put forward by Abbot Suger. Christ himself is enthroned above the main doorway as Judge and Ruler of the universe. He is flanked by the symbols of the four evangelists, with the apostles below and the 24 elders of the Apocalypse in the two outer **archivolts**. The right-hand **tympanum** shows Christ's incarnation: the Birth, the Presentation in the Temple, and the Infant Christ on the lap of the Virgin, who also stands for the Church. In the archivolts above are representations of the liberal arts as human wisdom paying homage to the divine wisdom of Christ. Finally, in the left-hand tympanum, we see the timeless Heavenly Christ (the Christ of the Ascension) framed by the everrepeating cycle of the year: the signs of the zodiac and their earthly counterparts, the labors of the 12 months.

CHARTRES CATHEDRAL, NORTH PORTALS. When Chartres Cathedral was rebuilt after the fire of 1194, the "Royal Portals" of the west facade must have seemed small and old-fashioned in relation to the rest of the new structure. Perhaps for that reason, the two transepts each received three large portals preceded by deep porches. The north transept (fig. 11-43) is devoted to the Virgin. She had already appeared over the right portal of the west facade in her traditional guise as the Mother of God seated on the Throne of Divine Wisdom (see fig. 11-41). Her new prominence reflects the growing importance of the cult of the Virgin, which had been actively promoted by the Church since the Romanesque period. The growth of Mariology, as it is known, was linked to a new emphasis on divine love, which was embraced by the faithful as part of the more human view that became increasingly popular during the Gothic era. The cult of the Virgin received special emphasis about 1204, when Chartres, which is dedicated to her, received the head of her mother, St. Anne, as a relic.

The north tympanum (fig. 11-43) depicts events associated with the Feast of the Assumption (celebrated on August 15), when Mary was transported to Heaven. They are the Death (Dormition), Assumption, and Coronation of the Virgin, which, along with the Annunciation (see fig. 11-46), became the most frequently portrayed subjects relating to her life. The presence of all three here is extraordinary. They identify Mary with the Church as the Bride of Christ and the Gateway to Heaven, in addition to her

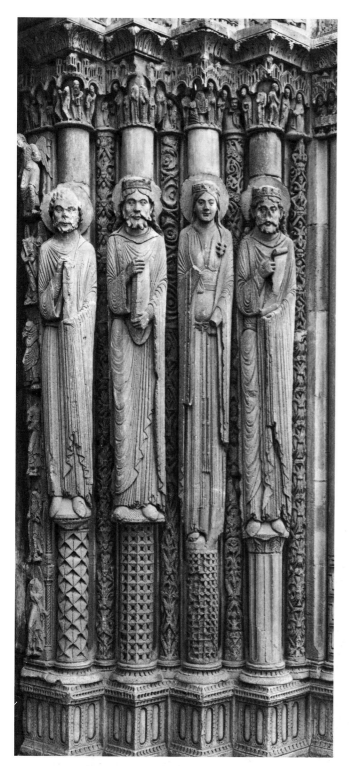

11-42. Jamb statues, west portal, Chartres Cathedral

with the result that these statues seem more abstract than their Romanesque predecessors. Yet they will not retain their rigid poses and unnatural proportions for long. The very fact that they are round gives them a stronger presence than anything in Romanesque sculpture, and their heads show a gentle, human quality that indicates the fundamentally realistic trend of Gothic sculpture.

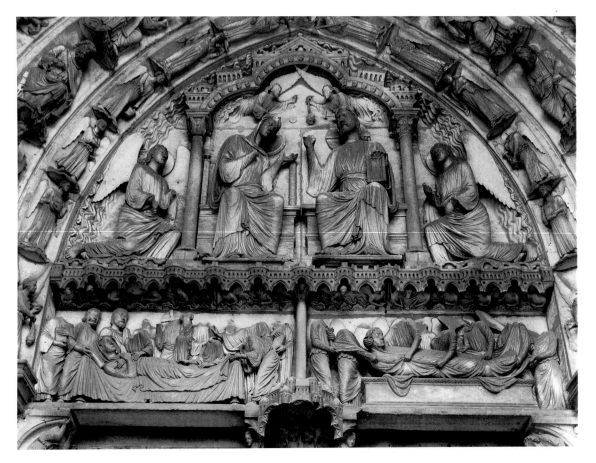

11-43. *Coronation of the Virgin* (tympanum), *Dormition and Assumption of the Virgin* (lintel), north portal, Chartres Cathedral. c. 1230

traditional role as divine intercessor. More important, they stress her equality with Christ. She becomes not only his companion (The Triumph of the Virgin) but also his Queen. Unlike earlier representations, which rely on Byzantine examples, these are of Western invention. The figures have a monumentality never found before in medieval sculpture. Moreover, the treatment is so pictorial that the scenes are independent of the architectural setting into which they have been crammed.

GOTHIC CLASSICISM. The *Coronation of the Virgin* represents an early phase of High Gothic sculpture. The jamb statues of the transept portals at Chartres, such as the group shown in figure 11-44, show a similar evolution. By now, the relationship of statue and column has begun to dissolve. The columns are quite literally put in the shade by the greater width of the figures, by the strongly projecting canopies, and by the elaborately carved bases of the statues.

In the three saints on the right, we still find echoes of the cylindrical shape of Early Gothic jamb statues, but even here the heads are no longer strictly in line with the central axis of the body. St. Theodore, the knight on the left, stands at ease, in a semblance of classical contrapposto. His feet rest on a horizontal platform, rather than on a sloping shelf as before, and the axis of his body, instead of being straight, describes a slight but perceptible S-curve. Even more surprising is the wealth of carefully observed detail in the weapons and in the texture of the tunic and chain mail. Above all, there is the organic structure of the body. Not since Imperial Roman times have we seen a figure as thoroughly alive as this. Yet the most impressive quality of the statue is not its realism, but the

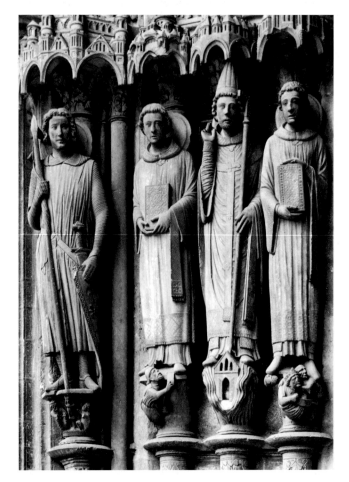

11-44. Jamb statues, south transept portal, Chartres Cathedral. c. 1215–20

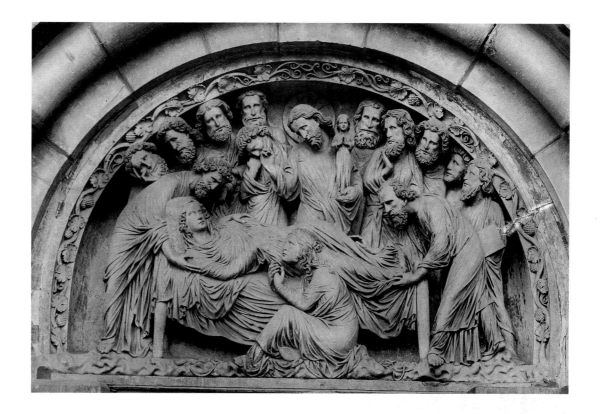

serene, balanced image that it conveys. In this ideal portrait of the Christian soldier, the spirit of the crusades has been expressed in its most elevated form.

The *St. Theodore* could not have evolved directly from the elongated columnar statues of Chartres' west facade. It also incorporates another, equally important tradition: the classicism of the Meuse Valley, from Renier of Huy to Nicholas of Verdun (compare figs. 10-31, 10-40, and 10-41). At the end of the twelfth century this style, previously confined to metalwork and miniatures, began to appear in monumental stone sculpture as well and transformed it from Early Gothic to Classic High Gothic.

STRASBOURG CATHEDRAL. The link with Nicholas of Verdun is striking in the *Death of the Virgin* (fig. 11-45), a tympanum at Strasbourg Cathedral slightly later than the Chartres north transept portals. Here the draperies, the facial types, and the movements and gestures have a classical flavor that recalls the work of Nicholas of Verdun (see fig. 10-40). What marks it as Gothic rather than Romanesque, however, is the deeply felt tenderness pervading the scene. We sense a bond of shared emotion among the figures, an ability to communicate by glance and gesture that surpasses even *The Crossing of the Red Sea* (fig. 10-41). This emotional quality has a long heritage reaching back to antiquity. It entered Byzantine art during the eleventh century as part of a renewed classicism (see figs. 8-48 and 8-51). Gothic expressiveness is unthinkable without such examples. But how much warmer and more eloquent it is at Strasbourg than at Chartres! What appears as merely one episode within the larger doctrinal statement of the earlier work now becomes the sole focus of attention. It serves as the means for an outpouring of feeling that had never been seen in the art of western Christendom.

(ABOVE) 11-45. *Death of the Virgin,* tympanum of the south transept portal, Strasbourg Cathedral, France. c. 1220.

If one were called upon to give a psychological characterization of the various phases of medieval sculpture, one might perhaps convey something of the difference, even irreconcilability, of their qualities by saying that Romanesque sculpture was the expression of faith, that Gothic sculpture was the expression of piety, and that the sculpture of the decline was the expression of devotion. . . .

. . .[T]he iconography of the twelfth century. . .was dominated by the Apocalypse, from which it derived its fearful visions and its image of Christ the Judge, enthroned in glory, with His inhuman entourage. [Figures 10-24 and 10-26 are two such twelfth-century examples.] From the Apocalypse it drew, if not all its resources, at least its predominant tonality, which was that of the epic poem. It transformed the Psychomachia *into a* chanson de geste. *It gave an Oriental tinge to Christian poetry, and exaggerated proportions to its heroes. Into its world it welcomed monsters conceived out of chaos, and obeying laws foreign to those of actual life. Thirteenth-century iconography made simultaneous renunciation of the visions, the epic, the East and the monsters. It was evangelic, human, Western and natural.*

—Henry Focillon. *The Art of the West in the Middle Ages.* Vol. 2, *Gothic Art.* Translated by Donald King. Ithaca: Cornell University Press, 1980, pp. 71–72. Originally published in 1963 by Phaidon Press Inc.

HENRI FOCILLON (1881–1943) is profiled on page 291. The passage cited here is characteristic of Focillon's encompassing knowledge of world art and his gift for using analogy to help bring readers to new insights.

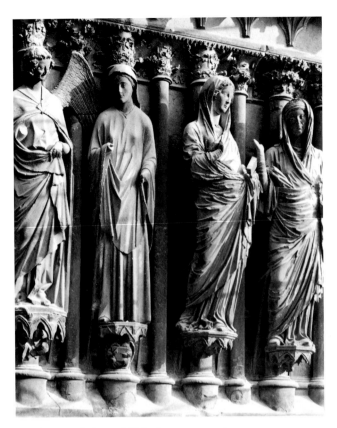

11-46. *Annunciation* and *Visitation,* west portal,
Reims Cathedral. c. 1225–45

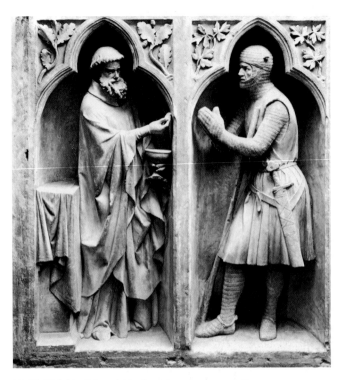

11-47. *Melchizedek and Abraham,* interior west wall,
Reims Cathedral. After 1251

REIMS CATHEDRAL. The climax of Gothic classicism is reached in some of the statues at Reims Cathedral. The most famous of them is the *Visitation* group (fig. 11-46, the two figures on the right). To have a pair of jamb figures enact a narrative scene such as this would have been inconceivable in Early Gothic sculpture. The fact that they can do so now shows how far the column has receded into the background. Now the S-curve, resulting from the pronounced contrapposto, is much more obvious than in the *St. Theodore.* It dominates the side view as well as the front view. The physical bulk of the body is further emphasized by horizontal folds pulled across the abdomen. The relationship of the two women shows the same warmth and sympathy we found at Strasbourg, but their classicism is far more monumental. They remind us so strongly of ancient Roman matrons that we wonder if the artist could have been inspired by large-scale Roman sculpture (compare fig. 7-32).

Because of the vast scale of the sculptural program at Reims, it was necessary to employ masters from other building sites. We therefore see several distinct styles among the figures. Two of these styles, both clearly different from the classicism of the *Visitation,* appear in the *Annunciation* group (fig. 11-46, left). The Virgin has a rigidly vertical axis and straight, tubular folds meeting at sharp angles. This severe style was probably invented about 1220 by the sculptors of the west portals of Notre-Dame in Paris; from there it traveled to Reims as well as Amiens (see fig. 11-49, top center). The angel, in contrast, is remarkably graceful. We note the tiny, round face framed by curly locks, the emphatic smile, the strong

S-curve of the slender body, and the rich drapery. This "elegant style," created around 1240 by Parisian masters working for the royal court, spread far and wide during the following decades. In fact, it soon became the standard formula for High Gothic sculpture. We shall see its effect for many years to come, not only in France but abroad.

A mature example of the elegant style is the group of *Melchizedek and Abraham,* carved shortly after the middle of the century for the interior west wall of Reims Cathedral (fig. 11-47). Abraham, in the costume of a medieval knight, recalls the vigorous realism of the *St. Theodore* at Chartres (see fig. 11-44). Melchizedek, however, shows clearly his descent from the angel of the Reims *Annunciation* (11-46). His hair and beard are even more elaborately curled, and the draperies are more ample, so that the body almost disappears among the play of folds. The deep recesses and sharply projecting ridges show a new awareness of effects of light and shadow that seem more pictorial than sculptural. So does the way the figures interact, despite being placed in deep niches.

THE VIRGIN OF PARIS. A half-century later every trace of classicism has disappeared from Gothic sculpture. The human figure now becomes strangely abstract. Thus the famous *Virgin of Paris* (fig. 11-48) in Notre-Dame Cathedral consists largely of hollows, and the projections have been reduced to the point where they are seen as lines rather than volumes. The statue is quite literally disembodied—its swaying stance bears little relation to classical contrapposto, since it no longer supports the figure.

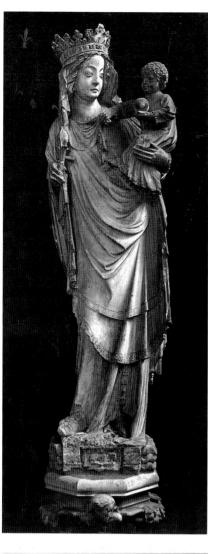

11-48. *The Virgin of Paris.* Early 14th century. Stone. Notre-Dame, Paris

Compared to such unearthly grace, the angel of the Reims *Annunciation* (fig. 11-46) seems solid indeed. Yet it contains the seed of the very qualities expressed so strikingly in *The Virgin of Paris.*

When we look back over the century and a half that separates *The Virgin of Paris* from the Chartres west portals, we cannot help wondering what brought about this graceful manner. The new style was certainly encouraged by the royal court of France and thus had special authority. However, smoothly flowing, calligraphic lines came to dominate Gothic art, not just in France but throughout northern Europe from about 1250 to 1400. It is clear, moreover, that the style of *The Virgin of Paris* represents neither a return to the Romanesque nor a complete rejection of the earlier realistic trend.

Gothic realism had never been systematic. Rather, it had been a "realism of particulars," focused on specific details rather than on overall structure. Its most characteristic products are small-scale carvings, such as the *Labors of the Months* in quatrefoil frames on the facade of Amiens Cathedral (fig. 11-49), with their delightful scenes of everyday life. This keen interest in nature, which we first saw at the end of the Romanesque (see fig. 10-42), seems to have come from Byzantine art, where it appears some 200 years earlier, although its origins can be traced back at least to early Christian times (compare fig. 8-7). The same intimate realism

11-49. *Signs of the Zodiac* and *Labors of the Months* *(July, August, September),* west facade, Amiens Cathedral. c. 1220–30

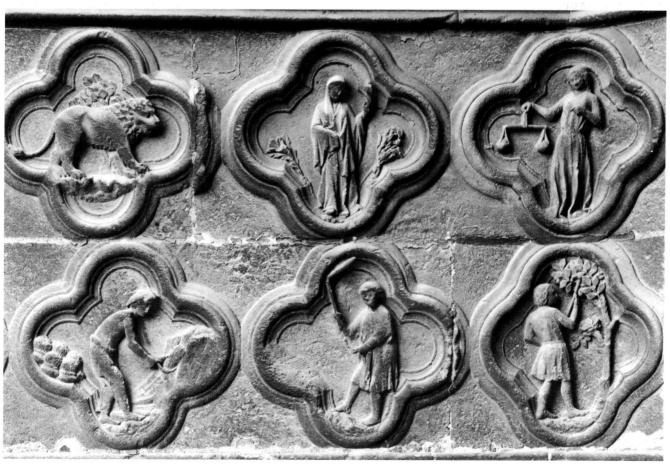

survives even in *The Virgin of Paris*. We see it in the Infant Christ, who appears here not as the Savior-in-miniature facing the viewer, but as a human child playing with his mother's veil. The statue thus retains an emotional appeal that links it to the Strasbourg *Death of the Virgin* and to the Reims *Visitation*. It is this expressive quality, not realism or classicism as such, that is the essence of Gothic art.

England

The spread of Gothic sculpture beyond France began only toward 1200, so that the style of the Chartres west portals had hardly any echoes abroad. Once under way, however, it proceeded very quickly. England may well have led the way, as it did in developing its own version of Gothic architecture. Unfortunately, so much English Gothic sculpture was destroyed during the Reformation that its evolution is difficult to study. The richest materials are the tombs, which were left undisturbed by Protestants later on. They include a type that has no counterpart on the other side of the Channel (fig. 11-50). It shows the deceased, not in the quiet repose found on most medieval tombs, but as a fallen hero fighting to the last breath. According to an old tradition, these dramatic figures honor the memory of Crusaders who died in the struggle for the Holy Land. As the tombs of Christian soldiers, they carry a religious meaning that helps to account for their expressive power. Their agony, which recalls the *Dying Trumpeter* (see fig. 5-73), makes them the finest achievements of English Gothic sculpture.

Germany

In Germany the growth of Gothic sculpture can be traced more easily. From the 1220s on, German masters trained in the sculpture workshops of the French cathedrals brought the new style back home. Because German architecture at that time was still mainly Romanesque, however, large statuary cycles like those at Chartres and Reims were not produced on facades, where they would have looked out of place. As a result, German Gothic sculpture tended to be less closely linked with its architectural setting. In fact, the finest work was often done for the interiors of churches.

THE NAUMBURG MASTER. This independence permitted a greater expressive freedom than in France. It is strikingly evident in the work of the Naumburg Master, an artist of real genius whose best-known work is the magnificent series of statues and reliefs made about 1240–50 for Naumburg Cathedral. The *Crucifixion* (fig. 11-51) forms the center of the choir screen; flanking it are statues of the Virgin and John the Evangelist. Enclosed by a deep, gabled porch, the three figures frame the opening that links the nave with the sanctuary. Rather than placing the group above the screen, as was usual, the sculptor has brought the subject down to earth both physically and emotionally. The suffering of Christ thus becomes a human reality through the emphasis on the weight and volume of his body. Mary and John, pleading with the viewer, convey their grief more eloquently than ever before.

The pathos of these figures is heroic and dramatic, as against the lyricism of the Strasbourg *Death of the Virgin* or the Reims *Visitation* (see figs. 11-45 and 11-46). If the classical High Gothic sculpture of France may be compared with Pheidias, the Naumburg Master might be considered the temperamental counterpart of Skopas (see page 155). The same intensity dominates the Passion scenes, such as *The Kiss of Judas* (fig. 11-52), with its unforgettable contrast between the meekness of Christ and the violence of the sword-wielding St. Peter. Attached to the responds inside the choir are over-lifesize statues of nobles associated with the founding of the cathedral. These men and women were not of the artist's own time—they were only names in a chronicle to him. Yet the famous pair *Ekkehard and Uta* (fig. 11-53) are as individual and realistic as if they had been portrayed from life.

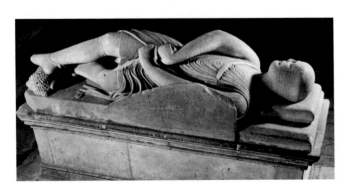

11-50. Tomb of a Knight. c. 1260. Stone. Dorchester Abbey, Oxfordshire, England

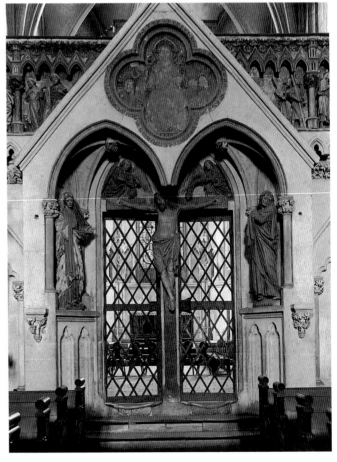

11-51. *Crucifixion,* on the choir screen, Naumburg Cathedral, Germany. c. 1240–50. Stone

11-52. *The Kiss of Judas,* on the choir screen, Naumburg Cathedral. c. 1240–50. Stone

THE PIETÀ. Gothic sculpture, as we have come to know it so far, reflects a desire to give a greater emotional appeal to traditional themes of Christian art. Toward the end of the thirteenth century, this tendency gave rise to a new kind of religious image. Originally designed for private devotion, it is often referred to by the German term ***Andachtsbild*** (contemplation image), since Germany played the leading part in its development. The most widespread type was a representation of the Virgin grieving over the dead Christ. It is called a **Pietà** after an Italian word derived from the Latin *pietas,* the root word for both pity and piety. No such scene occurs in the scriptural accounts of the Passion. The Pietà unites two iconic types from Byzantine art, the Madonna and Child, and the Crucifixion. (These images were often paired once they became familiar to western Europeans after the conquest of Constantinople in 1204.) We do not know where or when the Pietà was invented, but it portrays one of the Seven Sorrows of the Virgin. It thus forms a tragic counterpart to the motif of the Madonna and Child, one of her Seven Joys. [See Primary Sources, no. 28, page 391.]

The *Roettgen Pietà,* shown in figure 11-54, is carved of wood and vividly painted. Like most such groups, this large cult statue

11-53. *Ekkehard and Uta.* c. 1240–50. Stone. Naumburg Cathedral

11-54. *Roettgen Pietà.* Early 14th century. Wood, height 34½" (87.5 cm). Rheinisches Landesmuseum, Bonn

11-55. Claus Sluter. Portal of the Chartreuse de Champmol, Dijon, France. 1385–93. Stone

was meant to be placed on an altar. The style, like the subject, expresses the emotional fervor of lay religiosity, which emphasized a personal relationship with God as part of the tide of mysticism that swept fourteenth-century Europe. Realism here has become purely a means to enhance the work's impact. The faces convey unbearable pain and grief; the wounds are exaggerated grotesquely; and the bodies and limbs have become puppetlike in their thinness and rigidity. The purpose of the work clearly is to arouse so overwhelming a sense of horror and pity that the faithful will share in Christ's suffering and identify with the grief-stricken Mother of God. The ultimate goal of this emotional bond is a spiritual transformation that grasps the central mystery of God in human form through compassion (meaning "to suffer with").

At first glance, the *Roettgen Pietà* would seem to have little in common with *The Virgin of Paris* (see fig. 11-48), which dates from the same period. Yet they share a lean, "deflated" quality of form and exert a strong emotional appeal to the viewer. Both features characterize the art of northern Europe from the late thirteenth to the mid-fourteenth century. Only after 1350 do we again find an interest in weight and volume, coupled with a renewed desire to explore tangible reality as part of a change in religious outlook.

France

CLAUS SLUTER. The climax of this new trend came around 1400, during the time of the International Style (see pages 378–83). Its greatest representative was Claus Sluter, a sculptor of Netherlandish origin working at Dijon for the king's brother Philip the Bold, the duke of Burgundy. Between 1385 and 1393 Sluter decorated the portal (fig. 11-55) of the Carthusian monastery near Dijon known as the Chartreuse de Champmol (see box page 300). This work recalls the monumental statuary on thirteenth-century cathedrals, but the figures have grown so large that they almost overpower their framework. The effect is due not only to their size and bold three-dimensionality. It also stems from the fact that the jamb statues (showing the duke and his wife, with their patron saints) are turned toward the Madonna on the trumeau. The five figures thus form a coherent unit, like the *Crucifixion* group at Naumburg. In both cases the sculptural composition has been superimposed on the shape of the doorway, in contrast to Chartres, Notre-Dame, or Reims. Significantly, the Champmol portal did not pave the way for a revival of architectural sculpture. Instead, it remained an isolated effort.

Sluter's other works belong to a category that, for lack of a better term, we might label church furniture. It includes tombs, pulpits, and the like, which combine large-scale sculpture with a small-scale architectural setting. The most impressive is *The Moses Well* at the Chartreuse de Champmol (fig. 11-56). This symbolic well surrounded by statues of Old Testament prophets was at one time topped by a crucifix. The majestic Moses shows the same qualities we find in Sluter's portal statues. Heavy, draped garments envelop the body like an ample shell. The swelling forms seem to reach out into the surrounding space as if trying to capture as much of it as possible. (Note the outward curve of the scroll, which reads: "The children of Israel do not listen to me.") The effect must have been enhanced greatly by the polychromy added by the painter Jean Malouel (see pages 378–379), which has largely disappeared. At first glance, Moses seems to look forward to the Renaissance. (Compare Michelangelo's treatment of the same subject in fig. 13-13.) Only when we look more closely do we realize that Sluter remains firmly tied to the Gothic, just as the figures

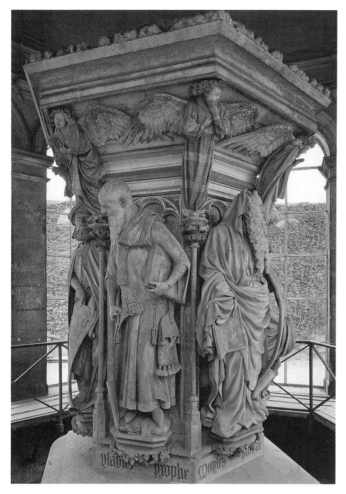

11-56. Claus Sluter. *The Moses Well*. 1395–1406. Stone, height of figures approx. 6' (1.8 m). Chartreuse de Champmol

NICOLA PISANO. Such was the background of Nicola Pisano (c. 1220/5–1284), who went to Tuscany from southern Italy about 1250, the year of Frederick II's death. Ten years later he completed the marble pulpit in the Baptistery of Pisa Cathedral (fig. 11-57). Pisano has been described as "the greatest—and in a sense the last—of medieval classicists." Whether we look at the architectural framework or the sculptured parts of the pulpit, the classical flavor is so strong that the Gothic elements are hard to detect at first. But we do find them in the design of the arches and the shape of the capitals. They can also be seen in the standing figures at the corners, which look like small-scale descendants of the jamb statues on French Gothic cathedrals.

The most striking Gothic quality is the human feeling in the reliefs such as the *Nativity* (fig. 11-58). The dense crowding of figures, however, has no counterpart in northern Gothic sculpture. The panel also shows the Annunciation and the shepherds in the fields receiving the glad tidings of the birth of Christ. The treatment of the relief as a shallow box filled almost to the bursting point with solid, convex shapes shows that Nicola Pisano must have been thoroughly familiar with Roman sarcophagi (compare fig. 7-39). The figures could almost be lifted from the Ara Pacis procession (fig. 7-32), and the Madonna herself has all the qualities of a Roman matron. Pisano must also have known Byzantine images of the Nativity (compare fig. 8-44). As seen in the bulging features and lumpy anatomy, however, Nicola's style remains Gothic despite his obvious fascination with antique sculpture.

remain firmly tied to their niches. Not until the early Renaissance will such sculptures regain their independence.

In the Isaiah (facing left), what strikes us is the masterful realism of every detail, from the particulars of the costume to the texture of the wrinkled skin. The head has all the individuality of the portraits of the duke and duchess on the Chartreuse portal. It is this attachment to the specific that distinguishes Sluter's realism from that of the thirteenth century.

Italy

We have left a discussion of Italian Gothic sculpture to the last, for here, as in Gothic architecture, Italy stands apart from the rest of Europe. The earliest Gothic sculpture in Italy was probably produced in the extreme south, in Apulia and Sicily. This region was ruled during the thirteenth century by the German emperor Frederick II, who employed Frenchmen and Germans along with native artists at his court. Few of the works he sponsored have survived, but there is evidence that he strongly favored a classicism derived from the sculpture of the Chartres transept portals and the *Visitation* group at Reims (see figs. 11-43 and 11-46). This style not only provided a fitting visual language for a ruler who saw himself as the heir of the Caesars, it also blended easily with the classical tendencies in Italian Romanesque sculpture (see pages 312–13).

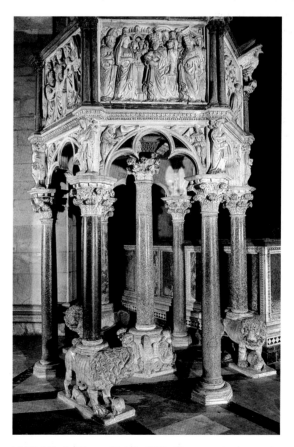

11-57. Nicola Pisano. Pulpit. 1259–60. Marble, height 15' (4.6 m). Baptistery, Pisa

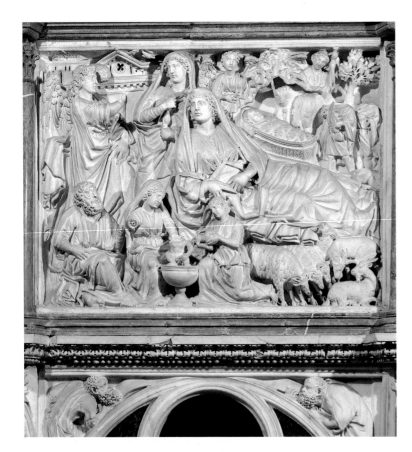

11-58. *Nativity,* detail of the pulpit by Nicola Pisano

The figures atop the columns include an even more startling classical element: a nude male (fig. 11-59), instantly recognizable as Hercules by the lion cub on his shoulder and the skin of the Nemean lion he slew with his bare hands (compare fig. 5-6). But what is he doing here? He is the personification of Fortitude. Whenever we meet the unclothed body, from 800 to 1400, we may be sure, with a few special exceptions, that such nudity has a moral significance. It may be negative (Adam and Eve, or sinners in Hell) or positive (the nudity of the Christ of the Passion, the martyrdom of saints, or the mortification of the flesh). Hercules' presence as one of the seven Cardinal Virtues was therefore perfectly acceptable to the medieval mind.

We may also be sure that such figures are derived, directly or indirectly, from classical sources, no matter how unlikely this may seem. Such is the case with Nicola's *Hercules,* who betrays his descent from Praxiteles' *Hermes* (fig. 5-70). However, Herakles' nearest ancestors are miniature figures of Daniel in the lions' den on Early Christian sarcophagi of the fifth century, which have the same squat proportions. His appearance here is thus based on highly respectable sources. Like all medieval nudes, even the finest, it lacks the sensual appeal that we take for granted in every nude of classical antiquity. This quality was purposely avoided rather than unattainable. To the medieval mind the physical beauty of the ancient "idols," especially nude statues, embodied the insidious attraction of paganism.

GIOVANNI PISANO. Half a century later, Nicola's son Giovanni (1245/50–after 1314), who was an equally gifted sculptor,

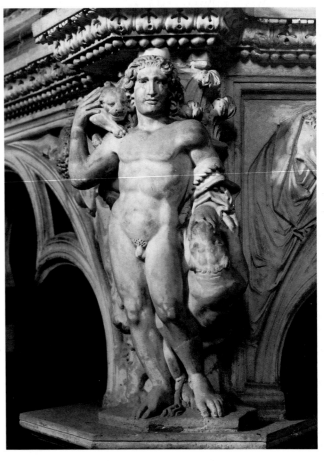

11-59. *Fortitude,* detail of the pulpit by Nicola Pisano

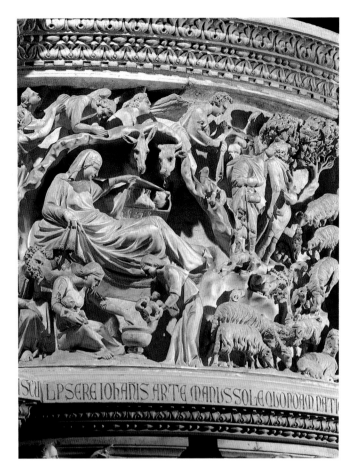

carved another marble pulpit for Pisa Cathedral. (It has two inscriptions by the artist praising his ability but bemoaning the hostility to his work.) This pulpit, too, includes a *Nativity* (fig. 11-60). As we might expect, both panels have much in common, yet they also present a sharp—and instructive—contrast. Giovanni's slender, swaying figures, with their smoothly flowing draperies, recall neither classical antiquity nor the *Visitation* group at Reims. Instead, they reflect the elegant style of the royal court at Paris, which had become the standard Gothic formula during the later thirteenth century (compare fig. 11-46, left pair). And with this change came a new treatment of relief. To Giovanni Pisano, space was as important as form. The figures are no longer tightly packed together. They are placed far enough apart to let us see the landscape setting, and each figure has its own pocket of space. Whereas Nicola's *Nativity* strikes us as a sequence of bulging, rounded masses, Giovanni's appears to be made up mainly of cavities and shadows.

Giovanni Pisano, then, follows the same trend toward disembodiment that we saw north of the Alps around 1300, only he does so in a more limited way. At first glance, his *Madonna* at Prato Cathedral (figs. 11-61 and 11-62) recalls Nicola's style. The firm

(LEFT) 11-60. Giovanni Pisano. *The Nativity,* detail of pulpit. 1302–10. Marble. Pisa Cathedral

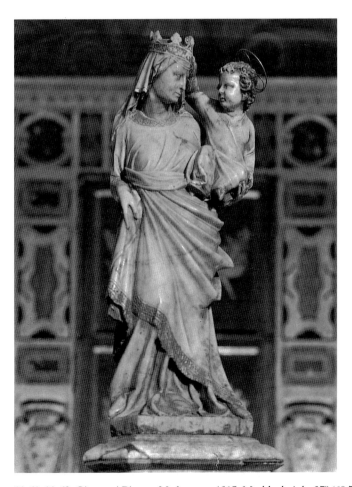

11-61, 11-62. Giovanni Pisano. *Madonna.* c. 1315. Marble, height 27" (68.7 cm). Prato Cathedral

modeling is emphasized by the strong turn of the head and the thrust-out left hip. We also note the heavy folds that anchor the figure to its base. Yet there can be no doubt that the Prato statue is derived from a French prototype that must have been much like *The Virgin of Paris* (see fig. 11-48). The back view, with its suggestion of "Gothic sway," reveals the connection more clearly than the front view, which hides the pose beneath the massive drapery folds.

TOMBS. Italian Gothic church facades generally did not attempt to rival those of the French cathedrals. The French Gothic portal, with its jamb statues and richly carved tympanum, never found favor in the south. Instead, we often find a survival of Romanesque traditions, such as statues in niches or small-scale reliefs on wall surfaces (compare figs. 10-30 and 10-29). Italian Gothic sculpture excelled in the field that we have called church furniture—pulpits, screens, shrines, and tombs.

CAN GRANDE. The most remarkable tomb is the monument of Can Grande della Scala, the lord of Verona. It was built outdoors next to the church of Sta. Maria Antica and is now in the courtyard of the Castelvecchio. This tall structure consists of a vaulted canopy housing the sarcophagus; above there is a truncated pyramid, which supports an equestrian statue of Can Grande (fig. 11-63). The ruler, astride his richly outfitted mount, is shown in full armor, sword in hand, as if he were standing on a windswept hill at the head of his troops. In a supreme display of

11-63. *Equestrian Statue of Can Grande della Scala,* from his tomb. 1330. Stone. Museo di Castelvecchio, Verona, Italy

self-confidence, he wears a broad grin. Clearly, this is no Christian soldier, no crusading knight, no embodiment of the ideals of chivalry, but a frank glorification of power.

Can Grande, remembered today mainly as the friend and protector of Dante, was an extraordinary figure. [See Primary Sources, no. 30, page 392.] Although he held Verona as a fief from the German emperor, he called himself "the Great Khan," thus asserting his claim to the absolute sovereignty of an Asiatic potentate. His freestanding equestrian statue—a form of monument that had traditionally been reserved for emperors (see fig. 7-40)—conveys the same ambition in visual terms.

ARNOLFO DI CAMBIO. The late thirteenth century saw the development of a new kind of tomb for leaders of the Catholic church. Its origins lie in French royal tombs, but the type spread quickly to Italy. There it was given definitive form by Arnolfo di Cambio, who had been an assistant to Nicola Pisano, under whom he developed a classicizing style that became even more assured after he moved to Rome. There he entered the employment of Charles of Anjou, which exposed him to French influences. The monument of Cardinal Guillaume de Braye (fig. 11-64), himself a Frenchman, reflects the artist's varied background. It combines a carved effigy resting on a sarcophagus with a tableau of St. Mark presenting the deceased to the Virgin and Child. The tomb was originally housed in an elaborate tabernacle (lost when it was moved from its original setting) rather than in its present shallow niche. Arnolfo's design proved so satisfying that it became the model followed by all Italian Gothic sculptors for funerary monuments. Even without its architectural setting, the tomb has a grandeur befitting a prince of the church. The two angels solemnly closing the curtains add a human note that is as unexpected as it is touching.

LORENZO GHIBERTI. During the later fourteenth century, Italy was especially open to artistic influences from across the Alps, not only in architecture but in sculpture as well. These crosscurrents gave rise to the International Style about 1400. Its outstanding representative in Italian sculpture was Lorenzo Ghiberti (c. 1381–1455), a Florentine who as a youth must have had close contact with French art. We first meet him in 1401–2, when he won a competition, later described in his *Commentaries,* for a pair of richly decorated bronze doors for the Baptistery of S. Giovanni in Florence. [See Primary Sources, no. 32, page 392.] (It took him more than two decades to complete these doors, which fill the north portal of the building.) Each of the competing artists had to submit a trial relief, in a Gothic quatrefoil frame, depicting the Sacrifice of Isaac. Ghiberti's panel (fig. 11-65) strikes us first of all with the perfection of its craftsmanship, which reflects his training as a goldsmith. The silky shimmer of the surfaces and the wealth of detail make it easy to understand why his entry was awarded the prize. If the composition seems lacking in drama, that is characteristic of Ghiberti's calm, lyrical temperament, which suited the taste of the period. Indeed, his figures, in their softly draped garments, have an air of courtly elegance even during acts of violence.

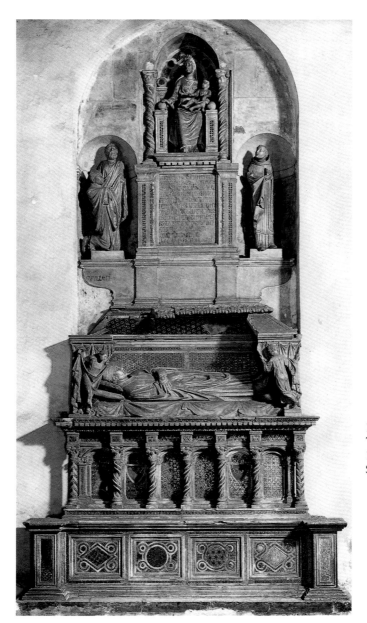

11-64. Arnolfo di Cambio.
Tomb of Guglielmo de Braye.
1282. Marble.
S. Domenico, Orvieto

Ghiberti's doors were not the first ones on the Florence Baptistery. Some 70 years earlier Andrea da Pisano (no relation to Nicola or Giovanni Pisano; c. 1290–1348?) had received a commission for the south doors to rival those of Pisa Cathedral. In *The Baptism of Christ* (fig. 11-66), Andrea shows that he was an able follower of the painter Giotto (compare fig. 11-78). Ghiberti's doors are a direct outgrowth of Andrea's, which had great influence on Florentine art. But the differences are equally important. Andrea's reliefs must have seemed hopelessly old-fashioned to Ghiberti in their stiff, angular poses and simplified compositions. Although both artists were strongly influenced by French metalwork, Ghiberti's work shows the fluid grace and the tangible reality of International Style sculpture. These characteristics also grew out of French manuscript painting (compare fig. 11-89), whose intimacy appealed to Ghiberti.

However much his work may owe to French influence, Ghiberti shows himself to be thoroughly Italian in one respect: his

admiration for ancient sculpture, which can be seen in the beautiful nude torso of Isaac. Here he revives a tradition of classicism that had reached its highest point in Nicola Pisano but had gradually died out during the fourteenth century. But Ghiberti is also the heir of Giovanni Pisano. In Giovanni's *Nativity* panel (see fig. 11-60) we noted a new emphasis on the setting. Ghiberti's trial relief carries this tendency a good deal further and achieves a far more natural sense of recession through subtle modeling. For the first time since classical antiquity, we experience the background of the panel not as a flat surface but as empty space from which the sculpted forms emerge, so that the angel in the upper right-hand corner seems to hover in midair. This pictorial quality relates Ghiberti's work to the painting of the International Style, where we find a similar concern with depth and atmosphere (see pages 378–83). While not a revolutionary himself, he prepares the ground for the momentous changes that will mark Florentine art during the second decade of the fifteenth century, at the beginning of the Early Renaissance.

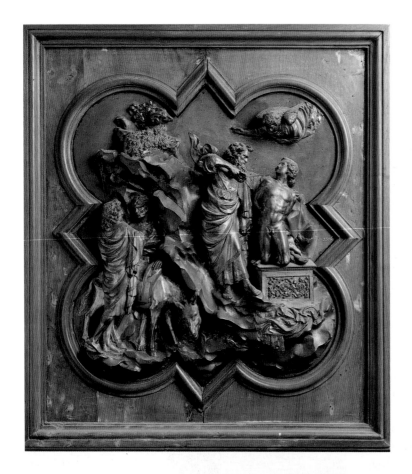

11-65. Lorenzo Ghiberti. *The Sacrifice of Isaac.* 1401–2. Gilt bronze, 21 x 17" (53.3 x 43.4 cm). Museo Nazionale del Bargello, Florence

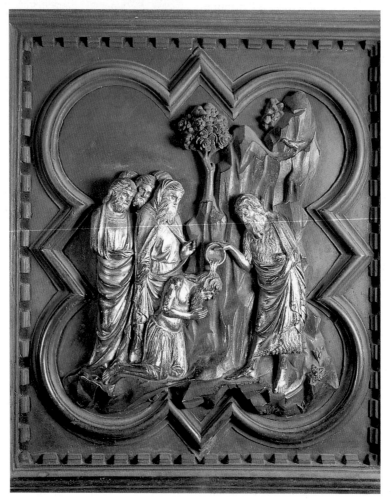

11-66. Andrea da Pisano. *The Baptism of Christ,* from the south doors, Baptistery of S. Giovanni, Florence. 1330–36. Gilt bronze

PAINTING

France

STAINED GLASS. Although Gothic architecture and sculpture began dramatically at St.-Denis and at Chartres, Gothic painting developed rather slowly at first. The architectural style sponsored by Abbot Suger gave birth to a new kind of monumental sculpture almost at once, but it did not demand any radical change in painting. To be sure, Suger's account of St.-Denis emphasizes the miraculous effect of stained-glass windows, with their "continuous light." Stained glass was thus an integral element of Gothic architecture from the very beginning. Yet the technique had already been perfected in Romanesque times, and the style remained essentially the same for nearly another hundred years, especially for single figures. Nevertheless, the "many masters from different regions" whom Suger assembled to execute the choir windows at St.-Denis faced a larger and more complex task than ever before.

During the next half-century, as Gothic structures became ever more skeletal and clerestory windows grew to huge size, stained glass displaced manuscript illumination as the leading form of painting. Since the production of stained glass was so closely linked with the great cathedral workshops, the designers were influenced more and more by architectural sculpture. The majestic *Notre Dame de la Belle Verrière* (fig. 11-67) at Chartres Cathedral is the finest early example of this process. The design recalls the relief on the west portal of the church (see fig. 11-41) but lacks its sculptural qualities. Moreover, it still betrays its Byzantine ancestry. By comparison, however, even the mosaic of the same subject in Hagia Sophia (see fig. 8-40) seems remarkably solid. The stained glass dissolves the group into weightless forms that hover effortlessly in indeterminate space.

The window consists of hundreds of small pieces of tinted glass held together by strips of lead. The maximum size of these pieces was limited by the primitive methods of medieval glass-making, so that the design could not simply be "painted on glass." [See Primary Sources, no. 34, page 393.] Rather, the window was painted *with* glass. It was assembled much like a mosaic or a jig-saw puzzle, out of odd-shaped fragments cut to fit the contours of the shapes. Only the finer details, such as eyes, hair, and drapery folds, were added by painting—or drawing—in black or gray on the glass surfaces. This process encourages an abstract, ornamental style, which tends to resist any attempt at three-dimensional effects. Only in the hands of a great master could the maze of lead strips lead to such monumental figures.

The stained-glass workers who filled the windows of the great Gothic cathedrals also had to face difficulties arising from the enormous scale of their work. No Romanesque painter had ever been called upon to cover areas so vast or so firmly bound into an architectural framework. The task required a degree of orderly planning that had no precedent in medieval painting.

VILLARD DE HONNECOURT. Only architects and stone-masons knew how to deal with this problem, and it was their methods that the stained-glass workers borrowed in mapping out their own designs. Gothic architectural design relied on a system of geometric relationships to establish numerical harmony. The

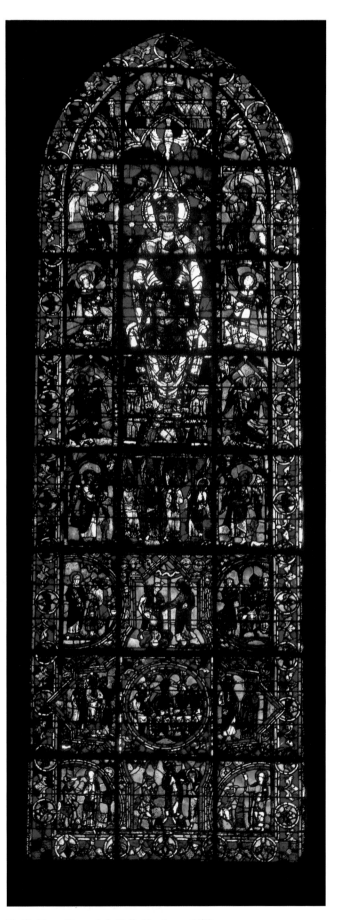

11-67. *Notre Dame de la Belle Verrière.* c. 1170. Stained-glass window, height approx. 14' (4.27 m). Chartres Cathedral

11-68. Villard de Honnecourt. *Wheel of Fortune.* c. 1240. Bibliothèque Nationale, Paris

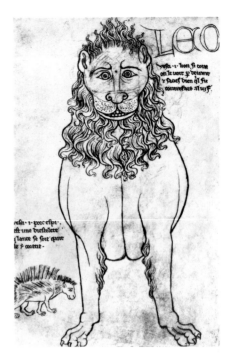

11-69. Villard de Honnecourt. *Front View of a Lion.* c. 1240. Bibliothèque Nationale, Paris

same rules could be used to control the design of stained-glass windows or even an individual figure.

We gain some insight into this procedure from the drawings in a notebook compiled about 1240 by the architect Villard de Honnecourt. What we see in the *Wheel of Fortune* (fig. 11-68) is not the final version of the design but the system of circles and triangles on which the image is based. The fundamental importance of these geometric schemes is illustrated by another drawing from the same notebook, the *Front View of a Lion* (fig. 11-69). According to the inscription, Villard has portrayed the animal from life. A closer look at the figure shows us that he was able to do so only after he had laid down a geometric pattern: a circle for the face (the dot between the eyes is its center) and a second, larger circle for the body. [See Primary Sources, no. 35, page 394.] To Villard, then, drawing from life meant something far different from what it does to us. It meant filling in an abstract framework with details based on direct observation.

The period 1200–1250 might be termed the golden age of stained glass. After that, as architectural activity declined and the demand for stained glass began to wane, manuscript illumination gradually regained its former position of leadership. By then, however, miniature painting had been thoroughly influenced by both stained glass and stone sculpture, the artistic pacemakers of the first half of the century.

ILLUMINATED MANUSCRIPTS. The resulting change of style can be seen in figure 11-70, from a **psalter** done about 1260 for King Louis IX (St. Louis) of France. The scene illustrates 1 Samuel 11:2, in which Nahash the Ammonite threatens the Jews at Jabesh. We first notice the careful symmetry of the framework, which consists of flat, ornamented panels. The architectural setting is remarkably similar to the choir screen by the Naumburg Master

(see fig. 11-51). It also recalls the canopies above the heads of jamb statues (see fig. 11-42) and the arched twin niches that enclose the relief of *Melchizedek and Abraham* at Reims (see fig. 11-47).

Against this two-dimensional background, the figures stand out in relief by their smooth and skillful modeling. But their sculptural quality stops short at the outer contours, which are defined by heavy, dark lines like the lead strips in stained-glass windows. The figures themselves show all the features of the elegant style originated about 20 years earlier by the sculptors of the royal court: graceful gestures, swaying poses, smiling faces, and neatly waved hair. (Compare the Annunciation angel in figure 11-46 and Melchizedek in figure 11-47.) Our miniature thus exemplifies the subtle and refined taste that made the court art of Paris the standard for all Europe. We find no trace of the expressive energy of Romanesque painting (see figs. 10-36 and fig. 10-37).

MASTER HONORÉ. Until the thirteenth century, illuminated manuscripts had been produced in the scriptoria of monasteries. Now, along with many other activities that were once the special preserve of the clergy, it shifted to urban workshops organized by laymen, the ancestors of the publishing houses of today. Here again the workshops of sculptors and stained-glass painters may have set the pattern.

Some of these new, secular illuminators are known to us by name. Among them is Master Honoré of Paris, who in 1295 did the miniatures in the *Prayer Book of Philip the Fair*. Our sample (fig. 11-71) shows him working in a style derived from the *Psalter of St. Louis*. Here, however, the framework no longer dominates

(OPPOSITE) 11-70. *Nahash the Ammonite Threatening the Jews at Jabesh,* from the *Psalter of St. Louis.* c. 1260.
5 x 3½" (17.7 x 8.9 cm). Bibliothèque Nationale, Paris

11-71. Master Honoré. *David and Goliath,* from the *Prayer Book of Philip the Fair.* 1295. Bibliothèque Nationale, Paris

the composition. The figures have become larger and their relieflike modeling more pronounced. They are even allowed to overlap the frame, which helps to detach them from the flat pattern of the background and thus introduce a certain, though very limited, depth into the picture.

Italy

Medieval Italy, although strongly influenced by northern art from Carolingian times on, had maintained contact with Byzantine civilization. As a result, panel painting, mosaic, and murals—mediums that had never taken firm root north of the Alps—were kept alive on Italian soil, although barely. Indeed, a new wave of influences from Byzantine art during the thirteenth century overwhelmed the Romanesque elements in Italian painting at the very time when stained glass became the dominant pictorial medium in France.

There is a certain irony in the fact that this neo-Byzantine style appeared soon after the conquest of Constantinople by the armies of the Fourth Crusade in 1204. (One thinks of the way Greek art had once captured the taste of the Romans.) Pisa, whose navy made it a power in the eastern Mediterranean, was the first

to develop a school of painting based on this "Greek manner," as the Italians called it. In some cases it was transplanted by Byzantine artists who had fled Constantinople during the Crusades. Giorgio Vasari later wrote that in the mid-thirteenth century, "Some Greek painters were summoned to Florence by the government of the city for no other purpose than the revival of painting in their midst, since that art was not so much debased as altogether lost."

There may be more truth to this statement than is often acknowledged. Byzantine art had preserved Early Christian narrative scenes virtually intact. When transmitted to the West, this tradition led to an explosion of subjects and designs that had been essentially lost for nearly 700 years. Many of them, of course, had been available all along in the mosaics of Rome and Ravenna. There had also been successive waves of Byzantine influence throughout the early Middle Ages and the Romanesque period. Nevertheless, they lay dormant, so to speak, until interest in them was reawakened through closer relations with Constantinople, which enabled Italian painters to absorb Byzantine art far more thoroughly than ever before. During this same period, we recall, Italian architects and sculptors took a different course: untouched by the Greek manner, they were assimilating the Gothic style. Eventually, toward 1300, Gothic influence spilled over into painting as well, and its interaction with the neo-Byzantine produced the revolutionary new style. Indeed Italian painting at the end of the thirteenth century produced a flood of creative energy as spectacular, and as far-reaching in its impact on the future, as the rise of the Gothic cathedral in France. When we ask what conditions made this development possible, we find that it arose from the same "old-fashioned" attitudes we met in Gothic architecture and sculpture.

TEMPERA. During the Gothic era altarpieces were painted on wood panel in **tempera**, an egg-based medium that dries quickly to form an extremely hard surface. The preparation of the panel was a complex, time-consuming process. First it was planed and coated with a mixture of plaster and glue known as **gesso**, which was sometimes reinforced with linen. Once the design had been drawn, the background was almost invariably filled in with **gold leaf** over red sizing. Then the underpainting, generally a green earth pigment *(terra verde),* was added. The image itself was painted in many layers of thin tempera with very fine brushes, a painstaking process that placed a premium on neatness, since few corrections were possible.

CIMABUE. Among the most famous painters in the Greek manner was the Florentine master Cimabue (c. 1250–after 1300). Vasari claims that he was apprenticed to a Greek painter and that he became Giotto's teacher. His huge altar panel, *Madonna Enthroned* (fig. 11-72), rivals the finest Byzantine icons or mosaics (compare figs. 8-39 and 8-40). What distinguishes it from them is mainly the more severe design and expression, which befits its huge size. Panels on such a monumental scale had rarely been attempted in the East. Equally un-Byzantine is the picture's gabled shape and the way the throne of inlaid wood seems to echo it. The geometric inlays, like the throne's architectural style, remind us of the Florence Baptistery (see fig. 10-19).

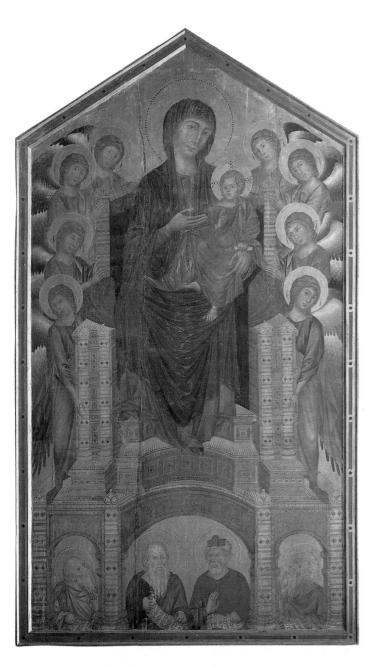

DUCCIO. A quarter century later Duccio of Siena (c. 1255–before 1319) painted another *Madonna Enthroned* (fig. 11-73) for the main altar of Siena Cathedral. It was called the *Maestà* (majesty) to identify the Virgin's role as the Queen of Heaven surrounded by her court of saints and angels. [See Primary Sources, no. 36, page 394.] At first glance, the picture may seem much like Cimabue's, since both follow the same basic scheme. Yet the differences are important. They reflect not only contrasting personalities and local tastes—the gentleness of Duccio is characteristic of Siena—but also the rapid evolution of style.

In Duccio's hands, the Greek manner has become unfrozen. The rigid, angular draperies have given way to an undulating softness. The abstract shading-in-reverse with lines of gold is kept to a minimum. The bodies, faces, and hands are beginning to swell with three-dimensional life. Clearly the heritage of Hellenistic-Roman illusionism that had always been part of the Byzantine tradition, however submerged, is asserting itself once more. But there is also a half-hidden Gothic element here. We sense it in the fluency of the drapery, the appealing naturalness of the figures, and the tender glances by which they communicate with each other. The chief source of this Gothic influence must have been Giovanni Pisano (see pages 356–58), who was in Siena from 1285 to 1295 as the sculptor-architect in charge of the cathedral facade.

On the reverse side of the *Maestà* are numerous small scenes from the lives of Christ and the Virgin. In these panels, Duccio's most mature works, the interaction of Gothic and Byzantine ele-

(LEFT) 11-72. Cimabue. *Madonna Enthroned.* c. 1280–90. Tempera on panel, 12'7½" x 7'4" (3.9 x 2.2 m). Galleria degli Uffizi, Florence

(BELOW) 11-73. Duccio. *Madonna Enthroned,* center of the *Maestà Altar.* 1308–11. Tempera on panel, height 6'10½" (2.1 m). Museo dell'Opera del Duomo, Siena

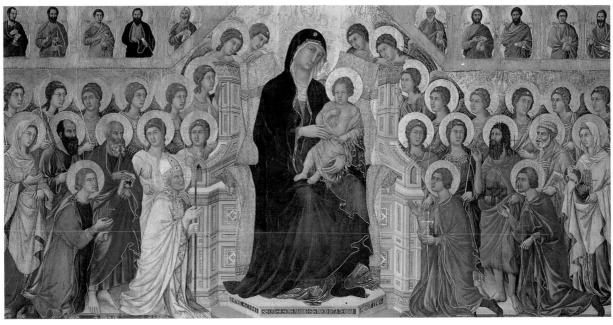

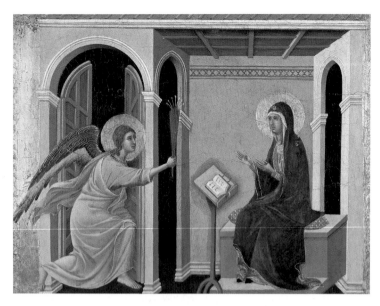

11-74. Duccio. *Annunciation of the Death of the Virgin,* from the *Maestà Altar*

ments has given rise to a major new development. Here we see a new kind of picture space and, with it, a new treatment of narrative. The *Annunciation of the Death of the Virgin* (fig. 11-74) shows us something we have never seen before: two figures enclosed by an architectural interior.

Ancient painters and their Byzantine successors had been unable to create such a space. Their architectural settings always stay behind the figures, so that their indoor scenes tend to look as if they were taking place in an open-air theater, on a stage without a roof. Duccio's figures, in contrast, inhabit a space that is created and defined by the architecture, as if the artist had carved a niche into the panel. This spatial framework is derived from the architectural housings of Gothic sculpture (compare figs. 11-47 and 11-51). Northern Gothic painters, too, had tried to produce architectural settings but only by flattening them out completely (see fig. 11-70). Because they were trained in the Greek manner, the Italian painters of Duccio's generation learned enough of Hellenistic-Roman illusionism (see fig. 7-52) to let them render such a framework without draining its three-dimensionality. Duccio, however, is not interested simply in space for its own sake. The architecture is used to integrate the figures within the drama more convincingly than ever before.

The architecture keeps its space-creating function even in the outdoor scenes on the back of the *Maestà,* such as *Christ Entering Jerusalem* (fig. 11-75). The diagonal movement into depth is conveyed not by the figures, which have the same scale throughout, but by the walls on either side of the road leading to the city, by the gate that frames the welcoming crowd, and by the buildings in the background. Whatever the shortcomings of Duccio's perspective, his architecture is able to contain and enclose. For that reason, it seems more understandable than similar views in ancient or Byzantine art (compare figs. 7-48 and 8-56). The composition,

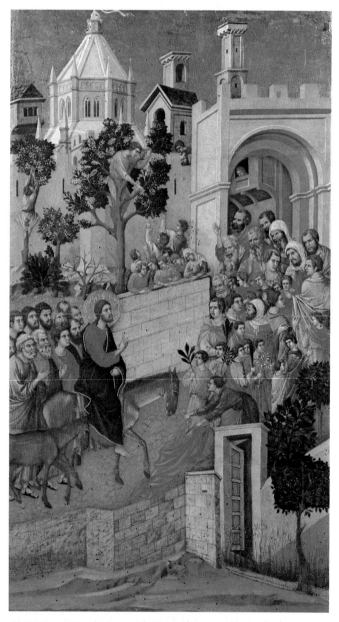

11-75. Duccio. *Christ Entering Jerusalem,* from the back of the *Maestà Altar.* 1308–11. Tempera on panel, 40½ x 21⅛" (103 x 53.7 cm). Museo dell'Opera del Duomo, Siena

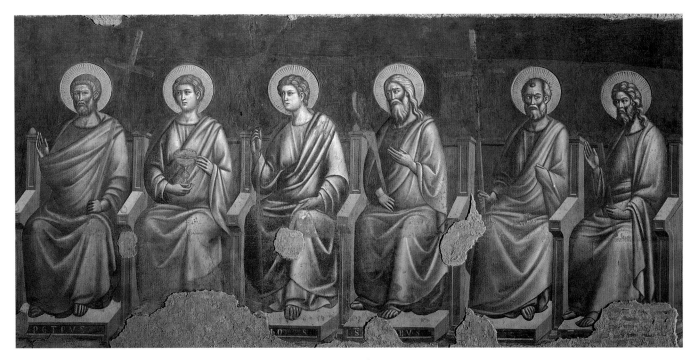

11-76. Pietro Cavallini. *Seated Apostles,* from *The Last Judgment.* c. 1290. Fresco. Sta. Cecilia in Trastevere, Rome

which goes back to Early Christian times (see illustration in box page 246), is based directly on a Byzantine example that was fully developed by the late 10th century.

GIOTTO. In Giotto (1267?–1336/7) we meet an artist of far bolder and more dramatic temperament. Ten to 15 years younger than Duccio, Giotto was less close to the Greek manner from the start, despite his probable apprenticeship under Cimabue. [See Primary Sources, nos. 31 and 33, pages 392–393.] As a Florentine, he inherited Cimabue's sense of monumental scale, but he was a wall painter by instinct, rather than a panel painter. The art of Giotto is so daringly original that its sources are far more difficult to trace than Duccio's. Apart from his knowledge of the Greek manner as represented by Cimabue, the young Giotto seems to have been familiar with the work of the neo-Byzantine masters of Rome. Among them was Cimabue's contemporary Pietro Cavallini (documented 1272–1303), who worked in both mosaic and fresco. Cavallini's style is a remarkable blend of Byzantine, Roman, and Early Christian elements. The figures in his *Last Judgment* (fig. 11-76) are in the best up-to-date manner of late Byzantine art (compare the *Anastasis* in fig. 8-57), but he has modeled them in a soft daylight that must have come from exposure to antique wall painting (see fig. 7-54). (He was also a fresco restorer.) The result is an almost sculptural monumentality that is remarkably classical. Indeed, these saints have the same calm air and gentle gravity found on the *Sarcophagus of Junius Bassus* (see fig. 8-21), but with the relaxed naturalness of the Gothic.

Cavallini set an important example for Giotto. In Rome Giotto must have become acquainted, too, with Early Christian and ancient Roman mural painting. Classical sculpture likewise seems to have left an impression on him. More fundamental, however, was the influence of late medieval Italian sculptors: Nicola and

Giovanni Pisano, and especially Arnolfo di Cambio. It was through them that Giotto came in contact with Northern Gothic art, which remains the most important of all the elements in Giotto's style. Indeed, Northern art is almost certainly the ultimate source of the emotional quality in his work.

Of Giotto's surviving murals, those in the Arena Chapel in Padua, painted in 1305–6, are the best preserved as well as the most characteristic. They are devoted mainly to events from the life of Christ, arranged in three tiers of narrative scenes (fig. 11-77) that culminate in *The Last Judgment* at the west end of the chapel. Giotto depicts many of the same subjects found on the reverse of Duccio's *Maestà,* including *Christ Entering Jerusalem* (fig. 11-78). But where Duccio has enriched the traditional scheme, spatially as well as narratively, Giotto simplifies it. The two versions have much in common, since both ultimately derive from Byzantine sources. Giotto's painting, however, suggests the example of Byzantine mosaics done on Italian soil during the twelfth century, for example in the Palatine Chapel at Palermo. The action proceeds parallel to the picture plane. Landscape, architecture, and figures have been reduced to a minimum. The austerity of Giotto's art is emphasized by the sober medium of fresco painting, with its limited range and intensity of tones. By contrast, Duccio's picture, which is executed in egg tempera on gold ground, has a jewel-like brilliance and sparkling colors. Yet Giotto's work has far more impact: It makes us feel so close to the event that we have a sense of being direct participants rather than distant observers.

The artist achieves this extraordinary effect by having the entire scene take place in the foreground. Even more important, the viewer's eye level falls within the lower half of the picture. Thus we can imagine ourselves standing on the same ground plane as the figures, even though we actually see them from well below. In contrast, Duccio makes us survey the scene from above

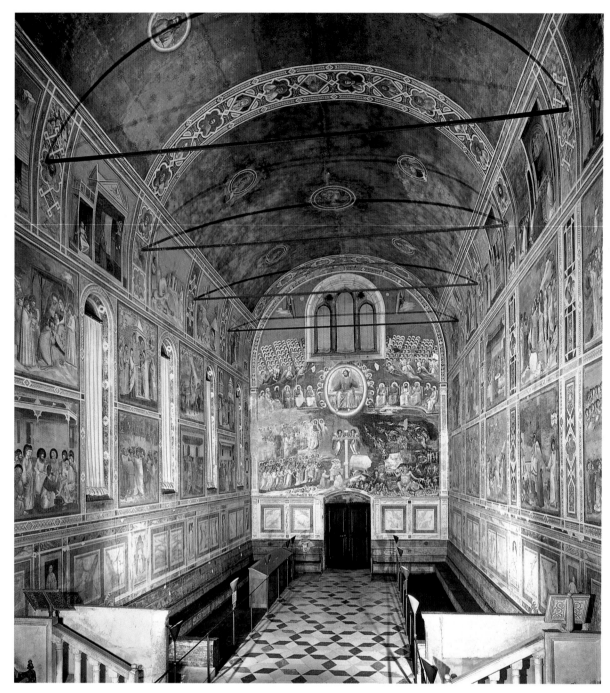

11-77. Interior, Arena (Scrovegni) Chapel. 1305–6

in "bird's-eye" perspective. The effects of Giotto's choice of view-point are far-reaching. Choice implies conscious awareness—in this case of a relationship in space between the viewer and the picture. Duccio does not yet treat his picture space as continuous with ours. Hence we have the feeling of floating above the scene. With the notable exception of the Villa of the Mysteries (see fig. 7-51), ancient painting rarely tells us where we stand as clearly as Giotto does. Above all, he gives his forms such a strong three-dimensional reality that they seem as solid as sculpture in the round.

With Giotto it is the figures, rather than the framework, that create the picture space. As a result, his space is more limited than Duccio's. Its depth extends no further than the combined volumes of the overlapping bodies in the picture—but within its limits it is much more persuasive. To Giotto's contemporaries, the tactile quality of his art must have seemed a near miracle. It was this quality that made them praise him as equal, or even superior, to the greatest of the ancient painters—although no more than a few samples of their work were known. His forms looked so lifelike that they could be mistaken for reality itself. Equally significant are the stories linking Giotto with the claim that painting is superior to sculpture. This was not an idle boast, as it turned out, for Giotto does indeed mark the start of what might be called the era of painting in Western art. The symbolic turning point is the year 1334, when he was appointed head of the Florence Cathedral workshop, an honor that until then had been reserved for archi-tects or sculptors.

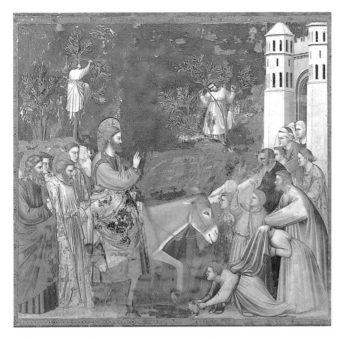

11-78. Giotto. *Christ Entering Jerusalem*. 1305–6. Fresco. Arena (Scrovegni) Chapel, Padua, Italy

tend to do so in installments, as it were. Our glance travels from detail to detail until we have surveyed the entire area. Giotto, on the contrary, invites us to see the whole at one glance. His large, simple forms, the strong grouping of his figures, and the limited depth of his "stage" give his scenes an inner coherence never found before. Notice how dramatically the massed verticals of the block of apostles on the left are contrasted with the upward slope formed by the welcoming crowd on the right, and how Jesus, alone in the center, bridges the gulf between the two groups. The more we study the composition, the more we come to realize its majestic firmness and clarity. Thus the artist has rephrased *Christ's Entry into Jerusalem* to stress the solemnity of the event as the triumphal procession of the Prince of Peace.

Giotto's achievement does not fully emerge from any single work. Only if we examine a number of scenes from the Arena Chapel cycle do we see how closely each composition is attuned to the emotional content of the subject. *The Lamentation* (fig. 11-79) was clearly inspired by a Byzantine example similar to the Nerezi fresco (see fig. 8-51), a composition that was soon known in Italy. The differences, however, are as important as the similarities. In its muted expression this *Lamentation* is closer to the Gothic *Death of the Virgin* on Strasbourg Cathedral (see fig. 11-45) than it is to the anguish conveyed so vividly by the Byzantine painter. The tragic mood, found also in religious texts of the era, is brought home to us by the formal rhythm of the design as much as by the gestures and expressions of the participants. [See Primary Sources,

Giotto's aim was not simply to transplant Gothic statuary into painting. By creating a radically new kind of picture space, he had also sharpened his awareness of the picture surface. When we look at a work by Duccio (or its ancient and medieval ancestors), we

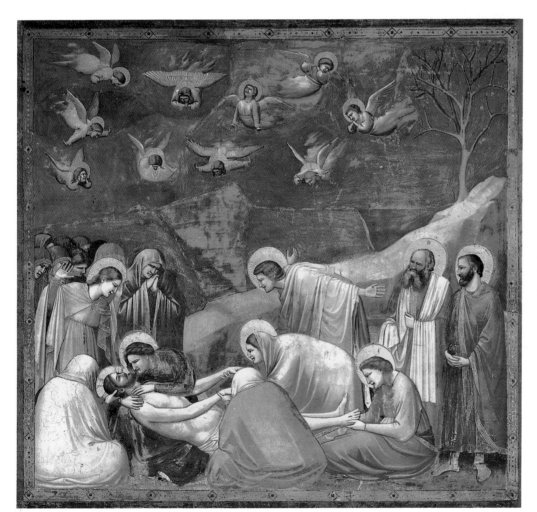

11-79. Giotto. *The Lamentation*. 1305–6. Fresco. Arena (Scrovegni) Chapel

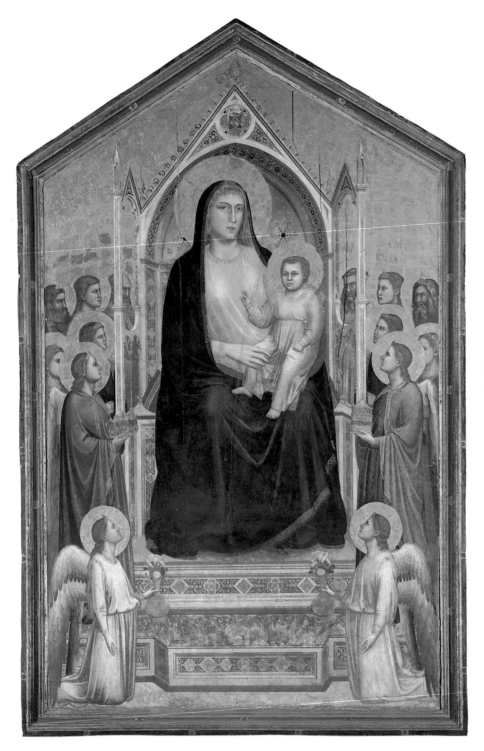

11-80. Giotto. *Madonna Enthroned.*
c. 1310. Tempera on panel,
10'8" x 6'8" (3.3 x 2 m).
Galleria degli Uffizi, Florence

no. 28, page 391.] The low center of gravity and the hunched figures convey the somber quality of the scene and arouse our compassion even before we have grasped the meaning of the event. With extraordinary boldness, Giotto sets off the frozen grief of the human mourners against the frantic movement of the weeping angels among the clouds. It is as if the figures on the ground were restrained by their obligation to maintain the stability of the composition, while the angels, small and weightless as birds, are able to move—and feel—freely.

Once again the impact of the drama is heightened by the simple setting. The descending slope of the hill acts as a unifying element. At the same time, it directs our glance toward the heads of Christ and the Virgin, which are the focal point of the scene. Even the tree has a twin function. Its barrenness and isolation suggest that all of nature shares in the sorrow over the Savior's death. Yet it also carries a more precise symbolic message: it refers (as does Dante in a passage in the *Divine Comedy*) to the Tree of Knowledge, which the sin of Adam and Eve had caused to wither and which was to be restored to life through the sacrificial death of Christ.

What we have said of the Padua frescoes applies equally to the *Madonna Enthroned* (fig. 11-80), the most important of the few panel paintings by Giotto's own hand. Done about the same time as Duccio's *Maestà,* it illustrates the striking differences between Florence and Siena. Its severity is clearly derived from Cimabue

(see fig. 11-72). The figures, however, have the same sense of weight and volume that we saw in the frescoes in the Arena Chapel. Moreover, the picture space is just as persuasive—so much so, in fact, that the halos look like foreign bodies, despite the neutral gold background.

The throne, based on Italian Gothic architecture, has now become a nichelike structure. It encloses the Madonna on three sides and thus "insulates" her from the gold background. Its lavish ornamentation includes one feature of special interest: the colored marble surfaces of the base and of the quatrefoil within the gable. Such make-believe stone textures had been highly developed by ancient painters (see figs. 7-48 and 7-52), but the tradition had died out in Early Christian times. Its sudden reappearance here offers concrete evidence that Giotto was familiar with whatever ancient murals could still be seen in medieval Rome.

SIMONE MARTINI. Few artists in the history of art equal Giotto as an innovator. His greatness, however, tended to dwarf the next generation of Florentine painters. Their contemporaries in Siena were more fortunate, since Duccio never had the same overpowering impact. As a result, it was they, not the Florentines, who took the next major step in developing Italian Gothic painting. The most distinguished of Duccio's disciples was Simone Martini (c. 1284–1344), who spent the last years of his life in Avignon, the town in southern France that served as the residence of the popes during most of the fourteenth century. *The Road to Calvary* (fig. 11-81), originally part of a small altar, was probably done there around 1340, as it was commissioned by Philip the Bold of Burgundy for the Chartreuse de Champmol. The sparkling colors and especially the architectural background still echo the art of Duccio (see fig. 11-75). However, the vigorous modeling of the figures, as well as their dramatic gestures and expressions, show the influence of Giotto. While Simone Martini is little concerned with spatial clarity, he is an acute observer. The sheer variety of costumes and physical types and the wealth of human activity create a sense of down-to-earth reality very different from both the lyricism of Duccio and the grandeur of Giotto.

THE LORENZETTI BROTHERS. This closeness to everyday life can also be seen in the work of the brothers Pietro and Ambrogio Lorenzetti (both died 1348?), but it appears on a more monumental scale and is coupled with a keen interest in space. The boldest spatial experiment is Pietro's *Birth of the Virgin* (fig. 11-82, page 372). In this triptych of 1342, the painted architecture has been related to the real architecture of the frame so closely that the two are seen as a single system. Moreover, the vaulted room where the birth takes place occupies two panels and continues unbroken behind the column that divides the center from the right wing. The left wing represents a small chamber leading to a large interior that suggests a Gothic church.

What Pietro Lorenzetti achieved here is the outcome of a development that began three decades earlier in the work of Duccio (compare fig. 11-74): the conquest of pictorial space. Only now, however, does the painting surface act like a transparent window *through* which—not *on* which—we perceive the same kind of space we know from daily experience. Duccio's work alone does not

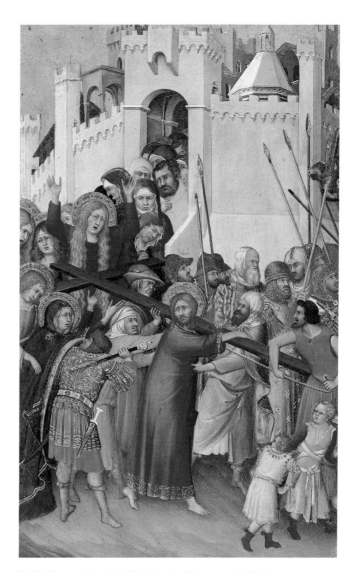

11-81. Simone Martini. *The Road to Calvary.* c. 1340. Tempera on panel, 9 ⅞ x 6 ⅛" (25 x 15.5 cm). Musée du Louvre, Paris

explain Pietro's astonishing breakthrough, however. His achievement became possible through a combination of the *architectural* picture space of Duccio and the *sculptural* picture space of Giotto.

This approach enabled Ambrogio Lorenzetti to unfold a view of the entire town before our eyes in his frescoes of 1338–40 in the Siena city hall (fig. 11-83, page 372). We are struck by the distance that separates this precise "portrait" of Siena from Duccio's Jerusalem (see fig. 11-75). Ambrogio's mural is part of an allegorical program depicting the contrast of good and bad government. For example, the inscription under *Good Government in the City* (fig. 11-84, page 372) praises Justice and the many benefits that derive from her. [See Primary Sources, no. 37, page 394.] To the right on the far wall of figure 11-83, we see the Commune of Siena guided by Faith, Hope, and Charity and flanked by a host of other symbolic figures. To show the life of a well-ordered city-state, the artist had to fill the streets and houses of *Good Government in the City* (fig. 11-84, page 373) with teeming activity. The bustling crowd gives the architectural vista its striking reality by introducing the human scale. On the right, outside the city walls, *Good Government in the Country* provides a view of the Sienese farmland, fringed by distant mountains (fig. 11-85, page 373). It is a true

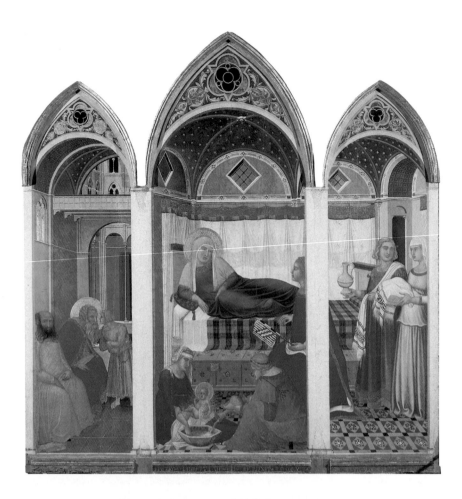

11-82. Pietro Lorenzetti.
Birth of the Virgin. 1342.
Tempera on panel,
6'1½" x 5'11½" (1.9 x 1.8 m).
Museo dell'Opera del Duomo, Siena

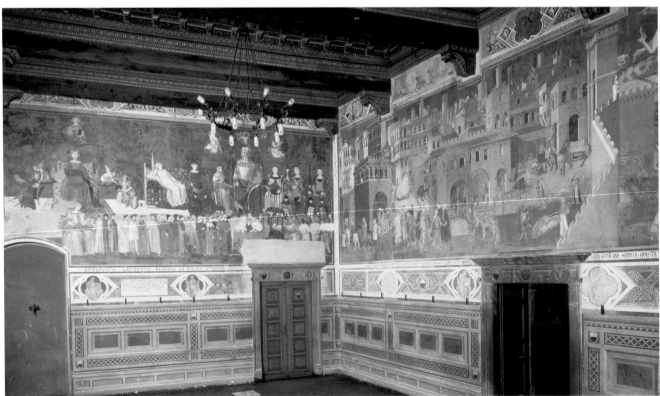

11-83. Ambrogio Lorenzetti. *The Commune of Siena* (left), *Good Government in the City,* and portion of
Good Government in the Country (right). 1338–40. Frescoes in the Sala della Pace, Palazzo Pubblico, Siena

(OPPOSITE ABOVE) 11-84. Ambrogio Lorenzetti. *Good Government in the City*
(OPPOSITE BELOW) 11-85. Ambrogio Lorenzetti. *Good Government in the Country*

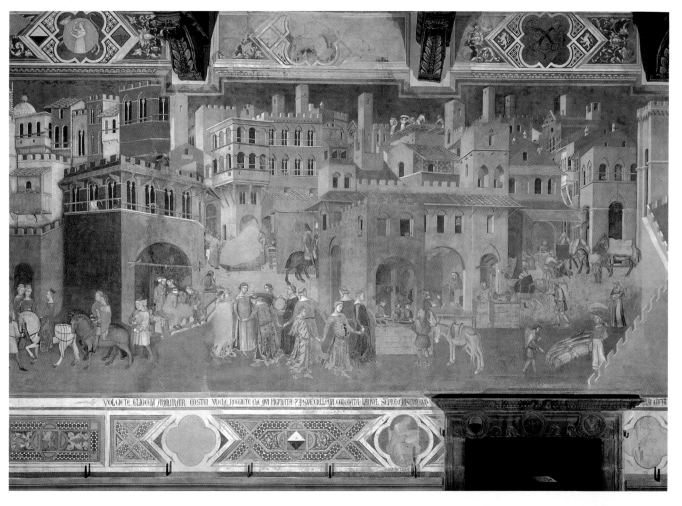

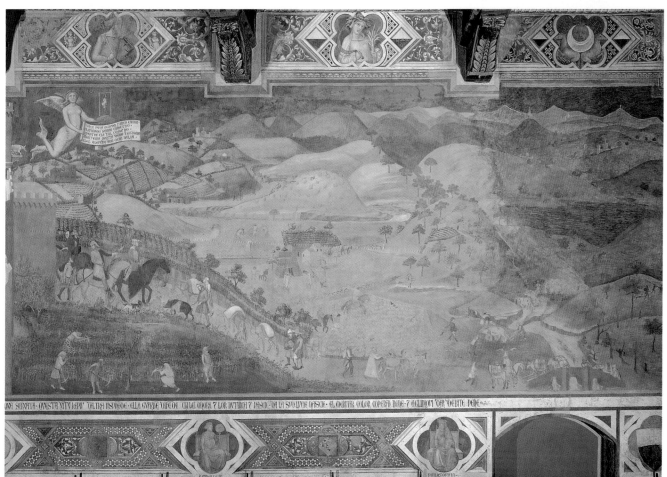

landscape—the first since ancient Roman times. The scene is full of sweeping depth yet differs from classical landscapes (such as fig. 7-49) in its orderliness, which gives it a domesticated air. The people here have taken full possession of nature: they have terraced the hillsides with vineyards and patterned the valleys with the geometry of fields and pastures. Ambrogio observes the peasants at their seasonal labors; his recording of this rural Tuscan scene is so characteristic that it has hardly changed during the past 600 years.

THE BLACK DEATH. The first four decades of the fourteenth century in Florence and Siena had been a period of political stability and economic expansion, as well as of great artistic achievement. In the 1340s, however, both cities suffered a series of catastrophes whose effects were to be felt for many years. Banks and merchants went bankrupt by the score, internal upheavals shook the government, and there were repeated crop failures as the agrarian revolution that had begun three centuries earlier (see pages 294–295) reached its limits and came to an end. Then, in 1348, the epidemic of bubonic plague—the Black Death—that spread throughout Europe wiped out more than half the population of the two cities (including, it seems, Pietro and Ambrogio Loren-

zetti). It was spread by hungry, flea-infested rats that swarmed into cities from the barren countryside in search of food. Popular reactions to these events were mixed. Many people saw them as signs of divine wrath, warnings to a sinful humanity to forsake the pleasures of this earth. In such people the Black Death aroused a mood of otherworldly exaltation. To others, such as the merry company in Boccaccio's *Decameron,* the fear of death intensified the desire to enjoy life while there was still time. [See Primary Sources, no. 38, page 395.] These conflicting attitudes were reflected in the pictorial theme of the Triumph of Death.

FRANCESCO TRAINI. The most impressive version of this subject is an enormous fresco attributed traditionally, if doubtfully, to the Pisan master Francesco Traini (documented c. 1321–1363), in the Camposanto, the cemetery building next to Pisa Cathedral (fig. 11-86). In a particularly dramatic detail at the left, the elegantly costumed men and women on horseback have suddenly come upon three decaying corpses in open coffins. Even the animals are terrified by the sight and smell of rotting flesh. Only the hermit Saint Macarius, having renounced all earthly pleasures, points out the lesson of the scene. His scroll

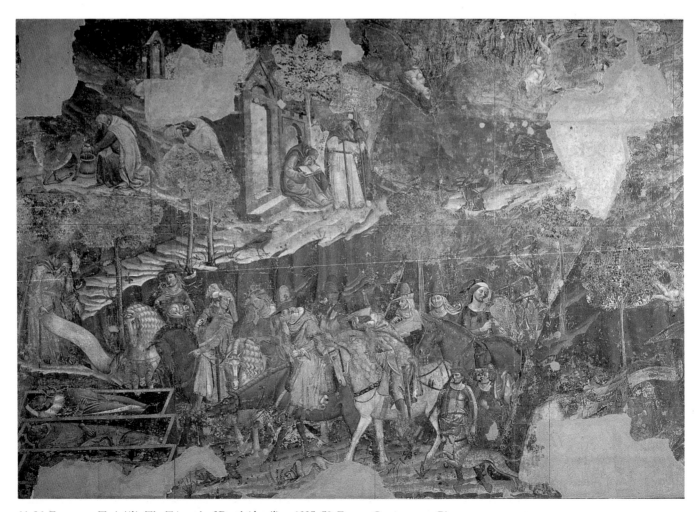

11-86. Francesco Traini(?). *The Triumph of Death* (detail). c. 1325–50. Fresco. Camposanto, Pisa

reads: "If your mind be well aware, keeping here your view attentive, your vainglory will be vanquished and you will see pride eliminated. And, again, you will realize this if you observe that which is written." As the hermits in the hills above make clear, the way to salvation is through renunciation of the world in favor of the spiritual life. But will the living confront their own mortality, or will they, like the characters of Boccaccio, turn away from the shocking spectacle more determined than ever to pursue their hedonistic ways?

In the center lie dead and dying peasants who plead with Death, "the medicine for all pain, come give us our last supper." Further to the right are courtiers in a delightful landscape enjoying earthly pleasures as a female figure of death swoops down and angels and devils fight over the souls of the deceased in the sky overhead. Although the moral is clear, the artist's own sympathies seem curiously divided. His style, far from being otherworldly, recalls the realism of Ambrogio Lorenzetti, although the forms are harsher and more expressive. (The other half of the mural depicts a Last Judgment and vision of purgatory that are the most conventional aspects of the cycle.)

The fresco was badly damaged by fire in 1944 and had to be detached from the wall in order to save what was left of it. This procedure exposed the plaster underneath, on which the composition was sketched out (fig. 11-87). These drawings, of the same size as the fresco itself, are amazingly free. They reveal the artist's personal style more directly than the painted version, which was carried out with the aid of assistants. Because they are done in red, these drawings are called *sinopie* (an Italian word derived from ancient Sinope, in Asia Minor, which was famous as a source of brick-red earth pigment).

11-87. Francesco Traini. Sinopia drawing for *The Triumph of Death* (detail). Camposanto, Pisa

FRESCO PAINTING. Sinopie serve to introduce us to the standard technique of painting frescoes in the fourteenth century. After the first coat of plaster (*arriccio* or *arricciato*) had dried, the wall was divided into squares using a ruler or chalk lines tied to nails. The design was then brushed in with a thin ocher paint, and the outline developed further in charcoal, with the details being added last in sinopia. During the Renaissance, sinopie were replaced by cartoons: sheets of heavy paper or cardboard (*cartone*) on which the design was drawn in the studio. The design was then pricked with small holes and transferred to the wall by dusting ("pouncing") it with chalk. In the High Renaissance, however, the contours were often simply pressed through the paper with a **stylus**. Each section of the wall was covered with just enough fresh plaster (*intonaco*) to last the current session, in order for the water-based paints to sink in. (Some insoluble pigments could only be applied *a secco* to dry plaster.) Since the work had to be done on a scaffold, it was carried out from the top down, usually in horizontal strips about 4 x 6 feet in size. Needless to say, fresco painting was a slow process that required several assistants for large projects.

MASO DI BANCO, TADDEO GADDI. If the artists who reached maturity around 1340 were not as innovative as the earlier painters we have discussed, neither were they blind followers.

At their best, they expressed the somber mood of the time with memorable intensity. The heritage of Giotto can be seen in tombs created about this time for members of the Bardi family in Santa Croce, Florence, by two of his foremost pupils (fig. 11-88). The larger of the two, probably by Maso di Banco (active 1341–1346), shows the dead man rising from his marble tomb to receive a personal Last Judgment from the risen Christ. The scene, with its eerie landscape and majestic Jesus, retains some of Giotto's grandeur without being at all derivative (compare fig. 11-77). The ensemble is among the first to combine painting and sculpture. The result is a mixture of temporal and visionary reality that expresses the hope—indeed, the expectation—of salvation and life after death.

The same theme is repeated in the tomb to the right by Taddeo Gaddi (1295/1300–1366). The deceased is painted on the side of the sarcophagus receiving the body of Jesus above her own sepulcher. The message is clear: by bearing witness to the Entombment, she shall rise again, just as Christ did. This tomb, like the other, incorporates the image, widespread at the time, of Jesus as The Man of Sorrows, whose suffering redeems humanity's sins and offers the promise of eternal life. Despite the debt to Giotto's *Lamentation* (see fig. 11-79), Taddeo has begun to feel the influence of the Lorenzetti, which was soon seen in the work of Maso and other Florentine artists as well.

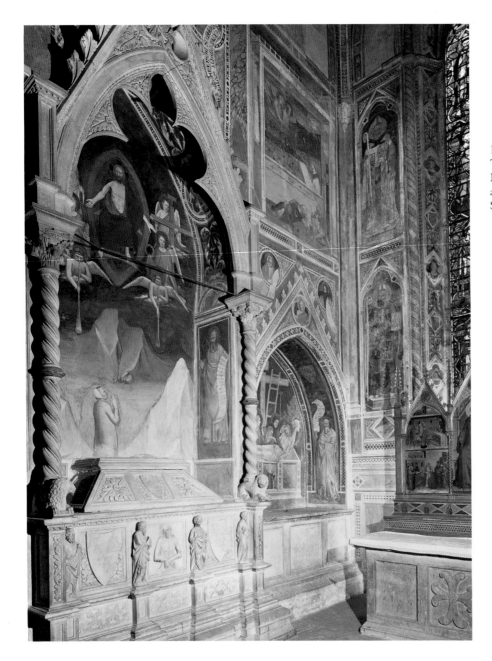

11-88. Maso di Banco (attr.) (left) and Taddeo Gaddi (right). Tombs of Members of the Bardi Family. c. 1335–45 and c. 1335–41. Bardi di Vernio Chapel, S. Croce, Florence

Painting North of the Alps

ILLUMINATED MANUSCRIPTS. What happened to Gothic painting north of the Alps during the second half of the fourteenth century was determined in large part by the influence of the great Italians. Some examples of this influence can be found even earlier, such as in the *Annunciation* in figure 11-89. This scene comes from a private prayer book—called a Book of Hours—illuminated by Jean Pucelle in Paris about 1325–28 for Jeanne d'Evreux, queen of France. The style of the figures recalls Master Honoré (see fig. 11-71), but the delicate *grisaille* (painting in gray) lends them a soft roundness that was not explored by other artists for another 50 years. This is not Pucelle's only contribution: the architectural interior clearly derives from Duccio (see fig. 11-74). It had taken less than 20 years for the fame of the *Maestà* to spread from Tuscany to the Île-de-France.

In taking over the new picture space, however, Jean Pucelle had to adapt it to the special needs of a manuscript page, which lends itself far less readily than a panel to being treated as a window. The Virgin's chamber no longer fills the entire picture surface. It has become an airy cage that floats on the blank background (note the supporting angel on the right), like the rest of the ornamental framework, so that the entire page forms a harmonious unit. Most of the details have nothing to do with the religious purpose of the manuscript. The kneeling queen inside the initial D is surely meant to be Jeanne d'Evreux at her prayers, but who is the man with the staff next to her? He seems to be a court jester listening to the lute player perched on the tendril above him. The page is filled with other enchanting vignettes. A rabbit peers from its burrow beneath the girl on the left, and in the foliage leading up to the initial we find a monkey and a squirrel.

DRÔLERIE. These fanciful marginal designs—or *drôleries*—are a common feature of Northern Gothic manuscripts. They had originated more than a century before Jean Pucelle in the regions

11-89. Jean Pucelle. *The Betrayal of Christ* and *Annunciation,* from the *Hours of Jeanne d'Evreux.* 1325–28.
Tempera and gold leaf on parchment, each page, $3\frac{1}{2} \times 2\frac{7}{16}$" (8.9 x 6.2 cm). Shown larger than actual size.
The Metropolitan Museum of Art, New York

THE CLOISTERS COLLECTION, PURCHASE, 1954

along the English Channel. From there they quickly spread to Paris and the other centers of Gothic art. [See Primary Sources, no. 39, page 395.] Their subjects include a wide range of motifs: fantasy, fable, and grotesque humor, as well as scenes of everyday life, appear side by side with religious themes. The essence of drôlerie is its playfulness. In this special domain the artist enjoys an almost unlimited freedom comparable to the jester's, which accounts for the wide appeal of drôlerie during the later Middle Ages.

The innocence of Pucelle's drôlerie nevertheless hides a serious purpose. The four figures at the bottom of the right-hand page are playing a game of tag called Froggy in the Middle, a reference to the Betrayal of Christ on the opposite page. We recognize this dramatic scene as a descendant of the mosaic in S. Apollinare Nuovo (see fig. 8-18). Below the *Betrayal* are two knights on goats jousting at a barrel. This image not only mocks courtly chivalry but also refers to Christ as a "scapegoat" and to the spear of Longinus that pierced his side at the Crucifixion.

FRESCOES AND PANEL PAINTINGS. In the mid-fourteenth century, Italian influence became widespread in Northern Gothic painting. Sometimes it was transmitted by Italian artists who were active on northern soil, such as Simone Martini, who worked at the palace of the popes near Avignon (see page 371).

One gateway of Italian influence was the city of Prague, the capital of Bohemia, thanks to Emperor Charles IV (1316–1378), the most remarkable ruler since Charlemagne. Charles was educated in Paris at the French court of Charles IV, whose daughter he married and in whose honor he changed his name from Wenceslaus. He returned to Prague and in 1346 succeeded his father as king of Bohemia. As a result of Charles's alliance with Pope Clement VI, who resided at Avignon, Prague became an independent archbishopric. It was also through Clement's intervention that Charles was named Holy Roman Emperor by the German Electors at Aachen in 1349. This title was confirmed by coronations in Milan and Rome six years later. In exchange, Charles later supported Pope Urban V's return to Rome in 1367, which lasted only three years, however.

Like Charlemagne before him, Charles wanted to make his capital a center of learning. In 1348 he established a university along the lines of the one in Paris; it soon attracted many of the best minds from throughout Europe. He also became a patron of the arts and founded an artists guild. As a result, Prague soon became a cultural center second only to Paris itself. Charles was most impressed by the art he saw during his two visits to Italy. (He is known to have commissioned works by several Italian painters.) Thus the *Death of the Virgin*, done by a Bohemian master about

1355–60 (fig. 11-90), brings to mind the works of the great Sienese painters. Its rich color recalls Simone Martini. The carefully defined architectural interior further shows its descent from such works as Pietro Lorenzetti's *Birth of the Virgin* (see fig. 11-82), but it lacks the spaciousness of its Italian models. Also Italian is the vigorous modeling of the heads and the overlapping of the figures, which reinforces the three-dimensional quality of the design but raises the awkward question of what to do with the halos. (Giotto, we will recall, had faced the same problem in his *Madonna Enthroned*; fig. 11-80.) Still, the Bohemian master's picture is not just an echo of Italian painting. The gestures and facial expressions convey an emotional intensity that represents the finest heritage of northern Gothic art. In this respect, our panel is far closer to the *Death of the Virgin* at Strasbourg Cathedral (see fig. 11-45) than to any Italian work.

The International Style

MELCHIOR BROEDERLAM. Around 1400 the merging of Northern and Italian traditions gave rise to a single dominant style throughout western Europe. This International Style was not con-fined to painting—we have used the same term for the sculpture of the period—but painters clearly played the main role in its development. Among the most important was Melchior Broederlam (active c. 1387–1409), a Fleming who worked for the court of the duke of Burgundy in Dijon, where he would have known Simone Martini's *The Road to Calvary* (see fig. 11-81). Figure 11-91 shows a pair of shutters for an altar shrine that Broederlam painted in 1394–99 for the Chartreuse de Champmol. (The interior consists of an elaborately carved relief by Jacques de Baerze showing the Adoration of the Magi, the Crucifixion, and the Entombment.) Each wing is really two pictures within one frame. Landscape and architecture stand abruptly side by side, even though the artist has tried to suggest that the scene extends around the building.

Compared to paintings by Pietro and Ambrogio Lorenzetti, Broederlam's picture space seems naive in many ways. The architecture looks like a doll's house, although it is derived from Duccio and the Lorenzettis (see figs. 11-74 and 11-83), while the details of the landscape, which reminds us of the background in Ghiberti's trial relief (fig. 11-65), are out of scale with the figures. Yet the panels convey a far stronger feeling of depth than we have found in any previous northern work, thanks to the subtlety of the modeling. The softly rounded shapes and the dark, velvety shadows create a sense of light and air that more than makes up for any shortcomings of scale or perspective. This gentle pictorial quality is a hallmark of the International Style. It appears as well in the ample, loosely draped garments, with their fluid curvilinear patterns, which remind us of the sculpture of Sluter and Ghiberti (see figs. 11-56 and 11-65).

Broederlam's panels also show another feature of the International Style: its "realism of particulars." It is the same kind of realism we first saw in Gothic sculpture (see fig. 11-49) and somewhat later among the drôleries in the margins of manuscripts. In the left panel we find it in the carefully rendered foliage and flowers of the enclosed garden to the left, and in the contrast between the Gothic chamber and the Romanesque temple. We see it as well in the right panel: in the delightful donkey (obviously drawn from life), and in the rustic figure of St. Joseph, who looks and behaves like a simple peasant and thus helps to emphasize the delicate, aristocratic beauty of the Virgin. This painstaking detail gives Broederlam's work the flavor of an enlarged miniature rather than of a large-scale painting, even though the panels are more than five feet tall.

The expansion of subject matter during the International Style was linked to a comparable growth in symbolism. In the left panel, for example, the lily signifies Mary's virginity, as does the enclosed garden next to her. The contrasting Romanesque and Gothic architecture stands for the Old and New Testaments respectively. This development paved the way for the elaboration of symbolic meaning 25 years later in works by Robert Campin and Jan van Eyck (see Chapter 15).

JEAN MALOUEL AND HENRI BELLECHOSE. More monumental still is the somewhat later *Martyrdom of St. Denis* (fig. 11-92), also from the Chartreuse de Champmol. It was probably begun by the court painter Jean Malouel (Jan Maelwel; active 1386–1415) and completed after his death by his successor, Henri

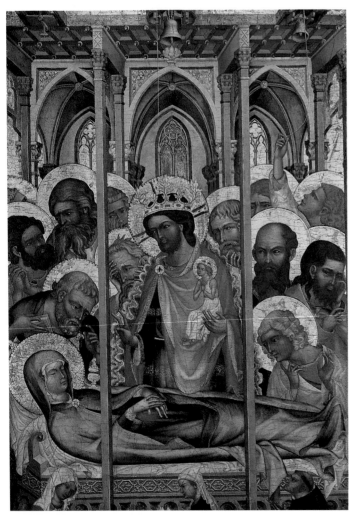

11-90. Bohemian Master. *Death of the Virgin.* 1355–60. Tempera on panel, 39⅜ x 28" (100 x 71 cm). Museum of Fine Arts, Boston

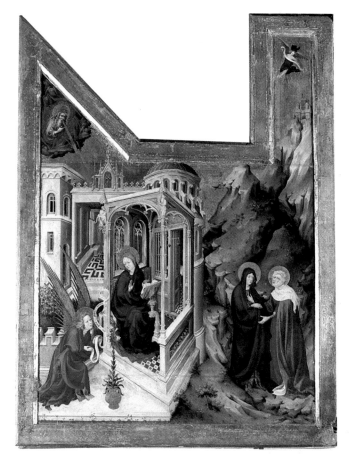

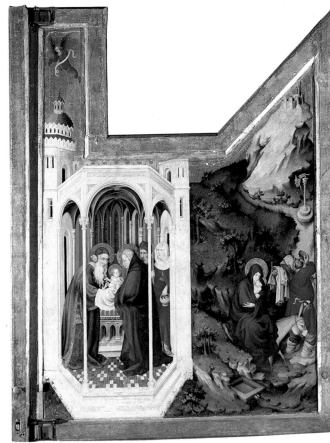

(ABOVE) 11-91. Melchior Broederlam. *Annunciation and Visitation; Presentation in the Temple;* and *Flight into Egypt.* 1394–99. Tempera on panel, each 65 x 49¼" (167 x 125 cm). Musée des Beaux-Arts, Dijon, France

(RIGHT) 11-92. Jean Malouel and Henri Bellechose. *Martyrdom of St. Denis with the Trinity.* c. 1415. Tempera on panel, 5'3⅜" x 6'10⅝" (1.61 x 2.1 m). Musée du Louvre, Paris

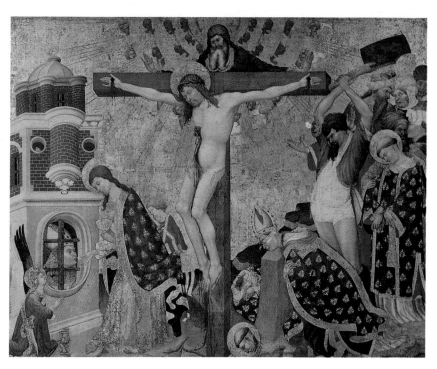

Bellechose (died 1440/44), who also was born in the Netherlands. The subject is unique: it equates the saint's martyrdom with the Crucifixion. At the left, Christ himself administers the last rites to Denis. To the right, we see the decapitation of the saint and his companions. Malouel also worked as an illuminator, but he was clearly a panel painter at heart. Although the diminutive prison is a remnant of manuscript illustrations, the figures combine French gracefulness with an impressive bulk that can have come only

from Italian art (compare fig. 11-86). The more robust figures, such as the executioner, were probably done by Bellechose, although the difference lies more in temperament than in style.

THE BOUCICAUT MASTER. Despite the growing importance of panel painting, book illumination remained the leading form of painting in northern Europe during the era dominated by the International Style. Among the finest of the many manuscript

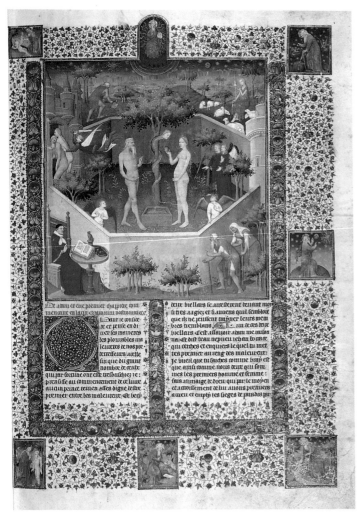

11-93. The Boucicaut Master. *The Story of Adam and Eve,* from Giovanni Boccaccio, *Des cas des nobles hommes et femmes* (The Fates of Illustrious Men and Women). Paris c. 1415. Gold leaf, gold paint, and tempera on vellum, 16¾ x 11½" (42.5 x 29.3 cm). The J. Paul Getty Museum, Los Angeles. Ms. 63, fol. 3

painters employed by the French courts was the Boucicaut Master, who may have been the Bruges artist Jacques Coen. In *The Story of Adam and Eve* (fig. 11-93), landscape and architecture are united in deep, atmospheric space, although the perspective is skewed in order to reveal as much of the scene as possible. Even such intangibles as the starry sky have become paintable. Note, too, how the sky becomes lighter toward the horizon—perhaps the earliest-known example of atmospheric perspective. Every detail, be it divine or natural, is rendered as if it were a miraculous revelation. Stemming from St. Augustine, who considered the temporal world a metaphor of the spiritual realm, this attitude represents a decisive change that soon leads to Late Gothic art (see Chapter 15).

THE LIMBOURG BROTHERS. The International Style reached its height in the luxurious book of hours known as *Les Très Riches Heures du Duc de Berry* (The Very Rich Hours of the Duke of Berry). This volume was produced for the brother of the king of France, a man of far from admirable character but the most lavish art patron of his day. The artists were Pol de Limbourg

and his two brothers, Herman and Jean. (All three died in 1416, most likely of the plague.) These Flemings were introduced to the court by their uncle, Jean Malouel, the painter who had applied the polychromy to Sluter's *The Moses Well* (fig. 11-56). They must have visited Italy, for their work includes numerous motifs and whole compositions borrowed from the great masters of Tuscany.

The most remarkable pages of *Les Très Riches Heures* are devoted to the calendar and depict the life of humanity and nature throughout the year. Such cycles, originally consisting of 12 single figures each performing an appropriate seasonal activity, were an established tradition in medieval art (compare fig. 11-49). Jean Pucelle sometimes enriched the margins of the calendar pages of his books of hours with scenes showing the changing aspects of nature, in addition to the labors of the months. The Limbourg brothers, however, integrated them into a series of panoramas of human life *in* nature.

The illustration for the month of October (fig. 11-94) shows the sowing of winter grain. It is a bright, sunny day, and the figures—for the first time since classical antiquity—cast visible

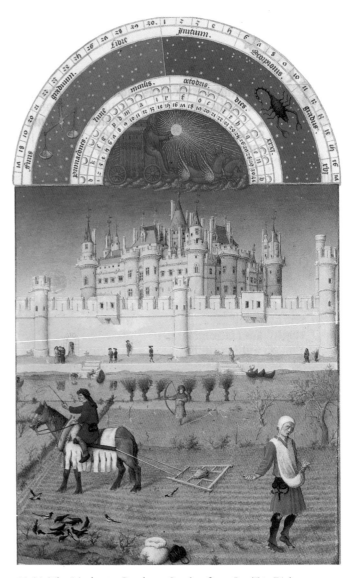

11-94. The Limbourg Brothers. *October,* from *Les Très Riches Heures du Duc de Berry.* 1413–16. 8⅞ x 5⅜" (22.5 x 13.7 cm). Musée Condé, Chantilly, France

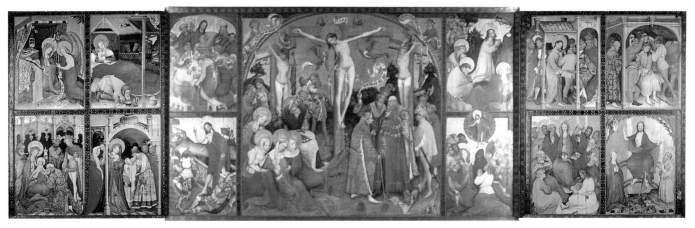

11-95. Konrad von Soest. *The Wildunger Altarpiece.* 1403? Panels, height 6'6¾" (2 m). Church, Bad Wildungen, Germany

shadows on the ground. There is a wealth of realistic detail, such as the scarecrow in the middle distance and the footprints of the sower in the soil of the freshly plowed field. The sower is memorable in many ways. His tattered clothing, his unhappy air, go beyond mere description. Peasants were often caricatured in Gothic art, but the portrayal here is surprisingly sympathetic, as it is throughout this book of hours. The figure is meant to arouse our compassion for the miserable lot of the peasantry in contrast to the life of the aristocracy, symbolized by the castle on the far bank of the river. (The castle, we recall, is a portrait of the Gothic Louvre; see page 337.) Here, then, Gothic art transcends its "realism of particulars" to produce an encompassing vision of life that reflects the Limbourg brothers' knowledge of Italian art, as a glance at Ambrogio Lorenzetti's *Good Government* frescoes attests (see fig. 11-84 and fig. 11-85).

KONRAD VON SOEST. The International Style spread to Germany from France and Bohemia mainly along the Rhine and Danube rivers, until it eventually converged on Cologne and nearby Westphalia. The finest representative of this regional style was Konrad von Soest (active 1394–1422) of Dortmund. His *Wildunger Altarpiece* (fig. 11-95) is a truly international blend of elements drawn from throughout Europe. The *Crucifixion* is descended from Duccio's *Muestà* altar by way of Paris, which accounts for the willowy Christ and delicate Mary. Her grief is sweetly lyrical, in contrast to the despair of St. John behind her. The courtly throng to the left of Christ (the "sinister" side) is patently wicked, and the difference between the two groups could hardly be more telling. The side panels are derived from Bohemian art. Densely packed with figures, they have a drama that is uniquely German but with the refinement typical of the International Style as a whole.

MASTER FRANCKE. This intensely expressive manner culminates in the paintings of Master Francke, a Netherlander who probably worked in Paris and Westphalia before settling in Hamburg as a member of the Dominican order. *Christ Carrying the Cross* (fig. 11-96) on the *Englandfahrer Altarpiece,* completed in

1424, has the physical brutality we saw in the Naumburg Master's *Kiss of Judas* (fig. 11-52). Now it is matched by an expressive violence that makes us feel the full force of Christ's suffering at the hands of the malevolent crowd, with its coarse, leering faces. Not until Hieronymus Bosch nearly a hundred years later will we again encounter such a pervasive sense of evil. Yet in the sorrowful faces to the left we can sense Master Francke's allegiance to the elegant manner of the International Style.

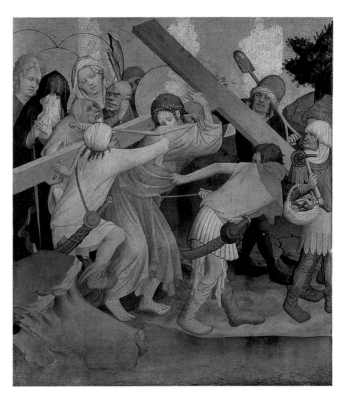

11-96. Master Francke. *Christ Carrying the Cross,* from the *Englandfahrer Altarpiece.* 1424. Panel, 39 x 35" (99 x 88.9 cm). Kunsthalle, Hamburg

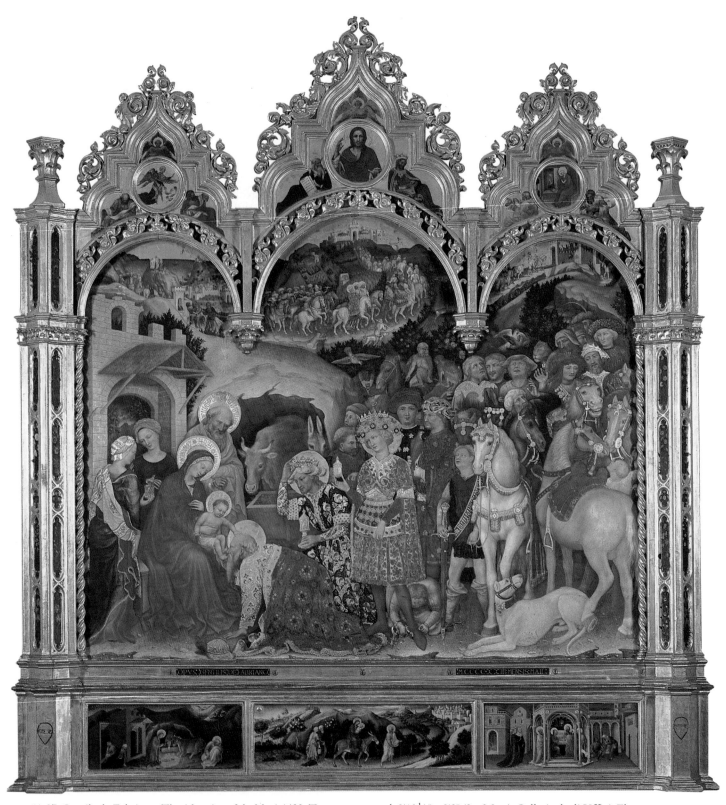

11-97. Gentile da Fabriano. *The Adoration of the Magi*. 1423. Tempera on panel, 9'10⅛" x 9'3" (3 x 2.8 m). Galleria degli Uffizi, Florence

GENTILE DA FABRIANO. Italy was also affected by the International Style, although it gave more than it received. The altarpiece with the three Magi and their train (fig. 11-97) by Gentile da Fabriano (c. 1370–1427), the greatest Italian painter of the International Style, shows that he knew the work of the Limbourg brothers. The costumes here are as colorful, the draperies as ample and softly rounded, as in Northern painting. The Holy Family, on the left, seems almost overwhelmed by the festive

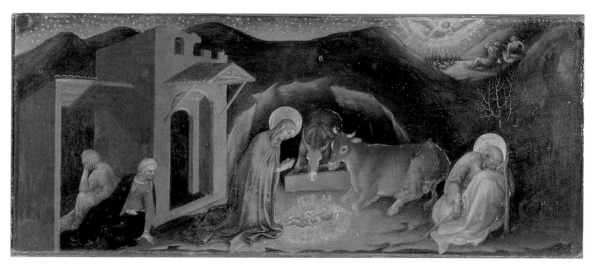

11-98. Gentile da Fabriano. *The Nativity,* from the predella of *The Adoration of the Magi.* 1423. Tempera on panel, 12¼ x 29½" (31 x 75 cm)

pageant. The foreground includes more than a dozen marvelously observed animals, not only the familiar ones but leopards, camels, and monkeys. (Such creatures were eagerly collected by the princes of the period, many of whom kept private zoos.) The Oriental background of the Magi is emphasized by the Mongolian facial cast of some of their companions. It is not these exotic touches, however, that mark this as the work of an Italian master, but something else, a greater sense of weight than we find in Northern painting of the International Style.

Despite his love of detail, Gentile clearly is not a manuscript illuminator but a painter used to working on a large scale. The panels decorating the base, or predella, of the altarpiece have a monumentality that belies their small size. Gentile was thoroughly familiar with Sienese art. Thus the *Flight into Egypt* in the center panel is indebted to Ambrogio Lorenzetti's frescoes in the Siena city hall (see fig. 11-85), while the *Presentation in the Temple* to the right is based on another scene by the same artist. They

nevertheless show that Gentile, too, could achieve the delicate pictorial effects of a miniaturist when he wanted to.

Although he was not the first artist to depict it, the night scene in *The Nativity* in the left panel (fig. 11-98), partly based on the vision received in Bethlehem by the fourteenth-century Swedish princess St. Bridget, has a remarkable poetic intimacy that shows the refinement which characterizes International Style art at its best. The picture reveals the new awareness of light as an independent factor, separate from form and color, that we first saw in the October page of *Les Très Riches Heures*. Even though the main sources of illumination are the divine radiance of the newborn Child ("the light of the world") and the angel bringing the glad tidings to the shepherds in the fields, their effect is as natural as if the Virgin were kneeling by a campfire. (Note the cast shadows.) Yet the artistic possibilities of this new world were not explored fully until two centuries later, and then by Northern, not Italian, artists.

Primary Sources for Part Two

The following is a selection of excerpts, in modern translations, from original texts by poets, historians, religious figures, and artists of the Early Christian and Byzantine eras through the Middle Ages. These readings supplement the main text and are keyed to it. Their full citations are given in the Credits section at the end of the book.

13
The Holy Bible, Exodus 20: 1–5

Exodus, the second book of the Old Testament, is one of five books traditionally attributed to Moses (these five, called the Pentateuch, are the Hebrew Torah). Exodus tells of the departure of the Jews from Egypt in the thirteenth century B.C. In Chapter 20, God speaks to Moses on Mount Sinai and gives him the Ten Commandments. The second commandment pertains to images.

And the Lord spoke all these words: I am the Lord thy God, who brought thee out of the land of Egypt. . . .

Thou shalt not have strange gods before me.

Thou shalt not make to thyself a graven thing, nor the likeness of any thing that is in heaven above, or in the earth beneath, nor of those things that are in the waters under the earth.

Thou shalt not adore them, nor serve them.

14
POPE GREGORY I (ruled 590–604)
From a letter to Serenus of Marseille

Bishop Serenus apparently moved to discourage excessive acts of devotion to paintings in his church by having the images destroyed. In this letter of 600 A.D., Pope Gregory the Great reprimands him, reminding him that images serve to teach those who cannot read. This remained the standard defense of figural painting and sculpture in the Western church throughout the Middle Ages.

Word has . . . reached us that you . . . have broken the images of the saints with the excuse that they should not be adored. And indeed we heartily applaud you for keeping them from being adored, but for breaking them we reproach you. . . . To adore images is one thing; to teach with their help what should be adored is another. What Scripture is to the educated, images are to the ignorant, who see through them what they must accept; they read in them what they cannot read in books. This is especially true of the pagans. And it particularly behooves you, who live among pagans, not to allow yourself to be carried away by just zeal and so give scandal to savage minds. Therefore you ought not to have broken that which was placed in the church not in order to be adored but solely in order to instruct the minds of the ignorant. It is not without reason that tradition permits the deeds of the saints to be depicted in holy places.

15
The Book of the Popes (Liber Pontificalis), from the life of Pope Sylvester I

This text is an official history of the Roman papacy from St. Peter (died c. 64 A.D.) to the twelfth century. Its biographies of the early popes were compiled from archival documents, for example, this list of gifts to Old St. Peter's by the emperor Constantine in the time of Pope Sylvester I (314–335 A.D.). Lavish imperial donations like these set a standard that subsequent popes and other prelates continued to match.

Constantine Augustus built the basilica of blessed Peter, the apostle, . . . and laid there the coffin with the body of the holy Peter; the coffin itself he enclosed on all sides with bronze. . . . Above he set porphyry columns for adornment and other spiral columns which he brought from Greece. He made a vaulted apse in the basilica, gleaming with gold, and over the body of the blessed Peter, above the bronze which enclosed it, he set a cross of purest gold, . . . He gave also 4 brass candlesticks, 10 feet in height, overlaid with silver, with figures in silver of the acts of the apostles, . . . 3 golden chalices, . . . 20 silver chalices, . . . 2 golden pitchers, . . . 5 silver pitchers, . . . a golden paten with a turret of purest gold and a dove, . . . a golden crown before the body, that is a chandelier, with 50 dolphins, . . . 32 silver lamps in the basilica, with dolphins, . . . for the right of the basilica 30 silver lamps, . . . the altar itself of silver overlaid with gold, adorned on every side with gems, 400 in number, . . . a censer of purest gold adorned on every side with jewels.

16
PROCOPIUS OF CAESAREA (6TH CENTURY)
From *Buildings*

Procopius was a historian during the reign of Emperor Justinian. He wrote an entire book (c. 550 A.D.?) about the fortifications, aqueducts, churches, and other public buildings constructed by Justinian throughout the Byzantine Empire. The book begins with the greatest of these, Hagia Sophia (see figs. 8-33–8-35).

The Emperor, disregarding all considerations of expense, . . . raised craftsmen from the whole world. It was Anthemius of Tralles, the most learned man in the discipline called engineering, . . . that ministered to the Emperor's zeal by regulating the work of the builders and preparing in advance designs of what was going to be built. He had as partner another engineer called Isidore, a native of Miletus. . . .

So the church has been made a spectacle of great beauty, stupendous to those who see it and altogether incredible to those who hear of it. . . . It subtly combines its mass with the harmony of its proportions, having neither any excess nor any deficiency, inasmuch as it is more pompous than ordinary [buildings] and considerably more decorous than those which are huge beyond measure; and it abounds exceedingly in gleaming sunlight. You might say that the [interior] space is not illuminated by the sun from the outside, but that the radiance is generated within, so great an abundance of light bathes this shrine all round. . . . In the middle of the church there rise four man-made eminences which are called piers, two on the north and two on the south, . . . each pair having between them exactly four columns. The eminences are built to a great height. . . . As you see them, you could suppose them to be precipitous mountain peaks. Upon these are placed four arches so as to form a square, their ends coming together in pairs and made fast at the summit of those piers, while the rest of them rises to an immense height. Two of the arches, namely those facing the rising and the setting sun, are suspended over empty air, while the others have beneath them some kind of structure and rather tall columns. Above the arches the construction rises in a circle. . . . Rising above this circle is an enormous spherical dome which makes the building exceptionally beautiful. It seems not to be founded on solid masonry, but to be suspended from heaven by that golden chain and so cover the space. All of these elements, marvellously fitted together in mid-air, suspended from one another and reposing only on the parts adjacent to them, produce a unified and most remarkable harmony in the work, and yet do not allow the spectators to rest their gaze upon any one of them for a length of time, but each detail readily draws and attracts the eye to itself. Thus the vision constantly shifts round, and the beholders are quite unable to select any particular element which they might admire more than all the others. No matter how much they concentrate their attention on this side and that, and examine everything with contracted eyebrows, they are unable to understand the craftsmanship and always depart from there amazed by the perplexing spectacle.

17

ST. THEODORE THE STUDITE (759–826 A.D.)
From *Second and Third Refutations of the Iconoclasts*

Theodore of the Stoudios monastery in Constantinople was a principal defender of icons against the Iconoclasts. He refuted their charges of idolatry by examining how an image is and is not identical to its prototype (the per-

son portrayed). Some of his arguments reflect the Neo-Platonic theory expounded by Plotinus that the sense-world is related to the divine by emanation.

The holy Basil [St. Basil the Great, c. 329–379 A.D.] says, "The image of the emperor is also called 'emperor,' yet there are not two emperors, nor is his power divided, nor his glory fragmented. Just as the power and authority which rules over us is one, so also the glorification which we offer is one, and not many. Therefore the honor given to the image passes over to the prototype." . . . In the same way we must say that the icon of Christ is also called "Christ," and there are not two Christs; nor in this case is the power divided, nor the glory fragmented. The honor given the image rightly passes over to the prototype. . . .

Every image has a relation to its archetype; the natural image has a natural relation, while the artificial image has an artificial relation. The natural image is identical both in essence and in likeness with that of which it bears the imprint: thus Christ is identical with His Father in respect to divinity, but identical with His mother in respect to humanity. The artificial image is the same as its archetype in likeness, but different in essence, like Christ and His icon. Therefore there is an artificial image of Christ, to whom the image has its relation. . . .

It is not the essence of the image which we venerate, but the form of the prototype which is stamped upon it, since the essence of the image is not venerable. Neither is it the material which is venerated, but the prototype is venerated together with the form and not the essence of the image. . . .

If every body is inseparably followed by its own shadow, and no one in his right mind could say that a body is shadowless, but rather we can see in the body the shadow which follows, and in the shadow the body which precedes: thus no one could say that Christ is imageless, if indeed He has a body with its characteristic form, but rather we can see in Christ His image existing by implication and in the image Christ plainly visible as its prototype. . . .

By its potential existence even before its artistic production we can always see the image in Christ; just as, for example, we can see the shadow always potentially accompanying the body, even if it is not given form by the radiation of light. In this manner it is not unreasonable to reckon Christ and His image among things which are simultaneous. . . .

If, therefore, Christ cannot exist unless His image exists in potential, and if, before the image is produced artistically, it subsists always in the prototype: then the veneration of Christ is destroyed by anyone who does not admit that His image is also venerated in Him.

18

NICHOLAS MESARITES (c. 1163–AFTER 1214)
From *Description of the Church of the Holy Apostles*

The Church of the Holy Apostles in Constantinople, destroyed in the fifteenth century, was decorated with

mosaics by the artist Eulalios in the twelfth century. The account written by the poet Constantinus Rhodius toward the end of his life is extremely lively, if slightly incomplete. (Certain standard subjects are omitted.) It essentially describes the program of the Twelve Great Feasts found in Middle and Late Byzantine mosaic and mural cycles.

The whole inner space has been covered with a mixture of gold and glass, as much as forms the domed roof and rise above the hollowed arches, down to [the revetment of] multicolored marbles and the second cornice. Represented here are the deeds and venerable forms which narrate the abasement of the Logos [Divine Word, God] and His presence among us mortals.

The first miracle is that of Gabriel bringing to a virgin maiden [the tidings of] the incarnation of the Logos and filling her with divine joy. . . .

The second is that of Bethlehem and the cave, the Virgin's giving birth without pain, the Infant, wrapped in swaddling clothes, reclining—O wonder—in a poor manger, the angels singing divine hymns, . . . the rustic lyre of the shepherds sounding the song of God's nativity.

The third is the Magi hastening from Persia to do homage to the all-pure Logos. . . .

The fourth is Simeon, the old man, bearing the infant Christ in his arms. . . . And that strange old prophetess Anna foretelling for all to hear the deeds which the infant was destined to accomplish [The Presentation in the Temple]. . . .

The fifth is the Baptism received from the hands of John by the stream of Jordan; the Father testifying to the Logos from above, and the Spirit coming down in the guise of a bird. . . .

Sixth, you may see Christ ascending the thrice-glorious mount of Tabor together with a chosen band of disciples and friends, altering His mortal form; His face shining with rays more dazzling than those of the sun, His garments a luminous white [The Transfiguration]. . . .

Next, you may see the widow's son, who had been brought on a bier to his tomb, returning alive and joyful to his house [The Raising of the Widow's Son of Nain]. . . .

Then again, Lazarus, who had been laid in his grave and had rotten four days long . . . leaping out of his tomb like a gazelle and returning once more to mortal life after escaping corruption.

Next, Christ mounted on a colt proceeding to the city of the God-slayers, the crowds, with branches and palm leaves acclaiming Him as the Lord when he arrives at the very gates of Zion. . . .

In addition to all the above wonders, you will see . . . Judas, that wretched man, betraying his Lord and teacher to be murdered . . . by an evil and abominable people. . . .

The seventh [actually, the eleventh] spectacle you will see among all these wonders is Christ's Passion [The Crucifixion]. . . . Christ naked, stretched out on the cross between two condemned criminals, . . . his hands and feet pierced with nails, hanging dead upon the wood of the cross . . . and this in the sight of His mother, the pure Virgin, and the disciple who is present at the Passion [St. Luke]. . . .

LINDISFARNE GOSPELS
Colophon

Colophons are notes written at the end of some manuscripts recording who wrote them, when, for whom, etc. The colophon at the end of the Lindisfarne Gospels *(c. 700 A.D.) was written some 250 years after the text, but most scholars believe that its information is accurate. It names the scribe, the binder, the maker of the metal ornaments on the binding, and the author of the English translation of the Latin text, but no painter. The painting seems to have been done by Eadfrith, the scribe.*

Eadfrith, Bishop of the Lindisfarne Church, originally wrote this book, for God and for Saint Cuthbert and . . . for all the saints whose relics are in the Island. And Ethelwald, Bishop of the Lindisfarne islanders, impressed it on the outside and covered it—as he well knew how to do. And Billfrith, the anchorite, forged the ornaments which are on it on the outside and adorned it with gold and with gems and also with gilded-over silver—pure metal. And Aldred, unworthy and most miserable priest, glossed it in English between the lines with the help of God and Saint Cuthbert. . . .

PS-20. Abbey Church of St.-Riquier (1673 engraving after a 1612 view by Petau, from an 11th-century manuscript illumination)

20
HARIULF (c. 1060–1143)
From *History of the Monastery of St.-Riquier*

Hariulf was a monk at St.-Riquier until 1105, when he became abbot of St. Peter's at Oudenbourg in Belgium.

The church dedicated to the Saviour and St. Richarius . . . was among all other churches of its time the most famous. . . . The eastern tower is close to the sepulchre of St. Richarius. . . . The western tower is especially dedicated to the Saviour. . . .

If one surveys the place, one sees that the largest church, that of St. Richarius, lies to the north. The second, somewhat smaller one, which has been built in honor of our Lady on this side of the river, lies to the south. The third one, the smallest, lies to the east. The cloisters of the monks are laid out in a triangular fashion, one roof extending from St. Richarius' to St. Mary's, one from St. Mary's to St. Benedict's and one from St. Benedict's to St. Richarius'. . . . The monastery is so arranged that, according to the rule laid down by St. Benedict, all arts and all necessary labors can be executed within its walls. The river flows through it, and turns the mill of the brothers.

21
ST. ANGILBERT (c. 750–814)
From *Customary for the Different Devotions*

Angilbert, a member of Charlemagne's court, became lay abbot of St.-Riquier in 781 and sponsored the monastery's rebuilding. His description reveals how the resident monks moved from one part of the basilica to another while chanting the devotions prescribed in The Rule *of St. Benedict.*

When the brethren have sung Vespers and Matins at the altar of the Saviour, then one choir should descend on the side of the holy Resurrection, the other one on the side of the holy Ascension, and having prayed there the processions should in the same fashion as before move singing towards the altars of St. John and St. Martin. After having prayed they should enter from both sides through the arches in the middle of the church and pray at the holy Passion. From there they should go to the altar of St. Richarius. After praying they should divide themselves again as before and go to the altars of St. Stephen and St. Lawrence and from there go singing and praying to the altar of the Holy Cross. Thence they should go again to the altar of St. Maurice and through the long gallery to the church of St. Benedict.

22
ST. BENEDICT OF NURSIA (c. 480–c. 553)
From *The Rule*

Monastic communities generally had a rule, or set of regulations, prescribing the discipline of their members' daily life. The Rule written by St. Benedict for his community at Monte Cassino in southern Italy was admired by Pope Gregory the Great and by Charlemagne, who obtained an exact copy of it when he visited Monte Cassino in 787. The plan of St. Gall was part of a Carolingian effort to impose the Benedictine rule on all monasteries in France and Germany. The Rule requires complete renunciation of the world in order to maintain a routine of collective prayer and chanting seven times a day, about four hours of reading and meditation on the Bible, and some manual labor.

Chapter 16: *The Day Office*

The prophet says: "Seven times daily I have sung Your praises" (Ps. 119:164). We will cleave to this sacred number if we perform our monastic duties at Lauds, Prime, Tierce, Sext, None, Vespers and Compline.

Chapter 17: *The number of psalms said in the Day Office*

Three psalms are to be chanted for Prime, each with a separate Gloria. An appropriate hymn is sung, before the psalms. . . . After the psalms a lesson from the apostle is recited, and the Hour is finished with the versicle, the Kyrie and dismissal. The Hours of Tierce, Sext and None are to be conducted in the same order.

Chapter 22: *How the monks are to sleep*

All the monks shall sleep in separate beds. . . . If possible they should all sleep in one room. However, if there are too many for this, they will be grouped in tens or twenties, a senior in charge of each group. Let a candle burn throughout the night. They will sleep in their robes, belted but with no knives, thus preventing injury in slumber. The monks then will always be prepared to rise at the signal and hurry to the Divine Office. But they must make haste with gravity and modesty.

The younger brothers should not be next to each other. Rather their beds should be interspersed with those of their elders. When they arise for the Divine Office, they ought encourage each other, for the sleepy make many excuses.

Chapter 48: *Daily manual labor*

Idleness is an enemy of the soul. Therefore, the brothers should be occupied according to schedule in either manual labor or holy reading. . . . From Easter to October, the brothers shall work at

manual labor from Prime until the fourth hour. From then until the sixth hour they should read. After dinner they should rest (in bed) in silence. However, should anyone desire to read, he should do so without disturbing his brothers.

None should be chanted at about the middle of the eighth hour. Then everyone shall work as they must until Vespers. If conditions dictate that they labor in the fields (harvesting), they should not be grieved for they are truly monks when they must live by manual labor, as did our fathers and the apostles. Everything should be in moderation, though, for the sake of the timorous. . . .

All shall read on Saturdays except those with specific tasks. If anyone is so slothful that he will not or cannot read or study, he will be assigned work so as not to be idle.

Chapter 53: *The reception of guests*

The kitchen of the abbot and guests should be separate from that of the community so as not to disturb the brothers, for the visitors, of whom there are always a number, come and go at irregular hours. . . .

No one may associate or converse with guests unless ordered. If one meets or sees a guest, he is to greet him with humility . . . and ask a blessing. If the guest speaks, the brother is to pass on, telling the guest that he is not permitted to speak.

Chapter 55: *Clothing and shoes*

Each monk needs only two each of tunics and cowls, so he will be prepared for night wear and washing. Anything else is superfluous and should be banished. . . .

Bedding shall consist of a mattress, coverlet, blanket and pillow. The abbot will make frequent inspections of the bedding to prevent hoarding. Any infractions are subject to the severest discipline and, so that this vice of private ownership may be cut away at the roots, the abbot is to furnish all necessities: cowl, tunic, shoes, stockings, belt, knife, pen, needle, towel and writing tablet.

Chapter 57: *Artisans and craftsmen*

Craftsmen present in the monastery should practice their crafts with humility, as permitted by the abbot. But if anyone becomes proud of his skill and the profit he brings the community, he should be taken from his craft and work at ordinary labor. This will continue until he humbles himself and the abbot is satisfied. If any of the works of these craftsmen are sold, the salesman shall take care to practice no fraud. . . .

In pricing, they should never show greed, but should sell things below the going secular rate.

Chapter 66: *The porter of the monastery*

The monastery should be planned, if possible, with all the necessities—water, mill, garden, shops—within the walls. Thus the monks will not need to wander about outside, for this is not good for their souls.

23

From *Pilgrim's Guide to Santiago de Compostela*

The Pilgrim's Guide, *written in the mid-twelfth century, gives a vivid account of the routes and what was to be met along them by pilgrims to the shrine of the Apostle James in Compostela. Describing Ste.-Madeleine (the church of St. Mary Magdalen) at Vézelay (see fig. 10-26), the* Guide *recounts a medieval legend that Mary Magdalen journeyed to France after Christ's death and died in Aix-en-Provence.*

There are four roads which, leading to Santiago, converge to form a single road at Puente la Reina, in Spanish territory. One crosses Saint-Gilles [see fig. 10-27], Montpellier, Toulouse [see figs. 10-1–10-3] and the pass of Somport; another goes through Notre-Dame of Le Puy, Sainte-Foy of Conques and Saint-Pierre of Moissac [see figs. 10-21 and 10-23]; another traverses Sainte-Marie-Madeleine of Vézelay [see fig. 10-26], Saint Léonard in the Limousin as well as the city of Périgueux; still another cuts through Saint-Martin of Tours, Saint-Hilaire of Poitiers, Saint-Jean-d'Angély, Saint-Eutrope of Saintes and the city of Bordeaux. . . .

One needs three more days of march, for people already tired, to traverse the Landes of the Bordelais.

This is a desolate region deprived of all good: there is here no bread, wine, meat, fish, water or springs; villages are rare here. The sandy and flat land abounds none the less in honey, millet, panic-grass, and wild boars. If perchance you cross it in summertime, guard your face diligently from the enormous flies that greatly abound there and which are called in the vulgar wasps or horse-flies; and if you do not watch your feet carefully, you will rapidly sink up to the knees in the sea-sand copiously found all over.

Having traversed this region, one comes to the land of Gascon rich in white bread and excellent red wine. . . . The Gascons are fast in words, loquacious, given to mockery, libidinous, drunkards, prodigal in food. . . . However, they are well-trained in combat and generous in the hospitality they provide for the poor. . . .

They have the habit of eating without a table and of drinking all of them out of one single cup. In fact, they eat and drink a lot, wear rather poor clothes, and lie down shamelessly on a thin and rotten straw litter, the servants together with the master and the mistress.

On leaving that country, . . . on the road of St. James, there are two rivers. . . . There is no way of crossing them without a raft. May their ferrymen be damned! . . . They have the habit of demanding one coin from each man, whether poor or rich, whom they ferry over, and for a horse they ignominiously extort by force four. . . . When boarding . . . one must be most careful not to fall by chance into the water. . . .

Many times the ferryman, having received his money, has such a large troop of pilgrims enter the boat that it capsizes and the pilgrims drown in the waves. Upon which the boatmen, having laid their hands upon the spoils of the dead, wickedly rejoice.

St. Mary Magdalene

On the route that through Saint-Léonard stretches towards Santiago, the most worthy remains of the Blessed Mary Magdalene must first of all be rightly worshipped by the pilgrims. She is ... that glorious Mary who, in the house of Simon the Leprous, watered with her tears the feet of the Savior, wiped them off with her hair, and anointed them with a precious ointment while kissing them most fervently. . . . It is she who, arriving after the Ascension of the Lord from the region of Jerusalem ... went by sea as far as the country of Provence, namely the port of Marseille.

In that area she led for some years ... a celibate life and, at the end, was given burial in the city of Aix. . . . But, after a long time, a distinguished man called Badilon, beatified in monastic life, transported her most precious earthly remains from that city to Vézelay, where they rest up to this day in a much honored tomb. In this place a large and most beautiful basilica as well as an abbey of monks were established [see fig. 10-26]. Thanks to her love, the faults of the sinners are here remitted by God, vision is restored to the blind, the tongue of the mute is untied, the lame stand erect, the possessed are delivered, and unspeakable benefices are accorded to many. Her sacred feast is celebrated on July 22.

The Stonecutters of the Church [of St. James] and the Beginning and Completion of Their Work

The master stonecutters that first undertook the construction of the basilica of the Blessed James were called Master Bernard the elder—a marvelously gifted craftsman—and Robert, as well as other stonecutters, about fifty in number, who worked assiduously under the most faithful administration of Don Wicart, the head of the chapter Don Segeredo, and the abbot Don Gundesindo, during the reign of Alphonso king of Spain and during the bishopric of Don Diego I, a valiant soldier and a generous man.

The church was begun in the year 1116 of the era. . . . And from the year that the first stone of the foundations was laid down until such a time that the last one was put in place, forty-four years have elapsed.

24
ST. BERNARD OF CLAIRVAUX (1090–1153)
From *Apologia to Abbot William of St.-Thierry*

Bernard of Clairvaux was a member of the Cistercians, an ascetic order founded in the eleventh century in opposition to the increasing opulence of the Benedictines. His letter to the Benedictine abbot William of St.-Thierry of about 1127 denounces all monastic luxury, especially the presence of art in cloisters. Like many others, Bernard believed that monks were spiritually superior to the "carnal" layfolk and so should not need material inducements to devotion.

As a monk, I put to monks the same question that a pagan used to criticize other pagans: "Tell me, priests," he said, "what is gold doing in the holy place?" I, however, say, . . . "Tell me, poor men, if indeed you are poor men, what is gold doing in the holy place?" For certainly bishops have one kind of business, and monks another. We [monks] know that since they [bishops] are responsible for both the wise and the foolish, they stimulate the devotion of a carnal people with material ornaments because they cannot do so with spiritual ones. But we who have withdrawn from the people, we who have left behind all that is precious and beautiful in this world for the sake of Christ, we who regard as dung all things shining in beauty, soothing in sound, agreeable in fragrance, sweet in taste, pleasant in touch—in short, all material pleasures— . . . whose devotion, I ask, do we strive to excite in all this? . . .

Does not avarice . . . cause all this . . . ? Money is sown with such skill that it may be multiplied. . . . The very sight of these costly but wonderful illusions inflames men more to give than to pray. In this way wealth is derived from wealth. . . . Eyes are fixed on relics covered with gold and purses are opened. The thoroughly beautiful image of some male or female saint is exhibited and that saint is believed to be the more holy the more highly colored the image is. People rush to kiss it, they are invited to donate, and they admire the beautiful more than they venerate the sacred. . . . What do you think is being sought in all this? The compunction of penitents, or the astonishment of those who gaze at it? O vanity of vanities . . . ! The Church is radiant in its walls and destitute in its poor. . . . It serves the eyes of the rich at the expense of the poor. The curious find that which may delight them, but those in need do not find that which should sustain them. . . .

But apart from this, in the cloisters, before the eyes of the brothers while they read—what is that ridiculous monstrosity doing, an amazing kind of deformed beauty and yet a beautiful deformity? What are the filthy apes doing there? The fierce lions? The monstrous centaurs? The creatures, part man and part beast? The striped tigers? The fighting soldiers? The hunters blowing horns? You may see many bodies under one head, and conversely many heads on one body. On one side the tail of a serpent is seen on a quadruped, on the other side the head of a quadruped is on the body of a fish. Over there an animal has a horse for the front half and a goat for the back; here a creature which is horned in front is equine behind. In short, everywhere so plentiful and astonishing a variety of contradictory forms is seen that one would rather read in the marble than in books, and spend the whole day wondering at every single one of them than in meditating on the law of God. Good God! If one is not ashamed of the absurdity, why is one not at least troubled at the expense?

25
SUGER OF ST.-DENIS (1081–1151)
From *On the Consecration of the Church of St.-Denis*

Abbot Suger left two accounts of his rebuilding of the Abbey Church of St.-Denis: a booklet that describes

the entire campaign from its conception to the consecration of the new east end on June 11, 1144; and a record of the precious outfittings, including the stained-glass windows, in a review of his accomplishments as abbot. In these excerpts from the first text (1144–47), Suger justifies his enlargement of the Carolingian building with reference to its overcrowding on religious holidays, and he recounts the auspicious discovery of a local quarry and the appearance of the workmen needed to execute his project. After rebuilding the west end of the Carolingian church, he destroyed its eastern apse and built a much larger, more elaborate choir over the old crypt. Suger notes as his principal innovation the radiating chapels filled with stained glass.

Through a fortunate circumstance . . . —the number of the faithful growing and frequently gathering to seek the intercession of the Saints—the [old] basilica had come to suffer grave inconveniences. Often on feast days, completely filled, it disgorged through all its doors the excess of the crowds as they moved in opposite directions, and the outward pressure of the foremost ones not only prevented those attempting to enter from entering but also expelled those who had already entered. At times you could see . . . that no one among the countless thousands of people because of their very density could move a foot; that no one, because of their very congestion, could [do] anything but stand like a marble statue, stay benumbed or, as a last resort, scream. The distress of the women . . . was so great and so intolerable that you could see . . . how they cried out horribly . . . how several of them, . . . lifted by the pious assistance of men above the heads of the crowd, marched forward as though upon a pavement; and how many others, gasping with their last breath, panted in the cloisters of the brethren to the despair of everyone. . . .

Through a gift of God a new quarry, yielding very strong stone, was discovered such as in quality and quantity had never been found in these regions. There arrived a skillful crowd of masons, stonecutters, sculptors and other workmen, so that—thus and otherwise—Divinity relieved us of our fears and favored us with Its goodwill by comforting us and by providing us with unexpected [resources]. I used to compare the least to the greatest: Solomon's riches could not have sufficed for his Temple any more than did ours for this work had not the same Author [God] of the same work abundantly supplied His attendants. The identity of the author and the work provides a sufficiency for the worker. . . .

Upon consideration, then, it was decided to remove that vault, unequal to the higher one, which, overhead, closed the apse containing the bodies of our Patron Saints, all the way [down] to the upper surface of the crypt to which it adhered; so that this crypt might offer its top as a pavement to those approaching by either of the two stairs, and might present the chasses [reliquaries] of the Saints, adorned with gold and precious gems, to the visitors' glances in a more elevated place. Moreover, it was cunningly provided that—through the upper columns and central arches which were to be placed upon the lower ones built in the crypt—the central nave of the old [church] should be equalized, by means of geometrical and arithmetical instruments, with the central nave of the new addition; and, likewise, that the dimensions of the old side-aisles should be equalized with the dimensions of the new side-aisles, except for that elegant and praiseworthy extension, in [the form of] a circular string of chapels, by virtue of which the whole [church] would shine with the wonderful and uninterrupted light of most luminous windows, pervading the interior beauty.

26
SUGER OF ST.-DENIS
From *On What Was Done Under His Administration*

St.-Denis was a Benedictine abbey, though its church was open to layfolk and attracted them in large numbers. The ostentatious embellishment of the church was the type of material display deplored by St. Bernard of Clairvaux. Suger's descriptions of it, recorded between 1144 and 1149, suggest a sensuous love of precious materials, but also a belief that contemplation of these materials could lead the worshiper to a state of heightened spiritual awareness. Like the Byzantine rationale for icons, the notion of "anagogical" transportation to another dimension is indebted to Neoplatonism.

We insisted . . . that the adorable, life-giving cross . . . should be adorned. . . . Therefore we searched around everywhere by ourselves and by our agents for an abundance of precious pearls and gems. . . . One merry but notable miracle which the Lord granted us in this connection we do not wish to pass over. . . . For when I was in difficulty for want of gems and could not sufficiently provide myself with more (for their scarcity makes them very expensive): then, lo and behold, [monks] from three abbeys of two Orders—that is, from Cîteaux and another abbey of the [Cistercian] Order, and from Fontevrault . . . offered us for sale an abundance of gems such as we had not hoped to find in ten years, hyacinths, sapphires, rubies, emeralds, topazes. Their owners had obtained them from Count Thibaut for alms; and he in turn had received them, through the hands of his brother Stephen, King of England [ruled 1135–54], from the treasures of his uncle, the late King [Henry I, ruled 1100–1135], who had amassed them throughout his life in wonderful vessels. We, however, freed from the worry of searching for gems, thanked God and gave four hundred pounds for the lot though they were worth much more. . . .

We hastened to adorn the Main Altar of the blessed Denis where there was only one beautiful and precious frontal panel from Charles the Bald [843–77], the third Emperor; for at this [altar] we had been offered to the monastic life. . . .

The rear panel, of marvelous workmanship and lavish sumptuousness (for the barbarian artists were even more lavish than ours), we ennobled with chased relief work equally admirable for its form as for its material. . . . Much of what had been acquired and more of such ornaments of the church as we were afraid of losing—for instance, a golden chalice that was curtailed of its foot and several other things—we ordered to be fastened there. . . .

Often we contemplate ... these different ornaments both new and old. ... When ... the loveliness of the many-colored gems has called me away from external cares, and worthy meditation has induced me to reflect, transferring that which is material to that which is immaterial, on the diversity of the sacred virtues: then it seems to me that I see myself dwelling, as it were, in some strange region of the universe which neither exists entirely in the slime of the earth nor entirely in the purity of Heaven; and that, by the grace of God, I can be transported from this inferior to that higher world in an anagogical manner. ...

We [also] caused to be painted, by the exquisite hands of many masters from different regions, a splendid variety of new windows. ...

Because [these windows] are very valuable on account of their wonderful execution and the profuse expenditure of painted glass and sapphire glass, we appointed an official master craftsman for their protection and repair.

27
ROBERT DE TORIGNY (d. 1186)
From *Chronicle*

Chartres Cathedral burned twice in the twelfth century, in 1134 and 1194. This contemporary notice of the rebuilding of the west front (see fig. 11-9) in the 1140s stresses the participation of masses of lay volunteers. This kind of piety was later referred to as the "cult of the carts."

In this same year, primarily at Chartres, men began, with their own shoulders, to drag the wagons loaded with stone, wood, grain, and other materials to the workshop of the church, whose towers were then rising. Anyone who has not witnessed this will not see the like in our time. Not only there, but also in nearly the whole of France and Normandy and in many other places, [one saw] everywhere ... penance and the forgiveness of offenses, everywhere mourning and contrition. One might observe women as well as men dragging [wagons] through deep swamps on their knees, beating themselves with whips, numerous wonders occurring everywhere, canticles and hymns being offered to God.

28
From *Meditations on the Life of Christ*

This late-thirteenth-century text, addressed to a Franciscan nun, represents a longstanding tendency to embellish the New Testament account of Christ's life with apocryphal detail. Unlike earlier such embellishments, this one dwells especially on the emotions of the participants in the story. From the twelfth century on, worshipers (especially women) were encouraged to experience Scripture through visualization and emotion rather than

as words alone. In its purpose the Meditations is related to such two- and three-dimensional representations as in figures 11-79 and 11-54.

Attend diligently and carefully to the manner of the Deposition. Two ladders are placed on opposite sides of the cross. Joseph [of Arimathea] ascends the ladder placed on the right side and tries to extract the nail from His hand. But this is difficult ... and it does not seem possible to do it without great pressure on the hand of the Lord. ... The nail pulled out, John makes a sign to Joseph to extend the said nail to him, that the Lady [Virgin Mary] might not see it. Afterwards Nicodemus extracts the other nail from the left hand and similarly gives it to John. Nicodemus descends and comes to the nail in the feet. Joseph supported the body of the Lord: happy indeed is this Joseph, who deserves thus to embrace the body of the Lord! ... The nail in the feet pulled out, Joseph descends part way, and all receive the body of the Lord and place it on the ground. The Lady supports the head and shoulders in her lap, the Magdalen the feet at which she had formerly found so much grace. The others stand about, all making a great bewailing over Him: all most bitterly bewail Him, as for a first-born son.

After some little time, when night approached, Joseph begged the Lady to permit them to shroud Him in linen cloths and bury Him. She strove against this, saying, "My friends, do not wish to take my Son so soon; or else bury me with Him." She wept uncontrollable tears; she looked at the wounds in His hands and side, now one, now the other; she gazed at His face and head and saw the marks of the thorns, the tearing of His beard, His face filthy with spit and blood, His shorn head; and she could not cease from weeping and looking at Him. ... The hour growing late, John said, "Lady, let us bow to Joseph and Nicodemus and allow them to prepare and bury the body of our Lord. ..." She resisted no longer, but blessed Him and permitted Him to be prepared and shrouded. ... The Magdalen ... seemed to faint with sorrow. ... She gazed at the feet, so wounded, pierced, dried out, and bloody: she wept with great bitterness. ... Her heart could hardly remain in her body for sorrow; and it can well be thought that she would gladly have died, if she could, at the feet of the Lord.

29
GIOVANNI PISANO
Inscriptions on the Pulpit in Pisa Cathedral

Giovanni Pisano's pulpit (1302–10) in Pisa Cathedral has two lengthy inscriptions, one of which is visible in figure 11-60. In the first inscription Giovanni praises his own talent; in the second, on the base of the pulpit, he laments that his work is not properly appreciated.

I praise the true God, the creator of all excellent things, who has permitted a man to form figures of such purity. In the year of Our Lord thirteen hundred and eleven the hands of Giovanni, son of

the late Nicola, by their own art alone, carved this work. . . . Giovanni who is endowed above all others with command of the pure art of sculpture, sculpting splendid things in stone, wood and gold . . . would not know how to carve ugly or base things even if he wished to do so. There are many sculptors, but to Giovanni remain the honours of praise. . . .

Giovanni has encircled all the rivers and parts of the world endeavouring to learn much and preparing everything with heavy labour. He now exclaims: 'I have not taken heed. The more I have achieved the more hostile injuries have I experienced. But I bear this pain with indifference and a calm mind.' That I (the monument) may free him from this envy, mitigate his sorrow and win him recognition, add to these verses the moisture (of your tears).

30

DANTE ALIGHIERI (1265–1321)
The Divine Comedy: Paradise, from Canto XVII

When Dante wrote the three books of The Divine Comedy, *he placed many of his contemporaries in Hell, Purgatory, and Paradise. In Paradise he meets his ancestor Cacciaguida, who describes Dante's exile from Florence for political reasons and his protection by Bartolommeo della Scala, father of Can Grande della Scala (see fig. 11-63). Dante stayed at Can Grande's court in Verona from 1314 to 1317.*

"Your first abode, your first refuge, will be the courtesy
 of the great Lombard lord [Bartolommeo della Scala]
 who[se coat of arms] bears the sacred bird [the eagle]
 upon the ladder,

and he will hold you in such high regard
 that in your give and take relationship
 the one will give before the other asks.

With him you shall see one [Can Grande] who at his birth
 was stamped so hard with this star's [Mars'] seal that all
 of his achievements will win great renown.

The world has not yet taken note of him;
 he is still very young, for Heaven's wheels
 have circled round him now for just nine years.

But even before the Gascon [Pope Clement V] tricks proud
 Henry [Emperor Henry VII, ruled 1308–13],
 this one [Can Grande] will show some of his mettle's
 sparks by scorning wealth and making light of toil.

Knowledge of his munificence will yet
 be spread abroad: even his enemies
 will not be able to deny his worth.

Look you to him, expect from him good things.
 Through him the fate of many men shall change,
 rich men and beggars changing their estate.

Now write this in your mind but do not tell
 the world"—and he said things concerning him
 incredible even to those who see

them all come true. . . .

31

DANTE ALIGHIERI
The Divine Comedy: Purgatory, from Canto XI

In the first circle of Purgatory are those guilty of the sin of pride. Dante meets a famous manuscript illuminator who has learned the vanity of pride and the fleeting nature of fame, illustrated by the rapidity with which Giotto eclipsed Cimabue.

"Oh!" I said, "*you* must be that Oderisi,
 honor of Gubbio, honor of the art
 which men in Paris call 'Illuminating.' "

"The pages Franco Bolognese paints,"
 he said, "my brother, smile more radiantly;
 his is the honor now—mine is far less.

Less courteous would I have been to him,
 I must admit, while I was still alive
 and my desire was only to excel.

For pride like that the price is paid up here;
 I would not even be here, were it not
 that, while I still could sin, I turned to God.

Oh, empty glory of all human power!
 How soon the green fades from the topmost bough,
 unless the following season shows no growth!

Once Cimabue thought to hold the field
 as painter; Giotto now is all the rage,
 dimming the lustre of the other's fame."

32

LORENZO GHIBERTI (c. 1381–1455)
The Commentaries, from Book 2

Ghiberti's incomplete Commentaries *is an important early document of art history. The first book consists largely of extracts from Pliny and Vitruvius; the second is about art in Italy in the thirteenth and fourteenth cen-*

turies and ends with an account of Ghiberti's own work (fig. 11-65). Like Giovanni Pisano, Ghiberti was not reluctant to praise himself.

Whereas all gifts of fortune are given and as easily taken back, but disciplines attached to the mind never fail, but remain fixed to the very end, . . . I give greatest and infinite thanks to my parents, who . . . were careful to teach me the art, and the one that cannot be tried without the discipline of letters. . . . Whereas therefore through parents' care and the learning of rules I have gone far in the subject of letters or learning in philology, and love the writing of commentaries, I have furnished my mind with these possessions, of which the final fruit is this, not to need any property or riches, and most of all to desire nothing. . . . I have tried to inquire how nature proceeds . . . and how I can get near her, how things seen reach the eye and how the power of vision works, and how visual [word missing] works, and how visual things move, and how the theory of sculpture and painting ought to be pursued.

In my youth, in the year of Our Lord 1400, I left Florence because of both the bad air and the bad state of the country. . . . My mind was largely directed to painting. . . . Nevertheless . . . I was written to by my friends how the board of the temple of St. John the Baptist was sending for well-versed masters, of whom they wanted to see a test piece. A great many very well qualified masters came through all the lands of Italy to put themselves to this test. . . . Each one was given four bronze plates. As the demonstration, the board of the temple wanted each one to make a scene . . . [of] the sacrifice of Isaac. . . . These tests were to be carried out in a year. . . . The competitors were . . . : Filippo di ser Brunellesco, Simone da Colle, Niccolo D'Arezzo, Jacopo della Quercia from Siena, Francesco da Valdambrino, Nicolo Lamberti. . . . The palm of victory was conceded to me by all the experts and by all those who took the test with me. The glory was conceded to me universally, without exception. Everyone felt I had gone beyond the others in that time, without a single exception, with a great consultation and examination by learned men.

. . . The judges were thirty-four, counting those of the city and the surrounding areas; the endorsement in my favor of the victory was given by all, and by the consuls and board and the whole body of the merchants' guild, which has the temple of St. John the Baptist in its charge. It was . . . determined that I should do this bronze door for this temple, and I executed it with great diligence. And this is the first work; with the frame around it, it added up to about twenty-two thousand florins.

33

LORENZO GHIBERTI
The Commentaries, from Book 2

Ghiberti, and Vasari after him, traced the origins of modern painting to Giotto. Giotto is presented here as a natural genius and hence unfettered by the "Greek manner" of his teacher.

The art of painting began to arise [again] in Etruria. In a village near the city of Florence, called Vespignano, a boy of marvelous genius was born. He was drawing a sheep from life, and the painter Cimabue, passing on the road to Bologna, saw the boy sitting on the ground and drawing a sheep on a flat rock. He was seized with admiration. . . . And seeing he had his skill from nature, he asked the boy what his name was. He answered and said, I am called Giotto by name, my father is called Bondone and lives in this house close by. Cimabue went with Giotto to his father; he made a very fine appearance. He asked the father for the boy; the father was very poor. He handed the boy over to him and Cimabue took Giotto with him and he was Cimabue's pupil. He [Cimabue] used the Greek manner, and in that manner he was very famous in Etruria. And Giotto grew great in the art of painting.

He brought in the new art, . . . and many pupils were taught on the level of the ancient Greeks. Giotto saw in art what no others added. He brought in natural art, and grace with it. . . . He was . . . the inventor and discoverer of much learning that had been buried some six hundred years.

34

THEOPHILUS PRESBYTER
On Divers Arts, from Book II: "The Art of the Worker in Glass"

"Theophilus" may have been the pseudonym of Roger of Helmarshausen, a Benedictine monk and metalworker. Metalwork is the subject of the third book of this treatise, following books on painting and stained glass. Theophilus' text, written in the twelfth century, is the first in the Western tradition to give a practitioner's account of the technology of art production.

Chapter 17: *Laying Out Windows*

When you want to lay out glass windows, first make yourself a smooth flat wooden board. . . . Then take a piece of chalk, scrape it with a knife all over the board, sprinkle water on it everywhere, and rub it all over with a cloth. When it has dried, take the measurements . . . of one section in a window, and draw it on the board with a rule and compasses. . . . Draw as many figures as you wish, first with [a point made of] lead or tin, then with red or black pigment, making all the lines carefully, because, when you have painted the glass, you will have to fit together the shadows and highlights in accordance with [the design on] the board. Then arrange the different kinds of robes and designate the color of each with a mark in its proper place; and indicate the color of anything else you want to paint with a letter.

After this, take a lead pot and in it put chalk ground with water. Make yourself two or three brushes out of hair from the tail of a marten, badger, squirrel, or cat or from the mane of a donkey. Now take a piece of glass of whatever kind you have chosen, but larger on all sides than the place in which it is to be set, and lay it on the ground for that place. Then you will see the drawing on the

board through the intervening glass, and, following it, draw the outlines only on the glass with chalk.

Chapter 18: *Glass Cutting*

Next heat on the fireplace an iron cutting tool, which should be thin everywhere except at the end, where it should be thicker. When the thicker part is red-hot, apply it to the glass that you want to cut, and soon there will appear the beginning of a crack. If the glass is hard [and does not crack at once], wet it with saliva on your finger in the place where you had applied the tool. It will immediately split and, as soon as it has, draw the tool along the line you want to cut and the split will follow.

35

VILLARD DE HONNECOURT (13TH CENTURY)
From *Sketchbook*

The first inscription below addresses the user of Villard's Sketchbook *and suggests what the book might be for. The others appear on the leaves shown in figures 11-68 and 11-69.*

Villard de Honnecourt greets you and begs all who will use the devices found in this book to pray for his soul and remember him. For in this book will be found sound advice on the virtues of masonry and the uses of carpentry. You will also find strong help in drawing figures according to the lessons taught by the art of geometry.

Here is a lion seen from the front. Please remember that he was drawn from life. This is a porcupine, a little beast that shoots its quills when aroused. Here below are the figures of the Wheel of Fortune, all seven of them correctly pictured.

36

AGNOLO DI TURA DEL GRASSO
From *History*

Duccio's Maestà *(figs. 11-73–11-75) stood on the main altar of Siena Cathedral until 1506, when it was removed to the transept. It was sawn apart in 1771, and some panels were acquired subsequently by museums in Europe and the United States. This local history of about 1350 describes the civic celebration that accompanied the installation of the altarpiece in 1311.*

This [the *Maestà*] was painted by master Duccio di Niccolò, painter of Siena, who was in his time the most skillful painter one could find in these lands. The panel was painted outside the Porta a Stalloreggi . . . in the house of the Muciatti. The Sienese took the panel to the cathedral at noontime on the ninth of June [1311], with great devotions and processions, with the bishop of Siena, . . . with all of the clergy of the cathedral, and with all the monks and nuns of Siena, and the Nove, with the city officials, the Podestà and the Captain, and all the citizens with coats of arms and those with more distinguished coats of arms, with lighted lamps in hand. . . . The women and children went through Siena with much devotion and around the Campo in procession, ringing all the bells for joy, and this entire day the shops stayed closed for devotions, and throughout Siena they gave many alms to the poor people, with many speeches and prayers to God and to his mother, Madonna ever Virgin Mary, who helps, preserves and increases in peace the good state of the city of Siena and its territory, . . . and who defends the city from all danger and all evil. And so this panel was placed in the cathedral on the high altar. The panel is painted on the back . . . with the Passion of Jesus Christ, and on the front is the Virgin Mary with her son in her arms and many saints at the side. Everything is ornamented with fine gold; it cost three thousand florins.

37

Inscriptions on the frescoes
in the Palazzo Pubblico, Siena

The first inscription is painted in a strip below the fresco of Good Government *(see figs. 11-83–11-85), which is dated between 1338 and 1340. The second is held by the personification of "Security," who hovers over the landscape in figure 11-84.*

Turn your eyes to behold her,
you who are governing, [Justice] who is portrayed here,
crowned on account of her excellence,
who always renders to everyone his due.
Look how many goods derive from her
and how sweet and peaceful is that life
of the city where is preserved
this virtue who outshines any other.
She guards and defends
those who honor her, and nourishes and feeds them.
From her light is born
Requiting those who do good
and giving due punishment to the wicked.

Without fear every man may travel freely
and each may till and sow,
so long as this commune
shall maintain this lady [Justice] sovereign,
for she has stripped the wicked of all power.

38
GIOVANNI BOCCACCIO (1313–1375)
Decameron, from *The First Day*

The young people who tell the 100 stories of Boccaccio's Decameron *have fled Florence to escape the bubonic plague. At the beginning of the book, Boccaccio describes the horror of the disease and the immensity of the epidemic, as well as the social dissolution it produced.*

The years of the fruitful Incarnation of the Son of God had attained to the number of one thousand three hundred and forty-eight, when into the notable city of Florence, fair over every other of Italy, there came the death-dealing pestilence, . . . through the operation of the heavenly bodies or of our own iniquitous doings, being sent down upon mankind for our correction by the just wrath of God. . . . In men and women alike there appeared, at the beginning of the malady, certain swellings, either on the groin or under the armpits, whereof some waxed to the bigness of a common apple, others to the size of an egg, . . . and these the vulgar named plague-boils. From these two parts the aforesaid death-bearing plague-boils proceeded, in brief space, to appear and come indifferently in every part of the body; wherefrom, after awhile, the fashion of the contagion began to change into black or livid blotches. . . .

Well-nigh all died within the third day from the appearance of the aforesaid signs, this one sooner and that one later, and for the most part without fever or other complication. . . . The mere touching of the clothes or of whatsoever other thing had been touched or used by the sick appeared of itself to communicate the malady to the toucher. . . .

Well-nigh all tended to a very barbarous conclusion, namely, to shun and flee from the sick and all that pertained to them. . . . Some there were who conceived that to live moderately and keep oneself from all excess was the best defense; . . . they lived removed from every other, taking refuge and shutting themselves up in those houses where none were sick and where living was best. . . . Others, inclining to the contrary opinion, maintained that to carouse and make merry and go about singing and frolicking and satisfy the appetite in everything possible and laugh and scoff at whatsoever befell was a very certain remedy for such an ill. . . .

The common people (and also, in great part, . . . the middle class) . . . fell sick by the thousand daily and being altogether untended and unsuccored, died well-nigh all without recourse.

Many breathed their last in the open street, by day and by night, while many others, though they died in their homes, made it known to the neighbors that they were dead rather by the stench of their rotting bodies than otherwise; and of these and others who died all about, the whole city was full. . . . The consecrated ground not sufficing for the burial of the vast multitude of corpses . . . there were made throughout the churchyards, . . . vast trenches, in which those who came . . . were laid by the hundred, . . . being heaped up therein by layers, as goods are stowed aboard ship. . . .

So great was the cruelty of heaven . . . that, between March and the following July, . . . it is believed for certain that upward of a hundred thousand human beings perished within the walls of the city of Florence. . . . Alas, how many great palaces, how many goodly houses, how many noble mansions, once full of families, of lords and of ladies, remained empty even to the meanest servant! How many memorable families, how many ample heritages, how many famous fortunes were seen to remain without lawful heir! How many valiant men, how many fair ladies, how many sprightly youths, . . . breakfasted in the morning with their kinsfolk, comrades and friends and that same night supped with their ancestors in the other world!

39
CHRISTINE DE PIZAN (c. 1363–c. 1430)
From *The Book of the City of Ladies*

Born in Venice but active in Paris and the courts of France, Christine de Pizan was a learned and well-known writer who championed the cause of women. This passage from her history of women (1404–5) mentions a manuscript illuminator who would have been a contemporary of the Limbourg brothers.

Regarding what you say about women expert in the art of painting, I know a woman today, named Anastasia, who is so learned and skilled in painting manuscript borders and miniature backgrounds that one cannot find an artisan in all the city of Paris—where the best in the world are found—who can surpass her, nor who can paint flowers and details as delicately as she does, nor whose work is more highly esteemed, no matter how rich or precious the book is. People cannot stop talking about her. And I know this from experience, for she has executed several things for me which stand out among the ornamental borders of the great masters.

	300–600	600–700	700–750
HISTORY AND POLITICS	**Constantine the Great (ruled 307–37)** reunites Roman Empire, moving capital to Constantinople, formerly Byzantium; 313, proclaims Edict of Milan, allowing religious toleration; c. 312, converts to Christianity. The religion spreads rapidly through the Roman world **410** Sack of Rome by the Visigoth Alaric **451** Attila, leader of the Huns, invades Gaul from eastern Europe and, in 452, Italy **476** Western Roman Empire falls, its territories divided among local rulers **c. 493** Theodoric, Eastern Roman Emperor, establishes Ostrogoth Kingdom in Italy **Justinian, Eastern Roman Emperor (ruled 527–65)** with Empress Theodora. Their reign is marked by peace, legal reforms, and attempts to reunite the Empire **568** Lombard kingdom created in northern Italy	**600–800** Golden Age of Celtic culture **669–90** Theodore of Tarsus begins organization of English rival groups; period of Graeco-Roman cultural revival **697 (traditional)** First doge of Venice elected by governing council	**711–15** Conquest of North Africa and Spain by Muslims; much of the Mediterranean controlled by the Arabs **717** Leo III, Byzantine emperor (ruled 717–41) defeats Arab invaders and establishes a period of peace; 726, his prohibition of images in churches sparks the Iconoclastic Controversy
RELIGION	**395** Christianity becomes official religion of the Roman Empire **432** St. Patrick (died c. 461) founds Celtic church in Ireland **529** St. Benedict (c. 480–c. 553) founds Benedictine monastic order		

> **ICONOCLASM** From the earliest days of Christianity, painted and carved images were used in churches as decorations, representing holy figures, biblical narratives, miracles, and other pious scenes. Such works of art have usually been considered precious and were sometimes venerated as holy themselves; but at some moments in history they have been attacked as idolatrous. In the eighth century the Byzantine emperor Leo III harshly criticized such images, placing himself in opposition to the pope, who declared them sacred. In 726 Leo issued a decree prohibiting images in churches. This touched off a power struggle between the Eastern emperor and the Western papacy. The controversy raised fundamental religious questions regarding the interpretation of the Bible and the divinity of Christ. In the course of it, Leo's followers, called Iconoclasts, destroyed much of the Byzantine art that existed at the time in churches, especially in the East. The Iconoclastic Controversy was no small event: cities revolted; battles were fought; and though the debate over artworks may have mainly been the excuse for a clash of the political forces of church and state, the importance of images—their power to move and stir people—should not be underestimated.
>
> An effect of the ban on pious images was that artistic energies were temporarily channeled into secular and private art—for example, illuminated manuscripts for private use. The debate was settled in favor of holy images in 843. Grand cycles of mosaics like those formerly found in Byzantine churches reappeared slowly, and these displayed a new humanism derived from the secular, classicizing work of the Iconoclastic period.

Virgin and Child Enthroned Between Saints and Angels, Monastery of St. Catherine, Mount Sinai, late 6th century

	300–600	600–700	700–750
MUSIC, LITERATURE, AND PHILOSOPHY	**Ammianus Marcellinus (c. 330–95),** Roman historian **Boethius (c. 480–524),** Roman philosopher whose *Consolation of Philosophy* held the struggle for knowledge to be the highest expression of love of God	**c. 600** Gregorian chants widely used in Catholic Mass **Isidore of Seville (died 636),** encyclopedist **The Venerable Bede (673–735),** English writer and historian, primary member of Theodore of Tarsus' intellectual group	**Early 700s** *Beowulf,* English epic
SCIENCE, TECHNOLOGY, AND EXPLORATION	**c. 410** First records of alchemical experiments, in which science and myth are utilized to try to create gold from metal **c. 550** Procopius of Caesarea writes *Buildings,* on architecture and public works of the Byzantine Empire **c. 600** Chinese invent woodblock printing	**c. 600** Stirrup introduced in western Europe **604** First church bell made in Rome	

750–800	800–850	850–900

756 Pepin the Short, king of the Franks (ruled 747–68), defeats the Lombards in Italy and destroys their kingdom. His gift of conquered central Italian lands to the pope (the Papal States) allows the papacy to be independent and earns France a privileged position

Charlemagne (ruled 768–814), Pepin's successor, establishes control of most of Europe. His organization of European society into semiautonomous regional centers (called marks) becomes the basis for feudal society; 800, crowned Holy Roman Emperor by the pope. Charlemagne's empire is divided after his death into eastern and western Frankish kingdoms (approximately present-day France and Germany)

Irene, first empress of Byzantium (ruled 797–802)

800-900 Invasions by Scandinavian peoples in the North, Muslims in the Mediterranean, and Magyars from the East destabilize much of Europe, which suffers extended warfare
804–800 Vikings invade Ireland and, 856–75, British Isles. By 878, Danes control Scotland

c. 850–900 Angkor Thom, capital of the Khmer people, founded in what is now Cambodia. The moated city covers five square miles and has elaborate temples and palaces
c. 900 Toltec people settle in Mexico; they clash with the Maya in Yucatán

CHARLEMAGNE In the late eighth century, Charlemagne consolidated much of what is now France, Germany, Italy, and the Balkans into a single kingdom, with his court at Aachen in Germany. So much territory in the West had not been under one rule since Roman times. His coronation by the pope in Rome in 800 was clearly understood throughout Europe as a sign of his power and at the same time creating a new interdependence of Church and State. Charlemagne was a great founder of schools, monasteries, and systems of civil administration. In the Carolingian period, named for his dynasty, the arts flourished as they often do in times of relative stability.

St. Angilbert (c. 750–814), monk at Charlemagne's court, rebuilds St.-Riquier Abbey
St. Boniface (died 755) converts Germanic peoples to Christianity
St. Theodore the Studite (759–826) defends use of icons

Crucifixion, bronze plaque from a book cover(?), Ireland, 8th century

Chi-Rho page, from the *Book of Kells,* Ireland, c. 800?

Virgin and Child Enthroned, mosaic, Hagia Sophia, Constantinople, c. 843–67

Lindau Gospels, upper cover of binding, c. 870

Hrabanus Maurus (784–856), German encyclopedist

c. 800 Carolingian schools chartered by Charlemagne, encouraging study of Latin texts
c. 800 First version of *The Thousand and One Nights,* a collection of Arabian stories of the court of Hārūn al-Rashīd

822 Earliest documented church organ, Aachen

c. 850 Horse collar adopted in western Europe for draft work
860 Danish Vikings discover Iceland; c. 866, they attack England; c. 980, they find Greenland

Timeline Two: 300 to 1350

	900–950	950–1000	1000–1050
HISTORY AND POLITICS	**907** In China, the Five Dynasties period sees the land politically divided	**962** Otto I the Great, ruler of Germany (ruled 936–73), defeats Magyar invaders and assumes crown of the Holy Roman Empire **Capetian kings (later, kings of France, 987–1792)** come to power in Frankish Kingdom with Hugh Capet (ruled 987–96)	**1016** Normans arrive in Italy from northern France, establishing a kingdom in the south, 1071, by taking Bari; between 1072 and 1091 they take Sicily, evicting the Arabs who had possessed the island **First kings of Scotland:** Duncan I (ruled 1034–40), murdered by the usurper Macbeth (ruled 1040–57), himself defeated by Malcolm Canmore (ruled 1057–93). Beginning of Anglicization of Scotland **Henry III the Black (ruled 1039–56)** aggressively asserts German imperial authority by personally nominating new popes and mastering the duchies of Poland, Hungary, and Bohemia
RELIGION	**c. 900** Russia converts to Christianity under the Eastern Orthodox church **910** Abbey of Cluny founded in France. Cluniac organization of monasteries and reforming methods spread through Europe	**Bishop Bernward (bishop 993–1022)** makes Hildesheim, in Germany, a cultural and artistic center	

MONASTERIES The great European monastic orders of the Middle Ages were founded during a time of weak governments and economic uncertainty; neither education nor literacy was common. Financed by kings, private patrons, and the papacy, abbeys such as Lindisfarne in England (635), Cluny (910) and Clairvaux (1115) in France, Hildesheim in Germany (1001–33), and Assisi in Italy (1209) were stable, self-contained societies in which strict religious observance was combined with intellectual and artistic experimentation, in a blend peculiar to the Middle Ages. Exempt from taxation, they became wealthy and powerful. Monastic life was dedicated to the furthering of Christian doctrine; this often meant not only pious works but the search for knowledge. Monks copied and wrote books; studied architecture, engineering, mathematics, medicine, and philosophy; painted frescos and panels and illuminated manuscripts.

Interior, Hildesheim Cathedral, 1001–33

The Harbaville Triptych, ivory altar, late 10th century

The Crucifixion, mosaic, Greece, 11th century

MUSIC, LITERATURE, AND PHILOSOPHY			**c. 1000** Ottonian revival in Germany **c. 1000** Development of modern music notation system in Europe **Solomon ibn Gabirol (1020–70),** Jewish poet and philosopher active in Muslim Spain
SCIENCE, TECHNOLOGY, AND EXPLORATION		**Ibn Sînâ (Avicenna) (980–1037?),** Arab physician and interpreter of Aristotle, active in Persia and the Middle East; chief medical authority of the Middle Ages	**c. 1000** Urban development of Europe begins; cities grow steadily in importance and size throughout the Middle Ages. Use of abacus for computation in Europe **1002** Leif Ericson sails to North America and establishes a settlement

1050–1100	1100–1150	1150–1200	
1066 French Normans under William the Conqueror, duke of Normandy, invade England and defeat local forces under King Harold at Battle of Hastings. William crowned king of England **1083** Henry IV, Holy Roman Emperor (ruler of Germany), invades Italy in a dispute with the pope; 1084, Rome sacked by Normans. Ensuing political chaos results in increased power of individual German principates and weakening of papacy **1096** First Crusade, called by Pope Urban II in 1095, to retake the Holy Land from the Muslims for Christianity. A disorganized mass of mostly French, Norman, and Flemish nobles and peasants, 30,000 or more, leaves Europe for Palestine in several waves; an estimated 12,000 are killed in Asia Minor; 1097–99, the crusading force takes Nicaea, Antioch, and Jerusalem, which they sack	**Foundation of the crusading orders of knighthood:** 1113, Knights Hospitalers; 1118, Templars; 1190, Teutonic Knights **1122** Suger becomes abbot of St.-Denis, near Paris, and adviser to kings Louis VI and Louis VII **1147–49** Second Crusade called, urged by the preaching of St. Bernard of Clairvaux; it achieves little. Suger is regent of France	**1171** Salah al-Din (Saladin), ruler of Egypt, dominates Damascus and captures Syria; 1187, he recaptures Jerusalem for Islam **1189–92** Third Crusade, a fruitless attempt to regain Jerusalem, led by Frederick I Barbarossa, Holy Roman Emperor; King Richard I the Lionhearted of England; and King Philip II of France, all of them rivals; the papacy is largely excluded. Project ends with capture of English king Richard I. The crusading armies, unable to oust Saladin from Palestine, conclude a pact with him that permits Christian pilgrims to visit Jerusalem unmolested	**HISTORY AND POLITICS**
1054 Final schism between Eastern (Orthodox) and Western (Catholic) Christian Churches **c. 1115** St. Bernard (1090–1153) heads the ascetic Cistercian order at the abbey of Clairvaux, in northern France			**RELIGION**

SUGER, ST.-DENIS, AND ARCHITECTURAL SYMBOLISM The prelate Suger, made abbot in 1122 of the Abbey Church of St.-Denis, was regent of France while King Louis VII was away on the Second Crusade. As such, his rebuilding of the church, begun c. 1140, was more than a simple architectural project. It set the standard for Gothic churches and is an early example of architecture used to represent political power and a philosophical idea.

The aesthetic design of the building has been attributed to Suger's interest in Scholasticism and Neo-Platonism. Thus the individual parts of the building support the entire structure, much as the individual believer upholds the Christian faith as a whole. St.-Denis was intended to be seen as the Christian universe in microcosm, an architectural experience of beauty through which the visitor comes to an emotional understanding of Christ. Technological innovations allowed the walls to be pierced with large windows that filled the interior with brilliant colored light. In Neo-Platonist terms, the stupendous stained-glass windows of the choir were meant not merely to illuminate the altar but to represent divine light itself, the ineffable spirit of God made visible.

In addition, as depository of holy relics and burial place of the kings of France, the Abbey Church had an important political function. Suger's new design served to glorify the nascent French state and to affirm the role of the monarch as defender of the faith. The building was thus created as a network of religious, aesthetic, and political ideas.

(LEFT) Speyer Cathedral, Germany, begun 1030
(RIGHT) *The Arrest of Christ,* fresco, S. Angelo in Formis, Capua, c. 1085

1050–1100	1100–1150	1150–1200	
c. 1050 *Chanson de Roland,* French epic tale **Hariulf (c. 1060–1143),** a monk at St.-Riquier, author of a history of the monastery **Peter Abelard (1079?–1144),** French Nominalist philosopher at the University of Paris, author of *Sic et Non,* a theological inquiry, and opponent of St. Bernard of Clairvaux	**c. 1100 Chrétien de Troyes,** French poet, writes Arthurian romances **Omar Khayyam (c. 1100),** Persian poet **Early 1100s** Troubadour poetry and music, a courtly, intricate style, often on the theme of love, popular in France and Italy **Ibn Rushd (Averroës) (c. 1126–98),** Spanish Muslim physician and philosopher, author of treatises on Plato and Aristotle	**c. 1160** *Nibelungenlied,* German epic **Nicholas Mesarites (c. 1163–after 1214),** Byzantine chronicler **Late 1100s** *Carmina Burana,* a collection of popular secular poems **Albertus Magnus (1192–1280),** German Scholastic philosopher **Matthew Paris (c. 1200–59),** French historian	**MUSIC, LITERATURE, AND PHILOSOPHY**
1086 Domesday survey in England, first full census of a population, for taxation purposes. Domesday Book, containing collected data, compiled	**1100s** Moorish paper mills in operation; use in Italy of lateen sail for improved sailing; soap in widespread use; Theophilus Presbyter, German scholar, publishes manual on building and decorating a cathedral	**c. 1150** Crossbow, more effective than the standard bow and arrow, in widespread use **c. 1170** Leonardo of Pisa, Italian mathematician, introduces Hindu mathematics, geometry, and algebra **1180–1223** Philip II of France embarks on a rebuilding of Paris. Roads are paved, walls erected, and, c. 1200, the Louvre palace is begun **1193** First merchant guild, England	**SCIENCE, TECHNOLOGY, AND EXPLORATION**

	1200–1225	1225–1250	1250–1275
HISTORY AND POLITICS	**1202–4** Fourth Crusade sets out for Palestine in Venetian ships. Diverted to Christian Constantinople, crusaders sack the city; entire enterprise excommunicated by the pope; 1208–74, numerous other crusades shift possession of lands in the Middle East from one of the Western powers to another and confront the Muslims, who nevertheless hold Jerusalem from 1244 until 1917 **1206–23** Mongol ruler Genghis Khan crosses Asia and Russia, threatening Europe **1215** Magna Carta, a pact between the English monarch and the feudal barons, signed by King John. The document, limiting the absolute powers of the monarchy, is the genesis of a new constitution that places the law over the will of the king, contains new legal, religious, and taxation rights for the individual, including the right to a trial and other reforms, and establishes a parliament	**Louis IX, king of France (St. Louis, ruled 1226–70),** leads Seventh and Eighth Crusades	**1254–73** Period of strife in Germany, with contested claims to the throne of the Holy Roman Empire, confirms fractured nature of individual German states and signals the end of the empire as a political power **By 1263** Papal grant to trade awarded to Teutonic Knights, originally a crusading order of chivalry. The order grows powerful in the absence of any strong monarch and controls much of Prussia, northern Germany, and parts of Lithuania and Poland. Founds numerous independent cities as a mercantile corporation; these later form part of the Hanseatic League of free trading cities of northern Europe **1271–95** The trader Marco Polo travels from Venice to the court of Kublai Khan. His journeys through India, China, Burma, and Persia open the first diplomatic relations between European and Asian nations
RELIGION	**1215** Fourth Lateran Council of bishops, in Rome, establishes major Catholic doctrines: transubstantiation, practice of confession, and worship of relics **1223** St. Francis of Assisi founds Franciscan monastic order, emphasizing poverty	**COURTLY LIFE AND THE INTERNATIONAL STYLE** Intricate miniature illuminations, small personal diptychs, and precious, jeweled objects epitomize one aesthetic thread of the fourteenth century. The small scale and great elegance of these works reflect the rise, particularly in France, of a class of wealthy nobles whose refined taste and habit of traveling required art to be both beautiful and portable. Illuminated books of hours containing daily prayers, calendars, and parts of the Gospels were fashionable items that advertised the owner's wealth, piety, good taste, and connoisseurship. Contemporary with this graceful, decorative style was a parallel new style in literature—secular, romantic, and written in contemporary language, rather than the educated Latin of previous generations; the troubadour poets in Provençal, the *Roman de la Rose* in French, and much of Dante's and Petrarch's poetry in Italian are examples. Poems and paintings alike celebrate the sensual pleasures of the material world.	

Interior, Chartres Cathedral, c. 1194–1220

Notre-Dame, Paris, 1163–c. 1250

	1200–1225	1225–1250	1250–1275
MUSIC, LITERATURE, AND PHILOSOPHY	**1200** Foundation of the University of Paris (called the Sorbonne after 1257); 1209, University of Valencia; 1242, University of Salamanca; these become centers for interchange between Arabs and Christians	**St. Thomas Aquinas (1225–74),** Italian Scholastic philosopher. His *Summa Theologica,* a founding text of Catholic teaching, examines the relationship between faith and intellect, religion and society	**Vincent of Beauvais (died 1264),** French encyclopedist **Dante Alighieri (1265–1321),** author of *The Divine Comedy,* in Tuscan vernacular. The poem is immensely influential for the development of the Italian language **1266–83** *The Golden Legend,* a collection of apocryphal religious stories by the Italian prelate Jacopo da Voragine (c. 1228–98)
SCIENCE, TECHNOLOGY, AND EXPLORATION	**1200s** Use of coal gains over wood fuel; mining begins in Liège, France. Advances in seafaring: sternpost rudder and compass in use in Europe; spinning wheel and gunpowder introduced	**Roger Bacon (died 1292),** English scientist who utilized observation and experiment in studying natural forces	

1289 John of Montecorvino establishes a permanent Christian mission in China
1290 Jews expelled from England; 1306, from France
1295 King Edward I of England institutes the Model Parliament, first bicameral English parliament

1302 First known convocation of French estates-general, parliamentary assembly of the crown, clergy, and commons, to support Philip IV the Fair in his struggle with Pope Boniface VIII over questions of papal authority
1305 Fearing political anarchy and desperate conditions in Rome, Pope Clement V establishes Avignon as the primary residence of the papacy; beginning of the so-called Babylonian Captivity (to 1376)
1310–13 Holy Roman Emperor Henry VII invades Italy to reestablish imperial rule

1325 Foundation of the city of Tenochtitlán by the Aztecs
1338 Hundred Years' War between England and France begins (until 1453)
1347–50 Black Death in Europe. Bubonic plague kills an estimated one-third of population

EUROPE AND THE EAST The relationship of Christian European cultures to non-Christian nations had been alternately cordial and combative since the Muslim conquest of the Mideast and Spain in the eighth century. Arab scholarship and technology were commonly exchanged with those of Europe through trade and travel, and the Crusades did much to increase knowledge of Arab culture in the West, but the regions farther to the East were little known. European contacts with Asia underwent a transformation in the late thirteenth century, after the Venetian trader Marco Polo, traveling to the courts of the Mongol emperor Kublai Kahn, China, India, and Persia, brought back the first accurate account of these places. As understanding of Asia grew, trade routes and trading colonies were established, as well as Christian missions. Lured by the prospect of great profit from trade in silk, exotic spices, and gold, as well as by adventure, merchants began to venture to these previously hostile nations in great numbers. Much of the zeal for the later Crusades has been attributed not only to religious fervor but to the opportunity to open trade routes and mercantile contacts with Eastern countries. The effect on European culture was dramatic. The city of Venice became a thriving center for trade from the East, as did the Spanish coastal cities; these cities became not only mercantile but cultural centers for the exchange of arts and ideas. The influence of Asian taste can be seen in such images as the English heraldic lion, which is thought to derive from a Chinese dragon figure, no doubt woven in a precious silk textile.

JEAN PUCELLE
Illuminated pages from the
Hours of Jeanne d'Evreux,
Paris, 1325–28

c. 1297 Publication of Marco Polo's *Book of Various Experiences*. These enormously popular tales of travels in the Far East fostered a general interest in foreign lands

c. 1300 The *Roman de la Rose*, satire on society written in vernacular French
William of Ockham (c. 1300–49), English Nominalist philosopher, stresses mystical experience over rational understanding
Petrarch (1304–74), Italian humanist scholar and poet
Giovanni Boccaccio (1313–75), Italian author of *The Decameron*, a collection of tales

1325–27 Ibn Batutah (1304–c. 1368), Arab traveler and scholar, visits North Africa, the Mideast, and Persia; 1334, reaches India and later, 1342, China; his memoirs contain commentary on political and social customs
Franco Sacchetti (1332?–1400), Italian poet and author of *Three Hundred Stories*
Geoffrey Chaucer (1340–1400), English diplomat and author of *The Canterbury Tales*

Late 1200s Arabic numerals introduced in Europe
c. 1286 Spectacles invented

Early 1300s Earliest cast iron in Europe; gunpowder first used for launching projectiles

1335–45 Artillery first used on ships
1340 Francesco Pegolotti writes *The Merchant's Handbook*, an Italian manual for traders
1346 Longbow replaces crossbow: at the Battle of Crécy the English use it to defeat the French, including cavalry; greater participation of foot soldiers in warfare follows

HISTORY AND POLITICS

RELIGION

MUSIC, LITERATURE, AND PHILOSOPHY

SCIENCE, TECHNOLOGY, AND EXPLORATION

Books for Further Reading

This list is intended to be as practical as possible. It is therefore limited to books of general interest that were printed over the past 20 years or have been generally available recently. However, certain indispensable volumes that have yet to be superseded are retained. This restriction means omitting numerous classics long out of print, as well as much specialized material of interest to the serious student. The reader is thus referred to the many specialized bibliographies noted below.

REFERENCE RESOURCES IN ART HISTORY

I. ANTHOLOGIES OF SOURCES AND DOCUMENTS

Documents of Modern Art. 14 vols. Wittenborn, New York, 1944–61. A series of specialized anthologies.

The Documents of Twentieth-Century Art. G. K. Hall, Boston. A new series of specialized anthologies, individually listed below.

Goldwater, R., and M. Treves, eds. *Artists on Art, from the Fourteenth to the Twentieth Century.* 3rd ed. Pantheon, New York, 1974.

Holt, E. G., ed. *A Documentary History of Art.* Vol. 1, The Middle Ages and the Renaissance. Vol. 2, Michelangelo and the Mannerists. The Baroque and the Eighteenth Century. Vol. 3, From the Classicists to the Impressionists. 2nd ed. Princeton University Press, Princeton, 1981.

Sources and Documents in the History of Art Series. General ed. H. W. Janson. Prentice Hall, Englewood Cliffs, N.J. Specialized anthologies, individually listed below.

2. BIBLIOGRAPHIES AND RESEARCH GUIDES

Arntzen, E., and R. Rainwater. *Guide to the Literature of Art History.* American Library Association, Chicago, 1980.

Barnet, S. *A Short Guide to Writing About Art.* 7th ed. Longman, New York, 2003.

Chiarmonte, P. *Women Artists in the United States: A Selective Bibliography and Resource Guide to the Fine and Decorative Arts, 1750–1986.* G. K. Hall, Boston, 1990.

Ehresmann, D. *Architecture: A Bibliographical Guide to Basic Reference Works, Histories, and Handbooks.* Libraries Unlimited, Littleton, Colo., 1984.

———. *Fine Arts: A Bibliographical Guide to Basic Reference Works, Histories, and Handbooks.* 3rd ed. Libraries Unlimited, Littleton, Colo., 1990.

Freitag, W. *Art Books: A Basic Bibliography of Monographs on Artists.* 2nd ed. Garland, New York, 1997.

Goldman, B. *Reading and Writing in the Arts: A Handbook.* Wayne State Press, Detroit, 1972.

Kleinbauer, W., and T. Slavens. *Research Guide to Western Art History.* American Library Association, Chicago, 1982.

Reference Publications in Art History. G. K. Hall, Boston. Specialized bibliographies, individually listed below.

3. DICTIONARIES AND ENCYCLOPEDIAS

Baigell, M. *Dictionary of American Art.* Harper & Row, New York, 1979.

Chilvers, I., H. Osborne, and D. Farr eds. *The Oxford Dictionary of Art.* 2nd ed. Oxford University Press, New York, 2001.

The Dictionary of Art. 34 vols. Grove's Dictionaries, New York, 1996.

Duchet-Suchaux, G., and M. Pastoureau. *The Bible and the Saints.* Flammarion Iconographic Guides. Flammarion, Paris and New York, 1994.

Encyclopedia of World Art. 14 vols., with index and supplements. McGraw-Hill, New York, 1959–68.

Fleming, J., and H. Honour. *A Dictionary of Architecture.* 4th ed. Penguin, Baltimore, 1991.

———. *The Penguin Dictionary of Decorative Arts.* New ed. Viking, London, 1989.

Hall, J. *Illustrated Dictionary of Symbols in Eastern and Western Art.* HarperCollins, New York, 1995.

———. *Subjects and Symbols in Art.* 2nd ed. Harper & Row, New York, 1979.

The Hutchinson Dictionary of the Arts. Helicon, London, 1994.

Lever, J., and J. Harris. *Illustrated Dictionary of Architecture, 800–1914.* Faber & Faber, Boston, 1993.

Mayer, R. *The Artist's Handbook of Materials and Techniques.* 5th ed. Viking, New York, 1991.

———. *The HarperCollins Dictionary of Art Terms & Techniques.* 2nd ed. HarperCollins, New York, 1995.

Murray, P. and L. *A Dictionary of Art and Artists.* 7th ed. Penguin, New York, 1998.

Osborne, H., ed. *Oxford Companion to Art.* Oxford, Clarendon Press, 1970.

Pierce, J. S. *From Abacus to Zeus: A Handbook of Art History.* 6th ed. Prentice Hall, Englewood Cliffs, N.J., 2000.

Reid, J. D., ed. *The Oxford Guide to Classical Mythology in the Arts 1300–1990.* 2 vols. Oxford University Press, New York, 1993.

Teague, E. *World Architecture Index: A Guide to Illustrations.* Greenwood Press, New York, 1991.

West, S., ed. *The Bulfinch Guide to Art History.* Little, Brown and Company, Boston, 1996.

The Worldwide Bibliography of Art Exhibition Catalogues, 1963–1987. 3 vols. Kraus, Millwood, N.Y., 1992.

Wright, C., comp. *The World's Master Paintings: From the Early Renaissance to the Present Day: A Comprehensive Listing of Works by 1,300 Painters and a Complete Guide to Their Locations Worldwide.* 2 vols. Routledge, New York, 1991.

4. INDEXES, PRINTED AND ELECTRONIC

ARTbibliographies Modern. 1969 to present. A semi-annual publication indexing and annotating more than 300 art periodicals, as well as books, exhibition catalogues, and dissertations. Data since 1984 also available electronically.

Art Index. 1929 to present. A standard quarterly index to more than 200 art periodicals. Data since 1984 also available electronically.

Avery Index to Architectural Periodicals. 1934 to present. 15 vols., with supplementary vols. G. K. Hall, Boston, 1973. Also available electronically.

BHA: Bibliography of the History of Art. 1991 to present. The merger of two standard indexes: RILA (Répertoire International de la Littérature de l'Art/International Repertory of the Literature of Art, vol. 1, 1975) and Répertoire d'Art et d'Archéologie (vol. 1, 1910).

5. WORLDWIDE WEBSITES

Visit the following Websites for reproductions and information regarding artists, periods, movements, and many more. Also refer to the Art and Architecture Websites directory in this book for museum Websites. Many art history departments and libraries of universities and colleges also maintain a Website where you can get reading lists and links to other Websites, such as museums, libraries, and periodicals.

http://aaln.org/ifla-idal International Directory of Art Libraries
http://www.aimco.org Art Museum Image Consortium
http://www.archaeological.org Archaeological Institute of America
http://archnet.asu.edu/archnet Virtual Library for Archaeology
http://www.artchive.com
http://art-history.concordia.ca/AHRC Art History Research Centre
http://www.arthistory.net Art History Network
http://classics.mit.edu The Internet Classics Archive
http://www.collegeart.org College Art Association
http://www.constable.net
http://www.cr.nps.gov/habshaer Historic American Buildings Survey
http://www.getty.edu Including museum, five institutes, and library
http://www.gold.ac.uk/aah Association of Art Historians
http://www.hart.bbk.ac.uk/VirtualLibrary.html Collection of resources maintained by the History of Art Department of Birkbeck College, University of London
http://www.icom.org International Council of Museums
http://www.icomos.org International Council on Monuments and Sites
http://www.ilpi.com/artsource
http://www.indiana.edu/~aah Association for Art History
http://www.siris.si.edu Smithsonian Institution Research Information System
http://www.umich.edu/~hartspc/histart/mother Mother of All Art History Links Pages, maintained by the Department of the History of Art at the University of Michigan
http://www.unesco.org/whc World Heritage Center
http://www.unites.uqam.ca/AHWA Art History Webmasters Association
http://vos.ucsb.edu Voice of the Shuttle: Art & Art History Page
http://witcombe.sbc.edu/ARTHLinks.html Art History Resources on the Web, maintained by Chris Whitcombe
http://wwar.com World Wide Arts Resources

6. GENERAL SOURCES ON ART HISTORY, METHOD, AND THEORY

Barasch, M. *Theories of Art 1: From Plato to Winckelmann.* Routledge, New York, 2000.

Baxandall, M. *Patterns of Intention: On the Historical Explanation of Pictures.* Yale University Press, New Haven, 1985.

Bois, Y.-A. *Painting as Model.* MIT Press, Cambridge, 1993.

Broude, N., and M. Garrard. *The Expanding Discourse: Feminism and Art History.* Harper & Row, New York, 1992.

————, eds. *Feminism and Art History: Questioning the Litany.* Harper & Row, New York, 1982.

Bryson, N., ed. *Vision and Painting: The Logic of the Gaze.* Yale University Press, New Haven, 1983.

————, et al., eds. *Visual Theory: Painting and Interpretation.* Cambridge University Press, New York, 1991.

Cahn, W. *Masterpieces: Chapters on the History of an Idea.* Princeton University Press, Princeton, 1979.

Chadwick, W. *Women, Art, and Society.* 3rd ed. Thames & Hudson, New York, 2002.

Freedberg, D. *The Power of Images: Studies in the History and Theory of Response.* University of Chicago Press, Chicago, 1989.

Gage, J. *Color and Culture: Practice and Meaning from Antiquity to Abstraction.* University of California Press, Berkeley, 1999.

Gombrich, E. H. *Art and Illusion.* 6th ed. Phaidon, New York, 2002.

Harris, A. S., and L. Nochlin. *Women Artists, 1550–1950.* Random House, New York, 1999.

Kemal, S., and I. Gaskell. *The Language of Art History.* Cambridge Studies in Philosophy and the Arts. Cambridge University Press, New York, 1991.

Kleinbauer, W. E. *Modern Perspectives in Western Art History: An Anthology of Twentieth-Century Writings on the Visual Arts.* Reprint of 1971 ed., University of Toronto Press, Toronto, 1989.

Kostof, S. A. *History of Architecture: Settings and Rituals.* 2nd ed. Oxford University Press, New York, 1995.

Kris, E., and O. Kurz. *Legend, Myth, and Magic in the Image of the Artist: A Historical Experiment.* Yale University Press, New Haven, 1979.

Kruft, H-W. *A History of Architectural Theory from Vitruvius to the Present.* Princeton Architectural Press, Princeton, 1994.

Kultermann, U. *The History of Art History.* Abaris Books, New York, 1993.

Nochlin, L. *Women, Art, and Power, and Other Essays.* HarperCollins, New York, 1989.

Panofsky, E. *Meaning in the Visual Arts.* Reprint of 1955 ed., University of Chicago Press, Chicago, 1982.

————. *Tomb Sculpture: Four Lectures on Its Changing Aspects from Ancient Egypt to Bernini.* Introduction by M. Kemp. Harry N. Abrams, New York, 1992.

Parker, R., and G. Pollock. *Old Mistresses: Women, Art, and Ideology.* Pantheon, New York, 1981.

Penny, N. *The Materials of Sculpture.* Yale University Press, New Haven, 1993.

Pevsner, N. *A History of Building Types.* Princeton University Press, Princeton, 1976.

Podro, M. *The Critical Historians of Art.* Yale University Press, New Haven, 1982.

Pollock, G. *Vision and Difference: Femininity, Feminism, and the Histories of Art.* Routledge, New York, 1988.

Rees, A. L., and F. Borzello. *The New Art History.* Humanities Press International, Atlantic Highlands, N.J., 1986.

Roth, L. *Understanding Architecture: Its Elements, History, and Meaning.* Harper & Row, New York, 1993.

Sutton, I. *Western Architecture.* Thames & Hudson, New York, 1999.

Tagg, J. *Grounds of Dispute: Art History, Cultural Politics, and the Discursive Field.* University of Minnesota Press, Minneapolis, 1992.

Trachtenberg, M., and I. Hyman. *Architecture: From Prehistory to Post-Modernism.* 2nd ed. Harry N. Abrams, New York, 2002.

Watkin, D. *The Rise of Architectural History.* University of Chicago Press, Chicago, 1980.

Wittkower, R., and M. *Born Under Saturn: The Character and Conduct of Artists: A Documented History from Antiquity to the French Revolution.* Norton, New York, 1963.

Wolff, J. *The Social Production of Art.* 2nd ed. New York University Press, New York, 1993.

Wölfflin, H. *Principles of Art History: The Problem of the Development of Style in Later Art.* Dover, New York, 1932.

Wollheim, R. *Art and Its Objects.* 2nd ed. Cambridge University Press, New York, 1992.

PART ONE: THE ANCIENT WORLD

GENERAL REFERENCES

Groenewegen-Frankfort, H. A., and B. Ashmole. *Art of the Ancient World: Painting, Pottery, Sculpture, Architecture from Egypt, Mesopotamia, Crete, Greece, and Rome.* Harry N. Abrams, New York, 1975.

Van Keuren, F. *Guide to Research in Classical Art and Mythology.* American Library Association, Chicago, 1991.

Wolf, W. *The Origins of Western Art: Egypt, Mesopotamia, the Aegean.* Universe Books, New York, 1989.

CHAPTER 1. PREHISTORIC ART

Chauvet, J.-M., É. B. Deschamps, and C. Hilaire. *Dawn of Art: The Chauvet Cave.* Harry N. Abrams, New York, 1995.

Fowler, P. *Images of Prehistory.* Cambridge University Press, New York, 1990.

Leroi-Gourhan, A. *The Dawn of European Art: An Introduction to Palaeolithic Cave Painting.* Cambridge University Press, New York, 1982.

Powell, T. G. E. *Prehistoric Art.* The World of Art. Oxford University Press, New York, 1966.

Ruspoli, M. *The Cave of Lascaux: The Final Photographs.* Harry N. Abrams, New York, 1987.

Sandars, N. *Prehistoric Art in Europe.* 2nd ed. Yale University Press, New Haven, 1992.

Twohig, E. S. *The Megalithic Art of Western Europe.* Oxford University Press, New York, 1981.

CHAPTER 2. EGYPTIAN ART

Aldred, C. *The Development of Ancient Egyptian Art, from 3200 to 1315 B.C.* 3 vols. in 1. Academy Editions, London, 1972.

Arnold, D., and C. Ziegler. *Egyptian Art in the Age of the Pyramids.* Harry N. Abrams, New York, 1999.

Davis, W. *The Canonical Tradition in Ancient Egyptian Art.* Cambridge University Press, New York, 1989.

Edwards, I. E. S. *The Pyramids of Egypt.* Rev. ed. Penguin, Harmondsworth, England, 1991.

Grimal, N. *A History of Ancient Egypt.* Blackwell, London, 1992.

Mahdy, C., ed. *The World of the Pharaohs: A Complete Guide to Ancient Egypt.* Thames & Hudson, London, 1990.

Malek, J. *Egyptian Art.* Phaidon, London, 1999.

Mendelssohn, K. *The Riddle of the Pyramids.* Thames & Hudson, New York, 1986.

Robins, G. *The Art of Ancient Egypt.* Harvard University Press, Cambridge, 1997.

Schaefer, H. *Principles of Egyptian Art.* Clarendon Press, Oxford, 1986.

Schulz, R., and M. Seidel. *Egypt: The World of the Pharaohs.* Könemann, Cologne, 1998.

Smith, W., and W. Simpson. *The Art and Architecture of Ancient Egypt.* Pelican History of Art. Rev. ed. Yale University Press, New Haven, 1999.

Wilkinson, R. *Reading Egyptian Art: A Hieroglyphic Guide to Ancient Egyptian Painting and Sculpture.* Thames & Hudson, New York, 1992.

CHAPTER 3. ANCIENT NEAR EASTERN ART

Amiet, P. *Art of the Ancient Near East.* Harry N. Abrams, New York, 1980.

Collon, D. *Ancient Near Eastern Art.* University of California Press, Berkeley, 1995.

————. *First Impressions: Cylinder Seals in the Ancient Near East.* University of Chicago Press, Chicago, 1987.

Crawford, H. *Sumer and the Sumerians.* Cambridge University Press, New York, 1991.

Frankfort, H. *The Art and Architecture of the Ancient Orient.* Pelican History of Art. 5th ed. Yale University Press, New Haven, 1997.

Leick, G. *A Dictionary of Ancient Near Eastern Architecture.* Routledge, New York, 1988.

Lloyd, S. *The Archaeology of Mesopotamia: From the Old Stone Age to the Persian Conquest.* Rev. ed. Thames & Hudson, New York, 1984.

Moscati, S. *The Phoenicians.* Abbeville Press, New York, 1988.

Oates, J. *Babylon.* Rev. ed. Thames & Hudson, London, 1986.

Parrot, A. *Sumer: The Dawn of Art.* Golden Press, New York, 1961.

Reade, J. *Mesopotamia.* British Museum, London, 1991.

CHAPTER 4. AEGEAN ART

Barber, R. *The Cyclades in the Bronze Age.* University of Iowa Press, Iowa City, 1987.

Getz-Preziosi, P. *Sculptors of the Cyclades.* University of Michigan Press, Ann Arbor, 1987.

Graham, J. *The Palaces of Crete.* Rev. ed. Princeton University Press, Princeton, 1987.

Hampe, R., and E. Simon. *The Birth of Greek Art from the Mycenean to the Archaic Period.* Oxford University Press, New York, 1981.

Higgins, R. *Minoan and Mycenaean Art.* The World of Art. Rev. ed. Oxford University Press, New York, 1981.

Hood, S. *The Arts in Prehistoric Greece.* Pelican History of Art. Yale University Press, New Haven, 1992.

————. *The Minoans: The Story of Bronze Age Crete.* Praeger, New York, 1981.

Hurwit, J. *The Art and Culture of Early Greece, 1100–480 B.C.* Cornell University Press, Ithaca, 1985.

McDonald, W. *Progress into the Past: The Rediscovery of Mycenaean Civilization.* 2nd ed. Indiana University Press, Bloomington, 1990.

Vermeule, E. *Greece in the Bronze Age.* University of Chicago Press, Chicago, 1972.

CHAPTER 5. GREEK ART

Beazley, J. D. *Athenian Red Figure Vases: The Classical Period: A Handbook.* The World of Art. Thames & Hudson, New York, 1989.

————. *Athenian Red Figure Vases: The Archaic Period: A Handbook.* The World of Art. Thames & Hudson, New York, 1991.

————. *Attic Black-Figure Vase-Painters.* Reprint of 1956 ed., Hacker, New York, 1978.

————. *The Development of Attic Black-Figure.* Rev. ed. University of California Press, Berkeley, 1986.

Boardman, J. *Athenian Black Figure Vases: A Handbook.* Thames & Hudson, New York, 1985.

————. *Greek Sculpture: The Archaic Period: A Handbook.* The World of Art. New ed. Thames & Hudson, New York, 1985.

———. *Greek Sculpture: The Classical Period:
A Handbook.* The World of Art. New ed.
Thames & Hudson, New York, 1985.
———, ed. *The Oxford History of Classical Art.*
Oxford University Press, New York, 2001.
Carpenter, T. H. *Art and Myth in Ancient Greece:
A Handbook.* The World of Art.
Thames & Hudson, New York, 1991.
Lawrence, A. *Greek Architecture.* Pelican History of Art.
5th ed., rev. Yale University Press, New Haven,
1996.
Moon, W., ed. *Ancient Greek Art and Iconography.*
University of Wisconsin Press, Madison, 1983.
Osborne, R. *Archaic and Classical Greek Art.* Oxford
University Press, New York, 1998.
Papaioannou, K. *The Art of Greece.* Harry N. Abrams,
New York, 1989.
Pedley, J. *Greek Art and Archaeology.* 2nd ed.
Harry N. Abrams, New York, 1997.
Pollitt, J. *The Ancient View of Greek Art: Criticism,
History, and Terminology.* Yale University Press,
New Haven, 1974.
———. *Art and Experience in Classical Greece.*
Cambridge University Press, New York, 1972.
———. *Art in the Hellenistic Age.* Cambridge University
Press, New York, 1986.
———, ed. *Art of Greece, 1400–31 B.C.: Sources and
Documents.* 2nd ed. Prentice Hall, Englewood
Cliffs, N.J., 1990.
Richter, G. M. A. *A Handbook of Greek Art.* 9th ed.
Da Capo, New York, 1987.
———. *Portraits of the Greeks.* Ed. R. Smith.
Oxford University Press, New York, 1984.
———. *The Sculpture and Sculptors of the Greeks.* 4th
ed., rev. Yale University Press, New Haven, 1970.
Ridgway, B. S. *Hellenistic Sculpture.* Vol. 1, *The Styles
of ca. 331–200 B.C.* Bristol Classical Press, Bristol,
England, 1990.
Robertson, M. *The Art of Vase Painting in Classical Athens.*
Cambridge University Press, New York, 1992.
———. *History of Greek Art.* 2 vols. Cambridge
University Press, Cambridge, 1975.
Schefold, K. *Gods and Heroes in Late Archaic Greek Art.*
Cambridge University Press, New York, 1992.
———. *Myth and Legend in Early Greek Art.*
Harry N. Abrams, New York, 1966.
Smith, R. *Hellenistic Sculpture.* The World of Art.
Thames & Hudson, New York, 1991.
Spivey, N. *Greek Art.* Phaidon, London, 1997.
Stewart, A. F. *Greek Sculpture: An Exploration.*
Yale University Press, New Haven, 1990.

CHAPTER 6. ETRUSCAN ART

Boethius, A. *Etruscan and Early Roman Architecture.*
Pelican History of Art. 2nd ed. Yale University
Press, New Haven, 1992.
Bonfante, L., ed. *Etruscan Life and Afterlife: A Handbook
of Etruscan Studies.* Wayne State University Press,
Detroit, 1986.
Brendel, O. *Etruscan Art.* Pelican History of Art.
Yale University Press, New Haven, 1995.
Haynes, Sybille. *Etruscan Civilization: A Cultural History.*
The J. Paul Getty Museum, Los Angeles, 2000.
Richardson, E. *The Etruscans: Their Art and Civilization.*
Reprint of 1964 ed., with corrections, University
of Chicago Press, Chicago, 1976.
Spivey, N. *Etruscan Art.* The World of Art.
Thames & Hudson, New York, 1997.
Sprenger, M., G. Bartoloni, and M. Hirmer.
The Etruscans: Their History, Art, and Architecture.
Harry N. Abrams, New York, 1983.
Steingräber, S., ed. *Etruscan Painting: Catalogue Raisonné
of Etruscan Wall Paintings.* Johnson Reprint,
New York, 1986.

CHAPTER 7. ROMAN ART

Andreae, B. *The Art of Rome.* Harry N. Abrams,
New York, 1977.
Brilliant, R. *Roman Art from the Republic to Constantine.*
Phaidon, London, 1974.
Jenkyns, R., ed. *The Legacy of Rome: A New Appraisal.*
Oxford University Press, New York, 1992.
Kleiner, D. *Roman Sculpture.* Yale University Press,
New Haven, 1992.
Ling, R. *Roman Painting.* Cambridge University Press,
New York, 1991.
L'Orange, H. *Art Forms and Civic Life in the Late Roman
Empire.* Princeton University Press, Princeton, 1965.
Macdonald, W. *The Architecture of the Roman Empire.*
2 vols. Rev. ed. Yale University Press, New Haven,
1982–86.
Nash, E. *Pictorial Dictionary of Ancient Rome.* 2 vols.
Reprint of 1968 2nd ed., Hacker, New York, 1981.
Pollitt, J. *The Art of Rome and Late Antiquity: Sources and
Documents.* Prentice Hall, Englewood Cliffs, N.J.,
1966.
Ramage, N. and A. *The Cambridge Illustrated History
of Roman Art.* Cambridge University Press,
Cambridge, 1991.
Strong, D. E. *Roman Art.* Pelican History of Art. 2nd ed.
Yale University Press, New Haven, 1992.
Vitruvius. *The Ten Books on Architecture.* Trans. I.
Rowland. Cambridge University Press,
Cambridge, 1999.
Ward-Perkins, J. B. *Roman Imperial Architecture.*
Pelican History of Art. Reprint of 1981 ed.,
Penguin, New York, 1992.
Zanker, P. *The Power of Images in the Age of Augustus.*
University of Michigan Press, Ann Arbor, 1988.

PART TWO: THE MIDDLE AGES

GENERAL REFERENCES

Alexander, J. J. G. *Medieval Illuminators and Their
Methods of Work.* Yale University Press, New
Haven, 1992.
Calkins, R. G. *Illuminated Books of the Middle Ages.*
Cornell University Press, Ithaca, 1983.
———. *Monuments of Medieval Art.* Reprint of 1979 ed.,
Cornell University Press, Ithaca, 1985.
Cassidy, B., ed. *Iconography at the Crossroads.* Princeton
University Press, Princeton, 1993.
Katzenellenbogen, A. *Allegories of the Virtues and Vices
in Medieval Art.* Reprint of 1939 ed., University
of Toronto Press, Toronto, 1989.
Pächt, O. *Book Illumination in the Middle Ages:
An Introduction.* Miller, London, 1986.
Pelikan, J. *Mary Through the Centuries: Her Place in the
History of Culture.* Yale University Press, New
Haven, 1996.
Schapiro, M. *Late Antique, Early Christian, and
Mediaeval Art.* Meyer Schapiro, Selected Papers, 3.
Braziller, New York, 1979.
Snyder, J. *Medieval Art: Painting, Sculpture, Architecture,
4th–14th Century.* Harry N. Abrams, New York,
1989.
Tasker, E. *Encyclopedia of Medieval Church Art.*
Batsford, London, 1993.

CHAPTER 8. EARLY CHRISTIAN AND BYZANTINE ART

Beckwith, J. *Early Christian and Byzantine Art.* Pelican
History of Art. 2nd ed. Penguin, New York, 1979.
Demus, O. *Byzantine Art and the West.* New York
University Press, New York, 1970.
Grabar, A. *The Beginnings of Christian Art, 200–395.*
The Arts of Mankind. Odyssey, New York, 1967.
———. *Christian Iconography: A Study of Its Origins.*
Princeton University Press, Princeton, 1968.
Kleinbauer, W. *Early Christian and Byzantine Architec-
ture: An Annotated Bibliography and Historiography.*
G. K. Hall, Boston, 1993.
Krautheimer, R., and S. Curcic. *Early Christian and
Byzantine Architecture.* Pelican History of Art.
4th ed. Yale University Press, New Haven, 1992.
Lowden, J. *Early Christian and Byzantine Art.* Phaidon,
London, 1997.
Maguire, H. *Art and Eloquence in Byzantium.* Princeton
University Press, Princeton, 1981.
Mango, C. *The Art of the Byzantine Empire, 312–1453:
Sources and Documents.* Reprint of 1972 ed.,
University of Toronto Press, Toronto, 1986.
Mark, R., and A. S. Çakmak, eds. *Hagia Sophia from
the Age of Justinian to the Present.* Cambridge
University Press, New York, 1992.
Mathews, T. *The Byzantine Churches of Istanbul:
A Photographic Survey.* Pennsylvania State
University Press, University Park, Pa., 1976.
———. *Byzantium from Antiquity to the Renaissance.*
Harry N. Abrams, New York, 1998.
———. *The Clash of Gods: A Reinterpretation of Early
Christian Art.* Princeton University Press,
Princeton, 1993.
Milburn, R. *Early Christian Art and Architecture.*
University of California Press, Berkeley, 1988.
Rodley, L. *Byzantine Art and Architecture: An Introduc-
tion.* Cambridge University Press, New York, 1994.
Simson, O. G. von. *Sacred Fortress: Byzantine Art and
Statecraft in Ravenna.* Reprint of 1948 ed., Princeton
University Press, Princeton, 1987.
Weitzmann, K. *Late Antique and Early Christian Book
Illumination.* Braziller, New York, 1977.

CHAPTER 9. EARLY MEDIEVAL ART

Alexander, J. J. G. *Insular Manuscripts, Sixth to the Ninth
Century.* Survey of Manuscripts Illuminated in the
British Isles. Miller, London, 1978.
Backhouse, J. *The Golden Age of Anglo-Saxon Art,
966–1066.* Indiana University Press, Bloomington,
1984.
———, ed. *The Lindisfarne Gospels.* Phaidon, Oxford,
1981.
Conant, K. *Carolingian and Romanesque Architecture,
800–1200.* Pelican History of Art. 4th ed. Yale
University Press, New Haven, 1992.
Davis-Weyer, C. *Early Medieval Art, 300–1150: Sources
and Documents.* Reprint of 1971 ed., University of
Toronto Press, Toronto, 1986.
Deshman, R. *Anglo-Saxon and Anglo-Scandinavian Art:
An Annotated Bibliography.* G. K. Hall, Boston, 1984.
Dodwell, C. R. *Anglo-Saxon Art: A New Perspective.*
Cornell University Press, Ithaca, 1982.
———. *The Pictorial Arts of the West, 800–1200.* Pelican
History of Art. New ed. Yale University Press,
New Haven, 1993.
Horn, W., and E. Born. *The Plan of St. Gall.* 3 vols.
University of California Press, Berkeley, 1979.
Kitzinger, E. *Early Medieval Art, with Illustrations from
the British Museum.* Rev. ed. Indiana University
Press, Bloomington, 1983.
Lasko, P. *Ars Sacra, 800–1200.* Pelican History of Art.
2nd ed. Yale University Press, New Haven, 1994.
Mayr-Harting, M. *Ottonian Book Illumination: An
Historical Study.* 2 vols. Miller, London, 1991–93.
Nees, L. *From Justinian to Charlemagne: European Art,
567–787: An Annotated Bibliography.* G. K. Hall,
Boston, 1985.
Rickert, M. *Painting in Britain: The Middle Ages.* Pelican
History of Art. 2nd ed. Penguin, Harmondsworth,
England, 1965.

Stone, L. *Sculpture in Britain: The Middle Ages.* Pelican
History of Art. 2nd ed. Penguin, Harmondsworth,
England, 1972.

Temple, E. *Anglo-Saxon Manuscripts, 900–1066.* Survey
of Manuscripts Illuminated in the British Isles.
Miller, London, 1976.

Werner, M. *Insular Art: An Annotated Bibliography.* G. K.
Hall, Boston, 1984.

Wilson, D. M. *Anglo-Saxon Art: From the Seventh
Century to the Norman Conquest.* Overlook Press,
Woodstock, N.Y., 1984.

CHAPTER 10. ROMANESQUE ART

Bizzarro, T. *Romanesque Architectural Criticism:
A Prehistory.* Cambridge University Press,
New York, 1992.

Boase, T. S. R. *English Art, 1100–1216.* Oxford History
of English Art. Clarendon Press, Oxford, 1953.

Cahn, W. *Romanesque Bible Illumination.* Cornell
University Press, Ithaca, 1982.

Chapman, G. *Mosan Art: An Annotated Bibliography.*
Reference Publications in Art History. G. K. Hall,
Boston, 1988.

Davies, M. *Romanesque Architecture: A Bibliography.*
G. K. Hall, Boston, 1993.

Focillon, H. *The Art of the West in the Middle Ages.*
Ed. J. Bony. 2 vols. Reprint of 1963 ed., Cornell
University Press, Ithaca, 1980.

Glass, D. F. *Italian Romanesque Sculpture: An Annotated
Bibliography.* Reference Publications in Art History.
G. K. Hall, Boston, 1983.

Hearn, M. F. *Romanesque Sculpture: The Revival of
Monumental Stone Sculpture.* Cornell University
Press, Ithaca, 1981.

Kaufmann, C. *Romanesque Manuscripts, 1066–1190.*
Survey of Manuscripts Illuminated in the British Isles.
Miller, London, 1978.

Lyman, T. W. *French Romanesque Sculpture:
An Annotated Bibliography.* Reference Publications
in Art History. G. K. Hall, Boston, 1987.

Mâle, E. *Religious Art in France, the Twelfth Century:
A Study of the Origins of Medieval Iconography.*
Bollingen series, 90:1. Princeton University Press,
Princeton, 1978.

Nichols, S. *Romanesque Signs: Early Medieval Narrative
and Iconography.* Yale University Press, New
Haven, 1983.

Petzold, A. *Romanesque Art.* Perspectives. Harry N.
Abrams, New York, 1995.

Platt, C. *The Architecture of Medieval Britain: A Social
History.* Yale University Press, New Haven, 1990.

Schapiro, M. *Romanesque Art.* Braziller, New York,
1977.

Stoddard, W. *Art and Architecture in Medieval France.*
Harper & Row, New York, 1972.

Toman, R. *Romanesque Architecture, Sculpture, Painting.*
Könemann, Cologne, 1997.

CHAPTER 11. GOTHIC ART

Belting, H. *The Image and Its Public: Form and Function
of Early Paintings of the Passion.* Caratzas, New
Rochelle, N.Y., 1990.

Blum, P. *Early Gothic Saint-Denis: Restorations and
Survivals.* University of California Press, Berkeley,
1992.

Bomford, D. *Art in the Making: Italian Painting Before
1400.* Exh. cat. National Gallery of Art, London,
1989.

Bony, J. *The English Decorated Style: Gothic Architecture
Transformed, 1250–1350.* Cornell University Press,
Ithaca, 1979.

———. *French Gothic Architecture of the Twelfth and
Thirteenth Centuries.* University of California Press,
Berkeley, 1983.

Bowie, T., ed. *The Sketchbook of Villard de Honnecourt.*
Reprint of 1968 ed., Greenwood, Westport, Conn.,
1982.

Camille, M. *Gothic Art: Glorious Visions.* Perspectives.
Harry N. Abrams, New York, 1997.

———. *The Gothic Idol: Ideology and Image Making in
Medieval Art.* Cambridge University Press,
New York, 1989.

Caviness, M. H. *Stained Glass Before 1540: An Annotated
Bibliography.* G. K. Hall, Boston, 1983.

———. *Sumptuous Arts at the Royal Abbeys of Reims and
Braine.* Princeton University Press, Princeton, 1990.

Cennini, C. *The Craftsman's Handbook (Il Libro
dell'Arte).* Dover, New York, 1954.

Erlande-Brandenburg, A. *Gothic Art.* Harry N. Abrams,
New York, 1989.

Frankl, P. *Gothic Architecture.* Rev'd by P. Crossley.
Pelican History of Art. Yale University Press,
Princeton, 2001.

Frisch, T. G. *Gothic Art, 1140–c. 1450: Sources and
Documents.* Reprint of 1971 ed., University of
Toronto Press, Toronto, 1987.

Grodecki, L., and C. Brisac. *Gothic Stained Glass,
1200–1300.* Cornell University Press, Ithaca, 1985.

Jantzen, H. *High Gothic: The Classic Cathedrals of
Chartres, Reims, Amiens.* Reprint of 1962 ed.,
Princeton University Press, Princeton, 1984.

Lord, C. *Royal French Patronage of Art in the Fourteenth
Century: An Annotated Bibliography.* G. K. Hall,
Boston, 1985.

Mâle, E. *Religious Art in France, the Thirteenth Century:
A Study of Medieval Iconography and Its Sources.* Ed.
H. Bober. Princeton University Press, Princeton,
1984.

Meiss, M. *Painting in Florence and Siena After the Black
Death.* Princeton University Press, Princeton, 1951.

Meulen, J. van der. *Chartres: Sources and Literary Inter-
pretation: A Critical Bibliography.* Reference Publi-
cations in Art History. G. K. Hall, Boston, 1989.

Morgan, N. *Early Gothic Manuscripts.* Survey of
Manuscripts Illuminated in the British Isles.
2 vols. Miller, London, 1982–88.

Murray, S. *Beauvais Cathedral: Architecture of
Transcendence.* Princeton University Press,
Princeton, 1989.

Panofsky, E. *Gothic Architecture and Scholasticism.*
Reprint of 1951 ed., New American Library,
New York, 1985.

———, ed. and trans. *Abbot Suger on the Abbey Church
of Saint-Denis and Its Art Treasures.* 2nd ed. Prince-
ton University Press, Princeton, 1979.

Pope-Hennessy, J. *Italian Gothic Sculpture.* 3rd ed.
Oxford University Press, New York, 1986.

Sandler, L. *Gothic Manuscripts, 1285–1385.* Survey of
Manuscripts Illuminated in the British Isles.
Miller, London, 1986.

Simson, O. von. *The Gothic Cathedral: Origins of Gothic
Architecture and the Medieval Concept of Order.*
3rd ed. Princeton University Press, Princeton, 1988.

Stubblebine, J. *Assisi and the Rise of Vernacular Art.*
Harper & Row, New York, 1985.

———. *Dugento Painting: An Annotated Bibliography.*
G. K. Hall, Boston, 1985.

Welch, E. *Art and Society in Italy 1350–1500.* Oxford
University Press, London, 1997.

White, J. *Art and Architecture in Italy, 1250–1400.*
Pelican History of Art. 3rd ed. Yale University
Press, New Haven, 1993.

———. *Duccio: Tuscan Art and the Medieval Workshop.*
Thames & Hudson, New York, 1979.

Williamson, P. *Gothic Sculpture, 1140–1300.*
Yale University Press, New Haven, 1995.

Wilson, C. *The Gothic Cathedral.* Thames & Hudson,
New York, 1990.

Selected Discography

¢ = Budget Recording
• = Period Instrument Recording
§ = Recording of Exceptional Merit
† = Monophonic Recording

EARLY MUSIC

• Music of Ancient Greece (Paniagua), Harmonia Mundi France
¢• Music from Ancient Rome (Synaulia), Amiata
¢• Chant I (Monks of Santo Domingo de Silos), EMI
¢• Ancient Music for a Modern Age (Sequentia), RCA
¢ Millenium, Music from the Middle Ages (Ensemble Gilles Binchois), Virgin
¢• Love Songs of the Middle Ages 1150–1450 (Sequentia), Deutsche Harmonia Mundi
¢• Early Music 1400–1500 (various groups), Deutsche Harmonia Mundi
¢•§ The Art of Courtly Love (Munrow), EMI
¢• A Medieval Banquet (Best), Nimbus
¢• French Chansons (The Scholars of London), Naxos
¢• Elizabethan Songs (Rose Consort of Viols), Naxos

COMPOSERS

¢• Bach: Brandenburg Concerti, *The Musical Offering* (Linde), EMI
• Bach: Mass in B-Minor (Koopman), Erato
Bach: *St. Matthew Passion* (Corboz), Erato
Bach: Sonatas for Cello (Maisky, Argerich), Deutsche Grammaphon
Bach: Sonatas, Partitas for Solo Violin (Milstein), Deutsche Grammaphon
Bach: Suites for Solo Cello (Ma), Sony
Bach: Organ Toccatas (Biggs), Sony
† Bach: *The Well-Tempered Clavier,* Book I (Landowksa), RCA
Bach: *The Well-Tempered Clavier,* Book II (Koopman), Erato
Barber: *Knoxville, Adagio,* Songs/Copland: Poems, *Quiet City* (Hendricks, Thomas), EMI
¢ Bartók: Concerto for Orchestra; Music for Strings, Percussion, and Celeste (Reiner), RCA
Bartók: Concerti for Violin (Gotowsky, Gerhardt), Pyramid
Bartók: Quartets #1–6 (Lindsay), ASV
¢§ Beethoven: Concerti for Piano #1 and #3, #2 and #4 (Fleischer, Szell), Sony
§ Beethoven: Concerto for Piano #5, Concerto for Violin (Immerseel, Beth, Weil), Sony
§ Beethoven: Quartets [Complete] (Emerson String Quartet), Deutsche Grammaphon
¢ Beethoven: Sonatas for Cello (DuPré, Barenboim), Deutsche Grammaphon
¢• Beethoven: Sonatas for Piano #11, #13, #14, #19, #20 (Tan), Virgin
¢•§ Beethoven: Sonatas for Piano #21, #23, #26 (Tan), Virgin

Beethoven: Sonatas for Piano #30, #31, #32 (Ashkenazy), London
Beethoven: Sonatas for Violin #5, #9 (Menuhin, Kempf), Deutsche Grammaphon
§ Beethoven: Symphonies [Complete] (Gardiner), Deutsche Grammaphon
Berg: *Wozzeck, Lulu* (Boehm), Deutsche Grammaphon
Berlioz: *Romeo and Juliet* (Dutoit), London
Berlioz: *Symphonie Fantastique* (Abbado), Deutsche Grammaphon
¢ Brahms: Concerto for Piano #1/ R. Schumann: Introduction and Allegro/ Mendelssohn: *Capriccio Brilliant* (R. Serkin, Szell), Sony
¢§ Brahms: Concerto for Piano #2/ Beethoven: Sonata #23 (Richter, Leinsdorf), RCA
¢ Brahms: Concerto for Violin/ Tchaikovsky: Concerto for Violin (Milstein, Steinberg, Fistoulari), EMI
Brahms: Double Concerto, Piano Quartet #3 (Stern, Ma, Abbado), Sony
¢§ Brahms: Symphonies #1–3, Overtures (Jochum), EMI
¢ Brahms: Symphony #4 (Swarowsky), Infinity
¢ § Britten: Violin Concerto, Cello Symphony (Hirsch, Hughes, Yuasa), Naxos
¢ Britten: Quartets (Britten Quartet), Collins
¢ Cage, Carter, Babbitt, Schuller: Orchestral Works (Levine), Deutsche Grammaphon
¢ Chopin: Concerti for Piano #1, #2 (Ax, Previn), RCA
Chopin: Piano Music (Arrau), Philips
§ Copland: Orchestral Music (Bernstein), Sony
•§ Corelli: Opus 5 (Trio Sonnerie), Virgin
• Corelli: Opus 6 (Europa Galante), Opus 111
§ Crumb: *Ancient Voices of Children, Music for a Summer Evening* (Weisberg), Nonesuch
Debussy: *La Mer,* Nocturnes (Previn), Philips
Debussy: Quartet/Ravel: Quartet (Budapest String Quartet), Sony
Donizetti: *Lucia di Lammermoor* (Bonynge), London
¢ • Dowland: *Treasures from My Mind* (King), EMI
• § Dufay: Complete Secular Music (Medieval Ensemble of London), L'Oiseau Lyre
¢ Dvořák: Cello Concerto/Bloch: *Schelomo* (Fournier, Szell), Deutsche Grammaphon
Dvořák: Quartet #12/Smetana: Quartet (Guarneri), Philips
¢ Dvořák: Symphonies #7, #8, #9 (Szell), Sony
¢ Elgar: Concerto for Cello, Serenade, Enigma Variations (Maisky, Chailly), Deutsche Grammaphon

Foss: Complete Vocal Music (Foss), Koss
Franck: Symphony in D (Monteux), RCA
Gay: *The Beggar's Opera* (Barlow), Hyperion
Geminiani: Opus 2 (Lamon), Sony
Gesualdo: Madrigals (Rooley), L'Oiseau-Lyre
Glass: Songs from the Trilogy (various artists), Sony
•§ Glück: *Orpheus & Eurydice* (Gardiner), Philips
Handel: *Messiah* (Shaw), Telarc
Handel: Opus 6 (Guildhall), RCA
Haydn: *Lark, Rider* Quartets (Hagen), Deutsche Grammaphon
¢ Haydn: Symphonies #93–104 (Fischer), Nimbus
Ives: *Three Places in New England,* Symphony #4 (Thomas, Ozawa), Deutsche Grammaphon
Janáček: Sinfonietta, *Taras Bulba* (Mackerras), London
¢• Josquin: Motets and Chansons (Hilliard), EMI
¢• Lassus: Motets (Hilliard), Virgin
Lutoslawski: Concerto for Orchestra, *Jeux Venitiens, etc.* (Lutoslawski), EMI
¢• Machaut: Messe de Nostre Dame (Parrot), EMI
Mahler: Lieder (Baker, Barbirolli), EMI
¢ Mahler: Symphony #1 (Haitink), Philips
§ Mahler: Symphony #9 (Karajan), Deutsche Grammaphon
¢ Mendelssohn: Symphony #3, Overtures (Maag), London
Messiaen: *Couleurs, Oiseaux, etc.* (Boulez), Montaigne
• Monteverdi: *Orfeo* (Harnoncourt), Deutsche Grammaphon Archiv
¢• Monteverdi: Soprano Duets (Rooley), IMP
Moussorgsky: *Boris Godunov* (Semkow), EMI
¢ Mozart: Concerti for Piano [Complete] (Anda), Deutsche Grammaphon
§ Mozart: Concerti for Violin #4, #5 (Schumsky, Tortelier), Nimbus
§ Mozart: *Don Giovanni* (Giulini), EMI
Mozart: *Marriage of Figaro* (Solti), London
Mozart: "Haydn" Quartets (Guarneri), Philips
¢ Mozart: Requiem (Karajan), Deutsche Grammaphon
Mozart: String Quintets K515, K516 (Melos), Deutsche Grammaphon
¢ Mozart: Symphonies #35–#41 (Karajan), Deutsche Grammaphon
Offenbach: *La Belle Hélène* (Plasson), EMI
Palestrina: *Missa Paper Marcelli*/Allegri: *Miserere*/Lotti: *Crucifixus* (Christophers), Collins
§ Piazzolla: *57 Minutos Con La Realidad* (Piazzolla), Intuition
Prokoviev: Concerti for Violin (Perlman, Rozhdestvensky), EMI
Prokoviev: *Romeo and Juliet* (Maazel), London

§ Puccini: *Tosca* (Karajan), London
• Purcell: *Dido and Aeneas* (Parrott), EMI
• Purcell: *Fairy Queen* (Christophers), Collins
§ Rachmaninov: Concerto for Piano #2, *Rhapsody on a Theme of Paganini* (Rubinstein), RCA
¢ Rachmaninov: Symphony #2 (Previn), RCA
Rimsky-Korsakov: *Sheherazade* (Mackerras), Telarc
Saint-Saëns: Symphony #3 (Ormandy), Telarc
Schoenberg: *Survivor from Warsaw,* 5 Pieces, etc. (Craft), Koch
Schoenberg: *Transfigured Night*/Wagner: *Siegried Idyll* (Ashkenazy), London
Schubert: Impromptus (Perahia), Sony
¢ Schubert: Lieder (Ludwig), Deutsche Grammaphon
Schubert: Octet (Academy of St. Martin's in the Fields), Philips
Schubert: Quartets #13, #14, #15 (Chilingirian), Chandos
¢ Schubert: Piano Sonatas [Complete] (Kempf), Deutsche Grammaphon
¢ Schubert: *Trout* Quintet (Marlborough), Sony
Schubert: Cello Quintet (Guarneri), Philips
¢• Schubert: Symphonies (Goodman), Nimbus
Schubert: Trio #1 (Borodin), Chandos
Schumann: Symphonies [Complete] (Haitink), Philips
§ Sessions: *When Lilacs Last in Dooryard Bloom'd* (Ozawa), New World
¢ Sibelius: Symphony #2, *Swan of Tuonela* (Barbirolli), EMI
¢ Sibelius: Symphonies #4, #5 (Karajan), EMI
§ Stravinsky: *The Firebird* (Stravinsky), Sony
§ Stravinsky: *Petrouchka, The Rite of Spring* (Stravinsky), Sony
¢ Tchaikovsky: Concerto for Piano #1 (Gilels, Mehta), Concerto for Violin (Zukerman), Sony
Tchaikovsky: Symphonies #1–#3 (Haitink), Philips
§ Tchaikovsky: Symphonies #4–#6 (Mravinsky), Deutsche Grammaphon
§ Telemann: Double and Triple Concerti (Hogwood), Oiseau Lyre
• Telemann: *Tafelmusik* (Goebbel), Deutsche Grammaphon Archiv
Vaughan-Williams: Symphony #8, Partita for Double String Orchestra (Thomas), Chandos
† Verdi: *Aida* (Serafin), EMI
Verdi: Requiem (Shaw), Telarc
Vivaldi: *L'estro Armonico* (I Filarmonici), Tactus
¢ Vivaldi: *Four Seasons* (I Musici), Philips
Wagner: Overtures (Tennstedt), EMI
Wagner: *Tristan and Isolde* (Karajan), EMI
Webern: Complete Music (Boulez), Sony
Weill: *The Threepenny Opera* (Lemper, Mauceri), London

Glossary

A

ABACUS. A slab of stone at the top of a classical capital just beneath the ARCHITRAVE (figs. 5-25, 5-28).

ABBEY. 1) A religious community headed by an abbot or abbess. 2) The buildings which house the community. An abbey church often has an especially large CHOIR to provide space for the monks or nuns (fig. 11-1).

ACADEMY. A place of study, the word coming from the Greek name of a garden near Athens where Plato and, later, Platonic philosophers held philosophical discussions from the 5th century B.C. to the 6th century A.D. The first academy of fine arts was the Academy of Drawing, founded 1563 in Florence by Giorgio Vasari. Later academies were the Royal Academy of Painting and Sculpture in Paris, founded 1648, and the Royal Academy of Arts in London, founded 1768. Their purpose was to foster the arts by teaching, by exhibitions, by discussion, and occasionally by financial aid.

ACANTHUS. 1) A Mediterranean plant having spiny or toothed leaves. 2) An architectural ornament resembling the leaves of this plant, used on MOLDINGS, FRIEZES, and Corinthian CAPITALS (figs. 5-25, 5-39, 10-27).

AISLE. See SIDE AISLE.

ALLA PRIMA. A painting technique in which pigments are laid on in one application with little or no UNDERPAINTING.

ALTAR. 1) A mound or structure on which sacrifices or offerings are made in the worship of a deity. 2) In a Catholic church, a tablelike structure used in celebrating the Mass.

ALTARPIECE. A painted or carved work of art placed behind and above the ALTAR of a Christian church. It may be a single panel (fig. 11-97) or a TRIPTYCH or a POLYPTYCH having hinged wings painted on both sides. Also called a reredos or retable.

ALTERNATE SYSTEM. A system developed in Romanesque church architecture to provide adequate support for a GROIN-VAULTED NAVE having BAYS twice as long as the SIDE-AISLE bays. The PIERS of the nave ARCADE alternate in size; the heavier COMPOUND piers support the main nave vaults where the THRUST is concentrated, and smaller, usually cylindrical, piers support the side-aisle vaults (figs. 10-9, 10-16).

AMAZON. One of a tribe of female warriors said in Greek legend to dwell near the Black Sea (fig. 5-66).

AMBULATORY. A covered walkway. 1) In a BASILICAN church, the semicircular passage around the APSE (fig. 11-1). 2) In a CENTRAL-PLAN church, the ring-shaped AISLE around the central space (fig. 8-25). 3) In a CLOISTER, the covered COLONNADED or ARCADED walk around the open courtyard.

AMPHITHEATER. A double THEATER. A building, usually oval in plan, consisting of tiers of seats and access corridors around the central theater area (figs. 5-41, 7-10).

AMPHORA (pl. **AMPHORAE**). A large Greek storage vase with an oval body usually tapering toward the base; two handles extend from just below the lip to the shoulder (figs. 5-3, 5-6).

ANDACHTSBILD. German for devotional picture. A picture or sculpture with a type of imagery intended for private devotion, first developed in Northern Europe (fig. 11-54).

ANNULAR. From the Latin word for "ring." Signifies a ring-shaped form, especially an annular barrel VAULT (fig. 8-7).

ANTA (pl. **ANTAE**). The front end of a wall of a Greek temple, thickened to produce a PILASTER-like member. Temples having COLUMNS between the antae are said to be "in antis" (fig. 5-26).

APOCALYPSE. The Book of Revelation, the last book of the New Testament. In it, St. John the Evangelist describes his visions, experienced on the island of Patmos, of Heaven, the future of humankind, and the Last Judgment.

APOSTLE. One of the 12 disciples chosen by Jesus to accompany him in his lifetime and to spread the GOSPEL after his death. The traditional list includes Andrew, Bartholomew, James the Greater (son of Zebedee), James the Lesser (son of Alphaeus), John, Judas Iscariot, Matthew, Peter, Philip, Simon the Canaanite, Thaddaeus (or Jude), and Thomas. In art, however, the same 12 are not always represented, since "apostle" was sometimes applied to other early Christians, such as St. Paul.

APSE. 1) A semicircular or polygonal niche terminating one or both ends of the NAVE in a Roman BASILICA (fig. 7-17). 2) In a Christian church, it is usually placed at the east end of the nave beyond the TRANSEPT or CHOIR. It is also sometimes used at the end of transept arms.

AQUEDUCT. Latin for "duct of water." 1) An artificial channel or conduit for transporting water from a distant source. 2) The overground structure which carries the conduit across valleys, rivers, etc. (fig. 7-9).

ARCADE. A series of ARCHES supported by PIERS or COLUMNS (fig. 7-24). When attached to a wall, these form a blind arcade (fig. 10-19).

ARCH. A curved structure used to span an opening. Masonry arches are built of wedge-shaped blocks, called voussoirs, set with their narrow side toward the opening so that they lock together (fig. 7-1). The topmost voussoir is called the keystone. Arches may take different shapes, as in the pointed Gothic arch (fig. 11-26), but all require support from other arches or BUTTRESSES.

ARCHBISHOP. The chief BISHOP of an ecclesiastic district.

ARCHITRAVE. The lowermost member of a classical ENTABLATURE; i.e., a series of stone blocks that rest directly on the COLUMNS (fig. 5-25).

ARCHIVOLT. A molded band framing an ARCH, or a series of such bands framing a TYMPANUM, often decorated with sculpture (fig. 10-22).

ARIANISM. Early Christian belief, initiated by Arius, a 4th-century a.d. priest in Alexandria. Now largely obscure, it was later condemned as heresy and suppressed.

ARRICCIO. See SINOPIA.

ATMOSPHERIC PERSPECTIVE. See PERSPECTIVE.

ATRIUM. 1) The central court of a Roman house (fig. 7-21) or its open entrance court. 2) An open court, sometimes COLONNADED or ARCADED, in front of a church (figs. 8-4, 10-15).

ATTIC. A low upper story placed above the main CORNICE or ENTABLATURE of a building and often decorated with windows and PILASTERS.

B

BACCHANT (fem. **BACCHANTE**). A priest or priestess of the wine god, Bacchus (in Greek mythology, Dionysos), or one of his ecstatic female followers, who were sometimes called maenads (fig. 8-22).

BALUSTRADE. 1) A railing supported by short pillars called balusters. 2) Occasionally applied to any low parapet (figs. 5-59, 11-8).

BAPTISTERY. A building or a part of a church, often round or octagonal, in which the sacrament of baptism is administered (fig. 10-19). It contains a baptismal font, a receptacle of stone or metal which holds the water for the rite (fig. 10-31).

BARREL VAULT. See VAULT.

BASE. 1) The lowermost portion of a COLUMN or PIER, beneath the SHAFT (figs. 5-25, 5-74). 2) The lowest element of a wall, DOME, or building or occasionally of a statue or painting (see PREDELLA).

BASILICA. 1) In ancient Roman architecture, a large, oblong building used as a hall of justice and public meeting place, generally having a NAVE, SIDE AISLES, and one or more APSES (fig. 7-17). 2) In Christian architecture, a longitudinal church derived from the Roman basilica and having a nave, apse, two or four side aisles or side chapels, and sometimes a NARTHEX. 3) One of the seven main churches of Rome (St. Peter's, St. Paul Outside the Walls, St. John Lateran, etc.) or another church accorded the same religious privileges.

BATTLEMENT. A parapet consisting of alternating solid parts and open spaces designed originally for defense and later used for decoration (fig. 11-39).

BAY. A subdivision of the interior space of a building, usually in a series bounded by consecutive architectural supports (fig. 11-19).

BENEDICTINE ORDER. Founded at Monte Cassino in 529 A.D. by St. Benedict of Nursia (c. 480–c. 553). Less austere than other early ORDERS, it spread throughout much of western Europe and England in the next two centuries.

BISHOP. The spiritual overseer of a number of churches or a diocese. His throne, or cathedra, placed in the principal church of the diocese, designates it as a cathedral.

BLACK-FIGURED. A style of ancient Greek ceramic decoration characterized by black figures against a red background (fig. 5-5). Black-figured wares preceded the RED-FIGURED style.

BLIND ARCADE. See ARCADE.

BOOK COVER. The stiff outer covers protecting the bound pages of a book. In the medieval period, frequently covered with precious metal and elaborately embellished with jewels, embossed decoration, etc. (fig. 9-19).

BOOK OF HOURS. A private prayer book containing the devotions for the seven canonical hours of the Roman Catholic church (matins, vespers, etc.), liturgies for local saints, and sometimes a calendar (fig. 11-94). They were often elaborately ILLUMINATED for persons of high rank, whose names are attached to certain extant examples (fig. 11-89).

BRACKET. A stone, wooden, or metal support projecting from a wall and having a flat top to bear the weight of a statue, CORNICE, beam, etc. (fig. 10-27). The lower part may take the form of a SCROLL; it is then called a scroll bracket.

BROKEN PEDIMENT. See PEDIMENT.

BRONZE AGE. The earliest period in which bronze was used for tools and weapons. In the Middle East, the Bronze Age succeeded the NEOLITHIC period in c. 3500 B.C. and preceded the Iron Age, which commenced c. 1900 B.C.

BUTTRESS. 1) A projecting support built against an external wall, usually to counteract the lateral THRUST of a VAULT or ARCH within (fig. 11-6). 2) FLYING BUTTRESS. An arched bridge above the aisle roof that extends from the upper nave wall, where the lateral thrust of the main vault is greatest, down to a solid pier (figs. 11-7, 11-19).

BYZANTIUM. City on the Sea of Marmara, founded by the ancient Greeks and renamed Constantinople in 330 A.D. Today called Istanbul.

C

CAESAR. The surname of the Roman dictator, Caius Julius Caesar, subsequently used as the title of an emperor, hence, the German Kaiser and the Russian czar (tsar).

CALLIGRAPHY. From the Greek word for "beautiful writing." 1) Decorative or formal handwriting executed with a quill or reed pen or with a brush (fig. 8-19). 2) A design derived from or resembling letters and used to form a pattern (fig. 9-3).

CAMPAGNA. Italian word for "countryside." When capitalized, it usually refers to the countryside near Rome.

CAMPANILE. From the Italian word campana, meaning "bell." A bell tower, either round or square and sometimes freestanding (figs. 8-13, 10-15).

CAMPOSANTO. Italian word for "holy field." A cemetery near a church, often enclosed.

CANOPY. In architecture, an ornamental, rooflike projection or cover above a statue or sacred object (fig. 11-44).

CAPITAL. The uppermost member of a COLUMN or PILLAR supporting the ARCHITRAVE (figs. 5-25, 5-39).

CARDINAL. In the Roman Catholic church, a member of the Sacred College, the ecclesiastical body which elects the pope and constitutes his advisory council.

CARMELITE ORDER. Originally a 12th-century hermitage claimed to descend from a community of hermits established by the prophet Elijah on Mt. Carmel, Palestine. In the early 13th century it spread to Europe and England, where it was reformed by St. Simon Stock and became one of the three great mendicant orders (see FRANCISCAN; DOMINICAN).

CARTHUSIAN ORDER. See CHARTREUSE.

CARVING. 1) The cutting of a figure or design out of a solid material such as stone or wood, as contrasted to the additive technique of MODELING. 2) A work executed in this technique.

CARYATID. A sculptured female figure used as an architectural support (figs. 5-20, 5-38). A similar male figure is an atlas (pl. atlantes).

CASTING. A method of duplicating a work of sculpture by pouring a hardening substance such as plaster or molten metal into a mold. See CIRE-PERDU PROCESS.

CATACOMBS. The underground burial places of the early Christians, consisting of passages with niches for tombs and small chapels for commemorative services.

CATHEDRA, CATHEDRAL. See BISHOP.

CELLA. 1) The principal enclosed room of a temple to house an image (fig. 5-26). Also called the naos. 2) The entire body of a temple as distinct from its external parts.

CENTERING. A wooden framework built to support an ARCH, VAULT, or DOME during its construction.

CENTRAL-PLAN CHURCH. 1) A church having four arms of equal length. The CROSSING is often covered with a DOME. Also called a Greek-cross church. 2) A church having a circular or polygonal plan (fig. 8-25).

CHANCEL. See CHOIR.

CHAPEL. 1) A private or subordinate place of worship. 2) A place of worship that is part of a church, but separately dedicated.

CHARTREUSE. French word for a Carthusian monastery (in Italian, Certosa). The Carthusian ORDER was founded by St. Bruno (c. 1030–1101) at Chartreuse near Grenoble in 1084. It is an eremitic order, the life of the monks being one of silence, prayer, and austerity.

CHASING. 1) A technique of ornamenting a metal surface by the use of various tools. 2) The procedure used to finish a raw bronze cast.

CHEVET. In Gothic architecture, the term for the developed and unified east end of a church, including CHOIR, APSE, AMBULATORY, and RADIATING CHAPELS (fig. 11-14).

CHOIR. In church architecture, a square or rectangular area between the APSE and the NAVE or TRANSEPT (fig. 11-2). It is reserved for the clergy and the singing choir and is usually marked off by steps, a railing, or a CHOIR SCREEN. Also called the chancel. See PILGRIMAGE CHOIR.

CHEVRON. A V-shaped decorative element which, when used repeatedly, gives a horizontal, zigzag appearance.

CHOIR SCREEN. A screen, frequently ornamented with sculpture, separating the CHOIR of a church from the NAVE or TRANSEPT (figs. 8-46, 11-51). In Orthodox Christian churches it is decorated with ICONS and thus called an iconostasis (fig. 8-43).

CIRE-PERDU PROCESS. The lost-wax process of CASTING. A method in which an original is MODELED in wax or coated with wax, then covered with clay. When the wax is melted out, the resulting mold is filled with molten metal (often bronze) or liquid plaster.

CISTERCIAN ORDER. Founded at Cîteaux in France in 1098 by Robert of Molesme with the objective of reforming the BENEDICTINE ORDER and reasserting its original ideals of a life of severe simplicity.

CITY-STATE. An autonomous political unit comprising a city and the surrounding countryside.

CLERESTORY. A row of windows in the upper part of a wall that rises above an adjoining roof; built to provide direct lighting, as in a BASILICA or church (figs. 11-15, 11-18).

CLOISTER. 1) A place of religious seclusion such as a monastery or nunnery. 2) An open court attached to a church or monastery and surrounded by a covered ARCADED walk or AMBULATORY. Used for study, meditation, and exercise.

CLUNIAC ORDER. Founded at Cluny, France, by Berno of Baume in 909. Leading religious reform movement in the Middle Ages. Had close connections to Ottonian rulers and to the papacy.

CODEX (pl. **CODICES**). A manuscript in book form made possible by the use of PARCHMENT instead of PAPYRUS. During the 1st to 4th centuries A.D., it gradually replaced the roll or SCROLL previously used for written documents.

COFFER. 1) A small chest or casket. 2) A recessed, geometrically shaped panel in a ceiling. A ceiling decorated with these panels is said to be coffered (fig. 7-12).

COLONNADE. A series of regularly spaced COLUMNS supporting a LINTEL or ENTABLATURE (fig. 2-32).

COLUMN. An approximately cylindrical, upright architectural support, usually consisting of a long, relatively slender SHAFT, a BASE, and a CAPITAL (figs. 5-25, 5-27). When imbedded in a wall, it is called an engaged column (fig. 5-40). Columns decorated with wraparound RELIEFS were used occasionally as free-standing commemorative monuments (fig. 7-37).

COMPOUND PIER. See PIER.

CONCRETE. A mixture of sand or gravel with mortar and rubble invented in the ancient Near East and further developed by the Romans (figs. 7-10, 7-11). Largely ignored during the Middle Ages, it was revived by Bramante in the early 16th century for St. Peter's.

CONTRAPPOSTO. Italian word for "set against." A method developed by the Greeks to represent freedom of movement in a figure. The parts of the body are placed asymmetrically in opposition to each other around a central axis, and careful attention is paid to the distribution of the weight (figs. 5-43, 5-44).

CORBELING. Roofing technique in which each layer of stone projects slightly over the previous layer (corbel) until all sides meet (figs. 4-14, 4-15).

CORINTHIAN ORDER. See ORDER, ARCHITECTURAL.

CORNICE. 1) The projecting, framing members of a classical PEDIMENT, including the horizontal one beneath and the two sloping or "raking" ones above (figs. 5-25, 5-27). 2) Any projecting, horizontal element surmounting a wall or other structure or dividing it horizontally for decorative purposes.

CRENELATED. See BATTLEMENT.

CROMLECH. From the Welsh for "concave stone." A circle of large upright stones, or DOLMENS, probably the setting for religious ceremonies in prehistoric Britain (figs. 1-17, 1-18).

CROSSING. The area in a church where the TRANSEPT crosses the NAVE, frequently emphasized by a DOME (fig. 10-17) or crossing tower (fig. 10-1).

CROSS SECTION. See SECTION.

CRYPT. In a church, a VAULTED space beneath the CHOIR, causing the floor of the choir to be raised above the level of that of the NAVE (fig. 9-24).

CUNEIFORM. Describes the wedge-shaped characters made in clay by the ancient Mesopotamians (fig. 3-14).

CYCLOPEAN. An adjective describing masonry with large, unhewn stones, thought by the Greeks to have been built by the Cyclopes, a legendary race of one-eyed giants (fig. 4-19).

D

DENTIL. A small, rectangular, tooth-like block in a series, used to decorate a classical entablature (fig. 5-25).

DIORITE. An igneous rock, extremely hard and usually black or dark gray in color (fig. 3-14).

DIPTYCH. 1) Originally a hinged, two-leaved tablet used for writing. 2) A pair of ivory CARVINGS or PANEL paintings, usually hinged together (figs. 8-22, 8-23).

DIPYLON VASE. A Greek funerary vase with holes in the bottom through which libations were poured to the dead (fig. 5-2). Named for the cemetery near Athens where the vases were found.

DOLMEN. A structure formed by two or more large, upright stones capped by a horizontal slab; thought to be a prehistoric tomb (fig. 1-16).

DOME. A true dome is a VAULTED roof of circular, polygonal, or elliptical plan, formed with hemispherical or ovoidal curvature (fig. 7-15). May be supported by a circular wall or DRUM (fig. 8-47) and by PENDENTIVES (fig. 8-27) or related constructions. Domical coverings of many other sorts have been devised (fig. 11-35).

DOMINICAN ORDER. Founded as a mendicant ORDER by St. Dominic in Toulouse in 1220.

DOMUS. Latin word for "house." A Roman detached, one-family house with rooms frequently grouped around two open courts. The first, the ATRIUM, was used for entertaining and conducting business; the second, usually with a garden and surrounded by a PERISTYLE or COLONNADE was for the private use of the family (fig. 7-21).

DONOR. The patron or client at whose order a work of art was executed; the donor may be depicted in the work.

DORIC ORDER. See ORDER, ARCHITECTURAL.

DRÔLERIES. French word for "jests." Used to describe the lively animals and small figures in the margins of late medieval manuscripts (fig. 11-89) and occasionally in wood CARVINGS on furniture.

DRUM. 1) A section of the SHAFT of a COLUMN (figs. 5-34, 7-16). 2) A wall supporting a DOME (fig. 7-15).

E

ECHINUS. In the Doric or Tuscan ORDER, the round, cushionlike element between the top of the SHAFT and the ABACUS (figs. 5-25, 5-28).

ELEVATION. 1) An architectural drawing presenting a building as if projected on a vertical plane parallel to one of its sides (fig. 11-18). 2) Term used in describing the vertical plane of a building.

ENAMEL. 1) Colored glassy substances, either opaque or translucent, applied in powder form to a metal surface and fused to it by firing. Two main techniques developed: champlevé (from the French for "raised field"), in which the areas to be treated are dug out of the metal surface; and cloisonné (from the French for "partitioned"), in which compartments or cloisons to be filled are made on the surface with thin metal strips. 2) A work executed in either technique (figs. 9-1, 10-41).

ENCAUSTIC. A technique of painting with pigments dissolved in hot wax (fig. 7-55).

ENGAGED COLUMN. See COLUMN.

ENTABLATURE. 1) In a classical order, the entire structure above the COLUMNS; this usually includes ARCHITRAVE, FRIEZE, and CORNICE (figs. 5-25, 5-27). 2) The same structure in any building of a classical style.

ENTASIS. A swelling of the SHAFT of a COLUMN (figs. 5-28, 5-31).

EVANGELISTS. Matthew, Mark, Luke, and John, traditionally thought to be the authors of the GOSPELS, the first four books of the New Testament, which recount the life and death of Christ. They are usually shown with their symbols, which are probably derived from the four beasts surrounding the throne of the Lamb in the Book of Revelation or from those in the vision of Ezekiel: a winged man or angel for Matthew, a winged lion for Mark (fig. 9-17), a winged ox for Luke (fig. 9-28), and an eagle for John (fig. 10-38). These symbols may also represent the evangelists (fig. 9-7).

F

FACADE. The principal face or the front of a building.

FATHERS OF THE CHURCH. Early teachers and defenders of the Christian faith. Those most frequently represented are the four Latin fathers: St. Jerome, St. Ambrose, and St. Augustine, all of the 4th century, and St. Gregory of the 6th.

FIBULA. A clasp, buckle, or brooch, often ornamented.

FINIAL. A relatively small, decorative element terminating a GABLE, PINNACLE, or the like (fig. 10-22).

FLUTING. In architecture, the ornamental grooves channeled vertically into the SHAFT of a COLUMN or PILASTER (fig. 5-34). They may meet in a sharp edge, as in the Doric ORDER, or be separated by a narrow strip or fillet, as in the Ionic, Corinthian, and Composite orders.

FLYING BUTTRESS. See BUTTRESS.

FONT. See BAPTISTERY.

FORUM (pl. **FORA**). In an ancient Roman city, the main public square which was the center of judicial and business activity and a public gathering place (fig. 7-8).

FRANCISCAN ORDER. Founded as a mendicant ORDER by St. Francis of Assisi (Giovanni di Bernardone, c. 1181–1226). The monks' aim was to imitate the life of Christ in its poverty and humility, to preach, and to minister to the spiritual needs of the poor.

FRESCO. Italian word for "fresh." 1) True fresco is the technique of painting on moist plaster with pigments ground in water so that the paint is absorbed by the plaster and becomes part of the wall itself (fig. 11-77). Fresco secco is the technique of painting with the same colors on dry plaster. 2) A painting done in either of these techniques.

FRIEZE. 1) A continuous band of painted or sculptured decoration (figs. 5-20, 7-32). 2) In a classical building, the part of the ENTABLATURE between the ARCHITRAVE and the CORNICE. A Doric frieze consists of alternating TRIGLYPHS and METOPES, the latter often sculptured (fig. 5-31). An Ionic frieze is usually decorated with continuous RELIEF sculpture (fig. 5-25).

G

GABLE. 1) The triangular area framed by the CORNICE or eaves of a building and the sloping sides of a pitched roof (fig. 9-21). In classical architecture, it is called

a PEDIMENT. 2) A decorative element of similar shape, such as the triangular structures above the PORTALS of a Gothic church (figs. 10-22, 11-20) and sometimes at the top of a Gothic picture frame.

GALLERY. A second story placed over the SIDE AISLES of a church and below the CLERESTORY (figs. 11-5, 11-19) or, in a church with a four-part ELEVATION, below the TRIFORIUM and above the NAVE ARCADE which supports it on its open side.

GESSO. A smooth mixture of ground chalk or plaster and glue used as the basis for TEMPERA PAINTING and for oil painting on PANEL.

GILDING. 1) A coat of gold or of a gold-colored substance that is applied mechanically or chemically to surfaces of a painting, sculpture, or architectural decoration (fig. 11-97). 2) The process of applying same.

GLAZE. 1) A thin layer of translucent oil color applied to a painted surface or to parts of it in order to modify the tone. 2) A glassy coating applied to a piece of ceramic work before firing in the kiln as a protective seal and often as decoration.

GLORIOLE OR GLORY. The circle of radiant light around the heads or figures of God, Christ, the Virgin Mary, or a saint. When it surrounds the head only, it is called a halo or nimbus (fig. 11-90); when it surrounds the entire figure with a large oval (figs. 8-57, 11-41), it is called a mandorla (the Italian word for "almond"). It indicates divinity or holiness, though originally it was placed around the heads of kings and gods as a mark of distinction.

GOLD LEAF, SILVER LEAF. 1) Gold beaten into very thin sheets or "leaves" and applied to ILLUMINATED MANUSCRIPTS and PANEL paintings (figs. 10-38, 11-90), to sculpture, or to the back of the glass TESSERAE used in MOSAICS (figs. 8-15, 8-29). 2) Silver leaf is also used, though ultimately it tarnishes (fig. 8-20). Sometimes called gold foil, silver foil.

GORGON. In Greek mythology, one of three hideous female monsters with large heads and snakes for hair (fig. 5-17). Their glance turned men to stone. Medusa, the most famous of the Gorgons, was killed by Perseus only with help from the gods.

GOSPEL. 1) The first four books of the New Testament. They tell the story of Christ's life and death and are ascribed to the evangelists Matthew, Mark, Luke, and John. 2) A copy of these, usually called a Gospel Book, often richly ILLUMINATED (figs. 9-15, 9-17).

GREEK-CROSS CHURCH. See CENTRAL-PLAN CHURCH.

GROIN VAULT. See VAULT.

GROUND-LINE. The line, actual or implied, on which figures stand (fig. 2-1, 2-2).

GROUND PLAN. An architectural drawing presenting a building as if cut horizontally at the floor level.

GUTTAE. In a Doric ENTABLATURE, small peglike projections above the FRIEZE; possibly derived from pegs originally used in wooden construction (fig. 5-25).

H

HALLENKIRCHE. German word for "hall church." A church in which the NAVE and the SIDE AISLES are of the same height. The type was developed in Romanesque architecture and occurs especially frequently in German Gothic churches (figs. 10-6, 11-30).

HALO. See GLORIOLE.

HIEROGLYPH. A picture of a figure, animal, or object standing for a word, syllable, or sound. These symbols are found on ancient Egyptian monuments as well as in Egyptian written records (fig. 2-21).

HIGH RELIEF. See RELIEF.

I

ICON. From the Greek word for "image." A PANEL painting of one or more sacred personages, such as Christ, the Virgin, or a saint, particularly venerated in the Orthodox Catholic church (fig. 8-55).

ICONOSTASIS. See CHOIR SCREEN.

ILLUMINATED MANUSCRIPT. A MANUSCRIPT decorated with drawings (fig. 9-48) or with paintings in TEMPERA colors (figs. 9-27, 10-38).

ILLUSIONISM. In artistic terms, the technique of manipulating pictorial or other means in order to cause the eye to perceive a particular reality. May be used in architecture and sculpture (fig. 7-35), as well as in painting (figs. 7-48, 7-53).

IN ANTIS. See ANTA.

INSULA (pl. **INSULAE**). Latin word for "island." 1) An ancient Roman city block. 2) A Roman "apartment house": a CONCRETE and brick building or chain of buildings around a central court, up to five stories high. The ground floor had shops, and above were living quarters (fig. 7-22).

IONIC ORDER. See ORDER, ARCHITECTURAL.

J

JAMBS. The vertical sides of an opening. In Romanesque and Gothic churches, the jambs of doors and windows are often cut on a slant outward, or "splayed," thus providing a broader surface for sculptural decoration (figs. 11-41, 11-42).

K

KEEP. 1) The innermost and strongest structure or central tower of a medieval castle, sometimes used as living quarters, as well as for defense. Also called a donjon (fig. 11-94). 2) A fortified medieval castle.

KEYSTONE. See ARCH.

KORE (pl. **KORAI**). Greek word for "maiden." An Archaic Greek statue of a standing, clothed female (fig. 5-15).

KOUROS (pl. **KOUROI**). Greek word for "male youth." An Archaic Greek statue of a standing, nude youth (fig. 5-11).

KRATER. A Greek vessel, of assorted shapes, in which wine and water are mixed. Calyx krater—a bell-shaped vessel with handles near the base; volute krater—a vessel with handles shaped like scrolls (fig. 5-7).

KYLIX. In Greek and Roman antiquity, a shallow drinking cup with two hori-

zontal handles, often set on a stem terminating in a foot (fig. 5-5).

L

LABORS OF THE MONTHS. The various occupations suitable to the months of the year. Scenes or figures illustrating these were frequently represented in ILLUMINATED manuscripts (fig. 11-94); sometimes with the symbols of the ZODIAC signs CARVED around the PORTALS of Romanesque and Gothic churches (figs. 11-41, 11-49).

LANTERN. A relatively small structure crowning a DOME, roof, or tower, frequently open to admit light to an enclosed area below (fig. 7-15).

LAPITH. A member of a mythical Greek tribe that defeated the Centaurs in a battle, scenes from which are frequently represented in vase painting and sculpture (fig. 5-50).

LEKYTHOS (pl. **LEKYTHOI**). A Greek oil jug with an ellipsoidal body, a narrow neck, a flanged mouth, a curved handle extending from below the lip to the shoulder, and a narrow base terminating in a foot. It was used chiefly for ointments and funerary offerings (fig. 5-59).

LIBERAL ARTS. Traditionally thought to go back to Plato, they comprised the intellectual disciplines considered suitable or necessary to a complete education and included grammar, rhetoric, logic, arithmetic, music, geometry, and astronomy. During the Middle Ages and the Renaissance, they were often represented allegorically in paintings, engravings, and sculpture (fig. 11-41).

LINTEL. See POST AND LINTEL.

LONGITUDINAL SECTION. See SECTION.

LOW RELIEF. See RELIEF.

LOZENGE. A diamond-shaped decorative element, or MOTIF.

M

MAESTÀ. Italian word for "majesty," applied in the 14th and 15th centuries to representations of the Madonna and Child enthroned and surrounded by her celestial court of saints and angels (fig. 11-73).

MAGUS (pl. **MAGI**). 1) A member of the priestly caste of ancient Media and Persia. 2) In Christian literature, one of the three Wise Men or Kings who came from the East bearing gifts to the newborn Jesus (fig. 11-97).

MANDORLA. See GLORIOLE.

MANUSCRIPT. From the Latin word for "handwritten." 1) A document, scroll, or book written by hand, as distinguished from such a work in print (i.e., after c. 1450). 2) A book produced in the Middle Ages, frequently ILLUMINATED.

MARTYRIUM (pl. **MARTYRIA**). A church, CHAPEL, or shrine built over the grave of a Christian martyr or at the site of an important miracle.

MASTABA. An ancient Egyptian tomb, rectangular in shape, with sloping sides and a flat roof. It covered a chapel for offerings and a shaft to the burial chamber (fig. 2-4).

MAUSOLEUM. 1) The huge tomb erected at Halikarnassus in Asia Minor in

the 4th century B.C. by King Mausolos and his wife Artemisia (fig. 5-65). 2) A generic term for any large funerary monument.

MEANDER. A decorative motif of intricate, rectilinear character applied to architecture and sculpture (figs. 7-34, 10-27).

MEGALITH. A huge stone such as those used in CROMLECHS and DOLMENS.

MEGARON (pl. **MEGARONS** or **MEGARA**). From the Greek word for "large." The central audience hall in a Minoan or Mycenaean palace or home (fig. 4-5).

MENHIR. A megalithic upright slab of stone, sometimes placed in rows by prehistoric peoples.

MESOLITHIC. Transitional period of the Stone Age between the PALEOLITHIC and the NEOLITHIC.

METOPE. In a Doric FRIEZE, one of the panels, either decorated or plain, between the TRIGLYPHS. Originally it probably covered the empty spaces between the ends of the wooden ceiling beams (figs. 5-25, 5-31).

MINIATURE. 1) A single illustration in an ILLUMINATED manuscript (figs. 9-3, 9-4). 2) A very small painting, especially a portrait on ivory, glass, or metal.

MINOTAUR. In Greek mythology, a monster having the head of a bull and the body of a man who lived in the Labyrinth of the palace of Knossos on Crete.

MODEL. 1) The preliminary form of a sculpture, often finished in itself but preceding the final CASTING or CARVING. 2) Preliminary or reconstructed form of a building made to scale. 3) A person who poses for an artist.

MODELING. 1) In sculpture, the building up of a figure or design in a soft substance such as clay or wax (fig. 6-8). 2) In painting and drawing, producing a three-dimensional effect by changes in color, the use of light and shade, etc.

MOLDING. In architecture, any of various long, narrow, ornamental bands having a distinctive profile which project from the surface of the structure and give variety to the surface by means of their patterned contrasts of light and shade (fig. 5-20).

MOSAIC. Decorative work for walls, VAULTS, ceilings, or floors composed of small pieces of colored materials (called TESSERAE) set in plaster or concrete. The Romans, whose work was mostly for floors, used regularly shaped pieces of marble in its natural colors (fig. 5-62). The early Christians used pieces of glass whose brilliant hues, including gold, and slightly irregular surfaces produced an entirely different, glittering effect (figs. 8-28, 8-29). See also GOLD LEAF.

MOTIF. A visual theme, a motif may appear numerous times in a single work of art.

MURAL. From the Latin word for wall, murus. A large painting or decoration either executed directly on a wall (FRESCO) or done separately and affixed to it.

MUSES. In Greek mythology, the nine goddesses who presided over various arts and sciences. They are led by Apollo as god of music and poetry and usually include Calliope, muse of epic poetry; Clio, muse of history; Erato, muse of love poetry; Euterpe, muse of music; Melpomene, muse of tragedy; Polyhymnia, muse of sacred music; Terpsichore, muse of dancing; Thalia, muse of comedy; and Urania, muse of astronomy.

MUTULES. A feature of DORIC architecture, mutules are flat rectangular blocks found just under the CORNICE (fig. 5-26).

N

NAOS. See CELLA.

NARTHEX. The transverse entrance hall of a church, sometimes enclosed but often open on one side to a preceding ATRIUM (fig. 8-4).

NAVE. 1) The central aisle of a Roman BASILICA, as distinguished from the SIDE AISLES (fig. 7-20). 2) The same section of a Christian basilican church extending from the entrance to the APSE or TRANSEPT (fig. 8-4).

NEOLITHIC. The New Stone Age, thought to have begun c. 9000–8000 B.C. The first society to live in settled communities, to domesticate animals, and to cultivate crops, it saw the beginning of many new skills, such as spinning, weaving, and building (fig. 1-10).

NEW STONE AGE. See NEOLITHIC.

NIKE. The ancient Greek goddess of victory, often identified with Athena and by the Romans with Victoria. She is usually represented as a winged woman with windblown draperies (figs. 5-59, 5-77).

NIMBUS. See GLORIOLE.

O

OBELISK. A tall, tapering, four-sided stone shaft with a pyramidal top. First constructed as MEGALITHS in ancient Egypt (fig. 2-32); certain examples since exported to other countries.

OLD STONE AGE. See PALEOLITHIC.

ORCHESTRA. 1) In an ancient Greek theater, the round space in front of the stage and below the tiers of seats, reserved for the chorus (fig. 5-41). 2) In a Roman theater, a similar space reserved for important guests.

ORDER, ARCHITECTURAL. An architectural system based on the COLUMN and its ENTABLATURE, in which the form of the elements themselves (CAPITAL, SHAFT, BASE, etc.) and their relationships to each other are specifically defined. The five classical orders are the Doric, Ionic, Corinthian, Tuscan, and Composite (fig. 5-25). See also SUPERIMPOSED ORDER.

ORDER, MONASTIC. A religious society whose members live together under an established set of rules. See benedictine; carmelite; chartreuse; cistercian; dominican; franciscan.

ORTHODOX. From the Greek word for "right in opinion." The Eastern Orthodox church, which broke with the Western Catholic church during the 5th century A.D. and transferred its allegiance from the pope in Rome to the Byzantine emperor in Constantinople and his appointed patriarch. Sometimes called the Byzantine church.

P

PALAZZO (pl. **PALAZZI**). Italian word for "palace" (in French, palais).

Refers either to large official buildings (fig. 11-39) or to important private town houses.

PALEOLITHIC. The Old Stone Age, usually divided into Lower, Middle, and Upper (which began about 35,000 B.C.). A society of nomadic hunters who used stone implements, later developing ones of bone and flint. Some lived in caves, which they decorated during the latter stages of the age (fig. 1-2), at which time they also produced small CARVINGS in bone, horn, and stone (figs. 1-7, 1-8).

PALETTE. 1) A thin, usually oval or oblong board with a thumbhole at one end, used by painters to hold and mix their colors. 2) The range of colors used by a particular painter. 3) In Egyptian art, a slate slab, usually decorated with sculpture in low RELIEF. The small ones with a recessed circular area on one side are thought to have been used for eye make-up. The larger ones were commemorative objects (figs. 2-1, 2-2).

PANEL. 1) A wooden surface used for painting, usually in TEMPERA, and prepared beforehand with a layer of GESSO. Large ALTARPIECES require the joining together of two or more boards. 2) Recently, panels of Masonite or other composite materials have come into use.

PANTHEON. From pan, Greek for "all." A temple dedicated to all the gods (figs. 7-12, 7-13) or housing tombs of the illustrious dead of a nation or memorials to them.

PANTOCRATOR. A representation of Christ as ruler of the universe which appears frequently in the DOME or APSE MOSAICS of Byzantine churches (fig. 8-49).

PAPYRUS. 1) A tall aquatic plant that grows abundantly in the Near East, Egypt, and Abyssinia. 2) A paperlike material made by laying together thin strips of the pith of this plant and then soaking, pressing, and drying the whole. The resultant sheets were used as writing material by the ancient Egyptians, Greeks, and Romans. 3) An ancient document or SCROLL written on this material.

PARCHMENT. From Pergamon, the name of a Greek city in Asia Minor where parchment was invented in the 2nd century B.C. 1) A paperlike material made from bleached animal hides used extensively in the Middle Ages for MANUSCRIPTS (fig. 9-5). Vellum is a superior type of parchment made from calfskin. 2) A document or miniature on this material (fig. 9-27).

PASSION. 1) In ecclesiastic terms, the events of Jesus' last week on earth. 2) The representation of these events in pictorial, literary, theatrical, or musical form (figs. 11-77, 11-81).

PEDIMENT. 1) In classical architecture, a low GABLE, typically triangular, framed by a horizontal CORNICE below and two raking cornices above; frequently filled with relief sculpture (fig. 5-22). 2) A similar architectural member, either round or triangular, used over a door, window, or niche. When pieces of the cornice are either turned at an angle or broken, it is called a broken pediment (fig. 7-23).

PELIKE. A Greek storage jar with two handles, a wide mouth, little or no neck, and resting on a foot (fig. 5-64).

PENDENTIVE. One of the spherical triangles which achieves the transition from a square or polygonal opening to the round BASE of a DOME or the supporting DRUM (figs. 8-34, 8-43).

PERIPTERAL. An adjective describing a building surrounded by a single row of COLUMNS or COLONNADE (figs. 5-26, 5-31).

PERISTYLE. 1) In a Roman house or DOMUS, an open garden court surrounded by a COLONNADE (fig. 7-24). 2) A colonnade around a building or court (fig. 5-26).

PICTURE PLANE. The flat surface on which a picture is painted.

PIER. An upright architectural support, usually rectangular and sometimes with CAPITAL and BASE (fig. 6-6). When COLUMNS, PILASTERS, or SHAFTS are attached to it, as in many Romanesque and Gothic churches, it is called a compound pier (fig. 10-9).

PIETÀ. Italian word for both "pity" and "piety." A representation of the Virgin grieving over the dead Christ (fig. 11-54). When used in a scene recording a specific moment after the Crucifixion, it is usually called a Lamentation (fig. 11-79).

PILASTER. A flat, vertical element projecting from a wall surface and normally having a BASE, SHAFT, and CAPITAL. It has generally a decorative rather than a structural purpose.

PILGRIMAGE CHOIR. The unit in a Romanesque church composed of the APSE, AMBULATORY, and RADIATING CHAPELS (figs. 10-2, 11-2).

PILLAR. A general term for a vertical architectural support which includes COLUMNS, PIERS, and PILASTERS.

PINNACLE. A small, decorative structure capping a tower, PIER, BUTTRESS, or other architectural member and used especially in Gothic buildings (figs. 11-21, 11-23).

PLAN. See GROUND PLAN.

PODIUM. 1) The tall base upon which rests an Etruscan or Roman temple (fig. 7-2). 2) The ground floor of a building made to resemble such a base.

POLYPTYCH. An ALTARPIECE or devotional work of art made of several panels joined together, often hinged.

PORCH. General term for an exterior appendage to a building which forms a covered approach to a doorway (fig. 11-20). See PORTICO for porches consisting of columns.

PORTA. Latin word for "door" or "gate."

PORTAL. A door or gate, usually a monumental one with elaborate sculptural decoration (figs. 11-41, 11-55).

PORTICO. A columned porch supporting a roof or an ENTABLATURE and PEDIMENT, often approached by a number of steps (fig. 7-2). It provides a covered entrance to a building and a link with the space surrounding it.

POST AND LINTEL. A basic system of construction in which two or more uprights, the posts, support a horizontal member, the lintel. The lintel may be the topmost element (fig. 1-18) or support a wall or roof (fig. 4-19).

PREDELLA. The base of an ALTARPIECE, often decorated with small scenes

which are related in subject to that of the main panel or panels (fig. 11-97).

PRONAOS. In a Greek or Roman temple, an open vestibule in front of the CELLA (fig. 5-26).

PROPYLAEUM (pl. **PROPYLAEA**). 1) The entrance to a temple or other enclosure, especially when it is an elaborate structure. 2) The monumental entry gate at the western end of the Acropolis in Athens (fig. 5-34).

PSALTER. 1) The book of Psalms in the Old Testament, thought to have been written in part by David, king of ancient Israel. 2) A copy of the Psalms, sometimes arranged for liturgical or devotional use and often richly ILLUMINATED (fig. 8-48).

PULPIT. A raised platform in a church from which the clergy delivers a sermon or conducts the service. Its railing or enclosing wall may be elaborately decorated (fig. 11-57).

PYLON. Greek word for "gateway." 1) The monumental entrance building to an Egyptian temple or forecourt consisting of either a massive wall with sloping sides pierced by a doorway or of two such walls flanking a central gateway (fig. 2-32). 2) A tall structure at either side of a gate, bridge, or avenue marking an approach or entrance.

Q

QUATREFOIL. An ornamental element composed of four lobes radiating from a common center (figs. 11-49, 11-65).

R

RADIATING CHAPELS. Term for CHAPELS arranged around the AMBULATORY (and sometimes the TRANSEPT) of a medieval church (figs. 10-1, 11-2, 11-21).

RED-FIGURED. A style of ancient Greek ceramic decoration characterized by red figures against a black background (fig. 5-7). This style of decoration developed around 500 B.C. and replaced the earlier BLACK-FIGURED style.

REFECTORY. 1) A room for refreshment. 2) The dining hall of a monastery, college, or other large institution.

RELIEF. 1) The projection of a figure or part of a design from the background or plane on which it is CARVED or MODELED. Sculpture done in this manner is described as "high relief" or "low relief" depending on the height of the projection (figs. 2-3, 7-37). 2) The apparent projection of forms represented in a painting or drawing.

RESPOND. 1) A half-PIER, PILASTER, or similar element projecting from a wall to support a LINTEL or an ARCH whose other side is supported by a freestanding COLUMN or pier, as at the end of an ARCADE (fig. 8-15). 2) One of several pilasters or half a wall behind a COLONNADE (fig. 7-23) which echoes or "responds to" the columns but is largely decorative. 3) One of the slender shafts of a COMPOUND PIER in a medieval church which seems to carry the weight of the VAULT (figs. 10-13, 11-16).

RHYTON. An ancient drinking horn made from pottery or metal and frequently having a base formed by a human or animal head (fig. 3-29).

RIB. A slender, projecting, archlike member which supports a VAULT either transversely (fig. 10-3) or at the GROINS, thus dividing the surface into sections (fig. 10-13). In Late Gothic architecture, its purpose is often primarily ornamental (fig. 11-27).

RIBBED VAULT. See VAULT.

ROOD SCREEN. See CHOIR SCREEN.

ROSE WINDOW. A large, circular window with stained glass and stone TRACERY, frequently used on FACADES and at the ends of TRANSEPTS of Gothic churches (figs. 11-8, 11-11).

ROSTRUM. 1) A beaklike projection from the prow of an ancient warship used for ramming the enemy. 2) In the Roman FORUM, the raised platform decorated with the beaks of captured ships from which speeches were delivered. 3) A platform, stage, or the like used for public speaking.

S

SACRISTY. A room near the main altar of a church, or a small building attached to a church, where the vessels and vestments required for the service are kept. Also called a vestry.

SANCTUARY. 1) A sacred or holy place or building. 2) An especially holy place within a building, such as the CELLA of a temple or the part of a church around the altar.

SARCOPHAGUS (pl. **SARCOPHAGI**). A large stone coffin usually decorated with sculpture and/or inscriptions (figs. 6-2, 8-21). The term is derived from two Greek words meaning "flesh" and "eating," which were applied to a kind of limestone in ancient Greece, since the stone was said to turn flesh to dust.

SATYR. One of a class of woodland gods thought to be the lascivious companions of Dionysos, the Greek god of wine (or of Bacchus, his Roman counterpart). They are represented as having the legs and tail of a goat, the body of a man, and a head with horns and pointed ears. A youthful satyr is also called a faun.

SCRIPTORIUM (pl. **SCRIPTORIA**). A workroom in a monastery reserved for copying and illustrating MANUSCRIPTS.

SCROLL. 1) An architectural ornament with the form of a partially unrolled spiral, as on the CAPITALS of the Ionic and Corinthian ORDERS (fig. 5-25). 2) A form of written text.

SECTION. An architectural drawing presenting a building as if cut across the vertical plane at right angles to the horizontal plane. Cross section: a cut along the transverse axis. Longitudinal section: a cut along the longitudinal axis.

SEXPARTITE VAULT. See VAULT.

SHAFT. In architecture, the part of a COLUMN between the BASE and the CAPITAL (fig. 5-25).

SIBYLS. In Greek and Roman mythology, any of numerous women who were thought to possess powers of divination and prophecy. They appear on Christian representations, notably in Michelangelo's Sistine ceiling, because they were believed to have foretold the coming of Christ.

SIDE AISLE. A passageway running parallel to the NAVE of a Roman BASILICA or Christian church, separated from it by an ARCADE or COLONNADE (figs. 7-17, 8-4). There may be one on either side of the nave or two, an inner and outer.

SILENI. A class of minor woodland gods in the entourage of the wine god, Dionysos (or Bacchus). Like Silenus, the wine god's tutor and drinking companion, they are thick-lipped and snub-nosed and fond of wine. Similar to SATYRS, they are basically human in form except for having horses' tails and ears (fig. 7-51).

SILVER LEAF. See GOLD LEAF.

SINOPIA (pl. **SINOPIE**). Italian word taken from "Sinope," the ancient city in Asia Minor which was famous for its brick-red pigment. In FRESCO paintings, a full-sized, preliminary sketch done in this color on the first rough coat of plaster or arriccio (fig. 11-87).

SPANDREL. The area between the exterior curves of two adjoining ARCHES or, in the case of a single arch, the area around its outside curve from its springing to its keystone (figs. 7-46, 10-22).

SPHINX. 1) In ancient Egypt, a creature having the head of a man, animal, or bird and the body of a lion; frequently sculpted in monumental form (fig. 2-12). 2) In Greek mythology, a creature usually represented as having the head and breasts of a woman, the body of a lion, and the wings of an eagle. It appears in classical, Renaissance, and Neoclassical art.

SPIRE. Commonly associated with church architecture, a spire is a tall tower that rises high above a roof. Spires are frequently found on GOTHIC structures (fig. 11-6).

STELE. From the Greek word for "standing block." An upright stone slab or pillar with a CARVED commemorative design or inscription (fig. 3-13).

STEREOBATE. The substructure of a classical building, especially a Greek temple (fig. 5-25).

STILL-LIFE. A term used to describe paintings (and sometimes sculpture) that depict inanimate, familiar objects such as household items and food (fig. 7-53).

STILTS. Term for pillars or posts supporting a superstructure; in 20th-century architecture, these are usually of ferroconcrete. Stilted, as in stilted arches, refers to tall supports beneath an architectural member.

STOA. In Greek architecture, a covered COLONNADE, sometimes detached and of considerable length, used as a meeting place or promenade.

STOIC. A member of a school of philosophy founded by Zeno about 300 B.C. and named after the STOA in Athens where he taught. Its main thesis is that man should be free of all passions.

STUCCO. 1) A concrete or cement used to coat the walls of a building. 2) A kind of plaster used for architectural decorations, such as CORNICES and MOLDINGS, or for sculptured RELIEFS (fig. 6-6).

STYLOBATE. A platform or masonry floor above the STEREOBATE forming the foundation for the COLUMNS of a classical temple (fig. 5-25).

STYLUS. From the Latin word *stilus*, a pointed instrument used in ancient times

for writing on tablets of a soft material such as clay.

SUPERIMPOSED ORDERS. Two or more rows of COLUMNS, PIERS, or PILASTERS placed above each other on the wall of a building (fig. 7-11).

T

TABERNACLE. 1) A place or house of worship. 2) A CANOPIED niche or recess built for an image. 3) The portable shrine used by the ancient Jews to house the Ark of the Covenant (fig. 8-2).

TABLINUM. From the Latin word meaning writing tablet or written record. In a Roman house, a room at the far end of the ATRIUM, or between it and the second courtyard, used for keeping family records.

TEMPERA PAINTING. 1) A painting made with pigments mixed with egg yolk and water. In the 14th and 15th centuries, it was applied to PANELS which had been prepared with a coating of GESSO; the application of GOLD LEAF and of underpainting in green or brown preceded the actual tempera painting (figs. 11-81, 11-97). 2) The technique of executing such a painting.

TERRA-COTTA. Italian word for "baked earth." 1) Earthenware, naturally reddish-brown but often GLAZED in various colors and fired. Used for pottery, sculpture, or as a building material or decoration. 2) An object made of this material. 3) Color of the natural material.

TESSERA (pl. **TESSERAE**). A small piece of colored stone, marble, glass, or gold-backed glass used in a MOSAIC (fig. 8-40).

THEATER. In ancient Greece, an outdoor place for dramatic performances, usually semicircular in plan and provided with tiers of seats, the ORCHESTRA, and a support for scenery (fig. 5-41). See also AMPHITHEATER.

THERMAE. A public bathing establishment of the ancient Romans which consisted of various types of baths and social and gymnastic facilities.

THOLOS. In classical architecture, a circular building ultimately derived from early tombs (fig. 5-40).

THRUST. The lateral pressure exerted by an ARCH, VAULT, or DOME which must be counteracted at its point of greatest concentration either by the thickness of the wall or by some form of BUTTRESS.

TRACERY. 1) Ornamental stonework in Gothic windows. In the earlier or plate tracery, the windows appear to have been cut through the solid stone (fig. 10-22). In bar tracery, the glass predominates, the slender pieces of stone having been added within the windows (fig. 11-21). 2) Similar ornamentation using various materials and applied to walls, shrines, facades, etc. (fig. 11-82).

TRANSEPT. A cross arm in a BASILICAN church placed at right angles to the NAVE and usually separating it from the CHOIR or APSE (fig. 8-4).

TREE OF KNOWLEDGE. The tree in the Garden of Eden from which Adam and Eve ate the forbidden fruit which destroyed their innocence.

TREE OF LIFE. A tree in the Garden of Eden whose fruit was reputed to give

everlasting life; in medieval art it was frequently used as a symbol of Christ.

TRIFORIUM. The section of a NAVE wall above the ARCADE and below the CLERESTORY (fig. 11-15). It frequently consists of a BLIND ARCADE with three openings in each bay. When the GALLERY is also present, a four-story ELEVATION results, the triforium being between the gallery and clerestory. It may also occur in the TRANSEPT and the CHOIR walls.

TRIGLYPH. The element of a Doric FRIEZE separating two consecutive METOPES and being divided by channels (or glyphs) into three sections. Probably an imitation in stone of wooden ceiling beam ends (figs. 5-25, 5-31).

TRIPTYCH. An ALTARPIECE or devotional picture, either CARVED or painted, with one central panel and two hinged wings (fig. 8-53).

TRIUMPHAL ARCH. 1) A monumental ARCH, sometimes a combination of three arches, erected by a Roman emperor in commemoration of his military exploits and usually decorated with scenes of these deeds in RELIEF sculpture (fig. 7-46). 2) The great transverse arch at the eastern end of a church that frames ALTAR and APSE and separates them from the main body of the church. It is frequently decorated with MOSAICS or MURAL paintings (fig. 8-15).

TROPHY. 1) In ancient Rome, arms or other spoils taken from a defeated enemy and publicly displayed on a tree, PILLAR, etc. 2) A representation of these objects, and others symbolic of victory, as a commemoration or decoration.

TRUMEAU. A central post supporting the LINTEL of a large doorway, as in a Romanesque or Gothic PORTAL, where it was frequently decorated with sculpture (figs. 10-21, 11-55).

TRUSS. A triangular wooden or metal support for a roof which may be left exposed in the interior (figs. 8-15, 11-33) or be covered by a ceiling (figs. 9-24, 10-18).

TURRET. 1) A small tower, part of a larger structure. 2) A small tower at a corner of a building, often beginning some distance from the ground.

TYMPANUM. 1) In classical architecture, the recessed, usually triangular area, also called a PEDIMENT, often decorated with sculpture (fig. 5-27). 2) In medieval architecture, an arched area between an ARCH and the LINTEL of a door or window, frequently carved with RELIEF sculpture (figs. 10-26, 11-45).

U

UNDERPAINTING. See TEMPERA PAINTING.

V

VAULT. An arched roof or ceiling usually made of stone, brick, or concrete. Several distinct varieties have been developed; all need BUTTRESSING at the point where the lateral THRUST is concentrated. 1) A barrel vault is a semicylindrical structure made up of successive ARCHES (fig. 7-1). It may be straight or ANNULAR in plan (fig. 8-7). 2) A groin vault is the result of the intersection of two barrel vaults of equal size which produces a BAY of four compartments with sharp edges, or groins, where the two meet (fig. 7-1). 3) A ribbed groin vault is one in which RIBS are added to the groins for structural strength and for decoration (fig. 10-12). When the diagonal ribs are constructed as half-circles, the resulting form is a domical ribbed vault (fig. 10-16). 4) A sexpartite vault is a ribbed groin vault in which each bay is divided into six compartments by the addition of a transverse rib across the center (figs. 10-12, 10-13). 5) The normal Gothic vault is quadripartite with all the arches pointed to some degree (fig. 11-16). 6) A fan vault is an elaboration of a ribbed groin vault, with elements of TRACERY using conelike forms. It was developed by the English in the 15th century and was employed for decorative purposes (figs. 11-28, 11-29).

VELLUM. See PARCHMENT.

VESTRY. See SACRISTY.

VICES. Often represented allegorically in conjunction with the seven VIRTUES, they include Pride, Avarice, Wrath, Gluttony, Unchastity (Luxury), Folly, and Inconstancy, though others such as Injustice are sometimes substituted.

VICTORY. See NIKE.

VILLA. Originally a large country house but in modern usage also a detached house or suburban residence. See DOMUS.

VIRTUES. The three theological virtues, Faith, Hope, and Charity, and the four cardinal ones, Prudence, Justice, Fortitude, and Temperance, were frequently represented allegorically, particularly in medieval manuscripts and sculpture.

VOLUTE. A spiraling architectural element found notably on Ionic and Composite CAPITALS (figs. 5-23, 5-37, 7-2) but also used decoratively on building FACADES and interiors.

VOUSSOIR. See ARCH.

W

WATERCOLOR PAINTING. Painting, usually on paper, in pigments suspended in water.

WESTWORK. From the German word *Westwerk*. In Carolingian, Ottonian, and German Romanesque architecture, a monumental western front of a church, treated as a tower or combination of towers and containing an entrance and vestibule below and a CHAPEL and GALLERIES above. Later examples often added a TRANSEPT and a CROSSING tower (fig. 9-21).

WING. The side panel of an ALTARPIECE which is frequently decorated on both sides and is also hinged, so that it may be shown either open or closed.

Z

ZIGGURAT. From the Assyrian word *ziqquratu*, meaning "mountaintop" or "height." In ancient Assyria and Babylonia, a pyramidal tower built of mud brick and forming the BASE of a temple; it was either stepped or had a broad ascent winding around it, which gave it the appearance of being stepped (figs. 3-1, 3-4).

ZODIAC. An imaginary belt circling the heavens, including the paths of the sun, moon, and major planets and containing 12 constellations and thus 12 divisions called signs, which have been associated with the months. The signs are: Aries, the ram; Taurus, the bull; Gemini, the twins; Cancer, the crab; Leo, the lion; Virgo, the virgin; Libra, the balance; Scorpio, the scorpion; Sagittarius, the archer; Capricorn, the goat; Aquarius, the water-bearer; and Pisces, the fish. They are frequently represented around the PORTALS of Romanesque and Gothic churches in conjunction with the LABORS OF THE MONTHS (figs. 10-26, 11-49)

Art and Architecture Websites

The directory below is made up mainly of the significant museums that provided illustrations for this book. A few additional art sites are also listed for your reference. All efforts have been made to gather up-to-date addresses, phone numbers, and Websites. Contact information is current as of the time of printing.

UNITED STATES

For additional information or to find out about museums not listed here, visit the following Websites:
http://www.amn.org
http://www.artcom.com
http://www.artmuseum.net
http://icom.museum/
http://www.museumstuff.com
http://www.world-arts-resources.com

ARIZONA
Center for Creative Photography
University of Arizona
1030 N. Olive Rd., Tucson 85719
(520) 621-7968
http://dizzy.library.arizona.edu/
branches/ccp

The Heard Museum
2301 N. Central Ave.
Phoenix 85004
(602) 252-8840
http://www.heard.org

Phoenix Art Museum
1625 N. Central Ave.
Phoenix 85004
(602) 257-1222
http://www.phxart.org

Tucson Museum of Art
140 N. Main Ave.
Tucson 85701
(520) 624-2333
http://www.tucsonarts.com

CALIFORNIA
Berkeley Art Museum and Pacific Film Archive University of California
2626 Bancroft Way
Berkeley 94704
(510) 642-0808
http://www.bampfa.berkeley.edu

Crocker Museum of Art
216 O St., Sacramento 95814
(916) 264-5423
http://www.crockerartmuseum.org

The Fine Arts Museums of San Francisco
California Palace of the Legion of Honor
Lincoln Park, near 34th Ave. and
Clement St.San Francisco 94122
(415) 863-3330

M. H. de Young Memorial Museum
75 Tea Garden Dr., Golden Gate Park
San Francisco 94118
(415) 863-3300
http://www.famsf.org

Huntington Library, Art Collections, and Botanical Gardens
1151 Oxford Rd., San Marino 91108
(626) 405-2141
http://www.huntington.org

Iris and B. Gerald Cantor Center for Visual Arts at Stanford University
Lomita Dr. at Museum Way
Stanford 94305
(650) 723-4177
http://www.huntington.org

The J. Paul Getty Museum
The Getty Center
1200 Getty Center Dr.
Los Angeles 90049
(310) 440-7300
http://www.getty.edu/museum

Los Angeles County Museum of Art
5905 Wilshire Blvd.
Los Angeles 90036
(213) 857-6111
http://www.lacma.org

The Museum of Contemporary Art, Los Angeles
250 S. Grand Ave.
Los Angeles 90012
(213) 382-6222
http://www.MOCA-LA.org

Museum of Contemporary Art, San Diego
1001 Kettner Blvd.
San Diego 92101
(619) 234-1001
http://www.mcasandiego.org

Norton Simon Museum
411 W. Colorado Blvd.
Pasadena 91105
(626) 449-6840
http://www.nortonsimon.org

San Diego Museum of Art
1450 El Prado, San Diego 92101
(619) 232-7931
http://www.sdmart.com

San Francisco Museum of Modern Art
151 3rd St., San Francisco 94103
(415) 357-4000
http://www.sfmoma.org

San Jose Museum of Art
110 S. Market St., San Jose 95113
(408) 294-2787
http://www.sjmusart.org

Santa Barbara Museum of Art
1130 State St., Santa Barbara 93101
(805) 963-4364
http://www.sbmuseart.org

COLORADO
Colorado Springs Fine Arts Center
30 W. Dale St.,
Colorado Springs 80903
(719) 634-5581
http://www.csfineartscenter.org

The Denver Art Museum
100 W. 14th Avenue Pkwy.
Denver 80204
(303) 640-2295
http://www.denverartmuseum.org

CONNECTICUT
Wadsworth Atheneum
600 Main St., Hartford 06103
(860) 278-2670
http://www.wadsworthatheneum.org

Yale Center for British Art
1080 Chapel St. , New Haven 06520
(203) 432-2800
http://www.yale.edu/ycba

Yale University Art Gallery
1111 Chapel St., New Haven 06520
(203) 432-0600
http://www.yale.edu/artgallery

DELAWARE
Delaware Art Museum
2301 Kentmere Pkwy
Wilmington 19806
(302) 571-9590
http://www.delart.org

DISTRICT OF COLUMBIA
The Corcoran Gallery of Art
500 17th St. NW, 20006
(202) 639-1700
http://www.corcoran.org

Freer Gallery of Art and Arthur M. Sackler Gallery, The National Museum of Asian Art for the United States, Smithsonian Institution
12th St. & Jefferson Dr. SW, 20560
(202) 357-4880
http://www.si.edu/asia

Hirshhorn Museum and Sculpture Garden, Smithsonian Institution
Independence Ave. & 7th St. SW, 20560
(202) 357-1300
http://hirshhorn.si.edu

National Gallery of Art
600 Constitution Ave. NE, 20565
(202) 737-4215
http://www.nga.gov

National Museum of American Art, Smithsonian Institution
8th & G St. NW, 20560
(202) 357-1300
Renwick Gallery
Pennsylvania Ave. at
17th St. NW, 20006
(202) 357-2700
http://www.nmaa.si.edu

National Museum of Women in the Arts
1250 New York Ave. NW, 20005
(202) 783-5000
http://www.nmwa.org

National Portrait Gallery, Smithsonian Institution
910 F St. NW, 20560
(202) 357-1300
http://www.npg.si.edu

The Phillips Collection
1600 21st St. NW, 20009
(202) 387-2151
http://www.phillipscollection.org

FLORIDA
John and Mable Ringling Museum of Art
5401 Bay Shore Rd., Sarasota 34243
(941) 359-5700
http://www.ringling.org

Lowe Art Museum, University of Miami
1301 Stanford Dr., Miami 33124
(305) 284-3535
http://www.lowemuseum.org

Saint Petersburg Museum of Fine Arts
255 Beach Dr. NE,
Saint Petersburg 33701
(727) 896-2667
http://www.fine-arts.org

GEORGIA
Georgia Museum of Art, University of Georgia
Jackson St., North Campus
Athens 30602
(706) 542-GMOA
http://www.uga.edu/gamuseum

High Museum of Art
1280 Peachtree St. NE, Atlanta 30309
(404) 733-4400
http://www.high.org

Michael C. Carlos Museum, Emory University, 571 S. Kilgo St.
Atlanta 30322
(404) 727-4282/0573
http://www.emory.edu/CARLOS

HAWAII
Honolulu Academy of Arts
900 S. Beretania St., Honolulu 96814
(808) 532-8700
http://www.honoluluacademy.org

ILLINOIS
The Art Institute of Chicago
111 S. Michigan Ave., Chicago 60603
(312) 443-3600
http://www.artic.edu

Krannert Art Museum, University of Illinois
500 E. Peabody Dr., Champaign 61820
(217) 333-1860
http://www.art.uiuc.edu/galleries/kam/
index.html

Museum of Contemporary Art
220 E. Chicago Ave., Chicago 60611
(312) 280-2660
http://www.mcachicago.org

Oriental Institute Museum,
The University of Chicago
1155 E. 58th St., Chicago 60637
(773) 702-9521
http://www.oi.uchicago.edu

Terra Museum of American Art
666 N. Michigan Ave., Chicago 60611
(312) 664-3939
http://www.terramuseum.org

INDIANA
Indiana University Art Museum,
Indiana University
Bloomington 47405
(812) 855-5445
http://www.indiana.edu/~iuam

Indianapolis Museum of Art
1200 W. 38th St., Indianapolis 46208
(317) 923-1331
http://www.ima-art.org

The Snite Museum of Art,
University of Notre Dame
Notre Dame 46556
(219) 631-5466
http://www.nd.edu/~sniteart

IOWA
Cedar Rapids Museum of Art
410 Third Ave. SE, Cedar Rapids 52401
(319) 366-7503
http://www.crma.org

University of Iowa Museum of Art
150 N. Riverside Dr., Iowa City 52242
(319) 335-1727
http://www.uiowa.edu/~artmus

KANSAS
Spencer Museum of Art,
University of Kansas
1301 Mississippi St., Lawrence 66045
(785) 864-4710
http://www.ukans.edu/~sma

Wichita Art Museum
619 Stackman Dr., Wichita 67203
(316) 268-4921
http://www.wichitaartmuseum.org

KENTUCKY
J. B. Speed Art Museum
2035 S. 3rd St., Louisville 40208
(502) 634-2700
http://www.speedmuseum.org

University of Kentucky Art Museum
Singletary Center for the Arts
Rose St. and Euclid Ave.
Lexington 40506
(606) 257-5716
http://www.uky.edu/ArtMuseum

LOUISIANA
The Alexandria Museum of Art
933 Main Street, Alexandria 71309
(318) 443-3458
http://www.themuseum.org

The Contemporary Art Center
900 Camp St., New Orleans 70130
(504) 528-3800
http://www.cacno.org

New Orleans Museum of Art
1 Collins Diboll Circle, City Park
New Orleans 70124
(504) 488-2631
http://www.noma.org

MAINE
Bowdoin College Museum of Art
Walker Art Building, Brunswick 04011
(207) 725-3275
http://www.academic.bowdoin.edu/
 artmuseum

Portland Museum of Art
7 Congress Sq., Portland 04101
(207) 775-6148; (800) 639-4067
http://www.portlandmuseum.org

MARYLAND
The Baltimore Museum of Art
Art Museum Dr. at North Charles and
31st Sts., Baltimore 21218
(410) 396-7100
http://www.artbma.org

Walters Art Gallery
600 N. Charles St., Baltimore 21201
(410) 547-9000; 547-ARTS
http://www.thewalters.org

MASSACHUSETTS
Addison Gallery of American Art,
Phillips Academy
Andover 01810
(508) 749-4015
http://www.andover.edu/addison

Davis Museum and Cultural Center,
Wellesley College
106 Central St., Wellesley 02181
(617) 283-2051
http://www.wellesley.edu/Davis
 Museum/davismenu.html

Harvard University Art Museums
The Arthur M. Sackler Museum
485 Broadway
Cambridge 02138
(617) 495-9400
Busch-Reisinger Museum
32 Quincy St.
Fogg Art Museum
32 Quincy St.
http://www.artmuseums.harvard.edu

Isabella Stewart Gardner Museum
280 The Fenway, Boston 02115
(617) 566-1401
http://www.boston.com/gardner

Mead Art Museum, Amherst College
Amherst 01002
(413) 542-2335
http://www.amherst.edu/~mead

Mount Holyoke College Art Museum
South Hadley 01075
(413) 538-2245
http://www.mtholyoke.edu/offices/
 artmuseum

Museum of Fine Arts, Boston
465 Huntington Ave., Boston 02115
(617) 267-9300
http://www.mfa.org

Peabody Essex Museum
East India Square, Salem 01970
(508) 745-1876
http://www.pem.org

Rose Art Museum, Brandeis University
415 South St., Waltham 02254
(617) 736-3434
http://www.brandeis.edu/rose

Smith College Museum of Art
Elm St. at Bedford Terrace
Northampton 01063
(413) 585-2760
http://www.smith.edu/artmuseum

Sterling and Francine Clark
Art Institute
225 South St., Williamstown 01267
(413) 458-9545
http://www.clarkart.edu

Williams College Museum of Art
Main St., Williamstown 01267
(413) 597-2429
http://www.williams.edu/WCMA

Worcester Art Museum
55 Salisbury St., Worcester 01609
(508) 799-4406
http://www.worcesterart.org

MICHIGAN
The Detroit Institute of Arts
5200 Woodward Ave., Detroit 48202
(313) 833-7900
http://www.dia.org

Grand Rapids Art Museum
155 Division North
Grand Rapids 49503
(616) 459-4677
http://www.gramonline.org

The University of Michigan,
Museum of Art
525 S. State St., Ann Arbor 48109
(313) 764-0395
http://www.umich.edu/~umma

MINNESOTA
The Minneapolis Institute of Arts
2400 3rd Ave. S., Minneapolis 55404
(612) 870-3131; 870-3200
http://www.artsMIA.org

Walker Art Center
Vineland Pl., Minneapolis 55403
(612) 375-7622
http://www.walkerart.org

MISSOURI
The Nelson-Atkins Museum of Art
4525 Oak St., Kansas City 64111
(816) 561-4000
http://www.nelson-atkins.org

The Saint Louis Art Museum
1 Fine Arts Dr., Forest Park
St. Louis 63110
(314) 721-0072
http://www.slam.org

NEBRASKA
Joslyn Art Museum
2200 Dodge St., Omaha 68102
(402) 342-3300
http://www.joslyn.org

Sheldon Memorial Art Gallery and
Sculpture Garden, University of
Nebraska–Lincoln
12th and R Sts., Lincoln 68588
(402) 472-2461
http://sheldon.unl.edu

NEW HAMPSHIRE
Hood Museum of Art,
Dartmouth College
Wheelock St., Hanover 03755
(603) 646-2808
http://www.dartmouth.edu/~hood

NEW JERSEY
The Art Museum, Princeton University
Princeton 08544
(609) 258-3788
http://www.princetonartmuseum.org

Jane Voorhees Zimmerli Art Museum,
Rutgers–The State University of
New Jersey
Hamilton and George Sts.
New Brunswick 08903
(732) 932-7237
http://www.zimmerlimuseum.rutgers.
 edu

The Montclair Art Museum
3 S. Mountain Ave. at Bloomfield Ave.
Montclair 07042
(201) 746-5555
http://www.montclair-art.com

The Newark Museum
49 Washington St.
Newark 07101
(973) 596-6500; (800) 7MUSEUM
http://www.newarkmuseum.org

NEW MEXICO
Georgia O'Keeffe Museum
217 Johnson St. , Santa Fe 87501
(505) 995-0785
http://www.okeeffemuseum.org

Millicent Rogers Museum
1504 Millicent Rogers Rd., Taos 87571
(505) 758-2462
http://www.millicentrogers.com

NEW YORK
Albright-Knox Art Gallery
1285 Elmwood Ave.,
Buffalo 14222
(716) 882-8700
http://www.albrightknox.org

Museum of Contemporary
Arts and Design
[formerly American Craft Museum]
40 W. 53rd St., New York 10019
(212) 956-3535
http://www.americancraftmuseum.org

The Brooklyn Museum
200 Eastern Pkwy.,
Brooklyn 11238
(718) 638-5000
http://www.brooklynart.org

Cooper-Hewitt National Design
Museum, Smithsonian Institution
2 E. 91st St., New York 10128
(212) 860-6868
http://www.si.edu/ndm

Everson Museum of Art
401 Harrison St., Syracuse 13202
(315) 474-6064
http://www.everson.org

The Frick Collection
1 E. 70th St., New York 10021
(212) 288-0700
http://www.frick.org

George Eastman House, International
Museum of Photography and Film
900 East Ave., Rochester 14607
(716) 271-3361
http://www.eastman.org

The Grey Art Gallery,
New York University
100 Washington Sq. East
New York 10003
(212) 998-6780
http://www.nyu.edu/greyart

Herbert F. Johnson Museum of Art,
Cornell University
Ithaca 14853
(607) 255-6464
http://www.museum.cornell.edu

International Center of Photography
Midtown
1133 Avenue of the Americas
New York 10036
(212) 860-1783
Uptown
1130 5th Ave., New York 10028
(212) 860-1777
http://www.icp.org

The Jewish Museum
1109 5th Ave., New York 10128
(212) 423-3200
http://www.jewishmuseum.org

Memorial Art Gallery,
University of Rochester
500 University Ave., Rochester 14607
(716) 473-7720
http://mag.rochester.edu

The Metropolitan Museum of Art
1000 5th Ave. at 82nd St.
New York 10028
(212) 879-5500
The Cloisters
Fort Tryon Park, New York 10040
(212) 923-3700
http://www.metmuseum.org

Munson-Williams-Proctor Institute
Museum of Art
310 Genesee St., Utica 13502
(315) 797-0000
http://www.mwpi.edu

The Museum of Modern Art
11 W. 53rd St., New York 10019
(212) 708-9400
http://www.moma.org

Neuberger Museum of Art, State
University of New York at Purchase
735 Anderson Hill Rd., Purchase 10577
(914) 251-6133
http://www.neuberger.org

The New Museum of Contemporary Art
583 Broadway, New York 10012
(212) 219-1222
http://www.newmuseum.org

The Pierpont Morgan Library
29 E. 36th St., New York 10016
(212) 685-0008
http://www.morganlibrary.org

Solomon R. Guggenheim Museum
1071 5th Ave., New York 10128
(212) 423-3500
http://www.guggenheim.org

Storm King Art Center
Old Pleasant Hill Rd.
Mountainville 10953
(914) 534-3115
http://www.stormkingartcenter.org

The Studio Museum in Harlem
144 W. 125th St., New York 10027
(212) 864-4500
http://www.studiomuseuminharlem.org

Whitney Museum of American Art
945 Madison Ave., New York 10021
(212) 570-3676
http://www.whitney.org

NORTH CAROLINA
The Ackland Art Museum,
University of North Carolina,
Chapel Hill
Columbia and Franklin Sts.
Chapel Hill 27599
(919) 966-5736
http://www.ackland.org

Duke University Museum of Art
Buchanan Blvd. at Trinity
East Campus, Durham 27708
(919) 684-5135
http://www.duke.edu/duma

North Carolina Museum of Art
2110 Blue Ridge Rd., Raleigh 27607
(919) 833-1935
http://www.ncmoa.org

OHIO
Allen Memorial Art Museum,
Oberlin College
87 N. Main St., Oberlin 44074
(440) 775-8665
http://www.oberlin.edu/allenart

The Butler Institute of American Art
524 Wick Ave.
Youngstown 44502
(216) 743-1711
http://www.butlerart.com

Cincinnati Art Museum
Eden Park, Cincinnati 45202
(513) 721-5204
http://www.cincinnatiartmuseum.com

The Cleveland Museum of Art
11150 E. Blvd., Cleveland 44106
(216) 421-7340
http://www.clemusart.com

The Columbus Museum of Art
480 E. Broad St., Columbus 43215
(614) 221-6801
http://www.columbusmuseum.org

Dayton Art Institute
456 Belmonte Park N.,
Dayton 45405
(513) 223-5277
http://www.daytonartinstitute.org

The Taft Museum
316 Pike St., Cincinnati 45202
(513) 241-0343
http://www.taftmuseum.org

The Toledo Museum of Art
2445 Monroe St.,
Toledo 43620
(419) 255-8000; (800) 644-6862
http://www.toledomuseum.org

Wexner Center for the Arts,
The Ohio State University
North High St. at 15th Ave.
Columbus 43210
(614) 292-3535
http://www.wexarts.org

OKLAHOMA
Gilcrease Museum
1400 Gilcrease Museum Rd., Tulsa 74127
(918) 596-2700
http://www.gilcrease.org

The Philbrook Museum of Art
2727 S. Rockford Rd., Tulsa 74114
(918) 749-7941
http://www.philbrook.org

OREGON
Portland Art Museum
1219 SW Park Ave., Portland 97205
(503) 226-2811
http://www.pam.org

The University of Oregon,
Museum of Art
1223 University of Oregon, Eugene 97403
(541) 346-3027
http://uoma.uoregon.edu

PENNSYLVANIA
The Andy Warhol Museum
117 Sandusky St., Pittsburgh 15212
(412) 237-8300
http://www.warhol.org

Barnes Foundation
300 North Natch's Ln.
Merion Station 19066
(610) 667-0290
http://www.barnesfoundation.org

The Carnegie Museum of Art
4400 Forbes Ave.,
Pittsburgh 15213
(412) 622-3131
http://www.cmoa.org

Institute of Contemporary Art,
University of Pennsylvania
118 S. 36th St., Philadelphia 19104
(215) 898-7108
http://www.icaphila.org

Museum of American Art,
Pennsylvania Academy of the Fine Arts
118 N. Broad St., Philadelphia 19102
(215) 972-7600
http://www.pafa.org

Philadelphia Museum of Art
26th St. and Benjamin Franklin Pkwy.
Philadelphia 19130
(215) 763-8100
http://www.philamuseum.org

University of Pennsylvania Museum of
Archaeology and Anthropology
33rd and Spruce Sts.
Philadelphia 19104
(215) 895-4000
http://www.upenn.edu/museum

RHODE ISLAND
Museum of Art,
Rhode Island School of Design
224 Benefit St.
Providence 02903
(401) 454-6500
http://www.risd.edu/museum.cfm

SOUTH CAROLINA
The Columbia Museum of Art
Main and Hampton Sts., Columbia 29202
(803) 799-2810
http://www.colmusart.org

Greenville County Museum of Art
420 College St., Greenville 29601
(864) 271-7570
http://www.greenvillemuseum.org

TENNESSEE
Knoxville Museum of Art
410 10th Ave., World's Fair Park
Knoxville 37916
(615) 525-6101
http://www.knoxart.org

Memphis Brooks Museum of Art
Overton Park, 1934 Poplar Ave.
Memphis 38104
(901) 722-3500
http://www.brooksmuseum.org

TEXAS
Amon Carter Museum
3501 Camp Bowie Blvd. ,
Fort Worth 76107
(817) 738-1933
http://www.cartermuseum.org

Contemporary Arts Museum
5216 Montrose Blvd., Houston 77006
(713) 526-0773
http://www.camh.org

Dallas Museum of Art
1717 N. Harwood , Dallas 75201
(214) 922-1200
http://www.dm-art.org

Kimbell Art Museum
3333 Camp Bowie Blvd.
Fort Worth 76107
(817) 332-8451
http://www.kimbellart.org

Marion Koogler McNay Art Museum
6000 N. New Braunfels Ave.
San Antonio 78209
(210) 824-5368
http://www.mcnayart.org

The Menil Collection
1515 Sul Ross, Houston 77006
http://www.menil.org

Rothko Chapel
3900 Yupon at Sul Ross, Houston 77006
(713) 524-9839
http://www.menil.org/rothko.html

Modern Art Museum of Fort Worth
1309 Montgomery St. at Camp
Bowie Blvd.
Fort Worth 76107
(817) 738-9215
http://www.mamfw.org

The Museum of Fine Arts, Houston
1001 Bissonnet St.
Houston 77005
(713) 639-7300
http://www.mfah.org

San Antonio Museum of Art
200 W. Jones St.
San Antonio 78215
(210) 978-8100
http://www.samuseum.org

VIRGINIA

The Chrysler Museum
245 W. Olney Rd., Norfolk 23510
(804) 664-6200
http://www.chrysler.org

Hampton University Museum
Hampton 23668
(804) 727-5308
http://www.hamptonu.edu/museum

Monticello
Charlottesville 22902
(804) 984-9822
http://www.monticello.org

Virginia Museum of Fine Arts
2800 Grove Ave.
Richmond 23221
(804) 367-0844
http://www.vmfa.state.va.us

WASHINGTON

Seattle Art Museum
100 University St., Seattle 98101
(206) 625-8900; 654-3100
http://www.seattleartmuseum.org

Tacoma Art Museum
12th and Pacific Ave.,
Tacoma 98402
(206) 272-4258
http://www.tacomaartmuseum.org

WISCONSIN

Milwaukee Art Museum
750 N. Lincoln Memorial Dr.
Milwaukee 53202
(414) 224-3200
http://www.mam.org

OUTSIDE THE UNITED STATES

AUSTRIA
For more information, visit
http://info.wien.at

Graphische Sammlung Albertina
1, Makartgasse 3, 1010 Vienna
581 306021
http://www.albertina.at

Kunsthistoriches Museum
1., Maria-Theresien-Platz,
1010 Vienna
431 525240
http://www.khm.at

Museum Moderner Kunst Stifflung Ludwig
Arsenalstr. 1, Vienna
431 7996900
http://www.mmkslw.or.at

Österreichische Galerie Belvedere
3, Prinz. Eugen. Str. 27, 1037 Vienna
79557134
http://www.belvedere.at

BELGIUM
For more information, visit
http://www.gotim.be/artexpo

Groeningemuseum, Stedelijke Musea
Dijver 12, 8000 Brugge
(05) 044.87.11

Musées Royaux des Beaux-Arts de Belgique
Musée Royaux d'Art et d'Histoire
10 Parc du Cinquantenaire, 1040 Brussels
(02) 741.72.11
Musées d'Art Moderne
1–2, Place Royale, 1000 Brussels
(02) 508.32.11
Musée d'Art Ancien
3 rue de la Régence, 1000 Brussels
(02) 508.33.33

CANADA

Art Gallery of Ontario
317 Dundas St. W.
Toronto, Ontario M5S 2C6
(416) 977-6648
http://www.ago.on.ca

Glenbow
130 9th Ave., SE
Calgary, Alberta T2G 0P3
(403) 268-4100
http://www.glenbow.org

Montreal Museum of Fine Arts
1379–80 Sherbrook St. W.
Montréal, Quebec H36 2T9
(514) 285-1600; 285-2000
http://www.mmfa.qc.ca

National Gallery of Canada
380 Sussex Dr.
Ottawa, Ontario K1N 9N4
(613) 990-1985
http://national.gallery.ca

Royal Ontario Museum
100 Queen's Park
Toronto, Ontario M5S 2C6
(416) 586-5549
http://www.rom.on.ca

Vancouver Art Gallery
750 Hornby St.
Vancouver, British Columbia V6Z 2H7
(604) 662-4719
http://www.vanartgallery.bc.ca

DENMARK

Louisiana Museum of Modern Art
Gl. Strandvej 13, 3050 Humlebaek
(45) 49190719
http://www.louisiana.dk

Ny Carlsberg Glyptotek
Dantes Plads 7, 1556 Copenhagen
(45) 33418141
http://www.glyptoteket.dk

EGYPT

Egyptian Museum
Maydan El Tahrir, Cairo
(02) 57 42 681
http://www.egyptianmuseum.gov.eg

FRANCE
For more information, visit
http://www.tourisme.fr

Bibliothèque Nationale de France
25 rue de Richelieu, Paris 75002
01.47.03.81.26
http://www.bnf.fr

Centre National d'Art et de Culture Georges Pompidou
Rue du Renard, Paris 75191
01.44.78.12.33
http://www.centrepompidou.fr

Château de Versailles
Versailles
01.30.84.74.00
http://www.chateauversailles.fr

Grand Palais
Ave. Winston Churchill, Paris
01.44.13.17.17

Musée de l'Orangerie
Jardin des Tuileries,
Palace de la Concorde, Paris
01.42.97.48.16

Musée des Antiquités Nationales
Château de Saint-Germain-en-Laye,
Saint-Germain-en-Laye 78103
01.34.51.53.65
http://www.musee-antiquitesnationales.fr

Musée des Beaux-Arts, Lyon
Palais St. Pierre,
20 place des Terreaux,
Lyon 69001
04.72.10.17.40

Musée d'Orsay
1 rue de Bellechasse, Paris 75007
01.40.49.48.14
http://www.musee-orsay.fr

Musée du Louvre
Rue de Rivoli, Paris 75058
01.40.20.51.51
http://www.louvre.fr

Musée d'Unterlinden
1 rue des Unterlinden,
Colmar 68000
03.89.20.15.50
http://www.musee-unterlinden.com

Musée Picasso
Hôtel Salé, 5 rue de Torigny, Paris 75003
01.42.71.25.21

Musée Rodin
77 rue de Varenne, Paris 75007
01.44.18.61.10
http://www.musee-rodin.fr

GERMANY

Alte Pinakothek
Barer Str. 27, 80333 Munich
(089) 23805216
http://www.stmukwk.bayern.de/kunst/museen/pinalt.html

Brücke-Museum Berlin
Bussardsteig 9, Berlin 14195
(030) 8312029
http://www.bruecke-museum.de

Hamburger Kunsthalle
Glockengiesserwall,
20095 Hamburg
(040) 24862612
http://www.hamburger-kunsthalle.de

Museum Ludwig
Bischofsgartenstr. 1,
50667 Cologne
(0221) 2212379
http://www.museenkoeln.de/ludwig

Staatliche Antikensammlungen und Glyptothek, Munich
Konigspl 1–3, 80333 Munich
(089) 598359; 286100

Staatliche Graphische Sammlung, Munich
Meiserstr. 10, 80333 Munich
(089) 28927030

Staatliche Kunsthalle, Karlsruhe
Hans-Thoma-Str. 2–6,
76133 Karlsruhe
(0721) 9263355
http://www.kunsthalle-karlsruhe.de

Staatliche Museen zu Berlin
(17 museums in different locations)
http://www.smb.spk-berlin.de

Staatsgalerie Stuttgart
Konrad-Adenauer Str. 30–32,
70173 Stuttgart
(0711) 212 4050
http://www.staatsgalerie.de

Städelsches Kunstinstitut und Städtische Galerie, Frankfurt-am-Main
Schaumainkai 63,
60596 Frankfurt-am-Main
(069) 6050980

GREAT BRITAIN
For more information, visit
http://www.artguide.org

Apsley House, The Wellington Museum
149 Piccadilly, Hyde Park Corner,
London N1V 9FA
(0171) 4995676
http://www.vam.ac.uk/vastatic/microsites/apsley

Ashmolean Museum of Art and Archaeology
Beaumont St., Oxford 0X1 2PH
(01865) 278000
http://www.ashmol.ox.ac.uk

Birmingham City Museum and Art Gallery
Chamberlain Sq.,
Birmingham B3 3DH
(0121) 3032834
http://www.birmingham.gov.uk/bmag

Blenheim Palace
Woodstock, Oxfordshire 0X20 1PX
(01993) 811091
http://www.blenheimpalace.com

British Library
Great Russell St.,
London WC1B 3DG
(0171) 3237595
http://portico.bl.uk

British Museum
Great Russell St.,
London WC1B 3DG
(0171) 6361555
http://www.british-museum.ac.uk

Courtauld Institute Galleries
Somerset House, Strand, London
WC2R 0RN
(0171) 8732526
http://www.courtauld.ac.uk

The National Gallery
Trafalgar Square,
London WC2N 5DN
(0171) 8393321
http://www.nationalgallery.org.uk

National Gallery of Scotland
The Mound, Edinburgh EH2 2EL
(0131) 5568921
http://www.natgalscot.ac.uk

Royal Academy of Arts
Burlington House, Piccadilly,
London W1V 0DS
(0171) 4397438
http://www.royalacademy.org.uk

Sir John Soane's Museum
13 Lincoln's Inn Fields,
London WC2A 3BP
(0171) 4052107
http://www.soane.org

Tate Gallery
Millbank, London SW1P 4RG
(0171) 8878000
http://www.tate.org.uk

Victoria and Albert Museum
Cromwell Rd., South Kensington,
London SW7 2R
(0171) 9388365
http://www.vam.ac.uk

GREECE
For more information, visit
http://www.culture.gr

Acropolis Museum
Athens
01 3214172
http://www.culture.gr/2/21/211/21101m/
e211am01.html

Corfu Archaeological Museum
Corfu 49100
0661 30680
Delphi Archaeological Museum
Delphi 33054
0265 82312

Eleusis Archaeological Museum
Eleusis
01 3463552

Heraklion Archaeological Museum
Xanthoudidou St. 1, Crete
081 226092

National Archaeological Museum of Athens
Patission 44 St., Athens 10682
01 8217717
http://www.culture.gr/2/21/214/21405m/
c21405m1.html

IRELAND
For more information, visit
http://www.artguide.org

National Gallery of Ireland
Merrion Square W., Dublin 2
(01) 6615133
http://www.nationalgallery.ie

ITALY
Galleria Borghese
Piazzale Scipione Borghese 5,
Rome 00197
(06) 858577
http://www.galleriaborghese.it

Galleria degli Uffizi
Piazza degli Uffizi 6, Florence 50122
(055) 2388651
http://www.uffizi.firenze.it

Galleria dell'Academia, Florence
Via Ricasoli 58–60, Florence 50122
(055) 238809
http://www.sbas.firenze.it/accademia

Galleria dell'Academia, Venice
Campo della Carità, Venice 30121
(041) 22247

Galleria Nazionale d'Arte Antica
Via delle Quattro Fontane 13,
Rome 00184
(06) 4824184

Musei Capitolini
Piazza del Campidoglio, Rome 00186
(06) 67102475

Museo Archeologico Nazionale
Piazza Museo 19, Naples 80135
(081) 440166
http://www.cib.na.cnr.it/remuna/mann/
mann.html

Museo Archeologico Nazionale di Firenze
Via della Colonna 38,
Florence 50121
(055) 23575

Museo Civico Archeologico
Via de' Musei, Bologna 840124
(051) 233849

**http://www.comune.bologna.it/bologna/
Musei/Archeologico**
Museo Civico Cristiana
Via Musei, 81, Brescia 25100
(030) 44327

Museo e Gallerie Nazionale di Capodimonte
Palazzo di Capodimonte,
Naples 80136
(081) 7410801
http://www.cib.na.cnr.it/remuna/capod/
indice.html

Museo Nazionale del Bargello
Via del Proconsolo 4, Florence 5012
(055) 210801
http://www.thais.it/scultura/fmndb1.htm

Museo Nazionale di Villa Giulia
Piazza di Villa Giulia 9, Rome 00195
(06) 350719

Peggy Guggenheim Collection
Palazzo Venier dei Leoni,
701 Dorsoduro,
30123 Venice
(041) 2450 411
http://www.guggenheim-venice.it

Vatican Museums
Viale Vaticano 00165,
Città del Vaticano 00120
(06) 69884947
http://www.christusrex.org/www1/
vaticano/0-Musei.html

THE NETHERLANDS
For more information, visit
http://www.hollandmuseums.nl

Centraal Museum Utrecht
Agnietenst. 1
3500 Utrecht
(030) 2362362
http://www.centraalmuseum.nl

Frans Halsmuseum
Groot Heiligland 62,
2011 ES Haarlem
(020) 5115775
http://www.franshalsmuseum.nl

Kröller-Müller Museum
Houtkampweg 6,
6731 AW Otterlo
(0318) 591041
http://www.kmm.nl

Museum Boijmans Van Beuningen
Museumpark 18–20,
3015 CX Rotterdam
(010) 4419400
http://boijmans.kennisnet.nl

Rijksmuseum
Stadhouderskade 42,
1071 Amsterdam
(020) 6732121
http://www.rijksmuseum.nl

Rijksmuseum Vincent van Gogh
Paulus Potterstraat 7,
1071 CX Amsterdam
(020) 5705200
http://www.vangoghmuseum.nl

Stedelijk Museum of Modern Art
Paulus Potterstraat 13,
1070 AB Amsterdam
(020) 5732911
http://www.stedelijk.nl

NORWAY

Nasjonalgalleriet
Universitetsgaten 13,
Oslo 0033
22 20 04 04
http://www.museumsnett.no/
nasjonalgalleriet

PORTUGAL
Museu Calouste Gulbenkian
Av. de Berna 45 A (1)
1093 Lisboa
(01) 76 50 61
http://www.gulbenkian.pt

RUSSIA
Hermitage Museum
36 Dvortsovaya Naberezhnaya,
Saint Petersburg
(812) 110 96 25
http://www.hermitagemuseum.org

Pushkin Museum of Fine Arts
12 Volkhonka Str.
Moscow
(095) 203 74 12
http://www.museum.ru/gmii

SPAIN
Guggenheim Museum Bilbao
Abandoibarra Et. 2
48001 Bilbao
(94) 435 9080
http://www.guggenheim-bilbao.es

Museo Nacional del Prado
Paseo del Prado,
28014 Madrid
(91) 330 2800, 2900
http://museoprado.mcu.es

SWEDEN
Moderna Museet
Spårvagnshallarna,
Box 16382,
Stockholm 10327
(08) 6664250
http://www.modernamuseet.se

Nationalmuseum
S. Blasieholmshamnen,
Stockholm 10324
(08) 5195 4300
http://www.nationalmuseum.se

SWITZERLAND
For more information, visit
http://www.swissart.ch

Kunstmuseum Bern
Hodlerstrasse 12, 3000 Bern 7
313110944
http://www.kunstmuseumbern.ch

Musée d'Art et d'Histoire
2 rue Charles Gallard,
Geneva 1211
223114340
http://karaart.com/mah

Öffentliche Kunstsammlung Basel, Kunstmuseum
St. Alban-Graben 16,
Basel CH-4010
612066262
http://www.kunstmuseumbasel.ch

Index

Works ascribed to a specific artist or architect are indexed under the artist's or architects's name, shown in SMALL CAPITAL letters. Other works, including buildings and archeological remains, are indexed by site of origin or by culture. See references (e.g., *Hermes, see Praxiteles*) are provided to assist in finding the correct name, site, or culture. The most significant subject references are given in **boldface** type. Illustration references are to figure numbers, not page numbers.

Credits and Copyrights

The author and publisher wish to thank the libraries, museums, galleries, and private collections for permitting the reproduction of works of art in their collections and for supplying the necessary photographs. Photographs from other sources are gratefully acknowledged below. With the exception of page and Primary Source numbers (indicated as p. xxx and PS-XX), all numbers refer to figure numbers.

PHOTOGRAPH CREDITS AND COPYRIGHTS

Harry N. Abrams Archives, New York: 7-32, 22-1; Albertina, Vienna: 17-21; ACL, Brussels: 10-31, 15-3, 15-4, 15-6, 15-22; Adros Studio, Rome: 10-36; AKG, London: 9-11, 9-12, 10-14, 11-3, 21-67; Stefan Brechsel/AKG, London: 11-30; Alison Frantz Collection, American School of Classical Studies, Athens: 5-34, 8-40; Archivi Alinari, Florence: 6-5, 7-4, 7-10, 7-35, 7-36, 7-38, 7-40, 7-42, 8-52, 10-15, 10-29, 11-37, 11-59, 11-64, 12-2, 12-13, 12-18, 12-19, 12-20, 12-27, 12-28, 12-32, 12-37, 12-54, 12-59, 13-1, 13-26, 14-23, 14-24, 14-31, 14-42, 17-8, 17-17, 17-20, 17-23, 17-31; Ronald Sheridan's Ancient Art & Architecture Collection, Pinner, England: 4-13, 5-59; Arcaid/David Churchill, Kingston upon Thames, U.K.: 21-68, 21-69; Andrea/Archivo White Star: 2-26; The Art Archive, London: 19-20; Artothek/Joachim Blauel, Peissenberg, Germany: 13-42, 16-7, 16-11, 16-13, 16-18, 18-2, 18-15, 21-54; **Artothek/Ursula Edelmann, Peissenberg, Germany: Cover (Combined Edition); Alinari, Florence/Art Resource, New York; p. 19, 12-31, 12-52, 13-35;** Cameraphoto-Arte, Venice/Art Resource, New York: 11-40, 13-40, 14-13, 14-25; Erich Lessing/Art Resource, New York: p. 19, 5-13, 8-50, 16-1; Foto Marburg/Art Resource, New York: 5-39, 9-8, 10-8, 10-13, 10-27, 11-8, 11-9, 11-13, 11-22, 11-47, 11-48, 11-52, 17-22, 19-9, 22-32, 22-33, 22-34, 26-5, 26-6, 26-9; The Pierpont Morgan Library/Art Resource, New York: 9-19; **Museum of Modern Art, Mrs. Simon Guggenheim Fund/Art Resource, New York: p. 666;** Scala/Art Resource, New York: 5-36, 7-44, 8-18, 10-25, 11-77, 11-78, 11-88, 11-98, 12-22, 12-48, 12-58, 13-11, 13-31, 13-32, 13-38; The Tate Gallery, London/Art Resource, New York: 22-17, 23-2; James Austin, U.K.: 21-16; Bank of England, London: 21-73; Erika Barahona Ede, Bilbao: 28-7; Foto Barsotti, Florence: 11-61, 11-62; Herbert Bayer Studio, Montecito, California: 27-19; Bayerische Staatsbibliothek, Munich: 9-27, 9-28, 10-42; Benedittine di Priscilla, Roma: 7-10; Jean Bernard, Aix-en-Provence: 11-11, 11-15; Constantin Beyer, Weimar, Germany: 11-53; Bildarchiv Preussischer Kulturbesitz, Berlin: 2-27, 2-28, 3-11, 3-22, 5-74, 5-76, 7-23, 9-29, 15-11, 15-16, 18-12, 21-51, 21-66; Black Star, New York: 27-26; Erwin Böhm, Mainz: 3-4; Lee Boltin Photo Library, Hastings-on-Hudson, New York: 2-29; Boyan & Sear, Glasgow: 23-33; W. Braunfels, *Mittelalterliche . . . Toskana:* 10-39; The Bridgeman Art Library, London: 19-14, PS-63; Brisighelli-Undine, Cividale, Italy: 9-7; The British Museum, London: 5-65, 5-28; British National Tourist Office, New York: 21-70; Jutta Brüdern, Braunschweig: 9-24, 9-25, 10-32; Martin Bühler, Basel: 23-25, 25-9; Photographie Bulloz, Paris: 10-24, 16-28, 21-63; Bundesdenkmalsamt, Vienna: 21-58; Studio C.N.B. & C., Bologna, Italy: 2-30; Caisse Nationale des Monuments Historiques et des Sites/© Arch. Phot. Paris: 1-16, 10-4, 10-21, 10-23, 11-16, 11-21, 11-41, 11-55, 13-14, 13-15, 16-1; Foto Marburg/Caisse Nationale des Monuments Historiques et des Sites: 10-5; René Jacques/Caisse Nationale des Monuments Historiques et des Sites: 11-56; F. Camard, Ruhlmann, *Master of Art Deco:* 26-43; Canali Photobank, Capriolo: p. 35, 316, 5-27, 5-28, 5-44, 5-49, 6-1, 6-8, 6-9, 7-2, 7-18, 7-21, 7-26, 7-31, 7-30, 7-47, 7-48, 7-49, 7-50, 7-51, 7-52, 7-53, 8-7, 8-10, 8-15, 8-16, 8-17, 8-19, 8-24, 8-27, 8-28, 8-29, 8-37, 10-16, 10-18, 10-19, 10-37, 11-33, 11-57, 11-60, 11-63, 11-65, 11-73, 11-76, 11-79, 11-82, 11-83, 11-84, 11-85, 12-5, 12-9, 12-16, 12-29, 12-38, 12-35, 12-50, 12-56, 12-57, 13-3, 13-7, 13-23, 13-27, 13-30, 13-33, 13-43, 14-1, 14-2, 14-8, 14-14, 14-15, 14-21, 14-22, 15-12, 16-16, 16-23, 17-1, 17-2, 17-3, 17-5, 17-7, 17-10, 17-11, 17-12, 17-16, 17-18, 17-29, 17-32, 17-34, 21-45, 21-59; Canali Photobank/Bertoni, Capriolo: 7-15, 11-97, 12-3, 12-8, 12-14, 12-46, 13-12; Canali Photobank/Codato: 8-44, 12-7, 12-17, 12-63; Canali Photobank/ Rapuzzi, Capriolo: 5-6; **Centre des Monuments Nationaux, Paris: 20-1;** Chicago Historical Society: 21-86; Cinémateque Française, Paris: 23-50 a & b; Editions Citadelles & Mazenod, Paris: 2-18; Peter Clayton: 2-12, 2-15, 2-21; Colorphoto Hans Hinz, Alschwill-Basel: 1-3; K. J. Conant, *Carolingian and Romanesque Architecture,* 800–1200: 10-2, 10-10; Paula Cooper Gallery, New York: 24-83, 24-84; Costa and Lockhart, *Persia:* 3-31; The Conway Library/Courtauld Institute of Art, University of London: 9-14, 11-43, 21-11, 22-9; Dennis Cowley, New York: 28-15; Culver Pictures, New York: 21-85; Dagli-Orti, Paris: 2-35, 8-51; D. James Dee, New York: 28-11; Deutsches Archäologisches Institut, Baghdad: 3-1, 3-3; Deutsches Archäologisches Institut, Rome: 7-16, 7-29, 7-39, 7-46, 22-5; Jean Dieuzade [YAN], Toulouse: 10-1, 10-20; Dom- und Diözesanmuseum, Hildesheim: 9-26; M. Droste, *Bauhaus 1919–1933:* 26-25; E. Du Cerceau, *Les Plus Excellents Bâtisements . . . :* 16-25; Dumbarton Oaks Washington, D.C. © Byzantine Visual Resources: 8-40, 8-49; Editoriale Museum/Pedicini, Rome: 7-15; **Egyptian Museum, Cairo/Preussischer Kulturbesitz: p.32;** Nikos Kontos Courtesy of Ekdotike Athenon, Athens: 8-39; English Heritage Photo Library, London: 21-8, 21-19; ESTO/© Peter Aaron, Mamaroneck, New York: 28-1; ESTO/© Peter Mauss, Mamaroneck, New York: 28-6; ESTO/© Ezra Stoller, Mamaroneck, New York: 25-32, 26-33, 26-34, 26-35, 26-42; Fischbach Gallery, New York: 25-22; B. Fletcher, *A History of Architecture:* 5-29; **Foster and Partners/Nigel Young: 26-48;** Fotocielo, Rome: 17-15; Fototeca Unione, American Academy, Rome: 5-29, 7-6, 7-8, 7-34; Peter Fowles, Glasgow: 23-34; © Klaus Frahm, Hamburg: 28-5; G. De Francovich, Rome: 10-30; H. Frankfort, *The Art and Architecture of the Ancient Orient:* 3-2; John R. Freeman, Limited, London: 12-60; French National Tourist Board, Paris: 21-61; Gabinetto Fotografico Nazionale, Rome: 14-30, 17-6, 17-28, 19-17; Gabinetto Nazionale delle Stampe, Rome: 13-24, 13-25; Henry Gaud, Molsenay: 11-20; G.E.K.S., New York: 26-39, 26-40, 7-37, 17-24, 26-20, 26-21, 26-29, 27-7; Philip Gendreau, New York: 22-35; G. Gherardi/A. Fioretti, Rome: 26-36, 26-37; Photographie Giraudon, Paris: 10-26, 11-23, 11-42, 11-94, 13-6, 16-27, 20-3, 21-12, 21-75, 21-78, 22-36, 23-9; P. Gössel and G. Leuthäuser, *Architecture in the Twentieth Century:* 26-44, 28-2; © Gianfranco Gorgoni, New York: 25-34; Edward V. Gorn, New York: 8-45; Foto Grassi, Siena: 11-74, 11-58, PS-6; The Green Studio, Limited, Dublin: 9-4; Dr. Reha Günay, Istanbul: 8-56, 8-57; President and Fellows of Harvard College, Harvard University/Michael Nedzweski: 21-30; Hedrih-Blessing/Bill Engdahl, Chicago: 26-1; Hirmer Fotoarchiv, Munich: 1-7, 2-3, 4-14, 5-12, 5-17, 5-23, 5-24, 5-33, 5-37, 5-40, 5-45, 5-46, 5-50, 5-52, 5-53, 5-54, 5-81, 5-82, 5-83, 5-84, 5-85, 6-2, 6-4, 6-6, 7-33, 7-45, 8-11, 8-35, 12-1, 12-4, 13-13, 13-22, 15-23; H. R. Hitchcock, *Architecture: Nineteenth and Twentieth Centuries:* 21-76, 23-32; Foto Karl Hoffmann, Speyer: 10-14; © Angelo Hornak Library, London: 14-26; Christian Huelsen, *Il Libro di Giuliano da Sangallo:* 12-24; Timothy Hursley: 28-3; Araldo de Luca/ IKONA, Rome: 7-41; Raffaello Bencini/IKONA, Rome: 11-38; Instituto di Etruscologia e Antichità Italiche, University of Rome: 1-5; *Jahrbuch des Deutschen Werkbundes (1915):* 23-35, 23-60, 26-7, 26-8; Anthony F. Janson: 21-18, 24-70; H. W. Janson: 11-32, 12-23, 23-27, 24-72; Bruno Jarret/ARS, New York/ADAGP, Paris: 22-30, 22-32; S. W. Kenyon, Wellington, U.K.: 1-9, 1-10; A. F. Kersting, London: 10-9, 11-28, 19-10; Jörg Klam, Berlin: 24-6; © Studio Kontos, Athens: 4-5, 4-6, 4-11, 4-12, 4-17, 4-18, 4-19, 4-21, 5-3, 5-11, 5-14, 5-16, 5-31, 5-35, 5-43, 5-47, 5-68, 5-51, 5-61, 5-70, 5-79, PS-3; S. N. Kramer, *History Begins at Sumer:* 3-12; Studio Koppermann, Gauting, Germany: 5-5, 5-63, 5-75; R. Krautheimer: *Early Christian and Byzantine Architecture:* 8-4; Kurt Lange, Oberstdorf, Allgäu, Germany: 2-1, 2-2; Ivan Lapper P., English Heritage Photo Library, London: 1-19; Lautman Photography, Washington, D.C.: 21-20; A.W. Lawrence, *Greek Architecture:* 5-32; William Lescaze, New York: 26-27; Library of Congress, Washington, D.C.: 21-44; Ralph Liberman: 11-39; Lichtbildwerkstätte Alpenland, Vienna: 8-20, 8-23, 10-6, 12-61, 14-3, 14-11, 14-19, 16-14, 16-21, 16-22; Maya Lin, New York: 25-33 ; Jannes Linders, Rotterdam: 26-11, 26-13; The Louvre, Paris: 16-30; Magnum, New York: 27-17; Barbara Malterm, Rome: 5-73; Marlborough Gallery, New York: 25-38; Alexander Marshak, New York: 1-6; Arxiu MAS, Barcelona: 15-14, 15-14, 17-35, 18-3, 21-23, 21-25, 21-36; Foto Maye, Vienna: 15-20; © Rollie McKenna, Stonington, Connecticut: 12-27; Arlette and James Mellaart, London: 1-11, 1-12, 1-13; H. Millon, *Key Monuments in the History of Art:* 11-31, 13-28, 17-25; Ministry of Culture/Archaeological Receipts Fund (Service T.A.P.), Athens: 5-60; Ministry of Public Buildings and Works, London: 1-17, 1-18, 21-14; Monumenti, Musei, e Gallerie Pontificie, Vatican City, Rome: 5-69, 6-11, 7-28; © Museum of Modern Art, New York: 26-14, 26-15; Ann Münchow, Domkapitel Aachen: 9-9; National Buildings Record, London: 11-26, 11-27, 19-21, 19-23, 21-74; **National Gallery of Art, Washington DC: p. 402** Otto Nelson, New York: 24-69; Richard Nickel, Chicago: 23-38, 23-39, 23-40, 23-41; Nippon Television Network Corporation, Tokyo: 13-17, 13-18, 13-19, 13-20, 13-21; © Takashi Okamura, Shizuoka City, Japan: 11-67, 11-98, 12-10, 12-11, 12-12, 12-25, 12-45, 13-36; Bill Orcutt Studios, New York: 28-17; The Oriental Institute of the University of Chicago: 3-6, 3-21, 3-26, 3-28; Oroñoz, Madrid: 13-37, 16-19, 20-25, 23-31; Pace Wildenstein Gallery/Bill Jacobsen, New York: 25-24; Gustav Peichl, Vienna: 26-43; N. Pevsner, *Outline of European Architecture:* 12-26; Erich Pollitzer, New York: 23-12; Winslow Pope/Michigan Consolidated Gas Company, Detroit, Michigan: 26-26; Port Authority, New York: 21-65; Josephine Powell, Rome: 8-50; © Museo del Prado: 15-10; Provinciebestuur van Antwerpen: 18-16; Pubbli Aer Foto, Milan: 7-3, 8-45; Antonio Quattrone (Courtesy of Olivetti), Florence: 12-40, 12-41, 12-42, 12-43; Mario Quattrone Fotostudio, Florence: 11-72, 11-80, 12-53, 14-4, 14-7, PS-3; Studio Rémy, Dijon, France: 11-91; © Réunion des Musées Nationaux, Paris: 1-8, 2-16, 3-13, 3-14, 3-16, 3-23, 3-27, 5-4, 5-7, 5-8, 5-9, 5-13, 5-77, 8-38, 8-53, 11-81, 11-92, 12-56, 13-2, 13-4, 13-29, 13-41, 15-19, 16-15, 17-9, 18-6, 18-23, 19-2, 19-3, 19-26, 20-4, 20-5, 20-7, 20-8, 21-1, 21-26, 21-28, 21-31, 21-32, 21-39, 21-42, 21-62, 22-2, 22-3, 22-4, 22-10, 22-11, 22-19, 22-20, 23-16, 23-17, 24-30, PS-2; © Réunion des Musées Nationaux, Paris/G. Blot/ C. Lean: PS-60; © Réunion es Musées Nationaux, Paris/H. Lewndowski: 15-5, 21-33; Rheinisches Bildarchiv, Cologne: 9-20, 9-21, 24-77, 25-35; **Rheinisches Landesmuseum, Bonn:p.222;** Ekkehard Ritter, Vienna: 10-40, 10-41; Photographie Roger-Viollet, Paris: 16-24, 21-77, 23-30, 26-23; Richard Ross: 28-12, 28-13; Jean Roubier, Paris: 7-9, 10-3, 11-5, 11-44, 11-45, 11-46, 11-49; Routhier/Studio Lourmel, Paris: 22-12; The Royal Collection Enterprises, Windsor Castle: 13-5, 14-12, 20-26; Sächsische Landesbibliothek, Deutsche Fotothek, Dresden: 11-51; Goro Sakamoto, Kyoto, Japan: 3-15; Armando Salas, Portugal: 25-21; Scala, Florence: 11-86, 11-97, 14-10, 17-8, 21-24, 21 27, PS-55; Toni Schneiders, Lindau, Germany: 20-21, 20-23; Silvestris Photo-Service, Kastl, Germany: 20-19; Aaron Siskind: 27-24; Haldor Sochner, Munich: 14-17; Société Archeologique et Historique, Avesnes-sur-Helpe: 10-38; Société Française de Photographie, Paris: 21-80; Holly Solomon Gallery, New York: 25-41; Soprintendenza Archaeologica, Ministero per i Beni Culturali Ambientali, Rome: 6-10; Soprintendenza Archaeologica all'Etruria Meridionale, Tarquinia: 6-3; Soprintendenza dei Monumenti, Pisa: 11-87; Spectrum Color Library, London: 16-32, 26-46, 26-47; Sperone Westwater Gallery, New York: 24-81; Stiftsbibliothek, St. Gallen, Switzerland: 9-13; Franz Stoedtner, Düsseldorf: 23-29; A. Stratton: *Life . . . : 19-22;* Adolph Studley, Pennsburg, Pennsylvania: 23-28; Wim Swaan: p. 32, 2-6, 2-8, 2-9, 2-13, 2-22 (and Cover,Volume 1), 2-25, 2-32, 2-33, 3-17, 3-30, 10-7, 10-17, 11-1, 11-6, 11-7, 11-17, 11-24, 17-13, 17-26, 19-11, 19-12, 19-13, 20-17; © Jean Clothes, SYGMA, New York: 1-1; Kenneth Frampton, *Modern Architecture,* Thames & Hudson, 3rd rev. ed.: 26-30; J. W. Thomas, Oxford: 11-50; Richard Todd, Los Angeles: 28-8; Marvin Trachtenberg, New York: 5-39, 8-34, 8-43, 11-35, 12-33, 14-27, 19-15, 20-20, 26-18, 26-31, 26-32; University Library, Uppsala, Sweden: 16-20; © University Museum of National Antiquities, Oslo: p. 224, 9-2; Vatican Library, Rome: 8-5, 8-6; Jean Vertut, Issy-les-Moulineaux: 1-2; Robert Villani: 26-2, 26-12; John B. Vincent, Berkeley, California: 14-29; Wolfgang Volz © Christo: 25-35; Leonard von Matt, Buochs, Switzerland: 9-16, 10-28; © Elke Walford, Hamburg: 11-96, 21-52, 21-53; Denise Walker, Baltimore: 21-71, 21-72; **Wallace Collection, London: p.404;** Clarence Ward: 11-4; © Lewis Watts, Anselmo, California: 28-14; Etienne Weil, Jerusalem: p. 677, 25-2, 26-45; Werner Forman Archive, London: 5-59; Whitaker Studios, Richmond,Virginia: 21-13; Joachim Wilke, Stuttgart: 21-15; David Wilkins, Pittsburgh: 12-6; Ole Woldbye, Copenhagen: 21-60; © CORBIS/Roger Wood, Bellevue, Washington: 4-4; Woodfin Camp & Associates, New York: 11-10; (former) Yugoslav State Tourist Office, New York: 7-24; © Arq. Sergio Zepeda C., Guadalajara, Jalisco, Mexico: 24-52; O. Zimmerman, Colmar, France: 16-1, 16-2 , 16-3; © Gerald Zugmann, Vienna: 28-4; Foto Zwicker-Berberich, Gerchsheim/Würzburg, Germany: 20-10.

TIMELINE PHOTO CREDITS

BOX PHOTO CREDITS

PRIMARY SOURCE TEXT CREDITS

SINGLE PC LICENSE AGREEMENT AND LIMITED WARRANTY

READ THIS LICENSE CAREFULLY BEFORE OPENING THIS PACKAGE. BY OPENING THIS PACKAGE, YOU ARE AGREEING TO THE TERMS AND CONDITIONS OF THIS LICENSE. IF YOU DO NOT AGREE, DO NOT OPEN THE PACKAGE. PROMPTLY RETURN THE UNOPENED PACKAGE AND ALL ACCOMPANYING ITEMS TO THE PLACE YOU OBTAINED THEM [[FOR A FULL REFUND OF ANY SUMS YOU HAVE PAID FOR THE SOFTWARE]]. THESE TERMS APPLY TO ALL LICENSED SOFTWARE ON THE DISK EXCEPT THAT THE TERMS FOR USE OF ANY SHAREWARE OR FREEWARE ON THE DISKETTES ARE AS SET FORTH IN THE ELECTRONIC LICENSE LOCATED ON THE DISK:

1. GRANT OF LICENSE AND OWNERSHIP: The enclosed computer programs <<and data>> ("Software") are licensed, not sold, to you by Pearson Education, Inc. publishing as Prentice Hall ("We" or the "Company") and in consideration [[of your payment of the license fee, which is part of the price you paid]] [[of your purchase or adoption of the accompanying Company textbooks and/or other materials,]] and your agreement to these terms. We reserve any rights not granted to you. You own only the disk(s) but we and/or our licensors own the Software itself. This license allows you to use and display your copy of the Software on a single computer (i.e., with a single CPU) at a single location for academic use only, so long as you comply with the terms of this Agreement. You may make one copy for back up, or transfer your copy to another CPU, provided that the Software is usable on only one computer.

2. RESTRICTIONS: You may not transfer or distribute the Software or documentation to anyone else. Except for backup, you may not copy the documentation or the Software. You may not network the Software or otherwise use it on more than one computer or computer terminal at the same time. You may not reverse engineer, disassemble, decompile, modify, adapt, translate, or create derivative works based on the Software or the Documentation. You may be held legally responsible for any copying or copyright infringement that is caused by your failure to abide by the terms of these restrictions.

3. TERMINATION: This license is effective until terminated. This license will terminate automatically without notice from the Company if you fail to comply with any provisions or limitations of this license. Upon termination, you shall destroy the Documentation and all copies of the Software. All provisions of this Agreement as to limitation and disclaimer of warranties, limitation of liability, remedies or damages, and our ownership rights shall survive termination.

4. LIMITED WARRANTY AND DISCLAIMER OF WARRANTY: Company warrants that for a period of 60 days from the date you purchase this SOFTWARE (or purchase or adopt the accompanying textbook), the Software, when properly installed and used in accordance with the Documentation, will operate in substantial conformity with the description of the Software set forth in the Documentation, and that for a period of 30 days the disk(s) on which the Software is delivered shall be free from defects in materials and workmanship under normal use. The Company does not warrant that the Software will meet your requirements or that the operation of the Software will be uninterrupted or error-free. Your only remedy and the Company's only obligation under these limited warranties is, at the Company's option, return of the disk for a refund of any amounts paid for it by you or replacement of the disk. THIS LIMITED WARRANTY IS THE ONLY WARRANTY PROVIDED BY THE COMPANY AND ITS LICENSORS, AND THE COMPANY AND ITS LICENSORS DISCLAIM ALL OTHER WARRANTIES, EXPRESS OR IMPLIED, INCLUDING WITHOUT LIMITATION, THE IMPLIED WARRANTIES OF MER-CHANTABILITY AND FITNESS FOR A PARTICULAR PURPOSE. THE COMPANY DOES NOT WARRANT, GUARANTEE, OR MAKE ANY REPRESENTATION REGARDING THE ACCURACY, RELIABILITY, CURRENTNESS, USE, OR RESULTS OF USE, OF THE SOFTWARE.

5. LIMITATION OF REMEDIES AND DAMAGES: IN NO EVENT, SHALL THE COMPANY OR ITS EMPLOYEES, AGENTS, LICENSORS, OR CONTRACTORS BE LIABLE FOR ANY INCIDENTAL, INDIRECT, SPECIAL, OR CONSEQUENTIAL DAMAGES ARISING OUT OF OR IN CONNECTION WITH THIS LICENSE OR THE SOFTWARE, INCLUDING FOR LOSS OF USE, LOSS OF DATA, LOSS OF INCOME OR PROFIT, OR OTHER LOSSES, SUSTAINED AS A RESULT OF INJURY TO ANY PERSON, OR LOSS OF OR DAMAGE TO PROPERTY, OR CLAIMS OF THIRD PARTIES, EVEN IF THE COMPANY OR AN AUTHORIZED REPRESENTATIVE OF THE COMPANY HAS BEEN ADVISED OF THE POSSIBILITY OF SUCH DAMAGES. IN NO EVENT SHALL THE LIABILITY OF THE COMPANY FOR DAMAGES WITH RESPECT TO THE SOFTWARE EXCEED THE AMOUNTS ACTUALLY PAID BY YOU, IF ANY, FOR THE SOFTWARE OR THE ACCOMPANYING TEXTBOOK. BECAUSE SOME JURISDICTIONS DO NOT ALLOW THE LIMITATION OF LIABILITY IN CERTAIN CIRCUMSTANCES, THE ABOVE LIMITATIONS MAY NOT ALWAYS APPLY TO YOU.

6. GENERAL: THIS AGREEMENT SHALL BE CONSTRUED IN ACCORDANCE WITH THE LAWS OF THE UNITED STATES OF AMERICA AND THE STATE OF NEW YORK, APPLICABLE TO CONTRACTS MADE IN NEW YORK, AND SHALL BENEFIT THE COMPANY, ITS AFFILIATES AND ASSIGNEES. THIS AGREEMENT IS THE COMPLETE AND EXCLUSIVE STATEMENT OF THE AGREEMENT BETWEEN YOU AND THE COMPANY AND SUPERSEDES ALL PROPOSALS OR PRIOR AGREEMENTS, ORAL, OR WRITTEN, AND ANY OTHER COMMUNICATIONS BETWEEN YOU AND THE COMPANY OR ANY REPRESENTATIVE OF THE COMPANY RELATING TO THE SUBJECT MATTER OF THIS AGREEMENT. If you are a U.S. Government user, this Software is licensed with "restricted rights" as set forth in subparagraphs (a)-(d) of the Commercial Computer-Restricted Rights clause at FAR 52.227-19 or in subparagraphs (c)(1)(ii) of the Rights in Technical Data and Computer Software clause at DFARS 252.227-7013, and similar clauses, as applicable.

Should you have any questions concerning this agreement or if you wish to contact the Company for any reason, please contact in writing:
Social Sciences Media Editor, Prentice Hall, One Lake Street, Upper Saddle River, NJ 07458.